Giorgio Vasari

Giorgio VASARI

Architect and Courtier

LEON SATKOWSKI

with photographs by Ralph Lieberman

Princeton University Press Princeton, New Jersey

Copyright © 1993 by Princeton University Press
Published by Princeton University Press,
41 William Street, Princeton, New Jersey 08540
In the United Kingdom: Princeton University Press,
Chichester, West Sussex

Library of Congress Cataloging-in-Publication Data
Satkowski, Leon George, 1947-
Giorgio Vasari : architect and courtier / Leon Satkowski ; with
photographs by Ralph Lieberman.
p. cm.
Includes bibliographical references and index.
ISBN 0-691-03286-6
1. Vasari, Giorgio, 1511-1574—Criticism and interpretation.
2. Architecture, Renaissance—Italy. 3. Architects and patrons—Italy.
4. Italy—Courts and courtiers. I. Title.
NA1123.V38S26 1993
720′.92—dc20 92-46795 CIP

Publication of this book has been aided by
a grant from the Millard Meiss Publication Fund of the
College Art Association of America

This book has been composed in Galliard.

Princeton University Press books are printed on acid-free paper and meet
the guidelines for permanence and durability of the Committee on
Production Guidelines for Book Longevity of the Council on Library Resources

Printed in the United States of America

10 9 8 7 6 5 4 3 2 1

Designer Mina Greenstein
Production Coordinator Anju Makhijani
Editor Timothy Wardell

FOR CHRISTINA AND JANE

Contents

LIST OF FIGURES

LIST OF PLATES

18. Rome, Del Monte Chapel, alternative design by Vasari. Paris, Louvre, Inv. 2198 (Réunion des Musées Nationaux).

19. Del Monte Chapel, general view (Ralph Lieberman).

20. Del Monte Chapel, detail showing effigy of Antonio del Monte and figure of Religion (Ralph Lieberman).

21. Del Monte Chapel, detail of tabernacle (Ralph Lieberman).

22. Del Monte Chapel, *Ananias Healing the Blinded Saul* by Vasari, 1551 (Rome, ICCD, E 35375).

23. Del Monte Chapel as seen from the nave of San Pietro in Montorio (Ralph Lieberman).

24. Del Monte Chapel, main tabernacle (Ralph Lieberman).

25. *Ananias Healing the Blinded Saul*, detail of lower left-hand corner showing self-portrait of Vasari (Ralph Lieberman).

26. Raphael, *Transfiguration*, Pinacoteca, Vatican Museums (Alinari/Art Resource, Anderson 1063).

27. Andrea Palladio, fanciful reconstruction of the Temple of Fortuna Primigenia at Palestrina. London, British Architectural Library, Palladio IX/7 (British Architectural Library/RIBA, London).

28. Rome, San Pietro in Montorio, Ricci Chapel by Daniele da Volterra, 1560s (Ralph Lieberman).

29. Rome, Villa Giulia, 1551–55, exterior view of casino by Vignola (Satkowski).

30. D. Boguet, view of the Villa Giulia in the eighteenth century. Rome, Gabinetto dei disegni e delle stampe, Villa Farnesina, FN 5944 (Istituto Nazionale per la Grafica).

31. Arezzo, Casa Vasari, fresco by Vasari showing landscape with the Basilica of Maxentius (Arezzo, Soprintendenza).

32. Onofrio Panvinio, map of Ancient Rome, 1565, detail showing site of the Villa Giulia (Satkowski).

33. Villa Giulia, garden court by Ammannati (Ralph Lieberman).

34. Villa Giulia, facade of the loggia c. 1690, drawing attr. to G-M. Oppenordt. Rome, Villa Giulia (Rome, Soprintendenza Etruria Meridionale, 1323).

35. Villa Giulia, composite image showing left, detail of loggia (Ralph Lieberman), and right, drawing by an anonymous sixteenth-century French(?) draftsman showing proposed decoration. Stockholm, Nationalmuseum, CC 1380 (Stockholm, Staten Konstmuseer).

36. Villa Giulia, detail of side walls of garden court (Ralph Lieberman).

37. Villa Giulia, detail of central part of loggia (Ralph Lieberman).

38. Villa Giulia, nympheum by Ammannati and Vasari, engraving (Bibliotheca Hertziana, U. Fi. CI 7d).

39. Villa Giulia, nympheum by Ammannati and Vasari, detail of lowest level (Ralph Lieberman).

40. Villa Giulia, nympheum, view towards loggia (Ralph Lieberman).

41. Villa Giulia, drawing of unexecuted scheme for nympheum court. Stockholm, National Museum, CC 1358 (Stockholm, Statens Konstmuseer).

42. Vatican Palace, Sala Regia, detail of north wall (Rome, ICCD, E 73637).

43. Florence, aerial view of Piazza della Signoria, the Palazzo Vecchio, the Uffizi, and surrounding area (Florence, Soprintendenza per i beni ambientali e architettonici, 75105).

44. Piazza della Signoria, view towards San Pier Scheraggio. Detail of Piero di Cosimo (attr.), *Portrait of a Warrior*, c. 1504 (London, National Gallery, Cat. no. 895).

45. Florence, Via della Ninna, bays of San Pier Scheraggio still visible in the ground floor of the Uffizi (Ralph Lieberman).

46. Piazza della Signoria, design by Francesco da Sangallo for an extended version of the Loggia della Signoria, c. 1546. Florence, Uffizi, 1683 A (Florence, Gabinetto Fotografico, 147758).

47. Piazza della Signoria, view of *strada nuova* opened in 1546. From *Entry of Pope Leo X into Florence* by Vasari, c. 1561–62, Palazzo Vecchio, Sala di Leone X (Ralph Lieberman).

48. Florence, proposal by Francesco da Sangallo for a building on the site of the *strada nuova*. Florence, Uffizi, 7958 A (Florence, Gabinetto Fotografico, 163261).

49. Uffizi, rejected first design by Vasari. Drawing by Giorgio Vasari il Giovane. Florence, Uffizi, 4881A (Florence, Gabinetto Fotografico, 107798).

191. Florence, Santa Maria Novella, interior (Ralph Lieberman).

192. Florence, Santa Croce, interior (Ralph Lieberman).

193. Santa Croce, reconstruction of nave with *tramezzo* (Satkowski).

194. Santa Maria Novella, engraving showing Vasari's (destroyed) tabernacles in 1724 for the funeral of King Louis I of Spain (Florence, Kunsthistoriches Institut, 3336).

195. Florence, San Lorenzo, Laurentian Library by Michelangelo, detail of doorway (Ralph Lieberman).

196. Santa Croce, details of altars in left and right aisles (Ralph Lieberman).

197. Rome, Pantheon, details of aedicular tabernacles (Ralph Lieberman).

198. Siena, San Domenico, project by B. Peruzzi for the reconstruction of the nave. Florence, Uffizi, 342 A (Florence, Gabinetto Fotografico, 11510).

199. Arezzo, San Francesco, interior (Arezzo, Soprintendenza).

200. Santa Croce, nineteenth-century engraving of nave (Florence, Kunsthistoriches Institut 23952).

201. Santa Croce, ciborium by Vasari begun 1567, now in Museo di Santa Croce (Alinari/Art Resource, Alinari 2191).

202. Rome, temporary archway for entry adjacent to Palazzo Venezia, 1536. Detail of drawing by Antonio da Sangallo the Younger. Florence, Uffizi, 1269A (Florence, Gabinetto Fotografico).

203. Florence, view along Via Mazzetta (Ralph Lieberman).

204. Florence, Boboli Gardens, Grotta Grande begun by Vasari, 1556–60 (Ralph Lieberman).

205. Giusto Utens, lunette depicting Medici Villa at Castello, 1599. Museo Firenze com'era (Alinari/Art Resource, Alinari 66610).

206. Castello, view of garden and surrounding countryside towards the south (Ralph Lieberman).

207. Castello, Appennino by Ammannati, 1563–65 (Ralph Lieberman).

208. Castello, interior of grotto (Ralph Lieberman).

209. Castello, drawing for grotto by Tribolo. Berlin, Staatliche Museen Preussischer Kulturbesitz, Kupferstichkabinett (Anders).

210. Triumphal entry of Johanna of Austria, archway at Canto alla Paglia. A: View of site (Ralph Lieberman). B: Plan and elevation of archway by Vincenzo Borghini. Florence, Biblioteca Nazionale Centrale, Cod. magl. II. X. 100, fols. 77v-78 (Sansoni).

211. Triumphal entry of Johanna of Austria, archway in Via dei Gondi. A: site (Ralph Lieberman). B. drawing of archway by Vincenzo Borghini, Florence, Biblioteca Nazionale Centrale, Cod. magl. II. X. 100, fol. 53v (Sansoni).

212. Florence, triumphal entry of Johanna of Austria, archway at entrance to the Borgo Ognissanti. A: Site (Ralph Lieberman). B: Drawing of archway by Vasari. Rome, Hebald Collection (Edmund P. Pillsbury).

213. Triumphal entry of Johanna of Austria, archway in Via dei Tornabuoni. A: Site (Ralph Lieberman). B: Drawing of archway by Borghini. Florence, Biblioteca Nazionale Centrale, Cod. magl. II. X. 100, fol. 78v (Sansoni).

214. Triumphal entry of Johanna of Austria. Amphitheater at Canto dei Carnesecchi. A: Site (Ralph Lieberman). B: Drawing of amphitheater by Borghini. Florence, Biblioteca Nazionale Centrale, Cod. magl. II. X. 100, fol. 57v (Sansoni).

215. Triumphal entry of Johanna of Austria, archway in Via dei Leoni. A: Site (Ralph Lieberman). B: Drawing of archway by Borghini. Florence, Biblioteca Nazionale Centrale, Cod. magl. II. X. 100, fol. 97v (Sansoni).

216. Triumphal entry of Johanna of Austria, construction at Porta al Prato. A: Site (Ralph Lieberman). B: Plan of construction by Borghini. Florence, Biblioteca Nazionale Centrale, Cod. magl. II. X. 100, fol. 47v (Sansoni).

217. Triumphal entry of Johanna of Austria, temporary facade on the Palazzo Ricasoli. A: Exterior of Palazzo Ricasoli (Ralph Lieberman). B: Alternative proposal, drawing by Borghini. Florence, Biblioteca Nazionale Centrale, Cod. magl. II. X. 100, fol. 49v (Sansoni). C: Alternative proposal, drawing by Vasari (attr.). Paris, Louvre, Inv. 11082 (Réunion des Musées Nationaux).

218. Serlio, renovation of a palace exterior (*Libro Settimo*, 157).

219. Triumphal entry of Johanna of Austria, screen wall at Ponte Santa Trinita. A: Site (Ralph Lieberman). B: Drawing of wall by Borghini. Florence, Biblioteca Nazionale Centrale, Cod. magl. II. X. 100, fol. 50 (Sansoni).

ACKNOWLEDGMENTS

Some words must be written about the origins of this book and the particular approach to Vasari's architecture that I have taken. Its purpose is to demonstrate Vasari's architecture in light of his capacity as architect to the courts of Pope Julius III and Duke Cosimo I de'Medici. The emphasis throughout is critical and analytical. Other kinds of books could have been written—a standard catalog of his buildings, an architectural biography based on archival documentation, an integral study of his architecture and decoration, or an account of his interaction with contemporaries—but none of these would uncover the essence of his work in its intersection of an ambitious, well-educated artist with powerful patrons. If Vasari's architecture derives much of its meaning from its physical and historical context, then modern perceptions of its style as derivative and the society it served as politically authoritarian have created hurdles to its appreciation. Like the fabled report of Mark Twain's death, the decline of Florence's creativity at the end of the sixteenth century is an exaggeration.

My interest in Vasari as an architect began in numerous conversations with my undergraduate teachers at Cornell University, most particularly with Colin Rowe and Michael Dennis. At Harvard University I was fortunate to have completed my doctoral dissertation on Vasari's architecture under James S. Ackerman, who has continued to provide me with counsel, information, and inspiration long after my departure from Cambridge. The thesis had a few virtues and all the vices of such a study—especially in its numerous factual errors and youthful enthusiasm of overconfident interpretations. I however do not regret my decision in 1979 to publish the study in dissertation format because whatever useful information it contained was made public without additional delay. Nonetheless I still planned to write a full-scale study on Vasari *architetto* sometime in the future, and the project was placed on the shelf to allow me to review the scholarship on Vasari that had grown alarmingly over the intervening years.

After working on other topics I returned to Vasari's architecture during a fellowship to Villa I Tatti, the Harvard University Center for Italian Renaissance Studies. During a visit to London in 1982 I met the late Anthony Blunt who encouraged me to begin work on the monograph that I had planned to write. Although his death a month later brought the

project to a momentary halt, it was Professor Blunt's urging that allowed me to begin work in earnest on the present publication.

It is a pleasure to recognize the institutions that have supported this endeavor. First and foremost, a National Endowment for the Humanities fellowship to Villa I Tatti in 1982–83 allowed me to enjoy the company of its fellows, the resources of its library, the Biblioteca Berenson, and the invaluable assistance of its talented staff. Its director, Craig Hugh Smyth, provided a stimulating environment and over the years listened kindly to my thoughts on Vasari. The American Academy in Rome deserves thanks for providing shelter and free access to its library in 1974–75 and again in 1990 that allowed my initial studies on Vasari to begin and the final research for the book to be completed. Its directors during my visits, Henry A. Millon and Joseph Connors, continue to be both teachers and friends in their discussions of problems, arranging of visits and research permits, and, above all, exacting and impeccably high standards of their own scholarships.

I owe much to numerous research facilities in Europe and the United States. In Florence, most of the work has been carried out at the Kunsthistoriches Institut, where Margaret Daly Davis has always been helpful. More recently, the Biblioteca Berenson at Villa I Tatti has provided a base for study, a task that was greatly enriched by the assistance of Anna Terni, Amanda George, and Fiorella Superbi. Lucilla Marino at the American Academy in Rome also deserves special recognition. I extend my thanks as well to the librarians and staff of the Biblioteca Vaticana, Biblioteca Hertziana in Rome, and Biblioteca Communale in Arezzo, Biblioteca Nazionale Centrale and Biblioteca Ricciardiana in Florence, and the British Library in London. Robert Babcock of the Beinecke Rare Book and Manuscript Library, Yale University, allowed me to consult the Vasari material from the Spini family archive in Florence. Lesley Le Claire, the Librarian of Worcester College, Oxford University, permitted extensive consultation of Inigo Jones' annotations to his copy of Vasari's *Lives*. Catherine Monbeig-Goguel at the Louvre, Lucia Monaci Moran at the Gabinetto Disegni e Stampe degli Uffizi, Neil R. Bingham of the British Architectural Library, and Ulf Cederlöf of the Nationalmuseum in Stockholm assisted me in the study of the architectural drawings.

The libraries of the University of Minnesota are uncommonly rich in material pertinent to this book. They include the central library for humanities and the social sciences. O. M. Wilson Library, the Biomedical Library, and the Wangensteen History of Medicine and Biology Library. Joon Mornes and Gerry Warner of the Architecture Library patiently listened to my requests and fulfilled all of them. The staff of the Interlibrary Loan Office in Wilson Library provided incalculable assistance in obtaining obscure books and articles. I was fortunate to have at my disposal the pre-eminent Benedictine monastic and university library in North America, that of St. John's University in Collegeville, Minnesota, which contains an extraordinary collection on all aspects of Church history.

The University of Minnesota also provided financial support toward the completion of this book. A generous grant in 1986 allowed for travel and research material, the funds for which were contributed by the Central Administration, the Institute of Technology and its Dean, Ettore F. Infante, and the School of Architecture and Landscape Architecture and its Head, Harrison Fraker, Jr. The Graduate School provided funds for travel, final research, and photographic rights.

From the outset it was clear that any publication on Vasari's architecture would require new architectural drawings to demonstrate the complexity of his buildings and new photography to illustrate the visual and contextual solutions that he created. A grant from the National Endowment for the Arts in 1985–86 allowed for the preparation of various site plans, building plans, sections, and reconstructions that were drawn by Karin Kilgore and John Enright. Additional drawings were executed by Linda Hamann.

Photography was an altogether more difficult problem. Because Vasari's buildings (and especially the Uffizi) are known primarily from photographs made at the end of the last century, they are seen through the haze of a late-Romantic filter that emphasizes the familiar grand views at the expense of details, interior spaces, and the general urban context of his structures. The Samuel H. Kress Foundation and the Graham Foundation for the Fine Arts provided funds for specially commissioned photographs that were made by Ralph Lieberman during an intense campaign of work in July and August 1991. I cannot sufficiently thank these foundations for their support of this project, nor can I adequately express my gratitude to Ralph for his unmistakable contribu-

tions to this book. Ralph's keen critical eye accounts for the splendid photographs that describe the ideas in my text. His sharp mind caught lapses in my arguments, and long discussions at sites or on the autostrada sharpened many points. An ironically profound joy was to see the first results of our collaboration—undertaken at the height of one of the hottest Italian summers in recent years—during a Minnesota blizzard in October.

Obtaining permits for our photographic campaign was facilitated by Silvia Meloni Trkulja, the director of the Gabinetto Fotografico of the Soprintendenza Beni Aristici e Storici, who graciously took considerable time from her own responsibilities to arrange for *permessi* in Florence and elsewhere. Anna Maria Petrioli Trofani, the Director of the Uffizi, kindly permitted the full inspection of the entire structure, including the important ground-floor chambers once belonging to the magistracies and recently vacated by the Archivio di Stato. Signor Leo, the *Casiere* of the Uffizi, patiently acceded to our repeated requests for rephotography at those moments when the light would be perfect. Franco Sottani kindly allowed us to work within the Palazzo Vecchio at our convenience. Permission to photograph in and around Arezzo required the assistance of Anna Maria Maetzke and Carlo Corsi Migliaia from the Soprintendenza, and from Father Pieri at the Curia Vescovile. Francesca Boitani Visentini allowed repeated visits to the Villa Giulia and also provided important photographs. Don Massimo Battignani regularly allowed access to the upper areas of the cupola of the Madonna dell' Umilità in Pistoia. Karin Einaudi of the Fototeca Unione at the American Academy also helped in obtaining photographs from several sources in Rome. David Bowers, architect and scholar of Louis Sullivan, took time from his own practice to make photographic prints from my own dull negatives. At the last minute Candace Adelson acquired important photographs on my behalf in Florence. All have my heartfelt gratitude.

Numerous individuals have helped by providing advice, offering information and bibliographic references, acquiring photographs, or by reading parts of this manuscript. Among those I should like to thank are James S. Ackerman, Nicholas Adams, Lee B. Anderson, Joel L. Bostick, Howard Burns, Charles Burroughs, Joseph A. Burton, Jean Cadogan, Malcolm Campbell, Giancarlo Cataldi, Bruce Coleman, Joseph Connors, Gino Corti, Laura Corti, Rebecca Drasin, Peter Dreyer, George Gorse, Francesco Gurrieri, Beth Holman, Charles Hope, Eva Karwacka Codini, Kathleen A. James, George Keyes, Martin Kubelik, Claudia Lazzaro, Alison Luchs, Johanna Lessmann, William L. MacDonald, Blake Middleton, Henry A. Millon, Edward Muir, Barbara Opar, Simon Pepper, John A. Pinto, Gary Radke, Howard Saalman, Monsignor Richard J. Schuler, Dain A. Trafton, Richard Tuttle, Susan Ubbelohde, Zygmunt Wazbinski, Robert Williams, Fikret Yegül, and Rev. John T. Zuhlsdorf. Those who have provided friendship and lodging over the years include Paige and Robertson Alford in Lucignano, Debra and Mike Dolinski in Como, Mary Ann and Amadeo Pinto in Florence, Eva Gammeter and Walter Hunzicker in Bern, Karin Winter in Stockholm, and Jill Moore and Simon Pepper in London. At Princeton University Press, I benefitted from the gentle insistence of my editor, Elizabeth Powers, for brevity and clarity. Timothy Wardell, production editor, deserves an author's thanks for patiently transforming an ungainly manuscript into a book.

Assistance of Andrew Morrogh must be singled out for special mention. For a number of years we have trodden the same ground while working on later sixteenth-century architecture in Florence. During this time I have benefitted from his unparalleled knowledge of the archival sources, architectural drawings, and bibliography in this area, the stuff out of which any study is made. During numerous expeditions in Florence and elsewhere his sharp eye forced me to take a second look at deceptively familiar buildings like the Uffizi or totally unfamiliar ones like the church at Mongiovino. In a real sense he has become a collaborator, contributing ideas that have left their mark throughout the book.

My wife Jane Immler Satkowski has also contributed in more ways than I can recount. She has checked all of the translations, and her review of the text has polished its prose. By taking time off from her own research she has allowed me to complete a book whose duration of preparation exceeds the age of our daughter Christina. In acknowledgment of their patience, support, and encouragement, I dedicate this book to them.

Minneapolis, summer 1992

LIST OF
ABBREVIATIONS

AB	*Art Bulletin*
ASF	Archivio di Stato, Florence
Alberti	Leone Battista Alberti, *L'architettura*, 2 vols. (Milan, 1966). Contains the Latin text of Alberti's *De re aedificatoria* (Florence, 1486) with a translation into Italian by G. Orlandi.
Arch. Arezzo 1985	Soprintendenza per i beni abientali, architettonici, artisti, e storici di Arezzo, *Architettura in terra d' Arezzo. I restauri dei beni architettonici dal 1975 al 1984*. Vol. 1. Arezzo-Valdichiana-Valdarno (Florence, 1985).
BM	*Burlington Magazine*.
Boase, *Vasari*	T. S. R. Boase, *Giorgio Vasari: The Man and the Book*, The A. W. Mellon Lectures in the Fine Arts, 1971 (Princeton, 1979).
Corti, *Vasari*	L. Corti, *Vasari. Catalogo completo* (Florence, 1989). Catalog of Vasari's paintings, with further documentation.
Frey	Karl Frey, *Der literarische Nachlass Giorgio Vasaris*, 2 vols. (Munich, 1923–30). Third volume published as *Neue Briefe von Giorgio Vasari* (Burg bei M., 1940). Republished as *Giorgio Vasari. Der literarische Nachlass*, 3 vols. (Hildesheim and New York, 1982).
Giorgio Vasari 1974	*Il Vasari storiografo e artista* (Florence, n.d.). Acts of a congress on the fourth centenary of Vasari's death.

Giorgio Vasari 1981	*Giorgio Vasari* (Florence, 1981.) Catalog to an exhibition at the Casa Vasari and the lower Church of San Francesco, Arezzo, 26 September–3 January 1982. The table of contents, index, revised bibliography, and corrections were printed separately in late 1982.
Giorgio Vasari 1985	*Giorgio Vasari. Tra decorazione ambientale e storiografia artistica*, ed. G. C. Garfagnini. (Florence, 1985). Acts of a conference in Arezzo 8–10 October 1981 in conjunction with the exhibition at Casa Vasari and San Francesco.
Heydenreich and Lotz	L. Heydenreich and W. Lotz, *Architecture in Italy 1400–1600* (Harmondsworth, 1974).
JSAH	*Journal of the Society of Architectural Historians.*
JWCI	*Journal of the Warburg and Courtauld Institutes.*
Lapini, *Diario fiorentino*	A. Lapini, *Diario fiorentino di Agostino Lapini*, ed. G. Corazzini (Florence, 1900).
Lessman 1975	J. Lessman, "Studien zu einer Baumonographie Giorgio Vasaris in Florenz" (Ph.D. diss., Bonn, 1975).
MKIF	*Mitteilungen des Kunsthistorischen Institutes in Florenz*
Morrogh 1985	A. Morrogh, *Disegni di architetti fiorentini 1540–1640*. Gabinetto Disegni e Stampe degli Uffizi, 43 (Florence, 1985).
Paatz, *Kirchen*	W. and E. Paatz, *Die Kirchen von Florenz: ein kunstgeschichtliches Handbuch*, 6 vols. (Frankfurt am Main, 1940–54).
RJ	*Römisches Jahrbuch für Kunstgeschichte*. After vol. 25 (1989) published as *Römisches Jahrbuch der Bibliotheca Hertziana.*
Satkowski 1979	L. G. Satkowski, *Studies on Vasari's Architecture* (New York and London, 1979).
Vasari-Bellosi	*Le vite de' più eccelenti architetti, pittori et scultori da Cimabue insino a' nostri tempi*, ed. L. Bellosi and A. Rossi (Turin, 1986). Reprint of 1550 edition of *Lives*.
Vasari-Milanesi	*Le opere di Giorgio Vasari*, ed. G. Milanesi (Florence, 1878–85). Reprint of 1568 edition of *Lives*.

Giorgio Vasari

Introduction

In addition to the help and protection which I must desire from your Excellency, as my lord and as protector of poor followers of the arts, it has pleased the goodness of God to elect as His Vicar on earth the most holy and most blessed Julius III, Supreme Pontiff and a friend and patron of every kind of *virtù* and of these the most excellent and difficult arts in particular, and whose great generosity I await in return for many years spent and many labors expended, and up to now without fruit. . . . Meanwhile, I am content if your Excellency has good faith in me and a better opinion than that which, by no fault of mine, you have perchance conceived of me. I hope that you will not let your judgment of me be formed by the malicious statements of other men, until at last my life and my works shall prove contrary to what they say.

GIORGIO VASARI,
Dedication of the 1550 edition of the *Lives* to Duke Cosimo I de' Medici[1]

Almost four and a half centuries have elapsed since Giorgio Vasari (1511–1574) wrote these words. To the modern reader they call up a popular conception of life at court in the Renaissance, a view that suggests artificial elegance, sycophantic dissipation, and a closed society with its own hierarchy and rules of etiquette.[2] But to Vasari these very words were totally honest if not brutally frank. If the dedication can be understood as a cynical solicitation for employment, it is also a realistic portrait of its author's character. As a seasoned painter with both grounding and expertise in architecture, the thirty-nine year old Vasari understood the jealous cmplexities of the Vatican and the vagaries of papal patronage. As an artist he was loyal, hard-working, and totally committed to the political aspirations of his patrons, qualities that accounted for his professional success but that would scarcely be considered appealing in later centuries. A solicitation if the guise of a dedication, of course, was not at all out of the ordinary; in Vasari's case, it was also successful and led to positions and projects that were probably beyond his expectation at this time. The painter was already a courtier and, as a consequence, he became an architect of distinction.

Five years later Giorgio Vasari began his domination of artistic life at the court of Duke Cosimo I de' Medici in Florence.[3] As the chief painter, architect, and artistic advisor for the politically ambitious ruler of a newly consolidated regional state, Vasari executed projects that in size and in the fusion of different arts were surpassed only by those of Bernini a century later in papal Rome. His lasting achievement, *Le vite de' più eccellenti scultori, pittori, ed architetti*, was first published in 1550 and later reissued in a revised and amplified form in 1568. Commonly known in English as the *Lives*, this book is at once a thorough account of Renaissance art and the autobiography of the man whose words bring it to life today.

The contribution of the man and his book to intellectual history was no less important. It is clear that Vasari intended to put himself in a class with men of letters. His friendship with cultured individuals like Pietro Aretino, Annibale Caro, Paolo Giovio, and Vincenzo Borghini fostered a deep respect for hu-

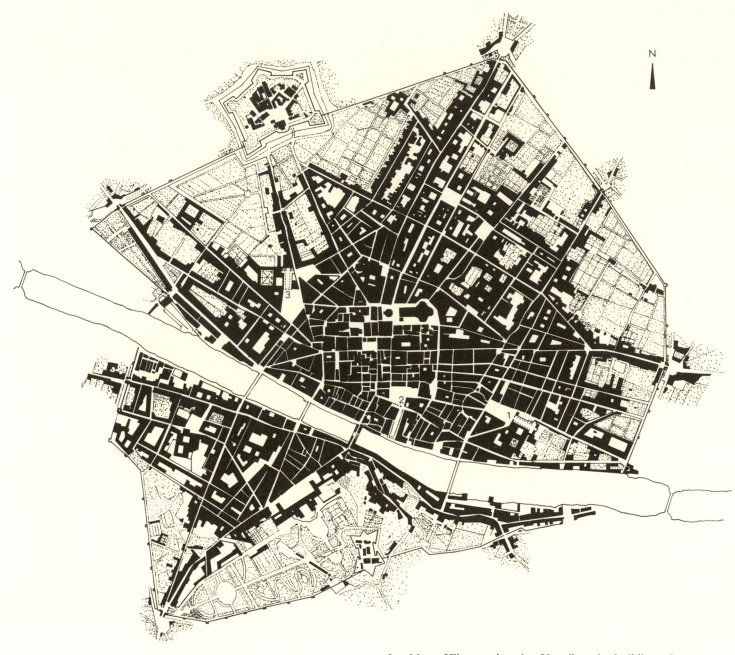

1. Map of Florence locating Vasari's major buildings. 1. Santa Croce. 2. Uffizi and Palazzo Vecchio. 3. Santa Maria Novella

manist thought. A regular correspondent with both his patrons and their learned advisors, Vasari was familiar with the literary concepts employed in his commissions. He was immensely alert and possessed a great capacity for the visual retention of works of art. The drawings executed by other artists in his famous collection, the *Libro dei disegni*, were notable for both their aesthetic merit and historical importance. Vasari's firm convictions about art are best expressed in the central tenet of the *Lives*, a biological division of Renaissance art into three periods— roughly corresponding to childhood, youth, and maturity—that culminated in the art of his own age. It is well known that Vasari's contentions are not always correct, and an obsequious personality did not make him universally popular. But personal and professional conduct did not constitute barriers to success. Vasari's self-portrait (plate 1), which prominently displays the emblems of the artist's profession and the gold chain and medallion representing his

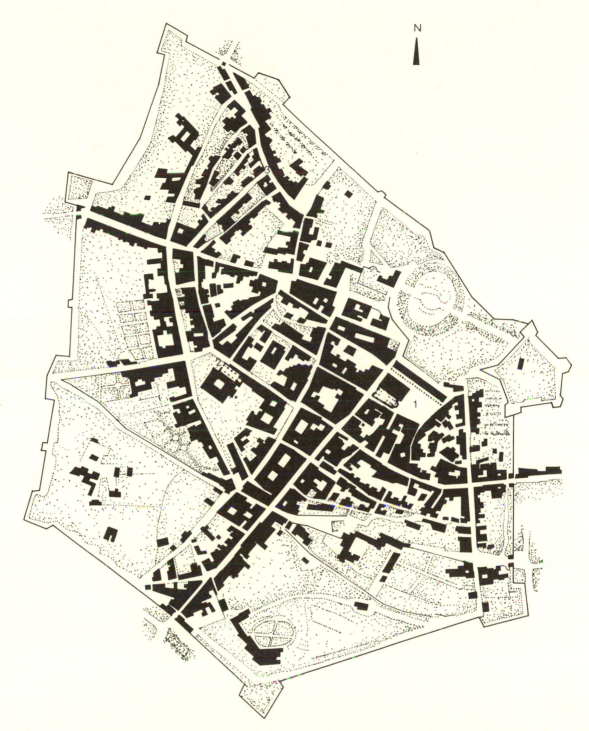

N

2. Map of Arezzo locating Vasari's major buildings. 1. Piazza Grande and the Loggia
2. Badia of Saints Flora and Lucilla. 3. Casa Vasari-first building to the southwest

knighthood of the Golden Spur of the Order of Saint Peter, testifies to his pride and self-satisfaction with his accomplishments.[4]

Vasari set out early and deliberately to make himself an artist of influence. His maturation as an architect at mid-century placed him in the company of Vignola, Palladio, and Ammannati, with whom he was a contemporary and collaborator. As a professional Vasari sought commissions exclusively from powerful individuals and institutions, and in turn wielded power over architects who were arguably his superiors in professional experience and technical ex-

pertise. It is a provocative question why Vasari, whose writings celebrated the individual artist, chose to structure his practice as a collaborative effort in all of his major architectural commissions.

Vasari's personality and capability as an architect is distinguished by the tremendous diversity in the sorts of buildings he created, their equally wide range of expression, and the ambitious meanings that they sought to convey. Although he lacked conventional training in architecture and came to it relatively late in his distinguished career, he learned quickly enough to design structures of considerable size, expense, and architectural complexity. To a somewhat greater degree than his contemporaries, Vasari's way of designing as an architect focused on the concepts and symbolism that lay behind the facades of his buildings. At their best, Vasari's buildings provide virtuoso solutions to the complexities posed by their urban sites.

The projects executed for Cosimo I in Florence (fig. 1) are Vasari's claim to immortality, a claim based on his contribution to the evolution of perhaps the most remarkable civic space in all Italy, the Piazza della Signoria. For seven centuries the civic life of Florence has converged on its surrounding buildings. Despite the pre-eminence of the late medieval civic structures on the square, its final form and political significance were the products of a radical renovation carried out by Vasari in the 1560s. Three related projects—the private passageway leading to the Palazzo Pitti, the Uffizi, and the renovations made to the Palazzo Vecchio—sought to establish the legitimacy of the new ducal state without denying the importance of structures executed during the Florentine Republic. As both a courtier and architect, Vasari conveyed the message of Cosimo I's dominance in buildings in Arezzo (fig. 2), his native city, and elsewhere throughout Tuscany. This theme was forcefully expressed by the Loggia in Arezzo (plate 2), a structure housing the apparatus of Medicean bureaucracy and the residences of those who administered it.

The Uffizi was Vasari's boldest and most original architectural design (plate 3). With its provision for the offices of thirteen magistracies and guilds, the Uffizi was a governmental structure for a state that prized efficiency and administration. As a building type, it had few precedents and no direct successors. The vista towards the Arno created by the Uffizi is as striking as the dominating mass of the Palazzo Vecchio is unforgettable. Its exterior—a street-like space flanked by repetitive facades, embellished by fine-spun detail, capped by projecting eaves, and concluded by a riverfront loggia—serves as a mask for a variety of interior spaces laid out according to a clever and accommodating plan. It is utterly ruthless in size and design yet coalesces with surrounding structures and is deferential to the Palazzo Vecchio. The component parts are familiar but their combination is unprecedented. Its space constituted the broadest thoroughfare in sixteenth-century Florence, but it never served as a street in the usual meaning of the term. The Uffizi is Vasari's architectural masterpiece because it is the building that best demonstrates his capacity as an architect and most fully expresses its patron's ambitions.

O N E

The Character and
Training of an Architect
and Courtier

Vasari's tendency to seek out patrons of great power was facilitated by an education uncustomarily rich in classical studies. In Arezzo, the city of Vasari's birth, the curriculum of its famed public schools stressed grammar rather than arithmetical education. Proficiency in Latin was considered the foundation of all education, just as *disegno* was the cornerstone of instruction in the visual arts. Aretines believed that they possessed an innate literary skill, a belief no doubt reinforced by the achievements of their learned men.[1] While Vasari's youthful education provided him with the mastery of written expression that was to be shown in the *Lives*, his success seems to have been due to a combination of hard work and natural aptitude. At the age of twelve Giorgio's knowledge of Latin and powers of memorization were sufficient to permit him to recite long passages from Virgil's *Aeneid* for Cardinal Silvio Passerini, a loyal ally of the Medici who served as the papal governor of Florence.[2] The consequences of this feat were profound. In Florence where he served as a companion to two of the younger Medici, Alessandro (who later became the first duke of Tuscany) and Ippolito (later a cardinal and supporter of

Vasari), Giorgio gained the support and protection of the family he would serve throughout his career.

Vasari's architectural education was a leisurely process, and own personal experiences seem to have been his first teacher in architecture. As an apprentice painter Vasari would have been familiar with the roles played by the architectural backgrounds in paintings and fresco decorations, and his training in the classics may have introduced him to Vitruvius. But there was no substitute for first-hand knowledge of the buildings of the past and present. Prompted by Duke Alessandro and the initiation of the Fortezza da Basso, Vasari claims to have begun the study of architecture in his early twenties.[3]

The outcome of Vasari's initial studies was not encouraging. In the monumental organ loft of Arezzo Cathedral (plate 4), he sought to harmonize his vertically unified composition with the tall proportions of the cathedral's architecture.[4] Only the overpowering scale of the surroundings can explain the bold articulation of the loft and its base when seen close at hand; the solution looks best when seen from a vantage point well back in the nave (plate 5). That the project can be considered a work of sculp-

ture is explained by the circumstances of the commission and its execution. The construction of the new loft involved the dismemberment of the Ubertini tomb, a monument attributed by Vasari in the *Lives* to Giovanni Pisano.[5] In creating its replacement, Vasari adopted the framework of the trecento monument to Guido Tarlati (plate 6). in the adjacent bay to the east.[6] Thus the organ loft retains the characteristic features of the medieval wall tomb: its sculpted base, raised loft, and canopy. All of this is cast in the forms of Michelangelo's design for the tomb of Pope Julius II (plate 7), which Vasari would have known only from drawings or fragments. The result was clearly less than pleasing, creating fodder for critics who seek to portray Vasari's architecture as a weak emulation of Michelangelo. The criticism is justified in this case; the most casual observer would recognize the struggling work of a beginning architect.[7]

Vasari's appreciation of ancient literature led to a study of its physical remains. During a trip to Rome in 1538, Vasari claims to have made over 300 drawings, which included the study of ancient grottoes.[8] In 1541 he began an extended trip through northern Italy, and on 1 December he arrived in Venice. This trip was a decisive turning point in his architectural career. Unfamiliar with the entire generation of architects who left Rome in the 1520s, Giorgio now had the opportunity to see new works by designers whom he would have known only by reputation.

In Venice Vasari met Pietro Aretino, who had invited him to prepare stage designs for one of his plays, *La Talanta*, a ribald comedy about a Roman prostitute. The backdrop showed a highly fanciful view of the Eternal City with representations of the Arch of Septimius Severus, the Templum Pacis, the Basilica of Constantine, and Trajan's Column.[9] The design appears to be derived from a drawing in Vasari's collection by Peruzzi (plate 8) that depicted a piazza full of arches, theaters, obelisks, pyramids, and porticoes, many of which must have been preserved in the Venetian design.[10] Shortly after the completion of the trip in 1542 Vasari was encouraged by Michelangelo to take up the study of architecture in earnest.[11]

At the same time, Vasari sought a social status commensurate with his professional achievement as a painter. Following the example of artists who constructed or renovated residences befitting their station, Vasari purchased a partially completed house and garden which he would transform into his principal residence.[12] The pastoral setting of the Casa Vasari (plate 9) in the northern quarter of the city surpassed the amenities enjoyed by his Florentine colleagues who lived in the semi-rural area near Santissima Annunziata.[13] The house's characteristic features—underground services, upper level gardens, and an extensive panorama—indicate that Vasari wanted his own dwelling to have the same conveniences found in the Villa Medici in Fiesole, or, on a larger scale, the Villa Madama.[14] Much of the large block to the south was undeveloped, and other residences adjoining Vasari's site enjoyed a grand panorama across the gardens aside the city walls to the plains and mountains beyond. The only nearby residence of size, the Palazzo Bruni-Ciocchi, was located at the foot of the street leading up to Giorgio's dwelling. In terms of siting and design, it is clear that Vasari considered his residence as a kind of *villa suburbana*.[15] Openly boasting of its location "in the best air of the city," the Casa Vasari was the source of both pride and nostalgia to its owner.[16]

The layout of the Casa Vasari was simple (fig. 3) and adapted itself well to its sloping, two-level site. As seen from the street, the house originally was somewhat narrower, five bays in width along its facade. With the exception of a small kitchen, all of the vaulted chambers in the street-level cellar apparently were used for storage or for the stabling of horses. From this room a few steps likely led to a landing before turning and rising directly to the domestic chambers on the piano nobile, an arrangement found in the *case nuove* in Pienza and elsewhere.[17] On the upper level Vasari placed the main salone (plate 10) and the bedroom along the facade overlooking the Via Borgo San Vito (the present-day Via XX Settembre); the three chambers to the rear opened out towards the garden and may have included the main kitchen. A small chapel occupies the narrow space at the center of the piano nobile. The rooms on the upper floor were given over to Vasari's brother, Pietro, and to servants. While it is impossible to determine the degree to which existing construction dictated the house's layout, Vasari almost certainly took advantage of the foundations and walls that were already in place.[18]

Completion of the structure and its surrounding garden, however, was less pressing than the acquaintance of great artists and their works. During his long tour of Northern Italy Vasari met Giulio Romano, an artist whose career was to have striking

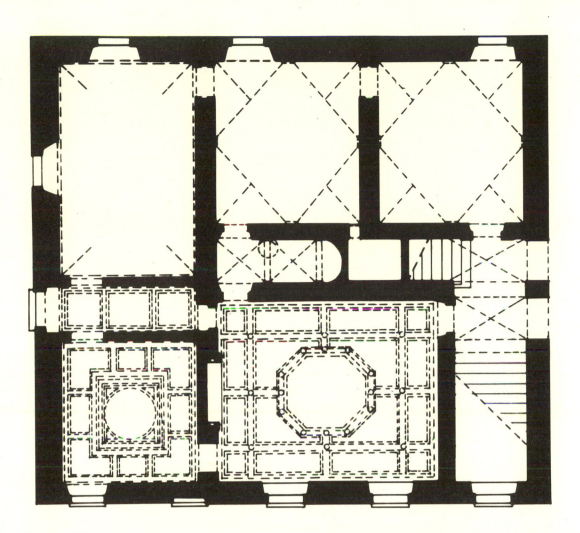

3. Arezzo, Casa Vasari, completed and decorated by Vasari c. 1541–50, plan

parallels with his own. With his elegant bearing and courtly manners, Giulio treated Vasari as a colleague by welcoming him into his house (plate 11). What Vasari saw was magnificent: a remarkable collection of drawings of ancient structures in the vicinity of Rome and Naples, studies and sketches for Giulio's executed buildings, for Giulio's own splendidly decorated palace, and, of course, for the Palazzo del Te. The impact of these buildings was so profound that Giulian ideas and motifs were to reappear two decades later in Vasari's own architecture.

As an indication of an artist's taste and social station, Vasari's residence owes much to Giulio Romano's Mantuan residence.[19] When Vasari visited Mantua in November 1541, he would have recognized that the house purchased by Giulio in 1538, then being refurbished, was roughly comparable to his own in terms of its nearly suburban location, size, room distribution, and comprehensive effect (though not in the style of painted decorations or their subjects). Impressed by the neo-antique splendor of Giulio's dwelling, Vasari selectively appropriated some of its features for his own residence. Just as a restored ancient statue of Mercury adorned its facade (plate 12) as an emblem of Giulio's identification with the deity, Giorgio showed a similar veneration for antiquity by placing Ammannati's torso of Venus over the fireplace in the main salone of the Casa Vasari (plate 10).[20] The simulated bronze reliefs flanking the fireplace in Giulio's salone were to reappear in the lower zone of the main salone of the Casa Vasari. With works by artists Parmigianino, Durer, and Michelangelo, the Casa Vasari became a museum of contemporary art in the same way that the legacy of antiquity was proudly displayed in Giulio's house.

What intrigued Vasari most was Giulio's status at court. Clearly Giulio's professional reputation was established by his call to Mantua and the subsequent design of the Palazzo del Te. A new type of social

respectability was being established, as evidenced by the marriage of Giulio's daughter to a member of the Malatesta family. In the words of Benvenuto Cellini, Giulio was living at the Gonzaga court "like a lord."[21] But power, in the form of Giulio's absolute authority over all projects built in Mantua, and wealth, as measured by his substantial estate at the time of his death, were what Vasari remembered best about his host's comfortable life. The benefits of secure and powerful patronage no doubt appealed to the visitor from Florence when Cardinal Ercole Gonzaga said that Giulio was much more the master of Mantua than himself.[22] Only by seeking out a position for himself in an enlightened court could Vasari attain the status and receive the monetary awards denied to other architects.

Outwardly confident and proud, Vasari was also hypersensitive to criticism, obsessed with work, and desirous of recognition and respectability. Later in his career he demonstrated an impatience verging on paranoia when dealing with inconsequential ducal bureaucrats at the Uffizi. A collapse of Vasari's authority was avoided by the intervention of Duke Cosimo, who attributed the difficulties to a characteristic distrust of non-Florentines by Giorgio's detractors:

> As for the Uffizi and the coolness of the Proveditori and any of their other moods, we do not understand what you mean by these complaints, but we will respond when we have understood them better. And remember that the Florentines always fight with one another, and since you are Aretine and not Florentine, don't get into any of their quarrels, since we have never been able to make two Florentines agree.[23]

The image of the ideal artistic personality that emerges from a reading of the *Lives* suggests that it should not mirror Vasari's own experience. Robust good health was necessary for pursuing an artistic career. The enviable details of Jacopo Sansovino's vigorous old age or sympathetic depiction of Antonio da Sangallo the Younger's medical difficulties seem to stem from the chronic sickness that Vasari experienced throughout his career.[24] The tireless enthusiasm that he showed in his first visit to Rome was seen as prerequisite for any aspiring artist; his words about Brunelleschi's supposed visit to Rome with Donatello—that he "cared nothing about eating or

sleeping . . . his sole interest was in the architecture of the past"—are repeated nearly verbatim in his own autobiography.[25]

Vasari was especially attentive to the accumulation of wealth that was the natural consequence of the new status accorded to the artist in the Renaissance, a direct reflection of the aspirations and pretensions that justified his residences and investments in farm land. In 1527, the death of his father had left Vasari responsible for the support of his mother and six brothers and sisters. From this time until his death he kept a scrupulous yearly account (the *Ricordanze*) of his earnings from "painted works in fresco, tempera, on wood, walls, or on cloth," which was later expanded to include his yearly salary for large architectural projects. While still in his twenties, Vasari earned at least 200 scudi a year, and in 1536, at age 25, he brought in 512 scudi. Almost immediately the funds were invested in rental housing or agricultural property, often in partnership with his brother, who must have managed the holdings during Vasari's regular absences from Arezzo. Although the Vasari brothers owned scattered property in Arezzo, the focal point of their activity was the farmland in Frassineto that was continually enlarged throughout Giorgio's career. The rewards from these investments must have been substantial, and Giorgio was generous with his family. Examples of Vasari's philanthropy include the endowments for his sister Rosa and two other women cloistered in nunneries, and dowries for another sister and a male relative.[26]

If the experience of maintaining a large family at the age of sixteen taught Vasari an important lesson in self-reliance, there was much to be learned from the investments made by successful painters and sculptors. While the ownership by artists of income-producing property was not uncommon, the worth of Michelangelo's holdings in Florence and elsewhere must have been grasped by Vasari.[27] In the numerous instances where the economics and sociology of artistic practice are mentioned in the *Lives*, Vasari reaffirms his belief that successful artists were entitled to the same status in Renaissance society as the bankers and merchants of the *piccola borghesia*[28] It is with pride that Vasari recounts how Cronaca would not release work to clients without having been paid first.[29] Just as in any great Renaissance commercial firm (or craftsman's studio), the *Ricordanze* provided a yearly record of income deriving from his artistic activities.[30] What distinguishes

Vasari from other artists like Bandinelli and Ammannati (who were equally precise in their record-keeping) is that the evidence in the *Ricordanze* demonstrates, in financial terms, the attainment of the artist's position.[31] If Vasari's life was unlike that of Rosso who maintained a household with servants, horses, and other riches, surviving records of disbursements show a comfortable existence for Giorgio with the freshest meats, vegetables, and Trebbiano wine imported from Venice.[32]

Vasari's pride in his newly found status and his boasts of wealth must have irritated other artists, forming the boorish part of an already complex character. Nor was Vasari particularly patient with others unlike himself. Intolerance and disdain for unconventional behavior is best expressed by his words to the painter Jacone, and, if they were meant to counter a malicious remark by Jacone, the reply is fully in keeping with Vasari's vanity:

Once I was poor like all of you, but now I have three thousand scudi or more. You considered me awkward (as a painter), but the friars and priests consider me an able master. Once I served you, and now I have a servant of my own, who looks after my horse. I used to dress in those rags worn by poor painters, and now I am dressed in velvet. Once I went on foot, and now I go on horseback. So, my Jacone, it goes quite well.[33]

Morality was Vasari's antidote to immoderation. While Vasari benignly tolerated the personal eccentricities of a Pontormo, he did not look kindly on the amorous excesses of Raphael, who, on all other counts, was a model of personal and artistic perfection. Similarly, Sodoma's life was regarded with suspicion, and Parmigianino's obsession with alchemy was looked upon with obvious disapproval.[34] Architects, on the other hand, were spared censure. One of the most touching stories in the *Lives* concerns Michele Sanmicheli, who, thinking he had fathered a child out of wedlock before returning to the Veneto, authorized Vasari to pay fifty scudi to the woman whom he had loved nearly twenty years earlier.[35] Such accounts should not be seen as just anecdotal or studio gossip. Like Alberti a century earlier, Vasari seemingly preached that the noble artist should abhor vices and licentiousness, practice moderation in food and drink, and serve as a model husband.

Convictions as strongly held as these served as the essence of a personal crisis that Vasari seems to have experienced just before publishing the first edition of the *Lives* in 1550. Vasari's own behavior, it appears, was not beyond reproach during the early years of his career. Behind the facade of the successful and worldly artist there were notable self doubts and an inference of sexual indiscretion with a male studio assistant.[36] Benvenuto Cellini, whose venomous hatred of Vasari dated back to their early days together in Rome, records insalubrious habits in the morbid anecdote about Giorgio, while asleep, scratching his *garzone* Manno, with whom he shared a bed in Rome.[37] While there is no evidence corroborating Cellini's spiteful tale, a somewhat pathetic side of Giorgio's personality is revealed in the steady stream of personal advice given by close personal friends and correspondents. The most principled of his advisors was Don Ippolito of Milan, the Master-General of the Olivetan order, who sought to reduce Vasari's consumption of wine:

But that you may be on guard concerning that evil wine Candiotta, when you go to Venice be careful how you spend your money, and this advice should suffice.[38]

While such conduct was by no means uncommon in the artistic community, Vasari's writings at times are nearly puritanical in strong disapproval of any form of eccentric behavior. Personally and professionally Vasari had much to lose from the disclosure of his alleged peccadilloes in the gossip of other artists. As in politics, truth mattered less than the damage to one's reputation caused by any plausible assertion. Anyone as obsessed with respectability as Vasari would have been fearful of unpredictable friends like Aretino, whose sarcasm would have diminished Vasari's intellectual stature and credibility with literati. But most of all there was the risk of losing commissions from the powerful supporters whom he had begun to acquire. Especially important must have been the anticipated favors coming from the dedication of the first edition of the *Lives* to Duke Cosimo I de' Medici, the great patron for whom Vasari had not yet worked.

Thus Vasari was forced to conform to his own standards for the deportment of a noble artist. Exposed to the discomforts of single life, Vasari startled his circle of close friends by deciding to take a wife. That Vasari was psychologically ill-prepared for mat-

rimony is brought out in the advice given by Paolo Giovio shortly before the completion of the main body of the *Lives* in 1547:

> and I can only tell you not to be in such a hurry to get married, and to be sure that you don't buy a cat in a sack. Nor should you be swayed by the dowry, because avarice for this has broken many a neck. But if the maiden is beautiful, and if her mother's honor is intact, in that case you will have happiness in your house instead of perpetual injury.
>
> But do take care. Don't ever suppose that you can go to the friars (*frittate*) of Monte Oliveto or the monks (*pani bianchi*) of Cesena or to receive pardons from Rome. And if you were to take her along with you, you should put iron underpants on her, or blacken her face with coal, just like Donatello did to his factotum (*fattore*).
>
> Oh, you might say "I shall live in my workshop and assume the debt of marriage in order not to catch syphilis, and to abstain from sin." And he, who is a hedgehog like you, wants to be a pony. But remember that Andrea del Sarto was a hedgehog like you, and his wife was very clever, and soon wanted two husbands instead of one.[39]
>
> Therefore, my dear Messer Giorgio, have the Mass of the Holy Spirit said for you, make the Sign of the Cross, and follow your fatal destiny.[40]

Vasari's actions in the selection of his wife were cool, rational, and impersonal.[41] On the advice of Aretino and Cardinal Giovanni Maria Del Monte (who was soon to become Pope Julius III), Vasari chose the daughter of a prosperous apothecary in his native Arezzo, Nicolosa Bacci,[42] whom he affectionately called Cosina. The wedding took place in January 1550, and within a month the new bridegroom established himself in Rome at the service of Pope Julius III. Giovio's counsel was auspicious. Vasari's career kept him away from Cosina and his Aretine residence for months at a time. Despite Vasari's occasional indication of personal fondness for his wife, the marriage was unemotional and detached. The union proved childless, whether by impotence, sexual repression, or just plain disinterest.

The conflicting demands of Vasari's successful career and his hollow personal life distressed Bishop Bernardetto Minerbetti of Arezzo, a friend universally admired for his learning and prudence.[43] The bishop was not afraid of offering Giorgio frank advice. Rome, in Minerbetti's opinion, was detrimental to Vasari's moral character. During the eventful completion of the Del Monte Chapel, the bishop thought that Vasari, too, would end up buried in San Pietro in Montorio, and later alluded to avarice and ambition as the causes of his failure to marry.[44] As part of his persistent strategy to lure Vasari back to his native city, Minerbetti created a sycophantic picture of Roman social life:

> And if Roman ambition were to be pleasing, imagine the plight of a carefree night's sleep, born and raised on a pillow, but then placed on the hard saddle of a tired old post horse? All day long it would go along, breaking its back and twisting its neck, in the halls of the Pope and all the Cardinals, making genuflections and bows, first to this and then to that illustrious lord. May God pardon them this sin, since whoever created the seven mortal sins by error omitted this one.[45]

Vasari's complex personality structured his perception of an artist's role at court. Family history, confidence, and insecurity were factors that worked perfectly at a court where deference to the ambitions of a strong-willed ruler were commonplace. Sublimation of personal experiences allowed for loyalty, perseverance, and the dutiful completion of his tasks. The lack of either real or platonic love in Vasari's life indicates that his character was just as wanting in the expression of real emotion as his paintings. Yet behind this grey personality was a man of notable ambition who attracted a lively and powerful group of friends and could draw the best out of literati like Borghini. Vasari's enthusiasms were hard work, the esteem of his contemporaries, pecuniary and professional success, and the achievement of status through the recognition of his work. Art became life, and architecture was to soon play a greater part in it.

T W O

Papal Favor

Del Monte Projects in Monte San Savino
and Rome

To understand Vasari's career is to place his work in the larger context of a continual search for patronage. Because Vasari, like all artists, was dependent upon official favor for the support and advancement of his career, the ideal ruler was interchangeable with the ideal patron. There was little that was new in this kind of relationship. For example, a century earlier Alberti baldly stated that artists should seek out only the most important individuals, for they alone had the requisite taste to appreciate the works of art and the funds to commission them.[1]

Vasari had been actively seeking this kind of patron for some time. As a youthful painter he obtained the favor of Alessandro de' Medici, the first duke of Florence. However, the assassination of this ruler in 1537 changed Vasari's position rather dramatically, obliging him to pursue and acquire commissions throughout Italy. Monastic patronage, like that enjoyed by Vasari at the beginning of his career, had its limitations. The boom in church construction during the middle ages already had given Italian cities many capacious structures, and subsequent work would be limited to their chapels, decorations, or furnishings. Vasari had experienced this first-hand in his reconstruction of the refectory of Santa Anna dei Lombardi in Naples (plate 13), where the curvature of its vault was altered to admit more light and to minimize its Gothic proportions.[2] Even the patronage of the papal family could be both demanding and capricious. Vasari later lamented the swift execution of the frescoes in the Sala dei Cento Giorni, the main audience hall of the papal chancellery in the Cancelleria.[3] The most extraordinary feature of the decoration was its illusionistic architecture (plate 14), a painted proscenium drawn from works by Bramante, Michelangelo, and Peruzzi. If the portraiture was not entirely satisfactory to his patrons, Vasari was sufficiently esteemed as an architect by the Farnese to participate in the competition for the design of the cornice of the Palazzo Farnese.[4]

Already thirty-five years old at the completion of the Sala dei Cento Giorni, Vasari had little to show for the frenetic activity of the previous decade. Having neither an attachment to the household of a wealthy and powerful individual nor a constant demand for his services, the artist once more had to seek a position that would bring status without servitude or professional humiliation. The most effective

means to satisfy this objective was his extensive network of artists, writers, and clergy. It was perhaps with such ambition in mind that in 1548 he visited Giovanni Maria Del Monte (plate 15), the cardinal legate of Bologna and the future Pope Julius III.[5]

Although Cardinal Del Monte was born and educated in Rome, he had strong ties with Tuscany. The Del Monte family originated in Monte San Savino, a small town 30 kilometers southwest of Arezzo. Giovanni Maria Del Monte's position in the church hierarchy was largely due to the early support of his uncle, Cardinal Antonio Del Monte, an influential advisor to Julius II. The younger Del Monte had assisted his uncle in governing Rome after the Sack of 1527, and soon was appointed to administrative positions overseeing Bologna, the second most important city in the papal states. By 1536 he was appointed cardinal, holding title first to San Vitale and later to Santa Prassede, a position previously held by his uncle Antonio. In the same year, Pope Paul III sufficiently trusted the diplomatic skills of the new cardinal to assign him the symbolically important task of greeting Charles V at Terracina, the first possession of the papal states encountered during the Imperial visit to Italy. The interests in the remains of Roman antiquity shared by both of these powerful individuals also prompted a visit to the imposing remains of the Temple of Jupiter Anxur overlooking the town.[6]

To add to his already considerable benefices, Del Monte in 1543 was appointed bishop of Palestrina, a prestigious position that he held in absentia.[7] His great reputation as a jurist and able administrator accounted for his appointment by Paul III to the Council of Trent as a legate and as its president. Often characterized as honorary, the position allowed Del Monte to exercise his skills both as a debater and conciliator.[8] The cardinal's Tuscan background, political acumen, and profound administrative experience made him attractive to Duke Cosimo de' Medici, who actively prepared the grounds for Del Monte's election to the papacy. Vasari, who later through marriage became a distant relative of the cardinal, may have known him as a youth in Arezzo. Personal connections, then, must have led Vasari to anticipate the kind of patronage doled out by Del Monte as Pope Julius III.

The period in Trent was particularly difficult for Del Monte, as his role as a papal emissary placed him in conflict with those cardinals who were vassals of the emperor. It also caused considerable physical pain. Although his gout was hereditary, a preference for rich food and plenty of drink was a contributing factor to the attacks that afflicted him throughout his life. Those in Trent were numerous and particularly painful, as were the recurring difficulties with his vision, hearing, and sense of taste.[9] At various times Del Monte attributed the deterioration of his health to both the capricious climate of Trent and his advancing old age.[10] The cardinal sensed his own ineffectiveness as president of the Council, which was the result of his ever more frequent absences. In order to recuperate from jaundice, apoplexy, and dropsy, he was forced into taking a period of convalescence along Lake Garda before returning to the Council.[11] Del Monte's typically paranoid sentiments are best expressed in a letter of 30 October 1546: "I am an old man . . . and I feel without having been told by the doctors that this cruel climate is shortening my life. I am losing my sight and hearing; neither divine nor human law obliges me to endure this martyrdom any longer."[12] After many entreaties he learned in March 1547 that his resignation had been accepted by the pope. An outbreak of typhus in 1547 forced the Council to move to Bologna. After the transfer complaints about ill health subsided although his gout persisted.[13] By the end of 1548, Del Monte was contemplating his return to Rome because his long absence had left personal matters in an "infinite disorder."[14] The need for the chronically sick cardinal to retreat from the pressures of excruciating responsibilities was as much acutely psychological as it was physical.

LA GEORGICA

A desire to withdraw from the affairs of the Church prompted Cardinal Del Monte to ask Vasari to design a villa located on family property just outside Monte San Savino.[15] The "gran coltivazione," as Vasari called it, was his first independent architectural commission, and it was in connection with its design that Vasari was addressed as an architect for the first time. Construction apparently began, but no drawings survive of Vasari's creation and any identifiable traces of it have long since disappeared. The only evidence for the villa's appearance and purpose is found in a letter from the patron to Vasari that recounts the villa's significant features:

I have seen the drawing that Master Baldovino sent me, and it could not please me more even if Vitruvius or Columella had made it. But what good is the drawing on paper if you don't go to the effort of executing it? Therefore I ask you, if it is not too much trouble, to go to Monte San Savino and order that the construction begin as soon as possible. Master Baldovino will explain my ideas to you, which can be summarized as a villa as complete as possible. It should be your primary concern that your design for the house be pleasing in every way. I think that the advantage of the villa's position is that it lies to one side of the road on our property, where the dove-cote is located, and that it receives the drainage of the site ("et che sia il resciaquattor di questa"), allowing for chickens of every sort, turkeys, peacocks, rabbits, large doves, ducks from the new world as well as our own, aviaries of quails and turtle-doves, and other similar birds. A fishpond will be made on the property, where you have designed the fountain. And I wish that the villa be named after you, and called La Georgica. There is no shortage of money. I have nothing more to add than that I remain yours, without more words and without further ceremony.[16]

From the outset the villa was meant to have had an all'antica air idealizing the countryside and those who inhabited it. Despite Del Monte's claim that La Georgica was named after its architect, the project was meant to recall the *Georgics*, Virgil's famous poetic treatise on farming. Further evocations of ancient agriculture are suggested by the cardinal's mention of Vitruvius and Columella. There can be no doubt that the villa was to have had some of the features of a working farm, including utilitarian features like dovecotes for different species of poultry, a fishpond in the place of a fountain, and an aviary.

The desire for fantasy at La Georgica was just as important as its demonstrated concern for agronomy. What is known of Del Monte's sycophantic existence would imply that his villa would have as much to do with recreation and personal delectation in the spirit of Pliny or his own time as it would with the cultivation of grand estates described by those ancient authors whom he cited. The atmosphere of the villa near Monte San Savino would have been similar to a rarified zoological garden, as indicated by the peacocks, doves, and once-exotic species like turkeys or ducks imported from the New World.[17] Although there can be no claim that the cardinal's choice of flora and fauna for La Georgica was meant

to be encyclopedic, the tendency to collect and exhibit living species from the New World was shared with the patrons of other gardens in Renaissance Italy.[18]

Del Monte's desire to build La Georgica was conditioned by the pleasures of villa life in Rome. Vasari's categorization of the project as a "gran coltivazione" is somewhat misleading, because it was improbable that Cardinal Del Monte wanted merely a working farm. More likely both he and Vasari considered it as a kind of suburban villa, as suggested by its location at "the foot" of Monte San Savino. As in the *vigne* built on the hills overlooking Rome, the cardinal could here enjoy the sensual attractions of colorful creatures, take in both their agreeably musical sounds and unpleasant rural aromas, and savor the sweet taste of the onions from Gaeta that he consumed in great quantity. For all of his affectations of a Tuscan *contadino*, Del Monte remained much the sophisticated and urbane Roman.

THE DEL MONTE CHAPEL

Almost immediately after his election to the papacy Julius III commissioned Vasari to design an elaborate funerary chapel in San Pietro in Montorio commemorating his grandfather Fabiano and uncle Cardinal Antonio Del Monte.[19] Vasari at first prepared several alternative proposals for the chapel, all characterized by elaborate carved decoration to be executed by Simone Mosca and sculptures by Raffaello da Montelupo. Vasari, however, remained fully responsible for the chapel's execution, although Ammannati was able to execute the tombs and stucco decorations from his own designs.

Vasari's initial design for the Del Monte monument (plate 16) challenged the concept of structural integrity that characterized recent Roman chapels. In his first proposal architecture, sculpture, painting, and stucco decoration dissolve walls into an ornamental pattern of figures and architectural grammar that intensifies the experience of the chapel as a whole. Visually the tombs and altar served as a base for the entire design, an idea that had been suggested by Antonio da Sangallo the Younger's Cesi Chapel (plate 17) in Santa Maria della Pace.[20] Above them niches containing allegorical figures of Religion and Justice flank the elaborate architectural aedicule whose own entablature continues that of the nave.

The profusion of elaborately posed figures in the semi-dome and above the archivolt gives the design a somewhat foreign aspect; the cherubs and angels supporting oval frames containing other scenes from the life of St. Paul would be more at home in Fontainebleau or Venice than in Rome. Most of all, the tomb below the altar table and the inscription IULIUS III P. M. makes it clear that it was conceived as a papal burial chapel as well.[21] Symbolically, this may have been the most objectionable part of the scheme, for entombment underneath an altar was normally reserved for saints and the fathers of the Church. Julius III, who passed away on 23 March 1555 after a severe attack of gout, was buried in St. Peter's.[22]

The circumstances of the Del Monte Chapel became entangled with the complex history of San Giovanni dei Fiorentini.[23] Sometime before signing the definitive contract for the chapel on 3 June 1550, Vasari made the suggestion that tombs should be placed in the main chapel of the national church of the Florentine colony.[24] Although only a small portion of the structure had been built, the authority of a papal tomb may have served as the pretext for its completion, thus giving members of the Florentine colony a reason to provide funds for additional chapels. Vasari's active role in the proposal no doubt was influenced by his loyalty to Florence, and he was also in a position to outmaneuver other architects in seeking this prestigious architectural commission. This keenly patriotic yet self-serving strategy for financing had the approval of the most important Florentines in Rome, Michelangelo and Vasari's close friend Bindo Altoviti, the influential banker and Consul of the Florentine colony in Rome. For a brief time, the pope himself endorsed the proposal.[25] But the change would have prolonged the chapel's completion, and by mid-October construction had begun in San Pietro.

A second design for the Del Monte Chapel (plate 18) may represent Vasari's solution for a site in San Giovanni dei Fiorentini. The most striking features of this drawing of the wall tomb are the tinted washes that represent the addition of colored marbles. Enlivened by a sense of warmth not found in Vasari's other commissions, the handsome presentation drawing shows that the Del Monte Chapel would have been bathed in harmonizing tones of green, yellow, and red marbles, as if one of Vasari's paintings suddenly had become three-dimensional. The chapel's flat elevation and its lack of correspondence with the architecture surrounding the apsidal transept of San Pietro in Montorio suggest that the design was intended for a different location.[26]

During the design phase of the Del Monte Chapel, the pope sought Michelangelo's opinion of Vasari's proposals. The criticisms led to radical revisions in the project's architecture (plate 19). All carved decoration, which would detract from the figures in the niches, was to be eliminated, and Montelupo, whose unsatisfactory work in the completion of the tomb of Julius II failed to please Michelangelo, was replaced, upon Michelangelo's suggestion, by Bartolomeo Ammannati. In effect, these drastic and decisive changes represent a sudden engagement with the architecture of Roman antiquity, as shown by its travertine encrustation and aedicular frame similar to ancient burial monuments.[27]

The literature on the chapel concentrates primarily on the question of authorship. Strong cases have been made for Ammannati, who carved the statuary and much of the decorative detail. The tendencies to minimize architectural framework and to accentuate the chapel's integration with the compositional arrangement of sarcophagi and memorial figures (plate 20) were by now established features of Ammannati's funerary monuments.[28] Abstract details like the contrast between the full shapes of the torus and scotia in the base of the tabernacle's columns (plate 21) and the taut curve supporting Vasari's altarpiece reveal a sculptor's concern for mass and volume. Because the Del Monte Chapel has been studied primarily by historians of sculpture, the possibility that Vasari planned and executed the monument as a unified work of art has never been seriously proposed. This coordination is, in fact, inescapable when the entire chapel is viewed in the context of its setting.

The executed design for the Del Monte Chapel gave greater visibility to Vasari's altarpiece, a scene showing *Ananias Healing the Blinded Saul* from the account of Paul's conversion in the Gospels (plate 22). Although work on the chapel had been underway for nearly a year before the painting was begun, its prominent position (if not the main features of its design) must have been considered in all revisions.[29] The viewer's participation begins far back in the nave when the exaggerated gesture of the figure of Religion draws the observer's glance into the chapel, which is distinguished from all others by size, color, and material (plate 23). Farther along the nave the

oblique view is reinforced by the asymmetrical composition of the figures set within the painting's oblique perspective, which is set subtly off-center from the chapel's main axis. When seen from the center of the crossing, the picture is gradually revealed and explained by a series of frames and curved forms: the arches supporting the church's domed crossing, the semicircular shape of the chapel's plan, the curved pediment of the aedicule surrounding the altarpiece, the convex and concave steps behind the main figures, and, finally, the columnar hemicycle at the rear of the picture (plate 24). By endowing the biblical figures with likenesses of the Pope, his ancestors, and his painter (plate 25), Vasari's dramatic presentation of the event gave the altarpiece a conscious and calculated theatrical quality.[30]

In both form and symbol Vasari conceived of his painting as a companion to Raphael's *Transfiguration* (plate 26), which then stood on the main altar of San Pietro in Montorio.[31] Although Vasari borrowed compositional and figural types from Raphael's masterpiece, it is the compelling imagery of real and divine light that both paintings share.[32] By representing Ananias in the act of healing Saul—almost as if he were about to be anointed—Vasari alludes to the doctrinal challenge to Protestantism that Julius III had faced as a papal legate and president of the Council of Trent.[33] The Petrine emphasis of Raphael's painting, so important in its expression of the primacy of the first bishop of Rome, is now matched by an explicit demonstration of the power of his heir in Vasari's picture.[34]

Vasari used the monumental exedra in the background of the altarpiece to clarify its composition and relationship to the chapel and to the church as a whole.[35] What makes the exedra significant is that it represents the same creative interpretation of ancient architecture that is found in other projects for Julius III, especially in the most celebrated of his commissions, the Villa Giulia. The central monument in this case is the Temple of Fortune at Palestrina. This is best shown by the affinities of Palladio's reconstructions (plate 27) of the upper level of the temple complex with Vasari's exedra, where similar arrangements of curved forms, central portals, and pediments above terminations to annular vaults are found in several drawings.

Vasari's links with the world of Palladio and Palestrina have never been duly recognized. Throughout his papacy Julius III favored the city of which he had been cardinal bishop.[36] The fame of its archeological remains was well known and had been stressed repeatedly by Renaissance travellers and antiquarians, most recently in 1550 by Leandro Alberti in *Descrittione di tutta Italia*.[37] Nor was it accidental that Vasari would take up an interest in ancient ruins during a period that saw an unparalleled interest in the architectural topography of Rome and its surrounding area. It is precisely in this way that the interests of Vasari and Palladio were to intersect. The evidence for this is circumstantial but strong; their paths easily could have crossed during Giorgio's Venetian residency or Palladio's visit to Rome in 1546, or notice of one's respective accomplishments could have been conveyed to the other by Sanmicheli or Ammannati.

A decade later the architecture of the Del Monte Chapel was repeated by Daniele da Volterra in the mirror-image form of the Ricci Chapel (plate 28), located in the opposite arm of the transept of San Pietro in Montorio.[38] If this chapel gave formal unity to the crossing of the church, it did so at the considerable expense of the Del Monte Chapel's effect and meaning. The construction of the Ricci Chapel required the closing of two windows in the semicircular southern apse, thereby depriving Vasari's design of the brilliant illumination that was so necessary to convey the complex formal unity of its parts and their iconographic relationship to Raphael's *Transfiguration*. Repairs to the apse and the reconstruction of its vault caused by Garibaldi's bombardment of the church in 1849 did little to alter the already poor visibility of Vasari's chapel.[39]

The unique qualities of the Del Monte Chapel were not overlooked by other artists. Palladio singled it out as one of the few praiseworthy contemporary works in a brief guidebook to Roman churches that focuses primarily on indulgences, relics, and miracleworking images of interest to the pilgrim.[40] No other chapel since the Chigi Chapel was so richly decorated, and the sumptuous marble walls, altar, and balustrade were appealing to the designers of other sixteenth-century papal chapels in Roman churches, a tradition that the Del Monte Chapel initiated.[41] In the next century it was Bernini who appreciated and fully understood the design.[42] While designing the Raimondi Chapel, also in San Pietro in Montorio, he must have realized how similar Vasari's problem of coordinating a pair of tombs, an altar, and a surrounding aedicule was to his own. Bernini

also revived the long obsolete tradition of showing the deceased twice, a convention that Vasari had also employed in the Del Monte chapel.[43] Had Bernini known the initial proposals for the Del Monte Chapel, he would have realized how closely Vasari's attempts to unify architecture with the other arts anticipated his own achievement in the Cornaro Chapel and in San Andrea al Quirinale.

THE VILLA GIULIA

Vasari's other concern was the creation of the Villa Giulia (plate 29), an arrangement of buildings and landscapes that evoked the splendor and pleasure of an ancient villa.[44] As if to turn to worldly pleasures after securing eternal fame, Julius III began to acquire property expanding the original vigna only after the plans for the Del Monte Chapel in San Pietro in Montorio were already well underway. It is well known that the magnificent design grew from what was originally a modest vigna.[45] Beginning in 1551, the Villa Giulia was fashioned from the efforts of Vasari, Vignola, and Ammannati as well as from the criticism of Michelangelo and the pope himself.[46] After four intense years of design, deliberation, and construction, an entire hillside had been transformed into a wooded preserve focusing on a walled enclosure—the casino, garden court, and nympheum (fig. 4). Vasari, nominally its architect, had already left, irritated by the capricious behavior of a patron who constantly meddled in the affairs of his architects. When Julius III succumbed on March 23, 1555, there was no certainty that the splendid residence would ever be completed along the lines that its architects had envisaged. The villa's fame was assured but its future was in doubt. The state of affairs compelled Ammannati to write a letter to Marco Benavides, his early patron in Padua, describing the villa's design in considerable detail.[47] The fears proved to be well-founded. Pillaged of its statuary, the villa underwent modifications by Pirro Ligorio in the 1560s, and it suffered a chaste classical restoration in the eighteenth century.

Precisely how the design evolved is a mystery that is still unfolding. Although there is now common agreement regarding the division of responsibilities for the completed structure, its early history is much less clear. This state of affairs has hindered an appreciation of Vasari's role because it is in the conceptual stages of planning and design that his contributions are to be found. Though sources are not in complete agreement and some problems remain unsolved, it is possible to obtain a fairly clear indication of Vasari's participation in the making of the Villa Giulia. This can be ascertained only by reviewing Vasari's diverse contributions which were always in collaboration (if not sometimes in direct competition) with the others. The only possible conclusion is clear and straightforward: there is no evidence supporting claims for Vasari as a designing architect, but there is ample proof indicating that his ideas influenced all parts of the Villa Giulia.

The Villa Giulia as a Classical Landscape

The extensive grounds of the Villa Giulia stretched from the Tiber to the Parioli hills. The estate was composed of four principal properties that surrounded the walled enclosure with a stretch of cultivated hills, gardens, and vineyards. The contrast between the vast expanse of nature and intimate scale of its architecture could not have been greater. Within a few years of Julius III's death, modifications were made to some of the secondary structures and the process of disposing of its properties was begun. But the overall appearance of the site remained unchanged for centuries, even if its architecture was left unattended and had begun to decay. Views like those by Boguet (plate 30) capture the spirit of the Villa Giulia before it was shorn of its splendid natural setting.[48]

Fortunately, the appearance of the Villa Giulia as Julius III knew it has been preserved in Ammannati's letter. This remarkably lucid and logical description of the villa and its surrounding property—the architectural equivalent of *ekphrasis*, the technique of describing paintings that was an essential feature of Vasari's *Lives*—follows a venerable tradition.[49] Extended architectural description as a literary form was established by Pliny the Younger in his *Letters* where he took the reader on a guided tour of his Laurentine and Tuscan villas.[50] Interest in the architecture of antiquity accounted for a resurgence of interest in the descriptions, as indicated by their impact on the planning of the Villa Madama and Raphael's famous letter evoking the design.[51] Nor was their influence limited just to architects. Paolo Giovio, the literato and close friend of Vasari, prepared a

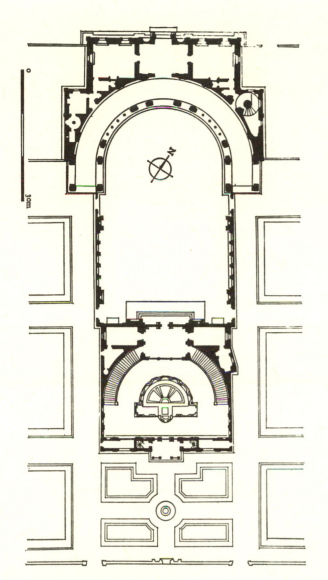

4. Rome, Villa Giulia, 1551–55, plan

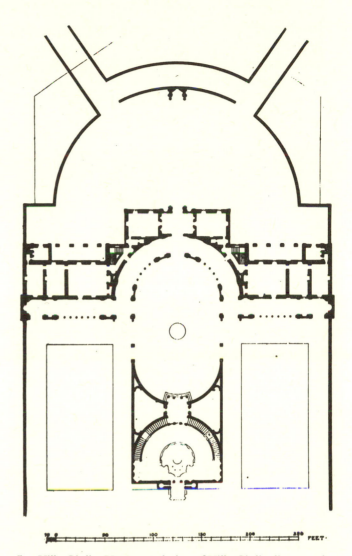

5. Villa Giulia. Unexecuted plan of Villa Giulia discovered by G. P. Stevens, now lost

description of his at Borgovico near Como.[52] Giovio was under the impression that his waterside villa, which was built on a promontory jutting out into the Lago di Como, was built on the ruins of a villa owned by Pliny.[53]

There were three distinct topographical divisions to the Villa Giulia's vast landscape of gardens, buildings, and ephemeral architecture. The flat area between the Tiber and the Via Flaminia provided no serious limitations. This sector of the villa, the one farthest from the Casino, served as informal entry to the complex for the pope and his guests. It contained a dock to anchor the boat that would bring the papal entourage by water from the Vatican, and a house for the captain of the papal flotilla. The two areas beyond

the Via Flaminia, the gently rising land to the north and the valley embraced by hillocks and escarpments beyond, were fashioned as a number of gardens and landscapes varying in design and formality. Surrounding the casino, enclosed courtyards, and nympheum of the villa proper were formal gardens planted with orange trees and separated from each other by low wicker fences. The outlying area was an informally planted park with woods and orchards, paths and trellises, ancient and modern statuary, tables and loggias in stone or greenery, and a preserve for the hunting of dove and quail. All in all, the forestation of the complex entailed planting as many as 36,000 fruit and shade trees of every conceivable species. At one point

The view from this hillock is more beautiful than one can desire, because one sees all of Rome, the Tiber and the beautiful Via Flaminia, with all of the seven hills, the Vatican with the great structure of St. Peter's, and the papal palace. It looks out towards the four points of the compass; the most beautiful is the view towards the East.[54]

It came naturally to Vasari, a painter with a broad knowledge of literature but little experience as an architectural designer, to formulate the concepts for the Villa Giulia that would be executed largely by his architectural collaborators. Its form and setting as conceived by Vasari and described by Ammannati in his letter was precisely the kind of suburban *hortus* or garden-villa that Alberti had described in the ninth book of *De re aedificatoria*.[55] Alberti was quick to point out that the suburban villa was a compromise to the conflicting demands of delight in rural life while maintaining ease of access to the city. The location of the Villa Giulia fulfilled the demands for a site close to town, with ease of communication with the city, and, above all, for an agreeable environment. The specific demands made on the setting of a suburban villa—a gently rising approach, pleasant views over the countryside, meadows full of flowers, shady groves, and water in springs, streams, or pools—would have been satisfied by the design of the Villa Giulia. An environment with a plentitude of fresh air was considered the healthiest of all by Alberti, and it also offered a special appeal to doctors who prescribed a temperate climate as a cure for the pope's gout.[56] These ideas, which are commonly associated with suburban villas in general, would have had a special relevance on account of the appearance in 1550 of an Italian translation of Alberti's treatise as a companion of sorts to the first edition of Vasari's *Lives*.

If the notion of the Villa Giulia as the evocation of a vast classical landscape was Vasari's, and that is by no means impossible, then it is not difficult to see how it drew upon his own background and interests. Looking at the craggy outline of the Parioli cliffs as seen from the plain of the Tiber valley, Vasari would have been reminded of ancient landscape paintings with fantastic architectural construction elements in their backgrounds. It has never been adequately recognized that Vasari regularly employed similar devices in the backgrounds of his paintings. If the elements of landscape in some instances were just a

formula, those in main hall of the Casa Vasari (plate 31) show a familiarity with ancient Roman structures and topography while others are the product of the artist's fertile imagination.[57] In this case landscape painting did not inspire the natural ambience of the Villa Giulia, it only shared a common source in the remains of antiquity that were omnipresent in Rome. But the essence of the idea was even more ambitious. It seems likely that Vasari and Julius III had in mind the recreation of not just an ancient villa but the entire natural environment that would have surrounded a villa in this location in antiquity. That Vasari's contemporaries considered the Villa Giulia a worthy successor to the ancient villas and gardens on the nearby Pincian Hill (plate 32) is confirmed by its appearance in maps reconstructing ancient Rome.[58]

If Vasari's intention was to portray the Villa Giulia's landscape as it might have been seen in antiquity, then many aspects of this environment—both natural and man-made—could be understood as an evocation of a lost world. Julius III and his erudite companions would have associated the escapist pleasures of the Villa Giulia with landscape themes drawn from the literature of antiquity.[59] In the garden court (plate 33), statues of Bacchus, and particularly Vertumnus and Pomona, the protectors of gardens and orchards, contributed to the allusion of a festive mood in a sylvan locale. The subject matter to have been depicted on the loggia's facade (plate 34) is also a selection of themes exalting the patron and his fondness for country life at the villa: in the central compartment of the attic an illustration of Hercules as a river god with a young maiden fleeing him.[60] Learned visitors immediately would have recognized this subject as a cipher announcing the presence in the nympheum of the waters of the Acqua Vergine, the ancient Roman aqueduct that supplied the villa with water.[61] To either side of the central portal mythological themes represent the four elements, and below, papal imprese in the rectangular and oval panels flank the single portal that once led to the nympheum.[62] If the entire arrangement of statuary did not follow any preconceived iconographical plan, it at least represented the full range of the pope's interests and achievements.

Architectural drawings indicate that Vasari planned to employ sculptural ornamentation in the outer bays as well (plate 35). In the attic there was to have been a relief depicting Daphne fleeing the advances of Apollo. Like the representation of Her-

cules and the maiden above the central portal, the subject has topographical significance because it symbolizes chastity, which, by extension, alludes to the Acqua Vergine.[63] The clumsy Latin grammar in the panels on the main level indicates that inscriptions selected by the pope would have completed the composition. Evidently something similar must have been planned for the corresponding panels in the left-hand bay. Neither the upper relief nor the inscriptions were executed.[64]

The Villa Giulia's landscape combines wild woods, composed groves, an elegant residence, and artificial caves, all elements commonly found in the paradises described by ancient writers. For example, knowledge of the tale of Apollo and Daphne from Ovid's *Metamorphoses* would have enriched the complex with specific topographical associations.[65] When seen in the context of the relief panel depicting this subject planned for the loggia's facade, the Villa Giulia's location in a pleasant valley surrounded by wooded slopes calls to mind the Vale of Tempe. Similarly, the Acqua Vergine recalls the river Peneus and the nympheum evokes the cave where Daphne's father gave laws to his waters and waternymphs. Above all, the landscape was to be understood as a sacred one, as attested by papal patronage, images of divinities, and the presence of motifs from ancient religious architecture in proposals for the casino's facade.[66] If this nostalgic view of the site did not establish a literary theme for the entire garden, it at least determined its idyllic mood.

The casino, garden court, and nympheum were inseparable from the surrounding landscape; or as Ammannati was to put it, its axial layout follows the general line of a beautiful and charming valley.[67] A plan discovered early in this century (fig. 5), now lost, shows that the Villa Giulia was originally conceived as a much grander undertaking than the executed structure.[68] Although there are no precedents for a plan of this ingenuity in its entirety, many of its individual features can be traced back to early sixteenth-century villas and their antique sources. The pope's initial intention may well have been the creation of a villa to compete in prestige, if not ancient splendor, with the Villa Madama, a structure that could easily be seen in the splendid panorama from the balcony above the main entrance to the Villa Giulia. Yet there has been understandable reluctance on the part of scholars to accept the missing sheet because of the lack of documentation attesting

to its authenticity.[69] Evidence in the form of specific details—the kiosks behind the sunken nympheum, niches in the entry hall, and the triangular stairs—whose existence was not demonstrated until later suggest otherwise. Peculiarities of the existing villa suggest that in fact this plan (or one very similar to it) was begun late in 1551, only to be abandoned by Easter 1552 when Ammannati proposed alterations to the garden court, nympheum, and the intermediate loggia. At any rate, the essential components of the plan were retained in a reduced and somewhat modified form.[70]

Other comparisons suggest that the luxury villas of ancient and Renaissance Rome need not have been the only models for the lost original plan. Its essential architectural concepts—axial movement through separate spaces, changes in level, low surrounding walls that minimize a sense of enclosure, and a grotto as its terminal feature—can be seen in the Medici villa at Castello (plate 205) outside of Florence, designed by the sculptor and garden designer Niccolò Tribolo in the late 1530s.[71] The unity of the Villa Giulia's palace and garden along the line of a natural valley also may have been suggested by the natural amphitheater that Tribolo had just begun to create out of the hollow behind the Palazzo Pitti.[72]

In considering these relationships, Vasari's authoritative testimony in the *Lives* provides evidence that is difficult to refute. The first drawings that he claims to have made need not have been finished drawings but only sketches or diagrams illustrating his *concetto*. If the master plan is understood as an organized framework of self-contained elements, then the adoption of this conservative and somewhat old-fashioned idea may well be due to Vasari, who was already intimately familiar with Tribolo's designs for Castello.[73] There can be no doubt Vasari participated in the proposal, discussion, and criticism of the initial concepts for the Villa Giulia soon after visits to the vigna in the company of Michelangelo and the pope in late 1550 or early 1551. Vasari's authority is also confirmed by the fact that only he and Michelangelo were working for Julius III in any significant architectural capacity when the pontiff's interests turned to the Villa Giulia. Clearly in a position to influence the future course of its development, Vasari was fully capable of proposing a design initially modelled on a Tuscan prototype that was then transformed into a Roman villa by the draughtsman of the lost plan.

The display of ancient statuary was an obsession of private collectors and their architects in sixteenth-century Rome. The pre-eminent model for the incorporation of ancient art into an architectural setting was the sculpture court of the Cortile del Belvedere where the arrangement sought to portray the collection as the Garden of the Hesperides—the legendary home of Apollo and the Muses—and their owner, Pope Julius II, as a second Julius Caesar responsible for the restoration of Rome's greatness.[74] If the members of the Roman and ecclesiastical nobilities who assembled the collections could not compete with the Vatican in terms of the quantity and renown of their statuary, they often installed them in a manner that would recall themes borrowed from classical mythology. By mid-century the casual organization of earlier collections had given way to systematic installations in the open air, allowing gardens to be understood as outdoor museums of antiquities.

The Villa Giulia was designed to display the collection of ancient sculpture being amassed by Julius III. Among Roman garden museums it is exceptional in the degree to which architectural elements determine the arrangement of the statuary. This function is most conspicuous in the garden court, but it pervades the entire complex and contributes to the effect of its neo-antique architecture. Public access to private collections of antiquities promoted by the *lex hortorum* explains its similarity to other garden statue-courts in Rome, especially the one created for Cardinal Andrea della Valle in his palace in the center of the city.[75] If the architecture of the Villa Giulia was designed by Ammannati and Vignola, the installation of its sculpture followed the precepts laid out by Vasari in the *Lives* and was derived from projects with which he was familiar.

The statuary in the garden court was displayed against the side walls that cosmetically screened the enclosure from the surrounding property (plate 36). Each wall was composed of five arcaded bays, separated by piers with Ionic half-columns simulating colored marble. To either side of the arcades, emphatic tower-like projections contained niches for additional figures. Shorn of their ornamentation, the walls today appear conservative in design and awkward in their relationship with the rest of the Villa Giulia. But in their original state they contributed to the Villa Giulia's remarkable visual effect, the pictorial juxtaposition of nature and architecture as shown by the contrast of the verdant hills and the brilliant white shapes of the Villa Giulia's architecture.[76]

Vasari took an interest in the display of statuary.[77] The subject fascinated him, as his comments on Orsanmichele in Florence indicate. What mattered was the immediacy and visibility of the works, which were placed close to ground level and in niches that were designed "with the best possible advice," presumably from the sculptors themselves.[78] Not surprisingly, he must have carefully studied the proportions of their tabernacles.[79] At the same time it is unlikely that Julius III would have permitted an installation of sculpture without first consulting Michelangelo. As Vasari understood it, the Campidoglio had been planned by Michelangelo as an outdoor museum of sculpture with the equestrian statue of Marcus Aurelius as its focal point.[80] It is virtually certain that the pope and his architects would have recognized a connection between the two projects on account of their respective chronologies, because the Villa Giulia was designed at the same time that the triangular stairway in front of the Palazzo dei Senatori (plate 144) was constructed and the river gods symbolizing Rome and the Nile set into its base.[81]

In terms of splendor, polychromy was the architectural complement to the ancient statuary in the garden court. With considerable pride Ammannati points to the black and green-veined marble columns on the loggia's facade (plate 37), which probably were among the ancient columns from Tivoli whose excavation was paid for by Julius III.[82] Similarly the oval reliefs were likened to ancient cameos.[83] The highest praise was reserved for the single portal, whose architectural surround was made from yellow stone so fine and beautiful that it appeared to be made out of metal. The terms on the loggia's upper order also were carved from a green-veined marble, befitting a structure that sought to emulate the luxury of the architecture of antiquity.

It is not difficult to detect the influence of Vasari's ideas behind the selection of colored marbles for Ammannati's facade. Vasari, after all, had already proposed their use for the Del Monte Chapel, a scheme that was probably meant to employ the same yellow stone for the incrustation of its walls. With his knowledge of classical marbles and a respect for the difficulties in working hard materials, Vasari had already provided a theoretical justification for their use

in the Introduction to the 1550 edition of the *Lives*.[84] Julius III, on the other hand, may not have been inclined to support magnificence on a grand scale, preferring instead to reuse statuary for the courtyard and already-existing architectural elements for the loggia. Such a discreet application of colored stone was not to Vasari's taste and may have contributed to the increasing tension between the pope and his main architectural advisor.

The Nympheum Court

The nympheum court was the full embodiment of the pleasures offered by the Villa Giulia (plate 38). This was the symbolic center of the villa where the waters of the Acqua Vergine, as represented by four caryatids, were now finally made visible yet teasingly inaccessible (plate 39). Underneath any of its loggias the pope could find a pleasant location for summer dining, redolent with water and greenery as advised by Alberti.[85] The concept of a villa all'antica would be evoked by its sequence of curved and rectangular courtyards commencing in an atrium, as in Pliny the Younger's Laurentine villa, or by the configuration of four plane trees in his mountain villa in Tuscany.[86] With considerable pride Julius could point to a new type of papal retreat that was intimate in scale and characterized by the cosmetic sense of enclosure in its walled courtyards.

Formally and ideologically, the nympheum was a place of refuge that still maintained the trappings of papal authority (plate 40). A preliminary scheme for the court (plate 41) would have employed an attic notable for its unusual disposition of elements above the curving staircase. The upper order is composed of rectangular panels alternating with blank surfaces supporting volutes, a grouping resembling the decorative effect of crenellations found on Rome's city walls, bastions, and gates.[87] Unlike the adjacent sector of the nympheum's side walls, where the disposition of the attic largely follows the lines of the stories below, the volutes and their supporting surfaces give the impression of existing independently of their continuous base. The lower level was adorned in a somewhat more conventional fashion with the decorative grammar of antiquity: pilasters with ornamental rinceaux instead of bold piers, masks instead of bucrania underneath the entablature in the outer bays, and a division into three equal bays for the

exhibition of statuary. The lack of coherence to the design, the incompatibility of its essential features, and the fact that the proposal employs at least three different architectural scales indicates that it was prepared by someone familiar with architectural decor, perhaps even by Vasari himself.

It is hardly accidental that the motifs of its stucco revetment—salient pediments without proper entablatures, the paired modillions supporting them, and particularly the serliana raised high above floor level and employed as a window or screen—have their origin in the architectural stuccowork of the Sala Regia (plate 42), the official papal audience hall in the Vatican that had just acquired its stucco revetment in the 1540s.[88] The decorations begun by Perino del Vaga and continued after his death by Daniele da Volterra were a source of amazement to Vasari who was to claim that they had surpassed anything previously accomplished in terms of their beauty and refinement. In contrast to the clear architectural logic of the main court, the nympheum was to have been an architectural caprice of sorts, as if it were a salone with its roof removed and now open to the sky. The concept was, like the themes represented by the frescoes inside the casino, wholly appropriate for a structure whose principal function was diversion from worldly responsibility: here Julius III and a few of his intimates could enjoy in private the pleasures of nature in a setting that was both the suburban equivalent to his official residence and a place of presentation to kings, other rulers, or their designates.[89]

Vasari's Share of the Design and His Fall from Papal Favor

Vasari's ideas for an ancient villa in its entirety reflected, as might be expected, his own experience. Familiarity with the outdoor display of the great collections of ancient sculpture belonging to the Cesi and della Valle can be taken for granted.[90] Vasari's attention to nature, a critical issue of the garden-like setting of his own house in Arezzo in the "miglior aria" of Arezzo, now was to be tested again. Problems of organizing an entire landscape had already been undertaken in the aborted project for the De Monte vigna in Monte San Savino. Vasari's collaboration in the design of the nympheum is equally credible on account of his great interest in recreating

the effects of caves and petrified springs, evidenced in the *Lives* by his discussion of ancient grottoes in the Introduction and by the particular attention paid to the nympheum and grotto fountain attributed to Giovanni da Udine at the Villa Madama. All of these features were absorbed in the Villa Giulia as executed.

Although there are no reasons to doubt the accuracy or authenticity of Vasari's own version of events, his account demands close scrutiny. The scattered references to the Villa Giulia in the *Lives* emphasize the authority that Vasari held over his collaborators as an administrative architect who communicated directly with the pope or his designate and sought the advice and criticism of Michelangelo. Vasari plainly states that he had been the first to formulate the concept of the Villa Giulia as a whole and to prepare drawings of it, leaving it open for the reader to determine how others completed the project in altered form.[91] Equally confident is the claim for participation with Ammannati in the design of the *fonte bassa*, a statement that distinguishes the nympheum from his collaborator's independent designs and, at the same time, implies that Vasari designed little elsewhere at the Villa.[92] Vignola's considerable technical skills and his friendship with the pope, which was forged during the latter's service as papal legate in Bologna, minimized Vasari's role in the creation of the casino.[93] The unmistakable implication is that Vasari contributed little in terms of actual designs to the Villa Giulia.

The bonds that united the pope and Villa Giulia's architects began to deteriorate shortly after the project began. Already in 1551 disagreements had arisen between Vasari and Julius III, a foretaste of the complaints about the pope's capricious behavior that were to characterize the remainder of Vasari' stay in Rome.[94] Although there is no evidence indicating their substance, almost certainly they were precipitated in no small part by Vasari's own actions. After the trip to Carrara in Autumn 1550, the purpose of which was to obtain marble for the Del Monte tomb, Vasari proceeded to Florence where he was invited by Cosimo I to return to Florence as soon as his obligations in Rome were completed.[95] With the exception of two brief trips to Arezzo, the purpose of one being the supervision of work on the Del Monte palace in Monte San Savino, Vasari was in Rome continually from October 1551 until his departure for Tuscany in December 1553. On the other hand, the tempting offer meant that Vasari would be able to enjoy the benefits of continuous patronage—wealth, power, and duration—without the lack of favor that would occur upon the death of the pontiff.

The solicitation must have been considered as a conflict of interest by the pope. The results of Vasari's actions were worse that outright dismissal. During this period much of his authority on the Villa Giulia was eroded to the point that Ammannati and Vignola had become the two architects responsible for its design and execution, thereby explaining why nothing of the executed structure came from Vasari's hands. Eventually Vasari's search for artistic independence and desire to advance his career broke the uneasy alliance between himself and the pope. Vasari's failure to obtain complete responsibility for the decoration of the villa in part must stem from papal dissatisfaction with Vasari's vacillating attitude and the conduct of his artistic practice.

T H R E E

Legitimacy

The Uffizi

Nowhere does the Florentine aspiration to greatness come to the fore more than in the Piazza della Signoria (plate 43) and its surrounding buildings.[1] Created at the end of the thirteenth century on confiscated land just to the north of the communal palace, the new square was intended to provide a place of public assembly, a setting for ceremonial pageantry, and a position from which the communal palace could be defended from a rebellious citizenry. But the readily available land that initially influenced the selection of the palace's site was insufficient from the start; purchases of additional property enlarged the square to the west and adjusted irregular boundaries to the north. Apart from a proposal in 1348 by the tyrannical duke of Athens to transform the communal palace into a isolated, free-standing fortress, nothing was done to unify the two virtually independent open spaces. Only with the demolition in 1356 of San Romolo, a small church with an adjacent cemetery located just to the northwest of the communal palace, and the completion of the Loggia della Signoria in 1382, the piazza finally evolved into the L-shaped square that we know today. The shift of the square's focus from its original northern to its later and larger western section was largely responsible for the creation of the commanding panorama seen from the Via dei Calzaiuoli.

Already in the fourteenth century the area around the communal palace had evolved into the city's administrative center. The clustering of satellite dependencies around the palace began with the situation of the Ufficiali di Condotta, the House of the Executor of Justice, and the impressive palace of the Mercanzia about the smaller northern part of the square.[2] The Florentine guilds, too, were grouped around the communal palace, with the Arte del Cambio once occupying chambers on the west side of the Piazza, and the Arte dei Vivai and the Arte dei Legnaiuoli nearby in the Via Lambertesca. To the south, the miscellany of buildings across the Via della Ninna were no less important (plate 44). San Pier Scheraggio, one of the earliest places of assembly for the Florentine Council, shared a small, irregularly shaped square with the Florentine Mint.[3] In order to provide an impressive approach to the Piazza della Signoria from the east, the Loggia's eastern facade was centered on the Via della Ninna (fig. 6). This arrangement was made possible by the removal of

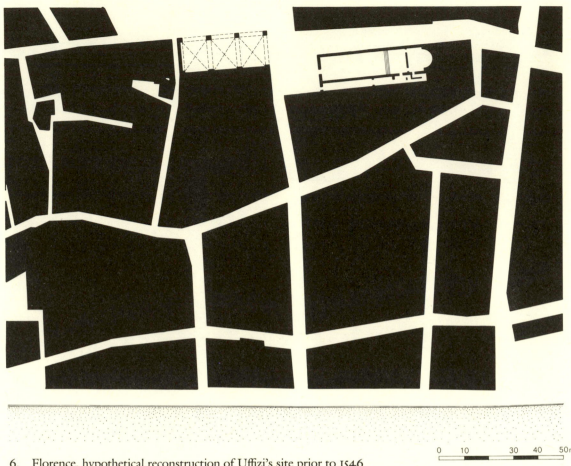

6. Florence, hypothetical reconstruction of Uffizi's site prior to 1546

the church's northern aisle in the second decade of the fifteenth century, of which five bays can still be seen (plate 45).[4] A vibrant commercial quarter, which contained the residences of some of the minor guilds and their workshops, was situated in the crowded area between the square and the river. Nearby, male travellers could find female companionship for the night at a hostelry of low reputation.[5]

In 1540 Duke Cosimo transferred his official residence from the Palazzo Medici in the Via Larga to the Palazzo Vecchio. The decision was the catalyst for an astonishing number of projects, many of them never executed, that exalted the consolidation of Medici power over Florence and her dominions. At first, Cosimo wanted to assure the dignity of his new residence before constructing major public works. With the political chaos and social misery that followed the 1529 siege now largely gone, Cosimo initiated a series of modifications to the Palazzo Vecchio, the rehabilitation of its interiors and the decoration of its interiors.[6] Architectural projects followed shortly. With the modernization of the palace under

way, the architectural setting of Cosimo's residence was to have been enhanced by a radical renewal of the square. A set of three drawings by the sculptor and architect Francesco da Sangallo executed c. 1543–1546 illustrate the major components of the project: an equestrian statue of Giovanni delle Bande Nere (inspired by the statue of Marcus Aurelius on the Campidoglio in Rome), a modernized extension of the Loggia della Signoria (plate 46), and a two-story structure to be placed along the eastern side of the *strada nuova* (plate 47), a new street opened in 1546 between the Piazza della Signoria and the Arno (fig. 7).[7]

The most extravagant idea was proposed by Baccio Bandinelli and Giuliano di Baccio d'Agnolo. Seeking to transform the trapezoidal block of the Palazzo Vecchio into a regular solid, both men conceived of cloaking the medieval exterior with a loggia on the ground level surmounted by a series of orders and arches rising to an open loggia just under the ballatoio.[8] Fearing Cosimo's retribution on account of the project's excessive expense, Baccio and Giu-

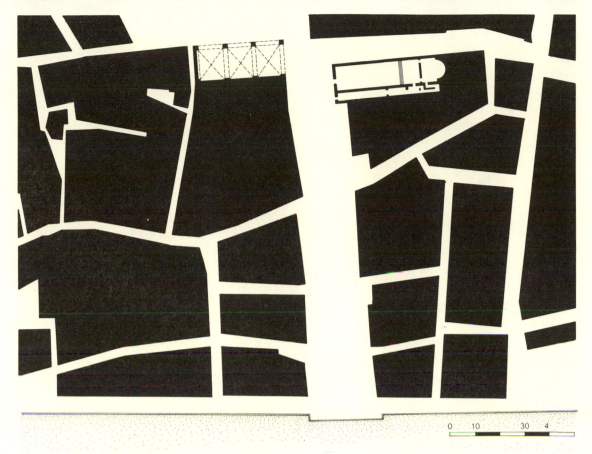

7. Florence, reconstructed plan of *strada nuova* on the site of the Uffizi, 1546–61 (above)

8. Florence, Piazza della Signoria, hypothetical reconstruction of project by Francesco da Sangallo to extend the Loggia della Signoria (below)

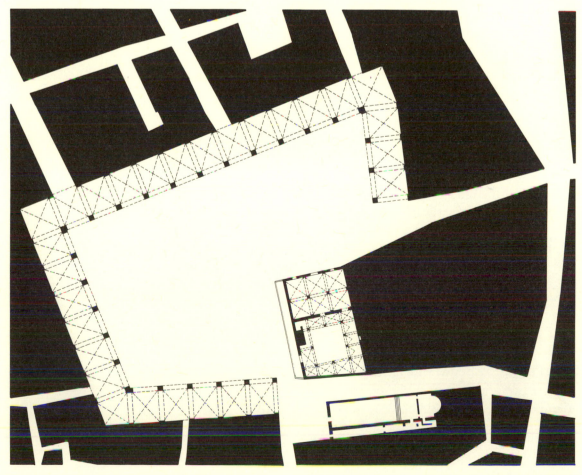

liano failed to present the project to the duke. Only a major renovation on this scale could have provoked Baccio Bandinelli into suggesting the construction of a new facade for the Palazzo Vecchio modelled on the Udienza. No more is known of the circumstances leading to projects that were created by two of Florence's most capable sculptors, but the grand scale and comprehensive scope is unmistakable.

Any ground plans showing the proposed ensemble of buildings appear to have been lost. However, the surviving drawings allow for two reconstructed layouts that show the impact of the most important planning schemes of the previous decade. The first solution (fig. 8), with a continuous portico and the equestrian statue in the position of Giambologna's later monument to Cosimo I, is an elaboration on Michelangelo's often overlooked suggestion to surround the square with a monumental arcade modelled on that of the venerable trecento loggia.[9] The second possible layout presupposes a return to the area's mid-fourteenth-century layout by building a loggia matching that of the Signoria in the northwest corner of the square. While this version is plausible, it is unlikely that Florentines would have tolerated changes to the square that ignored or blocked the entrance from Via dei Calzaiuoli.

The most original of Francesco's designs, the two-story building flanking the strada nuova (plate 48), would have provided a sober but uniform design for the new street. Articulated by shopfronts in the form of Roman *tabernae*, the facade's arched openings in the seventh bay would have easily accommodated two streets that disappeared with the construction of Vasari's Uffizi. There is evidence in the form of contemporary chronicles suggesting that the new artery was meant to accommodate the Florentine magistracies, but the tabernae in Sangallo's design are unseemly residences for the administration of Cosimo's ambitious new state.[10] At any rate, the essential concept of Vasari's building—administrative offices in the form of repetitive houses—is already suggested in a proposal made a decade and a half before the Uffizi was begun (fig. 9).

The other important feature in Sangallo's project was a open, private passageway on the upper level. Linked to Cosimo's private apartment in the Palazzo Vecchio by a bridge crossing the Via della Ninna, the pathway arched over the extension of the Via Lambertesca, and would have continued in a southerly direction before reaching the riverbank. Antici-

pating Vasari's Corridoio by nearly two decades, the passageway conceivably could have extended across the Arno to a stronghold on the site of the later Belvedere Fortress, or to the Palazzo Pitti, whose purchase may have been contemplated along with this scheme.[11]

The redesign of the Piazza della Signoria would have been perfectly credible in light of the recent consolidation of Cosimo's power over his dominion. In the 1540s Florence was in the midst of a powerful economic recovery that would last until the end of the decade, allowing Cosimo to build for the first time in his reign.[12] But the failure to realize the strada nuova passageway and the renewal of the structures on the Piazza della Signoria can be explained by their extraordinary nature and the considerable funds needed to execute them. Despite his ability to wield power in his own interest, Cosimo must have anticipated the resentment of the Florentines at the desecration of the most potent symbol of their Republican past. Pragmatism outweighed dynastic pretensions. Giovanni Battista del Tasso's Mercato Nuovo, begun in 1546 on the site of a medieval marketplace as the central exchange for gold and silk, may be the only executed portion of the new monumental precinct.[13] With the onset of the Sienese war in 1552, all available resources were diverted to military endeavors in expanding Medicean dominion. Equilibrium was restored only at the end of the decade with the annexation of Sienese territories and the cessation of fighting with Montalcino, the only town to resist incorporation. To use the metaphor of Giovanni Battista Adriani, Cosimo's official biographer, the ship of state had finally found a safe harbor.[14]

THE UFFIZI

The construction of the Uffizi culminated two centuries of active expansion of the dominion of Florence. Already by the trecento Florence had evolved into a territorial state controlling a chain of cities from Arezzo and Cortona in the south to Pisa and Livorno in the west. The relationship with dependencies was largely economic; a certain amount of political independence was benignly tolerated in compensation for the exploitation of revenues through increasingly heavier taxation and forced loans. With the advent of the Medici dukes, administration was effectively cen-

tralized from Florence. Under Duke Alessandro, who sought a comprehensive reorganization of the major organs of state, several minor guilds involving building construction were merged into a single confraternity, the Università dei Fabbricanti.[15] Individual craftsmen effectively had become agents of the state. Autonomous legal systems were homogenized through the adaption of uniform codes of law administered by Cosimo's own bureaucracy.[16] The annexation of Siena nearly doubled the size of the state. Moreover, Cosimo's preference to spend nearly half of the year outside of Florence surveying his dominions required an able body of administrators to attend to matters in his absence.

In order to maintain the legitimacy of the new state, Cosimo I turned to architecture on the gran-

dest possible scale. The foremost task that he faced after conquering Siena was the creation of a new setting for the administration of the increasingly autocratic state, and this required the assistance of an inspired and experienced architect. Unlike other Italian states that attracted architects after the Sack of Rome in 1527, Florence failed to assimilate the fruits of the Roman High Renaissance in architecture as a result of the siege by Imperial troops in 1529 and the political instability that followed. Lacking an architect of the stature of a Sansovino or a Giulio Romano, Cosimo repeatedly sought to entice Michelangelo to repatriate to Florence.[17] Michelangelo's reply, as reported by Vasari in the *Lives*, was little more than a polite refusal; too much was at stake for him to leave, despite his advanced age and poor

0 10 20 30 40 50m

9. Florence, reconstructed plan of Francesco da Sangallo's proposal for a building on the site of the Uffizi

health. It is logical to assume that if Michelangelo had chosen to return, he would have been given the principal design position in Cosimo's renewal of central Florence; Michelangelo, rather than Vasari, would have been the architect of the Uffizi and the decorator of the Palazzo Vecchio.

Early Projects

Florence's victory in the war with Siena rekindled Cosimo's aspirations of obtaining a royal crown as king of Tuscany.[18] Yearning to be considered the successor to Augustus and the equal of the Holy Roman Emperor and the kings of France and Spain, Cosimo again turned to the renewal of the Piazza della Signoria as a representation of his aspirations in the theater of European politics.[19] In contrast to the unbuilt proposals of the 1540s, which were excessively reverential of Florence's architectural traditions, the designs prepared by Bartolomeo Ammannati displayed a true grandeur inspired by the buildings of ancient and modern Rome. The Palazzo Vecchio, with its Republican associations, was not a palace fit for a king; one proposal (plate 93), emulating the forms of the Imperial residence on the Palatine, was to have occupied the full area between the Piazza della Signoria and the Arno.[20] Evoking the plan of the Palazzo Farnese, another scheme for a site fronting the Via Por Santa Maria would have necessitated the destruction of Santo Stefano.[21] But in the megalomania of Ammannati's grand proposals were the seeds of Vasari's executed project; the particular grouping of stair and salone in the ducal palace was to serve as the model for Vasari's stairs in the Palazzo Vecchio, and the layout of the offices on the upper floor of the Dogana was to reappear in the magistracies on the ground floor of the Uffizi.

Vasari's initial idea for the Uffizi (plate 49) is recorded in a drawing by his nephew, Giorgio Vasari the Younger.[22] In function, the combination of commemoration and administration was unprecedented. Conceived as a free-standing structure with continuous porticoes on its ground level, the scheme focuses on a circular monument that dominates the internal courtyard. The tempietto-like structure apparently was meant as a funerary monument for Cosimo, as indicated by the stairs that would have lead into a crypt. The magistrates' offices on the ground floor are entered from narrow passageways opening off the porticoes, and within each unit smaller stairs lead to mezzanine chambers. Monumental stairs at opposite corners of the court lead to the main floor, which presumably would have accommodated large meeting halls for guilds and magistracies. Other principles of its internal organization (lateral passageways, unit layout) are taken from the Procuratie Vecchie in Venice. Although the layout could have easily accommodated offices for the thirteen different organizations, the individual chambers in each suite would have been only two-thirds the size of those eventually executed. Most of all, Vasari discovered in this scheme the conceit of an open-air basilica that was later retained in the executed building.[23]

The project required more property than Cosimo was willing to acquire. It presumed the demolition of the entire area between the Piazza della Signoria and the river, taking the Loggia della Signoria with it as well (fig. 10). Even if its grandiosity were no problem, the scheme could have been criticized on practical grounds; it simply provided fewer and smaller offices on a site that was larger than necessary, more difficult to assemble into a single parcel of land, and more expensive to acquire than the existing right-of-way created by the strada nuova. As in modifications to the Palazzo Vecchio and the Palazzo Pitti, and elsewhere, Cosimo rejected planning on a grand scale in favor of projects that utilized existing construction.

Meanwhile the strada nuova had lain dormant for more than a decade. Sometime in 1559 Cosimo made the decision to construct the Uffizi along the lines of the executed scheme, and shortly thereafter Vasari began to prepare a wooden model.[24] By March of the following year, the project had proceeded far enough to require detailed plans for the magistracy offices in the west wing.[25] However, the design was still in flux, since Vasari was still acquiring property for the Uffizi's site. The process is vividly described by Vasari in a letter of March 5 to Cosimo:[26]

> In accordance with your orders, Sir Antonio de' Nobili and I have taken all the measurements of the floors, walls, and the roofs (of the existing houses) with great care, and we have appraised the houses, not so much in terms of the amounts their rents bring in today, (but) in the quality and dimensions of the walls. . . . As your Illustrious Excellency can see, the area below the Mint, where the best houses are located, is considered the most valuable. In order to build there, it would be necessary to penetrate into

the volumes of these houses because the line of the facade of the Mint continues right through them, and is impeded by those houses on the street leading to the Volta dei Girolami, since they occupy the area of the rooms on the right hand side (of the Uffizi). As a means of illuminating the audience chambers and the chancelleries of the magistracies, it is necessary to make a small courtyard measuring 10 *braccia*. This courtyard has a small staircase leading to the upstairs rooms, as your Illustrious Excellency can see in the plan; the staircase can (also) be brought forward slightly to connect it with the other rooms in front. . . . On the other side, below San Pier Scheraggio, there is no house of great value, because they are very poor and made of old materials, and I am even surprised they are still (privately) occupied, although they are convenient to the palace. . . . I have never seen anywhere worse pigsties, or more uncomfortable

residences and palaces to be inhabited. . . . In the meantime, in the course of my work on the design, I have discovered that on the area below the Mint, which slopes down four and a half *braccia* towards the river, a very beautiful stable could be built, having entrances toward the river. They could be entered through the houses on the right hand side. . . . (Above the stables) each magistracy will be provided with every convenience that it requires in terms of their rooms and (other spaces) without altering the disposition of spaces allotted by Your Excellency.

Evidently, many details had to be resolved. That Vasari continued to envisage a building encompassing more area than eventually employed is shown in a letter from Cosimo's personal secretary, Concini, that reflects the duke's practical mind at work:[27]

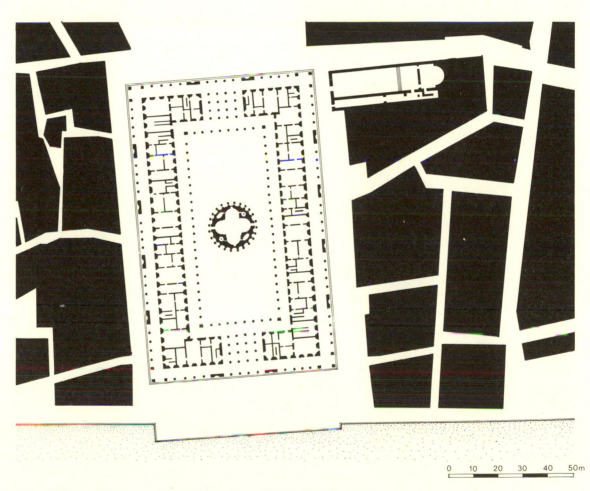

0 10 20 30 40 50m

10. Florence, Uffizi, reconstructed site plan of Vasari's first proposal

His Excellency has seen the report that you have sent concerning the houses, but states that he does not understand it, and is surprised by the number of houses, since it seems impossible to him that there are so many. He does not see why so many houses have to be demolished on the site to be rebuilt as indicated on your drawings, unless you have planned to include another street, or some other fanciful invention (*fantasia*). Therefore, my lord Giorgio, send us a clearer account, because his excellency cannot understand this one. Furthermore, the stables that you have designed do not please my lord the Duke. He has charged me to tell you all of the above, and orders that you carry on with other matters about which you have written.

The significance of the dispute lies in Vasari's reluctance to commit himself to smaller version of what was once a grandiose design. Disdainfully reminding Vasari that the architect had already gone beyond his authority, the calculated sarcasm of Concini's remarks suggest that the duke was fearful that Vasari would continue to ignore criticism of his architectural designs.

The Executed Design

Ultimately Vasari acceded to his patron's wishes. As built the Uffizi is an elongated, U-shaped structure that largely follows the outline of the street opened by Cosimo I in 1546. The three-story building is composed of two arms unequal in length: the "Uffizi lunghi" to the east originally containing seven offices and S. Pier Scheraggio, and the "Uffizi corti" to the west containing only six (plate 50). Retaining the visual characteristics of a street defined by repetitive facades (plate 51) but discarding the unbroken communication of a thoroughfare, the narrow space between the wings is a cul-de-sac known now as the Piazzale degli Uffizi. The canyon-like enclosure of this central vessel is broken only by the irregular course of the Via Lambertesca (plate 52). The only modifications to the facade's tripartite rhythm occur when it passes across the exterior of the old Florentine Mint at the end of the western arm (plate 53). Entrances to the offices and the church all uniform in design and located in the central bays of the facade units, are linked by a continuous portico (plate 54). Formed by a continuous barrel vault and supported by sequence of piers and a trebeated Tuscan order,

the portico takes on a decorative feeling with its raised coffers.

At the riverfront, the two arms are joined by the *testata* (plate 55), a screen-like loggia composed of superimposed serliana motifs on the two lower levels and the belvedere above. The spatial forms and effects are endlessly interesting. Just as in the cul-de-sac, where Vasari exploits the long, tunnel-like shape for dramatic effect, the loggia's ground level (plate 56) rivals the facade of the Pazzi Chapel for its striking rhythmic succession of domes and vaults supported by block-like piers and paired columns. The riverfront elevation, on the other hand, was never meant to be seen and thus its upper stories are anonymous in design. As a consequence of the importance given to the portico, only those elements on the ground floor are treated in a monumental fashion on the side facing the Arno (plate 59). Accurate measurements show that the spirit of regularity is matched by the precision of its construction.[28]

Vasari's greatest challenge was to create a coherent plan for the diverse needs of the eight magistracies and five guilds that previously had been scattered throughout the city (Table 1). Drawing on the Mediterranean tradition established in the Roman taberna, Vasari took the layout of a common shop (fig. 11), increased its size, gave it a one-story facade that increased both its status and privacy, and added additional rooms as necessity demanded. The offices, which were directly accessible from the ground-floor loggia, were composed of a generously sized, nearly square vaulted chamber (plate 57) flanked by smaller rooms for scribes or administrators (plate 58). Records were kept in a mezzanine archive at the rear of each unit. Vertical communication was usually to a single service stair, also at the rear. This system of cellular units supporting an essentially independent piano nobile was adjusted only in the case of one magistracy, the Ufficio delle Decima e Vendite in the western arm, which was provided with its own monumental stair to reach chambers on the floor above.

There seems to have been no hard-and-fast rule for the assignment of space in the various magistracies; neither their budgets nor the number of their employees were reflected in the design. Differences were marginal in most cases and may bear no relationship to their administrative structures. For instance, the chambers of the Arte della Seta had one more secondary office than the Grascia or the Pupilli (rights of minors), who had more administrators. Two of

TABLE 1. The Original Occupants of the Uffizi

Administrative Agency	Purpose	Data of Foundation	Budget in Scudi (1551–2)	Employees*
EAST WING (from southern end)				
Tribunale di Mercanzia	commercial court	1309	1195	6/8/6
Università dei Fabbricanti	consolidation of four minor guilds: Fabbri, Carozzai, Chiavai, Legnaiavi	1532	130.10	(?)/3/5
Arte dei Medici e Speziali	medicine, spices	13th c.	66.6	(1)/2/6
Arte della Seta	silk trade	12th c.	173.1	(2)/3/6
Arte del Cambio	banking, exchange, precious metals	1202	?	?
Arte dei Mercanti	merchant's guild	1150	289.5	(1)/7/4
Magistrato dei Nove Conservatori del Dominio Fiorentino	administration of provincial towns	1559–60	—	33 in 18th c.
WEST WING				
Ufficio dell' Onestà	superintendency of public morality	1415	49.5	(2)/1/2
Ufficio delle Decima e Vendite	land tax	joined 1552	1112.4	c.10 in 1550s; 28 in 1695
Ufficio di Grascia	provision of foodstuffs	14th c.	714.6	5/3/11
Magistrato dei Pupilli	protection of minors' rights	1393	624.13.2	5/5/2
Conservatori di Legge	legal protection	1428	260	8/2/6
Magistrato delle Bande	ducal militia	reorganized 1552	830	

*Paid or (unpaid) magistrates or conservators/administrative staff (*scrivano, cancelliere, camerlingo,* etc.)/office help or apprentices (*garzoni,* etc.).

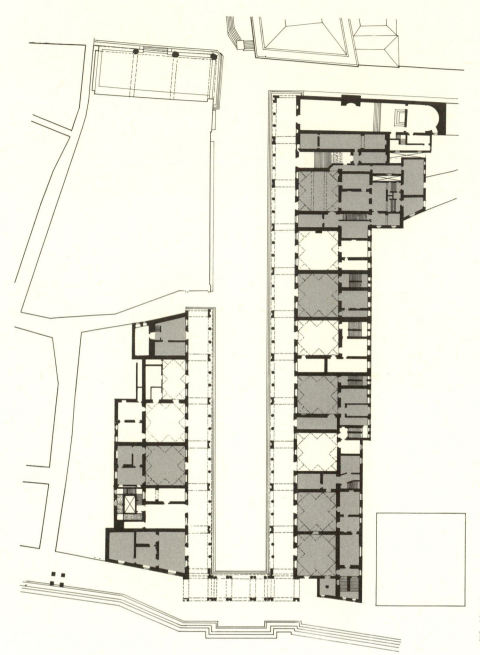

11. Uffizi, plan of magistracy offices in the eighteenth century. See also plate 50 A

the smallest agencies, the Ufficio dell' Onestà (morals) and the Magistrato delle Bande (national militia) were given prominent positions at the ends of the western wing.

Vasari's plan is particularly notable for the complexity of its internal design, which is best shown at the northern end of the east wing (fig. 12). San Pier Scheraggio, now reduced in width to the dimension of its nave, occupied part of the first bay. The remaining area, as well as the entire second bay, belonged to the Nove Conservatori del Dominio Fiorentino. Another exceptional element was Vasari's monumental

stair that led to the large salone located above the main floor of the four northernmost magistracies. The grand chamber could have functioned as a meeting hall for the governing councils of the various magistracies as well as the convocations of two consultative bodies, the Council of Forty Eight and the Council of Two Hundred, although there is no evidence that it ever served this purpose.[29] With a sloping floor and provision for seating against its side walls, the chamber became the first permanent theater in Florence, Buontalenti's Teatro Mediceo, which opened in 1586. However, there were few per-

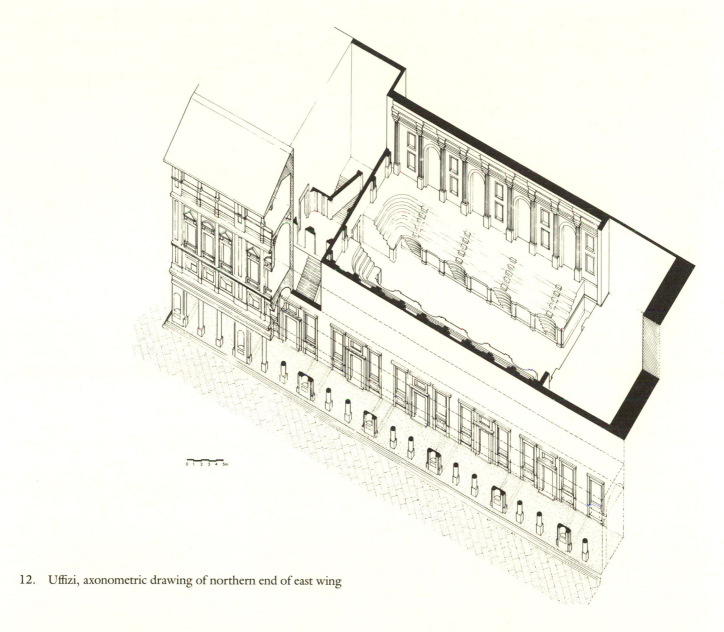

12. Uffizi, axonometric drawing of northern end of east wing

formances in the theater, and by the next century it had fallen into disuse. Only the few offices in the west wing and the hall seem to have been integral parts of the piano nobile from the beginning; spaces like the vaulted, well-illuminated rooms along the facade never seem to have had any specified function other than storage for the Medicean *guardaroba*, the vast ducal collection of personal effects and furnishings. Nor is there any indication that they were meant to serve as housing for diplomatic guests, members of the court, or the Swiss lancers who protected Cosimo I, another conceivable purpose for the chambers.

The history and uses of the uppermost floor, executed only after Vasari's death in 1574, are less perplexing.[30] Like the passageway in Francesco da San-gallo's proposal for the same site, whose design it resembles, the open gallery served as part of the Corridoio connecting the Palazzo Vecchio with the Palazzo Pitti. Presumably Vasari must have planned rooms behind it, although there is no evidence indicating what he intended them to contain. By the end of the century, most of the chambers on this level were given over to craftsmen and artisans serving the court. The nucleus of the Medicean art collection was housed in the Tribuna, the small octagonal chamber designed by Buontalenti in imitation of the Tower of Winds in Athens.[31] In 1600, Ferdinando I de' Medici proposed the creation of rooms for collection of arms and perhaps a collection of models of cities and fortresses.[32] Despite the essentially private character of its uses, the floor was easily reached by

Buontalenti's staircase that led to a secondary entrance on the Via Lambertesca.[33]

At the same time Vasari was also extraordinarily attentive to the particular difficulties posed by this site. The project utilized the right-of-way created by the new street, diverging from its axis only by a few degrees.[34] The other determinants of the layout were the facade of the Mint, which established the axis of the entire scheme, and the Palazzo Castellani, which constrained the depth of the magistracies and width of the facade along the Arno (plate 59). The incorporation of San Pier Scheraggio and the Mint into the Uffizi also were not the only instances of reusing existing construction. The staircase in the east wing constructed in 1737 across a room once part of the Arte dei Medici e Speziali closely follows the lines of a street that once existed in that location, and the irregular rhythm of smaller rooms at the rear of both wings also may involve the reuse of older foundations. In order to facilitate the clearing of the site (and, of course, to keep costs low) much of the Uffizi's walls and vaults were constructed out of the remains of the destroyed buildings.[35] Even the gentle downward slope of the new street towards the Arno permitted the construction of an artificial base to support the southern part of the complex. At the outset, Vasari proposed that this podium could contain stables that would supplement the *stalle* near Piazza San Marco, but none were built. Eventually they were constructed in the 1580s with access from the Via delle Carrozze.[36] While this use may seem attractive and logical, the dark environment with little or no change of air must have been uncomfortable if not unhealthy for some of nature's most temperamental animals.

Over the course of the next two centuries, the Uffizi became more of an archive than administrative structure due to the necessity for each of the magistracies to preserve its records. Even San Pier Scheraggio was not spared. In 1581 its parochial status was rescinded and the church was reassigned to the Padre Inquisitore of Florence.[37] After its deconsecration, it became a warehouse for the storage of additional records. Limited by the guardaroba above and the small chambers in the offices below, state agencies eventually had to find quarters elsewhere in the vicinity of the Palazzo Vecchio.[38] By the end of the eighteenth century, lack of space forced other magistracies, guilds, and administrative agencies to find space in structures on the Piazza della Signoria and in the vicinity of the Mercato Nuovo. The chambers created by Vasari were still held in the highest esteem; in his inspection of the Uffizi, Grand Duke Pietro Leopoldo found the offices to be "well lighted, well laid out, and commodious."[39]

The Contributions of Bartolomeo Ammannati

But was Vasari entitled to such praise? The circumstances of career and commission faced by Vasari point out the need for a professional advisor if not a full collaborator. The lack of experience in designing a large, multifunctional, urban building was an important consideration as none of his earlier architectural projects matched the Uffizi in size and complexity. Both the renovation and decoration of the Palazzo Vecchio (not to mention private commissions) placed considerable demands on his increasingly limited time. Reporting to Duke Cosimo and the Uffizi's building administration was necessary and frustrating. For counsel he could turn to his former collaborator in Rome, Bartolomeo Ammannati.

Ammannati left his mark on the planning of the offices for the magistracies. In both Vasari's initial proposal for the Uffizi and the executed building, the most characteristic feature of their layouts—the configuration and number of chambers around a generously proportioned vestibule—was a device that Ammannati employed in many of his own commissions. Throughout his career Ammannati seems to have been especially attracted to establishing intricate patterns of rectangular chambers in the plans of his buildings. The pattern of rooms in the Uffizi reappears in his plan for a *calonaca* (plate 60), in several plans for palaces or villas, and in an unexecuted design for a ducal palace in Pisa. In each of these examples, as in the layout of the Uffizi's magistracies, the scheme is generated from patterns of daily use.

Ammannati's facility in architectural planning resulted from his knowledge and understanding of palace design in the Renaissance. What differentiated Ammannati's plans from those of Palladio, from whom he often borrowed, was a disinterest in integrated systems of mathematics, geometry, and proportion, delighting instead in creating variations in the cellular arrangements of large structures. The facility for arranging flexible patterns of rooms also strikes a discordant note among Vasari's other projects, which never employed this technique. That

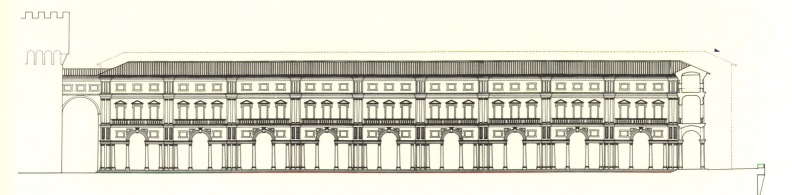

13. Uffizi, reconstruction of Ammannati's proposal for the Uffizi facade

both men had already collaborated in Rome on the De Monte Chapel in San Pietro in Montorio and the Villa Giulia must have secured a working relationship in Florence where Ammannati provided designs for some of the interior furnishings in the renovation of the Palazzo Vecchio.

Having influenced Vasari's initial proposal for the Uffizi, Ammannati felt sufficiently involved in the building's evolution to criticize the final design (plate 61). The facade of his radically different proposal (plate 62) emphasizes the divisions between the magistracies with robust pairs of pilasters on each of the three floors, thus emphasizing the elevation's periphery rather than its center. By enclosing the upper floor Ammannati created an attic story similar to those found in Roman palaces. Most of all, the repetition of the serliana on the facade of each magistracy gave the scheme a Palladian appearance inspired by the Basilica in Vicenza (fig. 13). The greatest defect was the reduction in the number of offices that would have resulted from the widening of the facades. Also, the squat proportions of the individual units would have failed to sufficiently compensate for the powerful verticality of the Palazzo Vecchio, a task admirably handled by the tall elevations of Vasari's exterior.

Ammannati's ideas can be seen in some of the Uffizi's details. The prominent serliana dominating the riverfront loggia may well be Ammannati's invention, as indicated by his employment of this motif in numerous projects throughout his career. Another remnant of Ammannati's influence may be the end elevation of the portico facing the Via della Ninna (plate 63), a detail close to one employed in the central bays of the Palazzo Pitti's courtyard (plate 64). Two decades later, Ammannati repaid the compli-

ment by reinterpreting Vasari's design of the niches on the Uffizi's piers in his facade for San Giovannino, the Jesuit church in Florence. In the end, while Ammannati contributed to the planning of the magistracies and suggested some details, it was undoubtedly Vasari who created the general concept for the Uffizi, designed its facades, and paid close attention to its execution through the close supervision of others.

Financing and Execution

In spite of Cosimo I's obsessive attention to the cost of construction, the Uffizi was an enormously expensive building. If the figure of 400,000 scudi mentioned in contemporary accounts is accurate, and there is no reason to think that it is not, then it was among the most costly structures of the late sixteenth century. For example, its cost was more than five times the amount spent on the Gesù in Rome.[40] To be certain, this was due to the immense size of the Uffizi, and the great amount of demolition it entailed. Even if detailed accounts in the form of recorded payments have been lost, it is not difficult to imagine the difficulties of coordinating the teams of laborers, masons, stonecutters, and haulers who contributed to the making of the Uffizi. It was the administration of building process that occupied much of Vasari's time.

The complexities of financing such an expensive project had a profound effect on the execution of the Uffizi. The cost of construction was shared by the magistracies, who were obliged to pay for their own residences, while Cosimo paid for most of the re-

maining the structure.[41] The system of apportioning the cost of public structures to the parties that would benefit the most from them was justified on several grounds. It was considered fair and just, and the division of responsibility would free ducal funds for other projects. It, too, was sanctioned by recent practice; the cost of Tasso's Mercato Nuovo was born by several commercial guilds and Florence's foreign consulates.[42]

But this policy created unnecessary expenses for the magistracies and created new taxes for Cosimo's subjects. Only one of the occupants, the Arte dei Mercanti, was able to pay its share of the cost of construction without creating supplemental sources of income. Typically the magistracies received funds from the sale of their former residences, but in most instances additional income was generated by higher dues or increased taxes. A representative example is the Magistrato delle Bande, which raised both its inscription fee and its penalties for failure to report for service.[43] The Ufficio dell' Onestà raised taxes on the common prostitutes and elegant courtesans who were tolerated by the ducal regime.[44] In the case of the Arte della Seta, a suspension of an annual contribution to the Ospedale degli Innocenti was threatened until overruled by Cosimo himself.[45]

The efficiency of the Uffizi's building administration was compromised by an equally complex chain of authority. Management of the largest building project in Tuscany initially was vested in the Magistrato della Fabbrica, a commission that acted both as client and contractor for the project. At the time of its creation in June 1560 this body was comprised of four nobles who had already served as chief administrators of magistracies, and only one artist, the elderly Francesco da Sangallo. Immediately it was clear to the magistracies that this arrangement failed to account for the widely varying interests of the Uffizi's occupants, and to Vasari it was evident that all lacked the skills in coordinating technical, administrative, and financial aspects of the building under construction. By the end of August 1560 twenty three members shared these responsibilities: the original five members, representatives of the thirteen magistracies, the architect and his appointed assistant, an administrator, his assistant, and a secretary.[46]

Personal conflicts were inevitable. Tensions arose between builders and Vasari's staff. Shortly after work began the trusted master mason, Bernardo di

Monna Mattea, was banished to a year in Pisa for insulting a member of the Magistrato on the building site.[47] Vasari's absences, too, sometimes created confusion, causing Antonio de' Nobili, Cosimo's general treasurer, to remark that "everyone wants to be pope."[48] Both de' Nobili and Vasari pressed for the appointment of a proveditore generale with organizational skills and expertise in building construction. Vasari provided a list of candidates, and in June 1561 Bernardo Puccini was appointed to the position, bringing with him considerable experience as a specialist in the design and construction of fortifications.[49] Although he was certainly qualified to test materials, coordinate construction, and make decisions in the architect's absence, Puccini's dedication, aloofness, and high-handed manner struck Vasari as humorless. Eventually the proveditore generale's name came to symbolize the worst excesses of an intractable bureaucracy, the "Puccini di palazzo" as Vasari's friend Don Vincenzo Borghini put it.[50]

Fortunately Vasari maintained a deep involvement in the administration of the project despite numerous other commitments. Whenever Duke Cosimo was out of town, Vasari wrote regular and detailed reports on the progress of the Uffizi's construction, and on two occasions travelled to Pisa to present them in person. The appraisal of houses to be demolished for the Uffizi's construction was conducted under his general supervision.[51] The pietra serena stone employed on the Uffizi's exterior quarried near San Martino a Mensola and conducted away on a roadway built with forced labor was another matter under Vasari's purview.[52] Although most cut stone was executed as piecework in the special huts built for this purpose in Piazza dei Castellani and near the Mint, concern for cost led to open bidding in 1562 for decorative stonework.[53] To Puccini this was the most economical means of contracting for building material, but to Vasari it was a direct challenge to his control over quality in construction.

The episode caused considerable embarrassment to Vasari, who was accused of favoritism in letting out contracts and profiting personally from this predicament by failing to accept the lowest bids.[54] In 1566, in response to charges by Prince Francesco of high costs and low quality of work, the five proveditori submitted a report with a point by point defense of their (and Vasari's) stewardship of the project.[55] Part of the blame must be attributed to Cosi-

mo, whose outburst of building monopolized and strained Florence's construction industry. In 1568 Vasari participated in an inquest resulting from a request by brick suppliers to increase prices in light of rising costs.[56] According to Bartolomeo Ammannati, who also served on the commission, government interference resulted in a low quality brick. Undoubtedly the problems that plagued the Uffizi were to a large degree beyond the control of the architect.

Typology and Design

Unlike villas, palaces, or certain kinds of church plans, administrative office buildings in the Renaissance did not correspond to a fixed typology of architectural forms.[57] Medieval communal palaces continued to serve their original purpose largely because the institutions of government had not changed radically over the centuries. Traditions died hard; designs for governmental buildings as diverse as Cesariano's reconstruction of the Vitruvian basilica at Fano and Michelangelo's Palazzo dei Conservatori on the Campidoglio in Rome still retained the porticoed facades sanctified by the conventions of an earlier age.[58] In the case of Bramante's design for the Palazzo dei Tribunali in Rome (plate 65), symbolism and its associations with power dictated a medievalizing, castellated appearance for the building in which Roman lawcourts were to have been centralized.[59] While the desire to create the visible symbol of the papal control over the city of Rome was clear, Vasari skirted the issue of the building's ideology, preferring to justify the gathering of Rome's public offices and tribunals as a convenience to merchants in their business.[60] When Florentines were faced with the question of the Uffizi's architectural typology, their responses were vague and inconsistent.[61]

The situation in sixteenth-century Spain was scarcely different. The discovery of America resulted in the creation of a massive bureaucracy that linked the emperor and his court with the viceroys at the periphery of the empire. The means of communication was primarily by edict, which resulted in the proliferation of diplomatic paper written by an increasingly large body of officials drawn from the nobility.[62] The councils that formed the central administrative organization of the empire lacked structures all their own, often meeting instead in the palace where the emperor resided.[63] It was even worse for the legions who drafted the documents, which were prepared at the homes of the individual secretaries and in the company of their clerks.[64]

Paradoxically, the idea of a new governmental building in Florence may have been encouraged in part by a Spanish viceregal project for a the tribunal courts of Naples. As a part of the governmental reform and physical transformation of Naples, Don Pedro de' Toledo, the Spanish Viceroy and Duke Cosimo's father-in-law, began a comprehensive renovation of the Castel Capuano.[65] Originally constructed in the twelfth century as a fortress guarding the eastern flank of the city (plate 66), the imposing building later became a royal palace, princely habitation, and a private residence before it was seized from the prince of Sulmona to accommodate the city's most important tribunal courts, a purpose it still serves today.[66] In terms of its use, the renovated structure was primarily a court house, containing the judiciary for civil and criminal law, appeals, fiscal matters, and small claims, in addition to the administration of weights and measures.[67] The selection of its site was not accidental; proximity to the Porta Capuana allowed supplicants from the provinces access to the courts without having to negotiate the labyrinthine center of the old city, and nearby open spaces were used for public executions. The result of these changes was a new permanence for the courts and increased prestige for the position of the magistrates.[68] The realization of this project no doubt would have had a special meaning for Cosimo I, who was married to Don Pedro's daughter, Eleonora of Toledo. Vasari, of course, was aware of the project as a result of his Neapolitan sojourn in the 1540s.

The Uffizi announced a new approach to the design of public office buildings. By departing from castellated prototypes such as the Palazzo dei Tribunali and the Castel Capuano, it divested itself of associations with tyranny. By conceiving the building's facade as architecturally distinct from the spaces behind it, the planning of the magistracies and the design of the exterior were rendered possible at their appropriate architectural scales. And by fusing loggiated facades with the domestic scale, the Uffizi showed its indebtedness to the continuous porticoes that ringed major squares throughout Italy. To Vasari this must have meant the Piazza San Marco in Venice, which he saw for the first time during his visit to

Venice in 1541–42. Although Vasari's appreciation of the ceremonial and historical center of Venice can be taken for granted, his familiarity with its surrounding structures was due to his friendship with Jacopo Sansovino, who lived in the Procuratie Vecchie (plate 67) on the north face of the square.[69] At this time Vasari would have also learned about Sansovino's proposal to replace the old medieval dwellings of the procurators of St. Mark's on the south side of the Piazza San Marco with new dwellings modelled on the Procuratie Vecchie.[70] For all of the prestige and power of the procurators, it is important to remember that their building was strictly a domestic building with rental shops on its ground floor. Nontheless the impact that it made on Vasari was considerable. Even if the Procuratie Vecchie did not contain administrative offices of any sort, their repetitive facades, serial houses, and deference to San Marco and the Doge's Palace anticipate the essential architectural ideas of the Uffizi.[71]

As it happens, the idea of constructing a street flanked by repetitive facades, as first proposed for the strada nuova by Francesco da Sangallo, was deeply rooted in Florentine urban history. By the end of the fourteenth century, the evolution of the Piazza della Signoria had reached a point where the reconfiguration of its northern edge was the predominant concern of the city council. In order to attain the desired effect of formal regularity, rusticated facings were constructed on the buildings flanking the newly widened Via delle Farine (plate 68), a street that had become one of the major approaches to the Palazzo Vecchio.[72] In 1390 the same regulations were proclaimed for the exteriors along the newly widened Via dei Calzaiuoli (plate 69) leading from the Piazza della Signoria to Orsanmichele.[73] While new facades rose barely more than a single story, they gave visible form to the arteries that physically and symbolically connected the government with the guilds and the city's religious center.[74] In turn the Uffizi was designed as a companion to the medieval streets, as reflected by the ground floor shops in the 1546 project and the repetitive facades in the executed building.

The historical and topographical importance of the Uffizi's site conferred special importance on the design of its facades. In the *Lives* Vasari mentions that pietra serena could only be used on public buildings, unless special permission was obtained.[75] The motivations behind the prohibition were both eco-nomic and artistic. The choice of the finely grained bluish-grey stone may have been due to Cosimo himself, who claimed ownership of the quarry near San Martino and had already dictated its use in the Mercato Nuovo and in Bandinelli's Udienza. The result was a specifically Medicean look to the projects, since Michelangelo already had employed it in the New Sacristy and the Laurentian Library. The elegance and proportions of the lowest level are largely due to the slender, elongated rendition of the Tuscan order whose use was also commanded by Duke Cosimo.[76]

Most of all, Vasari understood the design of the riverfront loggia (plate 55) as an opportunity to visually link the Piazza della Signoria with the cultivated fields and gardens on the hills overlooking the city in a vista of incomparable beauty. An inference to the view is found in a eulogy of Cosimo where the adjacent Palazzo Castellani, which served in Vasari's time as an adjunct to the Uffizi by housing the podesta and civil courts, was singled out for a splendid panorama across the Arno from its riverfront site.[77] To Florentines the visual potential of the Uffizi's site must have been too obvious to require commentary because of the outward view created in 1546 by the opening of the strada nuova. The panorama back toward the palace is equally compelling because the Uffizi's slight deviation from the axis of the strada nuova now brought the statuary in the Piazza della Signoria into full view.[78]

The magnificent unity of city and country was deliberate and consistent with sixteenth-century architectural traditions. It was precisely these similarities in setting that prompted Vasari to reinterpret Michelangelo's original project for the completion of the Palazzo Farnese (plate 70), which was stimulated by the discovery of an ancient statue of Hercules subduing the bull. The proposal called for the transformation of the sculptural group into a fountain for the palace's garden court, the construction of a new bridge across the Tiber, and the connection of the palace complex with another Farnese garden on the opposite side of the river. Vasari, who was present in Rome at the time of the statue's discovery, described the scheme in the *Lives* as a vista where all elements would be seen in a single glance, a conceit that also characterized the Uffizi's most powerful visual effect.[79] Vasari retained something of the transparency of Michelangelo's open loggia in the composition of the Uffizi's own loggia, especially in the riverfront

elevation that would not have been seen under normal circumstances. An allusion to Michelangelo's concept was also maintained by the construction of the Corridoio, which, like the bridge crossing the Tiber, provided access to a distant garden from the heart of the city.

The Palazzo Farnese effected the siting of the Uffizi in another fundamental way. When seen from the south, the Palazzo Vecchio seems visibly to protrude into the Piazza della Signoria, repeating the effect of the Palazzo Farnese as approached from the Via Monserrato (plate 71).[80] This configuration, which contributes much to the Palazzo Vecchio's aura of authority (plate 72), may not have been accidental. In 1541 Paul III proposed a realignment of a section of the Via Monseratto in order to provide a clear view from the papal apartment in the Palazzo Farnese towards the Chiavica di Santa Lucia, the irregular bident of streets formed by the intersection of the Via Monserrato with the Via dei Banchi Vecchi and the Via dei Pellegrini.[81] If the ostensible reason for the project was to protect the pope from further civil unrest, its execution demanded the demolitions of structures at a political price that the pope was unwilling to pay. Although the project was never begun, its authoritarian contempt was echoed in the demolitions that created the 1546 street in Florence, which it indeed may have inspired. At any rate, the domination that the Palazzo Farnese exerted over its surroundings clearly suggested to Vasari the deferential relationship of the space formed by the Uffizi to the ducal palace and square just to the north. One can easily imagine Cosimo I, glancing out from the windows of the Medicean apartments at the corner of the Palazzo Vecchio and looking down at the building which, upon its completion, would fully express the deferential relationship of the magistracies to the absolutist ruler from whom their own authority was derived.

The Meaning of the Uffizi

That Florentines understood the Uffizi as an extension of Cosimo's power cannot be doubted.[82] Its location adjacent to the Palazzo Vecchio expressed the deferential relationship of the magistracies to the absolutist ruler from whom their own authority was derived. Chroniclers opposed to the Medicean rule were ready to stress the social and economic hardships brought on by its construction; one anti-Medicean assessment of the damages born by artisans exaggerated the number of houses and workshops destroyed for the clearing of its site, asserting that over 300 structures had been removed.[83] Ducal insolence was displayed in the slow or partial payment for confiscated property, thus resulting in forced loans from a class of people who would scarcely benefit in any way from the new building.[84] Nor is there any evidence that Cosimo provided any assistance in resettling the dispossessed.

The embellishment of the Piazza della Signoria and the Loggia della Signoria played a prominent role in establishing the Uffizi's political meaning.[85] In 1495, Donatello's *Judith and Holophernes*, a strong symbol of anti-Medicean sentiments in its depiction of the overthrow of a tyrant, was transferred from the Palazzo Medici to a conspicuous position on the *ringhiera* aside the main entry to the Palazzo Vecchio. Only nine years later, Michelangelo's *David*, a biblical figure symbolizing the civic strength and liberty of the Florentine Republic, was erected in place of the Judith which was removed to the third bay of the loggia. After the fall of the Republic, Bandinelli's *Hercules and Cacus*, a ferocious allusion to the establishment of the Medici regime, was placed opposite David to complement its role as a guardian to the stair that entered the Palazzo Vecchio. Originally commissioned by the Republic to complement Michelangelo's colossal statue but completed later under Medicean rule, Bandinelli's group engendered controversy for its artistic inferiority and the circumstances of its history—the erection of civic statuary instilled with a meaning totally different from its original conception.

The grouping of these dissimilar works made a profound impact on observers (plate 73). The larger-than-life figures of David and Hercules showed complementary attributes of moral and physical strength. Their colossal size demanded visibility from a distance, where they would be seen in relief against the immense backdrop of the Palazzo Vecchio. Bandinelli's figures effectively close the composition by halting the line of vision emanating from David. Despite the energy and vitality inherent in David's pose, the extreme torsion in Cacus and the frontal gaze of Hercules give the grouping a pronounced two-dimensional quality. The shallow depth of the ringhiera would have heightened the flatness of the composition. Thus the grouping has only one primary

view: a position along an axial approach to the palace.

The formal and symbolic character of the Piazza was significantly altered by Ammannati's Neptune fountain, the first of the sculptural projects for the square to have been both planned and executed by the Medicean grand dukes. The idea for a large fountain in the square was conceived in the 1550s, and at first Baccio Bandinelli actively sought the commission by making a design that would "surpass all fountains on earth as well as those made by ancients, and at half the price." Bandinelli died in February 1559 and by June Ammannati had beaten out Cellini, among others, in a competition for the commission on account of his combined expertise in hydraulics and monumental sculpture. By placing the fountain at the northwest corner of the Palazzo Vecchio Ammannati assured its visibility from all sectors of the square, including the main axis of the Uffizi. By the end of the century Neptune acquired a political meaning by alluding to Cosimo's pro-Hapsburg naval policies.[86] A temporary installation of much of the fountain was completed by June 1565 for the wedding of Francesco and Johanna of Austria; the remainder of the work was finished only ten years later.

Inevitably any statuary had to conform to the new spatial arrangement created by the Uffizi. Ammannati's Neptune was carved to heighten the impact of the new arrangement of the square, his furtive gaze looking beyond the sculptures of Michelangelo and Bandinelli towards the riverfront loggia. Neptune's torso, however, counteracts the direction of the brief and hurried look by turning towards the square. The lack of movement for which it is often maligned results from Ammannati's attempt to respond to the axis emanating from the Uffizi while giving full visibility to the statue from the entire square.

Ambitious programs of sculpture for the Uffizi's exterior also recognized the new spatial arrangement.[87] Domenico Poggini's often misunderstood foundation medal of 1561 (plate 74) suggests that the new structure originally was associated with Justice, a theme that was not taken up in subsequent proposals.[88] Two years later, Vasari requested marble for two statues for the Uffizi, presumably the figures of Rigor and Equity to be placed under the serliana on the riverfront loggia.[89] Statues of Saints Peter and Cosmas were planned (but never executed) for the niches flanking the entry to San Pier Scheraggio, thus strengthening dynastic pretensions by equating

the establishment of Medicean rule with the foundation of the Church.[90] The remaining 26 niches were to have contained figures of *cittadini illustri*, Florentines who had distinguished themselves in letters, at arms, and in government.[91] In a funeral oration for Duke Cosimo, Bernardo Davanzati underlined the antiquity of this conception by comparing it to the Keramaikos Cemetery in Athens, and, more appropriately for its architecture, to the Roman Forum. The prominent display of statuary on the exteriors of public structures was, of course, rooted in Tuscan traditions, as shown by the figures of saints installed within the piers of Orsanmichele in Florence or the Loggia della Mercanzia in Siena. The choice of subject matter may have also intended a link with Medici history, recalling Tribolo's unexecuted busts of family members for the lateral walls of a garden at Castello, or Cosimo's economic ambitions, complementing the figures glorifying commerce envisaged for the piers of the Mercato Nuovo.[92] In scale and extent the cittadini illustri would have rivalled their forerunners, but the project was never executed. By the mid-nineteenth century portraits of famous Tuscans had been placed in the niches, finally completing a process that began nearly three centuries earlier (plate 75).

It is hardly conceivable that the recumbent figures of Rigor and Equity were meant to exist in isolation on the riverfront loggia. What may have been the earliest proposal for the completion of the Michelangelesque grouping is shown by a few roughly sketched black chalk strokes (plate 76) indicating a standing figure posing as a victorious warrior.[93] In this case the identification of the central figure as Cosimo is all but certain. Subsequently, two effigies of Cosimo were commissioned from Vincenzo Danti, who carved the original grouping of Rigor and Equity. The first, a seated figure mentioned by Vasari in the *Lives* (plate 77), was apparently never completed for reasons that are still unclear.[94] By autumn 1570 he began a standing figure of Cosimo that was to be placed on the riverfront loggia for more than a decade.[95] But in February 1585, more than ten years after Cosimo's death, Giambologna replaced Danti's figure with the portrait in situ today (plate 78).[96]

Cosimo's aspirations to international prominence would have been well-served by the ensemble. For the 1565 wedding another display of famous Florentines adorned the Porta al Prato, the gate through

which the Imperial party entered Florence. The theme would have been recalled by the guests as they passed into the Piazza della Signoria and Palazzo Vecchio, the terminus of the ceremonial entry. No doubt the idea for the arrangement of figures at the point of their entrance to the city was suggested by the cittadini illustri proposed for the Uffizi at the end of their triumphal entry. Sadly, scarcely enough of the facade had been built by the date of the wedding to justify the expenditure involved in its decoration, and consequently some of the figures were commissioned later. Eventually Cosimo and his son Prince Francesco lost interest in the project.

The ensemble would have affixed a new meaning to all of central Florence. The mythical virtues of heroic strength and triumph of good over evil, as embodied in the sculptures by Michelangelo and Bandinelli, would have been augmented by allusions to concrete achievements, as suggested by the naval strength associated with Neptune or the broader accomplishments of famous Florentines. Moreover, the figures on the Uffizi facade would have been presented as the secular counterparts of the saints at Orsanmichele and the descendants of the famous Romans in Ghirlandaio's frescoes in the Sala dei Gigli inside the Palazzo Vecchio.[97] Giambologna's equestrian figure of Cosimo, executed only at the end of the century, completed the ensemble of figures that sought to explain the legitimacy of Medicean rule.

Davanzati's comparison to ancient Athens clearly shows that the Uffizi's allusions to Florence's venerable past were cast in the imagery of antiquity. Following a tradition rooted in Vitruvius, Vasari retained the reference to ancient basilicas by adopting the 1:3 ratio between the loggia and the street that Renaissance theorists commonly employed in their reconstructions of Roman civic structures, giving Uffizi the attributes of an open-air basilica.[98] The source for the ornamental program, too, can be found in antiquity. Clearly, the Roman forum mentioned by Davanzati was meant to be understood as that of Augustus. Passages in Suetonius and in the *Scriptores Historiae Augustae* explicitly state that statues of *summi viri*, the ancient equivalents to the illustrious Florentines planned for the Uffizi, once decorated the inner porticoes flanking the Forum of Augustus.[99] That the association between this forum and its ornamentation was of interest to Renaissance architects is confirmed in reconstructions of it by Peruzzi, Francisco de Hollanda, Palladio, and others.[100] The Augustan Forum may have even suggested to Vasari the blank panel below each niche, emulating the epitaphs indicating the name and accomplishments of the effigies displayed above. The Augustan analogies suggested by the Uffizi's architecture, then, were the complements to Duke Cosimo's personal imagery; had the Uffizi's loggia been dominated by Danti's statue of Cosimo in Augustan garb, the affinity between the two rulers would have been manifest.

The serliana on the riverfront loggia also established the principal meaning of the Uffizi as it was to have been seen both from within and from outside Vasari's building (plate 79).[101] Ever since antiquity architectural enframement in the form of a baldachin or a serliana was employed in depictions of enthroned rulers to suggest by the temple-like *fastigium* the divine nature of their temporal powers.[102] The concept, which was readily assimilated into Early Christian iconographical traditions, was revived by Bramante's famous window in the Sala Regia. Diplomatic reception in this papal throne room was limited to royalty and royal ambassadors, and it was here in February 1570 (plate 80) that Cosimo was crowned as grand duke of Tuscany, a title that gave him political precedence over all dukes and other rulers of independent states. That Cosimo sought to be considered the equal of ancient emperors and contemporary popes was demonstrated earlier by the serliana's employment in Bandinelli's Udienza, the Florentine equivalent to the papal throne. Thus, by giving the Uffizi the attributes of an outdoor throne room, the Uffizi became both the external complement to the Salone dei Cinquecento and an explicit metaphor of Cosimo's absolute rule over Florence, two meanings that radically modified the original concept of Justice. As shown by Duperac's engraving of the Coronation scene in the Sala Regia, Cosimo now could be represented as the universal sovereign seeking to rule with the legal power of Augustus and the moral force of Jesus Christ.[103]

Visitors arriving at the main entry of the Palazzo Vecchio would have seen the Uffizi's statuary as an ensemble depicting the duke of Tuscany presiding over a court consisting of notable historical figures, the uomini illustri, and as an anticipation of their arrival at Cosimo's real throne, the Udienza. Of all the statues envisaged for the Uffizi's riverfront loggia, the seated figure of Cosimo was the one closest in accord with the Uffizi's concetto as the externaliza-

tion of courtly ceremony practiced within the Palazzo Vecchio. Both the iconography of the figure and the circumstances of its design point directly to Vasari as the originator of this proposal. The theme of the seated ruler, for example, serves as the focal point for several of his compositions in the Palazzo Vecchio, the most notable of which is the tondo of Cosimo surrounded by his artists (plate 81).[104] Evidence for this working relationship is provided by Danti's other sculptures that were based on formal and thematic conceptions supplied by Vasari.[105] There can be little doubt that Vasari wanted both architectural and iconographic consistency between the Palazzo Vecchio and the Uffizi.

The history of the Uffizi is properly a part of the larger history of the Piazza della Signoria. Indeed, one of the fundamental lessons of Vasari's design for the Uffizi was how buildings can exert an influence that extends far beyond the confines of their own site. Its most important contribution to the square as a whole was the creation of a "symbolic" axis emanating from the riverfront loggia. This change can be seen in the history of the representation of the square. Prior to the mid-sixteenth century, the most common form was an oblique view from the northwest sector of the square, like the one chosen by Brunelleschi for his famous perspective drawing of the Palazzo Vecchio.[106] Ammannati and Vasari changed our perception of the Piazza della Signoria by giving a second vantage point that became prominent through later representations. Unlike the viewpoint created in the trecento, the controlled panorama from the Uffizi was not dependant on the effect created by a single dominant structure. Nor did it seek to create the rational, ordered world of an Albertian one-point perspective, though similarity to it was often exploited. Whether the vista was oblique or axial mattered little.

In the final analysis the view from the Uffizi must be considered a work of historical imagination, aligning together along its vista some of the most important artistic artifacts of Florence's past in order to create a myth for Tuscany's political future. The symbolic axis was never experienced in ceremonial entries where it would have been most effective; the portion of the Arno opposite the Uffizi was not navigable by large vessels, and the riverfront loggia's steps prohibited entry in any way except by foot. It was left to artists to capture its drama. Cosimo and Vasari would have savored the flattery of Baldassare Lanci's 1569 design for the backdrop of *La Vedova* where Brunelleschi's cupola aligns with the Uffizi's axis, as if to make the architectural history of Florence visible from the grand-ducal effigy (plate 82). Equally striking is Zocchi's eighteenth-century engraving of the palace and statuary in front of it as seen from the ground floor of the Uffizi's riverfront loggia (plate 83). The grandest exploitation of the panorama, however, remained unfulfilled; in 1852 serious consideration was given to a proposal placing Michelangelo's *David* (plate 84) underneath the groundfloor serliana of the riverfront loggia.[107]

Viollet-le-Duc, the nineteenth-century architect normally unsympathetic to the works of Vasari's generation, expressed the greatest understanding of the Piazza della Signoria and the special role played by Uffizi in the ensemble. While travelling extensively in Italy from 1836 to 1838, the precocious young Frenchman, who was to become closely associated with the Gothic archeological movement in France, reacted predictably to Renaissance architecture. Of all architects, Brunelleschi was singled out for gracious and unaffected buildings rooted in ancient Roman methods of construction. Sixteenth-century architects fared less well. Viollet-le-Duc was disenchanted by Palladio, and buildings by Sansovino or Vignola were considered characterless. But the Uffizi was a matter altogether different. In a letter to his father, Viollet-le-Duc offered a perceptive appraisal of the building that would be commended by Cammillo Sitte for its views towards the Arno and evoked by Le Corbusier in his grouping of administrative buildings around the Governor's palace in Chandigarh:

Between the Loggia and the Palazzo Vecchio there is an immense building, with two porches and made of a beautiful architecture that is both simple and concise. It opens out toward the Arno, and, where it is terminated on the riverbank by an open portico, one has a magical and brilliant view. On one side it overlooks the Arno; on the other it looks to the Piazza della Signoria imposing, severe, and serious. Yes, I admit that this architecture so happily combined stirs me, raises my heart, and makes me forget the rest of the world, since there is nothing like it in this corner of Florence.[108]

Ceremonial and Refuge:

The Renovation of the Palazzo Vecchio and the Corridoio

The battle for the political hegemony of Renaissance Europe was fought with bricks and mortar whenever arms and armed forces could not prevail. Throughout the Mediterranean basin territorial or nation-states replaced a patchwork of city-states, bishoprics, and feudal dependencies. The creation of the great courts of the sixteenth century meant that a splendid and imposing urban palace was just as necessary as a fortified *manoir* or castle in the open country had been in the Middle Ages. The role of a ruler's residence as political propaganda was reconsidered everywhere and at every level of power and prestige. Both royalty and petty tyrants sought to impress each other with splendid residences that supported their authority, nobility, and legitimacy. Similarly, a private system of urban circulation was the privilege of popes, princes, and those who wielded sufficient power to control a substantial portion of a city or town. As a means of asserting his rank to both his subjects and other rulers, a duke could only build his principal residence in a way guaranteed to assert his priority over those of lesser stature.[1]

Encouraged by political theorists who fostered magnificence as a trait of princely patronage, sixteenth-century European rulers initiated an age of grand palace construction. If the development began in the papal states with the alterations made by Julius II and Bramante to the Vatican Palace and the Palazzo Apostolico (now the Palazzo Communale) in Bologna, it soon spread to France and Spain.[2] The idea of a palace fit for a king was expressed in projects for royal residences as diverse as Leonardo's project for Francois I at Romarantin (c. 1517–9), Charles V's new palace at Granada (begun 1528), the schemes for the Louvre by Serlio for Francois I (1540s) and by Lescot for Henri II (1550–51), and the Escorial for Philip II (begun 1561).[3] Nor was the urge to build grand palaces limited to royalty. In 1558 the Farnese commissioned a grand palace from Vignola for the Duchy of Parma and Piacenza that would ultimately eclipse their own monetary circumstances.[4] A similar pattern can be discerned in the construction of private passageways. When faced with the task of renovating the Palazzo Vecchio, Vasari claimed that the Salone dei Cinquecento would "surpass all of the halls of the Venetian Senate, as well as everything done by kings, emperors, and or popes of all times."[5] Neither flattery nor bombast, these words were the

fundamental ideological considerations in the renovation of the Palazzo Vecchio and the construction of the Corridoio.

THE PALAZZO VECCHIO

In Florence the circumstances of the Palazzo Vecchio's reconstruction (plate 85) were essentially different from the those of other grand palaces.[6] Although Cosimo I aspired to the same elevated status as other European rulers, the comparatively meager resources that remained after expenditures for the war with Siena and other military expenses had been paid placed a constraint on his patronage. Dignity had its price in architectural terms. Funds for the construction of entirely new buildings were given to the Uffizi and other projects because the authority of the Palazzo Vecchio was free from challenge, having been in form and symbol the embodiment of all Florentine governments for the last two and one-half centuries. Indeed the Palazzo Granducale (as the Palazzo Vecchio came to be called) embraced both the glory of Tuscany's past and the power exercised by its hereditary rulers.

Throughout its history the Palazzo Vecchio expanded eastward in awkward and ungainly leaps, commencing with Michelozzo's alterations to the courtyards and Cronaca's construction of the Salone dei Cinquecento in the fifteenth century and ending with the northeastern block, executed at the end of the sixteenth century by Bernardo Buontalenti (plate 86). But the kind of unity expressed by this variegated building was thematic, not formal. An expressive individuality of the component parts never outweighed the need for an effectively unified design where each successive designer approached the subject of a powerfully rusticated facade in terms that would complement, but not copy, those of the original structure.

The harmony of the Palazzo Vecchio's parts was perhaps closer to that of an Early Gothic cathedral than to other grand palaces. Unlike the Louvre or the Hofburg in Vienna, which became sprawling accumulations of discrete sectors before their completions in the nineteenth century, the Palazzo Vecchio retained a kind of integrality that was hidden behind its scarred exterior. Much of this is the consequence of the renovations carried out by Vasari from 1556 until almost the time of his death. If Vasari's decorations are not always appreciated on artistic terms, one must respect his masterful re-planning of the older structure, the dramatic and logical system of staircases that connect various functional divisions, and the evocation of a ruler's palace. With its clever planning and its numerous allusions to palatial architecture from antiquity, the Middle Ages, and Vasari's own era, the renovation of the Palazzo Vecchio is in every sense an architectural masterpiece of the same high caliber as the Uffizi.

When Vasari returned to Florence in January 1555, an ambitious program of decorating the Palazzo Vecchio had already been underway for over a decade. The earliest projects—Bandinelli's Udienza in the Salone dei Cinquecento, Salviati's frescoes for the Sala delle Udienze, Bronzino's decoration of the newly created chapel for Eleonora of Toledo, and the vast program of tapestries under the general supervision of Bronzino for the Sala dei Dugento—necessitated scarcely any alteration to the palace's physical fabric. Its spaces were sufficiently large to accommodate ducal ceremonies, but there existed scarcely any chambers or apartments for other ducal magistracies, for staff and servants, and for the numerous offspring whom Eleonora would produce with regularity. Cosimo had exchanged the relative comfort of his ancestral residence in the Via Larga for one symbolic of his autocratic power but insufficient with respect to the real needs of daily life. Major changes were inevitable.

A vast extension to this grand but unwieldy residence must have been foreseen at the start. With the protection of Cosimo's *maggiordomo*, Pier Francesco Riccio, Giovanni Battista del Tasso was appointed to the post of *architettore della muraglia del palazzo*, a position that he held until his death in May 1555. Charged with the responsibility for the design and execution of all new construction, Tasso sought to transform a structure outfitted as the residence of the priors of Florence into the resplendent habitation of the duke of Florence. Among Tasso's scattered alterations were the chapel constructed in the northeast corner of Eleonora's audience hall (1540–43), the stairs from the ground floor of the Cortile della Dogana to the Guardaroba on the second floor (1549–50), and the attic-level accommodations in the Stanze dei Signorini for Cosimo's eight sons (1549–55).[7] In his works Tasso paved the way for the two broad stylistic categories of Medicean architecture in the age of Cosimo I: the self-conscious, decorative

refinement of Vasari and the vigorous plasticity of Ammannati. Vasari would soon adopt the elongated Tuscan Doric columns of Tasso's Terraces of Eleonora (1549–51) and Saturn (1551–55) for the Uffizi's facade, and Ammannati no doubt recalled the powerful rustication of the portal on the Via dei Leoni (1550–52) in his extension to the Palazzo Pitti (plate 87).

Tasso's greatest contribution to the palace's evolution was the extension along the Via della Ninna from the southeast corner of the Salone dei Cinquecento towards the Piazza del Grano (plate 88). The area immediately to the east of the palace had been owned by the municipality since the fourteenth century. Two centuries later it was still a disordered collection of shops, residences, and towers that was first surrounded at its periphery by the extensions of the palace before its final destruction for the creation of the Cortile Nuovo (1588–96).[8] Almost certainly the utilization of the old foundations accounts for a labyrinthine plan at ground level, as suggested by the medieval archways that can still be seen today in the warped elevation along Via della Ninna.[9]

Tasso's new portal at the eastern end of the palace defined a sensible path of circulation that followed the path of an earlier street and had to be respected in any subsequent work.[10] Once this decision had been made, it logically followed to place the two new bearing walls of the southern wing perpendicular to the Via dei Leoni. The main advantage of this arrangement was the creation of the greatest number of workable chambers achieved within the context of a truly awkward site. Relatively few internal spaces were compromised by existing alignments, and when irregular alignments posed a problem, small, private chambers like the Scrittoio or the Segreteria del Gran Duca concealed the asymmetry. The placement of stairs in the wedge-shaped spaces adjacent to the Salone dei Cinquecento also facilitated communication between all levels of the new building.[11] The nature of the physical evidence and the chronology of its construction suggests that Tasso must have anticipated a second courtyard along the lines of the one existing today. Moreover, the circumstances infer the preparation of a master plan that Vasari, for reasons of insolence or cupidity, failed to mention in his all too brief passages about his predecessor in the *Lives*.

During the initial period of modifications to the palace Vasari worked on the decoration of the Quarter of the Elements and the Quarter of Leo X, pro-

jects that involved only minor structural modifications to Tasso's extension. It was only after these decorations were well under way that Cosimo asked Vasari to make various plans for the entire palace, and by July 1558 a wooden model was begun.[12] Just as in the initial scheme for the Uffizi, the scale of the project was ambitious and the design was in flux. Vasari's correspondence with Cosimo shows that the attention of both architect and patron was focused on the preparation of an overall design for the area between the existing palace and the Via dei Leoni. Initially Vasari favored a circular shape for the second courtyard (as in the Villa Madama, the Palace of Charles V in Granada, or the Farnese Villa at Caprarola) that would have easily masked the irregularities of the site and the presence of existing construction, but questions of size and lighting forced him to accede to Cosimo's stated desire for one in the form of a large rectangle.[13]

The early events in the planning of the Palazzo Vecchio were considerably more complex than Vasari's letters or his account in the *Lives* have led us to believe. For reasons that are still not clear Ammannati provided designs for various governmental structures intended presumably for the area bounded roughly by the Piazza della Signoria, the Ponte Vecchio, and the Arno.[14] The designs raised questions of practicality and propriety that conflicted with Cosimo's pragmatic nature. Apart from obvious considerations—cost of construction and the difficulty of acquiring property still in private ownership—Cosimo most certainly realized that there was no need to duplicate the ceremonial functions of the Palazzo Vecchio and the extensive residential accommodations that were soon to be included in the additions to Palazzo Pitti. As in almost all of Cosimo's major buildings, initial proposals of considerable grandeur gave way to those that effectively and creatively exploited existing buildings.

What the grandest projects had in common was an evocation of certain examples of domestic architecture from Roman antiquity, a feature that was retained in Vasari's executed scheme. One of Ammannati's plans (plate 89) takes up the sequence of courtyard-stairs-salone suggested by Francesco di Giorgio's imaginary reconstruction of the Imperial Palace on the Palatine. Even the palace as it exists today demonstrates strong classical overtones. This is most apparent in the sequential arrangement of its major spaces—with the courtyard as the equivalent

to an atrium and the Salone dei Cinquecento as a modern *tablinum*—which has been compared to *Casa degli antichi Romani* as described by Vitruvius and later illustrated by Palladio in the Barbaro edition of the ancient treatise.[15] In the end it was not the plan of the Palazzo Vecchio but its architectural details and painted decoration that would enforce the connection with antiquity.

The Courtyard

A stately courtyard was just as indispensable for creating a favorable impression on visitors in a ducal palace as it was in a Florentine merchant's residence. In the evolution of the Palazzo Vecchio, the courtyard became an important element only after the opening of the square to the west, the construction of the Loggia della Signoria, and the subsequent closing of the palace's northern entry in 1380 which gave its western facade an unanticipated pre-eminence.[16] In the next century the renovations of the courtyard executed by Michelozzo ostensibly served to decrease the loading on its rebuilt arches and columns. In the *Lives* Vasari points out that the design also carried an explicitly political message in the new bifora windows and tondi that were modelled on the Palazzo Medici's courtyard.[17] But the boldness of this architectural statement was tempered by the circumstances under which the Medici exercised their power; a year after Cosimo's death anti-Medicean forces sought to restore open elections for the Signoria, and by 1494 the overthrow of the Medici rendered Michelozzo's central idea meaningless.

In 1565 Vasari proposed a radical modernization of the courtyard as part of his temporary architecture for the ceremonial entry of Prince Francesco de' Medici and his bride, Johanna of Austria.[18] Without altering the irregular, trapezoidal shape of the courtyard, Vasari's subtle changes to its plan strengthened the approach to the state chambers on the upper floor, establishing a system of circulation that is still in use today (fig. 14). The new axis was extended into the southern addition to the palace, creating a line of march where changes in direction are barely perceptible. The closing of the doorway in the southernmost bay of the courtyard's eastern wall shifted the palace's main axis one bay to the north, necessitating the construction of a doorway (plate 90) of red

stone (in emulation of ancient porphyry) in an eccentric position with respect to the axis of the central bay (plate 91).[19] The irregularity, which was brought about by the position of ground-floor landing of the main stairs, was cleverly disguised by the sharply-angled jamb on the eastern side of Vasari's doorway (plate 92). A conflicting cross-axis was also removed from the main courtyard by replacing the doorway from the Sala d'Arme with a single window frame.[20]

Once the primacy of the main axis had been recognized, the courtyard's surrounding walls and vault began to take on an appropriately festive character (plate 93). The grotesque decoration framing seventeen panels with views of Austrian cities conveys an effect of richness and splendor calculated to impress the Hapsburg visitors and to secure their approval.[21] The ornamental and even light-hearted architecture of the courtyard was to have been continued on its upper walls. A drawing attributed to Vincenzo Borghini (plate 94) records that the windows created by Michelozzo in the previous century were to have been surrounded by a composition of aedicules, shallow niches, and numerous figures.[22] What is remarkable about this design is the fluency with which Vasari has assimilated the architectural style of Raphael's Palazzo Branconio dell' Aquila; as such, it is the only design from Vasari that showed the clear and direct influence of Roman palace architecture.[23] There also is an unintended irony in the design: the effect of a surface crowded with architecture and figures in fresco would have been comparable to the rich stucco exterior of the Casino of Pius IV by Pirro Ligorio, an architect for whom Vasari had little regard.[24]

The courtyard would have harmonized well with the temporary architecture created for the ceremonial entry of Francesco, Johanna, and their retinue. In Domenico Mellini's account of this event, prominence is given to the most curious feature of this already exceptional design, the stucco decoration and golden background applied to its nine columns.[25] Eschewing any of the traditional orders, Vasari cloaked the shafts with horizontal bands, making each column different in design. Rising from shallow torus and scotia moldings on polygonal plinths, the columns reveal a peculiar convex, stopped fluting that rises for more than a third of their height. Above the termination of the fluting, the remaining registers are divided into two or three unequal bands. In their ornamentation, the banded

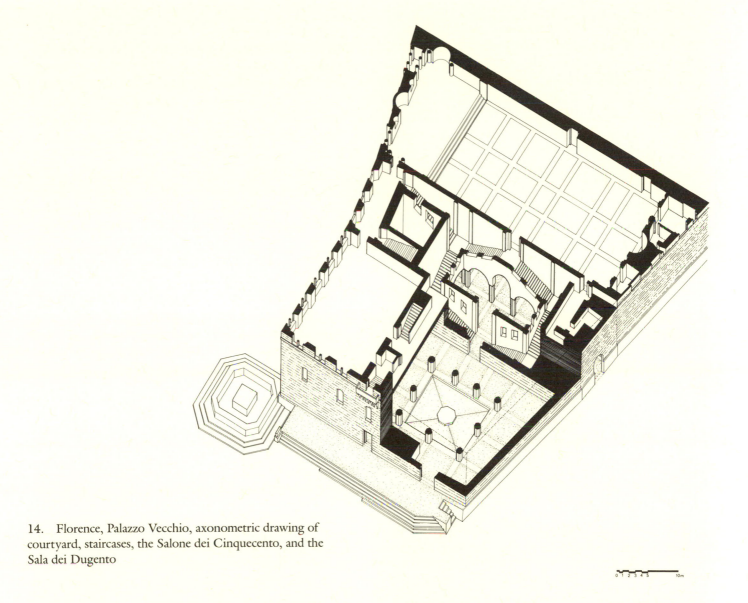

14. Florence, Palazzo Vecchio, axonometric drawing of courtyard, staircases, the Salone dei Cinquecento, and the Sala dei Dugento

0 1 2 3 4 5 10m

columns show the full panoply of classical motifs—masks, tendrils, putti, and candelabra—that appears extensively throughout the palace. Raphael would have approved of Vasari's ornamental vocabulary which, in fact, he and his assistants had used in the Vatican Logge and the Villa Madama.

As Vasari would have seen it, the origins for this type of column can be found in the columns with shafts covered by stylized foliation that appear frequently in Romanesque architecture of Tuscany (plate 95). In one building that Vasari knew well, the facade of the Pieve in Arezzo, similar columns appear on the upper levels of its screen-like exterior.[26] While Vasari, with his customary pride in the art of his native city, considered this example impressive due to the variety of bases, capitals, and shafts, he judged the columnar type as a whole extremely harshly, con-

sidering them to have been Germanic in origin and twisted like a screw in form.[27] Eventually this form of column made its way into the repertoire of Renaissance ornamental architecture, as shown by its appearance on numerous tombs and other monuments, which include the aedicule supported by Vasari's organ loft in Arezzo's Cathedral. What Vasari sought to emulate, however, was not the specific forms of these examples—his own foliate patterns and motifs tend to be more uniform and less three-dimensional than those found on Romanesque columns—but their position framing a building of symbolic importance.

Vasari's banded columns played an important role in revealing the symbolic content of the renovated building. The columns belonged to a larger family of decorative motifs created in the Hellenistic east and subsequently adopted by both Roman and Early

Christian architects.[28] Of these, the most famous were the twelve spiral columns that decorated the presbytery of Old St. Peter's, of which eight were reused by Bernini in the great crossing piers of the new basilica.[29] According to legend, the spiral columns were commonly believed to have been taken from the Temple of Solomon in Jerusalem.[30] A clear example of this can be seen in Raphael's tapestry cartoons for Pope Leo X, where spiral columns are used in the *Healing of the Lame Man at the Beautiful Gate of the Temple* to make specific allusions to *porta speciosa* inside the temple proper.[31] In turn, Vasari and his assistants borrowed this setting on several occasions for the architectural backgrounds of their paintings.[32] Its presence is especially prominent in the Palazzo Vecchio where the *Election of Leo X* in the Sala di Leone X, repeats the affinity between the Medici, the papacy, and King Solomon already manifest in the tapestry cartoons. In the apartments of Eleonora the appearance of the same motif in *Esther and Ahasuerus* now carried a double meaning (plate 96). In architectural terms, the assumed splendor of the palace of King Darius, the locale of entreaty of the young jewess to the Persian king, was presented as a prefiguration of the Palazzo Vecchio; in historical terms, it created a genealogy for the duchess that had allusions to the Virgin through her prefiguration in Esther.

To Vasari it mattered little that the spiral columns now took the form of cylindrical or polygonal shafts in the courtyard of the Palazzo Vecchio; it was their presence in the full setting of the palace that implied kingship and enlightened rule. This concept was further enforced by the dominant visual effect of the courtyard, a brilliant luminosity that would have made the columns appear as if they were made of gold. The association in this case, of course, was with Nero's great palace, the Domus Aurea. The rediscovery of that monument earlier in the sixteenth century had focused attention on its decoration, and if none of the gilding implied in its name was still visible, testimony in Pliny and Suetonius could be used to justify its existence.[33] Nor was the practice original in the context of Florentine ceremonial entries. Vasari had seen the generous amount of gilding that was applied to the columns in the courtyard of the Palazzo Medici for the visit of Charles V in 1536, and apparently he considered the re- use of this effect fitting and proper for an alliance by marriage with the Holy Roman Empire.[34]

In its direct allusions to King Solomon, the scheme for the renovation of the courtyard carried a universal and direct message in the ornamentation. Solomon, whose fame as a *rex pacificus* of a united Israel anticipated the peace enforced by Cosimo's victory in the Sienese War, now joined the illustrious company of popes, doges and emperors invoked by the Medici in their attempt to establish their connections with famed rulers of the past. No doubt the choice of a biblical prototype had a particular implication for Vasari, who had regarded Cosimo to be a modern day Solomon.[35] As a palimpsest of the legendary sovereigns of pagan and Christian history, already commonplace in the official art of the Medicean regime, the splendor of the courtyard justified Medicean rule by associating Cosimo I with the exalted rulers of the past. Although the scheme was intended to be impressive, the Imperial visitors, who were concerned with diplomatic courtesies, were not persuaded by Vasari's artistic flattery.[36]

Staircases

Staircases fascinated Vasari because visitors to palatial buildings always saw this element to the exclusion of much of the structure.[37] Throughout the *Lives* Vasari employed them as a measure of validating an architect's skill and professionalism. Without explicitly mentioning the numerous public and private staircases in the Palazzo Medici, Vasari certainly realized that they contributed to the separation of the various apartments and the creation of a grand residence that was both modern and useful.[38] The main stair in the Ducal Palace of Urbino (which Vasari thought to have been designed by Franceso di Giorgio) was singled out for having been well-conceived and more pleasing than other contemporary examples.[39] But Vasari was especially mindful of the ceremonial purposes of grand stairs. In words that could have been written three centuries later by Charles Garnier about the *grand escalier* of the Paris Opera, the circular stair within the octagonal tower of San Nicola in Pisa employed an open well that permitted simultaneous visibility of all individuals ascending the stair.[40] Similarly, Bramante's ramped, spiral stair in the Cortile del Belvedere was appreciated for the fact that it could be ascended on horseback, a convenience that was also found in the main stair of the Palazzo Communale in Bologna.[41]

Vasari's concerns for the design of staircases—that they are easy to ascend, ample in size, well lit, and in scale with the rest of the building—were conditioned by his experiences in the design of several new stairways for the Palazzo Vecchio.[42] During the summer of 1560 Vasari began the demolition of the existing stairs. Although work was carried out in a somewhat sporadic manner, enough of Vasari's new stairs had been completed by December 1565 to permit their use during the festivities celebrating the wedding of Prince Francesco. During this period, Cronaca's stair still remained in use; the entire system of ramps was not finished until 1571.

Little remains of the earlier stairs.[43] Even Michelozzo's extensive renovations to the palace could not remedy the faults of the original stair (supposedly designed by Arnolfo di Cambio) that ran along the north side of the court upwards to the Sala dei Dugento on the main floor and further to the Sala dei Gigli above it; to Vasari it was badly conceived, poorly located, steep and without light, and posed the threat of fire with its wood construction along its last runs.[44] The stair built by Cronaca giving access to the Salone dei Cinquecento from a door on the eastern side of the court fared no better. In spite of the ample width of its three runs and the exquisite Corinthian order that adorned it, it was characterized by a steep ascent impeding access to the main floor.

The third staircase was radically different in its form and dimensions. Around 1549 Tasso began to build a monumental vaulted stair running in two flights from the ground level to the Guardaroba on the second floor. Located at the east end of the Cortile della Dogana, Tasso's scheme was a monumental open cage with superimposed arcades looking down on the courtyard (plate 97). The novelty of the solution, the first fully covered stair in the long history of the palace, lay in its attempt to create a monumental architectural connection between the main floors of the palace. Yet it was flawed in two crucial respects: access from the main portal on the Piazza della Signoria was difficult at best because of the stair's orientation towards a secondary entry on the Via della Ninna, and it failed to provide a fitting entry into the Salone dei Cinquecento.

What Vasari sought was an integrated system of circulation to the ceremonial chambers and private apartments that would replace the older independent designs (plate 98). While Vasari's solutions built

upon the designs of his predecessors in terms of their general location within the palace, they greatly improved the utility of the older stairs by providing uniformity in visual appearance. Each vaulted flight was similar in its gradient of ascent and shared with the others a formal language composed of inclined barrel-vaults, shallow domes at the landings, and fully developed ornamentation in pietra serena. Like the arms and legs of the human figure (to which Vasari compared staircases in the *Lives*) that move a body ahead, the alternation of vaulted shapes above and the inclination of the steps below propel the visitor gently forward.[45] Thus the sensory instruction of Vasari's design is subtle but intentional; the result is an orderly progression through a structure that is complex in layout and dense in meaning.

Vasari's boldest ideas for the palace were represented in the design of the new grand staircase (plate 99). The system consists of two enclosed sets of stairs arranged around an open well on the axis leading from the courtyard of the Palazzo Vecchio to Tasso's portal on the Via dei Leoni. Starting at this point, the symmetrical ramps first diverge from the main axis, and then run parallel to it after reaching the domed first landing. Returning towards the main axis after arriving at a second landing, the ramps converge at the main entry to the Salone dei Cinquecento. Light, above all, heightened the effect of this complex grouping of diagonal shafts. Bare white walls in each of their three pairs of flights were brightly illuminated by windows aside the steps in each ramp, creating a carefully composed sequence of vaulted, inclined spaces that were at once luminous and shadowed. On the various landings, Composite pilasters (an order rarely employed by Vasari) harmonized with those employed by Bandinelli on the Udienza. Sadly, the overall impression of the stair's radiant interior was gravely altered in the nineteenth century by the construction of a bridge across the courtyard that now blocks all light.[46]

The new stairs facilitated the practice of courtly ceremony. The old external stairs would have exposed visitors to inclement weather during their ceremonial entry into the palace, thereby giving an aura of unseemliness to events governed by diplomatic protocol. Greater security was also an added advantage on account of the ability to control access to both ceremonial chambers and residential apartments from a single point at ground level. The most obvious advantage of the scheme, however, was a

new sense of drama in the experience of an official ducal reception. The duplication of the stairs, their easy ascent, and the consequent lengthening of their run contributed to the effect of a stately procession for the ever-greater number of retainers accompanying any official visitor. The number of intermediate landings, too, provided additional locations where ducal officials could greet their guests before proceeding to the Udienza or to private chambers.

An additional flight ran from the second landing in the northern arm to the vestibule located between the Salone dei Cinquecento and the Sala dei Dugento. Beyond this point lay the private realm of the family apartments, with the chambers of Cosimo on the main floor and those of his wife on the floor above that could be reached by ascending the *scala piana*, the logical, private continuation of the *scala grande*. The result was the creation of a palace within a palace. By placing the main stairs in the zone occupied by those of Cronaca and Tasso, Vasari effectively strengthened the extant divisions of the building's major functions while simultaneously providing a new clarity and grandeur for its circulation.[47]

None of the individual elements in this remarkable design were new. Among the many staircases of ancient Rome the example most pertinent to the Palazzo Vecchio is the set of monumental flights that led from the Campus Martius to the Temple of Serapis on the Quirinal (plate 100).[48] In Vasari's time traces of its construction were sufficient enough to permit its reconstruction in detailed plans by Giuliano da Sangallo, Sallustio Peruzzi, Serlio, Palladio, and Ammannati, among others.[49] What these drawings show is a symmetrical composition of two flights departing from a common point and leading to a central landing on the upper floor as well as to dependencies on either side. Although the Quirinal stairs originally surrounded closed chambers instead of an open court, the arrangement and the principle behind it were suggestive enough to permit their transposition into the Palazzo Vecchio; Ammannati, whose stairs in the rival plan for the Uffizi owe much to his knowledge of the Quirinal complex, may have suggested their employment to Vasari.[50]

Vasari would have been quick to appreciate the importance of the Quirinal stairs. In the sixteenth century there was little agreement on the identification of the ruins. The large block of the cella that remained until its destruction a century later would have suggested the remains of a religious structure, as they did to Palladio who was among the first to identify them as part of a Roman temple.[51] The size and layout of the stairs led others to believe that the ruins were part of a princely or imperial palace.[52] The fanciful iconography of the identifications and the creative application of the scheme were fully in keeping with Vasari's avowed intention of creating a residence to rival those of all rulers of all times. This, of course, was duly flattering to Cosimo, who now could fancy himself as a new Augustus living in the fabled splendor of Imperial Rome.

Medieval and Renaissance architects faced the same problems of clarity and security in the design of grand public structures. For instance, the circulation in the Palazzo Communale of Poppi (plate 101), a city not far from Giorgio's native Arezzo, had evolved into a bewilderingly complex system of ramps, culminating in the sixteenth century with the construction of its tentacular flights reaching out to each sector of the building. In Venice the proliferation of staircases that frustrated the ascent from the courtyard of the Doge's Palace to the major chambers is readily apparent in a late sixteenth-century woodcut.[53] The only exception to this confusion of choice was the Scala dei Giganti, whose construction was begun shortly after a disastrous fire on 14 September 1483.[54] By far the most imposing stair in the palace because of its use in ducal coronations and civic processions, it was a crucial link in the path that led from the ducal apartments through the Arco Foscari and the Porta della Carta into Piazza San Marco.

The ceremonial character of Venetian stairs was captured in the Palazzo Vecchio and was rivalled by the splendid functions at the Medicean court. Ironically, Vasari may not have witnessed any major diplomatic or princely reception during his sojourn in Venice, although he was familiar with the depictions of similar events in Venetian paintings.[55] It is likely that he could have seen the stairs in use during the annual festivals, such as the procession of the doge, ambassadors, and senators on *Giovedi grasso*. The well-known Venetian fondness for spectacle extended to noble confraternities who employed processions to display piety, wealth, or even brutal force in competition with their rivals. It would be interesting to know if Vasari had seen the staircases in Venice most similar to his own—the famous double-ramped designs of Mauro Codussi for the Scuola San Marco or the

Scuola San Giovanni Evangelista—under such compelling circumstances (plate 102).

Vasari's attention to the design of staircases was soon put to good use. The flood of September 1557 greatly damaged the archives of the Monte di Pietà, which were then in the Bargello. In conformity with Cosimo's policy of reusing Republican buildings for ducal purposes, secure quarters were found in the Palazzo di Parte Guelfa, whose main hall had been begun by Brunelleschi in the 1420s.[56] In addition to rearrangement of spaces and provision for a new *cancelleria*, Vasari designed a new staircase that led to the vestibule of Brunelleschi's unfinished Grand Hall (plate 103). Its open-well plan recalled similar stairs in medieval palaces, and both its layout and austerity anticipate the much grander arrangement of the flights in the Palazzo Vecchio. To modern observers this set of flights may not appear distinguished, but to Vasari they were very commodious.[57]

The spatial and architectural logic of the Palazzo Vecchio staircases were firmly rooted in Florentine traditions. Michelangelo's vestibule and stair of the Laurentian Library were well known to Vasari, who was involved in the negotiations securing the final design from the aged master. However, Vasari rejected a scheme with a freestanding staircase because the irregular shape and proportions of the Cortile della Dogana precluded the creation of a roofed, open well similar to the *ricetto*. In order to maintain unimpeded circulation along the main axis of the palace, Vasari turned to Michelangelo's earliest scheme for the library stairs where parallel flights ascend along the sides of the vestibule. But the need for enclosure and structural support demanded a bearing wall along the sides facing the Cortile della Dogana. With the placement of the ascending flights within what was now a single thick wall of masonry, Vasari had adopted a structural system already employed two centuries earlier in the Campanile of Florence Cathedral.[58]

Roman in their aspiration of grandeur, Venetian in visual effect, and Florentine in concept and structure, Vasari's stairs make a unique contribution to the evolution of the monumental staircase. The constraints that he faced were formidable. Conflicting demands of access and privacy necessitated the duplication of facilities. The symmetrical placement of ramps gave the design a sense of openness that was uncommon in Italy. In comparison to the stairs in the Farnese palaces in Rome or Piacenza, both of which evolved within the established practices of palace design, those in the Palazzo Vecchio had no single precedent for the scheme as a whole. The disposition of the major ramps—and ultimately their formal similarities with Codussi's stairs—stem from the problem of finding a rational way to enter a grand hall at a point near the center of its long side rather than a conscious evocation of Venetian precedent. To create a new sense of grandeur and architectural unity in spite of the limitations imposed by a demanding patron and existing construction was Vasari's greatest achievement in the Palazzo Vecchio. Justifiably, Vasari was proud of the new system of circulation that he had fashioned out of the fabric of the older structure. In a futile attempt to convince the reluctant Cosimo to construct the remaining branches, Vasari's words about the flights connecting the chambers on the first floor with those above (known as the *scala piana*) could stand for the design as a whole:

> I am certain the Your Excellency will see not just a staircase but a miracle in that place, and that it will appear to you as if you were traversing the stairs that lead from the Sala Regia in Saint Peter's in Rome. Up to this time no one had made such an admirable work in the Palazzo Vecchio as this, and one of its great virtues is that it corrects all the errors of the palace. And to tell you something else, its praises are being sung by all those who go up and down the staircase. Those people who climb and observe the stair see it but don't believe it. Yet it's really like this.[59]

The Salone dei Cinquecento

The close ties between the main hall of state in the Palazzo Vecchio, the Salone dei Cinquecento, and the political history of Florence hardly need enumerating.[60] As is well known, Cronaca's design for the hall closely followed the model of the Venetian Sala di Gran Consiglio in the Doge's Palace. Its trapezoidal site just to the east of the Cortile della Dogana posed problems of access which were solved by the construction of the external stair leading to a door in the south-west corner of the hall and the creation of a vestibule leading to the Sala dei Dugento, the old

council hall overlooking the square. But its greatest difficulty—the creation of a rectangular chamber on the irregular plot—apparently was considered insoluble. By making the eastern-most wall of the sala parallel with western facade of the Palazzo Vecchio, Cronaca emphasized the external, block-like appearance of the structure at the expense of the hall's internal configuration.

After the fall of the democratic government in 1512, the galleries, stalls, and benches designed by Baccio d'Agnolo and others were removed. Subsequent alterations transformed the noble meeting hall into a salt office and barracks for soldiers. The brief revival of the Republic in 1527–30 brought about the reconstitution of the Great Council and, similarly, led to the use of the Salone dei Cinquecento for public meetings. With the return of the Medici to power and the eventual disintegration of liberties, a public council hall was useless. The construction of the Fortezza da Basso under Duke Alessandro only postponed inevitable changes to the palace and its main hall. Cosimo I's decision in 1540 to appropriate the Palazzo Vecchio as his ducal residence meant that all associations with Florence's liberty were to be removed or given a thoroughly different context.

If the early appearance of the Salone dei Cinquecento helped to establish the meaning of the hall in the context of Florentine history, then subsequent alterations begun by Cosimo I created an architectural backdrop for the appearance of the duke and his retainers. A fundamental change was caused by the addition of Bandinelli's Udienza (begun c. 1542–43), the dais at the north end of the hall that served as the setting for official functions. This project was particularly significant because it answered two problems that were left unresolved in Cronaca's design. By conceiving of its facade as a decorative screen independent of the bearing walls, the impact of the room's trapezoidal shape was minimized, and by giving it an elevation modelled on a Roman triumphal arch an appropriate setting was created for courtly ritual.[61] The new emphasis given to the longitudinal axis and the Udienza evoked the functions of an Imperial Roman state hall or basilica at its north end. The arrangement also demanded a similar treatment of the south wall. Although this must have been anticipated at the outset, little was done to complete the scheme. The actual execution of this unfinished corner of the hall began only in 1563 when a temporary wooden wall was constructed to serve

as a backdrop for the marble fountain of Juno that Ammannati had planned for the Salone dei Cinquecento.[62]

Vasari worked out the general strategy for the renovation of the Salone dei Cinquecento long before construction was begun. The constraints posed by the plan of Cronaca's hall and the location of Bandinelli's Udienza meant that any architectural modifications would be limited to the lateral walls and the ceiling (plate 104). By 1560 the scheme presented to Michelangelo in the form of a wooden model had won the aged master's approval. The most radical change to the hall's structure, the raising of its roof by at least 12 braccia (c. 7 m.), appears to have been Vasari's idea.[63] The forthcoming wedding of Prince Francesco now focused attention on the hall's completion. As elaborated and revised by Vasari with the assistance of Giovanni Battista Adriani and Vincenzo Borghini, the main theme of the decoration of the side walls—the celebration of Florence's dominion over Tuscany—owed much to the subjects illustrated by Leonardo and Michelangelo in the same room. Working from Vasari's designs, his faithful corps of assistants completed the panels for the elaborate wooden ceiling that served to glorify the transformation of the Tuscan state by Duke Cosimo.[64]

Vasari's architectural concetto for the Palazzo Vecchio—to endow a ducal residence with features that compared favorably with those of ancient and modern rulers, and especially with the Vatican—is further revealed in the vicissitudes of the Salone dei Cinquecento's history. The advent of the Medicean duchy had rendered Republican imagery superfluous, but logically the great hall had to remain. With the construction of the Udienza, the Salone dei Cinquecento became a reception hall for dignitaries or ambassadors like the Sala Regia in the Vatican.[65] The architectural framework provided by Tasso was closer in concept to the functional layout of the Vatican Palace in the sixteenth century. This analogy is especially valid in the southeast wing of the Palazzo Vecchio, where adjacent suites of superimposed apartments took on positions and an architectural scale similar to the Vatican stanze and the Borgia apartments. As already noted, the approach to the Sala Regia finds a counterpart in Vasari's description of the Palazzo Vecchio's main stairs. In the end, the dramatic orchestration of an official progression to the Duke Cosimo in the Salone dei Cinquecento sought to recapture the structure of an experience

shared by the royalty and their ambassadors who sought an audience with the pope in the Sala Regia. Because of his knowledge of the papal apartments and Vatican ceremonies, Vasari's ceremonial route was clear in plan and architecturally consistent with other modifications to the Palazzo Vecchio.

A practical attitude towards structure and decoration differentiates the Salone dei Cinquecento from the Sala Regia. The first matter of business was to dismantle Cronaca's tall roof trusses and increase the height of the supporting walls.[66] After this work had been completed, a staggered arrangment of 24 trusses were set at two different heights. This distinctive structural system allowed one set to support the roof and the other to carry the weight of Vasari's painted ceiling.[67] By increasing the room's height Vasari increased the amount of wall space to be given over to fresco decoration and ensured its visibility to all those present in the Salone dei Cinquecento. This intent was matched by a concern for the illumination of the wall decorations and the ceiling, which was solved by the creation of tall arched windows at either end of the hall and the insertion of clerestory windows under the ceiling (plate 105). The primary entrances into the Salone dei Cinquecento were incorporated into a high base in the long walls, thereby avoiding the irregular pattern of the Sala Regia's openings and the contrast in scale made by Sangallo's portals. Notwithstanding these considerations, the lower zone of the lateral walls leaves a vast area of the hall architecturally weak in locations that are visually prominent, in effect denying the apparent weight of the ceiling and the architectural surrounds of Vasari's frescoes.

Apartments

The apartments in a typical Florentine merchant's palace could scarcely make an appropriate setting for the courtly ritual of a duke or king. In terms of size, they were sufficient for comfortable lodging or running a family trading operation, but they could scarcely conjure up the impression of power needed to govern a modern state. The diminishing size of rooms in an enfilade made for a certain intimacy at the expanse of privacy and flexibility; however, there was no distinction between circulation and habitation in an enfilade apartment, and its linear arrangement could not be altered. Clearly these issues mat-

tered much to Cosimo and his architects, as is evidenced by Ammannati's adaptation of parts of the Medici Villa at Poggio a Caiano and the Ducal Palace at Urbino in the layout of Palazzo Pitti's interior arrangements.

Purely architectural considerations shaped the circumstances and conditions of what may be called the decorative environment (plate 106). The layout of the apartments—two files of chambers defined by parallel bearing walls—and the stairs connecting them were the architectural legacy of Tasso. Structural modifications were out of the question, and any attempt to improve the irregularly shaped rooms had to be accomplished with decorative devices. Minor changes, such as the window created to illuminate the grotesque fresco decoration in the staircase, were permitted if they were inexpensive and did not alter the structural system of the palace.[68] The variation in floor heights—a conspicuous feature on the exterior of Tasso's wing—caused difficulties with the decoration of the interior spaces. The crossbeams of the roof above the Quarter of the Elements were set uncommonly low with respect to the walls below, making the space appear confined and limiting the amount of wall surface that could be decorated in fresco (plate 107). In order to alleviate the room's claustrophobic sense of confinement, the two deep beams spanning the Via della Ninna facade to the central bearing wall were encased within the ceiling's coffer-like construction.[69] As in the Salone dei Cinquecento, the benefits of the change were sensible and utilitarian: by raising the apparent height of the chamber the impact of its squat proportions was diminished. Similarly, the Correggesque illusionism of its central scene was made more effective. In the Quarter of Leo X, difficulties in changing the erratic disposition of the existing doors and windows (in all chambers excepting the Sala di Leone X) led to the placement of the major scenes on the vaults, the only areas that could readily accept any decoration. The elaborate tracery of the grotesque decoration on their walls, by comparison, minimized the impact of the mean dimensions of the mural surfaces.

The functions of the apartments never seem to have been clearly defined and changed over time. During ceremonial entries and diplomatic visits they were used occasionally to house the highest ranking visitors to the Medicean court, such as cardinals and ambassadors.[70] In the case of the festivities for the 1565 wedding, the Prince of Bavaria occupied the

chambers next to the Salone dei Cinquecento. Otherwise, the apartments seem to have been occupied by various members of the Medici family; in the 1570s the Quarter of Leo X served as the apartment of Cosimo I's son, Cardinal Ferdinando de' Medici, and the chambers directly above were occupied by the niece of Duchess Eleonora.[71] With the eventual transfer of courtly ritual to the Palazzo Pitti after its completion, the apartments in the Palazzo Vecchio were normally used by visitors at court.[72] By the eighteenth century they had become the seat of the high bureaucracy.[73]

Of all the chambers, the Sala di Leone X (plate 108) was exceptional in its clear formal and iconographic integration of wall and ceiling decoration. An ingenious layout of the wooden ceiling permitted a relationship in both form and content between scenes within its Greek Cross composition and those on the walls below. At the center of the ceiling is Vasari's depiction of the *Siege of Milan*, certainly the major military achievement of Leo X's reign in its recapture of Lombardy's most important city from the French. The remaining images are explicitly biographical, with the outer zone containing scenes from the life of Leo X during his cardinalate. The scheme continues down from the ceiling to the walls below where three large panels related in size and position to those above portray events after his election to the papacy.

The principal room of the lower apartments, the Sala di Leone X, is one of Vasari's most carefully considered interiors. His sophisticated architectural judgment is visible everywhere. In terms of its architectural narrative, the decorative program descends from the ceiling and merges with the architectural relief on the walls, creating a configuration of panels framed by doorways in each corner of the room. In creating a system of wall partition utilizing illusionistic views above a monochromatic base, Vasari is associated with a tradition reaching back to Raphael's stanze in the Vatican. To this Vasari marries an architectural veneer and wall elevation inspired by the New Sacristy in San Lorenzo (plate 109). The association of Michelangelo's design with Leo X would have been perfectly natural to Vasari, because the pope, who initially proposed its design, was the brother of Giuliano, Duke of Nemours, and uncle to Lorenzo of Urbino, the two Medici commemorated in the chapel. But the designs are fundamentally different. Vasari sought to make architecture intrude as

little as possible within the context of the ensemble of rooms, and consequently details tend to maintain this by stressing refinement and coherence rather than individuality and contrast. The fireplace designed by Ammannati further reinforces the sense of the classical (plate 110).[74] To compare the Sala di Leone X with an early project using the same forms, the main salone (plate 10) in the Casa Vasari, is to measure Giorgio's growth in proficiency in architectural decoration.

THE CORRIDOIO

In concept and in fact the idea of a concealed passageway answered the perceived needs of rulers for safety and protection from the sudden exposure of their own vulnerability in times of rebellion and revolution. Utilitarian requirements for urban corridors— privacy, direct means of communication, and enclosure from inclement weather—meant that their forms would vary little. In contrast to buildings with prominent facades and grand principal entrances, where the outward expression of a patron's status was paramount, questions of appearance and articulation never arose in the design of the Corridoio because they were irrelevant to the problem. Concealed passageways function best if they are not seen at all.[75]

In terms of function, location, and symbol, the Corridoio was the element that made Cosimo's renewal of Florence more than just a collection of individual projects.[76] Constructed in the brief period of five months in 1565, the Corridoio followed wherever possible a line of march to the Palazzo Pitti that used existing construction and rights of way (plate 111). Commencing with an unobtrusive doorway in the Camera Verde (plate 112), a chamber adjacent to the Chapel of Eleonora on the second floor of the Palazzo Vecchio, the Corridoio spans the Via della Ninna on a tall arch linking it to the Uffizi (plate 113). After passing the chambers that housed the nucleus of the Medicean art collection and the workshops of the artists who were paid to create it, the Corridoio then proceeds across the upper level of the Uffizi's eastern arm, traverses the riverfront loggia and, at the end of the western arm, descends two stories down a vaulted, single-ramp stair to the piano nobile of an adjacent house (plate 114). At this point the Corridoio emerges along the Lungarno degli Ar-

chibusieri, taking on the appearance along the northern bank of the Arno of a great Roman aqueduct (plate 115). It abruptly turns southward to traverse the Arno, stepping over the shops on the eastern side of the Ponte Vecchio (plate 116). At the center of the bridge, the Corridoio becomes a three-bay public loggia with a triplet of singularly large windows on the private level above, a clear response to the public square at the center of the bridge and the fabulous panorama from it (plate 117). In Oltrarno, stone brackets maneuver the passageway around the imposing mass of the Martelli Tower, where, according to tradition, Cosimo I's affair with Cammilla Martelli began during a visit to inspect the passageway's construction (plate 118). Immediately after crossing the Via dei Bardi on a high, flat arch (plate 119), it follows the path of an old alleyway to Santa Felicita, where its three-bay portico inadvertently creates Vasari's only executed church facade (plate 120). Until the 1580s the Corridoio continued only as far as the Grotta Grande in the Boboli Garden, which was begun as a fishpond by Vasari in 1556 and resumed by Buontalenti in 1583 (plate 204). There is no way of ascertaining if Vasari wanted to bring the passageway directly into the Palazzo Pitti; the completion of its extension into the grand-ducal residence (plate 121) was one of the numerous projects executed by Grand Duke Ferdinando I de' Medici.[77]

In form and structure the Corridoio is a utilitarian construction, little more than an extended version of the passageway proposed by Francesco da Sangallo in 1546. Its interior width of approximately 5½ braccia (c. 3.3 meters) was sufficient to accommodate carriages drawn by court retainers that regularly passed the distance between the two palaces (plate 122). Apart from the grey stone moldings composing its surfaces into a series of panels, no ornamentation was employed along its entire length. Problems of privacy caused by the adjacent palaces along the Lungarno degli Archibusieri and visual monotony in such a long structure were solved by contrasting the small circular windows affording privacy from the city side with the more generous square windows opening out towards the river (plate 123). The barrel-vaulted structure of this tract is particularly notable, providing sufficient mass to withstand strong winds along the unprotected riverfront.[78]

The resolution to the paradoxical contrast of the Corridoio's great historical importance and modest form can be explained by considering the message that it conveyed to those visitors familiar with the other courts of Europe. If the Corridoio was designed to give privacy to the court, facilitate administration of the state (especially in times of natural disasters, like the great flood of 1557), or even to satisfy a paranoid concern for security by providing a convenient means of escape to a secure location, it was more likely to have impressed Cosimo's guests at the 1565 wedding than his subjects. Although Vasari flatly states that it was constructed for this event, the renowned passageway contributed little to the celebrations.[79] Accounts of the ceremonies indicate that nothing of consequence was held at the Pitti due to the construction of Ammannati's addition to the quattrocento palace. Likewise, the view of Florence drawn in 1565 by Hendrik van Cleve (plate 124) clearly demonstrates that the makeshift course through unfinished sectors of the Uffizi must have been treacherous.[80]

Such inconveniences were overlooked because the Corridoio's prestige was sanctioned by antiquity. Associations with the Florentine passageway are evoked by Suetonius' descriptions of two ambitious constructions in Imperial Rome. If the image of the Domus Aurea was central to the meaning of the Palazzo Vecchio, then its predecessor, the Domus Transitoria, a mile-long triple portico constructed by Nero to connect the Imperial residence on the Palatine with the Gardens of Maecenas on the Esquiline, is a source for a veiled but unmistakable allusion to the Corridoio's itinerary. The other is Caligula's fantastic bridge over the temple of the Deified Augustus linking the Capitoline with the Palatine, a project that evokes the connection of a ruler's permanent residence with the origins of the legitimacy of his government.[81] Although the veracity of these literary descriptions was open to question, Cosimo's well-established predilection for Imperial imagery was well-served by his creation of a modern *palatium*.[82]

Only the Renaissance architectural theorists who had a full knowledge of ancient life from literary sources remarked upon this tradition.[83] In mid-sixteenth-century Florence the ideas of Leone Battista Alberti were given a new timeliness by the publication of an Italian edition of *De re aedificatoria* (1550). If the text was now accessible to those who could not read the original Latin text, it was also more politically relevant due to its dedication to Duke Cosimo. According to Alberti, both conve-

nience and raw political power justified the construction of private passageways or entrances.[84] Princes had to receive messages and advice without the constant interruptions of friends and family. Even more important was the need for a means of escape during civil unrest.[85] In its most essential form Alberti's message was that wise princes always stayed out of the way of troublesome commoners. If this advice could not have eluded Cosimo I, to whom the first edition of the *Lives* was dedicated, it was also familiar to Vasari, who maintained a close friendship with Cosimo Bartoli, Alberti's translator.

It is important to note that private passageways, as Alberti implies, were neither limited to fortifications nor constructed solely by despotic rulers. Passageways, in fact, played a critical role in creating family enclaves within medieval cities. The best evidence can be found in Florence, where it was common for private residences and towers to have been connected above street level by wooden bridges. Logically these constructions, like drawbridges, would be withdrawn in times of danger. In some instances religious citadels were created by temporarily linking churches with their satellite structures, as in the connection that once existed between Florence Cathedral and the Campanile.[86] In fact, private access to ecclesiastical buildings was common throughout Europe; at one time a set or bridges or passageways connected the cathedral at Chartres with adjacent structures along its southern flank.[87]

Vivid personal experiences made the papal passageways of Rome obviously far more important for Cosimo I than the local Tuscan examples. During the Sack of Rome in 1527, Clement VII, a Medici pope, successfully evaded capture by Imperial troops when he escaped through the Passetto, the passageway that links the Vatican with the Castel Sant'Angelo (plate 125). Cosimo, too, may have had an opportunity to traverse the Passetto during his unsuccessful attempt to obtain the title of grand duke of Tuscany from Pius V. On 28 October 1560 heavy rain marred the customary ceremonial accorded a head of state upon his arrival at the Vatican, but Cosimo was oblivious to the bad weather, taking part in an artillery salute in his honor fired from the Castel Sant'Angelo. Whether Cosimo, the 26 bishops, and an infinite number of other high-ranking clergy in this party braved the weather or chose the security of the enclosed Passetto is not known, but the experience of this near-disaster in papal protocol only could rein-

force the need for a private passageway in Florence.[88] At the time of Cosimo's death, the Passetto was openly acknowledged as the inspiration for Vasari's Corridoio.[89]

Paradoxically, the Corridoio, a structure so representative of Medicean aspiration to political status, did not significantly alter the evolution of Florence. As in other examples, it coalesced imperceptibly with the urban fabric until it was fully part of city from which its builders had sought security. Without knowledge of its earlier function, modern visitors to Florence would likely see the Corridoio as several different and distinct structures, each responding to its location in the city and possessing its own history.

The Corridioio's capacity to adapt to its surroundings and changing circumstances is shown best by the history of the tract of land running along the Lungarno to the Ponte Vecchio. In January 1558, a new loggia was begun for the fish market on a site near the Ponte Vecchio.[90] The structure stood for only six years and was demolished during the construction of the Corridoio. The fish market, on the other hand, was transferred to a different location in the Mercato Vecchio and within three years occupied a new loggia that in all probability was scarcely different from the one that was destroyed. But the prominent location of the old market was too favorable to ignore, and commerce continued to flourish at this busy intersection. In January 1570, the arcades underneath the Corridoio were enclosed, thereby creating the permanent shops that existed along the Arno until their removal at the end of the nineteenth century.[91] By eliminating the objectionable shops, the Corridoio's vitality was sapped and its form divorced from urban meaning. But its utility remained undiminished. In August 1944, the Corridoio permitted covert observation of the German forces who were preparing for the bombing of the bridges across the Arno and the devastation of the structures surrounding them.[92] After the horror of the evening of August 3, what little that remained of the Corridoio allowed those Florentines held against their will in the Palazzo Pitti to see what remained of their noble city.[93]

Medicean building policy under Cosimo began a subtle but measurable social transformation of Florence.[94] The creation of a ducal residence in the Palazzo Pitti provided a center of gravity that gave a new importance to Oltrarno as the focal point of

courtly life in Florence. Indisputably, the extended (if not linear) structure of ducal Florence was as much the consequence of locations of existing buildings as it was of Cosimo's political ambitions. If the motives behind the projects are manifest, then the hierarchy of power that they express is equally conspicuous. As in the evolution of papal Rome, the purposeful appropriation of Republican symbols played a key role in this process; Cosimo I's residency in the Palazzo Vecchio was as strong a statement of Medicean legitimacy as the arrival of Marcus Aurelius on the Campidoglio that marked the concession of Roman sovereignty to the papacy.[95] Apart from Uffizi, it is the utilization of the religious and secular buildings from Florence's communal period and the minimal alteration of the physical fabric of her streets and squares that gives urbanization under Cosimo I and Vasari its distinctive character.

By the time Medici courtiers populated Oltrarno, Florence had lost its prominence as an artistic, political, and financial center, and consequently the process of creating a grand-ducal city had come to a halt. But projects begun by Cosimo I and Vasari formed a program so intelligible to the observer that even today its coherence can be appreciated even if their original functions no longer exist. To pass today from the Palazzo Vecchio to the Palazzo Pitti without encountering another individual anywhere along the Corridoio captures the essence of the privileges enjoyed by the grand dukes of Tuscany and their retainers.

F I V E

Dominion

State Power and Territorial Architecture

Architectural patronage has eluded valid generalization. In its widest sense, it involves the use of wealth and power to support building projects that serve the interests and needs of a society. Renaissance patrons built to promote specific political and economic interests and advance their personal standing.[1] During the Renaissance Alberti and others wrote at length about how expenditures for palace buildings, monastic complexes, or family chapels gave to the family as an outward manifestation of its wealth and status.[2] Architecture was imperative for the patron just as patronage was indispensable for the architect. The expansion of building activity under Cosimo the Elder, as illustrated by the similarity in Michelozzo's designs for the courtyards of the Palazzo Medici and the Palazzo Vecchio, expressed family values and political policies in a century when the Medici held no *de iure* title of authority. With this Florentine achievement in mind, other princes went on to build on a scale for which Cosimo the Elder's projects were the only precedent.

Under Duke Cosimo state interests and ducal building policy were inseparable, and any new construction in some way served to support the legit-

imacy of Medicean control over the new state. But the degree to which power was concentrated in Duke Cosimo's hands was new to Tuscany and was rivalled only by the papacy. The different conditions under which architecture operated led to new geographic patterns of building patronage. Cosimo I's most architecturally elaborate projects were built in Florence, while similar commissions in Pisa or Arezzo were constrained by tight budgets, accounting in large part for their reticent exteriors. Instead of constructing sumptuous public buildings like those in Florence, elsewhere in Tuscany an ambitious program of fortification and refortification sought to protect the peace obtained by victory in the Sienese War.[3] The great costs of building the new fortresses and maintaining a standing army with food, firepower, and artillery left little funding for the kind of polemical projects that were begun in Florence. Siena seems to have benefited least from the architectural largesse of Cosimo I; apart from the vast Fortezza di Santa Barbara (1561), no public building of consequence was built in Tuscany's second largest city after its annexation. Seen against the strangulation of architectural patronage outside of Florence,

the buildings executed by Vasari in Pisa, Pistoia, and Arezzo are exceptional. Otherwise, projects in most localities were small in scale and provincial in their importance.

Neither the church nor the nobility, who no longer had the resources to construct the grand merchants' palaces of the previous century, played major roles as architectural patrons. In their stead, courtiers and other appointed office-holders became the primary patrons of new domestic construction, which, like courtly etiquette, deferred in both size and style to the main centers of ducal activity, the Palazzo Vecchio and the Palazzo Pitti.[4]

Official projects took on a decidedly practical cast. The infrastructure of highways dating back to the trecento was modernized to accommodate transportation by carriage. Tuscany's topography—a confluence of productive valleys and plains bounded by a chain of mountains and a lengthy seacoast—dictated a policy of land development similar to that of the Venetian state.[5] The Medicean villas at Castello, Poggio a Caiano, and Cerreto Guidi were completed or refurbished for use as courtly retreats, hunting lodges, or agricultural centers for the vast *latifondi* controlled by Cosimo and his family.[6] A newly strengthened office for the construction and maintenance of canals, the Ufficio dei Fossi di Pisa, sought to reclaim the extensive, malaria-infested swampland along the western coast.[7] The motivation behind the project was primarily economic. Having the knack of turning a detriment into a profit, Cosimo transformed swampland into fish hatcheries, providing markets in nearby Siena and Florence with an adequate supply of fish.[8]

Cosimo's attitude towards the countryside cannot have been more different than that of his Venetian contemporaries. Throughout the sixteenth century the Medici continued to acquire land, amassing a colossal assemblage of holdings throughout their entire domain. The extent of ducal intervention stifled the participation of the Florentine aristocracy in a Tuscan agricultural revolution that never really materialized. Unlike the Veneto, where individual families still played an active role in the architecture and economy of the Terraferma, Florentines had little incentive to invest in Tuscan agriculture. Robert Dallington, who visited Tuscany at the start of the seventeenth century, recognized the princely control over culture and society when he observed that "Il duca è la comunita" was the proverb of each city and large town.[9]

The cities subject to Florence also played a significant, if limited, role in the patronage process. Like the Terraferma towns of the Veneto, each was supervised by a podesta and captain.[10] The Chancellery of the Magistrato dei Nove Conservatori del Dominio Fiorentino effectively controlled local governance in each of the major centers by participating in budgetary deliberations and ratifying every expenditure of the communities.[11] Yet the priors and councils of the localities retained rights to regulate a substantial part of their own affairs, which included the approval of new construction. Eventually the two-tier system provided for the preservation of the old elite who continued to serve on local councils, while a professional bureaucracy distinct from the old ruling class managed ducal interests from the Chancelleries.[12] The divisions were most sharply drawn in Arezzo, where the citizen membership in the Consiglio Grande exercised partial control of the surrounding countryside. In any case, both survival of the nobility and stability in government were assured by the preservation of the town's aristocratic heritage.

THE CUPOLA OF THE MADONNA DELL' UMILITÀ IN PISTOIA

Pistoia was potentially one of the richest cities in Tuscany (plate 126). Both extensive meadowland in the mountains to the north and the plains to the south guaranteed a thriving agricultural economy, and its location at the foot of the Collina pass leading to Bologna gave access to major Italian and European markets.[13] The building industries of medieval Florence were direct beneficiaries of the plentiful wood in the mountain forests north of Pistoia.[14] By the fifteenth century commercial success in local and international trade assured stability and moderate prosperity to a community that was always in the shadow of neighboring Florence. Nor was physical charm lacking. Citing the city's numerous advantages, Domenico Tedaldi asserted that Pistoia, lacking only a navigable waterway, was "placed in the loveliest, most convenient, and best site which exists in all Italy."[15]

The promises remained largely unfulfilled. Pistoia had been a free commune until 1351, after which it became a part of Florence's territorial holdings. Bellicose quarreling within the Cancellieri family led to the creations of the black and white factions, whose

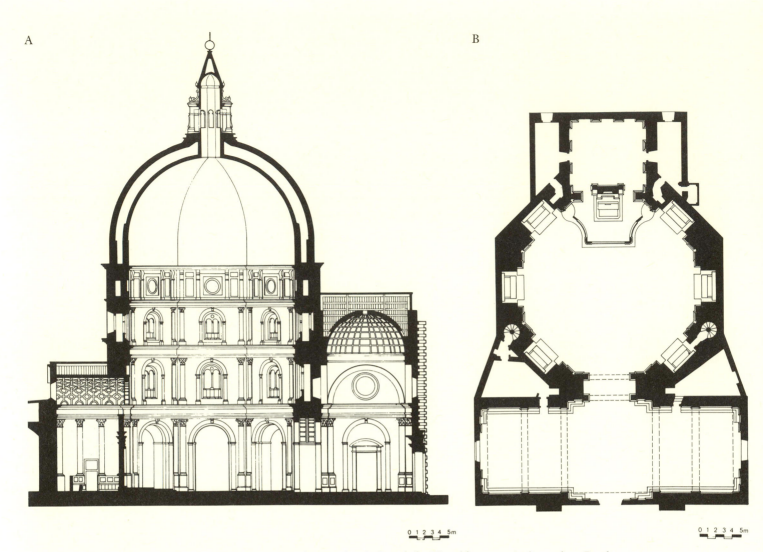

A B

15. Pistoia, Madonna dell' Umiltà, begun 1495 by V. Vitoni. Cupola by Vasari begun 1561 A: section. B: plan

internal feuding was memorialized by Dante. Peace under the Florentine protectorate brought Pistoia relative autonomy, but the atrocities and fierce vendettas of the earlier conflict never subsided. The renewal of hostilities in the sixteenth century between the Cancellieri and the Panciatichi had grave consequences for the city. Peace was restored only through the force of arms; the military magistracy instituted by Duke Cosimo placed the town under a state of siege, culminating in the construction of the Fortezza Santa Barbara.

The bitter feuds indirectly accounted for Vasari's most technically challenging project, the construction of the cupola of the Madonna dell' Umiltà in Pistoia (fig. 15).[16] Based on a design by Giuliano da Sangallo, the church was begun in 1495 under the supervision of the Pistoiese architect Ventura Vitoni.[17] Among the central plan churches of Italy, the

Madonna dell' Umiltà is notable for the separation of its domed octagonal sanctuary from the disproportionately large, barrel-vaulted vestibule (plate 127). Each unit is articulated with such clarity as to assert its independence, and to pass from one into the other is to move into an altogether different realm (plate 128). Inspired by Sangallo's sacristy for Santo Spirito in Florence (1492–4), the church shows a search for all-encompassing grandeur. This was achieved by doubling the diameter of the octagonal hall and adding an additional story to its model. The resulting division between parts became schizophrenic: truly majestic in the vestibule but repetitive and unexceptional in the octagonal hall.

The ambitious edifice soon fell upon bad times. Construction was plagued by frequent interruptions due to the unstable political climate. By 1522, the year of Vitoni's death, the vestibule had been completed

and the octagonal drum had risen to the entablature of the third level, twenty five meters above the floor. At this point all work stopped, leaving the octagon without even a temporary roof to keep out the rain. For nearly forty years the structure remained untouched. The date of the decision to complete the church is unknown, but by 1561 Vasari was at work on the dome.[18] In the meantime, weather exerted a predictable toll on the unprotected structure. The greatest damage was caused by moisture that was allowed to seep into the walls, and the alternation of hot Tuscan summers followed by cold winters caused the saturated masonry to expand and contract. The price paid for nearly a half-century of neglect was a weakened structure that had to be completed. To make matters worse, the construction was far from accurate. All sides of the central octagon are different in length, which ultimately was to cause the rotation of the dome in the direction of least resistance and its fabric and its shells to crack.[19] It was certainly with some justification that Vasari blamed Vitoni, an architect inexperienced in the construction of large buildings, for not providing enough mass to receive the weight of the dome.[20]

Before the construction of the cupola there was the more urgent work of repairing what Vitoni had left unfinished. Predictably, Vasari sought to increase the strength and stiffness of the octagonal drum before constructing the dome. The vaults of six chapels opening off the octagon were reinforced with supporting arches under their openings; the arches joining the octagon to the choir and the vestibule were left unaltered in order to provide a clear view of the main altar. Within the octagonal drum, pairs of iron tie rods were added at the eastern and western corners of the octagon's second and third levels. Here the structure was weakest due to the lack of buttressing in the form of any adjacent construction; elsewhere the vestibule and choir contributed to the equilibrium of the building. Although Vasari's emendations to the existing church were neither scientific nor original, they were instinctively correct.

So far so good. However, Vasari's subsequent additions and changes were as capricious in style as they were in structure. With Michelangelo's New Sacristy in mind, Vasari added a fourth story eight *braccia* (c. 4.5 meters) high, thereby giving the sanctuary a well-defined vertical emphasis (plate 129). Seeking to harmonize the new level with the existing structure, Vasari designed for each face a tripartite elevation composed of panels, strapwork moldings, and brackets or triglyphs employed as capitals (plate 130). The decoration of the cupola's intrados, following the example of Michelangelo's decoration of vaults in St. Peter's and in the dome of San Giovanni dei Fiorentini, reversed the bold geometry of his models by transforming them into a decorative latticework that continues the architectural membering below (plate 131). Even the lantern continues the debt to Michelangelo by combining the lanterns of the New Sacristy and Brunelleschi's cupola of Florence Cathedral. In Vasari's hands, powerful scrolls have become three-dimensional penstrokes, deep niches have become flat panels, and malleable masses are treated as taut surfaces. Expressive motifs were now used in orthodox contexts, as if they were substitutes for the standard elements of Vitruvian grammar. The obvious lack of cohesion in the design was sufficient grounds for Jacopo Lafri, who made repairs to the cupola in the seventeenth century, to chastise Vasari for failing to follow a design already set by a predecessor.[21]

As a structure, Vasari's cupola is composed of two brick shells roughly 95 cm. apart (fig. 16). The conspicuous precedent for this arrangement was Brunelleschi's cupola of Florence Cathedral, a work that Vasari appreciated for its historical significance but failed to fully comprehend in architectural terms (fig. 17 and plate 133). By making the outer shell thicker, Vasari gives the misleading impression that it alone carries most of the structure's weight.[22] The single center of curvature that determined the Pistoiese dome's eight faces is actually located above the uppermost cornice, therby concealing its semi-circular profile. Even more curious are the three different systems of ribs supporting the dome. A primary group of eight radial ribs that bear the weight of the lantern rise from the octagonal base to the summit of the vaults. In addition, eight pairs of secondary ribs, which only serve to separate the shells, run along courses perpendicular to the octagon's faces from the ledge of the inner shell to points located roughly two thirds along the length of its curvature. A third radial set begins on the central axis of each face where the secondary ribs stop and continue to the oculus. Although similarities in appearance and structure have led modern critics to insist that Brunelleschi's cupola served as the model for that of the Madonna dell' Umiltà, the relationships are dubious on structural grounds.[23]

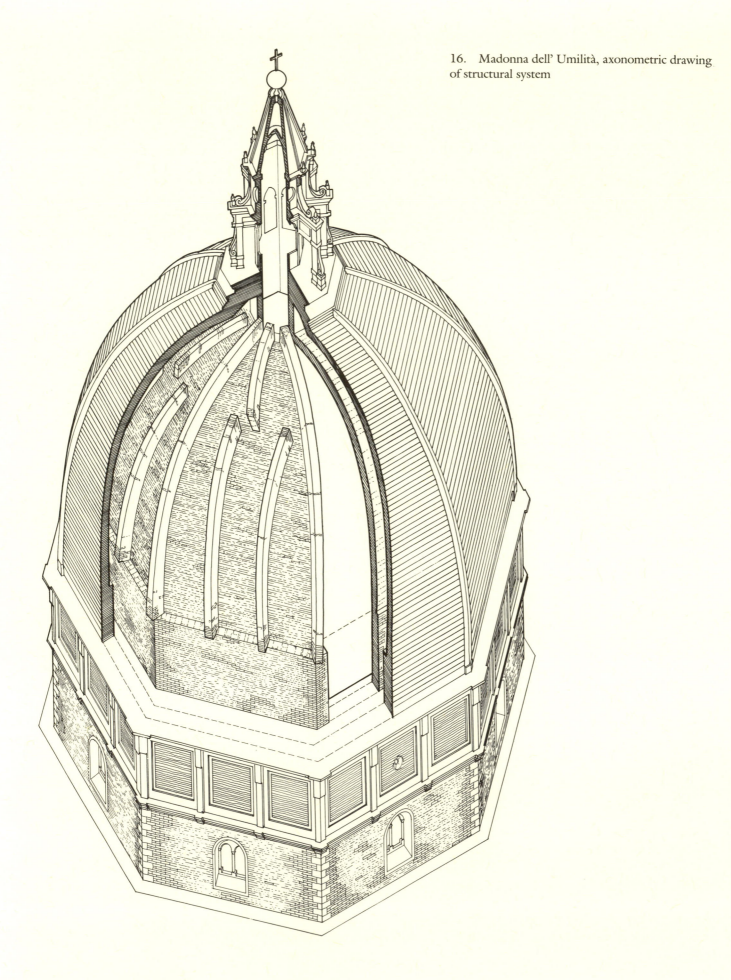

16. Madonna dell' Umilità, axonometric drawing of structural system

Fortunately for Vasari, there was a more appropriate model close at hand. In span (21 m.) Vasari's cupola is comparable to the Florentine Baptistery (25 m.). Their shared structural technique—a deep, hollow, masonry wall where its inner and outer surface appear to function independently of each other—assured a double-shell solution by making a monolithic, Pantheon-like dome both anomalous and unfeasible. A combination of radial and perpendicular ribs would assure simplified construction (fig. 18). The tripartite panels on the exterior of Vasari's addition to the octagonal drum, too, appear to reflect the attic of the medieval structure just as the ledges strengthening the inner shell of the Pistoiese cupola are modelled on similar features in the Baptistery. No doubt Vasari's own professional experience conditioned the praise he gave the Baptistery's vaults in the second edition of the *Lives*.[24]

On all counts the construction of Vasari's cupola is extremely crude (plate 132). His lack of participation in structural and architectural questions is partly explained by his role as an absentee architect, no doubt caused by the demands of his Florentine projects. It seems that Vasari was not responsible for the supervision of construction which was let out to others. There seems to have been little control over the manufacture of bricks, mortar (a task to which Brunelleschi devoted considerable time), or their bonding.[25] In addition, the setting of bricks in extremely thick courses of mortar without pointing gave the internal surfaces of Vasari's dome an appearance of Byzantine techniques of construction.[26] Had he paid attention to the necessity for cohesion between the shells of his dome by using chains, tie rods, or other forms of secure attachment, the controversies that plagued the later history of the cupola would never have come to pass and the external chains added by Ammannati and Lafri would not have been required.

The task of designing a domical vault over Vitoni's base was by any measure enormous. To assure its stability, Vasari likely sought Bartolomeo Ammannati's advice, if not his active collaboration. Even more than in the planning of the Uffizi, an exchange of information was particularly relevant because Vasari's knowledge of structural matters was largely limited to his comments in the *Lives* and correspondence with Michelangelo on the vaulting of St. Peter's. Already in 1558, Ammannati had been called to Siena to repair cracks in the vaulting of the Duomo's cupola, and the remedies that Vasari used in Pistoia

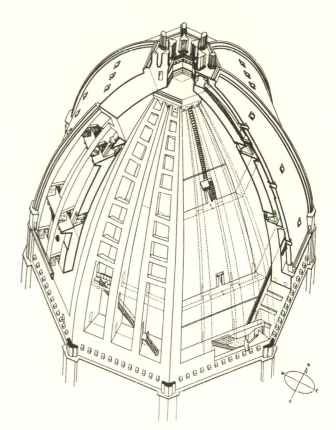

17. Florence, cupola of Florence Cathedral by Brunelleschi, axonometric drawing of structural system

may reflect this experience.[27] Although there is no documentation to link Ammannati with the cupola at this moment in its history, he was certainly a participant in the long history of repairs made to its fabric. Beginning in 1575, Ammannati made substantial repairs to Vasari's dome, most notably in the addition of four iron chains around its exterior near the base. Later architects censured Vasari for incompetent design and poor construction, but Ammannati, who may have been a silent partner in its initial stages, never blamed Vasari for damage to the cupola.

Vasari's cupola may be considered a triumph of imagery over structure (plate 134). Having no predetermined viewpoint within the city, the cupola is barely visible from nearby streets and is totally hidden from the Cathedral square. By raising the drum eight *braccia* Vasari improved the dome's exposure to view in the only panorama of consequence, the expansive vista of Pistoia's skyline from the roads to Florence and Prato. In terms of its effect, the prospect recreates the elements of the Florentine skyline—dome, baptistery, and campanile—encircled by hills

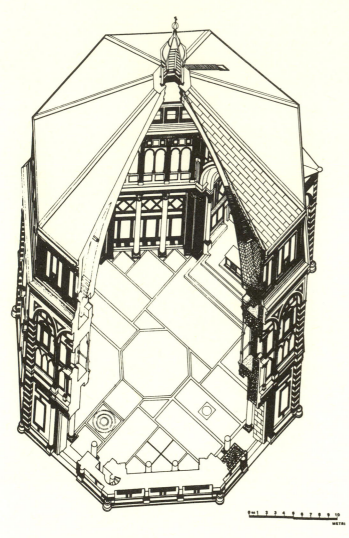

18. Florence, Baptistery, axonometric drawing of structural system after Saalman

pre-eminence of the dome is raised to the level of an artistic *concetto*: it is a manifestation in building of the Duke's domain.[29] Clad in Imperial armor, Alessandro stares fixedly at his city, and particularly at its most prominent structure. The association of the skyline of Florence with the duke was continued in several portraits of Cosimo I, and in an *impresa* in which the city serves as a backdrop for his astrological sign, Capricorn.[30] Vasari's decorations in the Palazzo Vecchio, executed at the same time as the cupola in Pistoia, repeat the same theme on a grander scale by depicting specific historical events. What makes the cupola of the Madonna dell' Umilità so compelling, then, is its emblematic nature and its link to Medicean pictorial and iconographic traditions; what makes it so disappointing is the failure to express these ideas in equally compelling architectural forms.

SANTO STEFANO DELLA VITTORIA IN FOIANO DELLA CHIANA

The political message carried by the dome of the Madonna della Umilità was affirmed in a monument commemorating a pivotal Medicean conquest during the war with Siena. On 2 August 1554, Imperial forces fighting for Florence found Franco-Sienese troops in an indefensible location near the Fòsso di Scanagallo, a small stream in the Val di Chiana near the border with Siena. After ineffectual negotiations the Sienese unwisely attacked Imperial locations, only to be forced into retreat almost immediately. By the end of the battle more than 4000 French soldiers had been killed and an equal number injured or taken prisoner. The encounter signified a crucial turning point in the war, culminating in the decisive attack on Siena early in the next year.[31]

Santo Stefano della Vittoria in Foiano della Chiana is one of Vasari's most distinctive architectural creations (plate 136). Evidently 's Vasari's familiarity with the countryside near Arezzo allowed him to personally select the site, an isolated hillock on the field of the bloody battle. There were Christian overtones to this location as well. In the construction of this octagonal chapel (fig. 19) some finely crafted walls and the remains of a cemetery led Vasari's close friend, Bishop Minerbetti of Arezzo, to believe that a church once stood on exactly the same site.[32] In pre-

as seen from the broad plain of the Arno valley (plate 126). To Vasari's mind the association of the two cities was a natural form of blandishment to Duke Cosimo, who only recently had secured Florentine domination of a notoriously embattled city.

Accordingly, the meaning of the cupola was direct and immediate. By equating political control with the pre-eminence of single structures, Vasari's design belonged to a long standing tradition of representing the skyline of Florence. From the quattrocento onwards, Brunelleschi's cupola had always provided a powerful and easily identifiable image for the depiction of Florence in symbolic terms.[28] But under the first dukes of Tuscany, the predominance of the cupola came to represent specifically the authority of the Medicean state. In Vasari's portrait of Alessandro de' Medici (plate 135), the first duke of Tuscany, the

paring the design for this small, centrally planned structure, Vasari was able to recall both the traditions of Christian martyria and religious monuments that pay homage to secular events.

There were readily available prototypes for a church that commemorated the outcome of warfare. The most notable example is Santa Maria della Pace in Rome, which was begun after 1478 in thanksgiving for peace in Florence after the uncertainties that followed the Pazzi conspiracy.[33] While peace and victory are totally different concepts, Vasari, in his role as the architectural courtier, conflated their architectural iconography. If the eminence of the Roman church explains the choice of Santo Stefano's octagonal plan and general appearance, there can be no doubt that Vasari sought to evoke the image of the church in Pistoia in the details of his design.[34] As in the earlier project, the problem of visibility at great distances was resolved by emphasizing the structure's height, in this case accounting for its attenuated proportions. The new element, however, is the canting of the piers at the corners of the octagon, an arrangement probably suggested by the exterior of the oratory of the Madonna della Consolazione (plate 137) near Castiglion Fiorentino in the Val di Chiana.[35] The effect of this minor variation is easily appreciated in a view looking up at the dome, establishing a direct relationship between the supporting pilasters with their assertive triglyph capitals and the external ribs of the cupola.[36]

THE PIAZZA DEI CAVALIERI IN PISA

Of all Tuscan cities, none was more crucial than Pisa (fig. 20) to Florence's policy of aggressive expansion.[37] After suffering through a long economic decline on account of her defeat by Genoese forces in 1284, Pisa fell into the hands of the Visconti at the end of the fourteenth century, only to be overtaken by Florence in 1406 following the defeat of their Milanese overlords. In the quattrocento Pisa enjoyed peace and relative prosperity for the first time in two centuries, but the capture of the city by Charles VIII once more meant foreign control of the city. French protection also brought about a desire among Pisans to recapture their ancient liberty. Florence responded with plans to divert the Arno's course and other schemes to cut off Pisa from sources of foodstuffs and wood, and with the capture of her con-

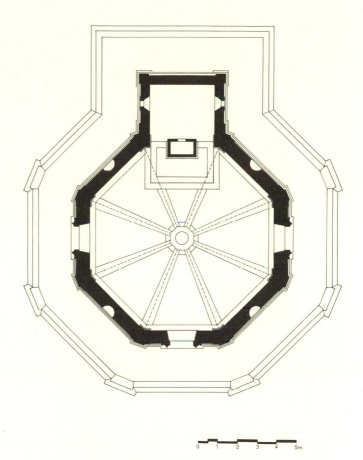

19. Foiano della Chiana, Santo Stefano della Vittoria by Vasari, 1569–72, plan

tado, Pisa was forced in 1509 to capitulate to Florence for the second time. The construction of the new fortress begun in the same year by Giuliano and Antonio da Sangallo the Elder was prompted by Florentine fears of losing this most important city again.[38] After the election of Cosimo I, a plan promoted by Pier Luigi Farnese, the son of Pope Paul III, to hand over Pisa's fortress to Florentine exiles attests to her strategic importance.[39]

The reign of Cosimo I signified a revival of interest by the Medici in Pisa's architecture and commerce. Cosimo initiated a remarkably comprehensive program of urban regeneration that endeavored to transform Pisa into the economic and demographic center of western Tuscany, with Livorno now serving as the preeminent port.[40] The scope of his activities was as broad as those initiated in Florence, ranging from economic development and communication to education and architectural propaganda. As in most of the ducal projects, the proposal courted in equal measure the favor of the cities subject to Florence and Cosimo's own purposes. The lack of drinking

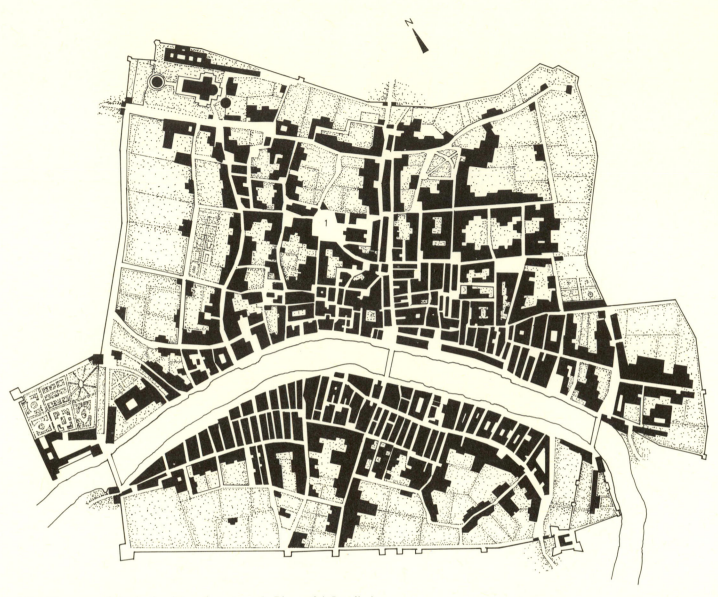

20. Pisa, map of city in the sixteenth century. 1: Piazza dei Cavalieri

water that had plagued Pisa was largely solved by the construction of the Asciano aqueduct, begun under Cosimo I and completed in the 1590s by Ferdinando I.[41] The transformation of the Piazza del Grano into quarters for Pisa's university, begun by Lorenzo de Medici in the 1470s, was finally completed by Cosimo in 1543.[42] The Canale dei Navicelli (1541–73) created a direct link by water with Livorno, the port city enlarged by Ferdinando I that would ultimately outstrip Pisa as Tuscany's maritime center.[43] The location of the new ducal shipyards in Pisa (1548) was largely determined by her proximity to thick forests that would provide wood used in building Tuscany's new commercial and military vessels. At the same time, the fortifications of Ferraio (the fu-

ture Portoferraio) on Elba were begun, strengthening Tuscany's offshore possessions that now included Isola del Giglio and Castiglion della Pescaia, acquired by Cosimo through his marriage to Eleonora of Toledo.[44] Fearing an alliance between Corsica and Turkey, Cosimo desired that island for its strategic location and the potential recruits it offered Tuscan forces.[45]

Cosimo's seaward ambitions are best shown by the structures renovated or built anew by Vasari for the Cavalieri di Santo Stefano in Pisa. This knightly order was established by ducal decree on 9 January 1562.[46] The dedication to St. Stephen, pope and martyr, recalled the crucial Florentine military victories over exiled Florentines at Montemurlo (2 August

1537) and over Sienese forces at Fòsso di Scanagallo (2 August 1554), which both took place on the saint's feast day.[47] According to Castiglione in *The Courtier*, the creation of such an order was a characteristically princely deed.[48] The mission of the knights was largely economic. Charged with protecting navigation from the attacks of Turkish and Berber pirates, the order's ships played a crucial role in opening markets and preserving trade routes that were of special importance to Tuscany. By October 1571 the order was strong enough to participate in the impressive victory over Turkish naval forces in the Battle of Lepanto.

At first Cosimo planned to locate the order permanently on Elba, almost certainly in emulation of the Knights of St. John who were given their new insular base on Malta by Charles V in 1530.[49] The proposal immediately encountered Spanish opposition and was soon dropped. The selection of Pisa involved no diplomatic consultation or the payment of tribute money to any foreign power. It possessed one crucial drawback however: the silting of the lower Arno made for a poor harbor, and hence Portoferraio became their naval base and remained so for forty years before finally establishing their home port in Livorno.[50] Thus its location in Pisa would be purely symbolic, offering the possibility of transforming the emblems and associations of a Republican past by revamping her medieval civic center, the Piazza di Sette Vie.

The regulations governing Cosimo's mercenaries were rooted in the chivalric practices and crusades of the Middle Ages. Following the example of the Knights of Malta, new recruits professing knighthood had to submit proof of their nobility as well as take vows of poverty, chastity, and obedience to the order. A corps of chaplains who had to spend a year at the conventual church in Pisa heightened the resemblance of the order to that of a religious confraternity. Often laden with booty and prisoners from their skirmishes at sea, the knights who attended a triennial convocation of the order must have contributed greatly to the myth of a *renovatio Pisae* and the recovery of her lost sea power.

In medieval and Renaissance Pisa, commercial activity was concentrated along the Arno riverfront and in its nearby markets. The Piazza di Sette Vie, by contrast, was located on the probable site of Pisa's Roman forum, roughly equidistant between the commercial district and the ecclesiastical center on the Piazza del Duomo.[51] Prior to Vasari's reorganization of its surrounding structures, the Piazza di Sette Vie had evolved into an irregular triangular space dominated by the imposing bulk of the Palazzo degli Anziani. Begun during the great period of building communal palaces in Tuscany at the end of the thirteenth century, the structure was enlarged by the incorporation of surrounding buildings. Eventually it accommodated the major administrative bodies of the Pisan Republic—the Consiglio Grande and the dormitories for her twelve elected representatives of the citizenry, the Anziani. Other buildings on the square, such as the Palazzo di Giustizia and the Torre della Fame (where Count Ugo della Gherardesca, according to Dante, died of starvation) were decidedly political in character. Yet apart from Vasari's description of the Palazzo degli Anziani's architecture as "wicked and distorted," little is known about the appearance of the square in the Middle Ages.[52] Despite their fanciful architectural detail, modern reconstructions have captured its sense of isolation at the outskirts of the populated districts of Pisa.[53]

The transformation of Pisa's civic center into the Piazza dei Cavalieri (fig. 21) began with the radical changes made by Vasari to the Palazzo degli Anziani.[54] Although heavily burdened with the ongoing renovation of the Palazzo Vecchio and the construction of the Uffizi, Vasari found time to discuss the new commission with Cosimo during a visit to Pisa in late December 1561.[55] A remarkable letter to Vincenzo Borghini reveals that Vasari had already formulated a strategy for modernizing the old palace. Writing shortly after a meeting with Cosimo, Vasari makes the extraordinary claim of actually convincing his patron to spend less money than originally planned for the project:

> I arrived in Pisa where His Excellency awaited me, and expressed his desire that I devote myself to the Palazzo dei Cavalieri. This happened the other day, the feast day of St. Stephen, their (i.e., the Cavalieri di Santo Stefano) namesake. The plan for this palazzo, which I have just finished, will be a renovation of the building next to the Torre della Fame where the Commissioner used to stay. Whereupon His Excellency was thinking of spending the goodly amount of 15,000 scudi, I found a way that will cover all expenses with only 3,000 scudi. All of this has been approved by His Excellency, as eventually you will see and understand, because I have been ordered to make

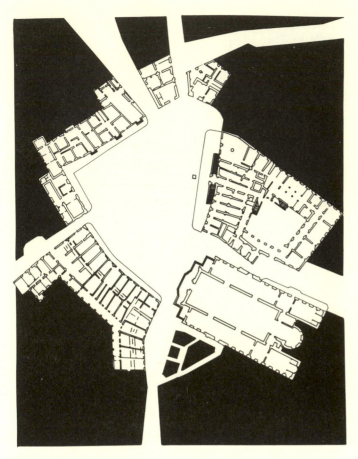

21. Pisa, Piazza dei Cavalieri, redesigned by Vasari 1561, plan

a model, which you will also see. We will discuss this matter later at our convenience.[56]

The following events show how swiftly and how efficiently Vasari prepared the initial design for the conventual palace. Upon returning to Florence, Vasari immediately arranged for the execution of architectural ornament—window frames, doors, and fireplaces—before a definitive solution had been agreed upon.[57] Procurement of materials and other less crucial matters were delegated to Davide Fortini, Vasari's able deputy for the duration of the Pisan projects. But the complex details of providing accommodations for about 20 knights, apartments for the most prominent officers of the order, and its armory still had to be worked out. A wooden model was ready by the end of February, but Cosimo's approval of the design without having seen the finished scheme was not without its drawbacks.[58] Heated difficulties arose regarding an internal staircase that, according to Vasari, was rejected by Cosimo without a full understanding of its design. The significance of the dispute lies in Cosimo's concerns for the efficient

use of existing buildings that motivated most of his architectural patronage:

On the subject of the staircase, it would be a great mistake to destroy much of the existing building, which is completely against the wishes of His Excellency, who would like to enjoy the finished building as soon as possible. As with all the facets of this project, everything must accommodate the older building.[59]

Vasari cleverly adapted the palace to its new use without radically altering the internal disposition of its structural elements. The original chambers of the Palazzo dei Anziani included a council hall, dormitory, and refectory, requirements compatible with housing apprentices to knighthood and educating them in nautical and other military matters. The three major halls of the renovated structure—the armory, the Sala delle Armi, and the fencing room—occupied most of the building's western portion; the two-room apartments for the knights overlooked the square in the eastern half. But the most impressive feature of the palace's interior was a T-shaped stair that anticipated the monumental flights in the Palazzo Vecchio by connecting the Sala delle Armi on the second floor with the prior's quarters and the fencing room above. Presumably Vasari's design for the staircase satisfied Cosimo's initial criticism of it.

Vasari's design for the facade of the Palazzo dei Cavalieri required major modifications to the older structure's exterior (plate 138). After nearly three months of demolition, the razing of its tower and the removal of the shields of the Florentine commissioners that decorated the exterior of the Palazzo degli Anziani resulted in a compact, rectangular profile for the new building. The adoption of repetitive window frames, all aligned vertically under a common cornice line, gave an appearance of regularity to what was in fact an asymmetrical composition spread out over the bent surface created by the two sectors of the communal palace. With a depth nearly equal to that of a full story, the register beneath the upper windows provided a location for the concentration of Medicean symbols. The new coats of arms, prominently placed over the main entry and at the corner opposite the Via Ulisse Dini, provided the only three-dimensional relief to an otherwise flat facade. The three-story loggia at the rear gave the palace the air of a suburban villa by opening out to the fields beyond.

From the beginning Vasari conceived the facade in

painterly terms (plate 139). In compensation for the lack of architectural ornamentation, the exterior was executed in *sgraffito*, a technique first used in pottery decoration and later applied to the architectural embellishment of palace facades.[60] The basic principle of its application—scratching through a coat of whitewash to reveal layers of another color, usually a pearl grey—provided the double advantage of quick execution and resistance to the corrosion of water. The decorative program for the lower levels called for a selection of familiar humanistic themes (virtues, deities, and astrological signs) glorifying the Medicean creation of the new military order. By July 1566, the decoration had been completed from Vasari's designs by Alessandro Forzori.

Vasari appears to have intended the continuation of the grotesques into the frieze. The proposal, however, met with Cosimo's disapproval, because the forms "would appear too small in the upper reaches of the facade."[61] Instead, the duke sought to proclaim the similarity between the Cavalieri di Santo Stefano and the older established crusading orders. Portrait busts of the founders of the six most important orders originally were to alternate with epitaphs appropriate to each, and the intervening spaces would have contained allegorical figures in niches. Under Ferdinando I the iconographical program of the facade was altered by substituting portraits of those grand dukes who had served as grand master of the Knights for portrait busts originally intended for the exterior.[62] The carving of the first three portrait busts and their niches in the 1590s marked the facade's completion.[63]

Excepting only the *palazzi di sapienza* of Italian universities (which housed functions similar to those of the Palazzo dei Cavalieri), there were no Renaissance prototypes for the buildings of a profoundly medieval institution like the Cavalieri di Santo Stefano.[64] Similarly, the Pisan buildings differ from the monastic seclusion in the structures of other chivalric orders. The only significant departure from this norm was the order of the Knights of St. John on Malta whose *auberges* (individual structures that housed recruits of single nations) were scattered throughout the town of Birga. On Malta, the grand master was provided with separate accommodations in the Fortezza San Angelo. While this pattern was continued on a larger scale when the order moved to the new town of La Valetta, Cosimo would have known the earlier arrangement from Baldassare

Lanci, his specialist in fortifications who spent three months on Malta in 1562.[65]

The physical environment that Vasari created was not a square in the strict sense of the term (plate 140). The irregular geometry of the Piazza di Sette Vie and the existing buildings surrounding it precluded the creation of an impressive piazza salone. Given these constraints, Vasari's accomplishment was the creation of an intelligent and informal grouping of buildings that served as the backdrop for the ceremonial activities of the cavalieri. In part this was rooted in Pisan tradition. The Piazza di Sette Vie had been the site of the Gioco del Mazzascudo, a violent form of a joust that was outlawed by Lorenzo dei Medici in 1490 and was replaced subsequently by the Gioco del Ponte on the city's central bridge across the Arno. Although in Pisa there were neither princes nor ambassadors to greet nor were there important religious festivals of a public nature, the daily passage of the knights in their robes or the processions during the triennial convocations must have given the piazza an aura of ritual not unlike Piazza San Marco in Venice. The theatrical quality of the space was especially suited to this purpose, as if its adjacent streets formed a perspective backdrop and the piazza was now a stage scaled to the city and to the far-flung activities of the order.

The allusion to Piazza San Marco was preserved in the design of the Palazzo dell' Orologio (plate 141), the small structure spanning the Via Dalmazia at the northwest corner of the square.[66] Created by joining the Palazzo di Giustizia with the Torre di Fame, this multi-purpose building originally housed the prison, infirmary, and apartment of the prior of the conventual church and later served as a residence for elder members of the order. It can hardly be accidental that this prominent structure, leading out towards the monuments on the Piazza del Duomo, terminates the important vista across the square from the Chiesa dei Cavalieri, just as the clock tower in Venice serves as both the focal point of a panorama seen from the Piazzetta and the lagoon and a triumphal archway leading to the Rialto (plate 142). Also, the displacement of the facade of the Chiesa dei Cavalieri away from the Via Dini allows the Palazzo dei Cavalieri to occupy the beholder's vision in a way scarcely different from how San Marco grasps the visitor's attention when arriving by sea to Venice. Vasari, who was familiar with Sansovino's renovation of the Piazzetta, attached particular importance to the impos-

ing prospect from the water's edge.[67] The resemblance of the Palazzo dell' Orologio to its Venetian counterpart was heightened further by the transfer in 1696 of the clock from the campanile of the conventual church. If Vasari's participation in these changes cannot be fully documented, no doubt he would have considered the final solution congenial to his architectural sensibilities.[68]

Other aspects of the Piazza dei Cavalieri recalled Roman buildings. The proportions, disposition of windows, and neutral wall plane of the conventual palace echo the facade of the Palazzo Farnese (plate 143), which Vasari knew well from his participation in the competition for the design of its cornice. Yet the diminutive scale of Vasari's design is the antithesis of the immense and ample facade created by Sangallo and Michelangelo. Although architectural orders and secondary relief were needed to dominate the square, sgraffito decoration forced a two-dimensional character upon the window frames that eventually gave the facade of the conventual palace an unrelenting flatness. The facade of the Palazzo dei Senatori on the Campidoglio as it existed before Michelangelo's refacing, too, may have conditioned Vasari's response (plate 144). In both form and symbol, the stairway in front of the conventual palace was the most apt Roman quotation. Clearly derived from Michelangelo's stair for the Senator's Palace, it both allowed access to different floors of the Palazzo dei Cavalieri and infused a small amount of visual drama into the square.[69] Symbolism, too, must have played a role in its selection. The recumbent figures of river gods at the base of the Roman stair, which were described at length in the *Lives*, may have suggested affinities with the maritime purposes of the Cavalieri di Santo Stefano.[70]

The Chiesa dei Cavalieri remains one of Vasari's most curious architectural creations (plate 145).[71] Its architecture is medievalizing in spirit, looking back to aisleless, box-like monastic churches exemplified by San Martino in Pisa or, to name an example to which Medicean associations were attached through architectural patronage, San Marco in Florence. Its ample square chancel flanked by smaller rectangular sacristies was only slightly more up-to-date, reflecting a type initiated in Florence by Brunelleschi in the Old Sacristy of San Lorenzo or Cronaca in San Francesco al Monte (plate 146). The richly ornamented organ loft that Vasari designed for the church (plate 147) strikes an uncustomary note

in the context of his religious architecture, which was notable for its visual austerity and architectural unity. The simplicity and clarity of Vasari's church was destroyed by Pier Francesco Silvani's side aisles that were added in 1682. A major reconstruction was begun in 1852 according to Pasquale Poccianti's design for the choir and corresponding nave elevation. The proposal, which employed a monumental serliana opening into a choir terminated by a semi-domed apse, was abandoned shortly after the first columns were set in place. Subsequently they were removed and the choir was rebuilt in its present form.[72]

The way in which the Chiesa dei Cavalieri's character differs from contemporary churches like Vignola's Gesù or Palladio's San Giorgio Maggiore can be explained by its essentially secular purpose. Although the church was served by 12 chaplains who ministered to the spiritual needs of the knights, its most visible purpose was the setting of the triennial convocation of the order with its elaborate ceremonies and processions.[73] By deferring in form and location to the conventual palace it follows the ancient usage of churches adjacent to public palaces for civic functions, just as the Pisan Council used to meet in San Sisto or the Florentine priors took their oath of office in San Pier Scheraggio. Significantly enough, the knights used San Sisto as their conventual church prior to the completion of the Chiesa dei Cavalieri.[74]

It is tempting to speculate whether Vasari would have held a favorable opinion on the later outfitting of the Chiesa dei Cavalieri's interior.[75] Over time, the church born of Counter-Reformation severity acquired a Baroque grandeur in the triumphal rhetoric of its banners, military spoils, and paintings of military victories, thereby giving the interior the effect of a great salone. The effect must have been spectacular, if somewhat overindulgent. When Charles de Brosses visited Pisa in 1739, he was forced to wonder cynically if the knights' standards were hanging in any mosque.[76]

The evidence regarding Vasari's lost design for the facade of the Chiesa dei Cavalieri is tantalizingly fragmentary (plate 148). Unlike the other projects on the square, economy was no longer a factor in its design. Cosimo instructed Vasari to employ mixed colored marbles from the Medicean quarries at Seravezza, the same quarry discovered by the Duke himself in 1563 and that would later supply colored stone for a new Medicean mausoleum at San Lorenzo, the Cappella dei Principi.[77] Whatever Co-

simo's motivations might have been in this instance, his charge was conditioned by the buildings that he would have seen in Florence. It is important to note that the desire for a facade with the outmoded technique of polychrome incrustation may have been inspired by a contemporary dilemma, that of faithfully completing the design of an older structure. Like many Florentine churches, the Cathedral still lacked a completed facade, and it also required the cladding of its side walls in some areas. With the exception of the facade, its polychrome exterior was completed only in the 1580s.[78] The ease with which the Cathedral was completed at this late date illustrates that the kind of facade envisaged by Cosimo was within his grasp.

Revolutionary in its conservatism, the charge articulated by Cosimo also required Vasari to provide a design closer in appearance to the shimmering facades of medieval Pisa and Florence than to the brilliant luminosity of Palladio's Redentore or the studied rhythms and elegant relief of Vignola's proposal for the Gesù. The constraints imposed by the colored marbles were, in fact, admirably suited to Vasari's painterly sensibilities. The sensation created by the ensemble of buildings on the Piazza dei Cavalieri would have approximated the effect of Vasari's topographical paintings where an even light brings out the depth of color in the background architecture. If Vasari were to have employed the warm red and green marbles of Seravezza as well as brilliant white Carrara marble, the facade of the Chiesa dei Cavalieri offered the possibility of creating a vivid and harmonious complement to the monochromatic exterior of the conventual palace.

Precisely how Vasari would have achieved this synthesis, a marriage of chromatic qualities found in Tuscan Romanesque churches with the architecture of his own age, is not known.[79] The only clue to Vasari's approach to this problem is found in the facade illustrated in the background of his *Martyrdom of St. Stephen* (plate 149), executed in 1570 for the conventual church.[80] The design—a compact, two-story composition capped by a pediment in its central bay—clearly recalls the triumphal arch in Peruzzi's *Allegory of Mercury* (plate 8).[81] Admittedly, the proportions of the arch were too squat to adapt convincingly to the Pisan church, but the pictorially effective composition is marvelously suited to the complexities of the Piazza dei Cavalieri. Seen from the Via Dini, the giant columns would have closed

the vista into the Piazza dei Cavalieri created by the church's setback facade; from the square the composition would have been grasped as an equal partner to the conventual palace.

Both Vasari and Cosimo I failed to see the completion of the Piazza dei Cavalieri.[82] As in the Uffizi and the Palazzo Pitti, Francesco I took little interest in the grand projects initiated by his father. The responsibility for its completion passed to Ferdinando I, who constructed the order's own aqueduct (1591–95) and commissioned statuary for the location visible from all streets entering the square. Sadly, neither Pietro Francavilla's small fountain opposite the conventual palace nor his larger, excessively stiff, and uninspired statue of Cosimo I in the guise of grand master of the Knights provided a dominant focus to a square characterized by excessive breadth. Nor was Don Giovanni de' Medici's completed facade for the Chiesa dei Cavalieri (plate 150) any more successful in relating the conventual church to the square and its surrounding buildings. Work on the Canonica (housing for the prior and chaplains), the Palazzo del Consiglio dei Dodici (archive, chancellery, and other administrative functions), and other structures on the southern side of the square dragged on well into the next century.

In spite of its apparent ingenuity, the Piazza dei Cavalieri cannot escape criticism. The artificiality of the design originated in Cosimo's fanciful vision of creating a grouping of buildings conceived for pageantry and loaded with political symbolism in a somnolent town of only 10,000 inhabitants.[83] The failure of Cosimo or his architect to be bound by an overall design only increased the difficulty of creating a harmonious ensemble. The references to the maritime greatness in Pisa's past and in Tuscany's present intended in the square were lost on later visitors whose interest rightly centered on the cathedral, baptistery, and campanile. Charles Dickens, for instance, remarked upon the empty streets, with scarcely any people in them except for beggars.[84] More acerbic was the characterization of the city by William Dean Howells as "pitiless Pisa."[85] But the most censorious words were written less than a decade after Vasari's death. When the ever-observant Montaigne visited Pisa in 1581, he was struck by the languor that pervaded the city:

Except for the Arno and the beautiful way it flows through the town, these churches and vestiges of an-

tiquity, and its private works, Pisa has little charm. It seems deserted. And in this respect, in the shape of its buildings, its size, and the width of its streets, it is a lot like Pistoia.[86]

Still the attempt at reconciliation of the older buildings with their new purposes was laudable on all counts, and the fruits of this difficult task were to mature only in Vasari's last urban project, the Loggia on the Piazza Grande in Arezzo.

THE LOGGIA IN AREZZO

In Arezzo the impact of urbanism on Vasari's architecture was very different, as is shown by that city's unusual topography and long history of foreign subjugation.[87] Located in the upper Arno valley, the city rises gently from a broad plain until its growth is arrested by a sharp ridge on its northern edge. Now dominated by the imposing thirteenth-century Cathedral, the crest of the hill also contains a park incorporating the remains of a sixteenth-century fortress (plate 151). This natural citadel dominated the confluence of the Val d'Arno and the Val di Chiana from prehistoric times, and it was easily accessible to the upper Tiber valley to the northeast. Already in the Augustan era, Arretium was a major agricultural and artistic center famous for its red-surfaced pottery. The inhabited area of this thriving center exceeded that of its fortress, and subsequently the Etruscan and Roman towns extended outward along the major roads leading to the west and southwest. With the acceptance of the radial patterns of communication suggested by the topography, the fan-shaped layout of the city was now assured.

What is known of Arezzo's urban history is similar to that of other Tuscan cities. As in Florence, the residents of Arezzo in the ninth and tenth centuries sought refuge within the confines of the earlier settlement, making the community little more than a village within a larger citadel. But the skeletal outline of the ancient town survived well into the Middle Ages. The return of economic prosperity from the twelfth century onwards brought about the expansion of the town through the construction around 1194–1200 of a new set of city walls, whose gates were determined by the existing means of communication with Florence and Siena and with the upper Tiber Valley to the northeast. Arezzo's connections with Florence

and its surrounding area were particularly extensive, allowing the conduct of individuals and goods along both the right bank of the Arno by way of Pelago and along the left bank via Cintoia and Impruneta.[88] Once Arezzo had begun to expand within this framework, the original Etrusco-Roman citadel was little more than an appendage to a thriving, growing city.

The construction of Arezzo's twelfth-century walls coincided with the emergence of a new set of civic institutions that definitively altered the city's layout. The most important factor was the migration of the town's market from the ancient forum, presumably near the modern Cathedral, to the large, sloping open area known as the Platea Communis just beyond the Porta Burgi, the southern gate to the citadel.[89] The presumed outline of its walls followed a course roughly parallel to the northern boundary of the square. Once the site of the future Piazza Grande was established, the Palazzo del Commune (1232), the Palazzo del Pretorio (1278), and the Pieve were built on sites adjacent to or near Arezzo's new public square. As a consequence of the tension between the town and the bishop, the only structures of importance outside the new civic and religious center were the city's fifth-century cathedral and the bishop's residence on a fortified hilltop about a mile to the southwest.

Real security and lasting peace were elusive. The reign of Guido Tarlati, elected bishop of Arezzo in 1312 and *signore* for life in 1321, was the only peaceful period in more than a century of civil strife. Following his death in 1328, rebellion contributed to a precipitous decline of the city's fortune. The factionalism of the 1380s between the Guelphs and Ghibellines concluded with the sale of Arezzo 1384 to Florence by the French condottiere Enguerrand de Coucy for 40,000 *scudi*. Arezzo's history has always been one of strong reaction to Florentine rule—there had been rebellions in 1409, 1431, 1502, and 1529—and a fortress was begun in 1502 according to the designs of Giuliano da Sangallo. Constructed on the commanding site of the medieval Cassero di San Donato at the northern edge of the old citadel, the new stronghold was the strongest and most effective symbol of Florentine domination (plate 152).

The specter of Arezzo's disloyalty caused Medici dukes to inflict inordinate punishment by systematically destroying many of her medieval monuments.[90] The most important symbol of Aretine

freedom, the Palazzo del Commune, was destroyed by Florentine order in 1533. Arezzo's strategic position near the confines of Tuscany account for the renewal of work on her fortress in 1537 and the reconstruction of her last set of city walls.[91] Ignoring the pleas of Aretines for the preservation of the Duomo Vecchio, Cosimo in 1561 ordered the destruction of the unusual eleventh-century polygonal church that had been occupied by Piero Strozzi in 1554 during the Sienese War.[92] As noted by Gregorio Sinigardi in his diary, the demolition of the church caused "great trouble for the city to see the destruction of such a beautiful and holy Duomo where there were many beautiful, sacred, and notable things."[93]

In comparison to public squares in other Italian cities, the Piazza Grande must have appeared dilapidated to visitors and natives alike. The completion of the fortress had precipitated the destruction of the palaces, shops, and towers that had been built on Arezzo's Etruscan nucleus, leaving only the residences and potter's shops on the devastated north side of the Piazza. The structures in the background of Bartolomeo della Gatta's *San Rocco* (plate 153), which was commissioned by the rectors of the Misericordia in 1478, indicates that the houses varying in height and design along the Piazza Grande's northern flank were probably no different than other structures facing onto the square.[94] At the southwest corner of the square, six small shops and a votive chapel dating back to the trecento obstructed the prospect towards the apse of the Pieve.[95] The northwest corner was in a nearly continuous renewal while the Confraternity of the Misericordia acquired and fashioned existing structures into warehouses and stables.[96]

Shortly after his return to Arezzo in late 1548, Vasari prepared a design for the clock tower and belfry (plate 154) that was constructed above the balcony that formed the uppermost story of the Palazzo della Misericordia.[97] Undoubtedly there are belfries more compelling than this minor project, and Vasari failed to mention it in the *Lives*. Its design resembled the surrounds of Vasari's altarpieces: an aedicule of Doric piers supporting a curved pediment, buttressed weakly by small scrolls, flanked by open, arched bays, and placed on a disproportionately high socle with a clock in the square panel at its center. All this, however, resounded with civic significance. Almost certainly one of its bells was the one that had hung in the Palazzo del Commune prior to

its destruction. With its transfer to a new location, this symbol of Aretine freedom now announced the sale of grain to the citizenry.

Vasari's Loggia was but one of several projects that brought about the renewal of Arezzo's main square (plate 155).[98] In 1547 Mariotto Cofani, an Aretine merchant, bequeathed a substantial amount of funds and property to the Confraternity.[99] Although the will did not identify specific projects for which the funds would be disbursed, the donor was presumably aware that his generosity would serve to generate income from real property. But time had to elapse to allow the accrual of interest, and the donation had no immediate effect on the Piazza Grande. In 1562 Vasari presented to Duke Cosimo a proposal for the construction of a new aqueduct for Arezzo that would terminate with a public fountain in the Piazza Grande. The need for the project must have been obvious to all. Arezzo, like most hill-top cities, lacked a plentiful and continuous supply of water, and her citizens had to be content with wells located outside the city walls. Even if the most prominent part of the Piazza Grande was ravaged, the anticipation of the aqueduct must have given an aura of desirability and respectability to the property surrounding the square. Ironically, Vasari's Loggia, too, depended upon the hope of realizing the aqueduct and fountain, which were not completed until 1603.[100]

Nearly ten years passed before any other changes were proposed for the Piazza Grande. In July 1570 the council of Arezzo was petitioned by the rectors of the Misericordia to use funds from Cofani's estate for construction of a building to beautify the city.[101] Although records fail to identify the proposed building, there is no evidence to suggest that a structure other than the Loggia was planned. The timing of the deliberation was carefully considered, for in early September Prince Francesco de' Medici visited Arezzo in the company of Vasari, among others, as part of a month-long tour of Tuscany.[102] There were reasons for concern for both the Aretines and Prince Francesco; Arezzo had built no major public structure since the fourteenth century, and it lacked the architectural symbols of Medicean authority that Vasari had built in Florence and Pisa. What transpired during the official visit to Arezzo is not known, but any major expenditure would have been discussed. Vasari must have realized that this was an opportunity to make a mark on his native city by effectively designing its center. The boldness of the

project and Francesco's diffidence towards monumental public constructions suggest that Vasari, who was a member of the Confraternity and had executed artwork for it in the past, may even have initiated the project himself. Vasari's intimacy with the Medicean court was no guarantee of official favor; Francesco's interest was lukewarm at best, and the project received his definitive approval only two years later. The favorable sanction, however, was anticipated, for the Confraternity had already began to record financial and administrative records for a project that would continue nearly into the next century.[103]

Vasari's imposing design effectively separated the Piazza Grande from the grubby disorder near the Fortress. The Loggia gave a new regularity to the north side of the Piazza with its severe, repetitive facade 126 meters in length (plate 156). Following a tradition rooted in Vitruvius' description of an ancient basilica and repeated in several sixteenth-century squares, its twenty bays facing the square contain shops with storage areas at the rear and mezzanine chambers above (fig. 22).[104] In the eleventh bay, an open stair connects the Piazza with higher ground at the rear. The path created by the staircase may have its origins in an earlier street or alley in the same location, as indicated by its continuation of the Via della Pescaja in the lower part of the Piazza Grande (plate 157).

At the rear of the Loggia, the stair's symmetrical ramps lead to the upper levels, which seems part of an altogether different building (plate 158). The lack of association was in part the result of a utilitarian exterior without any architectural distinction, and it was further enforced by differences in use and plan. Offices for the Monte di Pietà, the chancellery of the Nove Conservatori del Dominio, and the Dogana were located in the western half. Five row houses incorporated into its eastern half were leased to civil administrators, officers of the Misericordia, and other members of the Aretine nobility. The Grand Salone at the western end of the upper level was apparently meant to contain a theater from the outset, as Vasari had done for the Teatro Mediceo in the Uffizi.[105] Later modifications included the official printing offices for Arezzo.[106]

Vasari's ingenious use of the sharply sloping site permitted access to both shops and houses at street level from opposite sides of the building (fig. 23). But the Loggia's prominent location presented additional constraints. Because of its position on the highest side of the square, any new construction would overwhelm the diverse mixture of neighboring structures, which ranged from tall medieval houses to the Misericordia's own palace and the stunning Romanesque apse of the Pieve. Elaborately ornamented or columnar facades would have been particularly inappropriate, since they would have failed to harmonize with the wall architecture of the important religious and institutional structures on the west side of the Piazza Grande. The fountain that Vasari had envisioned for the center of the Piazza Grande, too, may explain the extreme reticence of the Loggia's facade.[107] The rebellious history of Arezzo may explain why a grand-ducal effigy like that of Cosimo I in Pisa apparently was not planned for the square; a late sixteenth-century statue of Ferdinando I is located in a less prominent position near the cathedral.[108]

By constructing a new Medicean administrative center for Arezzo, Vasari instigated a process that modified the social geography of the town. In effect the Loggia became an aristocratic district in its own right. The crucial point in this respect is that the occupants of its houses frequently held governmental positions, and those who comprised such a category of administrators often were descendants of the Aretine nobility. The social significance of the Loggia was officially recognized only in the next century. In 1687 a law was passed forbidding "plebs" to pass under the arcades facing the Piazza Grande, thereby reserving the Loggia and its surrounding spaces for the same class of people who lived and worked in it.[109] What was once public by law and consent had become private, and the social stratification based on status promoted by Renaissance architectural theorists was now distinguished by political affiliation.[110] With its concentration of ducal offices and patrician residences, the Loggia was both an aristocratic district and the most visible symbol of Medicean presence in Arezzo.

Vasari's clear sympathy for the medieval facades adjacent to the Loggia is the most surprising feature of its design. While its individual bays repeat the verticality of the nearby tower houses, the most important influence on the facade's design was the Misericordia's own palace (plate 159). Transferring the ABA composition of the older structure to the Loggia, Vasari altered its proportions only to accommodate the dimensions of the shops behind the facade. Despite obvious differences in architectural gram-

B

22. Arezzo, Loggia by Vasari, 1570–96, plans.
A: Shops opening onto Piazza Grande.
B: Governmental offices and rental houses
opening onto upper level

A

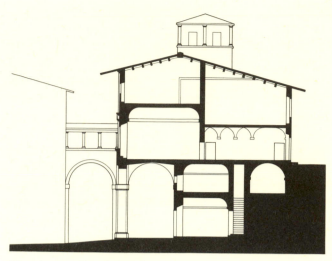

23. Arezzo, Loggia, section

mar, the common denominator for both is the uniform sense of scale obtained by the repeating common unit along the northern side of the square. The model for Vasari's creation of visual continuity between structures different in age and style was Vignola's Portico dei Banchi in Bologna, which reinterprets the motifs of the Palazzo del Podesta in the lower level of its elevation (plate 160).[111] Presumably Vasari had seen the Bolognese structure under construction during his northern journey in 1566. It is tempting to think that Vignola's building, so similar in its use, siting as a backdrop for the major public square, and acceptance of public rights of way, actually prompted Vasari to suggest the design of the Loggia.

The Loggia has typically been seen as a later rendition of the Uffizi, but this comparison is somewhat misleading in both institutional and formal terms.[112] In all respects the Loggia is a particularly astylar building, perhaps closer in form and spirit to the riverfront sector of the Corridoio than to any other of Vasari's buildings. It is abstract in its avoidance of the conventional elements of architectural grammar, relying on vast, unbroken surfaces instead of architectural orders or decoration for its effect. Lacking active forces within its structure, all of the Loggia's elements—large or small, horizontal or vertical, protruding or planar—are resolved in a neutral, equilibrated composition. In comparison to the elaborate layering of architectural elements on the facade of Vignola's Portico dei Banchi in Bologna, potentially expressive details like the Loggia's window frames raised on high socles have given up their individu-

ality for an over-all austerity largely determined by a tight budget (plate 161). Such an architectural severity was congenial to Vasari's pictorial sensibilities, as is shown by the appearance of the Loggia in his painting of the *Forge of Vulcan* (plate 162).[113]

Institutional factors also account for the Loggia's form. The charges of its nominal patron, the Confraternity of the Misericordia, extended far beyond the promotion of the seven works of mercy. In the broadest sense it was a private organization charged with the public responsibility of promoting the social welfare of the city in the broadest sense. These services were paid from the income generated by land, houses, and other income-producing property bequeathed to the Misericordia by merchants and artisans. By providing social services consistent with official fiscal policy, it was a political organ of the Medicean state accountable to the grand duke and serving his interests through the actions of its members. The deference that Vasari showed to the Misericordia's facade in the Loggia's design was a measure of the Confraternity's importance in Arezzo.[114]

The Confraternity's purposes were functionally related and architecturally linked to those of the Monte di Pietà, the most important of the Loggia's occupants (plate 163). Unlike their sister institutions elsewhere in Italy, the *monti* in Tuscany engaged in commercial speculation to advance Medicean interests and provided private loans that once were the province of Jewish moneylenders.[115] Originally located in chambers in the Misericordia's palace that opened out to the Via Vasari, the Monte di Pietà sought offices in the Loggia at the outset and was informed of changes before construction began.[116] The relocation of the Monte in the new structure was primarily symbolic, because the regular staff was composed only of a treasurer, a secretary, a bookkeeper, two estimators, and two assistants.[117] Other tenants were no less important. The Dogana, which in Florence was located in the Palazzo Vecchio, collected taxes on goods entering Arezzo. The Cancelleria was perhaps the most important agency of all, for it was the grand duke's eyes and ears in Arezzo, regularly reporting to Florence on all financial and civic affairs.[118] Apart from their general location in the western end of the Loggia's upper floor, little else is known about the original layouts of the office suites, which have not survived.

The Loggia's site on the Piazza Grande and its primary function as headquarters for the Monte di

Pietà contributed to its form and iconography.[119] According to Vitruvius, the stalls of money changers were located under the porticoes of basilicas surrounding Roman fora (plate 164). In this respect, the Loggia, which housed Arezzo's most important financial institution, is a kind of basilica overlooking a forum. But the porticoed facade was also justified by several recent buildings. Falconetto's Monte di Pietà in Padua (plate 165), with its loggia-like facade attached to a conventional palace, proved at least that the Vitruvian connection between basilicas and finance was still compelling to architects in the sixteenth century.[120] Vasari also knew that both utilitarian markets such as those along the Rialto in Venice and more splendid structures like Sansovino's Library in Venice (1537), Palladio's Basilica in Vicenza (1542), and Seregni's Palazzo dei Giureconsulti in Milan (1561)[121] were all descendants of the ancient basilica. Whether or not Vasari sought to emulate any of these structures is beside the point. To architects of Vasari's generation the shallow, stoa-like form of the Loggia illustrated a direct link with ancient architecture that both signified its importance as a communal institution and responded to the practical demands of limited depth in plan and unlimited horizontal expansion in its facade.

Vasari did not live to see the completion of the Loggia. The responsibility for its execution fell to the capo maestro, Alfonso Parigi the Elder, the architect from Prato who established a dynasty of artists serving the Medicean court.[122] Here Parigi's talents were directed toward the construction of the Loggia as economically as possible.[123] The changes that Parigi introduced to Vasari's design (as shown by comparison with the wooden model) accentuated the severity of a building which was already largely without architectural detail (plate 166). An increase in height and the omission of the Doric order caused the attenuation of the piers separating each bay, thus making the already tall units seem excessively vertical.[124] The introduction of square windows in the mezzanines of the shops further enhanced the Loggia's Roman imagery (plate 167), recreating the exterior of the tabernae that were still to be seen in the great hall of Trajan's Markets.[125] It was also under Parigi's stewardship that most of the government offices were built and its rental housing planned.

The Loggia's rental housing occupies a singular position in the history of urban development. Ever since the Middle Ages it was common for churches, monasteries, or charitable organizations to construct large tracts of housing in many Italian cities. In most cases the purpose of new residential construction was to furnish these institutions with sources of income for their own work or, less often, provide residences for those dispossessed by new construction.[126] Florence was no exception to this procedure, evolving a variety of housing types differentiated by both the status of the residents and the peculiar preferences of the developers of the property. As in other cities throughout Europe, the relatively narrow width of the plots and the shortage of available space dictated verticality in their exterior appearance. Conditions varied, of course in each city, the most extreme case being Naples in which the density of population and the narrowness of adjacent streets caused the creation of extremely tall palaces with elaborately carved portals and stairs at the rear of their small courtyards.[127] In the most elaborate examples interior arrangements adjusted the main features of seigniorial palaces—the vaulted entry hall, central courtyard, and main salone—to the physical constraints posed by much smaller structures. The small row palaces in the Via dei Servi built by the Arte della Lana and the Mercanzia constitute the clearest example of the domestication of palatial conveniences.[128]

Monumental structures with porticoes or loggias posed different problems to the planning of speculative housing. Since this form of the row house was usually located on streets or squares, the main rooms were normally located at the front of the structure. Customarily, the lower floors contained shops, thereby limiting access to the residences to positions at the rear of the structure or along rights of way passing through the building, as in the Procuratie Vecchie in Venice (plate 67), the Piazza Ducale in Vigevano, or the Portico dei Banchi in Bologna.[129] Those providing entrances through the portico, as in row houses of the Servite Loggia on the Piazza Santissima Annunziata in Florence (plate 168), were rare.[130] The size and grandeur of the units varied in each case, ranging from those of a few rooms to the palatial scale of the flats overlooking the Piazza San Marco in Venice.

Clearly Parigi's most important contribution was the design of the Loggia's rental housing.[131] That the units were less elaborate than their Florentine counterparts cannot justify their clumsy design or disregard of earlier models. In each house a narrow hallway leads to the salone whose main axis is

perpendicular to the facade overlooking the Piazza Grande. As a consequence of this arrangement, two parallel files of rooms are created. In this departure from common practice, a rigid adherence to evenly spaced structural bays dictated by the facade has created a series of nearly square, almost equally sized chambers. The monotonous effect of the plan, then, was due to the lack of hierarchy in the size of spaces. The technique of employing a repetitive network of cellular units was a hallmark of the planning arrangements favored by Bartolomeo Ammannati (to whom Parigi was related by marriage), but it was employed in the Loggia with little concern for utilitarian matters.[132] Little consideration was given to the section of the units, for the unrelated facades with windows at different heights failed to create a uniform floor level for the upper rooms.

Paradoxically the Loggia recalled the experiences of an earlier era. Writing at the end of the fourteenth century, Matteo Villani noted in his comments on the Loggia della Signoria how that structure signified tyranny instead of freedom.[133] Although his words were directed at the similarity of the Loggia della Signoria to private loggias owned by aristocratic families, they are still important for a full understanding of Vasari's design. Like the earlier family loggia, the late cinquecento "public" loggia in Arezzo became the realm of the local aristocracy and the political system that they supported. There is no evidence suggesting that the loggia planned in 1670 for the southwest corner of the Piazza Grande would have been different in terms of the conventions defining its use.[134] Combining an innovative building type with objectionable social restrictions and questionable political uses, the Loggia and its subsequent history represented the best and worst aspects of the Medicean state.

SIX

The Church

Religious Architecture in Arezzo and Florence

Vasari practiced architecture during a period of fundamental and momentous change for the Church, especially as it related to the arts. What church historians call "Catholic Reform" was, to a large degree, a continuation of reforming impulses from the Late Middle Ages.[1] Frequent church attendance and preaching during Mass gave a new importance to the architectural design of the nave, and the stress on frequent communion reflecting an increasing devotion to the Eucharist gave visual importance to the main altar, the spiritual center of the new buildings.[2] Architectural studies have rightfully stressed the architectural innovations adopted by the newer orders (especially the Theatines and Jesuits), but continuity and reform within the older established orders was equally strong, if not as visible. In the fifteenth century, the renewal of monasticism initiated by the Cassinese branch of the Benedictine order and its founder, Ludovico Barbo, yielded to increased activity by mendicant orders and regular clerics who were concerned with the religious renewal of society. A new sense of religious piety was manifest throughout Italy in institutions as diverse as small Roman confraternities or as wealthy as the

Venetian *scuole*, the charitable institutions often attacked for ostentation at the expense of the services they were supposed to offer the poor.[3] Reform in the Church also meant frank exchange of views at the drawing board; architects and churchmen frequently shared responsibilities in the creation of religious structures, and by the end of the sixteenth century commissions were regularly being given to priests who served as architects for their orders.[4]

Vasari's religiosity was conditioned less by the institution of the Church than by personal experience. The assassination of Alessandro de' Medici in 1537 struck a particularly cruel blow to Vasari's search for Medicean patronage, causing him to seek commissions from monastic orders.[5] His youthful acquaintance with Don Miniato Pitti had already introduced him to the austere rule of the monks of Monte Oliveto who sought monastic reform in the fourteenth century by returning to a primitive life of asceticism and solitude. As a guest in their houses he would have observed first-hand a slight relaxation of the rigorous constitution of the Olivetans' founder, St. Bernard Tolomei: straw bedding, coarse clothing, and, at first, a fanatical abstinence from serving wine

with their meals.[6] The monks at Camaldoli for whom Vasari painted several altarpieces had adopted an even more uncompromising constitution. The rule of St. Romuald, which was transmitted only by oral tradition, was of the greatest severity. In Vasari's time it still retained much of its rigor, observing nearly continual silence except in recitation of the Hours and providing separate houses for individual hermits in the surrounding forest.[7]

In Florence, the Counter Reformation tended to sustain existing institutions rather than support new religious orders.[8] In Vasari's era there were no powerful reformers. The spiritual reforms of the major Florentine figures, Caterina de' Ricci (1522–1583) or Maria Maddelena de' Pazzi (1565–1619), were to come only at the end of the century, and the most important reformer of Florentine descent, San Filippo Neri (1515–1595), lived in Rome where he founded the Congregation of the Oratory. Prior to the return of Archbishop Antonio Altoviti in 1567, the frequent, long, and usually enforced absences of Florence's bishops rendered episcopal powers useless.[9] Under Duke Cosimo I the reform of Florence's extensive network of hospitals and monasteries both corrected administrative excesses and brought about the capitulation of the Church to the state. New religious organizations also had to bear the weight of established traditions. For example, the Company of San Tomasso, which espoused a contemplative and sacramental life for youth, was organized along the lines of older confraternities like the Misericordia that had figured prominently in Florentine charitable and spiritual life since the Middle Ages.[10] In architectural terms, new construction in Florence would have been ill-spent; her numerous and capacious monastic churches answered the demand for accommodating large numbers of the faithful, as created by the newly rejuvenated liturgy.

Florentine reform was characterized by sacramental piety in Eucharistic devotion. Parish confraternities dedicated to the Blessed Sacrament promoted its adoration, the company at Santa Maria Novella being among the first organized after the return of the Medici in 1530.[11] Visibility of the Eucharist was a primary consideration in the *quarantore*, or the Forty Hours Devotion, where the Sacrament was placed on a high platform for a period of time recalling the interval between Christ's death and Resurrection. The practice came to Florence around the mid-sixteenth century and soon became a ritual that linked church and state. Attendance was mandatory for nobles and members of the Medicean court. With the official patronage of the grand dukes, the *quarantore* showed, in the words of one scholar, the link between the representation of the heavenly court and obedience to the earthly court in Florence.[12]

Vasari may have had a personal stake in these devotional practices through connections with Antonio Altoviti, the exiled archbishop and son of Giorgio's patron in Rome, Bindo Altoviti.[13] The circumstances of the archbishop's return to his diocese clearly display the same kinds of sacramental concerns that had been part of Florentine religious practice for the previous three decades. Central to this was the presentation of the consecrated Host as proof of the Transubstantiation of the Body and Blood of Christ.[14] Planning for the archbishop's ceremonial entry probably began shortly after 1 June 1565 when Cosimo I invited the exiled archbishop to return from Rome.[15] Arriving in Florence to take possession of his bishopric on 15 May 1567, Altoviti celebrated his first solemn Mass in the Cathedral three days later, and the festivities celebrating his arrival culminated in the Procession of Corpus Domini (29 May), the feast exalting the presence of Christ in the Host.[16] Any changes in liturgy were motivated by the new cult of the Sacrament. Furthermore, Altoviti's subsequent pastoral visits, which spread the dogma of Eucharistic devotion throughout his entire diocese, also had the effect of promoting church renovation by requiring a full documentation of all sacred objects, both old and new, used in the service of the Mass.[17] No doubt Vasari's preference for open interiors and unimpeded vistas was shared by a significant number of the Florentine clergy and motivated by their concerns.

SANTA MARIA NUOVA IN CORTONA

Vasari's first church, Santa Maria Nuova in Cortona, stands apart from such concerns. As part of the multitudinous family of Renaissance central-plan churches, its design recalls the architectural concerns of an earlier era.[18] The church contains a miracle working image of the Virgin that accounts for its construction by public subscription, like its more famous relations in Prato or Montepulciano. If seen at a distance from the Porta Colonia, Cortona's northern gateway (plate 169), Vasari's church appears to

occupy a position similar to Francesco di Giorgio's Santa Maria del Calcinaio, located on the opposite slope of Monte Sant'Egidio. From a viewpoint on the terrace created to serve as its base, the church reveals an exterior without scarcely any articulation, as if the far view was the only one considered (plate 170). Inside it reveals an architectural paradox: a five-dome, tetrastyle plan (fig. 24) similar to those found in Venice yet enclosed by weightless planes of the Florentine quattrocento (plate 171).

Seen in light of contemporary church design, its Venetian plan and Tuscan surface elegance look back to an earlier era. This unusual combination can be explained by the history of the project, whose plan had been established prior to the death of its initial architect, Battista Sensi, in late 1553 or early 1554. Much of the original design for Santa Maria Nuova was modelled after the sanctuary church at Mongiovino (plate 172), a small town in Umbria some 35 kilometers south of Cortona. Begun in 1526 by Rocco da Vicenza, a mason and architect originally from the Veneto, this forgotten church was the source for both Sensi's tetrastyle plan (fig. 25) and the repetitive facades begun for each of Santa Maria Nuova's major faces. The differences are minor but revealing: the Mongiovino church is somewhat larger, the proportions of its interior stubby (plate 173), and its main entry is placed on the church's cross axis. This curious feature was dictated by a southerly approach from the nearby village. If this structure provides the necessary link between Santa Maria Nuova and Venetian architecture, Vasari was apparently unaware of this distant though direct connection, mentioning neither the Mongiovino church nor its architect in the *Lives*.

Santa Maria Nuova's three-dimensional appearance is entirely due to Vasari, who had come to Cortona in 1554 to execute frescoes for the Compagnia del Gesù. Within the limitations of the foundations already constructed by Sensi, Vasari was free to modify only the proportions of Santa Maria Nuova's interior and the articulation of its bounding surfaces. The result was a particular emphasis on structural clarity and visual equilibrium. Vasari sought the legibility of mass and surface, an effect entirely different from the emphasis on spatial units found in Venetian architecture. Unlike the Venetian churches of Mauro Codussi (plate 174), where tall piers raised on plinths contribute to their characteristic spaciousness, the corresponding elements in Vasari's design

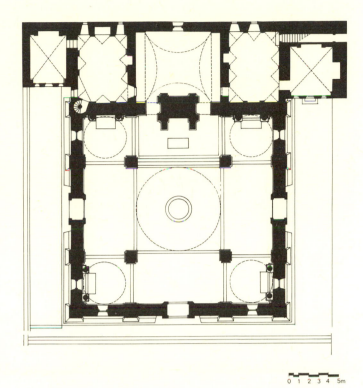

24. Cortona, Santa Maria Nuova, completion by Vasari begun 1554, plan

sit squarely on the ground and give pre-eminence to the crossing. While the elegance of Santa Maria Nuova's interior cannot be faulted, its space is somewhat earthbound and lacks dramatic emphasis; the proportion of wall surface and void is balanced by nearly equal heights on the interior elevations, and the side chapels are granted visual independence without compromising the centrality of the interior. The overall effect of Santa Maria Nuova, then, is closer to those churches deriving from Saint Peter's than any of its Venetian prototypes.

THE PIEVE IN AREZZO

The transformation of Santa Maria Assunta in Arezzo was prompted by Vasari's desire to construct a fitting memorial for his family and himself in the parish where he was born. Commonly known as the Pieve (plate 175), the collegiate church of Vasari's native city enjoyed a prestige second only to that of the Cathedral.[19] Construction of the Romanesque church, which was begun in 1185, was prolonged for several centuries. By the beginning of the sixteenth century deterioration of the church's structural fabric necessitated frequent repairs, and in 1534 profes-

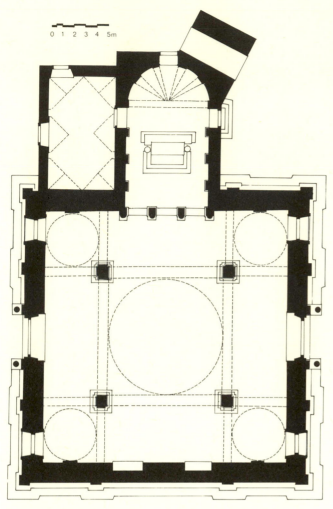

25. Mongiovino, sanctuary church by Rocco da Vicenza, begun 1526, plan

of Lazarus above the altar was a clear allusion to his great-grandfather, the painter Lazzaro Vasari, who stood at the head of the artistic dynasty.

Within a year Vasari proposed a radical plan to transform the disorderly medieval church interior into a single unified space (plate 177).[22] Some changes, like the whitewashing of the columns and walls and the opening of new windows, were merely superficial. Others profoundly altered the relationship between the Church and the faithful. Both the nave and the side aisles were covered by barrel vaults, an arrangement similar to that found in the nearby Cathedral in Cortona and Santa Maria della Querce in Lucignano, a church for which Vasari may have provided a design.[23] The Pieve's raised choir was removed, creating a single level for all liturgical elements in the church (plate 178). The *tramezzo*, or rood screen, separating the choir and altar from the nave was destroyed, thereby allowing the direct participation of the faithful in the Mass. The focal point of the interior was one of Vasari's most remarkable conceptions—a tall, freestanding, double-sided altar that replaced the medieval high altar and served as a shrine commemorating his ancestors and marking his burial place in the choir behind it. The entire arrangement was situated underneath an enormous baldachin whose spirit and scale anticipate Baroque constructions. Within three years, the entire renovation had been completed, and on 25 March 1564, Bernardetto Minerbetti, the Bishop of Arezzo, consecrated the modernized church. The effect must have been startling; the interior of the Pieve was no longer artificially divided, and its tall altar as seen from a distance now had a curiously Gothic effect found in Michelangelo's late works—as if the Porta Pia had been transposed indoors. Giorgio openly boasted about his achievement in a letter to Duke Cosimo:

But the fact that I have razed the wooden choir up front and placed it in back, in the *cappella maggiore* where the voices (in the choir) sound better, has improved (the Pieve) more than anything anyone else has done before. The relocation of the choir has provided more space for the church, commodity for the priests, and has conferred a sense of elegance for this work. The faithful seated in the rows between the columns free up the three aisles, and the entire body assembled in the church sees the raising of the Sacrament without rising from their seats. Previously, on account of the tramezzo and the impediment of the

sional advice on the campanile's statics was sought from Antonio da Sangallo the Younger.[20] However, a comprehensive modernization of the Pieve seems not to have been proposed, regardless of the church's worsening condition.

In October 1559 Vasari proposed the enlargement of his family's small altar in the right-hand aisle of the Pieve (fig. 26). What Vasari envisaged was scarcely different from designs of altarpiece frames commissioned by his patrons. A preparatory drawing for the chapel (plate 176) shows a tripartite composition of motifs derived from Michelangelo, an arrangement that Vasari already had employed for the Mei Chapel in Lucca, and in a more elaborate way, for the Del Monte Chapel.[21] The symbolism of the altarpiece, rather than the surrounding architectural veneer, was the most significant feature of the design; the *Raising*

music stand, one had to twist and turn his head in order to see it.[24]

Vasari's church renovations are customarily explained in light of a single aesthetic conception—the desire for a visually unified religious space.[25] While Vasari certainly admired the visual qualities of Brunelleschi's church interiors (from which the general appearance of his own renovations are ultimately descended), his primary concerns were good acoustics and visibility of the Host at the moment of the consecration of the bread and wine into His Body and Blood. By then the Pieve's retrochoir had become one of the standard forms of church planning, but Vasari certainly understood its dual purposes of musical performance and the recitation of prayers intermittently throughout the day. The use of acoustics to justify the shifting of the choir into a vaulted chamber behind the altar, possibly foreseen in Francesco Zorzi's suggestions for San Francesco della Vigna in Venice, actually worked.[26] Vasari understood empirically that the vaulted, isolated volume of the choir was an efficient shape for the transmission of the human voice, spoken or sung; the hard, smooth surfaces of its architecture created a clear, sustained acoustic satisfactory to Counter Reformation demands for intelligibility in music.[27]

Vasari was already familiar with the problem of refurbishing a medieval church. Upon the prodding of his friend, Bishop Minerbetti, he had prepared a decade earlier several plans for the rearrangement of the high altar and choir in Arezzo Cathedral.[28] The proposals made in 1554 involved the removal of the choir to a position behind the altar, the placement of the Arca di San Donato and a tabernacle or ciborium upon it, and the fabrication of new seats for the choir by Giuliano di Baccio d'Agnolo from a design by Vasari. While the choir seats were in place a year later, the obstinace of the clergy and overseers of the Cathedral, together with the frequent absences of both the bishop and the architect, delayed the project for more than a decade.

Almost certainly the idea for renovating the Cathedral initiated with Minerbetti.[29] Born into a noble Florentine family, he was appointed bishop of Arezzo in 1538, succeeding his uncle Francesco Minerbetti, whose see he finally inherited in 1543. An active reformer in a conservative bishopric, Minerbetti surely would have taken part in the second ses-

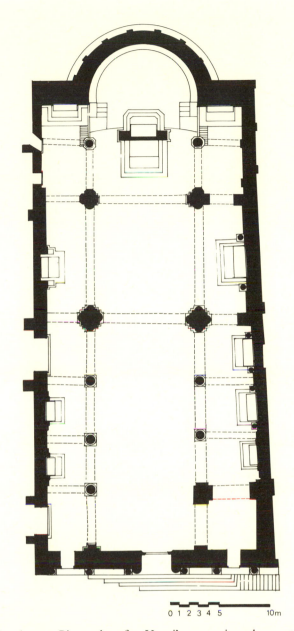

26. Arezzo, Pieve, plan after Vasari's renovations, begun 1560

sion of the Council of Trent had he not been serving Cosimo I as ambassador in Madrid.

Minerbetti's pastoral concerns affected his cliental relationship with Vasari the architect. The advice he freely gave Vasari concerning his private life also extended to his architectural designs. The obsession for the visibility of the Sacrament that pervades Vasari's descriptions of his church renovations may well have originated with the bishop. An exchange of correspondence regarding the arrangement of the altar area in Arezzo's Cathedral illustrates Minerbetti's capacity to give incisive and thoughtful architectural

criticism. In a letter accompanying his designs for the altar, Vasari describes their salient features:

> This (design) would make for the following effects: for one thing, the Sacrament would be isolated for everyone (to see) in the middle of the altar, and for another, the choir which today stands in front of the altar would be placed behind it, which would be good. And the Arca di San Donato would be saved, and the expense would not be great.[30]

But Vasari's professed concern for the Eucharist failed to solve some troublesome problems with the service of the Mass. Minerbetti, ever the professional clergyman, was quick to respond:

> According to my humble judgment, it appears that the altar would be too long and narrow, and this stems from the fact that it has been made a *palmo* less wide than the old one, whereas I would have wanted one a *braccia* and a half less than the one proposed. The base where the angels are placed obstructs the (view from the) two seats of the canons who sit to either side of the bishop. They do not see the elevation of the Host, which is no small problem. And since the canons are in pairs, there are four who would not see it.[31]

Minerbetti's letter concluded with a rough sketch of a polygonal flight of steps allowing both axial and diagonal approaches to the high altar; an axial design, similar to Raphael's steps leading to the altar in his Vatican fresco *Disputa*, was deemed "graceless."

If liturgical considerations motivated the proposed layout of the Cathedral's east end, Vasari's concern for everlasting fame stimulated the design of the Pieve's high altar (plate 179). Anticipating that Cosimo I would never see the altar, Vasari described its features in a letter to his patron.[32] Visible on all four sides, the shrine was in concept a monumental retable nearly 30 feet high. The entire structure sat on a base of five travertine steps, underneath which was a small, stuccoed reliquary chamber containing relics of several saints, including the head of Saint Donato, the patron saint of Arezzo. Small altar tables were placed to either side of the retable, whose triptych-like composition was adorned with figures of saints, virtues, and portraits of members of the Vasari family. The altarpiece facing the choir, *St.*

George Slaying the Dragon, was a direct reference to the patron, as were many of the smaller scenes; the altarpiece facing the nave, *The Calling of Saints Peter and Andrew*, originally commissioned a decade earlier by Pope Julius III for a chapel in the Vatican, was one of the few scenes that contained no outward adulation of Giorgio or his kin.[33]

The funerary monument in the form of a free-standing construction occurred but rarely in the Renaissance. For Vasari and his generation, the indisputable archetype was the tomb of Pope Julius II in St. Peter's. There is an undeniable similarity in concept and proportion and with the upper portion of the 1513 project as illustrated in numerous drawings after Michelangelo's proposal.[34] By adopting its religious imagery and discarding its rich sculptural ornamentation, Vasari's transformation of Michelangelo's idea was now in keeping with the severe architecture of the church renovation. Architectural elements, such as the frames for its paintings or feigned marble in imitation of travertine, have a Michelangelesque pedigree that can be seen in preliminary drawings for the Medici tombs in San Lorenzo.

The free-standing altar, itself a detached rendition of the quattrocento wall tomb, was equally uncommon. Often the need to control access to a retrochoir resulted in the addition of spur walls, thereby compromising the three-dimensional appearance of the retable. The altar constructed by Baccio d'Agnolo in the early sixteenth century under the triumphal arch leading to the choir of Santissima Annunziata, the Servite church in Florence, was perhaps the most readily available prototype. According to tradition, the design was based on a sketch by Leonardo and the retable contained a *Deposition* by Filippino Lippi and an *Assumption* by Perugino.[35] The prestige of this minor construction may be adequately measured by Minerbetti's suggestion that Vasari use it as a model for the completion of the high altar in Arezzo Cathedral.[36]

The solution of combining these two types was suggested by the high altar of Santa Maria dei Servi in Bologna designed by Fra Giovanni Montorsoli (plate 180), the Servite sculptor who was one of the founders of the Accademia del Disegno.[37] The prestigious commission from Giulio Bovio, master of the order to which Montorsoli belonged, could not have been refused by the sculptor despite continual absence from his native Florence. The idea for the pro-

ject apparently originated with Bovio, who seems to have wanted a modern altar along the lines of the one in Santissima Annunziata. Montorsoli's design consists of two separate parts, a free-standing altar suggested by the Florentine example, and an ornate marble pavement in the choir, which served as Bovio's burial chamber. Its resemblance to the Arezzo plan likely was not accidental; Vasari certainly would have heard of Montorsoli's project from Duke Cosimo, who was aware of Montorsoli's desire to return to Florence. When Vasari finally saw Montorsoli's altar in 1566, he reacted equivocally to its overall effect. Hiding his disappointment with the project that had inspired his own creation, Giorgio expressed admiration for its architecture but not its figures, in which he found little praiseworthy.[38]

There were numerous precedents for burial in the pavement nearby a high altar. The most famous, of course, was the tomb of the apostle located under the dome of St. Peter's, but there were others in Tuscany with which Vasari may have been familiar.[39] It was a concern for the artist's status that made Vasari recall aspects of the tomb of Donatello, who was granted a burial plot in San Lorenzo's crypt near that of his patron, Cosimo de' Medici the Elder.[40] In the case of the Arezzo tomb, the artist and members of his family already buried within the Pieve were now reunited in perpetuity, and their eternal fame was celebrated in the religious offices provided for in Vasari's will.[41] In a monument that was both ancient and modern and with explicit recollections of works by Donatello and Michelangelo, the tomb commemorated Vasari as the universal Christian artist.

The ostentatious religiosity of grand altars struck a responsive chord in patrons during the Counter-Reformation era. Vasari's most elaborate design in this genre of church furnishings was the high altar commissioned for Santa Croce in Bosco Marengo, the birthplace of Pope Pius V.[42] At first Vasari's project may have been conceived as a papal tomb, but custom dictated that the remains of the zealous reformer were to be buried in Rome after his death in 1572. It is a bitter irony that the canonization of Pius V provoked the restoration of the church and the destruction in 1710 of the work that characterized his religiosity.[43]

A stunning drawing by Vasari records the altarpiece, the *Last Judgment*, and its architectural frame (plate 181). Its design was an ennobled variant of the Pieve altar, keeping its attenuated proportions while cloaking the retable in a composition derived from Serlio.[44] Yet, unlike Vasari's other altars, its form recalls triumphal arches or city gates rather than any kind of church furnishing. Vasari labeled this elaborate construction a "macchina," implying a theatrical effect related to his own temporary architecture which it resembles.[45] Vasari also provided a near copy of the Aretine altar for the Badia in Florence, a commission that he obtained with the assistance of his friend and collaborator, Don Vincenzo Borghini.[46] And it was equally suitable for wall altars, as in the enframement designed for Mei Chapel in Lucca.[47] The tabernacle of the Camaiani Chapel that formerly stood in the second bay of the Pieve's left aisle was merely a variation on the Vasari altar's elevation removed to the inner wall of the church. Vasari's most demanding critic, Bishop Minerbetti, found it too similar to the main altar.[48]

The vicissitudes of taste that facilitated the Pieve's renovation by Vasari also were responsible for its destruction. The projects for the completion of the facades of Florence Cathedral and Santa Croce, in part stimulated by the desire for national unity in the nineteenth century, brought about a re-awakening of interest in Tuscany's medieval past.[49] While this attitude in Florence resulted in facades modelled on the Arnolfian incrustation of the Cathedral, in Arezzo it accounted for a radical restoration of the Pieve to its supposed original form, begun in 1865 under the patronage of Bishop Giovanni Ristori. In direct response to the visible deterioration of the structure, Vasari's alterations were destroyed, and the entire structure was restored in a cold, medieval style that was the Italian counterpart to Viollet-le-Duc's projects in France. The bishop, who was certainly prejudiced in matters of architectural style, considered the renovated structure an unhappy mixture of styles that led towards the grandiose altar *alla romana*.

One incident recorded in the diary kept by Ristori is instructive of the change in Vasari's reputation. In February the choir was dismantled, and by April workers began to demolish the vaults. Soon the foreman admitted a few Aretines who approved the razing of Vasari's interior to watch the spectacle. When the entire vault had been demolished and the medieval nave fully revealed, those invited "were surprised at the grand magnificence, and they exclaimed in unison 'Oh quanta è bella, oh quanta è bella.'"[50]

THE BADIA OF SAINTS FLORA AND LUCILLA IN AREZZO

Under Cosimo I matters of religious reform were an extension of his political activity. Although he sent several bishops to the Council of Trent, his interest was aroused only when debates touched matters close to his own heart, such as the support of the Cavalieri di Santo Stefano who were meant to protect Tuscany's long coastline from attacks by Moslem pirates. Cosimo was generally in accord with the Council's religious decrees, especially when papal interests coincided with his own.[51] But the reforms that Cosimo put into practice were concerned more with administration than building. If any architectural commissions would reflect the new spirit of the reformed church, they were to originate from sources outside the Medicean court.

Vasari's most important link to the world of monastic reform was his friend and collaborator, Don Vincenzo Borghini.[52] Born into a noble Florentine family, Borghini entered the Florentine Badia, where he first studied Greek and Latin under the tutelage of the monks of the Cassinese congregation of the Benedictine order. Conventual life, however, did not preclude contact with the world outside the monastery. In the late 1530s he traveled to Arezzo, where he likely met Vasari for the first time, and, later, to Rome, Montecassino, and Naples. After his ordination in 1541 in the Badia of Arezzo, Borghini continued to travel widely, attending the annual convocation of the Cassinese congregation at San Benedetto al Po, to which he was briefly assigned.

The Cassinese reflected a long and advanced tradition of monastic reform.[53] In response to the weakened central authority of the Church, monastic discipline was restored by combining asceticism with intensely active religious scholarship.[54] Greek patristic writings were commonly used to define the dilemmas of Western Christendom. The new order was highly pietistic, and each monk had his own cell where he followed a "devotio moderna" rooted in the religious mysticism of the Middle Ages. Separation from public life was considered absolutely necessary, although restrictions governing the temporal activities of monks were later relaxed. Material wealth accompanied spiritual enrichment, in no small part due to the number of patrician families who were recruited for the order. The centralization of power within the Cassinese institutional structure was reflected in its finances, for the property and wealth of individual monasteries was considered to be at the service of the entire congregation.

Despite their immense wealth, the Cassinese took a sensible attitude towards new construction. Churches were built anew only when previous structures were inadequate in size or in poor repair, and in many instances extant structures were only renovated or adapted. The depopulation of monasteries prior to Barbo's reforms resulted in the serious dilapidation of conventual buildings, which, on the whole, preceded the churches in their renovation. Because of the emphasis on concentration and silence within the seclusion of the cloister, the church was in spiritual terms less important than the monastery as a whole. In sharp contrast to the Jesuits, who sought to reform society through effective preaching, the Cassinese (who never established permanent pulpits in their churches) were devoted to reform within the institution of the Church.

Annual meetings where major issues affecting the order were discussed gave the Cassinese a sense of identity and unity. No new construction could be undertaken without the approval of a majority of the order's deputies, who reviewed proposed designs. The process fostered both tradition and diversity. Judging from the evidence of the earliest designs, the variety of plans and structural systems was due to the preferences of the local architects employed by the individual monasteries. Their only common feature, a longitudinal plan with a trilobed presbytery, was due to the tenacious survival of Lombard Romanesque church types in Northern Italy rather than to any interference on the part of the order.

Vasari obtained the commission for the complete reconstruction of the Badia of Saints Flora and Lucilla in Arezzo, one of the most important monastic projects in Tuscany during the ducal era (plate 182). There can be no doubt that this involved Borghini's assistance, as the Badia was a member of the Cassinese congregation. Plans drawn up in 1565 provided for the complete reconstruction of the existing thirteenth-century church.[55] They called for the destruction of the older building, an aisleless, box-like structure similar to nearby San Francesco, famous for Piero della Francesca's frescoes in its sanctuary recounting the *Legend of the True Cross*.[56] The outline of the older church can be read in the nave and right-hand aisle of Vasari's design, and the existing facade determined the length of the new structure. From the

outset Vasari must have been aware of the financial limitations of his clients; the Cassinese in Tuscany were less well-endowed with material goods than sister institutions.[57] A continual lack of funds may explain why Vasari never bothered to provide a design for the facade of the church, despite its prominent location on a small square. Already plagued by shoddy craftsmanship on the part of stonecutters, construction was slow and prolonged due to a continual lack of funds. Anticipating the worst in an already troublesome situation, Vasari failed to mention the Badia's renovation in his autobiography in the *Lives*. Construction dragged on intermittently for several decades. A report written in 1650 for Pope Innocent X noted that the church lacked a facade and one of its domes, roughly the same condition seen today.[58]

As if to compensate for the monotony of an uneventful exterior, Vasari created a spacious interior (plate 183) based on the contrast of different vault forms. The dramatic effect of alternating barrel vaults and domes along the main axis is the consequence of a syncopated plan (fig. 27) that fuses two cross-domed units. The axial thrust towards the high altar is counterbalanced first by transverse vaults and then by smaller vaults opening off the main chapels in the twin transepts. Along the side aisles gigantic serliana motifs redirect movement towards the high altar. Each serliana serves as a facade for a three-bay chapel that is a discreet entity with its own oval dome and barrel vaults, a representation in miniature of the architectural system of the church. Both the stark simplicity of the Tuscan columns and minor details such as the removal of the frieze in the entablature contribute to a surprising effect of grandeur in this comparatively small structure. In deference to the rest of the church, the tribune was modest in design, housing the main altar and a vaulted retrochoir. The transferral of the Vasari altar in 1865 from the Pieve to the Badia finally gave the rhythmic nave the terminating feature that it had lacked.

Vasari's selection of a syncopated plan can be explained in two ways. The first focuses on the impact of contemporary publications in architectural theory, a form of discourse that did not directly discuss issues of church planning. The cross-domed units to which rectangular side chapels and a retrochoir are appended bear a close resemblance to the plan of a *Templum Etruscum* illustrated in Cosimo Bartoli's translation of Alberti's *De re aedificatoria* (plate 184).

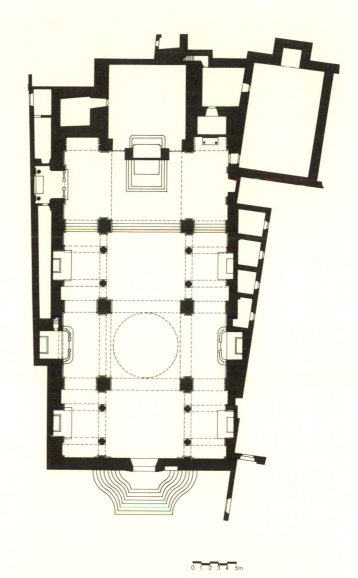

27. Arezzo, Badia, renovation by Vasari begun 1565, plan

Familiar with the text of this treatise from his experiences at the Villa Giulia and Castello, Vasari now turned to a free rendition of Alberti's already corrupt translation.[59] The lack of vaults or a dome mattered little to the Badia's architect; it was the weight of historical tradition that made a syncopated plan fitting for a town whose Etruscan beginnings were familiar to Vasari.

The second explanation involves the derivation of the Badia's layout from the Byzantine revival churches of Venice. Already in the fifteenth century the Carthusians had adopted the cross-domed plan for San Andrea della Certosa, but its isolated location on an island in the Venetian lagoon near the outlet of the Bacino to the Adriatic may have limited its familiarity to architects and churchmen.[60] San Salvatore, on the other hand, had a prominent site in

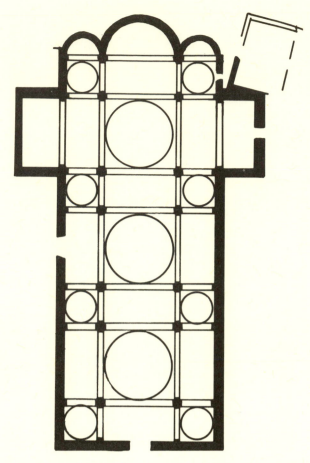

28. Venice, San Salvatore by Spavento, begun 1526, plan

the heart of the commercial district near the Rialto bridge and thus was accessible to all.[61] With its grand syncopated interior (plate 185) begun by Giorgio Spavento in 1506, San Salvatore was in the early sixteenth century the most impressive Venetian Church after San Marco, from which its plan was derived (fig. 28). Coming shortly after the fall of Lepanto to the Turks and the circumnavigation of the Cape of Good Hope by the Portuguese, and a few years before the War of the League of Cambrai, San Salvatore maintained the myth of Venice as the head of a Christian Empire. Curiously Vasari failed to mention San Salvatore in the *Lives*, although it was by far the most notable sixteenth-century church that he would have seen during his visits to the city of Titian, Tintoretto, and Sansovino.

The Byzantine architectural revival soon was fused with a tradition established by the Cassinese in the design of their churches. Beginning with the abbey church at Praglia, the polycentric plan was employed in several notable Cassinese churches.[62] By far the most innovative design of this period was San Be-

nedetto in Ferrara (fig. 29), designed in 1510 by Biagio Rossetti.[63] Crossing the spatial variety of the syncopated plan with Tuscan sobriety in its articulation, San Benedetto paved the way for the more complex design of Santa Giustina in Padua (fig. 30), the mother house of the order.[64] Its most striking feature—an extended chancel behind the high altar taken from the repertory of Venetian quattrocento architecture—reflected the Cassinese's concern for music (plate 186). Barbo, who was convinced by the need for a dignified liturgy enriched with music, called for prayers and hymns to be sung in unison.[65] Neophytes were trained in music, and compositions for religious ceremonies were written by members of the order. The retrochoir, a form that was taken up by Palladio in the plan of San Giorgio Maggiore in Venice, was admirably suited for projecting singing into the church. Although some chapters condemned polyphonic singing and the use of organ accompaniment, such bans remained ineffectual, as is shown by the prominence given to the king of instruments in San Giorgio and elsewhere.

One other point is specifically relevant in this situation. Although there were precedents in Tuscany for employing the serliana in ecclesiastical structures, the Badia's interior was largely an appeal to Cassinese taste.[66] Of all Cassinese projects, Giulio Romano's design for San Benedetto al Po outside Mantua (plate 187) was by far the most significant for the Badia. The monastery was almost always the site of the congregation's annual meeting, and the renovations made to its church from 1540 on must have greatly impressed the numerous abbots who stayed there. The project must have also been considered magnificent by Vasari and Borghini, who had seen San Benedetto al Po in the 1540s. In preparation for the second edition of the *Lives*, it was with considerable pleasure and affection that Vasari revisited the monastery again in 1566.[67] Travelling with the Badia's abbot for part of the second journey, Vasari would have had ample time to discuss the design of the new church.[68]

The main embellishment to San Benedetto al Po's interior was a gigantic serliana that screens the side aisles and chapels from the renovated late Gothic nave (plate 188). The chief architectural virtue of this motif was its flexibility in adapting to the circumstantial conditions found in the modernization of any older building. By inserting the serliana into bays flanked by raised Corinthian pilasters Giulio

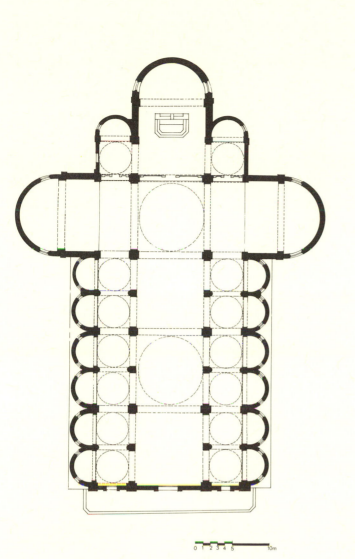

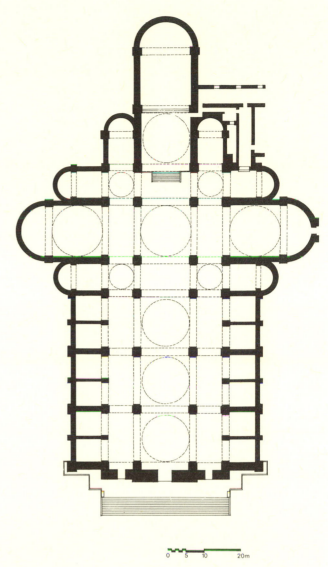

29. Ferrara, San Benedetto by Biagio Rosetti, begun 1510, plan

30. Padua, Santa Giustina by A. Moroni and A. della Valle, begun 1532 .

cleverly disguised the considerable irregularities in the church's plan. The repetition of the serliana theme in the interior of the side aisles and again on the exterior also suggested a kind of uniformity to the church's layout that did not exist in fact. Just as he had done previously at the Palazzo del Te, the renovation reveals how Giulio could turn a physical constraint into an expressive form.

Building on these sources, Vasari created a design that was intellectually interesting but unsatisfactory in overall effect. Somehow the distinctive spatial quality of the Byzantine revival churches were lost. Unlike San Salvatore or Santa Giustina (plate 189), where the tall proportions of the interior contribute to the effects of transparency and airiness, the Badia

is squat and earthbound (plate 190). Nor is the nave organic in the unity of its parts; the Tuscan emphasis on planes demonstrates how Vasari considered each spatial unit in the Badia's nave separately. Vasari's approach also alters the whole character of Giulio's design by abandoning its serial quality and treating it as an isolated element in the nave, thereby creating a staccato rhythm articulated by a Doric order of extreme and uncompromising severity. At the Badia, the wall surface has become pre-eminent, creating a passive relationship between space and solid. The present low level of illumination would have been greatly improved if Vasari had sought to solve the problem inherent with the adjacent cloister, which blocks direct light from the south.

The Badia was too deeply rooted in intellectual questions to be satisfying in architectural terms. Its rarified atmosphere lacks the sense of exhilaration and wonderment found in Palladio's church interiors, and its grandeur seems artificial when compared to Vignola's Gesù. If these factors make the Badia an equivocal work of art, it is by no means an unsuccessful design. Vasari seems to have tried to make the nave a monumental, clearly distinguished space as in other contemporary churches. Vasari's architectural ingenuity is best expressed in its plan, which is clearly adapted to the Badia's constrained, urban site bounded by the existence of a major street on one side and the monastery on the other. The attention to the historical context of the commission was unprecedented. The dilemma facing Vasari was the need for historical conformity in architecture, a predicament scarcely different from that illustrated by the medievalizing frame attributed to him that surrounds the Cimabue drawing in his *Libro dei Disegni*.[69]

Also to be considered is Borghini's role in the Badia's design. Combining a vast knowledge of humanistic studies with a keen appreciation for the visual arts, Borghini participated in the design of Vasari's decorations in the Palazzo Vecchio and other projects.[70] The working relationship between them involved the mutual exchange of drawings and the offer of criticism and corrections. On architectural matters Vasari was more knowledgeable and his judgments were more sophisticated. Borghini's drawings of architectural subjects are schematic in comparison to those of Vasari that have survived. Borghini's opinion of Santo Spirito as "magnificent and beautiful" was merely conventional, and his preference for the longitudinal plan as appropriate for Catholic services was commonly held by most churchmen.[71] While documents show that from the outset Borghini collaborated on the preparation of the design and served as arbitrator between architect and client, both he and Vasari contributed within their own spheres of activity. As a member of the Cassinese congregation, Borghini was aware of the Venetian origins of his order as well as their programmatic concerns regarding a church's layout. It seems likely that Borghini contributed the note of self-conscious Byzantinism in the Badia.[72]

Eventually these concerns for an expression of the Cassinese's history intersected with Vasari's approach to medieval architecture in the *Lives*. Lacking a consistent critical terminology for discussing non-classical, pre-Gothic architecture, Vasari categorized both Byzantine and Romanesque structures as Gothic or as examples of the "maniera greca."[73] Within this broad category of buildings, stylistically unrelated monuments like San Marco in Venice and Santi Apostoli in Florence were warmly praised for their grace and proportion; in contrast, the major monuments in Ravenna were "grand and magnificent, but designed in a clumsy kind of architecture."[74] Among the most prominent examples in Tuscany were the seven churches created at the end of the ninth century by Count Ugo of Brandenburg, of which the original Badia of Arezzo was one. It must have mattered little to Vasari that he lacked the visual evidence to support his claims about the "maniera greca" in the *Lives*, as only one of the original churches was standing in his lifetime. Thus the problem at hand was how to design a new building for a church so closely associated with the "maniera greca," the only solution to which was to build in a modern reinterpretation of the original style. No doubt Vasari's knowledge of the Cassinese's origins, which he must have learned from his collaborator, pointed towards a solution decidedly more Venetian and less Tuscan in its sources.

The great sixteenth-century Cassinese churches in Italy were built at a moment when the order's power had already begun to decline. Its sense of spirituality was confused because the order was divided by a challenge to the old scholarly piety coming from forms of devotion that the Cassinese themselves deemed heretical.[75] Although its wealth and the sense of obedience to the order as a whole remained untouched by theological controversy, the focus on monastic activities within the cloister was now less relevant to contemporary society than the activities of preaching or missionary orders. As one scholar has put it, the Cassinese "found themselves out in the cold, and their teachings (were) now rejected."[76] The order had become old-fashioned and out-of-date, and, consequentially, so had the Badia's architecture.

THE FLORENTINE CHURCH RENOVATIONS

Vasari's renovations of Santa Maria Novella (plate 191) and Santa Croce (plate 192) in Florence are his

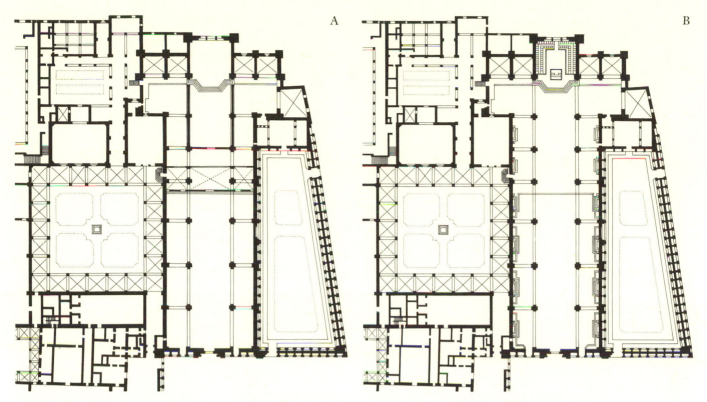

31. Florence, Santa Maria Novella. A: Plan with *ponte*. B: Plan with Vasari's altars after renovation begun 1565

most significant contributions to religious architecture.[77] Conceived in the mid 1560s and executed over the following two decades, the new interiors of Florence's largest monastic churches were composed of unbroken naves and unified side aisles containing altars, each in the form of a large tabernacle containing an altarpiece by Vasari or a member of his school. The motivations behind the renovations fully accorded with the religious practices promoted during the "Catholic Reform" and codified by the Council of Trent: visual unity, direct involvement of laity in the Mass, and accessibility of sacred images. The changes were so convincing that their architectural spaciousness has come to characterize the original condition of Gothic churches in Tuscany before their subsequent transformations.

The original appearance of the interiors of Santa Maria Novella and Santa Croce has been shown to have been otherwise.[78] Prior to Vasari's renovations, their naves were radically different from the open spaces seen today. Numerous and diverse family chapels occupied the side aisles. In both churches, tall, deep, vaulted structures physically divided the nave into separate zones for the clergy and for the faithful, thereby obstructing a full view of the tribune. In

Santa Maria Novella, the "*ponte*," as the structure was known for its bridge-like appearance, created a wall about 14 feet high and 26 feet deep that began ahead of the fifth bay (fig. 31). The *tramezzo* in Santa Croce, also located in the fifth bay, was a considerably more elaborate structure (fig. 32). Adorned with elaborately decorated trefoils and gables at its apex approximately 50 feet above the nave, the *tramezzo* also contained a private family chapel and, on its second level, the church's organ. In design it resembled a screen of Gothic wall chapels or tabernacles akin to those on the exterior of Orsanmichele (plate 193). While the primary purpose of such constructions was the isolation of the clergy from the laity, they performed several other functions. In Santa Croce the *tramezzo* supported a pulpit from which the gospels were read on high feast days, and in both clausura was maintained by providing direct access to the cloisters without encountering the faithful. The rood screens also may have served to segregate those present according to gender, as women were customarily denied access to the area surrounding the choir.

The modernization of the two great Florentine churches owed much to Vasari's earlier moderniza-

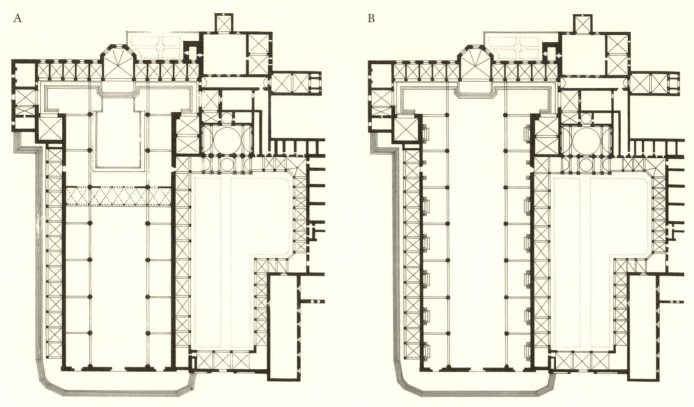

A

B

32. Florence, Santa Croce. A: Plan with *Tramezzo*. B: Plan with Vasari's altars after renovation begun 1566

tion of the Pieve in Arezzo. However, the Pieve's side aisles were not originally part of Vasari's renovation; the heterogeneous altars added after its completion gave the project a somewhat disorderly appearance. In Florence, the design of the interior sustained movement towards the high altar as demanded by the great lengths of their plans of Cistercian derivation. But the unprecedented vast scale of the open interior failed to silence criticism. A modern layout had its price in spite of praise lavished on it by contemporary writers. The exposed high altar disturbed both the monks, who were forced to sacrifice participation in the Eucharist, and some of the laity, who only begrudgingly accepted group prayer at the expense of customary private devotions in the chapels.[79]

The aedicular chapels in the side aisles were the elements that distinguished Vasari's renovations from the medieval contexts in which they were placed. In Santa Maria Novella the architectural enframement of the altarpieces consisted of two superimposed tabernacles: a conventional curved pediment supported by a pulvinated entablature and alternating reverse-tapered pilasters and half columns forming the outer enclosure, and an inner one

of alternating broken or segmental pediments above the picture frame (plate 194). The system is broken only in the fifth bay in response to the wall-mounted organ. By employing superimposed pediments similar to the doorway to the reading room of the Laurentian Library, Vasari gave the design a Michelangelesque vigor (plate 195). As a whole the chapels represent a calculated attempt to animate the interior walls by the application of a complex pattern of architectural texture, thereby creating an unexpected tension between the Michelangelesque tabernacles and the Gothic ribs and composite piers in the nave. Sadly, the tabernacles designed by Vasari were removed in the 1860s and replaced by the cold and uninspired Gothic Revival frames seen today.

The forms of the altars in Santa Croce represent an equally sensitive response by Vasari to the surrounding architecture (plate 196). Conceived fully in three dimensions and conveying a sense of scale appropriate to the vast interior of the church, the freestanding Corinthian columns that support the alternating pediments are set squarely on the floor. Emphasizing mass and volume, the tabernacles in Santa Croce convey a sculptural quality that harmonizes with the blunt polygonal columns of the individual bays.

Seemingly their effect is more classical than that achieved by the tabernacles in Santa Maria Novella; this is due to its compatible relation to the gravity and poise of Santa Croce's nave. With their roots in the aedicular tabernacles of the Pantheon (plate 197), the tabernacle altars in Santa Croce are, in a certain sense, just as indebted to the architecture of ancient Rome as are the interiors of Palladio's churches. The isolation of the Santa Croce altars would have been mitigated by a continuous fictive entablature to link the boldly projecting pediments, a solution already employed by Raphael in the Palazzo Pandolfini and similar to the unexecuted scheme for the modernization of the Palazzo Vecchio courtyard proposed by Vasari only a year earlier.[80] The interiors of Florence's greatest monastic institutions, as well as their secular counterparts, the renovated chambers of the Palazzo Vecchio, share a contemporary, up-to-date architectural style that extended across the city of Florence.

The dissimilar architectural forms of the altars in both churches have raised questions of their authorship. In Santa Croce Vasari entrusted the design and supervision of the chapels to the elderly Francesco da Sangallo, the last Florentine survivor of the generation of Bramante and Raphael. Vasari himself acknowledged this point in the documentation by stating that both he and Francesco had designed the chapels.[81] In spite of the weight of the evidence, the actual division of responsibility between the architects is still open to conjecture. As in Vasari's other architectural collaborations, it is likely that Vasari maintained overall responsibility for the project, suggested the chapels' overall forms, or even specified their details to Francesco. For all one knows, Francesco must have felt embittered for having been snubbed by Vasari and Cosimo on the Uffizi, and that his claim of authorship of the Santa Croce tabernacles was in part colored by the desire for revenge.

The Florentine renovations are part of the broad tradition of unobstructed interiors that emerged during the sixteenth century. The motivations behind the projects varied in nearly every case, thereby ensuring considerable variety in both remodelled and new churches. Peruzzi's designs for the reconstruction of the nave of San Domenico in Siena (plate 198) are often compared with Vasari's projects on account of their common use of altar tabernacles that contain paintings of the same size.[82] In Rome, the necessity of providing visibility for the funerary monuments of Leo X and Clement VII in Santa Maria sopra Minerva helped to bring about the construction of a new retrochoir, rendering the church "open and spacious," as it was described by a cardinal in a letter.[83] More often the new open spaces were justified because they facilitated prayer in common instead of private devotion. In Mantua, Cardinal Ercole Gonzaga sought the assistance of Giulio Romano in the renovation of the cathedral, "a structure so badly constructed that very few people can hear, let alone see, when the divine offices are celebrated."[84] While no project other than that of Giulio sought to deliberately evoke the Early Christian architecture of Constantine's St. Peter's, features drawn from medieval churches were common.[85] When Vasari was at work in Rome during the early 1550s, Nanni di Baccio Bigio had prepared his architecturally uninspiring proposal for the Gesù which, like Santa Croce, would have required a wooden roof over its broad, open nave.[86]

The Florentine renovations are linked to reforms in northern Italy as well. The Franciscans at San Angelo in Milan constructed their new church with the familiar retrochoir and visually unimpeded nave a full decade before their church in Florence.[87] The concern for the full development of the tribune and the clear separation of liturgical functions appears in somewhat different form in Galeazzo Alessi's Santi Paolo e Barnaba in Milan, and the design of the naves with a regard for amplitude, illumination, and the logical arrangement of its chapels is characteristic of Palladio's San Giorgio Maggiore. But to what extent would Vasari have been swayed by the precedent of earlier projects? Vasari was aware of their eminence, but he was unlikely to have been inspired by any or all of the aforementioned examples. The emerging tradition of open planning in church design was just simply too strong and too well established to ignore. If Vasari had been asked in 1565 to propose alternative architectural solutions to the Florentine renovations, he surely would have considered that there were none.

To treat the issue of church renovation purely as an aspect of the Counter-Reformation is to deny the specifically Florentine context of Vasari's projects. The austere articulation and luminous naves of Michelozzo's Santissima Annunziata or Giuliano da Sangallo's Cestello, two church interiors once divided by *tramezzi*, are the quattrocento counterparts to Vasari's projects.[88] But Vasari categorically re-

jected their aisleless, box-like spaces on practical grounds. Modifications requiring new vaults, ceilings, or walls were both strategically impractical and financially extravagant in Santa Maria Novella or Santa Croce. The consequence of those constraints was the return to medieval types like San Francesco in Arezzo (plate 199) or the Carmine in Florence where the naves were lined by altars surmounted by Gothic baldachins.[89]

There were also precedents for Medicean patronage in the renovation of church interiors. The notion of modernizing an entire monastery dates back to the projects executed by Michelozzo for Cosimo the Elder at San Marco. The acquisition of the rights to the main chapel facilitated the enlargement of the choir chapel, but disagreement with the monks of San Marco and the patrons who considered family chapels as private property prevented any major work in the nave.[90] Tinkering with the church's appearance continued into the following century. Nothing came of the comprehensive proposals for the rebuilding of the church made by Baccio d'Agnolo in 1512, save, perhaps, for the whitewashing of the church five years later. Additional plans for rebuilding the monastic church were prepared by Antonio da Sangallo the Younger in the 1530s, but once again nothing was built. By 1563, the nave required attention once more, resulting this time in the rearrangement of the altars in the nave, the renewal of its ornamentation, and the destruction of a wall built in the quattrocento that served to segregate the faithful according to gender.[91] Unquestionably Duke Cosimo wished to avoid the haphazard planning that characterized the work at San Marco.

Circumstances of patronage distinguish the Florentine church renovations from projects like the Gesù in Rome or San Giorgio Maggiore in Venice. Under the Medici, the largest churches in Florence functioned partly as churches of state and partly as public mausolea in addition to their established monastic uses. Until the 1560s religious architecture mattered little to Duke Cosimo. The compelling need for the creation of a new center for the court and for the administration of his state logically gave precedence to the construction of the Uffizi and the renovations of the Palazzo Vecchio. But Cosimo's avowed desire for the grand-ducal crown meant that he had to demonstrate the qualities of a Christian prince in the eyes of the pope as well as those of a secular leader in the minds of European heads of state. Indirectly a new importance was given to churches as a result of these goals. Beginning in June 1565, the interior of Florence Cathedral was whitewashed in preparation for the Mass sung on the following 18 December in celebration of the wedding of Prince Francesco to Princess Johanna of Austria.[92] At the same time, Cosimo was seeking to convince Antonio Altoviti to return to his bishopric in Florence, an overt action by Cosimo to gain the favor of the papacy. Given the climate of eucharistic devotion already present in Florence, it is completely plausible that the removal of medieval rood screens and the transfer of choirs in the renovations of Santa Maria Novella (begun October 1565), Santa Croce (begun late 1565), Ognissanti (begun 1566), or the Carmine (planning begun December 1566) were to no small degree motivated by both Cosimo's personal political ambitions and the anticipation of a reforming archbishop.[93] In the case of Santa Maria Novella, there was opposition from some members of the Dominican order, who were under the impression that the renewal was done under Cosimo's orders and that similar projects were anticipated for the main churches of the quarters of Florence.[94] Active sponsorship of the church renovations was one of the prices Cosimo had to pay for the political status that he desired so strongly.

The renovation of Santa Croce is inevitably linked to its function as the location of Michelangelo's tomb.[95] The death of Michelangelo in Rome on 18 February 1564 came as no surprise to his friends and associates, and preparations began almost immediately for the removal of his body to Florence and a solemn commemorative service in San Lorenzo. The selection of Santa Croce as a final resting place had been purportedly made by Michelangelo himself, although there is no evidence that the great artist had planned—let alone desired—a monumental tomb of the kind his friends sought to erect for him. Conceived by Borghini and executed to Vasari's design, the monument has found few admirers. But it was not without effect on the later renovation of Santa Croce. That the church served as a mausoleum for Florentine worthies including Michelangelo made the aedicules designed by Vasari and Franceso Sangallo especially appropriate in terms of their orthodox decorum. The allusions to the Pantheon contained in their design were also fitting because of the tomb of Raphael which lay within it. This experience must have suggested to both Cosimo and Vasari the

potential for a unified interior and the necessity of strict artistic control by the patron and his delegate. Above all, it must have reinforced their resolve to proceed with its implementation.

Whatever the precise impetus behind the renovations, a new and different kind of religious space was created. Its purposes were sacramental and eucharistic rather than simply liturgical, concerns that were embodied in the ciborium designed by Vasari and other collaborators for the high altar of Santa Croce.[96] The removal of the *tramezzo* had given the altar visibility but left it without a focal point, and on 21 July 1566 the *operai* of Santa Croce wrote to Cosimo suggesting that a ciborium or a great crucifix be placed on its table. It is hardly conceivable that something along these lines was not planned at the outset, and by 7 April 1569 the ciborium was in place. In scale and size, the ciborium is a work of architecture in its own right.

Vasari's design for the ciborium was clearly motivated by a concern for its visibility and compatibility with the tabernacles (plate 200). At first Vasari proposed a tall octagonal object that immediately recalled the form of a centrally planned temple. Above its octagonal base, tall plinths supported columnar aedicule with broken pediments; consoles bolstered the ciborium's drum, a balustrade was to ring the dome, and buttresses braced the lantern. But there was something alien to the renovation in its fussy design that minimized the impact of its scale. As executed, the ciborium layout is closer to a Greek cross and therefore more compact; its extraneous pediments, balustrades, and consoles have been eliminated, and the crisp detailing is congenial to the renovation as a whole. Static in its formal sobriety and isolated from surrounding architecture, it is the spiritual climax to the aesthetic journey planned by Vasari.

The ciborium (plate 201) gave a new dimension to Santa Croce in terms of its visual and spiritual impact. Originally it sheltered a sculpted figure of the Redeemer visible through the opened central portal. With its inlaid wood throughout, painted scenes from the Old Testament in the lunettes on each of its four faces, and gold leaf on its base, columns, dome, and lantern, it was the architectural complement to the austerity of the whitewashed nave and the locus of spiritual enlightenment. Religiosity aside, there is something curiously pictorial about this concept, as if the presentation of the Host in the *Disputa*, Raphael's fresco in the Vatican stanze, were now transposed into architecture. Vasari's deeply felt words about the *Disputa* have a direct relevance for understanding the interior of Santa Croce; the revealing of "all the clemency and devoutness that Divinity can show to mortal men through the medium of painting" is now expressed in building.[97] The transcendental effect of the renovation was lost when the ciborium was moved in 1869 and can be recaptured only in engravings and selected old photographs.[98]

There is no clear-cut evidence indicating the respective roles of Vasari, Duke Cosimo, or an ecclesiastical advisor like Vincenzo Borghini in the conception and development of these grandiose renovations.[99] Cosimo had the most to gain in terms of prestige from their execution, and blandishment was given by Vasari in his Solomonic allusion to Cosimo's support for these projects.[100] Like the renovations themselves, this form of princely glorification was meant to secure support for the grand-ducal crown from the papacy and confirm Cosimo's reputation as a worthy Christian monarch. But it was Vasari, fresh from the completion of the Pieve in Arezzo, who had already formulated the architectural solutions to the problem of refurbishing the two churches. In the end, their success can be measured by their impact on similar reconstructions of Santa Trinita in Florence, on the Cathedral in Arezzo, and on numerous smaller projects throughout all of Tuscany.[101]

Ephemera

Gardens, Temporary Constructions, and the Myth of Medicean Magnificence

Vasari's reputation as an architect has been shaped by the buildings he designed during two phases of professional activity: the short but intense period in Rome during the papacy of Julius III, and, to a much greater degree, the years spent in Florence at the service of Cosimo I. This picture is based largely on the survival of structures that have remained in use to this present day and whose importance remains undiminished. Nevertheless, the picture is incomplete and fails to indicate the wide range of artistic challenges that he faced throughout his career. Over the course of forty years Vasari had the opportunity to design, decorate, or supervise the execution of numerous examples of temporary architecture that are no longer extant. Known only from drawings or Vasari's own descriptions in the *Lives* or his letters, these projects were essential obligations of a court architect who was charged with giving form to the myth of Medicean magnificence.

Festive processions were key elements in pageantry and politics during the Renaissance. In Italy, solemn entries were rare until the end of the fifteenth century, when a succession of invasions pulled independent city-states and duchies into the theater of European diplomacy.[1] The pageants of Vasari's era sought to convey the greatness of a state to its absentee rulers, allies, or protectors. As sanctioned by the triumphal returns of Roman emperors in antiquity, the ceremonial entry involved the preparation of temporary constructions drawn from the repertory of Imperial monuments—triumphal arches, statuary, inscriptions, columns, and other elaborate displays of architectural elements—which were disposed along the march of the progress. The scale of the endeavor necessitated collaboration, not just between artists but also with literati who selected the historical events or mythological themes, occasionally so recondite that they were beyond the comprehension of most individuals. The cost of mounting such an extravagant display of hospitality could equal or exceed the cost of a building. By definition, temporary architecture serves a transient purpose and is not meant to last. Although there is no evidence indicating how long the decorations stayed up, it is reasonable to think that most constructions, like modern exhibition pavilions, were used for single events and were demolished shortly afterwards.

The architectural principles behind temporary

constructions, if never written down in the form of treatises, were remarkably consistent in the application of a formal and iconographical vocabulary, which was invariably that of Imperial Rome. The primary criterion was the visibility of the decorations. This required an unimpeded view of the monument, which was to be seen along an axial perspective and was designed to complement the architectural features of a prominent location where public officials and citizens would congregate. Second, the length of the progress was less important than the concern for continuous movement along streets that were both wide and straight, thereby contributing to the visibility of the decorations and ease of passage for a train of individuals, carts, and horses that sometimes numbered into the thousands; if not the shortest route to the destination, it was by far the easiest route, a path that logically was comprised of major thoroughfares from city gates. Finally it was planned for greatest effect. The wooden structure, stucco surfaces, and painted or gilt decorations of most temporary architecture was relatively simple in terms of construction and could be put up in a short period of time; they were also sufficiently flexible in accommodating inevitable irregularities in siting. The progress also required a staging point some distance from the city where all of its participants could assemble and the principal guest and his retinue could be refreshed from their journey and housed overnight.[2] In Florence this was usually one of the Medicean villas or the Certosa at Galluzzo, depending upon the direction from which any party approached the city. On the appointed day, the progress typically would depart in the late afternoon, allowing sufficient time to observe and appreciate the temporary decorations. The entourage would then arrive at the final destination at sunset, permitting the guest to disappear within a structure especially decorated and prepared for him, to the wonder and amazement of all present.

The increasingly frequent reliance on temporary structures for political purposes coincides with the emergence of Emperor Charles V of Spain, a ruler with pretensions to universal rule.[3] By inheritance, marriage, and alliance, Charles V was able to shape a new empire that included nearly half of Europe, and by acquisition of silver from his dominions in the New World he amassed wealth that was dissipated on the suppression of heresy and revolt in Germany and struggles with France and the Turks. What matters in the context of temporary architecture is that Charles V was an absentee sovereign who, during his forty years as king, spent only seventeen in Spain. Ideologically, the formal repertory of classical antiquity could be legitimately applied to the imperial ambitions of Charles V, and his constant travel—including seven visits to Italy—guaranteed the supranational character of his rule. The receptions and processions accorded this itinerant monarch were important manifestations of a presumed imperial destiny, a point upon which the ambitions of Charles V and the education of the young Vasari intersect.

THE CORONATION OF CHARLES V IN BOLOGNA (1530)

Vasari was present in Bologna for the imperial coronation of Charles V on 24 February 1530. Over the course of five months there were four separate processions and two ceremonies of coronation, whose planning was largely the responsibility of papal officials.[4] Pope Clement VII, who entered Bologna on 24 October 1529, and Charles V, who arrived a week later on 5 November, were given triumphal processions along the different paths that led to their lodgings in the Palazzo Communale. In each instance the temporary architecture consisted of three triumphal arches; the structures erected for the pope were decorated with biblical and Christian themes exalting the power of the Holy See and Old Testament precedents for the forthcoming coronation, while those seen by Charles V were more classical in content, alluding to the power and dominion of the Empire.

If the triumphal arches were a logical choice for a papal or imperial progress, they also contributed to the notion that Bologna had suddenly become another Rome. Despite urging from the pope, Charles V adamantly refused to be crowned in St. Peter's. In order to satisfy ritual and ceremonial procedures, the Palazzo Communale and San Petronio became the Vatican, and San Domenico served as the San Giovanni in Laterano, the cathedral of Rome. The symbolic resemblance was carried further by a mock consistory hall constructed in the piazza before San Petronio and the reworking of its chapels and crossing to resemble those of St. Peter's. If the driving conceit behind the decorations was to recreate in ephemeral form the topography of papal Rome, this idea did not extend to the arches and their architec-

ture. No evidence exists connecting them by design or symbol to specific triumphal arches in Rome. In fact, the Doric order employed on the Bolognese arches was probably selected for its allusions to strength and power, an association shared by many who wrote on the architectural orders, including Vasari. In a world where power was apprehended in visual terms, symbols mattered more than fidelity to ancient models.

The impressionable, eighteen year-old Vasari saw little, if any, of the grand state occasion first-hand. There is no account of the spectacle in the *Lives*, nor is there any evidence that the youthful painter from Arezzo met Titian or Parmigianino who were present at the coronation. It appears that he spent just enough time in Bologna to obtain work painting triumphal arches that were being decorated for the coronation. The initial coronation took place in a private ceremony on February 22 in the chapel of the Palazzo Communale. Two days later the pope, the emperor, eighteen cardinals, and numerous attendants drawn from Italian nobility passed along an open raised walkway into San Petronio for the official investiture. Vasari was probably among the thousands massed in the Piazza Maggiore who witnessed the procession. It is highly unlikely that his status permitted him to attend the ceremony inside the church; the depiction of it that he later painted inside the Palazzo Vecchio in Florence was more likely drawn in part from familiarity with the setting as seen after the ceremony, and in part from one or more of the many printed descriptions that were issued throughout Europe in several languages.

After the coronation, Charles V and Clement VII proceeded along a route to San Domenico evoking the *via papalis*, the route from the Vatican to the Lateran taken by newly crowned popes, where they would take possession of Rome's cathedral in their capacity of bishop of Rome. As in the papal procession, the passage was tortuous and constricted, proceeding through the eighth-century Lombard addition to the Roman core of Bologna's city plan. If the trip was considerably shorter than its prototype, the itinerary was meandering and roundabout, and included the church of Santo Stefano before returning to the Piazza Maggiore. The decorations placed along this processional path included two triumphal arches; Vasari's statement that he painted some arches for the coronation (as opposed to the entry)

of Charles V suggests that the temporary constructions along this route were the ones upon which he worked.

VASARI AND THE IMPERIAL ENTRY OF CHARLES V IN FLORENCE (1536)

Charles V returned to Italy after seizing the city of Tunis from Barbarossa and the Turks in July 1535.[5] It is ironic that this military action, which ultimately proved to be of little consequence for Charles' Mediterranean policy, was followed by lavish celebrations along the full length of the peninsula on a scale that had never been seen before. In the triumphal processions bestowed upon the victor, Charles was regularly portrayed as a new Scipio Africanus, thereby cloaking the recent military victory of a crusading emperor in the guise of a Roman military triumph over modern-day Carthaginians. Like any intelligent and well-educated ruler of his era, Charles would have had no difficulty in deciphering the flattering historical allusions made by his hosts at each of his stops. The cumulative effect of such display must have been repetitive. Nearly every city constructed festive structures of some sort (if not outfitting existing gates with new statuary and ornamentation), and at Cosenza, Charles's first major reception on the mainland, there were no fewer than four triumphal archways for a procession of about a half-mile! A reading of the accounts of the processions suggests that the architectural iconography was conventional to the point of stultification.

In the *Lives* Vasari took an interest in the arrangements underway for the progress from the standpoint of a biographer of artists. Although this holds true for almost all of the celebrations, Vasari was particularly interested in the contributions of those artists who worked on the preparations of Charles V's Imperial entry into Rome, which took place on 5 April 1536. In Vasari's lively words, nearly all Roman artists, both "the good and the bad," were employed in the massive spectacle put on by Pope Paul III.[6] The course of the progress sought to follow the presumed route of triumphal processions made by Roman emperors from the Porta San Sebastiano, which had been decorated by Battista Franco. Whenever possible, ancient Roman remains were taken into account and sometimes were refurbished with suitable

painted decorations, statuary, or Latin inscriptions. The most visible examples of enhancing antiquity were the temporary additions to the arches of Constantine, Titus, and Septimius Severus, under all of which Charles V passed before reaching the Campidoglio and continuing on to the Vatican.

The temporary construction that fascinated Vasari the most was the archway built by Antonio da Sangallo the Younger adjacent to the Palazzo Venezia (plate 202). Properly speaking, it was not a free-standing structure but a fragment of a wall, roughly triangular in plan with a curving central passage to connect its two faces.[7] The arrangement resulted from the non-rectilinear intersection of what is now the Via del Plebiscito with the Piazza San Marco and the crooked disposition of building lines around this point. In concept Sangallo's construction was similar to the condition of the Arch of Titus, which was embedded into the structures surrounding it. Sangallo's real achievement in this instance was to create a coherent architectural entity out of the irregularities of pre-existing street frontages and resolve the divergent orientations so deftly that the pope and the emperor would never notice.

Vasari's admiration for the archway had little to do with urban design. After briefly describing the site of the archway, the account in the *Lives* focus upon its richness of material (especially the gilt foliage of its Corinthian capitals), the painted scenes of the deeds of Charles V, and the statues of Hapsburg emperors who preceded him. Had it been made out of permanent materials, Vasari thought it would have been beautiful enough to be regarded as one of the seven wonders of the world.[8] Vasari did not discuss the demolition that took place to create the route of the procession; he also failed to mention the new street running from the Septizodium to the Arch of Constantine, a long, straight vista created specifically to emphasize the dominating mass of the Colosseum.[9] The omissions, of course, were the result of second-hand information. Throughout this period Vasari was in Florence actively preparing for the forthcoming entry of Charles V. Vasari probably never saw the arch that was the center-piece of his account of the Imperial procession, and his knowledge of the event was probably based on the accounts of the painter Battista Franco and the sculptor Baccio da Montelupo, two artists who worked on the Imperial entries in both Rome and Florence.

Charles V entered Florence on April 29.[10] If the city and its Medicean rulers had no ancient monuments to feature in the Imperial procession, they had the financial resources to mount the most elaborate entry accorded the emperor in Italy. The charge of planning the event fell to a committee composed of members drawn from some of Florence's oldest families—Luigi Guicciardini, Giovanni Corsi, Palla Rucellai, and Alessandro Corsini—who subsequently delegated authority to the artists responsible for the individual monuments or displays.[11] The result was the construction of two triumphal arches, an ornamented facade, and thirteen statues, not to mention the laudatory inscriptions on the temporary monuments or affixed to permanent structures.

After entering the city through the Porta Romana, the procession passed down the Via dei Serragli, zigzagged back up the Via Sant' Agostino to Piazza San Felice, and then turned north down the Via Maggio, crossing the Arno at the Ponte Santa Trinita. The progress then followed the outlines of Roman Florence along the Via dei Tornabuoni and Via Martelli to the cathedral, where Charles V stopped briefly for devotions before proceeding along the Via Larga to the Palazzo Medici. The route was uncustomary in two important ways. First, it failed to include a visit to the Palazzo Vecchio, still the symbol of Republican Florence and not yet the official residence of the Medici dukes. Second, the roundabout itinerary emphasized vistas along straight streets, creating the impression that the diversion down the Via dei Serragli was little more than an opportunity for additional pageantry at a visually prominent intersection. It is fascinating to think that the massive artistic resources of the city were mobilized for an event of so short a duration; Charles V stayed in Florence for only five days, and the decorations were removed certainly no later than May 31, when a formal entry was also given to the emperor's illegitimate daughter, Margaret.[12] But the long-term effect of the policy behind the entry never has been in doubt. The decision to side with Spain and the Empire paid its long-awaited dividends with the Peace of Cateau Cambresis in 1559. With this accord the authority of the Tuscan state and the legitimacy of its conquest of Siena was no longer in question, and the construction of buildings like the Uffizi was now both possible and necessary.

Vasari's contributions to the Florentine entry of

A. Peace and Eternity
B. Happiness and
 Fortune
C. Coronation of the
 King of Tunis

D. Opportunity and
 Generosity
E. Victory
F. Capture of Barbarossa
G. Victory

33. Florence, triumphal entry of Charles V, decorated facade by Vasari at Piazza San Felice, reconstruction

Charles V involved three separate projects: at Porta Romana, a triumphal arch with the Imperial columnar device, and, above it, the Imperial motto *plus ultra*; at the Piazza San Felice, a decorated facade with scenes from the North African campaign in the central panels, and in the flanking bays, symbolic personifications of victory and other attributes; and, above the central portal to the cathedral, an epitaph with a Latin inscription and three theological virtues.[13]

Of these enterprises the facade at San Felice was by far the most outstanding monument. A reconstruction based upon Vasari's description (fig. 33) shows that it consisted of two superimposed architectural units placed upon a high base and terminated by an attic. Forty braccia tall (c. 21 meters), the facade was as prominent as a sizable church. A lofty exterior was totally in keeping with the practice of triumphal entries; Vasari's facade precisely equalled the height of the arches built by Giulio Romano for Charles V's 1530 entry into Mantua.[14] The overpowering scale necessitated atypical architectural details. If Vasari correctly claims that the facade's Doric order was 13 braccia high (6.8 meters), then its columns would have been somewhat attenuated in proportion and similar in effect to those employed later by Vasari on the Uffizi.

If the iconography of the facade was defined by precedent and convention, then Vasari derived expressive freedom from the characteristics of the site. Recognizing that the configuration of the area was "a little awry," Vasari assured the visual dominance of the facade by allowing views of it from both the Via Maggio and the Via Mazzetta (plate 203), the streets that form an acute angle at their intersection with Piazza San Felice. Terminated at one end by Vasari's decorated facade and at the other by a triumphal arch, the entire stretch of street from the Canto alla Coculia (the intersection of the Via dei Serragli and the Via Sant' Agostino) to the Piazza San Felice was now an extended enclosure of the sort that the Via Pia would become a quarter-century later in Rome.

Vasari fully understood the conventions of temporary architecture that he saw first during his brief stay in Bologna in 1530. The Florentine decorations for the 1536 entry of Charles V are notable for their synthesis of architecture, painting, and sculpture in the service of artistic diplomacy. It is hardly surprising, then, that the same decorations embodied the most characteristic concerns of Vasari as architect and courtier: prompt execution and clear organization, attention to the visibility and setting of an architectural work, recognition of symbolism on several levels, and the city as the setting for the display of power.

GARDENS AND ARCHITECTURE AT CASTELLO AND THE BOBOLI

The embellishment of Medicean villas was a logical consequence of the domination of the Tuscan coun-

tryside. Already by the fifteenth century the Medici possessed property that was developed for both pleasure and profit, and in the case of the famous villa at Poggio a Caiano, both functions were exercised at the same location. The Medicean patrimony in the countryside was extended by Cosimo I in the following century with the purchase of Petraia, the construction of the hunting lodge at Seravezza, and the completion of the private apartments at Poggio a Caiano.[15] Inside the city walls of Florence, the Palazzo Pitti and the Boboli Garden announced Cosimo's quasi-imperial ambitions through the U-shaped hillside behind the palace, a natural hippodrome that suggested affinities with the Imperial palace on the Palatine or Pliny's Tuscan Villa. Cronies at court often became the proprietors of land seized from members of the Florentine nobility under the excuse of political intrigue.[16] In political terms, the message was clear: whoever controls the land controls the state.

The garden of the Medici Villa at Castello was a visible manifestation of Cosimo I's dominion over Tuscany.[17] Almost immediately after his election in 1537, he began to transform an already palatial estate into a princely residence. The initial scheme for Castello's layout, which was designed by the sculptor and garden architect Niccolo Tribolo (fig. 34), was described at length by Vasari in the *Lives*.[18] The approach road was to have been an extension of an existing natural trellis of mulberry trees all the way to the Arno riverbank. At the rear of the palace, the principal garden lay within a walled enclosure on the gently sloping land that lead all the way up the hillside of Monte Morello, the most prominent peak in the chain of mountains just to the north of Florence. Inside this precinct the garden was composed of three separate, self-contained spaces. The first sector combined a grass terrace for outdoor dining with a U-shaped arrangement of ten geometric compartments surrounding the garden's principal ornaments, a labyrinth of cypress trees encircling the fountain of Florence, and the small rectangular terrace in front of it that served as the location of the fountain of Hercules, both developed from designs by Tribolo. At the upper end of this conventional grouping, a low wall separated the compartments from a narrow enclosure where its isolation from the winds made it suitable for exhibiting orange trees. The northern side of this second garden was a retaining wall supporting the trapezoid-shaped grove of

cypress, holm oak, fir, and laurel trees that Vasari called the *salvatico*.

Only the general layout of the garden and some of its plantings had been completed before Tribolo's death on 7 September 1550.[19] Vasari, who had returned to Tuscany two months earlier with Ammannati to negotiate contracts for the Carrara marbles to be used in the Del Monte tombs, had the opportunity to meet with Tribolo during the last months of his life and discuss the design for the gardens at Castello. At this time Vasari would have learned that important architectural features such as the long approach road or the loggias for each of the garden's three sectors were considered extravagant by Cosimo I and would not be built. Likewise he would have known that neither of the fountains, for which Tribolo had prepared designs, had been erected in their entirety and both lacked their major sculpted figures.[20] Despite Vasari's apparent full knowledge of Tribolo's design, he was not among the individuals who were considered to complete the princely garden. Vasari was, after all, already committed to working on projects for Julius III in Rome, and he also lacked a background in hydraulics or the making and arrangement of statuary. He would shortly acquire experience of this kind at work on the Villa Giulia.

When Vasari returned to Florence in 1554, Cosimo I placed him in charge of supervising the numerous projects already underway at Castello, a task that involved only his occasional participation due to the more important projects that constituted the renewal of central Florence. It was Vasari's avowed intention to complete the garden according to the drawings and model that Tribolo had prepared, an assertion that can be understood only if it applies to the general outlines of the scheme. During Vasari's stewardship at Castello three significant changes to the garden were effected: the radical alterations made to Tribolo's project for the Grotto, the construction of the island in the fishpond, and the design of the new garden in the area just to the east of the palace. Sadly, documentary information about these important projects is incomplete; even in the *Lives* Vasari is strangely silent on these matters. Whatever the uncertainties about Vasari's authorship and the respective roles that he and his assistants played, there is no question that they determined the garden's design and thematic content as it is known today.

Before beginning in earnest the work at Castello,

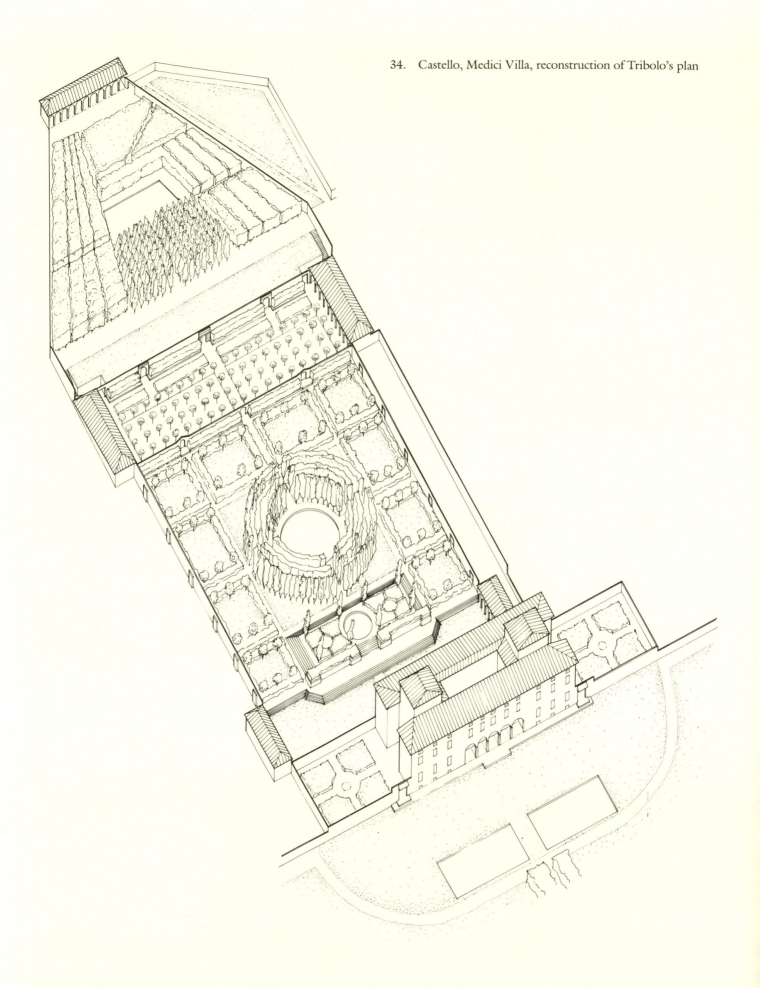

34. Castello, Medici Villa, reconstruction of Tribolo's plan

Vasari became involved in another important Medicean garden project. Presumably with the intention of creating a new princely residence, Eleonora of Toledo, Cosimo I's wife, purchased in 1549 the Palazzo Pitti and vast amount of open area surrounding it. Shortly before his death Tribolo prepared a plan for what has became known as the Boboli Garden.[21] Between 1556 and 1560, Vasari built a small fishpond at the northeast corner of the site . Although it was subsequently incorporated into Buontalenti's Grotta Grande (1583–89), its facade (plate 204) was one of Vasari's wittiest and most learned architectural creations.[22] The lower story of a columnar screen flanked by niches, containing statues of Apollo and Ceres by Baccio Bandinelli, was an arrangement that would be later used to great effect for the facade of the Uffizi. The upper story is more problematic due to the conflicting evidence presented by the written documentation, which attests to its completion and transformation by Buontalenti, and by the architectural logic of Vasari's design, which demands an attic or upper level above its entablature. Unfortunately, it is not clear how Vasari would have completed the facade. The most likely solution is similar to the one adopted by Buontalenti, an arched opening flanked by rectangular panels articulated by framing strips similar to those employed on the lower level.[23]

The sources of the facade provide important clues to Vasari's intentions. In effect it was a version of a screen found in the halls of ancient Roman baths. Vasari certainly had first hand familiarity with this thermal device from his own visits to the ruins of Roman baths, and he may have even seen it in Palladio's drawings of ancient monuments.[24] Like its ancient counterparts, the fishpond owed its existence to a recently constructed aqueduct that brought water from a spring in the hills overlooking the city into the Boboli Garden, and then across the Arno to the Palazzo Vecchio.[25] If the Boboli Garden, resplendent with statuary depicting aquatic themes from Roman mythology, can be understood symbolically as the source for Florence's water, then Vasari's little facade is a singularly appropriate element reinforcing the garden's concetto.

The understanding of aquatic themes and hydraulic engineering that Vasari acquired first in Rome at the Villa Giulia and then at the fishpond in the Boboli prepared him for the challenges he faced at Castello (plate 205). The fishpond, or *vivaio*, in the wooded grove at the upper end of the garden had remained unfinished despite the completion of the aqueduct that was to supply it with water. In 1559 Vasari began to construct the wall that would separate the grove from the wooded areas to either side. Tribolo had planned to build a loggia along the grove's rear wall, but the irregular geometry of the parcel and the loggia's non-rectilinear relationship to the aqueduct precluded the possibility of a pleasing architectural scheme.[26] Vasari prepared a drawing illustrating a design that specifically addressed these issues, but Cosimo was interested in building only the fishpond and nothing else.[27] The refusal of his patron to construct this modest structure must have been a blow to Vasari, for it was conceived as the ideal viewpoint for his thematic rearrangement of Tribolo's garden. From this pleasant spot (plate 206) Cosimo I was supposed to see all of his dominion in a panorama that included the Medici villa at Poggio a Caiano, and the cities of Florence, Prato, and Siena.[28]

The immediate consequence of completing the fishpond was the creation of its principal ornament, the rustic island in its center and, upon it, Ammannati's bearded figure personifying the Appenine mountains (plate 207). Tribolo's original project for the *vivaio* apparently did not include provisions for its sculptural ornamentation, which was not mentioned in the description of his design in the *Lives*. No doubt Vasari considered this arrangement incomplete, as if a panel had been left blank in a crucial position of an ambitious program of mural or ceiling decoration. From the outset of work on the fishpond it is clear Vasari had other ideas for what was little more than a crater-like depression left by his predecessor. In two letters written to Cosimo in 1561, the year in which work on the fishpond was begun anew, Vasari mentions both the island and a fountain, although it is not clear if more than one figure was intended for this position.[29] By 1563, Ammannati was ready to cast the figure in bronze, and two years later it was set up in the fishpond.

Unlike Tribolo's plan for the Castello, which included personifications of Monte Senario and Monte Falterona (the mountains that serve as the source for Florence's two rivers, the Mugnone and the Arno) in less prominent locations within the retaining wall below, the imagery of the fishpond as completed focused visibly on the Appenine mountains as an entirety. In geo-political terms, this was appropriate for a garden conceived as an epitome of Medicean Tuscany because the dominant figure at the northern

terminus of Castello's main axis was a cipher for the range of mountains that formed the northern boundary of Cosimo's state. The new arrangement fully accounted for the fertility of lands under Cosimo's dominion; the water created by the melting snow from the Apennines fed the springs that, in turn, were the sources for Castello's garden and fountains. Under Vasari's supervision the benevolent processes of Nature had become a tool of state.

For all their attention to the topography of Tuscany, Vasari's alterations to the garden at Castello were conditioned by the experience that he and Ammannati shared at work on the nympheum of the Villa Giulia. There allusions to the source of the villa's water are found twice along the central axis of the Roman garden, first in the symbolic depiction of Hercules as a river god in the central relief on the nympheum's facade, and then in the representation of a legendary event, the *Discovery of the Acqua Vergine*, a small octagonal relief in the vault of the grotto on the main level of the nympheum. Buried, as it were, within the classical imagery of the Villa Giulia, this conceit was isolated by Vasari from its architectural context, given visibility, and disposed along the full length of Castello's primary axis. With a painter's attention to effective visual communication, Vasari clarified the symbolic content of the garden. As a result, each of the garden's major divisions was a component in proclaiming the natural wonder of Cosimo I's Tuscan state. Without significantly altering the architectural experience of the ensemble, Vasari gave Castello a unifying theme that matched the downward progress of its waters.

The grotto (plate 208) is the most vexing problem in the history of the garden at Castello. In this instance Vasari was notably silent in the *Lives* about Tribolo's intentions, mentioning only that the scheme had three niches and that it formed a beautiful architectural design.[30] Drawings for the grotto indicate that Tribolo envisaged an interior with different proportions and more architectural membering than what exists in the chamber today.[31] The most important features were its fountains in the niches at the center of the walls, which were to include a statue of Pan in the central niche and Neptune in another (plate 209). With an iconography evoking both earth and water the proposal would have been suitable for such a mountain cave, but its architecture was little more than a rustic recollection of the Old Sacristy in San Lorenzo. The extent of construction

completed before Tribolo's death cannot be determined with any degree of certainty.

Circumstances suggest that Tribolo's ideas may not have been well received. A vogue for grottoes covered with pumice stalactites already had appeared in the suburban villas and gardens around Rome, a phenomenon in large part encouraged by the necessity for the effective display of ancient statuary.[32] It is understandable that Cosimo would have wanted something similar for his own retreat. As indicated by a letter of 1546 from Antonio da Sangallo the Younger, Cosimo sought a rustic grotto along the lines of contemporary Roman examples, and along with the reply he received samples of the stone used to decorate the fountains of an ancient villa near Tivoli.[33] That Cosimo was sufficiently interested in the grotto to request advice from an architect in Rome is highly unusual, and it may well have been motivated by his disappointment with Tribolo's design.

A preference for a more naturalistic rendition of the grotto is clearly visible in its appearance today. The architectural membering favored by Tribolo was rejected in favor of the stalactites from nearby Monte Morello that cover the barrel-vaulted recesses. The squat proportions of the central chamber give a distinctive prominence to the vault, which was treated as a grouping of diamond and wedge-shaped compartments outlined in *spugna* and containing grotesque masks made from shells and pebbles. Instead of stolid figures taken from classical mythology, the walls above the basins in each niche are decorated with an assortment of animals wild and tame, common and exotic; bronze birds were attached to the vault. At once a menagerie and an aviary, Tribolo's sober Grotto of the Elements had become Vasari's playful and witty Grotto of the Animals. It is generally assumed that Vasari was responsible for the design of the grotto, which was executed under his supervision c. 1565–72.[34]

The explanation for Vasari's radical transformation of Tribolo's design can be found in the first edition of the *Lives*. Here an entire chapter of the introductory section on architecture is devoted to a discussion of grottoes, rustic fountains, and how their wall surfaces are made from tartars and petrified deposits of dripping water.[35] Two types of grotto are identified, and, although Vasari is not clear on this point, the main distinction between them is the presence or lack of architectural membering in the form

of a rustic order. In the first, stalactites resembling those found near Tivoli or Pièdiluco in Umbria are attached with iron bars to the architecture, leaving the framework in view. That Vasari associated his project with this grouping is demonstrated by the insertion of a brief discussion of stalactic formations in Tuscany (including those found near Monte Morello and their use at Castello) in the second edition of the *Lives*.[36] The second type, which Vasari considered more rustic, imitated woodland fountains or springs (*fonti alla selvatica*) by their use of grass or other living plant material to give the ensemble a more natural appearance. Another characteristic of this type was the mingling of stones and shells of maritime origin in bands and compartments of a grotto's walls and vault. Something from both examples was embodied in the Castello grotto. When Vasari edited his text for the second edition of the *Lives*, his experience at Castello allowed him to rewrite a considerable portion of the section on grottoes, thereby giving the short chapter greater coherence by emphasizing the resemblance to *fonti alla selvatica* as characteristic of both forms.

Quite by accident, it seems, the Grotto at Castello became an illustration of Vasari's architectural theory. To be certain, Vasari would have been familiar with Alberti's brief mention of grottoes in the chapter of his architectural treatise devoted to the ornamentation of private buildings.[37] Although Vasari's text on grottoes in the first edition exceeds that of Alberti in length, it has a simplicity to it that may be due to factors other than the author's lack of personal experience with his subject. Rather Vasari may have directed the passage squarely at the dedicatee of the *Lives*, his future patron Duke Cosimo I de' Medici, as a demonstration of his knowledge of garden architecture and his own capability to co-ordinate the completion of the grounds of Castello. Although necessarily brief, the passage on grottoes likely served to advance Vasari's stature in the eyes of a future patron and to assist in securing the position of court architect.

THE WEDDING OF FRANCESCO DE' MEDICI AND JOHANNA OF AUSTRIA
(1565)

In the development of ephemeral architecture for state occasions, the wedding of Prince Francesco I de' Medici to Johanna of Austria occupies a special position.[38] Joining the heir of Cosimo I with the seventeen year-old sister of Emperor Maximillian II, the celebration mustered together the entire resources of Medicean Florence. The wedding was publically announced on 21 March 1565, and Cosimo I charged Vasari's friend and collaborator, Don Vincenzo Borghini, with devising the program of events and their erudite iconography. In affairs of state, precedent amounted to legitimacy, and, therefore, Borghini began the daunting task of researching the history and practice of ceremonial entries throughout Europe. By the beginning of April Borghini had prepared a lengthy letter to the duke in which he described three categories of ceremonial entry, one of which was the reception accorded a prince or princess on the occasion of a state wedding. The temporary architecture erected for each of these categories of events had its own iconography. In the case of a princely wedding, the symbolism was extremely complex, combining allusions to the legitimacy of ruling princes and majesty of foreign rulers (the other two categories identified by Borghini) with a demonstration of public support for the alliance.[39]

In the letter Borghini outlined the decorations for the grand entry and its thirteen temporary architectural ornaments. Of these, five were architectural frontispieces masking older structures, three were free-standing elements, and only two were triumphal arches similar to those built in antiquity. The most extraordinary creations, however, were the architectural environments that were to be fashioned out of the irregular patterns of streets and buildings at three crucial locations along the route. The ensemble was coherent thematically, starting with an introduction to Florence, continuing with themes related to marriage, following with exaltations of the families of the bride and groom, and culminating in the expressions of the qualities of Cosimo I's rule.

Vasari provided the overall direction for the celebration's many projects. Although busy with the renovation and decoration of the Palazzo Vecchio, he collaborated closely with Borghini throughout the planning phase on the design of the main elements constructed for the celebrations; aspects relating to the provision of materials, general supervision of the artists, and distribution of funds were handled by Giovanni Caccini, the individual who represented the interests of Cosimo I and Prince Francesco.[40] Vasari's responsibilities also included the design of its

architectural elements, some of which were farmed out to other artists. If all of the temporary constructions were not designed by Vasari, they bore his stamp of approval and represented his tastes and principles.

On the afternoon of 16 December 1565 the bride made her formal entrance into Florence (fig. 35). In the course of the next three months, the festivities included the performance of Francesco d'Ambra's comedy *La Cofanaria* in a temporary theater constructed inside the Salone dei Cinquecento, the mock siege of a castle erected in front of Santa Maria Novella, and the *Genalogia degli Dei*, a cavalcade of twenty-one triumphal chariots and hundreds of costumed figures representing the pagan deities who had come down from Mount Olympus to witness the nuptials in Florence.[41] But even the blessing of the gods was insufficient to sustain the alliance between two individuals who were totally unsuited for each other. The union was a political one, pure and simple. If the festivities were meant to impress the bride and the noble visitors accompanying her with Medicean splendor and achievements, the Florentines must have seen this as a sham. Francesco had never broken his attachment with Bianca Cappello, the beautiful Venetian widow of a Florentine merchant, splendidly supporting his mistress in what constituted a second Medicean court in Florence, and married her upon the death of Johanna in April 1578.[42]

The direction of Johanna's entry was determined by her approach from the Medici Villa at Poggio a Caiano, where she spent eight days in preparation for the official commencement of the ceremonies.[43] The initial tract proceeded from the Porta al Prato along the Borgo Ognissanti to the Palazzo Ricasoli near the Ponte alla Carraia. From here the cortege followed the Lungarno Corsini to the Ponte Santa Trinita, where it turned north onto the Via dei Tornabuoni, then east towards the cathedral, and finally south to pass the Bargello before entering the Piazza della Signoria from the Via dei Gondi. Once the ceremonial entry had been completed, there was no need for the continued presence of the temporary constructions erected along this route. Their removal began on 29 January 1566, and within a short time all had disappeared.[44]

If the existence of straight streets characterized the first sector of the entry, the partial clockwise loop that completed the approach to the Palazzo Vecchio

was steeped in tradition and laden with ideological considerations. In avoiding the dense core of central Florence, earlier ceremonial entries followed the circuit where the city's ancient Roman walls once stood, itself the course of the foundation rites around the ancient castrum that accompanied the establishment of a Roman town.[45] Vasari was no doubt aware of this form of ancient ritual, which he depicted in his painting of *The Foundation of Florence* for the ceiling of the Salone dei Cinquecento in the Palazzo Vecchio, as was Borghini, whose knowledge of Florence's ancient topography was considerable.[46]

Yet Johanna's *entrata* was not symbolic of Florence's foundation. None of its activities followed the civic rituals that Vasari and Borghini would have known from ancient authors, and none of its temporary constructions can be linked with actual Roman structures that may have been known to exist on the same location.[47] Only the Arch of Religion at the Canto alla Paglia (plate 210) shows an attempt to respond to the precedent of an ancient structure, standing as it did near the location of the northern gate of the Roman city. But this correspondence was largely conceptual and is not born out by the design of the arch. Quite unlike the Roman gateway flanked by towers, Vasari built a four-way arch inspired by the Janus Quadrifrons on the Forum Boarium in Rome. Instead of standing freely, this arch completely filled the space created by the intersection of four major streets and disguised its irregularity.[48] The other triumphal arch constructed for the entry, the Arch of Civil Prudence dedicated to Cosimo I, stood at the end of the Via dei Gondi (plate 211) and was also not meant to be understood as a free-standing structure.

Other triumphal arches departed from classical prototypes. At the entrance to the Borgo Ognissanti (plate 212), Vasari originally had proposed a triumphal arch that contained within it figures representing Austria and Tuscany.[49] At first, its design may appear conventional, employing a large central opening and a shallow attic similar both to illustrations in Serlio and to other temporary archways constructed for ceremonial entries elsewhere in Europe.[50] But what made the design unusual were the split, reverse-curve pediments that Buontalenti was to employ in the Porta delle Suppliche in the Uffizi. Although there was much to admire in the arch's correct symbolism and appropriate type, Borghini rejected it because it would block the vista of this straight street,

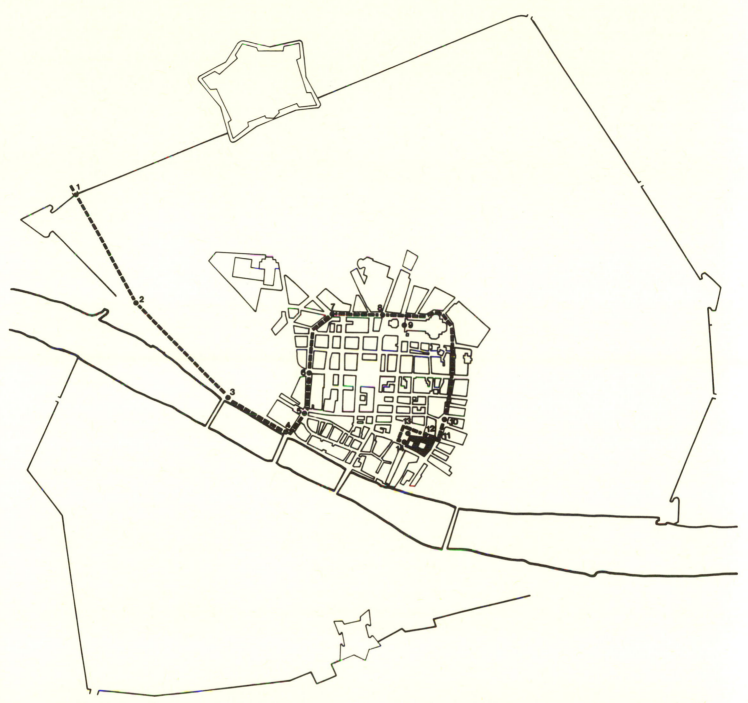

35. Florence, course of ceremonial entry of Johanna of Austria, 1565. 1. Porta al Prato, Arch of Florence. 2. Borgo Ognissanti, Arch of Austria and Tuscany. 3. Ponte alla Carraia, temporary facade of Palazzo Ricasoli. 4. Ponte Santa Trinita, arches and screen wall celebrating the maritime empires of the Medici and the Hapsburgs. 5. Piazza Santa Trinita, Column of Victory. 6. Via dei Tornabuoni, Arch of Austria. 7. Canto de' Carnesecchi, Medici "Teatro." 8. Canto alla Paglia, Arch of Religion. 9. Cathedral portal, Arch of the Virgin Mary. 10. Piazza di Sant' Apollinare, equestrian monument of Virtue overcoming Vice. 11. Borgo dei Greci, fountain of Mirth and Happiness. 12. Via dei Gondi, Arch of Civil Prudence. 13. Piazza della Signoria, Neptune fountain. 14. Palazzo Vecchio, portal dedicated to Security

the most impressive of many laid out at the periphery of medieval Florence.[51] His claims that it was too large for the space and would impede passage along the street were well founded, and the decorations ultimately took the form of an aedicule behind each of the statues.

The architectural environments form a category all to themselves. The tasks faced by Vasari were practical ones, primarily the construction on irregular sites and the creation of modern exteriors for medieval structures. The "arco" that was built across the Via dei Tornabuoni (plate 213) was properly a facade similar to a palace courtyard that terminated the view from Santa Trinita some meters to the south.[52] Borghini described the site in terms of the confinement and lack of proportion, an appearance caused by the projection of the Tornaquinci tower into the space of the street. In order to disguise the narrowing of the street as it proceeded northwards, two bays were constructed across the right of way, of which only one could be traversed. Just to the north, the "teatro" dedicated to the House of Medici was truly an amphitheater (plate 214) in the shape of an irregular octagon allowing the cortege to change direction by proceeding towards the cathedral. The intersection, which Borghini described as ugly, lacking in proportion, and needing help, was surrounded by a continuous facade about 14 meters high in the guise of a modern Roman place by Bramante or Raphael.[53] But Borghini's most condemnatory remarks were reserved for the point where the Via dei Leoni, Borgo dei Greci, and the Via dei Gondi converge (plate 215). If the intersection was to be considered as "obscene," it was successfully camouflaged by a fountain dedicated to the Mirth and Happiness of the Florentine people.[54] Of all the temporary constructions, this was perhaps the most playful and ingenious in its transformation of a rustic garden portal into a fountain spewing red and white wine. With relief the bride might have realized that Medicean Tuscany was not a land of mythical heroes but of real people like artisans and peasants who prepared the stuff out of which the fountain was made.

In the end, the *entrata* of Princess Johanna was characterized by an extraordinary variety in the design of its architecture and range of its sources. Some of its ornaments communicated an ideology of magnificence in ways that repeated designs previously employed in other festivals. In large part, formal standardization in the design of temporary structures (as distinct from their iconography) was promoted by the numerous published accounts of ceremonial entries that usually included woodcuts of the special decorations. This can be seen most clearly in the triumphal arches and especially in the decoration of the Porta al Prato (plate 216), a sort of architectural frontispiece and forecourt to the medieval gateway modelled on a similar construction built by Florentine merchants for the 1549 entry of Philip II into Antwerp.[55]

Though equally conventional, other decorations were inspired by illustrations in contemporary architectural treatises. The publications of Serlio provided a wide selection of designs capable of modification or adaption for festival decorations. These illustrations had a far-reaching influence on Vasari and Borghini in terms of both the composition and setting of the temporary constructions. The clearest examples of this indebtedness are the archways of the "teatro" at the Canto dei Carnesecchi which seem to have been lifted directly from Serlio's *Third Book* (1537).[56] But Serlio's ideas may have had a deeper impact on the principles that informed their design. The central architectural intention of the alternative schemes for the celebration of Hymen on the temporary facade (plate 217) of the Palazzo Ricasoli—the creation of a modern palace exterior by exhanging the windows for paintings and their elaborate frames—closely parallels the concept behind one of Serlio's most compelling illustrations in his *Seventh Book* (plate 218).[57] If the design for a modernized palace exterior was meant to court princely favor, then it is conceivable that this idea would have been taken for granted by Cosimo I and his artists.[58]

The impact of Michelangelo was equally apparent, although it was mainly confined to architectural details. The one to which Vasari turned most frequently was a tabernacle of the type found above the doorways of the New Sacristy or as windows on the upper level of the Palazzo Farnese's courtyard. The utility of the motif was almost limitless, because it could easily serve as an enframement for figures on a triumphal arch as wells as the portal to the cathedral. It appears that Vasari, who was familiar with many of Michelangelo's unbuilt designs, also may have studied some of the late master's architectural drawings. The composition of the triumphal arches and the ornamental wall (plate 219) that screened the remains of the Ponte Santa Trinita (which had been destroyed in the great flood of 1557) repeat the ar-

rangements with which Michelangelo had experimented but had discarded in his development of the New Sacristy tombs and for the facade of San Lorenzo. The most Michelangelesque of these borrowed designs was the ornamental enframement of the main entry to the Palazzo Vecchio (plate 220), a confection employing the herms from the tomb for Julius II, the central portal of the Porta Pia in Rome, and the culminating tabernacle from the courtyard of the Palazzo Farnese!

What Vasari's contribution to ceremonial architecture shares with his other architectural projects lies less in their design than in the process and principles by which they were achieved. That they were completed in the first place was a minor miracle attesting to Vasari's organizational skills as well as his capacity to elicit from other artists a commitment to the project's completion as strong as his own. If the ephemeral forms of the individual ornaments were determined by the conventions of ceremony, their physical settings were no less carefully considered than in truly original masterpieces like the Uffizi. The apparent difference between the ideally Roman image of the decorations and the actual condition of the city is less important than the coherent framework that was created with minimal disruption to Florence's urban fabric. This important principle has continued down to the twentieth century, and was applied whenever triumphal entries sought to recall Roman grandeur (plate 221).

The temporary theater constructed in the Salone dei Cinquecento was Vasari's other major contribution to the wedding festivities. The idea of converting a hall of state into a theater for state occasions was neither new nor Florentine, having already had its origins in the creation of a theater and stage inside the Palazzo della Ragione in Ferrara for the 1502 wedding of Isabella d'Este with Franceso Gonzaga of Mantua.[59] Because this practice was so widespread in the sixteenth century, it did not immediately lead to the creation of the theatre building as a separate, permanent structure. The temporary, wooden theatre that Vasari created was the heir to similar constructions that had been built in palace courtyards and looks forward to both Buontalenti's Teatro Mediceo inside the Uffizi and to permanent structures like the one built by Scamozzi at Sabbioneta.[60] By comparison with these constructions, Palladio's Teatro Olimpico in Vicenza is exceptional in every way.

Although Vasari's construction was understood as

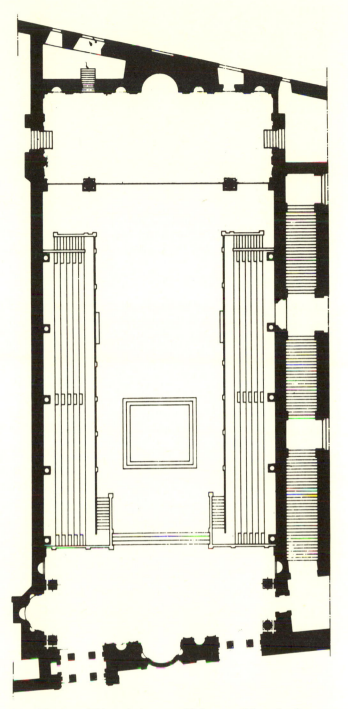

36. Florence, Triumphal entry of Johanna of Austria, theater built in the Salone dei Cinquecento, plan

having been built along the conventions of an ancient theater, the actual design (fig. 36) was unlike any ancient Roman prototype.[61] Strictly speaking it was an odeon, a roofed theater that accepted the elongated shape of the existing hall as the main determinant of its design. Within this space there were three categories of seating where each guest was given a distinctive position according to rank and

gender. The most prestigious was a platform at the center with three steps on its sides served as the dais for Johanna's retinue and for guests of princely rank. In terms of architecture, the most elaborate were the two tiers of seating placed along each of the hall's long sides. Each tier was composed of six levels reserved for noble women, forming in effect balconies that were raised four braccia above the floor of the chamber. Their height would have allowed each installation to neatly fit underneath Vasari's battle scenes. In addition, courtiers and individuals who were not guests of honor were provided with benches at floor level.

Of the many precedents for a temporary theater of this type, the one with which Vasari would have been most familiar, is the theater illustrated by Serlio (plate 222) in the *Second Book* (1545). That it ultimately had little effect on Vasari's executed project can be explained by its main disadvantage. A theater with an amphitheatrical recess in the tiered seating would have compromised the visibility of the *Udienza* at the northern end of the hall, and it is highly doubtful that a *cavea* like the one illustrated by Serlio was built or even considered for the Salone dei Cinquecento. It is plainly evident that the arrangement of the "auditorium" section of Vasari's design was scarcely more than a variation of seating commonly employed in halls of state, a group that would include the very same hall's appearance during the Florentine Republican era.

The stage erected at the southern end of the hall posed fewer constraints (plate 223). It was raised four braccia above the floor, the same height as the tiered seating nearby. The parapet wall served two purposes, physically separating the stage from the auditorium while visually linking the observer's space with a painted staircase that was considered three dimensional. Presumably this fictive element was composed of symmetrical ramps commonly found in Serlian and other stage sets, a device that Vasari employed as well in paintings and other decorations. Above this base, two Corinthian columns and their entablature created a skeletal structure from which was hung a curtain painted by Federico Zuccaro. This vast canvas, which was decorated with a hunting scene and an idealized view of Florence in the background, functioned not as a backdrop but as a form of proscenium curtain that hid the fixed scenery from view until the play began.

The fixed scene that Vasari devised followed the tradition of elaborate perspectival depictions that had been common throughout the sixteenth century. Although *La Cofanaria* was a comedy, the noble structures that recreated the view from the Ponte Santa Trinita up the Via Maggio were seemingly more appropriate as a tragic scene. Instead the choice of this panorama was likely meant to recall an earlier Imperial entry. Borghini noted that when Charles V passed along the Via Maggio in 1536 the emperor thought the view of the street with tapestry decorations hung from its windows to have been one of the most beautiful things he had ever seen.[62]

Vasari intended his temporary theater to have a certain degree of permanence. What distinguishes this design from other theaters is that it was to have been disassembled, put into storage, and assembled again for subsequent theatrical performances at the Medicean court.[63] Sadly, there is no evidence that the tiered seating or stage was employed in any subsequent performances, and by 1589 the construction of Buontalenti's Teatro Mediceo in the Uffizi rendered Vasari's useless.

EIGHT

Conclusion

Style, Criticism, and Architecture at Court

Vasari was one of the most versatile architects of his generation. His achievements reflected not only the architectural programs espoused by patrons but also his virtual dominance over artistic matters in Florence during the age of Cosimo I. Vasari did this in part by absorbing what he saw in the buildings of the previous generation of architects in Italy. By temperament a courtier and by training a painter, Vasari evolved into an architect whose buildings involved symbolic expression but were never constrained by their designer's intellect. He possessed a highly cultivated mind that stored an immense mental repertoire of images and facts about the architects and architecture of his epoch. Although he never cites ancient Roman architecture in his buildings, he was conversant with Vitruvius and imparted a classical image to a building if appropriate to its concept. If his buildings show an aversion to the full language of the architectural orders (plate 224), his written language in the *Lives* vividly brings to life an architect's personality and achievement, including his own.

ARCHITECTURAL STYLE

Vasari's architecture is the antithesis of Sangallo the Younger, Vignola, or Palladio. If his architectural career has been relegated to obscurity it is because his buildings do not easily correspond to accepted definitions of style. There is no homogeneous group of executed works that can identify the development of an architect's ability to design over the course of a long and productive career. Neither does it yield easily to archetypal yardsticks of artistic development—early or late styles, pre- or post-Roman experiences, the study of antiquity, or the influence of Renaissance humanism. Nor is there a typical plan type among Vasari's buildings; they were generally too particular in purpose and too pragmatic in design to permit such systematic analysis. At the same time, there are a sufficient number of common traits that point towards the heart of Vasari's fundamentally different and distinctively personal approach to architectural design. An investigation of artistic mo-

tivations poses a deceptively simple question: what is the nature of Vasari's architecture and is it compatible with his other endeavors?

The Uffizi facades (plate 225) demonstrate the theories of eclecticism espoused by Vasari in the *Lives*. If artistic perfection had been attained in the works of Raphael and Michelangelo, as Vasari claimed in the *Lives*, then the rendition of their forms with greater facility, elegance, and quickness was the only way artists could improve upon their achievements. While this doctrine often limited the sources of Vasari's paintings to those masters, it liberated Vasari's architecture from the constraints of his own view of artistic development. So extensive was Vasari's network of architectural sources that it appears as if he were wishing willingly to repeat the achievement of Raphael (plate 226), who formed a distinctly personal style out of numerous sources.[1] In the end, a real synthesis of the major architectural trends was elusive. Vasari was capable of producing sophisticated designs manufactured from borrowed ideas, yet he did not create a new style.[2]

What made Vasari so formidable as an architect was his training as a painter and his experience of large-scale painted decorations. In formal terms, this accounts for a bias towards an essentially planar architectural style characterized by elaborate textural relief (as in the Uffizi) as well as the absence of architectural embellishment (the Loggia) or the rejection of classical grammar in favor of painted decoration (the Palazzo dei Cavalieri). The method of design for such a diverse selection of buildings was painterly as well, building outward from a surface that serves as a reference or backdrop for the facade. The fictive architecture in Vasari's paintings exhibits the same forms and stylistic characteristics as his buildings, as indicated by the similarity of the setting of *The Incredulity of Saint Thomas* (Florence, Santa Croce, 1569) to the interior of the Badia or *The Forge of Vulcan* (Florence, Uffizi, 1565–67) to the arcade of the Loggia.[3]

Vasari seems to have conceived his buildings to be seen in the neutral, undifferentiated light that is found everywhere in his paintings and fresco decorations. The brilliant illumination of an Italian summer's day is detrimental to their architectural effect; it washes out the subtle effects of the Uffizi's exterior, and raking shadows tend to exaggerate the already severe exterior of the Loggia. Ironically, their facades are seen best when the quality of natural light is most pictorial or under conditions of diminished illumination. The interiors of Santa Maria Novella and Santa Croce are more effective in terms of luminosity because of their visual unity as well as the need to illuminate the altarpieces produced by Vasari and his assistants. Vasari's most ingenious application of the warmth and radiance of natural light, the clerestory windows in the Salone dei Cinquecento of the Palazzo Vecchio, served primarily to heighten the visibility of the panels in the painted ceiling. It is ultimately the idea of an architecture without shadows that distinguishes Vasari's use of light from the dramatic chiaroscuro of his Roman or Venetian contemporaries.

The pietra serena and white stucco facades of the Uffizi are exceptional and show Vasari's approach to light at its most sophisticated. Its windows, balconies, frames, and brackets do not create bright highlights or deep shadows but serve as decorative relief in an equilibrated composition that calls particular attention to its subtly refined details. The facade's genuine tension results from the juxtaposition of familiar motifs seen in a diffused light congenial to the effect of the pietra serena. Elegance and austerity exist in equal measure. Window pediments contribute to the design's overall balance by marking the central axis of each bay, and, when seen obliquely, give it a dynamic quality by creating a clear horizontal band that the eye follows easily without break, such as that along the perimeter of the Uffizi's street.

In addition to Vasari's interest in the effects of a particular kind of light, his concern for the observer's viewpoint posed a persistent challenge to him. This, too, was the result of a pictorial sensibility. Just as the ceiling of the Salone dei Cinquecento is best seen from a point just inside its main door, the Uffizi is presented to its most dramatic effect from a position outside the main portal of the Palazzo Vecchio (plate 227). Unlike the prospect from ground level (plate 228), which exaggerates both the height of the adjacent facades and the length of space defined by them, the vista as seen from a higher point outside the Uffizi proper retains a sense of balance and equilibrium that gives greater immediacy to the riverfront loggia and its sculpture. From this location the analogy with the ancient basilica is most compelling, placing the visitor in a position equivalent to the sculpted figure of Cosimo I on the *testata* but below it in terms of height and social status. Similar viewpoints may be discerned in other projects: the oblique view contrasting the Loggia with the Misericordia Palace in

Arezzo, the streets that open into the Piazza dei Cavalieri in Pisa, or the rigorously symmetrical interiors of the churches in Florence and Arezzo.

It would be misleading to assume that the pictorial qualities in Vasari's architecture was grounded exclusively in techniques of perspective that enforced an external station point, as if a drawing in the *costruzione legittima* invented by Brunelleschi and codified by Alberti had suddenly been built. It is obvious, of course, that Vasari's training as a painter permitted familiarity with this type of illusionism, and he employed it to great effect in the Del Monte Chapel. Whether or not Vasari conceived of his designs in this fashion is difficult to establish, or, as it seems, altogether beside the point.

It was, instead, a concern for unimpeded vistas that explains the special concern for an architectural viewpoint in many of Vasari's designs. The fact that his most important projects were destined for tightly constrained urban sites meant that by definition they could not be understood in the course of the beholder's ongoing movement, a factor that differentiates his work from that of Michelangelo. The anchoring of Vasari's buildings in their contexts also creates a misleading comparison with the conventions of Renaissance stage design. If the Uffizi, for instance, recalls Serlio's well-known Tragic Scene (plate 229), it does so only because Vasari fully absorbed theatrical conventions in earlier projects.

The concept of a straight street seen in perspective and terminated by a triumphal arch was shared with other triumphal decorations for the visit of Charles V, and in the case of the Piazza San Felice facade, the tall proportions of the channel formed by the buildings flanking the Via Mazzetta demanded a vertical accent to serve as the termination to a panorama that Vasari called magnificent and superb.[4] If the overall effect seems more medieval than classical, it does so because it was inspired by the high, projecting towers of medieval fortifications. It is striking to see how closely a distant view of Vasari's facade recalls the view of the Porta Romana (plate 230) as seen from the Via Romana or the Via dei Serragli. The constant preference for an effective viewpoint along a predetermined vista underlay the designs for the apparato of 1565. In the well-known letter to Cosimo I where Borghini describes the temporary decoration of the apparato, he repeatedly refers to the visibility of the constructions, paying particular attention in most instances to what the eye can or cannot see.

This is indicated most clearly in his discussion of the decorations along the Borgo Ognissanti where he allays any possible fears that the statues would block the street.

In one sense, there was nothing novel in this; Renaissance architects regularly used well-chosen viewpoints to show their buildings to the best possible effect. The distinguishing consideration in Vasari's projects was how it served to represent the architect's concetto, which may be defined as his essential intention for a building.[5] This notion, which is normally associated with the work of Baroque artists like Bernini, has a particular relevance in Vasari's case because each of his architectural projects was conceived as an illustration of an essentially symbolic idea. It cannot be accidental that the concetti of the Uffizi as an open-air basilica and the Palazzo Vecchio as an evocation of an imperial palace with Medicean overtones would be understood simultaneously from the same location outside the palace's main entry, the spot where honored visitors would leave a city saturated with architectural propaganda of political dominance and enter the world of mythical destiny inside the ruler's palace. Similarly, the concetti associated with the Loggia in Arezzo or the Palazzo dei Cavalieri are most evident from the locations where the buildings are most visually striking.

As in other aspects of Vasari's approach to architecture, the prominence given to a building's concetto was a consequence of a painter's familiarity with iconography. The architectural concetto was effectively the equivalent of a single episode in a large narrative where the story is told in bricks and mortar instead of fresco. If the architectural concetto embodied in a single building lacked the continuity of a full cycle with its own complex and coherent program, it at least benefitted from the powerful impact of a single chosen vista. None of the architectural concetti involved complex imagery or erudite allusions, as was often the case in painted his cycles, and they were so integral to the buildings as to suggest that they were formulated by Vasari without the assistance of a learned advisor. Nor did the lack of a written program obstruct its apprehension by the beholder; the architectural concetti were based on a visible (if not patently obvious) dialogue between one or more structures, as in the case of the projects in Florence, Arezzo, and Pisa. Even allusions to the architecture of Roman antiquity, which are present to varying degrees in the concetti of the Uffizi and

the Arezzo Loggia, were to a large degree sublimated to the whole in Vasari's buildings and never were expressed in discernable classical form, as in the case of Palladio's Basilica in Vicenza. The procedure of defining a work of architecture in conceptual terms is in accord with Vasari's theory of art; the importance given to the concetto is the architectural manifestation of his well-known commitment to the supremacy of *disegno*, the formal training in drawing and perspective shared by nearly all Renaissance artists and architects, over *colore*.

If the notion of an architectural concetto is rooted in Vasari's intellectual formation of art, it was also integral to his architectural practice. Unquestionably he was trained to draw architecturally and did produce sophisticated presentation drawings illustrating the architectural framework of his paintings or large-scale decorations, but the scarcity of architectural drawings by his hand has always puzzled scholars. While this lack of graphic evidence may be understood as indifference towards technical aspects of a building's execution, Vasari's procedure was also pragmatic, a reflection of his interest in a building's concetto and the great skill and success with which he could supervise projects large and small. With a limited amount of time at his disposal, Vasari was either unwilling or unable to make the kind of detailed drawings that were produced by his contemporaries; it seems likely that his verbal concepts or rough sketches would be worked up by his assistants before their transformation into a wooden model or even the actual building. Only a handful of drawings from this category have survived. A measure of Vasari's esteem in the eyes of his contemporaries was his unchallenged personal knowledge of the architects and architecture of his time. Vasari seems to have been acquainted with almost every major architect of his generation, and whenever or wherever he travelled, he leads us to believe that he was a welcome guest in their houses. Along the way he was able to obtain a first hand knowledge of executed works not normally accessible to others; the drawings that he acquired or bartered from his friends formed the core of his collection of drawings, the *Libro dei disegni*, and in some instances may have been the source of his own architectural ideas.

It was during Vasari's first Venetian sojourn in 1541–42 that the already mature painter became familiar with the works of Sanmicheli, Serlio, and Palladio.[6] This is readily shown by Serlio's influential design for the facade of a Venetian palace (plate 231), whose restrained ornamentation and complex composition focusing on a dominant serliana anticipates the spirit of Vasari's later buildings, especially the composition of the Uffizi's facade. In Sanmicheli's Veronese fortifications and gateways, which Vasari described at length in the *Lives*, he saw a forceful expression of the Doric order and the rustication encasing it; in the facade of the Palazzo Canossa he would have been attracted to the sophisticated arrangement of mouldings behind the paired pilasters, a detail that Vasari recalled for its implication of a major order on the main level of the Uffizi's facade (plate 232). Just as Palladio had been attracted to the compositional types suggested by Sanmicheli's buildings, Vasari acquired a taste for complex arrangements of architectural grammar not found in his native Tuscany. Yet regional differences prevailed in both cases. Palladio's buildings retained the sensuous qualities of Venetian art; Vasari, in contrast, saw the same forms through a filter of Florentine disegno that transformed their warm colors and rich ornamentation into the equilibrium and sharp precision of pietra serena. By the end of his Venetian sojourn in August 1542, Vasari seems to have acquired more than a passing interest in architecture. Later that year, his principal teacher, Michelangelo, grasped the importance of Vasari's Venetian sojourn by suggesting that Giorgio return in earnest to the study of architecture.[7]

Of all the architects whose friendship and trust Vasari acquired while travelling across Italy—the example of Michelangelo forming a special case altogether—Giulio Romano exerted the greatest impact on Vasari's buildings. In a way quite unlike Sanmicheli or Palladio, who regarded Giulio as a source for expressive motifs, Vasari sought to derive from him principles of broader application. What must have impressed Vasari the most about Giulio's buildings was the historical breadth of their sources and the fluency with which they were combined to create an architecture that was both individual and innovative without denying the continuing relevance of classical antiquity. This approach, which was evidently congenial to Vasari, is best shown by the facility in transforming diverse motifs on the Uffizi's facades. It is particularly the design of the loggia facing the Arno (plate 233) that repays Vasari's obligation to his model for the noble painter at court. Faced with the task of linking ground floor arcades and the

upper level *altane*, Vasari turned to the garden facade of the Palazzo del Te for its changing rhythms, variations on the form of the serliana, open loggias, and emphasis on the ground floor (plate 234).[8] Even the effect of reflecting a facade in water may derive from the mirror image of Giulio's Mantuan exterior as seen in the fish pond separating the palace from the garden. That Vasari could convincingly fuse the approaches of Michelangelo and Giulio Romano into a coherent design lies at the core of his achievement.

Michelangelo was the central figure in Vasari's education as an artist. Vasari's close associations with Michelangelo were numerous and constantly changing—sculptor and painter, teacher and student, master and disciple, subject and biographer, hero and worshipper, divine and human—and in this differed from Vignola's or Ammannati's relationship to Michelangelo. The essential lessons that Michelangelo taught Vasari dealt with the integrity of the artist and the dignity of the profession of architecture. The dome of St. Peter's was the great architectural protagonist in the last years of Michelangelo's career, and from it Vasari learned lessons involving the intrigues of an architect's collaborators and supervisors, the single-minded devotion to the completion of a building, and the preparation of a design that could be completed without disturbance after the departure or death of its author. When Vasari compares Michelangelo's wooden model for St. Peter's to the one produced by Sangallo the Younger, he does so with the same concern for economy that characterized his buildings on the Piazza dei Cavalieri in Pisa.[9]

Yet, literally, Vasari's buildings are far less clearly indebted to Michelangelo than is normally thought. As the Sala di Leone X clearly demonstrates, Vasari would go to Michelangelo for a bracket, window, or doorway. Yet the overall effect of Vasari's transformation of these motifs is appropriately domestic, lacking the tensions found in the great master's Florentine architecture (plate 235). Vasari never designed an entire structure that can be considered a close reflection of one by Michelangelo, and only in the case of the organ loft in Arezzo is there a striking direct resemblance to a Michelangelesque prototype. The similarity of the cupola in Pistoia to Michelangelo's work is superficial and largely confined to the design of its lantern (plate 236) and the decorative coffers on its inner surface. The only exception may have been the lost design for the Cappella dei Prin-

cipi adjacent to the right-hand transept of San Lorenzo. This design was characterized by Vasari as a third sacristy similar to the one already built by Michelangelo, but more ornate in its colored marbles and mosaics.[10]

Is Vasari's architecture truly "Michelangelesque," as generations of critics have claimed? In all of his buildings Vasari avoided unusual juxtapositions of elements, and whenever he borrowed motifs from Michelangelo, as he did freely in the Uffizi facade, he took particular care to emphasize their secondary role in a balanced if not orthodox composition. Similarly, Vasari avoided the powerful sculptural quality of Michelangelo's Roman work in the same way that he refrained from using novel arrangements of architectural orders in the fashion of a Palladian facade. To be certain, Vasari's detached, unemotional rendition of Michelangelo's forms is as much the product of the physical and symbolic constraints of commissions for unusual building types as it is of their Florentine setting and context.

A simple but insufficiently stressed facet of Vasari's approach to architecture is his real caution towards imitating the works of Michelangelo. Already in the first edition of the *Lives* Vasari baldly stated that the great master's boldness had caused other architects to make imitations that bordered on fancy rather than reason or rule.[11] The admonition expressed in this well-known passage appears to have been derived from his understanding of Vitruvius, whose precepts Vasari often cited as standards of architectural beauty.[12] But when Vasari repeated the passage in the second edition eighteen years later, he had already become a mature architect who had collaborated with Michelangelo on the Del Monte commissions and sought his opinions on Medicean projects. With Michelangelo's death in 1564, most echoes of his architecture disappear from Vasari's buildings, which ranged from the neo-Venetian spaces of the Badia to the austere church renovations and the astylar facade of the Loggia.

ARCHITECTURAL CRITICISM

Vasari's architectural criticism is anti-theoretical and delights in the anecdotal and professional and technical aspects of architectural practice as he understood it. To a very great degree it was influenced by his own career as an architect, which flourished during the

years between the two editions of the *Lives*. The typical method of revision was to append new paragraphs to the text from the earlier edition, but in some instances entire chapters were rewritten. Michelozzo is a particular case in which the summary biography of the first edition gave way to a full study that includes a sophisticated description of the Palazzo Medici as defined by its household functions. The changes were prompted by Vasari's experiences in the transformation of the Palazzo Vecchio into a suitable ducal residence, and the emphasis on its comforts may even express the opinions of Duke Cosimo who resided there until 1540. Vasari's identification with the architect who created the key example of a Florentine merchant's palace also may have been prompted by the similarity in their careers as Medicean architects whose reputations were obscured by the figures of a Brunelleschi or a Michelangelo.[13]

Not all architects fared as well as Michelozzo in the later edition. The polite skepticism that Vasari demonstrated at first towards Leone Battista Alberti turned into an indictment against a purely theoretical approach to architectural design.[14] While Vasari admired the fact that the *De re aedificatoria* had been translated into Tuscan by Cosimo Bartoli, he clearly deplored the lack of technical knowledge in projects that were often attributed to Alberti. The vaulting problems in the Rucellai Loggia, which Vasari briefly summarized in the first edition of the *Lives*, were now given a full description in the second. Here Vasari points to the arches of the chapels in the circular choir of the church of the Santissima Annunziata, which, in his mind, appeared to fall backwards. Practical experience would have avoided such difficulties; in both versions Vasari makes it clear in his opinion that theory when separated from practice amounts to very little.

If Vasari's criticism of Alberti's attention to theory (or *scienza*, as he termed it) recalls for us the controversy regarding the balance of theory and practice that arose during the construction of the cathedral of Milan, it also was firmly rooted in his concept of disegno. Vasari referred to the vaulting of the Rucellai Loggia (which he believed was designed by Alberti) as "goffo," a word in his critical vocabulary that meant not only "awkward" but also implied a hideous appearance worthy of mockery and ridicule.[15] If these examples lacked disegno it was because their architect failed to recognize a link between an architectural concept and its execution. The

penalty for such a transgression was the removal from the second edition of the epitaph that called Alberti a Florentine Vitruvius.

The architectural publications of Sebastiano Serlio offered a resolution to the question of the relationship between architectural theory and practice, and if Vasari did not give their author the full recognition that he deserved, it was because the theoretical section on architecture in the *Lives* owed much to Serlio's publications.[16] Vasari divided his "treatise" into seven extremely brief chapters, the same as the number of books that were projected by Serlio. Even if Vasari's unsystematic presentation of subjects is unoriginal and his discussions inadequate, having been lifted in the main from Vitruvius and Alberti, he consulted Serlio's *Libro IV* whenever he needed information on the architectural orders. It was from Serlio that Vasari pilfered both information regarding the association of specific orders with deities and the appropriate examples to illustrate the idea. When faced with the task of discussing the origins and significance of the Corinthian order, for example, Vasari merely paraphrased Serlio's commentary. In one instance Vasari modified one of Serlio's ideas to fit his own concepts of propriety; the Tuscan order was renamed as the Rustic, as if it were inappropriate to identify the most primitive order with the artistically most sophisticated region of Italy.

In two instances Vasari turned to Serlio for information about rustication. The first was the enframement around the entry portal to the new offices for the Monte di Pietà in Florence (plate 237). Executed in conjunction with Vasari's renovation of the interior, the gateway combines the form of the genre of garden gateways with specific examples from Serlio (plate 238). The principal gateway that Vasari designed for the Medici Villa at Poggio a Caiano (plate 239) was more personal and innovative in design, recalling Florence's medieval city gates with its height and lower flanking walls.[17] At the same time, its rustication, brackets, and scrolls evoke Serlio's illustrations of gateways in the *Estraordinario Libro* without suggesting any specific prototype. Lacking the bold relief commonly found in rusticated portals, those by Vasari seem cautious if not tame.

Nothing has been said so far about how useful the *Lives* may have been to artists and especially to architects. In terms of size, its three volumes with more than a thousand pages must have made it a luxury publication with a readership limited to those who

could afford it. The 1550 edition was considered a rarity a decade after its publication, and the existence of an audience in no small part accounted for the decision to prepare a second edition. If its text could be understood by a large number of potential readers, fewer individuals were prepared to appreciate its subtleties. The ideal reader had to be sufficiently educated to master Vasari's sometimes difficult Italian prose and had to possess the skill of visualizing the works of art that he described. Although Vasari drew from descriptive techniques in ancient and modern literature in order to give immediacy to his descriptions, these conventions demanded comprehension before they made any emotional impact on the reader. This was not beyond the intellectual capacity of the artist. Copies owned by El Greco, Federigo Zuccaro, the Carracci, and Velasquez still survive and suggest that the *Lives* may have been essential reading for the educated painter.[18] In fact, modern bibliophiles have surmised that books like the *Lives* are scarce today because they were heavily read in their own time.

Why would an architect want to read the *Lives*? Admittedly there were no illustrations like those found in contemporary treatises. If this was a drawback in terms of its potential influence on completed designs, there was much that it offered architects with an interest in history, especially to the increasing number of foreigners visiting Italy. By placing painting and sculpture at the service and ornament of architecture, Vasari acknowledged its primacy among the arts and its existence as a profession.[19] Above all, it presented biographies of major architectural figures from Arnolfo to Palladio and, in some cases, recounted projects that were not known from other sources. As expected, the buildings that he chose to discuss are those found in surveys of Renaissance architecture today.

How architects may have utilized the *Lives* is illustrated by the copy acquired by Inigo Jones.[20] Like the more famous example of Palladio's *Quattro Libri*, Vasari's book may have served him as a guidebook to Italian art during his tour of Italy in 1613–14.[21] Like many other readers of the *Lives*, Jones annotated the text to locate those passages that interested him most. Like many readers of the *Lives*, Jones underlined pithy aphorisms and sometimes fully translated them in the margins.[22] If many of Jones's selections are commonplace at best, some are revealing about his own architectural sources. For example, Jones

takes particular interest in Fra Giocondo's proposal for replanning the Rialto in Venice. As described by Vasari, the project was composed of three concentric colonnaded squares that focused on a church.[23] But the building that absorbed Jones's interest the most was the Palazzo del Te, not just for the complex subject matter of its decorations as described by Vasari but also for its construction in brick and stucco.[24] This reaction was the result of first-hand observation by Jones, as is proven by his note challenging Vasari's description of the Sala dei Giganti.[25] It is likely that Jones, like Vasari before him, was drawn to Giulio by the similarity of their roles as court architects, Giulio serving the Gonzaga in Mantua and Jones serving the Stuarts in London.[26] The outcome can be seen in Jones' plans for Covent Garden and Whitehall Palace, the two projects most similar to the buildings that he had studied in the *Lives*.

COLLABORATION

To the historian Vasari's frequent collaboration with other architects, artists, and literati is the most troublesome aspect of his architectural career. Misgivings about Vasari's claims to authorship are in large part the result of equivocal evidence, documented but not fully described in the Villa Giulia, inferred by the history and planning of the Uffizi, and long hidden from view in the Badia and the Loggia. At the same time, a division of labor was found in the workshop of nearly every artist, and in the case of architecture, the larger scale of a building always involved the coordination of numerous crafts. What made Vasari's collaborative efforts in architecture different from those of other artists was their anticipation of a system of academic patronage.[27] In each instance Vasari was the controlling force of an organization staffed by reliable assistants, all working in the service of an individual or institutional patron capable of defining the concept and content of an architectural project. If this form of enforced collaboration was the result of unwanted interference, as Vasari perceived the Villa Giulia, then any contribution by an individual architect would be diminished in the final result.

Yet for all of his artistic and administrative skills, Vasari did not envisage himself as either sole master or figurehead manager of an architectural workshop. For example, the basic principle of his practice involved the notable separation of design from execu-

tion, a procedure advocated by Alberti and followed later by many sixteenth-century architects. A passage appended to the biography of Alberti in the second edition of the *Lives* shows that Vasari recognized the full value of capable assistants who could be trusted not to alter their master's design:

> Since architects cannot always be at the site, it is of the utmost advantage to have a faithful and friendly assistant, and if no one else has discovered this, I know this well, and from long experience.[28]

At times this approach was fraught with difficulties. Although Vasari sought to avoid the violent disagreement with fellow professionals that often plagued Vignola's commissions, Giorgio's broad concept of authorship unquestionably piqued his colleagues; in the case of the altar tabernacles for Santa Croce, his own assertion of authorship before an ecclesiastical tribunal contradicted the testimony of Francesco Sangallo, to whom the design had been farmed out.[29]

This phenomenon was as much an outgrowth of the belief in the primacy of disegno as it was characteristic of the workshop tradition. Like many others, Vasari evidently felt that disegno formed a common basis to all of the arts, including architecture. This is not surprising, since the concept of shared experience both facilitates collaboration and justifies the existence of artist-architects like Vasari in an era of emerging specialists. On the other hand, Vasari equated the formulation of a concetto with the authorship of architecture. Consequently, the philosophy of aesthetics that he espoused gave primacy to the *idea* or primary concept behind the creation of any work of art and, by extension, a position of superiority over all others. This conviction posed no contradiction to Vasari, as shown by his rudeness towards carpenter-architects and the unfairness in rendering the efforts of his collaborators in the *Lives*.

The organization of Vasari's architectural workshop was in many ways unlike those of his contemporaries in that it closely followed his handling of large decorative commissions. The structure of authority was corporate, with Giorgio responsible for design, communication with the patron, and overall supervision of numerous anonymous assistants who were regularly employed for items ranging from foundations to decorative stonework and woodwork. As in the Sala dei Cento Giorni, the execution of major buildings were left in the hands of capable assistants who could be trusted not to alter their master's design. The size of individual projects and their demands on Vasari's time elsewhere usually meant that much was delegated to specialists; Bartolomeo Ammannati was almost certainly consulted in the construction of the cupola of the Madonna della Umiltà in Pistoia, and the completion of both the Uffizi and the Arezzo Loggia was directed by Alfonso Parigi the Elder, the first member of a family of architects and decorators who served the Medici grand dukes down to the first half of the seventeenth century.[30] The contributions of other figures have gone unnoticed because of difficulties in defining their role in any project. Shadowy figures like the mastermason Bernardo di Antonio di Monna Mattea, the carpenter Dionigi di Matteo Nigetti, or the stonecutters from the Mechini family appear regularly in the documents and records of payments for the renovation of the Palazzo Vecchio and the construction of the Uffizi.[31]

The choice of collaborators usually depended on the nature of the project. Once again Ammannati assumes an important position in Vasari's projects with the execution of the sculpture in the Del Monte Chapel and participation in the planning of the Uffizi.[32] In the case of the reconstruction of the Badia in Arezzo, Don Vincenzo Borghini, his close friend and documented collaborator, may have assisted Giorgio in a number of ways: securing the commission, providing informed advice about the peculiar needs of the Cassinese order (of which he was a member), and serving as an intermediary between the client and the architect.

Even more important than Vasari's dependence upon collaborators was his professional relationship with Duke Cosimo. While it is not possible to fully determine the roles played by both individuals, Vasari's letters offer much insight into the responsibilities that he shared with his patron. That Cosimo was frequently absent from Florence justified extensive correspondence on architectural matters and demonstrates the authority delegated to Vasari. Always respectful of his patron and clear in his description of work already executed, Vasari took considerable care to accurately represent the current state of any project. In response, Cosimo usually limited his comments to a few words offering approval of further work and financial expenditure. Sometimes the responses were written by secretaries, and Cosimo's own letters are models of brevity. Above all, deci-

sions about architecture were left in Vasari's hands; there is no indication that the duke supplied his architect with directives or ideas to be incorporated into the final design.

In the end, Vasari's collaboration with other architects allowed the Florentine Accademia del Disegno to organize itself into a coherent body capable of executing artistic projects. No event did more to bring about the transformation of an organization of artists into an organ of state policy than the Academy's homage to Michelangelo upon his death in 1564.[33] Here Vasari faced the task of creating an imposing funeral service for the deceased artist. The words that Borghini wrote about the event ("because I am content to start all kinds of things, and you may finish them") are important in this context because they fully characterize Vasari's working relationships with his architectural collaborators.[34] Like the Villa Giulia, the preparation of the obsequies was marred by the animosities and jealousies between artists. Eventually Vasari was able to maintain order by employing his own pupils and younger, more impressionable, artists.[35]

Strictly speaking, the memorial service was initiated by the members of the Academy. But it also had the trappings and symbolism of a state funeral due to a ducal contribution to its cost (albeit a measly one) and its location in San Lorenzo. In spite of Cosimo I's lack of interest in the ceremony, he recognized the political value of an alliance with his artists, many of whom were to serve him the following year in the projects for the ceremonial entry of Princess Johanna. With the adoption of the procedures formulated by Vasari for countless other entries, marriages, baptisms, and funerals, the individuality and identity of the artists now mattered less than the dynastic ambitions of patrons.

THE COURTIER AS ARCHITECT

Vasari practiced architecture within the framework of the court of Cosimo I de' Medici in Florence, by all odds one of the shrewdest patrons in architectural history. The renovation of the Palazzo Vecchio, the Uffizi, and the Corridoio are the most representative examples of Vasari's courtly architecture. The selection of Vasari as his pre-eminent court architect assured the creation of buildings that would further his political and dynastic ambitions in the theater of Eu-

ropean politics. There were compelling reasons to pass over talented artists like Ammannati or Cellini: both lacked the experience of co-ordinating large projects that involved a unity of the arts, their working procedures emphasized deliberation at the expense of speed and efficiency, and their temperaments were unreliable. Vasari, in comparison, presented all of the qualities desired of an artist-courtier: diligence, deference, loyalty, and a broad knowledge of the artistic achievements of other courts.

If an architect was still a necessary adjunct to a cultivated and refined court, his role differed from that exercised by his predecessors a century earlier. The new status of architects meant that Vasari or Giulio Romano were to appear well-bred, be well-educated, and faithfully obey the wishes of their princely employers. This was less the result of calculated unscrupulousness than the need for an architect to fully understand the ambitions of his patron. Only when the architect was fully imbued with the goals and aspirations of his patron could he provide the appropriate imagery for palaces and churches and understand the obscure symbolism of state entries.

The ambitious young Vasari faced fewer opportunities to practice as a painter or architect than the artists of a generation or two earlier. The new political order that resulted from the Spanish peace enforced by Charles V ultimately resulted in the consolidation of smaller states into larger ones, almost all of which were monarchical in their constitutional structures.[36] Inevitably there was a new concentration of patronage within courts as a consequence of centralization of power in their rulers. As a result, the commissions that had come from the members of feudal and urban aristocracies, republican governments, and other forms of civic authority now were more likely to derive from rulers or the administrative bodies to whom power was delegated. The architects who were Vasari's contemporaries did not have to be attached to a court or serve great patrons in this nexus of new patterns of patronage. It is this fundamental change in the circumstances of architectural practice that accounts for Vignola's service to the Farnese in Rome, Alessi's activity in Genoa and Milan, and Palladio's villas designed for members of the Vicentine and Venetian patriciate. By their continuous service to individuals, families, or communities who were at the apex of an increasingly restricted society, architects in the later sixteenth century created a distinctive courtly architecture.

Vasari's attraction to courtly patronage may have been encouraged by Baldassare Castiglione's *The Courtier*, the pre-eminent guide to behavior in sixteenth-century Italy.[37] Given the immediate and vast success of Castiglione's book, it is inconceivable that Vasari would not have read it. At the time of its publication in 1528, the impressionable, seventeen year-old Vasari had just begun his career as a painter in provincial Arezzo, only to leave for Florence in the following year. It cannot be proven precisely if Vasari read *The Courtier* at this time, but he fully understood its text when he was writing the *Lives*. In terms of art theory, the quality of grace that Vasari attributes to painters like Raphael was likely modelled on Castiglione's description of the ideal courtier's behavior.[38] Elsewhere Vasari utilizes literary constructs from *The Courtier* to embellish his biographies. By far the most important of these borrowings is Vasari's adaption of the form of Castiglione's book, a series of conversations between some of the most illustrious figures of the age, as his explanation of how he was encouraged by Paolo Giovio to write the *Lives*. Castiglione's legacy must have taken on a personal dimension when Vasari met Giulio Romano, the close personal friend of Castiglione who became Giorgio's model for the successful artist at court.

Vasari exhibited many of the attributes of Castiglione's ideal courtier. Although not of noble birth, he was on close terms with popes, princes, and members of their courts. If his physical appearance was not groomed and his physical strength, agility, and gracefulness were sometimes compromised by poor health, Vasari's scholarship and familiarity with classical antiquity compensated for any weakness. In one of the dialogues in *The Courtier*, Castiglione asserts that the ideal courtier should know how to draw and paint.[39] In the company of the many humanist writers who were his friends, Vasari must have been a cordial and engaging speaker, as the courteous conversational style of the *Lives* suggests. A master of strategy in obtaining work, Vasari established his reputation by writing biographies that praised great men, as if to follow Castiglione's advice that noble subject matter is the reason why great writings endure.[40]

On the other hand, Vasari was not a courtier in the simple pejorative sense. Whenever he showed fawning admiration, as in the dedications of the *Lives*, he did so within accepted and established conventions.

Nor was he given to compulsive self advancement at court because he had attained the position that he coveted—the primary advisor to Cosimo I on artistic affairs. At a deeper level, Vasari exercised an instructive influence upon Cosimo I and his fame through architectural projects that would achieve a splendor consonant with the greatness of his rule. Something of the cumulative effect of the Uffizi and the Palazzo Vecchio are echoed in Ottaviano Fregoso's exhortation to the courtier to incite his prince to greatness by the examples of ancient figures who were immortalized in statuary erected in public places.[41] Ottaviano also states that great buildings have always been memorials to great rulers, and the courtier's role is to persuade the prince to build in this fashion. More to the point is his advice that princes choose good officials to administer such things, words that justify the kind of position Vasari held, as well as the collaborative effort that he supervised.[42] Just as the courtier who instructs the prince is worthy of a greater title, Vasari's role at the court of Cosimo I was more than that of a painter or an architect.[43] While it would be untenable to claim that Castiglione's writings were the theoretical justification for Vasari's Medicean buildings, it is fair to say that Vasari practiced architecture in the same spirit of commitment to his court as that exercised by Castiglione's ideal courtier.

To discuss the style of patronage in the Uffizi, the renovation of the Palazzo della Signoria, and the Corridoio is to offer a comprehensive assessment of Vasari's architecture. At first glance, these three projects appear radically different in design, as if they had been designed by three separate architects, each with his own distinct preferences for the sources of motifs and ideas. As examples of a courtly architecture, they were intended to facilitate the business of life at court and to glorify the achievements of a kingly ruler. Above all, Vasari's task as the pre-eminent artist at the court of Cosimo I was the creation of its identity. If the result may appear to modern observers as formally incoherent or rhetorically overstated, there is a pervasive and consistent meaning underlying their forms. As such, these examples of courtly architecture were first conceived as symbols of power that were subsequently modified by the circumstances of their sites and use. The architectural *concetti* that Vasari furnished were the keys to the collective identity of Cosimo's new state, a trait

that can be found as well in the Florentine church renovations and the Arezzo Loggia.

The concept of a courtly architecture also assists in revealing new patterns of interchange in architectural ideas. Conventional views of architectural style are based on visible similarities between buildings, but the style of a courtly architecture is measured by the symbols and aspirations that are held in common. Thus courtly buildings may not necessarily resemble the structures that inspired their construction. The sources of Vasari's Florentine buildings show a contentious rivalry with other Italian cities and courts— especially with the papal court in Rome during the reign of Paul III.[44] In terms of siting, they occupy positions of eminence in order to convey the myth of a golden age of peace, prosperity, and justice under the benign dominance of Cosimo I. The few but deliberate references to the architecture of antiquity sought not a revival of its forms but an evocation of greatness of the Imperial court as expressed by Vasari's own designs. Moreover, the utilitarian concerns posed by an active patron facilitated the clever architectural planning of each of these projects, while the generous but still limited source of funds made use of existing buildings; in the case of the Corridoio, it allowed the passageway to nearly disappear altogether.

If the court architect in later sixteenth-century Italy can be defined by his continuous service to a distinguished superior, then Vasari had few peers in the proper sense of the term. Of the various courts in Italy, only that of the Farnese carried out construction on a grand scale that necessitated the residency of Vignola at court. Nor were all architects working in courtly surroundings like Vasari. This is especially true for the architects in Turin, whose service to the dukes of Savoy was valued for their expertise in military design, or Alessi and Palladio, whose rather homogeneous class of patrons constitute a court only to a limited degree.[45] Vasari's true successors were the great court artists of the seventeenth century: Inigo Jones as Surveyor of the King's Works under James I and Charles I; Bernini, whose monumental chapels are the direct heirs of the Del Monte Chapel; and Pietro da Cortona, whose work in the field of large-scale decoration continues a tradition to which Vasari had made notable contributions in Rome and Florence.[46] In Florence, the characteristic details of the Uffizi survived briefly after Vasari's death in the works of Ammannati and Buontalenti, only to be superseded by the sober, more ornamental architecture of the seventeenth and eighteenth centuries.

If we free ourselves from these constraints and begin to look closely at Vasari's buildings and their history, what emerges is the picture of an architect whose creative ideas were stimulated by particular circumstances, those of his patron as well as his own. In no way does this diminish an assessment of Vasari's creativity nor does it make him a puppet architect. To illustrate this point with a specific example all one has to do is view the Uffizi as Viollet-le-Duc and countless other architects have done, rediscovering the panorama that makes one forget the rest of the world.

N O T E S

INTRODUCTION

1. Vasari-Milanesi, 1:3–4.
2. N. Elias, *Power and Civility*, trans. of *Wandlungen der Gessellschaft* by E. Jephcott (New York, 1982), p.8.
3. The best account is still Vasari's own in the *Lives* (Vasari-Milanesi, 7:649–724). Boase, *Vasari*, presents a welcome re-assessment of Vasari's career, but the author's evident antipathy toward Giorgio's paintings and inability to come to grips with his architecture diminishes its achievement. For a full discussion of its merits and shortcomings, see the reviews by M. Baxandall (*Times Literary Supplement*, 1 February 1980, 111), Satkowski (*JSAH* 29, 1980, 244), and S. B. Butters (*BM* 123, 1981, 622–23).
4. Although the painting is normally considered a self-portrait, opinion is divided regarding its authorship. See A. Cecchi in *Giorgio Vasari* 1981, 311–2, and Corti, *Vasari*, 120.

CHAPTER ONE

1. J. Kliemann, "Vasari, Pollastra, e l'allegoria della concezione," *Giorgio Vasari* 1981, 103–4; R. Black, "Humanism and Education in Renaissance Arezzo," *I Tatti Studies. Essays in the Renaissance* 2 (1987):171–238.
2. It is important to note the circumstances that brought the youthful Vasari to the attention of a prince of the Church. Evidently Vasari's family sought to promote the talent of their son and to prepare the way for his later achievements. Cardinal Passerini, a native of Cortona, was a kinsman of Vasari's father, Antonio. For Vasari's family see P. Barolsky, *Giotto's Father and the Family of Vasari's Lives* (University Park and London, 1992), 47–50 and 113; and Boase, *Vasari*, 4–8. For the encounter with Passerini, see Vasari-Milanesi, 7:6–7; for a summary of Passerini's contentious career, see P. N. Holder, *Cortona in Context* (Clarksville, Tenn., 1992), 99–107.
3. Vasari-Milanesi, 7:658.
4. Vasari-Milanesi, 1:312; A. and U. Pasqui, *La cattederale di Arezzo* (Arezzo, 1880); A. del Vita, *Il Duomo di Arezzo* (Milan, 1915), 49–50; Lessmann 1975, 171.
5. Vasari-Milanesi, 1:312; Del Vita, *Il Duomo di Arezzo*, 29n.4.
6. J. Pope-Hennessy, *Italian Gothic Sculpture* (London and New York, 1972), 187.
7. Another possible source deserves brief attention. Vasari would have known Rosso Fiorentino's unbuilt

design for an altar, designed in spring 1529 for a presumed location in the Madonna della Lagrime in Arezzo. Like Vasari's organ, this project incorporated an altar table into a composition of architectural relief on the lower level that focused on a central niche. See E. A. Carroll, *Rosso Fiorentino: Drawings Prints, and Decorative Arts* (Washington, 1988), 162–69.

8. Vasari Milanesi, 7:662–63.

9. For Vasari's visit, see J. Schulz, "Vasari at Venice," *BM* 103 (1961):500–1. For Vasari's description of the decoration, see Frey, 1:111–9, esp. 112.

10. Vasari-Milanesi, 4:610; L. Ragghianti Collobi, *Il Libro de' Disegni del Vasari* (Florence, 1974), I:110.

11. Vasari-Milanesi, 7:672.

12. Artist's houses were first recognized as a special type of residence in J. Burckhardt, *The Architecture of the Italian Renaissance*, trans. James Palmes (Chicago, 1985), 14, with particular attention given to Giulio Romano and the Casa Vasari in Arezzo. For later studies, see M. Wackernagel, *The World of the Florentine Renaissance Artist*, trans. A. Luchs (Princeton, 1981), 345–46; Nikia S. C. Leopold, "Artist's Houses in Sixteenth Century Italy" (Ph.D. diss., The Johns Hopkins University, 1982); and especially E. Hüttinger, ed., *Künstlerhäuser von der Renaissance bis zur Gegenwart* (Zurich, 1985). For Mantegna's house and its still unclear history, see E. E. Rosenthal, "The House of Andrea Mantegna in Mantua," *Gazette de Beaux Arts* 60 (1962):327–48; M. Kraitrova, "Das Haus von Andrea Mantegna in Mantua und von Piero della Francesca in Sansepolcro," in Hüttinger, ed., *Künstlerhäuser*, 51–56.

For recent reviews of the literature on the Casa Vasari and its decorations, with citations to earlier publications, see *Giorgio Vasari* 1981, 21–37; L. Cheney, *The Paintings of the Casa Vasari* (New York and London, 1985), 17–57; A. Paolucci-A. M. Maetzke, *La casa del Vasari in Arezzo* (Florence, 1988). For its architecture and restoration, see A. Secchi, "La Casa del Vasari in Arezzo," in *Giorgio Vasari* 1974, 75–87; *Arch. Arezzo* 1985, 6–9. Although Vasari indicates in the *Lives* that he purchased it in 1540 (Vasari-Milanesi, 7:667–8), the contract for its purchase was not signed until September 1541 (*Giorgio Vasari* 1981, 21).

13. C. Elam, "Lorenzo de' Medici and the Urban Development of Renaissance Florence," *Art History* 1 (1978):43–66; J. Shearman, *Andrea del Sarto*, 2 vols. (London, 1965), 2–6; D. Heikamp, "Federigo Zuccaro a Firenze," *Paragone* 18, n. 207 (1967):3–34.

14. Vasari's description of the Villa Medici at Fiesole (Vasari-Milanesi, 2:442–43) with its site on the slope of a hill and services within its base is virtually interchangeable with the similar elements found in the Casa Vasari. For an analysis of the siting of the Villa

Madama, see J. Shearman, "A Functional Interpretation of the Villa Madama," *RJ* 20 (1983):313–27.

15. For Peruzzi's house in Siena, see C. L. Frommel, *Baldassare Peruzzi als Maler und Zeichner* (Vienna-Munich, 1967–8), 19–20, and R. N. Adams, "Baldassare Peruzzi: Architect to the Republic of Siena, 1527–1535" (Ph.D. diss., New York University, 1977), 11–12, points out that Peruzzi likely spent much of 1530 in Siena working on the decorations for the entry of Charles V. For Titian's house and studio at the edge of the lagoon in Venice, see J. Schulz, "The Houses of Titian, Aretino, and Sansovino," in *Titian: His World and his Legacy*, ed. D. Rosand (New York, 1982), 73–118. For the house of Domenico Beccafumi in Siena, see F. Sriccha Santoro, "La vita," in *Domenico Beccafumi e il suo tempo* (Milan, 1990), 62 and 698.

16. Vasari-Milanesi, 7:667–68.

17. Secchi correctly dismisses earlier hypotheses regarding the existence of an external stair on the north side of the house as lacking both archeological and documentary evidence (Secchi, "La casa del Vasari in Arezzo," 80). It is possible that a smaller door aside the rusticated portal opened directly into the Borgo San Vito, as in the *case nuove*, Pienza. For Pienza, see G. Cataldi, *Rilievi di Pienza* (Florence, 1977); and C. R. Mack, *Pienza: The Creation of a Renaissance City* (Ithaca and London, 1987), 150–3.

18. Secchi, "La Casa del Vasari in Arezzo," 77, suggests without any evidence that the entire lower floor at street level was already extant when the house was purchased and was not altered during the subsequent completion of the house.

19. F. Hartt, *Giulio Romano*, 2 vols. (New Haven, 1958), 1:236–41; K. W. Forster and R. J. Tuttle, "The Casa Pippi: Giulio Romano's House in Mantua," *Architectura* 3 (1973):104–30; F. P. Fiore, "La casa di Giulio Romano a Mantova," in *Giulio Romano* (Milan, 1989), 481–85.

20. A. Conti has noted the influence of Giulio in the decorations of the Casa Vasari, which was limited to the figure of God the Father in the Camera of Abraham (*Giorgio Vasari* 1981, 36).

21. B. Cellini, *Autobiography of Benvenuto Cellini*, ed. C. Hope (London, 1983), 49.

22. Vasari-Milanesi, 5:553.

23. Frey, 1:640.

24. Vasari-Milanesi, 7:509 (Sansovino); 5:469 (Sangallo). See also M. Tafuri, *Venice and the Renaissance*, trans. J. Levine (Cambridge and London, 1989), 229n.101, for a discussion of the resentful tone in Vasari's remarks about Sansovino's well-being.

25. Vasari-Milanesi, 2:337 (Brunelleschi); 7:13 (Vasari).

26. For documents relating to Vasari's investments in

farm land near Arezzo, see G. degli Azzi, "Documenti vasariani," *Il Vasari* 4 (1931):216–31.

27. H. Grimm, "Michelangelos Mutter und seine Steif-mutter," *Jahrbuch der Königlich Preussischen Kunst-sammlungen* 2 (1885):185–201, esp. 199–200; Wack-ernagel, *The World of the Florentine Renaissance Artist*, 346.

28. A. Chastel, "Vasari économiste," in *Fables, Formes, Figures* (Paris, 1978), 387–89.

29. Vasari-Milanesi, 4:445–46.

30. P. J. Jacks, "The Composition of Giorgio Vasari's *Ricordanze*: Evidence From an Unknown Draft." *Renaissance Quarterly* 45 (1992):739–84.

31. For Bandinelli see Barolsky, *Giotto's Father*, 99.

32. Vasari-Milanesi, 5:172–74. Records for Vasari's dis-bursements for June 1572 are in Filza 66, filzetta 2, in the Spinelli *Fondo* at Beinecke Library, Yale University.

33. Vasari-Milanesi, 5:453–54; P. Barolsky, *Why Mona Lisa Smiles and Other Tales by Vasari* (University Park and London, 1991), 97–98. See also K. Clark, Intro-duction to the reprint of the de Vere translation of the *Lives*, 3 vols., (New York, 1979), 1:xxvii.

34. Vasari-Milanesi, 6:379 (Sodoma), and 5:231 (Parmi-gianino). See also R. and M. Wittkower, *Born under Saturn* (New York, 1962), 84–86 and 173–75.

35. Vasari-Milanesi, 6:365; Boase, *Vasari*, 279.

36. For the practice of using apprentices and others as nude models, see Wackernagel, *The World of the Flor-entine Renaissance Artist*, 332n.53; for the story about how Jacopo Sansovino made his assistant pose all day in the nude during winter, see Vasari-Milanesi, 7:493–94.

37. Cellini, *Autobiography*, 88. For a full discussion of Cellini's own prodigal sexuality and its manifestations at the court of Cosimo I, see James M. Saslow, *Gan-ymede in the Renaissance: Homosexuality in Art and Society* (New Haven and London, 1986), 143–56. In this context note particularly Paolo Giovio's coy words in a letter to Vasari "baciandovi dolcemente la fronte sotto al leggiadro vostro ciuffo riccio." See P. Giovio, *Lettere*, ed. G. G. Ferrero, 2 vols. (Rome, 1956), 2:108. Frey, 1:200, transcribes the crucial word as "bassandovi."

38. Frey, 1:207. Evidently Vasari was considering another trip to Venice.

39. For Vasari's comments on the manipulative Lucrezia and his attitude towards artists' spouses in general, see Barolsky, *Giotto's Father*, 47–50.

40. Frey, 1:193–94 (5 January 1547). The extraordinarily free translation of this important letter in Boase, *Vasari* 41, fails to give an accurate rendition of the writer's intentions. Boase also borrows material from a letter of 25 January 1549 (Frey, 1:228).

41. Frey, 1:229–30.

42. Boase, *Vasari*, 41–42; *Giorgio Vasari* 1981, 21.

43. For Minerbetti, see A. Tafi, *I vescovi di Arezzo* (Cor-tona, n.d.), 129–31.

44. Frey, 1:322 and 336.

45. Frey, 1:327–28.

CHAPTER TWO

1. Alberti, 2:864.

2. Vasari-Milanesi, 7:674; P. L. De Castris, "Napoli 1544: Vasari e Monteoliveto," *Bolletino d'Arte* 66, n.12 (1981):59–88. Vasari considered its low vaults clumsy and old-fashioned, contributing to the overall darkness of the interior. The hall was divided into three bays, each nearly square in plan but different in dimension. In order to provide a regular surface for the application of stucco and fresco, the intrados of the vaults was altered by cutting away at its haunches and thickening the apex by nailing the cut *tufa* to its surface. According to Vasari, this volcanic stone com-monly employed in Neapolitan vault construction "could be cut like wood, or better, like partially baked brick." The subsequent addition of plaster allowed further corrections to its surface.

3. For the Sala dei Cento Giorni, see C. Robertson, *"Il Gran Cardinale": Alessandro Farnese, Patron of the Arts* (New Haven and London, 1992), 55–68.

4. Vasari-Milanesi, 5:470; J. S. Ackerman, *The Architec-ture of Michelangelo*, 2 vols. (London, 1961), 2:72–73.

5. For a review of projects commissioned by Julius III, see A. Nova, *The Artistic Patronage of Pope Julius III (1550–1555): Profane Imagery and Buildings for the De Monte Family in Rome* (New York and London, 1988).

6. V. Saletta, "Il viaggio in Italia di Carlo V," *Studi merid-ionali* 10 (1977): 280–1.

7. K. Eubel, *Hierarchica catholica medi et recentibus aevi*, 8 vols. (Regensburg, 1898–1978), 3:57.

8. H. Jedin, *History of the Council of Trent*, 2 vols. (St. Louis, 1957–61), 2:46–48.

9. *Concilium tridentinum: Diariorum actorum epistula-rum tractatum*, 11 vols. (Freibourg i. B., 1901–38), 10:711.

10. *Concilium tridentinum*, 11:490.

11. *Concilium tridentinum*, 1:267; and 10:193–94.

12. *Concilium tridentinum*, 10:711; Jedin, *History of the Council of Trent*, 2:279.

13. *Concilium tridentinum*, 1:633, and 2:382.

14. *Concilium tridentinum*, 11:486.

15. Vasari-Milanesi, 7:689; L. Satkowski, "The Palazzo Del Monte in Monte San Savino and the Codex Gey-müller," *Renaissance Studies in Honor of Craig Hugh*

Smyth, ed. A. Morrogh et al., 2 vols. (Florence, 1985), 2:653–66; Nova, *Artistic Patronage*, 65–66.

16. Cardinal Del Monte in Bologna to Vasari in Arezzo, 30 November 1548 (Frey, 1:229).

17. For the kinds of imported animals found in sixteenth-century Italy, see J. B. Lloyd, *African Animals in Renaissance Literature and Art* (Oxford, 1971); L. Möller, "Der Indische Hahn in Europa," *Art the Ape of Nature: Studies in Honor of H. W. Janson*, ed. M. Barasch and L. Sandler (New York, 1981), 313–40, esp. 335n.7; C. Lazzaro, *The Italian Renaissance Garden* (New Haven and London, 1990), 182–84.

18. Lazzaro, *Italian Renaissance Garden*, 13.

19. The literature on the Del Monte Chapel is extensive. Giorgio's own description of the complex events relating to this project can be found in Vasari-Milanesi, 7:227–31, 521, 693. For the tombs as executed by Ammannati, see J. Pope-Hennessy, *Italian High Renaissance and Baroque Sculpture* (London, 1970), 376–77; for the drawings by Vasari for the initial schemes, see C. Monbeig-Goguel, *Vasari et son temps* (Paris, 1972), 154–56, and especially Morrogh 1985, 31–33. For a recent summary of the chronology see the perceptive remarks by Charles Davis in *Giorgio Vasari* 1981, 91–94, and for new documentation confirming Vasari's central role in the project, see A. Nova, "The Chronology of the De Monte Chapel in San Pietro in Montorio in Rome," *AB* 66 (1984): 150–4. Its important position in the history of chapel decoration in Rome is discussed by S. Kummer, *Anfänge und Ausbreitung der Stuckdekoration im Römischen Kirchenraum (1500–1600)* (Tübingen, 1987), 70–78.

20. Morrogh 1985, 31–32.

21. Correctly noted by Charles Davis in *Giorgio Vasari* 1981, 91. The role of the chapel in the history of San Pietro in Montorio has never been fully explained. According to the documents published by Nova, the amount of money spent on masonry suggests that the apsidal form of the chapel was either new construction or completely rebuilt.

22. *Concilium tridentinum*, 2:248.

23. For a summary of the history of San Giovanni dei Fiorentini, see H. Hibbard, *Carlo Maderno* (University Park and London, 1971), 142–55.

24. Pope-Hennessy, *High Renaissance and Baroque Sculpture*, 376; Nova, "Chronology of the De Monte Chapel," 151.

25. Vasari-Milanesi, 7:229.

26. The connection of the scheme in the Louvre with the tomb in San Giovanni was first made by C. Monbeig-Goguel, *Vasari et son temps*, 156.

27. It is probable that the Del Monte Chapel was based on funerary monuments like that of P. Quinticius as illustrated in E. Nash, *Pictorial Dictionary of Ancient Rome*, 2 vols. (New York, 1961), 2:348–49. This example was discovered c. 1916–18; other tombs of this type likely existed in Rome during the sixteenth century.

28. C. Davis, "Ammannati, Michelangelo, and the Tomb of Francesco Del Nero," *BM* 118 (1976):484, points to similarities in plinth, molding profiles, and the bases of sarcophagi in the Del Nero tomb in Santa Maria Sopra Minerva.

29. Acts 9:10–18. For a review of its iconography in sixteenth-century painting, see L. Steinberg, *Michelangelo's Last Paintings: The Conversion of St. Paul and the Crucifixion of St. Peter in the Cappella Paolina, Vatican Palace* (New York, 1975), 22–26.

30. On one level of meaning, the picture is an elaborate portrait of the donor surrounded by other members of his family. The figure of Ananias is clearly Julius III, as indicated by the long, coarse beard, the sharp pointed aquiline nose with a prominent impression at its bridge, and the rather weary, listless posture of an individual inflicted with considerable physical distress. Just behind Julius the figure observing the healing and baptism with marked detachment is Antonio Del Monte, whose bearded head repeats the features of the recumbent portrait of the deceased on the sarcophagus to the left; the figure of Saul is similar to Fabiano Del Monte in the corresponding tomb to the right. Even the immediately recognizable likenesses of Vasari and his new wife Cosina, whose recent marriage had been facilitated by Julius III, appear respectively in the lower left hand corner and behind Ananias. For other Del Monte portraits, see A. Nova, *The Artistic Patronage of Pope Julius III*, 30–37.

The link to conventions of stage design was noted in C. Davis, review of L. Vagnetti, *De naturali et artificiali prospettiva*, *JSAH* 39 (1980):251–53.

31. The *Transfiguration* measures 405 × 278 cm (1.45:1.00); the contract for the Del Monte altarpiece measures 6⅓ braccia by 4½ braccia (369 × 262 cm, or 1.41:1.00). The width of Vasari's executed painting is 225 cm, or about 3.8 braccia. The contract is included in the *Ricordanze* (Frey, 2:869; *Giorgio Vasari* 1981, 91).

32. K. W-G. Posner, *Leonardo and Central Italian Art: 1515–1550* (New York, 1974), 44–46.

33. For a discussion of the combination of these saints in the context of the Counter-Reformation, see A. Chastel, "Two Roman Statues: Saints Peter and Paul," in *Collaboration in Italian Renaissance Art*, ed. W. S. Sheard and J. T. Paoletti (New Haven and London, 1978), 59–63.

The personal importance of sight to Julius III may also explain why a theme from the life of St. Paul was selected for a chapel in a church linked so closely with

the life of St. Peter. In addition to well-known difficulties with gout, Julius was plagued by problems with his vision. Although there is insufficient evidence to identify their precise nature or when then began, such problems are regularly mentioned in letters and dispatches from Trent. In one instance this may have even resulted in temporary blindness. See Jedin, *History of the Council of Trent*, 2:414.

34. E. Gombrich, "Ecclesiastical Significance of Raphael's *Transfiguration*," in *New Light on Old Masters* (Chicago, 1986), 145–46.

35. Architectural compositions of this sort were not unknown in sixteenth-century painting. A similar exedra (but without Vasari's conspicuous colonnade) can be seen in the background of the *Virgin and Child with Saint John* in the Walters Art Gallery in Baltimore. For this picture and its variants, see F. Zeri, *Italian Paintings in the Walters Art Gallery*, 2 vols. (Baltimore, 1976), 2:355–57 (as Raffaello Dal Colle), and S. Ferino Pagden, "Giulio Romano pittore e disegnatore a Roma," in *Giulio Romano* (Milan, 1989), 75 (as Giulio assisted by Dal Colle).

36. C. Burroughs, "Palladio and Fortune: Notes on the Meaning of the Villa Rotunda," *Architectura* 15 (1988):82, notes the support given by the Pope to the famous musician and composer, Giovanni Pierluigi da Palestrina.

37. L. Alberti, *Descrittione di tutta Italia* (Bologna, 1550), 135–37; Burroughs, "Palladio and Fortune," 82n.89.

38. Vasari-Milanesi, 7:62; G. Andres, *The Villa Medici in Rome*, 2 vols. (New York and London, 1976), 1:102–5; *Oltre Raffaello*, ed. L. Casanelli and S. Rossi (Rome, 1984), 89–90; Kummer, *Stuckdekoration*, 78–80.

39. *Fabbriche romane del primo '500* (Rome, 1984), 56.

40. "Et hora vi e una bellisima sepoltura fabricata de Papa Iulio terzo al Zio Cardinal d'Monte." A. Palladio, *Descritione de le Chiese, Stationi, Indulgenze, et Reliquie de Corpi Sancti, chi sonno in la Città de Roma* (Rome, 1554), 28, reprinted in P. Murray, *Five Early Architectural Guides to Rome and Florence* (Farnborough, 1972). For an English translation and commentary, see E. Howe, *Andrea Palladio: The Churches of Rome* (Binghamton, 1991).

41. Kummer, *Stuckdekoration*, 75.

42. H. Hibbard, *Bernini* (Baltimore and Harmondsworth, 1965), 239–40; I. Lavin, *Bernini and the Unity of the Visual Arts* (New York and London, 1980), 25.

43. Lavin, *Bernini*, 28.

44. Vasari's participation was analyzed first by Frey, 1:348–56. The fundamental studies are J. Coolidge, "The Villa Giulia: A Study of Central Italian Architecture in the Mid-Sixteenth Century," *AB* 25 (1943):178–225, and T. Falk, "Studien zur Topographie und Geschichte der Villa Giulia in Rom," *RJ* 13 (1971):101–78. The most important recent contributions are C. Davis, "Villa Giulia e la 'Fontana della Vergine,'" *Psicon* 4 (1977):132–41; D. Coffin, *The Villa in the Life of Renaissance Rome* (Princeton, 1979), 150–74; F. Lucchini and R. Pallavacini, *La Villa Poniatowski e la Via Flaminia* (Rome, 1981); F. Lucchini, ed., *L'area Flaminia: L'auditorium-Le ville-I musei* (Rome, 1987); Nova, *Artistic Patronage*, 58–135. S. Cocchia, A. Palminteri, and L. Petroni, "Villa Giulia, un caso esemplare della cultura e della prassi costruttiva nella metà del Cinquecento," *Bolletino d'arte* 72, no.42 (1987):47–90. For accurate measured drawings of the casino, garden court, and nympheum, see Associazione per il rilievo, lo studio, ed il restauro del patrimonio architettonico, *La villa di Papa Giulio III* (Rome, 1987).

45. The documentation has been collected by Falk, "Villa Giulia," 135–70, and summarized by Coffin, *Villa*, 152–58.

46. Vasari-Milanesi, 1:111; 7:81–82, 106–7, 233, 497, 521, 694–95.

47. The letter is in the Biblioteca Oliveriana, Pesaro, Ms. 374, vol. II. fol. 91–96. It was first published by S. Betti in "Descrizione delle Villa di Papa Giulio III: Lettere inedita di Bartolomeo Ammannati, Architetto," *Giornale arcadico* 4 (1819):387–98. It was republished by M. Bafile in *Villa Giulia: L'Architettura-Il Giardino* (Rome, 1948), 31–32, and again with emendations by Falk, "Villa Giulia," 171–73.

The main purpose of the letter was to record the design of the Villa Giulia at the time of the death of Julius III. This is clearly supported by Ammannati's statement "L'ornamento non è finito perche andava con grandissima spesa, e tempo e morte ne ha interotti questi e altri disegni belli et honorevoli, de quali non scrivo per non havuto effeto" (Falk, "Villa Giulia," 173)."

But the attention to statuary underscores another objective, which was to exalt the pope's extensive collection of ancient and modern sculpture. The collection was not yet in existence a few years earlier when Ulisse Aldrovandi prepared his enumeration of ancient sculpture in Roman collections, and Ammannati was probably aware that it would not be mentioned when Aldrovandi published *Delle statue antiche che per tutta Roma in diversi luoghi si veggono* (Venice, 1556). Ammannati completed the letter in May 1555, two months after the death of Julius III. No doubt he wished to record the condition of the villa before alterations to its structure and the dispersal of its statuary. The letter's length, clarity, and circumstances of its authorship suggest that this panegyric was meant for publication in some form.

48. Coffin, *Villa*, 171–75. This occurred only after the International Exposition of 1911 and the creation of the Viale dei Belli Arti.

49. S. Alpers, "Ekphrasis and Aesthetic Attitudes in Vasari's *Lives*," *JWCI* 23 (1960):190–215.

50. H. Tanzer, *The Villas of Pliny the Younger* (New York, 1924).

51. D. Coffin, "The Plans of the Villa Madama," *AB* 49 (1967):119–20; Coffin, *Villa*, 248; Raphael's letter was rediscovered by P. Foster, "Raphael on the Villa Madama: The Text of a Lost Letter," *RJ* 11 (1967–68):307–12. An English translation can be found in R. Jones and N. Penny, *Raphael* (New Haven and London, 1983), 247–48.

52. P. Giovio, "Museo iovani descripto," *Scritti dell' arte del Cinquecento* ed. P. Barocchi, 3 vols. (Milan-Naples, 1971–7), 3:2904–18. This was kindly brought to my attention by Candace Adelson.

53. P. De Vecchi, "Il museo gioviano e le *verae imagines* degli uomini famosi," in *Omaggio a Tiziano: La cultura artistica nell età di Carlo V* (Milan, 1977), 87–93; The villa of Paolo Giovio enjoyed considerable fame in its own time. It often served as a retreat for the Spanish governors of Milan in Giovio's absence, falling into disrepair after Giovio's death and demolished in the early seventeenth century. The villa was best known for the portraits of famous men that adorned its interior, several of its features—access by water, a loose arrangement of rectangular courts, and a casino for the display of art—were to reappear in the Villa Giulia. Julius III was familiar with the "iovalissimo edificio" on account of his correspondence with Giovio; for this see, P. Giovio, *Lettere*, ed. G. G. Ferrero, 2 vols. (Rome, 1956), 1:203–4. Vasari, too, only knew the structure second-hand, but its collection of portraits was one of the inspirations for the *Lives*, a book that originally Giovio had intended to write. Ultimately it was the idea of the villa and the authority of its patron that Vasari found appealing. If Paolo Giovio's vague description ultimately offered little direct architectural guidance, it at least reinforced the notion of recapturing the effect of an ancient villa.

54. Falk, "Villa Giulia," 173.

55. Alberti, 2:792–93; F-E. Keller, *Zum Villenleben und Villenbau am Römischen Hof der Farnese* (Berlin, 1980), 4; Nova, *Artistic Patronage*, 129n.181.

56. M. Mercati, *Instruttioni sopra la peste* (Rome, 1576), 109; D. Schullian, "Jacopo Bonacossa and his Regimen for Diseases of the Joints," *Journal of the History of Medicine and Allied Sciences* 4 (1964):347.

57. For example, see the domed temple with four porticoes in the scene of a miraculous resurrection from the predella of the *Deposition* begun in 1539 for the monastic church at Camaldoli (Corti, *Vasari*, 31).

58. See also the plan by Bernardo Gamucci illustrated in A. Frutaz, *Le piante di Roma*, 3 vols. (Rome, 1962), vol. 2, plate 33.

59. For the themes see J. Pinto, "The Landscape of Allusion: Literary Themes in Gardens of Classical Rome and Augustan England," *Smith College Studies in History* 48 (1980):97–113.

60. Falk, "Villa Giulia," 172

61. Belli-Barsali, *Ville di Roma*, 168–69; Davis, "Villa Giulia," 135–37.

62. It has been recognized that the attic in the early eighteenth-century drawing in the Museo di Villa Giulia shows the family crest of Pope Pius V instead of the Discovery of the Acqua Vergine (Falk, "Villa Giulia," 125). With the recovery of the design in the Stockholm drawing, the four reliefs shown in the attic of the Rome drawing are now problematic. Although their subjects have never been conclusively identified, they clearly represent a different selection of themes than those outlined in Ammannati's letter. Apparently they still allude to the four elements; the bathing figures in the first panel suggest water and the flying figure in the third suggests air. It differs also in the number, location, and poses of the roof-top statuary, and in the arrangement of the herms. For the most recent study, see E. MacDougall, "Imitation and Invention: Language and Decoration in Roman Renaissance Gardens," *Journal of Garden History* 5 (1985): 120 and 127. For the attribution of the drawings, see MacDougall, "*L'Ingegnoso Artifizio*: Sixteenth-Century Garden Fountains in Rome," in *Fons sapientae: Renaissance Garden Fountains* (Washington, D.C., 1978), 102n.57.

63. E. E. Rosenthal, *The Palace of Charles V in Granada* (Princeton, 1985), 262–63, claims that in the context of the Counter-Reformation the story of Apollo and Daphne would have been understood as a symbol of the fate of heretics and Protestants who fled Christianity.

64. The drawing is one of twelve sheets in the Cronstedt Collection in the Nationalmuseum, Stockholm, that illustrate various stages in the development of the Villa Giulia and its dependant structures. Their ownership can be traced back to the eighteenth century when they were acquired in Paris by the Swedish architect Carl Johan Cronstedt from the heirs of the painter Claude Audran, who died in 1734 (C. D. Moselius, "Carl Johan och F.A.U. Cronstedts Samlingar pa det damla Fullerö," *Nationalmusei Arsbök* (1942–3): 39–105). That the drawings remained unnoticed can be explained by their possession in the hands of Cronstedt's heirs until March 1942, when his entire collection of 547 sheets was acquired by the Nationalmuseum. Shortly thereafter a selection from the col-

lection was exhibited to the public for the first time. Three drawings from the Villa Giulia group were included and correctly identified without further comment in a brief catalog by E. Langenskold and C. D. Moselius, *Arkitekturritningar, planer ock teckningar ur Carl Johan Cronstedts Fulleröstammling* (Stockholm, 1942). The drawings were called to my attention by Andrew Morrogh. A preliminary assessment was presented by this writer in "The Villa Giulia: Unpublished Drawings in Stockholm" (paper delivered at the 44th Annual Meeting of the Society of Architectural Historians, 24–28 April 1991). Six of the sheets are nearly identical to those in the British Architectural Library (Royal Institute of British Architects), London, suggesting that they are copies after lost originals. For the London drawings, see F. L. Moore, "A Contribution to the Study of the Villa Giulia," *RJ* 12 (1969):171–94.

65. Ovid, *Metamorphoses*, 1:568–76 (trans. F. J. Miller, Cambridge, 1921, 1:43).

66. Particularly important in this context is an unpublished drawing in the Nationalmuseum, Stockholm (CC 1367) that shows a proposal for the Villa Giulia facade employing a central pediment with a serliana beneath it.

67. "perche col palazzo si e voluto obedire ad una bella ed amena valle." Falk, "Villa Giulia," 172.

68. G. P. Stevens, "Notes on the Villa di Papa Giulio," *Journal of the American Institute of Architects* 2 (1914): 539–40. Stevens saw the drawing while it was in the collection of Lawrence Grant White, son of the architect Stanford White. In correspondence Prof. Paul Baker has suggested that the drawing was presumably acquired by White after the death of his father in 1906 and the subsequent dispersal of his drawings to Avery Library, Columbia University, and to the New York Historical Society. Despite the efforts of this writer and Prof. Richard Tuttle to locate the drawing, it remains lost.

69. Coolidge, "Villa Giulia," 184n.46, considered the sheet a scheme for a seventeenth- or eighteenth-century comprehensive restoration of the Villa Giulia. Falk, "Villa Giulia," 124–25, republished the drawing as the earliest known scheme for the villa, an opinion that was supported by Nova, *Artistic Patronage*, 66–67.

70. Claims based exclusively on circumstantial evidence have been advanced for Vasari's authorship, but they should be dismissed on account of his skimpy previous experience as a designing architect. Parallels with the Cortile del Belvedere suggest that Michelangelo or Julius III may have contributed the initial ideas for the casino's interior facade. A much stronger case for Vignola can be made on the basis of his ele-

gant manipulations in composition and in the use of architectural orders, intimate familiarity with Roman antiquity, and preference for lozenge shapes and curved stairs in later designs (especially at Caprarola but also in less-known works like the interior of the Madonna del Piano in Capranica). But the evidence permitting an attribution exclusively to Vignola is not unequivocal. Drawings by Ammannati that illustrate his interest in complex geometric shapes (although not in the lozenge per se) are compelling enough to suggest a role for him in the design of the Villa Giulia's courtyard.

71. E. MacDougall, "The Villa Mattei and the Development of the Roman Garden Style" (Ph.D. diss., Harvard Univ., 1970), 48, notes the similarity of the Villa Giulia to Castello.

72. Lazzaro, *Italian Renaissance Garden*, 196.

73. For Vasari's knowledge of Tribolo's design for Castello, see chapter 7 below.

74. U. Geese, "Antike als Programm-Der Statuenhof des Belvedere im Vatikan," in *Natur und Antike in der Renaissance* (Frankfurt, 1985), 24–50; J. S. Ackerman, *Distance Points: Essays in Theory and Renaissance Art and Architecture* (Cambridge and London, 1991), 357–8.

75. C. L. Frommel, *Der Römische Palastbau*, 3 vols. (Tübingen, 1973), 2:336–54; D. R. Coffin, *Gardens and Gardening in Papal Rome* (Princeton, 1991), 21–22.

76. "et molto rallegra la vista il verde fra il biancho." Falk, "Villa Giulia," 173.

77. For a drawing attributed to Vasari that shows a small chamber oufitted to display ancient sculpture (Budapest, Museum of Fine Arts, no. 1873), see *Giorgio Vasari* 1981, 33–34.

78. Vasari-Milanesi, 1:576–77.

79. This is most apparent in the proportions of the pier niches in the garden courtyard's side walls. Departing from the tall and narrow niches favored by Bramante in the upper level of the Cortile del Belvedere, those at the Villa Giulia follow a 2:5 ratio approximating the geometric schemata employed in the design of the various Orsanmichele tabernacles. Vasari was to bring this motif to Florence, employing it first on the facade of Grotta Grande in the Boboli Garden, and later on the exterior of the Uffizi. For Orsanmichele, see D. Zervas, "Ghiberti's St.Matthew Ensemble at Orsanmichele. Symbolism in Proportion," *AB* 58 (1976): 36–44.

80. Vasari-Milanesi, 7:222. Vasari's claim that the exterior facade of the Palazzo dei Conservatori was to have contained ground floor niches for the display of ancient figures seems to be erroneous. It is not clear how Michelangelo would have accomplished this, nor can

the date of the proposal be determined with any certainty. For a review of the problem, see G. Hedberg, "The Farnese Courtyard Windows and the Porta Pia: Michelangelo's Creative Process," *Marsyas* 15 (1970–71):69–70; and particularly A. Morrogh, "The Palace of the Roman People: Michelangelo at the Palazzo dei Conservatori," forthcoming in *RJ*.

81. J. S. Ackerman, *The Architecture of Michelangelo*, 2 vols. (London, 1964), 2:64–65.

82. Coffin, *Villa*, 163; R. Lanciani, *Storia degli scavi di Roma*, 4 vols. (Rome, 1902–12), 2:109.

83. Falk, "Villa Giulia," 172.

84. A. Morrogh, "Vasari and Coloured Stones," in *Giorgio Vasari* 1985, 309–20.

85. Alberti, 2:806–7.

86. Coffin, *Villa*, 163; Nova, *Artistic Patronage*, 98–99.

87. For Michelangelo's use of this motif, see H. A. Millon and C. H. Smyth, "A Design by Michelangelo for a City Gate: Further Notes on the Lille Sketch," *BM* 117 (1975): 162–66. For the date of the drawing, which falls near (if not within) the period of the Villa Giulia's construction, see H. A. Millon and C. H. Smyth, *Michelangelo Architect* (Milan, 1988), 143–47.

88. C. L. Frommel, "Antonio da Sangallos Cappella Paolina," *Zeitschrift für Kunstgeschichte* 27 (1964): 1–42; B Davidson, "The Decoration of the Sala Regia under Pope Paul III," *AB* 58 (1976):395–423; L. Partridge and R. Starn, "Triumphalism and the Sala Regia," in *Art and Pagentry in the Renaissance and Baroque*. Papers in Art History from the Pennsylvania State University, VI (University Park, 1990), 1:22–81. For the stuccowork of the Villa Giulia, see P. Hoffmann "Scultori e stuccatori a Villa Giulia. Inediti di Federico Brandini," *Commentari* 17 (1967):48–66.

89. As a consequence of the renewed interest in the medical practices of antiquity, many writers urged the restoration of taking water cures as therapy for gout, among many other diseases; one leading physician prescribed bathing inflated limbs with water of the Acqua Vergine (Mercati, *Instruttione*, 115; Coffin, *Villa*, 170). Nor was comfort denied to those who were incapacitated; the kind of luxury exemplified by the Villa Giulia was considered in the sixteenth century to be the proper complement to the cure. For this practice, see R. Palmer, "'In this our Lightye and Learned Tyme': Italian Baths in the Era of the Renaissance," *The Medical History of Waters and Spas, Medical History*, supplement No. 10, ed. R. Porter (London, 1990), 18–19. Although the link between gout and heredity was already well-known in antiquity, Renaissance physicians typically understood gout as the consequence of overindulgence. For a clinical history of gout, see W. Copeman, *A Short History of the Gout and*
the Rheumatic Diseases* (Berkeley and Los Angeles, 1964), 48–64; and J. Talbott and T-F. Yu, *Gout and Uric Acid Metabolism* (New York, 1978), 1–25. Lack of knowledge resulted in a variety of questionable treatments.

The pope's own doctors were divided on this subject; the most prominent, Agostino Ricchi of Lucca, a member of the Vitruvian Academy who had translated the work of the ancient physician Galen, prescribed hydrotherapy while another, Jacopo Bonacossa of Ferarra (1483–1553) who had served as *primarius medicus* to both Paul III and Julius III, advocated a regimen that avoided excess in food, drink, and physical activity. Hess, in a resume of a lecture on the Villa Giulia, *Rendiconti. Atti della Pontifica Accademia Romana di Archeologia* 27 (1953):155, cites the name of Ricchi. Schullian, "Jacopo Bonacossa," 342–44, cites the Ferrarese Bonnacossa. Further links with the pope may be inferred by an epitaph commemorating Bonacossa in San Pietro in Montorio, the location of the Del Monte Chapel. It is unlikely that Julius III ever followed this prescription, though he clearly would have welcomed Bonacossa's suggestion that playing dice was good therapy for lack of movement in the upper members (Schullian, "Jacopo Bonnacossa," 354). For the Jewish doctors consulted by Julius III, see H. Vogelstein, *A History of the Jews in Rome*, tr. M. Hadas (Philadelphia, 1940), 264.

Whatever cures Julius III may have taken at the villa, they never would have involved bodily immersion in the nympheum's waters. The route to the lowest level of the nympheum was too narrow and tortuous for an individual with limited mobility, and the watercourse was simply too shallow to be effective. A more convincing example of the pope's infirmities affecting the design is the adoption of the ramped circular staircase in the Casino that permitted access to the upper level in a litter or on a donkey.

90. M. Van der Meulen, "Cardinal Cesi's Antique Sculpture Garden: Notes on a Painting by Hendryck van Cleef III," *BM* 116 (1974):14–24; Davis, "Villa Giulia," 134; Lazzaro, *Italian Renaissance Garden*, 109–110.

91. Vasari-Milanesi, 7:694.

92. Vasari-Milanesi, 7:81 and 694.

93. Vasari-Milanesi, 7:106–7.

94. Frey, 1:314–15.

95. Vasari-Milanesi, 7:694.

CHAPTER THREE

1. For the role of the square in the political history of Florence, see N. Rubinstein, "The Piazza della Sig-

noria in Florence," in *Festschrift Heinrich Siebenhü-ner*, (Wurzburg, 1978), 19–26; for its relationship to the construction of the Palazzo Vecchio, M. Trachtenberg, "What Brunelleschi Saw: Monument and Site at the Palazzo Vecchio," *JSAH* 47 (1988):14–44.

2. Rubinstein, "Piazza della Signoria," 26. For additional details, see also P. Spilner, "*Ut civitatis amplietur*: Studies in Florentine Urban Development" (Ph.D. diss., Columbia Univ., 1987), esp. 391–92.

3. P. Sanpaolesi, "San Pier Scheraggio," *Rivista d'arte* 15 (1933):129–50 and 16; (1934):1–24; H. Saalman, "Michelozzo Studies: The Florentine Mint," in *Festschrift für Ulrich Middeldorf*, 2 vols. (Berlin, 1968), 2:140–42.

4. Paatz, *Kirchen von Florenz*, 4:663.

5. Lessmann 1975, 46 and 382n.176.

6. The most important was Bandinelli's Udienza in the Salone dei Cinquecento. See particularly C. Adelson "The Decoration of the Palazzo Vecchio in Tapestry: The *Joseph* Cycle and other Precedents for Vasari's Decorative Campaigns," in *Giorgio Vasari* 1985, 145–78; and J. Cox-Rearick, "Bronzino's *Crossing of the Red Sea and Moses Appointing Joshua*: Prolegomena to the Chapel of Eleonora of Toledo," *AB* 69 (1987): 45–67.

7. Morrogh 1985, 17–20.

8. Vasari-Milanesi, 6:171–2.

9. The proposal was first mentioned by F. Bocchi-G. Cinelli, *Le belleze della città di Firenze* (Florence, 1677), 71. Subsequent literature on the project is reviewed in Morrogh 1985, 21–22. Though audacious, the design would not have been unique. The scheme recalls several contemporary projects to construct squares in the manner of Roman *fora*, such as Bramante's Piazzale Apostolico in Loreto, Sansovino's transformation of the Piazza San Marco in Venice (1537), and Giulio Romano's proposal to surround the Piazza dei Signori in Vicenza with a new arcade (1542).

10. The chronicles and other documentary evidence are collected in Lessmann 1975, 353–8; for a review of this in light of the identification of the drawing by Sangallo, see Morrogh 1985, 18–19.

11. Morrogh 1985, 19. D. Heikamp, "La Galleria degli Uffizi descritta e designata," in *Gli Uffizi: quattro secoli di una galleria*, ed. P. Barocchi and G. Ragioneri, 2 vols. (Florence, 1983), 1:474, takes the position that Vasari's Corridoio was originally meant to provide a secure access to the Belvedere; the same kind of protection would have been provided by Sangallo's scheme were it to have continued on to the Boboli Gardens.

12. E. Cochrane, *Florence in the Forgotten Centuries, 1527–1800* (Chicago and London, 1974), 53–6;

F. Diaz, *Il Granducato di Toscana. I Medici*, vol. 13 *Storia d' Italia*, (Florence, 1976), 127–48.

13. F. Del Migliore, *Firenze: Città Nobilissima* (Florence, 1684), 554–68; F. Borsi, *Firenze del Cinquecento* (Rome, 1974), 100–3; Morrogh 1985, 30–31.

14. G. B. Adriani, *Istoria de' suoi tempi* (Florence, 1583), 605; Lessmann 1975, 19 and 363n.32.

15. A. d' Addario, "Burocrazia, economia, e finanze dello Stato Fiorentino alla metà del Cinquecento," *Archivio storico italiano* 121 (1963):422n.36; R. Goldthwaite, *The Building of Renaissance Florence* (Baltimore and London, 1980), 270.

16. E. Fasano Guarini, *Lo stato mediceo di Cosimo I* (Florence, 1973); R. B. Litchfield, *Emergence of a Bureaucracy: The Florentine Patricians, 1530–1790* (Princeton, 1986).

17. For Vasari's own account see Vasari-Milanesi, 7:245–8; for documentation, see particularly the letters between Michelangelo and Vasari dated 8 May 1557 (Frey, 1: 475–76) and 22 May 1557 (Frey, 1: 477–78), and 1 July 1557 to his nephew Lionardo (Frey, 1: 483); for their impact on St. Peter's, see H. A. Millon and C. H. Smyth, "Michelangelo and Saint Peter's. Observations on the Interiors of the Apses, a Model of the Apse Vault, and Related Drawings," *RJ* 16 (1976):172–74.

18. L. Pastor, *History of the Popes*, 15:81–82 and 100; Morrogh 1985, 36.

19. For Cosimo's adoption of Augustan themes, see P. Richelson, *Studies in the Personal Imagery of Cosimo I de'Medici, Duke of Florence* (New York and London, 1977), 76n.8.

20. Morrogh 1985, no. 12 (Uffizi 3457A), 37–40.

21. Morrogh 1985, no. 11 (Uffizi 3408A), 33–36.

22. Morrogh 1985, no. 23 (Uffizi 4881A), 63–67.

23. Morrogh 1985, 46.

24. Frey, 1:522; Lessmann 1975, 229, Frey assumes that this is the same wooden model mentioned in a letter of 19 December 1561 (Frey, 1:649).

25. Frey, 1:537.

26. Frey, 1:535–36.

27. Frey, 1:538–45.

28. Measurements taken by Ralph Lieberman and the author indicate that there are minor differences in the dimensions of the central space, which is marginally wider at the testata, and in the widths of the facade units. For example, the face-to-face dimension of the central space increases from 17.90 m at the intersection of the Via Lambertesca to 18.10 m at the testata. On the eastern arm, the width of the central openings in each facade unit (as measured by the distance between the inner faces of their flanking piers) averages 10.68 m, excepting only the second bay containing the stairs to the theater on the piano nobile,

which is 10.57 m. The corresponding units on the western arm show a remarkable precision, all of which measure 10.65 m.

29. Lessmann, "Uffizi," 364n.41; for the history of the theater, see D. Heikamp, "Il Teatro Mediceo degli Uffizi," *Bolletino del Centro Internazionale di Studi di Architettura "Andrea Palladio"* 16 (1974):323–34; Morrogh 1985, 61–63.

30. Using both construction documents and painted representations, A. Forti, "L'opera di Giorgio Vasari nella fabbrica degli Uffizi," *Bolletino degli Ingegneri* 19 (1971): 23–25, 33–39, and 20; (1972): 13–25, argues that the upper floor was not part of the original design. This is clearly incorrect, because it appears in Domenico Poggini's 1561 foundation medal.

31. D. Heikamp, "Zur Geschichte der Uffizientribuna und der Kunstschränke in Florenz und Deutschland," *Zeitschrift für Kunstgeschichte* 26 (1963): 193–268.

32. W. Prinz, "Informazione di Filippo Pigafetta al Serenissimo di Toscana per una stanza di piantare lo studio di architettura militare," in *Gli Uffizi: quattro secoli di una galleria*, 1:343–53.

33. N. Bemporad, "Gli Uffizi e la scala buontalentiana," *L'architettura* 14 (1968–1969):611–19. For the exhibition of art in the Uffizi, see P. Barocchi, "La storia della Galleria degli Uffizi e la storiografia artistica," *Annali della Scuola Normale Superiore di Pisa* 12 (1982):1411–1523. For the first drawings showing the arrangement of paintings, see M. McCarthy, "The Drawings of Sir Roger Newdigate: The Earliest Unpublished Record of the Uffizi," *Apollo* 134 (1991):159–68.

34. Lessmann 1975, 44–46 and fig.13; Morrogh 1985, 18.

35. The reuse of material presumably from the destroyed houses is mentioned in a letter of 6 May 1564 from the *proveditori* to Duke Cosimo: "Questa fabbrica viene mancando di sassj, et sarebbe bene haver de sassi di cava per mescolar con questi pezzami delle rovine" (Frey, 3, 199).

36. Lessmann 1975, 94–95.

37. G. Richa, *Notizie istoriche delle chiese fiorentine*, 10 vols. (Florence, 1754–62), 2:15–16.

38. Pietro Leopoldo d'Asburgo Lorena, *Relazioni sul governo della Toscana*, ed. R. Salvestrini, 2 vols. (Florence, 1970), 2:283.

39. Pietro Leopoldo d'Asburgo Lorena, *Relazioni*, 2:270.

40. For a comparison of the costs of other buildings, see J. Connors, *Borromini and the Roman Oratory* (Cambridge and London, 1980), 60.

41. Lessmann 1975, 57–63.

42. U. Dorini, "Come sorse la fabbrica degli Uffizi," *Rivista storica degli archivi toscani* 5 (1933):7.

43. Goldthwaite, *Building of Renaissance Florence*, 257.

44. Dorini, "Uffizi," 11.

45. Dorini, "Uffizi," 8.

46. Frey, 3:190–1; Lessmann, 1975, 66. The office maintained by the *Proveditori* was located in the former residence of the Arte della Seta near the Mercato Nuovo.

47. Dorini, "Uffizi," 17n.1; Lessmann 1975, 270.

48. Cited by Frey, 1:588, and Dorini, "Uffizi," 16. Transcribed in full by Lessmann 1975, 247–48.

49. For new documentation and an assessment of Puccini's role in the administration of the Uffizi, see D. Lamberini. *Il principe difeso. Vita e opere di Bernardo Puccini* (Florence, 1990), 145–62.

50. Frey, 2:640–2.

51. Frey, 1:538; Dorini, "Uffizi," 2–3, Lessmann 1975, 76. There is no reason to doubt the accuracy of Vasari's count of 43 houses as mentioned in the letter originally published by Frey. Documents account for 34 houses. The extravagant claim of 300 houses by Francesco Settimanni reflects his anti-Medicean sentiments.

52. Dorini, "Uffizi," 15. Confirmed by Lessmann 1975, 69, and 249–50 doc. 29 (ASF, Magistrato di Nove Conservatori, 3710, fol. 123r).

53. Dorini, "Uffizi," 19; Lessmann 1975, 78.

54. Dorini, "Uffizi," 29–30; Goldthwaite, *Building of Renaissance Florence*, 231; Lamberini, *Il principe difeso*, 154–56.

55. Lessmann 1975, 416n.410; transcribed in full, 324–326 doc. 160 (ASF, Magistrato di Nove Conservatori, 3710, fol. 162v–164).

56. Goldthwaite, *Building of Renaissance Florence*, 204–6.

57. Lessmann 1975, 146–54, links the Uffizi to the Palazzo dei Conservatori on the Capitoline and by extension, the medieval porticoed communal palace; the discussion of administrative office buildings is limited mainly to the agencies found in Bramante's Palazzo de Tribunali. N. Pevsner, *A History of Building Types* (Princeton, 1976), 27–34, studies only Italian communal palaces, as outlined by J. Paul, *Der Palazzo Vecchio in Florenz* (Florence, 1969).

58. C. W. Westfall, *In This Most Perfect Paradise. Alberti, Nicholas V and the Invention of Conscious Urban Planning in Rome, 1447–55* (University Park, Pa., and London, 1974), 99–100.

59. C. L. Frommel, *Der römische Palastbau der Hochrenaissance*, 3 vols. (Tübingen, 1973), 2:327–35; S. von Moos, "The Palace as Fortress: Rome and Bologna under Julius II," in *Art and Architecture in the Service of Politics*, ed. L. Nochlin and H. A. Millon (Cambridge and London, 1978), 50–56.

60. Vasari-Milanesi, 4:159–60.

61. Cosimo saw the Uffizi in administrative terms, preferring to call it the "Magistrati" in his correspondence (Frey, 1:522). Other references were more general in their vocabulary, referring to the "Uffizi" or offices, thereby confirming the validity of the name we know today (Frey, 1:537). Some chroniclers characterized the project by visible architectural features ("Residentie de Magistrati insieme nella Via de Magistrati," Lessmann 1975, 232; "stanze de' Magistrati, nouve, et a dove sono le logge innanzi a dette stanze, rimpetto alla Zecca," Lapini, *Diario fiorentino*, 129). A considerable number of references emphasized its links to urban planning (strada nuova de' Magistrati, Via de' Magistrati), including Vasari himself in the *Lives* (Dorini, "Uffizi," 30n.1). The term that Vasari used in both his correspondence and in the *Lives*, the Fabbrica de' Magistrati, was vague because it could mean either "the building under construction for the Magistrates" or the administrative office in charge of its construction. Modern conceptions of the Uffizi as a palace or a courtyard never appear in sixteenth-century documents.

 In the 1568 edition of the *Lives* Vasari characterized the Uffizi as "strada de' Magistrati" (G. Vasari, *Vite de' più eccellenti pittori, scultori, e architettori*, 3 vols. [Florence, 1568], 1:20), the term that was repeated in Bottari's eighteenth-century reprint (G. Vasari, *Vite . . .* , ed. G. Bottari, 3 vols. [Rome, 1759–60], I:xviii). Much of the modern confusion over the classification of the Uffizi as a building type may be due to Milanesi, who incorrectly transcribed Vasari's text as "stanza de' Magistrati" (Vasari-Milanesi, 1:126). Modern authors have failed to notice a question of textual accuracy raised by this important passage.

62. J. H. Elliot, "Spain and its Empire in the Sixteenth and Seventeenth Centuries," *Early Maryland in a Wider World*, ed. D. B. Quinn (Detroit, 1982), 58–83, reprinted in Elliot, *Spain and its World, 1500–1700: Selected Essays* (New Haven and London, 1989), 7–26.

63. J. H. Elliot, "The Court of the Spanish Habsburgs: a Peculiar Institution?" in *Politics and Culture in Early Modern Europe: Essays in Honor of H.G. Koenigsberger*, ed. P. Mack and M. C. Jacob, (Cambridge, 1987), 8–9.

64. J. M. Batista i Roca, foreward to H. G. Koenigsberger, *The Practice of Empire*, 2nd ed. (Ithaca, N.Y., 1969), 14.

65. G. d'Agostino, "Il governo spagnolo nell Italia meridionale (Napoli dal 1503 al 1580)," in *Storia di Napoli*, 10 vols. (Naples, 1967), 3:3–159); F. Strazzullo, *Edilizia e urbanistica a Napoli dal '500 al '700* (Naples, 1968), 6–17.

66. R. Filangieri, *Il Castello di Capuana* (Naples, n.d.); F. de Filippis, *Castelcapuano, reggia e fortezza* (Naples, 1956); C. de Seta, *Napoli* (Bari, 1981), 118–19.

67. For the appearance of Castel Capuano around 1700, see the painting by Asciano Luciani in *Painting in Naples 1606–1705: From Caravaggio to Giordano*, ed. C. Whitfield and J. Martineau (London, 1982), 27fig.7.

68. F. Nunziate, "Castel Capuano, sede dei tribunali," in *Napoli nobilissima*, 2:113–18.

69. D. Howard, *Jacopo Sansovino* (New Haven and London, 1975), 8–10.

70. Howard, *Jacopo Sansovino*, 14–15. The Procuratie Nuove, which take up the entire south side of the square, were constructed after Sansovino's death by Scamozzi.

71. Other sources have been proposed for the Uffizi's plan. For the Piazzetta in Venice, see L. Berti, "L'architettura manieristica a Firenze e in Toscana," *Bolletino del Centro Internazionale di Studi di Architettura "Andrea Palladio"* 9 (1967):211–18; for the Calle del Paradisio, also in Venice, see Lessmann 1975, 165; for the Strada Nuova in Genoa, see Heydenreich and Lotz, 322. The similarities in concept between the Strada Nuova and the Uffizi are accidental. There is no evidence that Vasari had ever visited Genoa or had met Galeazzo Alessi, to whom the layout of the Strada Nuova is traditionally attributed. It is probable that he heard of the Genoese project from the sculptor, Fra Giovanni Montorsoli, who had returned to Florence in 1561, by which time the design for the Uffizi had been finalized and construction begun. For Vasari's interest in Montorsoli's work in Genoa, see A. Morrogh, "Vasari and Coloured Stones," in *Giorgio Vasari* 1985, 314.

72. Trachtenberg, "What Brunelleschi Saw," 36–37.

73. W. Braunfels, *Mittelalterliche Stadtbaukunst in der Toskana* (Berlin, 1952), 119; Spilner, "Studies," 431–33.

74. B. Poccetti, view from frescoes illustrating the *Life of St. Anthony*, as shown in G. Fanelli, *Firenze: architettura e città*, 2 vols. (Florence, 1973), 2fig. 634.

75. Vasari-Milanesi, 1:125–26; Maclehose and Brown, *Vasari on Technique*, 58n.97.

76. Vasari-Milanesi, 1:130–1.

77. "Ma col medesimo consiglio preparò egli un palazzo per la podesta et per li giudici delle cause civili, et questo con magnificenza di vero et in tutti le parti adornato, essendo condito ancora con dolcezza per la vista del fiume, che correndo quasi lo bangna, et de'campi similimente con leggiadra coltivati" (P. Vettori, *Orazione recitata nell' esequie del Sereniss.*

Cosimo de' Medici, Gran Duca di Toscana [Florence, 1574], 9v).

78. Lessmann 1975, fig. 13; Morrogh 1985, 18.

79. Vasari-Milanesi, 7:224–25. For the most recent review of the history of the rear wing of the Palazzo Farnese and the unbuilt bridge proposed by Michelangelo, see C. L. Frommel, "La construction et la decoration du Palais Farnèse. Sangallo et Michelange," *Le Palais Farnèse*, 2 vols. in 3 (Rome, 1981), 1, i:168.

80. For the adoption of this arrangement in Rome, see J. Connors, "Alliance and Enmity in Roman Baroque Urbanism," *RJ* 25 (1989):227–29.

81. Frommel, *Der Römische Palastbau*, 2:107no.42; L. Spezzaferro and R. J. Tuttle, "Place Farnèse: Urbanisme et politique," *Le palais Farnèse*, 115–16.

82. There is no consensus among modern writers regarding the Uffizi's meaning. Most critics have stressed its formal qualities at the expense of its symbolism; the most characteristic examples are the *raumflucht* mentioned by German writers on Mannerist architecture and its relationship to the works of Michelangelo—"a free transposition of the (Laurentian) library reading room to the outdoors (J.S. Ackerman, *Michelangelo*, 2 vols. [London, 1961], 1:140). Using contemporary descriptions of the Uffizi as evidence, Vasari's design has been explained as a street by W. Lotz, "Mannerism in Architecture. Changing Aspects," in *Studies in Western Art, 2: The Renaissance and Mannerism. Acts of the Twentieth International Congress of the History of Art,* (Princeton, 1963), 239–46; and Heydenreich and Lotz, 322. Georg Kauffmann's interpretation of the Uffizi as a forum was the first to suggest that its imagery was rooted in Roman antiquity (G. Kauffmann, "Das Forum von Florenz," *Studies in Renaissance and Baroque Art Presented to Anthony Blunt* [London, 1967], 37–43). Provocative as the ideas were, Kauffmann's study did not fare well in subsequent publications. Largely due to its failure to identify specific ancient illusions in the Uffizi's forms, the interpretation was regarded as "speculative" (K. Forster, "Metaphors of Rule. Political Ideology and History in the Portraits of Cosimo I de' Medici," *MKIF* 15 [1971]: 86n.72). Links with Roman architecture, however, have been confirmed in Morrogh's characterization of the Uffizi as a basilica open to the sky (Morrogh 1985, 46, 66). Most recently the testata and its sculptural ornamentation has been interpreted as "a claim to extra-Florentine grandeur in an Augustan age reborn through Cosimo" (R. J. Crum, "*Cosmos, the World of Cosimo*: The Iconography of the Uffizi Facade," *AB* 71 [1989]: p.253).

83. "A 24 Luglio si cominciorno i fondamenti delle Logge delli Uffizi e della Zecca e fu gran danno di molti artigiani chi avevano case, e botteghe, e di molti cittadini ancor che ci avevano case e edifizi che in tutto furono 300." BNCF, Panciatichi, 116, "Diario di N.N. delle cose seguite in Firenze dall' anno MDLVII al (vacant)," vol. 3, 321 (Lessmann 1975, 234–35no.8).

84. Dorini, "Uffizi," 6.

85. The best studies of the evolution of the arrangement of statuary and its political message are V. Bush, "Bandinelli's *Hercules and Cacus* and Florentine Traditions," *Studies in Italian Art and Architecture, 15th through 18th Centuries*, ed. H. A. Millon (Cambridge, 1979), 163–206; and K. Weil-Garris, "On Pedestals. Michelangelo's *David* and Bandinelli's *Hercules and Cacus* and the Sculpture of the Piazza della Signoria," *RJ* 20 (1983): 377–415. See also M. Fader, "Sculpture in the Piazza della Signoria as an Emblem of the Florentine Republic" (Ph.D. diss., University of Michigan, 1977), and for *David*, N. R. Parks, "The Placement of Michelangelo's *David*: A Review of the Documents," *AB* 56 (1975): 560–70.

86. M. Campbell-G. Corti, "Ammannati's Neptune Fountain in Florence and the Spanish Armada," *Essays Presented to Myron P. Gilmore*, ed. S. Bertelli and G. Ramakus, 2 vols. (Florence, 1978), 2:92.

87. For the ornamentation of the facade as a whole, see Lessmann 1975, 216–20; for the statuary on the riverfront loggia, see Crum, "The Iconography of the Uffizi Facade," 241–47.

88. For Poggini's medal, see G. Hill and G. Pollard, *Renaissance Medals form the Samuel H. Kress Collection at the National Gallery of Art* (London, 1967), 63 no.341. Poggini's omission of the riverfront loggia has lead some scholars to assume that the Uffizi was originally conceived as two separate structures, and that the riverfront loggia was built as a later addition. This view was most recently restated by Crum, "The Iconography of the Uffizi Facade," 238. For a discussion of the subject, see L. Satkowski, "On the Iconography of the Uffizi Facade," *AB* 72 (1990):131–32, and the response by Crum, Ibid., 132–5. Such an account fails to consider that the omission of the loggia was primarily an artistic conceit to show more effectively the visual relationship of the proposed building with the Palazzo Vecchio, and that the Corridoio, which determined the level of the Uffizi's upper floor, was already an old idea (Morrogh 1985, 17–18). That Vasari was considering the loggia's sculptural ornamentation as early as 1563 (Frey 3:54) clearly indicates that it was not designed and constructed merely for the 1565 wedding of Francesco de' Medici and Johanna of Austria.

89. Vasari-Milanesi, 7:632–33; Frey 3:54; J. D. Summers, *The Sculpture of Vincenzo Danti: A Study in the Influence of Michelangelo and the Ideals of the Maniera* (New York and London, 1979), 165–69 and 396–97.

90. Lessmann 1975, 215 and 317–18no.148.

91. B. Davanzati, "Orazione Terza in morte del Gran Duca Cosimo Primo," *Prose Fiorentine raccolte dallo Smarrito Accademia della Crusca*, 6 vols. (Venice, 1735), 1:25. Cited by K. Fortser, "Metaphors of Rule," 86n.72; Morrogh 1985, 46–47; Crum "Iconography of the Uffizi Facade," 253. The authorship of the program is not clear. R. Williams, "Vincenzo Borghini and Vasari's *Lives*" (Ph.D. diss., Princeton University, 1988), 143n.204, speculates that Vincenzo Borghini may have been its originator. The suggestion is attractive and is supported by the fact that Borghini had contemplated a universal *uomini illustri* as an alternative for the completion of the *Discorsi*.

92. For Castello, see Vasari-Milanesi, 6:83–84, and D. Wright, "The Medici Villa at Olmo a Castello" (Ph.D. diss., Princeton University, 1976), 158–61; for the Mercato Nuovo, see F. del Migliore, *Firenze. Città nobilissima* (Florence, 1684), 563.

93. This drawing was first called to my attention by Andrew Morrogh.

94. K. Langedijk, *The Portraits of the Medici, 15th-18th Centuries*, 2 vols. (Florence, 1981), 1:475; J. Cox-Rearick, *Dynasty and Destiny in Medici Art* (Princeton, 1984), 282n.117. Summers, *Sculpture of Vincenzo Danti*, 169–74 and 398–99, links this statue with the statue of Perseus in the Boboli Gardens.

95. Summers, *The Sculpture of Vincenzo Danti*, 305–7 and 421–24. The statue is now in the Bargello.

96. Langedijk, *Portraits*, 1:468; J. Holderbaum, *The Sculptor Giovanni Bologna* (New York and London, 1983), 169–72; C. Avery, *Giambologna: the Complete Sculpture* (Oxford, 1987), 167–68 and 254.

97. N. Rubinstein, "Classical Themes in the Decoration of the Palazzo Vecchio," *JWCI* 50 (1987):29–43.

98. Morrogh 1985, 46.

99. Severus Alexander, *Scriptores Historiae Augustae*, 28, 2 vols., trans. D. Magie (London and New York, 1924), 2:234–35; Suetonius, *The Lives of the Caesars*, 2.31, 2 vols., trans. J. C. Rolfe (London and New York, 1914), 1:172–73); for the statuary, P. Zanker, *Forum Augustum: das Bildprogramm* (Tübingen, 1971).

100. Zanker, *Forum Augustum*, figs. 14, 15, 43.

101. The original designs for the testata apparently did not include glazing. In the instances where glass windows were employed, most notably those on the piano nobile, a noticeable reveal on the inner side of the jambs of the stone surrounds permit the insertion of a wooden window. Close inspection indicates that details of this sort do not exist on the testata's upper floors. On the interior of the piano nobile, a continuous stone plinth breaks forward at the base for the statue of Cosimo I. This detail, as well as the fully carved rear side of the standing statue, indicate that the ensemble was meant to be seen without impediment from both sides. All windows now in the testata's piano nobile are attached to the inner walls. By custom, roof-top loggias were unglazed, and the windows on the uppermost level are clumsily cut into the surfaces of the columns or flanking piers.

102. For a brief history of the serliana, see S. Wilinski, "La serliana," *Bolletino del Centro Internazionale di Studi di Architettura "Andrea Palladio"* 7 (1965): 115–25, and K. De Jonge, "La serliana di Sebastiano Serlio. Appunti sulla finestra veneziana," in *Sebastiano Serlio* (Milan, 1989), 50–56. For its relation to what has been called "the iconography of rulership," see E. E. Rosenthal, *The Palace of Charles V in Granada* (Princeton, 1985), 208–10, and esp. 254–55; Crum, "Iconography of the Uffizi Facade," 238–42.

103. Langedijk, *The Portraits of the Medici*, 1:445; Crum, "Iconography of the Uffizi Facade," 243n.26.

104. W. C. Kirwin, "Vasari's Tondo of Cosimo I with his Architects, Engineers, and Sculptors in the Palazzo Vecchio," *MKIF* 15 (1971):105–22.

105. C. Davis, "Working for Vasari. Vincenzo Danti in Palazzo Vecchio," in *Giorgio Vasari*, 1985, 246–49.

106. For a review of the literature on Brunelleschi's perspective panel and its relation to what may have been a consciously created viewpoint for the square at its northwest corner, see Trachtenberg, "What Brunelleschi Saw," 42–43.

107. L. Zanghieri, "Pasquale Poccianti: Le opere," in *Pasquale Poccianti Architetto, 1774–1858* (Florence, 1974), 67. Other alternatives were the loggia of the Mercato Nuovo and the Loggia della Signoria.

108. 18 September 1836. See G. Viollet-le-Duc, *Lettres d'Italie, 1836–1837, addresses par Eugène Viollet-le-Duc a sa famille, 1836–37* (Paris, 1970), 143–9; reprinted in *Le voyage d'Italie d'Eugène Viollet-le-Duc 1836–37* (Florence, 1980), 184. For Sitte, see C. Sitte, *City Planning*, 57. Le Corbusier, who was aware of Sitte's writings, was lodged in the palazzo at the intersection of the Via dei Calzaiuoli and the northwest corner of the square during his first trip to Italy. For this and other aspects of Le Corbusier's first visit to Italy, see G. Greslieri, *Le Corbusier. Il viaggio in Toscana (1907)* (Venice, 1987), 11–12.

CHAPTER FOUR

1. N. Elias, *The Court Society*, trans. of *Die höfische Gesellschaft* by E. Jephcott (New York, 1983), 63.

2. R. J. Tuttle, "Julius II and Bramante in Bologna," in *Le arti a Bologna e in Emilia dal XIV al XVII secoli. Atti del XXIV Congresso Internazionale di Storia dell' Arte*, 9 vols. (Bologna, 1982), 4:3–8.

3. For Romarantin, see C. Pedretti, *Leonardo da Vinci: the Royal Palace at Romarantin*, (Cambridge, MA, 1972). For Granada, see E. Rosenthal, *The Palace of Charles V in Granada* (Princeton, 1985). For Serlio, see M. N. Rosenfeld, "Sebastiano Serlio's Late Style in the Avery Version of the Sixth Book on Architecture," *JSAH* 28 (1969):162–64, and S. Serlio, *Sebastiano Serlio's On Domestic Architecture* (Cambridge, Mass., and New York City, 1978), plate LXXI. For the Escorial, see G. Kubler, *Building the Escorial* (Princeton, 1982).

4. W. Lotz, *Vignola-Studien* (Hamburg, 1938), 64–76; P. Dreyer, "Beiträge zur Planungsgeschichte des Palazzo Farnese in Piacenza," *Jahrbuch der Berliner Museen* 18 (1966):160–203; Heydenreich and Lotz, 272.

5. Frey 1:722. See also J. L. Draper, "Vasari's Decorations in the Palazzo Vecchio. The *Ragionamenti* Translated with an Introduction and Notes" (Ph.D. diss., University of North Carolina at Chapel Hill, 1973), 55.

6. A definitive history of the Palazzo Vecchio remains to be written. The most provocative study of its meaning is J. Paul, *Der Palazzo Vecchio. Ursprung und Bedeutung seiner Form* (Florence, 1969). Although it contains inaccuracies and omissions, the best comprehensive study is still A. Lensi, *Palazzo Vecchio* (Milan, 1929). More recent information and better photographic documentation can be found in G. Lensi-Orlandi, *Il Palazzo Vecchio di Firenze* (Florence, 1977). An exhaustive documentation of its Medicean period is E. Allegri-A. Cecchi, *Palazzo Vecchio e i Medici* (Florence, 1980). The only studies that consider the architectural aspects of Vasari's renovations as separate from his decorations are G. L. Maffei, "Gli interventi vasariani in Palazzo Vecchio," *Studi e documenti di architettura* 6 (1976), 49–66, and E. Mandelli, "La funzionalità degli interventi vasariani nel Palazzo Vecchio," Ibid., 67–82.

7. For Medicean alterations prior to Vasari's arrival, see Allegri-Cecchi, *Palazzo Vecchio*, 9–51.

8. Allegri-Cecchi, *Palazzo Vecchio*, 359–71.

9. The degree to which Roman foundations were reused in the Palazzo Vecchio is not clear. A superimposition of the plan of the Roman theatre discovered in 1875 over that of the Palazzo Vecchio (Lensi-Orlandi, *Palazzo Vecchio*, plan opposite page 289) suggests that the eastern wall of the court formed by the additions of Tasso and Buontalenti follows the alignment of the supports of an ancient vault.

10. Illustrated in Lensi-Orlandi, *Palazzo Vecchio*, plan opposite page 288. This was also confirmed in conversation with Nicolai Rubinstein.

11. Allegri-Cecchi, *Palazzo Vecchio*, 16.

12. Frey, 1:504n.4. Frey rightly notes that there is no agreement on the number of wooden models for the Palazzo Vecchio prepared under Vasari's direction.

13. Frey 1:517. See also Lensi, *Palazzo Vecchio*, 198, and Allegri-Cecchi, *Palazzo Vecchio*, 364–65.

14. Morrogh 1985, 33–40.

15. G. Kauffmann, *Florence: Art Treasures and Buildings*, trans. E. Kustner and J. A. Underwood (London, 1971), 153–54.

16. M. Trachtenberg, "What Brunelleschi Saw: Monument and Site at the Palazzo Vecchio," *JSAH* 47 (1988), 25–28. For the closing of the northern portal on 1 April 1380 and its re-opening in 1910, see Lensi, *Palazzo Vecchio*, 35 and 384; Lensi-Orlandi, *Palazzo Vecchio*, 49.

17. Vasari-Milanesi, 2:435–36; Lensi, *Palazzo Vecchio*, 56–58. For the most recent consideration of the problem, see M. Trachtenberg, "Archeology, Merriment, and Murder: The First Cortile of the Palazzo Vecchio and its Transformation in the Late Florentine Republic," *AB* 71 (1989), 565–611, esp. 605–6.

18. E. Pillsbury, "An Unknown Project for the Palazzo Vecchio Courtyard," *MKIF* 14 (1969), 57–66.

19. E. Pillsbury, "Vasari's Staircase in the Palazzo Vecchio," in *Collaborations in Italian Renaissance Art*, ed. W. S. Sheard and J. Paoletti, (New Haven and London, 1978), 128–29. The portal, which originally led to the stairway built by Cronaca, stood beside Vasari's doorway until the early 1570s, when the south arm of the grand staircase was completed. At this time it was transformed into niches for the display of statuary, first housing the bronze *David* by Donatello and, after 1592, Pierino da Vinci's *Samson and the Philistine*. For additional documentation, see Allegri and Cecchi, *Palazzo Vecchio*, 379–80.

20. For repairs to the columns and other additions and restorations made by Giuseppe del Rosso beginning in 1819, see Lensi-Orlandi, *Palazzo Vecchio*, 208.

21. A similar program composed of views of seven different Hapsburg cities can be found in the Emperor's Hall of the Medicean castle at Melegnano near Milan. There is no secure attribution of their authorship, and they can be dated only to the mid-sixteenth-century. For a description, see G. Sannazzaro, "Per uno studio di alcune silografie nella *Cosmografia Universalis*: raffronti con affreschi lombardi del millecinquecento," *Il conoscitore di stampa* 49 (1979):10–29.

22. E. Pillsbury, "Vincenzo Borghini as a Draftsman," *Bulletin. Yale University Art Gallery* 34 (1973):6–11.

23. C. L. Frommel, *Der Römische Palastbau der Hochrenaissance*, 3 vols. (Tübingen, 1973), 3: figs. 8d and 9d.

24. For Vasari on Pirro Ligorio, see Boase, *Vasari*, 291–93.

25. Of the nine columns, the original octagon shape was retained for those in the four corners of the courtyard. The columns in the center of each face are cylindrical.

26. Vasari-Milanesi, 1:277.

27. Vasari-Milanesi, 1:138; R. Wittkower, *Gothic vs. Classic. Architectural Projects in Seventeenth-Century Italy* (New York, 1974), 15–6.

28. J. M. C. Toynbee and J. B. Ward-Perkins, "Peopled Scrolls. A Hellenistic Motif in Imperial Art, *Publications of the British School in Rome* 18 (1950): 1–43.

29. J. B. Ward-Perkins, "The Shrine of Saint Peter's and its Twelve Spiral Columns," *Journal of Roman Studies* 42 (1952): 21–33; I. Lavin, *Bernini and the Crossing of Saint Peter's* (New York, 1968), 10–18.

30. Lavin, *Bernini and the Crossing of Saint Peter's*, 14–15.

31. J. Shearman, *Raphael's Cartoons in the Royal Collections* (London, 1972), 55–56.

32. G. Zander, "Il Vasari, gli studiosi del suo tempo e l'architettura antica," *Giorgio Vasari* 1974, 349.

33. A. Boethius, *The Golden House of Nero. Some Aspects of Roman Architecture* (Ann Arbor, 1960), 105; W. L. MacDonald, *The Architecture of the Roman Empire*, 2nd ed. (New Haven and London,1982), 21n.3.

34. Frey, 1:60.

35. Vasari-Milanesi, 7:710.

36. A. Segarizzi, ed., *Relazioni degli ambasciatori veneti*, 3 vols. in 4 (Bologna, 1916), 3.1: 193–94). In his *relazione* of 1566, Lorenzo Priuli, the Venetian ambassador in Florence writes that "È vero che li tedeschi, che hanno accompagnato la principessa in Italia, son partiti da Firenze malissimo sodisfatti per le poche cortesie che li sono usate, ed in Bologna, al mio ritorno, intesi che andavano publicamente dicendo male del duca, biasimando la sua altezza e sopra tutto l'avarizia."

37. Vasari-Milanesi, 1:147.

38. Vasari-Milanesi, 2:433.

39. Vasari-Milanesi, 3:71.

40. Vasari-Milanesi, 1:299.

41. Vasari-Milanesi, 4:158. The stair in Bologna was called to my attention by Richard Tuttle.

42. New documentation for Vasari's reconstruction of the system of staircases in the Palazzo Vecchio can be found in Pillsbury, "Vasari's staircase in the Palazzo Vecchio," 125–35; supplemented by Allegri-Cecchi, *Palazzo Vecchio*, 215–19. For staircases in general, see A. Chastel and J. Guillame, eds., *L'Escalier dans l'architecture de la Renaissance* (Paris, 1985); C. Wilkinson, "The Escorial and the Invention of the Imperial Staircase," *AB* 57 (1975): 65–90; and idem, "Il Bergamasco e il Palazzo Viso a Marques," in *Galeazzo Alessi e la architettura del Cinquecento* (Genoa, 1975), 625–30. For Venetian examples see P. Sohm, "The Staircases of the Venetian Scuole grandi and Mauro Codussi," *Architectura* 8 (1978): 125–49; idem, *The Scuola Grande di San Marco 1437–1550: The Architecture of a Venetian Lay Confraternity* (New York and London, 1982), 184–221.

43. The best accounts of the palace's stairs prior to Vasari's renovation are Pillsbury, "Vasari's Staircases," 125, and Trachtenberg, "The First Cortile of the Palazzo Vecchio," 589–94.

44. Vasari-Milanesi, 2:437.; Pillsbury, "Vasari's Staircase," 131n.1. The stair is commonly thought to have risen along the north side of the courtyard to the main floor, and from there within the palace to the Sala dei Gigli on the second floor. There is no evidence supporting the assertion by Lensi Orlandi, *Palazzo Vecchio*, 68–70, that Michelozzo's stair was located in the Cortile della Dogana and that its piers were reused in the construction of the supports for Cronaca's Salone dei Cinquecento.

45. Vasari-Milanesi, 1:147; C. Wilkinson, "The Escorial Staircase," 76.

46. For an account of the changes made by Carlo Falconieri between 1864 and 1870, see Lensi-Orlandi, *Il Palazzo Vecchio*, 223–27.

47. Peter Dreyer called my attention to a drawing attributed to Vasari in the Kupferstichkabinett, Berlin (KdZ 18485v) that shows a monumental flight of stairs. Neither the design nor the surrounding chambers can be connected in any way with those in the Palazzo Vecchio. The recto of the sheet contains a drawing of a seated (Medici?) prince clearly by the hand of an artist other than Vasari.

48. E. Nash, *Pictorial Dictionary of Ancient Rome*, 2 vols. (New York, 1962), 2:376–81.

49. H. Egger, *Römische Veduten*, 2 vols. (Vienna, 1931), 2:36pl. 85.

50. M. Fossi, ed., *La città di Bartolomeo Ammannati* (Rome, 1970), 196.

51. H. Spielmann, *Palladio und die Antike* (Munich, 1966), 36.

52. The mistaken attribution can be illustrated by Francesco da Sangallo's notes on the copy of a plan by his uncle Giuliano (Uffizi 1681A) that refer to the "mecante in Monte Cavallo," and by Serlio's description of them as "the remains of a most costly palace" (S. Serlio, *Terzo libro*, 85).

53. For a discussion of the woodcut in Cesare Vecellio's *Degli habiti antichi e moderni* (Venice, 1580), see D. Pincus, *The Arco Foscari: The Building of a Trium-*

phal Gateway in Fifteenth Century Venice (New York and London, 1976), 12–14.

54. M. Muraro, "La scala senza giganti," in *Essays in Honor of Erwin Panofsky*, ed. M. Meiss (New York, 1962), 350–70; D. Pincus, *Arco Foscari*, 67n.50; J. Mac-Andrew, *Venetian Architecture of the Early Renaissance* (Cambridge and London, 1980), 89–101; R. Lieberman, *Renaissance Architecture in Venice*, (New York, 1982), text to plates 79–80.

55. See particularly Patricia Fortini Brown, *Venetian Narrative Painting in the Age of Carpaccio* (New Haven and London, 1977), 235–36.

56. G. Carocci, "Breve notizie sopra alcuni edifici di Piazza San Biagio, Via Por S. Maria, e Borgo San Jacopo," *Bolletino dell' Associazione per la difesa di Firenze antica* 2, no.1 (1901): 41–42; I. del Badia, "Il vecchio palazzo del Parte Guelfa," ibid. 2, no.3, 63–74.

57. Vasari-Milanesi, 2:380.

58. M. Trachtenberg, *The Campanile of Florence Cathedral* (New York, 1971), 65–68.

59. Frey 1:593–95.

60. J. Wilde, "The Hall of the Great Council of Florence," *JWCI* 7 (1944):65–81 (reprinted in Creighton Gilbert, ed., *Renaissance Art* [New York, 1970], 92–132); Allegri-Cecchi, *Palazzo Vecchio*, 231–33. For a history of the hall up to the modern era, see U. Muccini, *The Salone dei Cinquecento of Palazzo Vecchio* (Florence, 1990). For an extended study of the hall and its triumphal imagery, see R. Starn and L. Partridge, *Arts of Power: Three Halls of State in Italy, 1300–1600* (Berkeley and Los Angeles, 1992), 151–256.

61. For a comparison of the Udienza with Sansovino's Loggetta in Venice, see M. Campbell, "Observations on the Salone dei Cinquecento in the Time of Cosimo I de' Medici," in *Firenze e la Toscana dei Medici nell' Europa del '500*, 3 vols. (Florence, 1983), 3:819–31.

62. D. Heikamp, "Ammannati's Marble Fountain for the *Sala Grande* in the Palazzo Vecchio of Florence," in *Fons Sapientae. Renaissance Garden Fountains*, ed. E. B. MacDougall (Washington, 1978), 115–73; C. Rousseau, "The Pageant of the Muses at the Medici Wedding of 1539," in *Art and Pageantry*, Papers in Art History from the Pennsylvania State University 2, ed. B. Wisch and S. S. Munshower, 2 vols. (University Park, 1990), 2:425–27.

63. The raising of the roof by at least 12 braccia is first mentioned in Michelangelo's letter of 25 April 1560 to Duke Cosimo (Frey, 1:561). Vasari's own account in the *Lives* mentions an addition height of 13 braccia (Vasari-Milanesi, 7:700).

64. For a full bibliography of studies of Vasari's decorations, see Starn and Partridge, *Arts of Power*, 347n.96.

65. For the Sala Regia, see B. Davidson, "The Decoration of the Sala Regia under Pope Paul III," *AB* 58 (1976): 395–423.

66. For Vasari's detailed description of Cronaca's roof, see Vasari-Milanesi, 4:449–50; for a diagrammatic reconstruction, see Muccini, *The Salone dei Cinquecento*, 56.

67. Muccini, *The Salone dei Cinquecento*, 55–76. From the evidence of changes in the construction of the wall Muccini hypothesizes that Vasari originally set the ceiling at a level approximately 1.30 m. lower than the present one. According to Muccini, the purpose of this change (which presumbably happened shortly after work was begun) was to further increase the ceiling's height.

68. Allegri-Cecchi, *Palazzo Vecchio*, 178–80.

69. Vasari-Milanesi, 6:238.

70. Segarizzi, *Relazioni*, 3.2:222. Noted by Andrea Gussoni, the Venetian ambassador to Florence, in his *relazione* of 1576.

71. P. Baxter, "Vasari's *Raggionamenti*: the Text as the Key to the Decorations of the Palazzo Vecchio" (Ph.D. diss., University of Edinburgh, 1988), 132–33.

72. Lapini, *Diario fiorentino*, 199 and 220; Baxter, "*Raggionamenti*," 139–40.

73. For some unexecuted projects of restoration during this period, see D. Mignani Galli, "Restauri ed burocrazia. Palazzo Vecchio a Firenze nel Settecento," *Labyrinthos* 1–2 (1982), 165–202. The cramped quarters, poor lighting, and inadequate facilities for the storage of documents in governmental offices on the ground floor of the Palazzo Vecchio is brought out in the account of a visit by Duke Pietro Leopoldo in 1771. See Pietro Leopoldo d'Asburgo Lorena, *Relazioni sul governo della Toscana*, 2 vols., ed. A. Salvestrini (Florence, 1970), 2:266–69.

74. Ammannati, *La città*, 322.

75. The essential prototype for the private corridor in the Renaissance is Bramante's Cortile del Belvedere. For this project, see primarily J. S. Ackerman, *The Cortile del Belvedere*, Studi e documenti per la storia del Palazzo Apostolico Vaticano 3 (Vatican City, 1954); and C. L. Frommell, "Lavori architettonici di Raffaello in Vaticano," in *Raffaello architetto*, ed. Manfredo Tafuri (Milan, 1984), 357–62. For Paul III's private corridor connecting the Palazzo Venezia with his villa-fortress adjacent to Santa Maria in Aracoeli on the Capitoline Hill, see Lanciani, *Storia degli scavi di Roma*, II: 55–57; J. Hess, "Die päpstliche Villa bei Aracoeli: Ein Beitrag zur Geschichte der kapitolinischen Bauten," *Miscellanea Bibliothecae Hertzianae zu ehren Leo Bruhns—Franz Graf Wolff Metternich—Ludwig Schudt* (Munich, 1961), 239–54; D. Coffin, *The Villa in the Life of*

Renaissance Rome (Princeton, 1979), 31–34; L. Spez- zaferro and R. Tuttle, "Place Farnése: urbanisme et politique," *Le Palais Farnése*, 2 vols. in 3 (Rome, 1981), 1.1: 111. For a similar passageway built in 1550 at the Hofburg in Vienna, see M. Dreger, *Baugeschichte des K. K. Hofburg in Wien* (Vienna, 1914), 104, and Sat- kowski 1979, 254n.34.

The renown of Vasari's Corridoio can be seen in its immediate progeny. For the Petit Galeric in Paris built by Charles IX to link the Louvre with the Tuileries, see H. Ballon, *The Paris of Henri IV: Architecture and Ur- banism*, (Cambridge and London, 1991), 19 and 304n.8. For the Corridore built in the 1580s to con- nect the Rochetta with the Ducal Palace in Parma, see B. Adorni, *L'architettura farnesiana di Parma* (Parma, 1974), 34 and 48–51. For the contemporary system of circulation above street level in Sabbioneta, see K. Forster, "Stagecraft and Statecraft: The Architec- tural Integration of Public Life and Spectacle in Sab- bioneta," *Oppositions* 9 (1977):86n.8.

76. I. Del Badia, "Il corridore dal Palazzo Vecchio al Pa- lazzo Pitti," *Miscellanea Fiorentina* (1902), 1:3–11; Lessmann 1975, 175–77; Satkowski 1979, 76–97 and 195–99.

77. L. Satkowski, "The Palazzo Pitti. Planning and Use in the Grand-Ducal Era," *JSAH* 42 (1983):338–40.

78. Lessmann 1975, 453n.759, has compared this tract of the Corridoio to the vaulted substructure of the Tem- ple of Jupiter Anxur at Terracina. While Vasari may have seen its ruins in the course of travelling to Naples in the 1540s, other sources were closer at hand. Simi- lar structural systems in the Passetto (the private pas- sageway between the Vatican and the Castel Sant' An- gelo) and in the Aurelian walls of Rome have been noted in Satkowski 1979, 93–94. Also the similarity to Francesco di Giorgio's description of an arcaded riverfront square is coincidental (Lessmann 1975, 453n.760).

79. Vasari-Milanesi, 7:703–4.

80. Lessmann 1975, 416n.408.

81. Suetonius, *Lives of the Caesars*, 4.22, 2 vols., trans. J. C. Rolfe, (London and New York, 1914), 1:437 for Caligula, and 6.31 2:134–39 for Nero. For the im- portance of Nero's project, see MacDonald, *Architec- ture of the Roman Empire*, 21–25.

82. Medieval derivations from these sources were also well known. Private passageways linking residences with palaces chapels were characteristic features of Imperial Palaces in the Middle Ages. For the connec- tion between the Chalke Gate and Santa Sophia in Constantinople, see C. Mango, *The Brazen House. A Study of the Imperial Palace of Constantinople* (Copen- hagen, 1959), 87–92; for the wooden gallery running from Charlemagne's Regia to the Palatine Chapel in Aachen, see J. Buchkremer, "Die Karolingische Por- ticus der Aachener Pfalz," *Bonner Jahrbucher* 149 (1949):212–38. Other passageways were primarily secular in purpose and were constructed for reasons of defense or convenience, such as the Passetto that was built into the walls constructed by Leo IV (847–855) connecting the Vatican with the Castel Sant' Angelo, or the *via coperta*, an external passageway that ran along the lines of an old escarpment between the Pal- azzo del Corte and the Castello di San Giorgio in Mantua (G. Zaretti, "Il Passetto del Vaticano," *L'illus- trazione vaticana* 4 [1933]:841–43; E. Ponti, "Il corri- dore," *Capitolium*, [1934], 243–56; S. Gibson and B. Ward-Perkins, "The Surviving Remains of the Leonine Walls. Part II. The Passetto," *Publications of the British School in Rome* 38 [1983]: 222–39).

83. For example, Filarete's illustrations for a bridge link- ing palaces on opposite sides of a river looks back to the *porticus triplices* of Nero's Domus Transitoria. See Filarete, *Tratatto d'architettura*, trans. J. Spencer, 2 vols. (New Haven and London, 1965), 1:164. Sug- gestive as the illustration may be, it had little impact on Vasari, who deemed Filarete's treatise "mostly ri- diculous, and perhaps the most stupid book that was ever written" (Vasari-Milanesi, 2:457).

84. Alberti, 1:340–1.

85. An example is the Cassero in Prato, which was built shortly after the annexation of the city by Florence in 1351. The passageway, which was recorded in a draw- ing by Sangallo the Younger (Uffizi 270A), the Cas- sero linked the Castello dell' Imperatore with the Porta San Marco in order to provide its foreign gover- nor a direct means of escape. See G. Miniati, *Nar- razione e disegno della terra di Prato* (Florence, 1596), 29–32; G. Pampaloni, "Prato nella repubblica fioren- tina," in *Storia di Prato*, 3 vols. (Prato, 1980), 2:8; P. Ruschi, "Prato nel '500: città e mura nell' ico- nografia," in *Prato e i Medici nel '500* (Rome, 1980), 83–92.

86. Trachtenberg, *The Campanile of Florence Cathedral*, 67–68.

87. J. van der Meulen and J. Hohmeyer, *Chartres. Biogra- phie der Kathederale* (Cologne, 1984), 183.

88. L'oldradi, *L'entrata dell' Eccellenza S. Duca e Signora Duchessa di Firenze in Roma* (Rome, 1560?), 3.

89. P. Vettori, *Orazione recitata nell' esequie del Sereniss. Cosimo de' Medici Gran Duca di Toscana* (Florence, 1574), 10r; Satkowski, "Palazzo Pitti," 339n.18; Mor- rogh 1985, 19.

90. Lapini, *Diario fiorentino*, 123.

91. Lapini, *Diario fiorentino*, 142; Del Badia, "Corri- dore,", 9. The nineteenth-century drawing in ASF,

Piante, Acquisto Gonelli, 40, shows the shops under the arches of the Corridoio prior to their removal.

92. See the particularly moving account of the events written by Ugo Procacci in F. Hartt, *Florentine Art Under Fire* (Princeton, 1949), 39–44.

93. For the condition of the Corridoio as it crossed the Via dei Bardi, see ibid., fig. 6. War damage was concentrated to its sectors at the northern and southern ends of the Ponte Vecchio. Damage to the Uffizi was limited to shattered windows and damage of frescoes on the gallery level (ibid., 128).

94. Satkowski, "Palazzo Pitti," 344–45.

95. For overviews of urbanism in sixteenth-century Rome, see J. S. Ackerman, "The Planning of Renaissance Rome, 1480–1580," *Rome in the Renaissance: The City and its Myth*, ed. P. Ramsey (Binghamton, 1982), 3–18; C. L. Frommel, "Papal Policy: The Planning of Rome During the Renaissance," in *Art and History*, ed. T. K. Rabb and J. Brown (Cambridge, 1988) 39–66.

CHAPTER FIVE

1. E. H. Gombrich, "The Early Medici as Patrons of Art; A Survey of Primary Sources," in *Italian Renaissance Studies: a Tribute to the Memory of the Late Cecilia M. Ady*, ed. E. F. Jacob (London, 1960), 279–311; reprinted in idem, *Norm and Form* (London, 1966), 35–57. See also A. D. Fraser Jenkins, "Cosimo de' Medici's Patronage of Architecture and the Theory of Magnificence," *JWCI* 33 (1970):162–70. The most important study to date on Cosimo I's architectural patronage is G. Spini, "Architettura e politica nel principato mediceo del cinquecento," *Rivista storica italiana* 83 (1971):792–845; reprinted with emendations in the introduction to G. Spini, ed., *Architettura e politica da Cosimo I a Ferdinando I* (Florence, 1976), 9–77. Useful information is also contained in F. Borsi, *Firenze nel cinquecento* (Rome, 1974), and in A. Godoli and A. Natali, *Luoghi della Toscana medicea* (Florence, 1980).

2. Fraser Jenkins, "Cosimo de' Medici's Patronage," 167.

3. Spini, *Architettura e politica*, 19–21; S. Pepper and N. Adams, *Firearms and Fortifications: Military Architecture and Siege Warfare in Sixteenth Century Siena* (Chicago and London, 1986), 157–58.

4. Spini, *Architettura e politica*, 22–25, suggests that there was no break in palace construction under Cosimo. There is, however, a significant difference in scale and cost; older structures were often renovated, as the palace of the Spanish courtier Ramirez de Montalvo in Borgo degli Albizi. The only structures worthy of comparison with those of the preceding century are the Palazzo Grifoni on Piazza Santissima Annunziata, Palazzo Mondragone in Via de' Banchi, and Palazzo Giugni in Via degli Alfani, all by Ammannati. For these palaces, see M. Fossi, *Bartolomeo Ammannati* (Cava dei Tirreni, n.d.), 81–98. The other palaces cited by Spini are modest by comparison.

5. Spini, *Architettura e politica*, 32–33.

6. Spini, *Architettura e politica*, 34. For Poggio a Caiano, see P. Foster, *A Study of Lorenzo de' Medici's Villa at Poggio a Caiano* (New York and London, 1978), 1:49–81; for Castello, see D. Wright, "The Medici Villa at Olma a Castello" (Ph.D. diss, Princeton, 1976), 8–29. An excellent characterization of the Medicean villas can be found in the introduction to D. Mignani, *Le Ville Medicee di Giusto Utens* (Florence, 1980).

7. G. Nudi, *Storia di Livorno* (Venice, 1959), 85–89; Spini, *Architettura e politica*, 45; R. Mazzanti, "Il territorio livornese," in *Livorno. Progetto e storia di una città tra 1500 e 1600* (Pisa, 1980), 75–82.

8. Spini, *Architettura e politica*, 37–38.

9. R. Dallington, *A Survey of the Great Duke's State of Tuscany in the yeare of our Lord 1596* (London, 1605), 53.

10. For Florentine government and its relationships to its subject towns, see A. Anzilotti, *La costituzione interna dello stato fiorentino sotto Il Duca Cosimo I de' Medici* (Florence, 1910); E. Fasano-Guarini, *Lo stato mediceo di Cosimo I* (Florence, 1973); R. B. Litchfield, *The Emergence of a Bureaucracy: The Florentine Patricians, 1530–1790* (Princeton, 1986).

11. Spini, *Architettura e politica*, 52.

12. R. B. Litchfield, "Office Holding in Florence after the Republic," in *Renaissance Studies in Honor of Hans Baron* (Florence and DeKalb, Ill., 1971), 536.

13. E. Repetti, *Dizionario geografico fisico storico della Toscana*, 6 vols. (Florence, 1833–48), 4:401–63; D. Herlihy, *Medieval and Renaissance Pistoia* (New Haven and London, 1967), 39–51.

14. H. Saalman, *Filippo Brunelleschi. The Cupola of Santa Maria del Fiore* (London, 1980), 195.

15. V. Minuti, "Relazione del commissario Gio. Battista Tedaldi sopra la città e il capitanato di Pistoia," *Archivio storico italiano* 10 (1892):314; Herlihy, *Medieval and Renaissance Pistoia*, 53.

16. Vasari-Milanesi, 4:165–67; J. Durm, "Santa Maria dell' Umilità. Grosskonstructionen der italienischen Renaissance," *Zeitschrift für Bauwesen* (1902):13–14; A. Venturi, *Storia del arte italiana*, 11 vols. in 25 (Milan, 1901–40), 11.2: 443–47; A. Chiti, *Il santuario della Madonna dell' Umilità in Pistoia* (Pistoia, 1952); U. Procacci, "L'architettura nell' aretino," in

Atti del XII Congresso di Storia di Architettura, Arezzo, 1961 (Rome, 1969), 124; Lessmann 1975, 177–78; M. Fossi, "La Basilica della Madonna del Umilità in Pistoia. I Lavori di Bartolomeo Ammannatti," *Atti e memorie della accademia Toscana di scienze e lettere 'La Colombaria'* 24 (1973):83–136; Heydenreich and Lotz, 395n.11; M. Fossi, "Il Vasari e la basilica della Madonna dell' Umilità in Pistoia," Vasari 1974, 127–42; Satkowski 1979, 12–44 and 167–77; M. Buscioni, "La Chiesa della Madonna dell' Umilità," in *Ventura Vitoni e il Rinascimento a Pistoia* (Pistoia, 1977), 39–44; M. Fossi, "Regesto dei lavori eseguiti alla Basilica dell' Umilità di Pistoia dal 1585 al 1637. Direzione di Jacopo Lafri e Jacopo e Lionardo Marcacci," *Antichità viva* 22 (1983): 22–28; G. C. Romby, "Jacopo Lafri, architetto pistoiese del Cinquecento. Nuova documentarie," *Bulletino storico pistoiese* 91 (1989):78–80.

17. P. Sanpaolesi, "Ventura Vitoni, architetto pistoiese," *Palladio* 3 (1939):248–66.

18. Chiti, *Santuario*, 32, asserts that completion of the dome was suggested by Cosimo during a visit to Pistoia to inspect the completion of its fortress. Although there is no documentation to substantiate this claim, Cosimo's lively interest is borne out by his correspondence on the project.

19. The dimensions of the interior faces of the octagon (clockwise, starting with the opening from the vestibule) are 8.91 m., 8.48 m., 8.48 m., 8.53 m., 8.39 m., 8.40 m., 8.38 m., 8.37 m. The greater width of the face adjacent to the vestibule (about a half meter longer than the shortest sides) may have been an accident of construction caused by the somewhat trapezoidal shape of the church's site, which is narrower on the sacristy side of the structure.

20. Vasari-Milanesi, 4:166.

21. Vasari-Milanesi, 4:169–74. Lafri's *Memoriale* has also been reprinted as an appendix to L. Bargiacchi, *Tempio e opere della Madonna della Umilità in Pistoia* (Pistoia, 1890). See also Satkowski 1979, 234n.23.

22. Presumably this was dictated by the shallow thickness of Vitoni's drum and the location of the passageway at its center. In compensation, ledges rising against the inner surfaces of the shells stiffen the vaults at their base by providing buttressing near their spring points.

23. Most recently by Saalman, *Cupola*, 217. This connection dates back to the eighteenth century when Giovanni Battista Nelli, the great scholar of Brunelleschi's dome, described a hypothetical cupola that seems to have been modelled on Vasari's, for which he had served as a consultant on repairs in 1724. For the text of Nelli's *Ragionamento sopra la Maniera di voltar le Cupole senza adoparvi le Centine*, see Saalman, *Cupola*, 230–36.

24. Vasari-Milanesi, 1:332

25. Saalman, *Cupola*, 197–98.

26. Compare, for instance, the descriptions of Byzantine mortar in J. B. Ward-Perkins, "Notes on the Structure and Building Methods of Early Byzantine Architecture," *The Great Palace of the Byzantine Emperors*, ed. D. Talbot Rice (Edinburgh, 1958), 55–56 and 83–84.

27. For a description of the Sienese cupola, see C. Pietramellara, *Il Duomo di Siena: Evoluzione della forma alla fine del trecento* (Florence, 1980), 16–20.

28. For example, see Botticelli's *Crucifixion with Penitent Magdalen* (Cambridge, Mass., Fogg Art Museum) where the cupola helps identify Florence as a New Jerusalem. See R. Lightbown, *Sandro Botticelli*, 2 vols. (Berkeley and Los Angeles, 1978), 1:130–33, and 2:94). For other Quattrocento views, see Saalman, *Cupola*, 169.

29. Corti, *Vasari*, 15.

30. For the portraits see K. Langedijk, *The Portraits of the Medici, 15th-18th Centuries*, (Florence, 1981), 1:416, 419, and 434.

31. Pepper and Adams, *Firearms and Fortifications*, 129–31.

32. Frey, 2:431. There is a persistent tradition crediting Ammannati with the design of Santo Stefano della Vittoria. Although there is no documentary evidence to suggest this, critics often remark upon similarities to the Maddona della Umilità, using Ammannati's role in its restoration as sufficient evidence to maintain the attribution. For the most recent restatement of this view, see Fossi, *Ammannati*, 99–101. This position has been refuted by U. Procacci, "L'architettura nel Aretino," 123–24, and, with new documentation by L. Borri Cristelli, "Un' architettura da restituire al Vasari: il Tempio di S. Stefano della Vittoria," *Storia architettura* 8 (1985):37–42.

33. P. Tomei, *L'architettura a Roma nel Quattrocento* (Rome, 1942), 129–33; G. Urban, "Die Kirchenbaukunst des Quattrocento in Rom," *RJ* 9–10 (1961–2):176–218; Heydenreich-Lotz, pp.59–60.

34. *Arch. Arezzo* 1985, 244–47.

35. *Arch. Arezzo* 1985, 174–85. M. Salmi, *Civiltà artistica della terra aretina* (Novara, 1971), 105, attributes its design to "un solido maestro cortonese," presumably on the basis of the similarity of its details to those of Francesco di Giorgio's Santa Maria del Calcinaio.

36. A drawing for a centrally planned church similar to the Santo Stefano della Vittoria can be found on page 157 of the so-called "Vasari Sketchbook," a scrapbook of miscellaneous sheets now in the Sir

John Soane Museum in London. The attribution of this sheet to Vasari by Borri Cristelli, "Un' architettura da restituire al Vasari," 37, is questionable. The most significant difference is that the building depicted in the London sheet is considerably smaller. Its dimensions indicated that it was to be slightly more than half the size of the Foiano church, suggesting that it was meant to be a garden tempietto or family chapel. In addition, the fortified villa and garden on the verso of the sheet cannot be connected with any of Vasari's commissions.

37. E. Repetti, *Dizionario geografico*, 4:297–396; D. Herlihy, *Pisa in the Early Renaissance* (New Haven and London, 1958); E. Tolaini, *Forma Pisarum* (Pisa, 1979); *Livorno e Pisa. Due città e un territorio nella politica dei Medici* (Pisa, 1980).

38. G. Severini, *Architetture militari di Giuliano da Sangallo* (Pisa, 1970), 47–60; idem., "Le fortificazioni," *Livorno e Pisa*, 206–18.

39. G. Spini, *Cosimo de'Medici e la indipendenza del principato mediceo* (Pisa, 1945), 72.

40. Nudi, *Livorno*, 85–89.

41. Tolaini, *Forma Pisarum*, 166; *Livorno e Pisa*, 64–67.

42. M. Kiene, "Der Palazzo della Sapienza. Zur italienischen Universitätsarchitektur des 15. und 16. Jahrhunderts," *RJ* 23–24 (1988):226–37. See also Tolaini, *Forma Pisarum*, 163–64; *Livorno e Pisa*, 249.

43. Nudi, *Livorno*, 85–89; Spini, *Architettura e politica*, 45; *Livorno e Pisa*, 58–59.

44. M. Salmi, *Il Palazzo dei Cavalieri e la Scuola Normale Superiore di Pisa* (Bologna, 1932), 19; G. M. Battaglini, "Portoferraio," *Livorno: progetto e storia*, 309–15.

45. R. Galluzzi, *Istoria dell' Granducato di Toscana sotto il governo dell' casa Medici*, 5 vols. (Livorno, 1820), 2:58; C. Booth, *Cosimo I Duke of Florence* (Cambridge, 1927), 223–27.

46. The best history of the order is G. Guarnieri, *I cavalieri di Santo Stefano nella storia della Marina Italiana* (Pisa, 1960). For a synopsis of the most important documentation see idem, *L'Ordine di Santo Stefano e i suoi aspetti interni sotto il Gran Magistero Mediceo* (Pisa, 1966).

47. Galluzzi, *Istoria*, 1:252; Guarnieri, *Cavalieri*, 43.

48. *Courtier*, 3:2. Langedijk, *Portraits*, 1:112.

49. Salmi, *Palazzo dei Cavalieri*, 19.

50. Tolaini, *Forma Pisarum*, 159.

51. D. C. Scavone, "Pisae," *Princeton Encyclopedia of Classical Sites*, ed. R. Stilwell et al. (Princeton, 1976), 713–14.

52. Frey, 1:667.

53. See Salmi, *Palazzo dei Cavalieri*, fig. 5.

54. The most complete studies are E. Karwacka Codini, *Piazza dei Cavalieri: urbanistica e architettura dal Medioevo al Novocento* (Florence, 1989), and Salmi, *Palazzo dei Cavalieri*, 3–56. Exhaustive documentation of the square's history was first published by G. Capovilla, "Giorgio Vasari e gli edifici dell' ordine militare di Santo Stefano," *Studi storici* 17 (1908):305–79; 18 (1909):581–602; 19 (1910):27–226. See also Lessmann 1975, 177, and E. Karwacka Codini, "Piazza dei Cavalieri ed edifici adiacenti," *Livorno e Pisa*, 223–41.

55. Vasari's mention of a palace plan in a letter written in May 1558 has led some scholars to believe that inital ideas for the Piazza dei Cavalieri originate from this date (Frey, 1:502–4; Karwacka-Codini, *Piazza dei Calalieri*, 20 and 65). There is no other evidence supporting this claim. In all likelihood, Vasari was probably referring to either the Palazzo Vecchio of the Palazzo Pitti.

56. Frey, 1:652.

57. Frey, 1:660–1.

58. Frey, 1:667–68.

59. Frey, 1:671–73.

60. G. and C. Thiem, *Toskanische Fassanden-dekoration in Sgraffito und Fresko 14. bis 17. Jahrhundert* (Munich, 1964), 100–2.

61. Frey, 2:135–6; Thiem, *Toskanische Fassaden-dekoration*, 102; Karwacka-Codini, *Piazza sei Cavalieri*, 72–89.

62. Langedijk, *Portraits*, 1:454.

63. Karwacka Codini, *Piazza dei Cavalieri*, 95–96.

64. For the buildings of Italian universities, see Kiene, "Der Palazzo della Sapienza," 219–71.

65. Q. Hughes, *The Building of Malta* (London, 1959), 21, 58, and 125–27.

66. Karwacka-Codini, *Piazza dei Cavalieri*, 163–95. The Gothic quadrifora window on the second floor is the result of a restoration carried out in 1919.

67. Vasari-Milanesi, 7:501.

68. Karwacka Codini, *Piazza dei Cavalieri*, 177.

69. The stairs completed by Vasari in 1567 were replaced by a similar staircase in marble between 1819 and 1821 (Salmi, *Palazzo dei Cavalieri*, 23).

70. Vasari-Milanesi, 7:222.

71. Karwacka-Codini, *Piazza dei Cavalieri*, 197–267.

72. L. Zanghieri, "Pasquale Poccianti: le opere," *Pasquale Poccianti architetto* (Florence, 1974), 68.

73. Guarnieri, *Cavalieri di Santo Stefano*, 56–58.

74. Capovilla, "Giorgio Vasari," 19 (1921): 151.

75. For drawings of the organ basement and the Grand Master's chair, see J. von Henneberg, "I disegni di architettura del codice ottoboniano latino 3110 di Pier Leone Ghezzi," *Miscellanea bibliothecae vaticanae* 4 (1990): 79–87, and idem, "The Church of Santo Stefano dei Cavalieri in Pisa: New Drawings," *Antichità viva* 30, no. 1–2 (1991): 29–42. Although the drawings are attributed to Vasari by von Hen-

neberg, the claim of authorship is by no means secure. Other drawings in the collection date from the seventeenth century and are connected to works executed by Alessandro Pieroni. The sheets depart from Vasari's customary elegant and economical draftsmanship in their rich layering of motifs. Architectural features like the reversed pediment and decorative elements like the cartouches suggest a later date.

76. C. de Brosses, *Lettres familiares d' Italie écrites en 1739 et 1740*, 5th ed., 2 vols. (Paris, 1886), 1:290.

77. For the facade, see Frey, 3:134–5. For the quarry at Serraveza, see Vasari-Milanesi, 1:201; and Morrogh, "Vasari and Coloured Stones," *Giorgio Vasari* 1985, 313.

78. Paatz, *Kirchen*, 3:335.

79. A drawing for the facade of the Chiesa dei Cavalieri (Uffizi 2448A) has been recently attributed to Vasari by F. Paliaga (*Livorno e Pisa*, 376–77). Although the scheme is clearly for the Pisan church, its architectural elements and the drawing style of the ornamental figures cannot be connnected with Vasari in any way. For the facade as designed by Don Giovanni de' Medici, see Karwacka-Codini, *Piazza dei Cavalieri*, 213–18.

80. The same facade appears in Vasari's *Return of Gregory XI from Avignon* in the Sala Regia (1572). See Boase, *Vasari*, 326fig.223.

81. L. Ragghianti Collobi, *Il Libro de' Disgni del Vasari*, 2 vols. (Florence, 1974), 1:110.

82. For the later history of the buildings on the square, see Karwacka-Codini, *Piazza dei Cavalieri*, 268–332.

83. Spini, *Architettura e politica*, 46; Tolaini, *Forma pisarum*, 157.

84. Charles Dickens, *Pictures from Italy* (New York, 1974), 152.

85. W. D. Howells, *Tuscan Cities* (Boston and New York, 1884–85), 211–40.

86. M. de Montaigne, *The Diary of Montaigne's Journeys to Italy in 1580 and 1581*, trans. E. J. Trechmann (New York, 1929), 246.

87. Repetti, *Dizionario geografico*, 1:112–26; H. Comfort, "Arretium," *Princeton Encyclopedia*, 95–96; A. Sestini, "Studi geografici sulla città minori di Toscana," *Rivista geografica italiana* 45 (1938):22–65; V. Franchetti Pardo, *Arezzo* (Bari, 1986).

88. For the road network of medieval Tuscany (including Arezzo), see J. Plesner, "Una rivoluzione stradale del Dugento," *Acta Jutlandica* (Aarsskrift for Aarhus Universitet, X) 10 (1938):1–105.

89. Sestini, "Studi geografici," 51–53.

90. M. Falciai, *Storia di Arezzo dalle origini alle fine del Granducato Lorenese* (Arezzo, 1928), 185; A. Andanti, "L'evoluzione del sistema difensivo di Arezzo:

1502–1560," *Architettura militare nell' europa del XVI secolo* (Siena, 1988), 127–48.

91. Severini, *Architetture militari di Giuliano da Sangallo*, 37–42.

92. The plan of the church was recorded by Giorgio Vasari the Younger (Uffizi 4788A).

93. Falciai, *Storia*, 214.

94. Vasari-Milanesi, 3:215; U. Pasqui, *Bartolommeo della Gatta pittore camaldolese* (Arezzo, 1926), 14–16.

95. M. Mercantini, *Il Palazzo di Fraternita in Piazza Grande ad Arezzo*, (Arezzo, 1980), 20 and 32. The shops and the "Volto Santo" were demolished 1602–03 in preparation for the construction of the Piazza Grande's public fountain.

96. Mercantini, *Il Palazzo di Fraternita*, 24.

97. For attribution and documentation, see Mercantini, *Il Palazzo di Fraternita*, 24–26.

98. D. Viviani-Fiorini, "La construzione delle Logge Vasariane di Arezzo," *Il Vasari* 12 (1941):109–117, and 13 (1942):39–46; Salmi. *Civiltà artistica*, 105; Heydenreich and Lotz, 323; Lessmann 1975, 179–80; R. Ramagli, "Le Logge vasariane in Arezzo," *Studi e documenti di architettura* 6 (1976):87–104; Satkowski 1979, 98–135 and 200–25; Tafi, *Arezzo*, 290–304; P. Roselli, "La vicenda costruttiva delle Logge Vasari ad Arezzo," *Quasar* (1989) 1:31–42.

99. Tafi, *Arezzo*, 303; Mercantini, *Il Palazzo di Fraternita*, 51.

100. Sestini, "Studi geografici," 47; M. Mercantini, *Il Palazzo di Fraternita*, 66–71; Roselli, "La vicenda," 37. Work on the aqueduct was begun on 27 September 1593 and completed on 23 May 1603.

101. Satkowski 1979, 209.

102. Frey, 2:523n.6.

103. Satkowski 1979, 201–2.

104. W. Lotz, "16th-Century Italian Squares," *Studies in Italian Renaissance Architecture* (Cambridge and London, 1977), 78. Originally published as "Italienische Plätze des 1. Jahrhunderts," *Jahrbuch 1968 der Max-Planck Gesellschaft zur Förderung der Wissenschaften e V.*, 41–60.

105. Tafi, *Arezzo*, 290–1. Mercantini, *Il Palazzo di Fraternita*, 32. For the Teatro Mediceo, see Morrogh 1985, 61–63. The theater was founded by the confraternity, to which it was connected by a bridge over the present-day Via Giorgio Vasari. The *cavalcavia*, as it was called, was completed in 1613, although it has been presumed by most writers (without secure evidence) to have been part of Vasari's original design. Its location close to the Dogana and other public agencies suggests that it may have been used as a sort of courtroom. Over the course of nearly three centuries its name changed several times, and in its last years it was called Teatro La Fenice in emulation of

the great Venetian opera house. It continued to function as a theater until 1867, and it now houses the Corte d'Assise.

106. A. Angellucci, *Memorie per servire di guida al forestiero in Arezzo* (Florence, 1819), 102.

107. Mercantini, *Il Palazzo di Fraternita*, 66–70.

108. For the statue of Ferdinando I, which was carved by Francavilla from Giambologna's design, see J. Holderbaum, *The Sculptor Giovanni Bologna* (New York and London, 1983), 178–79; and C. Avery, *Giambologna: the Complete Sculpture* (Oxford, 1987), 33 and 254no.18. A statue of Grand Duke Ferdinando III once stood in the Piazza Grande for more than a century. Carved by the Florentine academic sculptor Stefano Ricci, the figure was placed in April 1822 on a pedestal near the center of the northern edge of the square. Contemporary maps (as illustrated in Franchetti Pardo, *Arezzo*, or Ramagli, "Le Logge Vasariane," 89) record its position between the 15th and 16th bays of the facade in alignment with the northern side of the Misericordia Palace. In the 1920s the houses surrounding the square were restored. With the ascendancy of Fascism there was no longer a need for a symbol of a non-existent political regime, and in 1932 the statue was moved to its present (and less conspicuous) location on the Piazza di Murello.

109. A. del Vita, *Guida di Arezzo* (Arezzo, 1953), 38; Tafi, *Arezzo*, 303–4. The law is recorded in a plaque on the Loggia's facade. See also Satkowski 1979, 134–35.

110. J. S. Ackerman and M. N. Rosenfeld, "Social Stratification in Renaissance Urban Planning," *Urban Life in the Renaissance*, ed. S. Zimmerman and R. F. E. Weissman (Newark, Del., 1989), 21–49.

111. Lotz, "Italian Squares," 89; N. Miller, *Renaissance Bologna* (New York, 1989), 107–12.

112. G. Rondinelli, *Relazione sopra lo stato antico e moderno di Arezzo* (Arezzo, 1755), 95. Most recently this has been restated by Ramagli, "Le Logge," 90.

113. L. Corti, *Vasari*, 111.

114. To my knowledge there is no comprehensive modern study of the Confraternity of the Misericordia and its relationship to the Medicean state. Information on the administration of the state and the delegation of power to local bodies can be found in Fasano Guerini, *Lo stato mediceo di Cosimo I*, passim; R. B. Litchfield, "Office Holding in Florence," 531–55.

115. For *monti* in general, see A. Sapori, "Monte di Pietà," *Enciclopedia italiana* (Rome, 1934), 23:725–27; B. Pullan, *Rich and Poor in Renaissance Venice* (Oxford, 1971), 584; N. Miller, *Renaissance Bologna*, 149–51.

116. For example, see Vasari's letter of 5 August 1572 addressed to "li signori deputati sopra la frabrica (sic) del Monte di Pietà de' Arezzo" in Satkowski 1979, 213.

117. Tafi, *Arezzo*, 291.

118. Anzilotti, *La constituzione interna*, 52.

119. For a survey of the buildings of other *monti* in Italy, see Satkowski 1979, 104–6.

120. D. Howard, *Jacopo Sansovino: Architecture and Patronage in Renaissance Venice* (New Haven and London, 1975), 58–59.

121. For the Library, see particularly Howard, *Sansovino*, 17–28. For the Basilica's civic significance, see M. Kubelik, "The Basilica Palladiana and the Loggia del Capitanato,: An Architectural and Sociohistorical Confrontation," *Palladio. Ein Symposium*, Biblioteca Helvetica Romana XVIII, ed. K. W. Forster and M. Kubelik (Rome, 1980), 47–56. For the Giureconsulti, see M. Rosci, "Il Palazzo dei Giureconsulti e l'urbanistica del Cinquecento a Milano," *Galeazzo Alessi e l'architettura del Cinquecento* (Genoa, 1975), 493–501.

122. Satkowski 1979, 119–20; Mercantini, *Il Palazzo di Fraternita*, 30. For a summary of work by the Parigi, see D. Lamberini, "I Parigi, una familia di artisti pratesi alla corte medicea," *Prato e i Medici nel '500* (Rome, 1980), 138–57.

123. For a graphic reconstruction of the Loggia's phases of construction, see Roselli. "La vicenda," fig. 10.

124. Roselli, "La vicenda costruttiva delle Logge Vasari ad Arezzo," 35fig. 5.

125. G. Incisa della Rochetta, "D'un cartone di Giulio Romano e del aula coperta dei mercati Traianei," *Miscellanea Bibliothecae Hertzianae* (Munich, 1961), 204–5. A plan of the hall after its transformation into the convent of S. Caterina di Siena (c.1575) is illustrated in P. Marconi et al., *I disegni di architettura dell' Archivio storico dell' Accademia San Luca*, 2 vols. (Rome, 1974), 2: fig. 2366.

126. P. Tomei, "Le case in serie nell' edilizia romana dal '400 al '700," *Palladio* 2 (1938):83–92; E. Trincanato, *Venezia minore* (Milan, 1948); B. Zevi, *Biagio Rosetti architetto ferrarese* (Turin, 1960), 46–48; R. Fregna and S. Polito, "Fonti di archivio per una storia edilizia di Roma," *Controspazio* 3, no.9, 2–20; *La Maison de ville a la Renaissance*, Centre d'etudes superieures de la Renaissance, *De Architectura*, I (Paris, 1983); *Edilizia seriale pianificata in Italia, 1500–1600 (Studi e Documenti di architettura*, 14), 1987; C. Mack, *Pienza: The Creation of a Renaissance City* (Ithaca, N.Y., and London, 1987), 150–5; R. Goy, *Venetian Vernacular Architecture* (Cambridge, England, 1989); N. Adams, "The Construction of Pienza (1459–1464) and the Consequences

of *Renovatio*," in *Urban Life in the Renaissance*, ed. S. Zimmerman and R. F. E. Weissman (Newark, Del., 1989), 50–79.

127. G. Labrot, *Baroni in città. Residenze e comportamenti della aristocrazia napoletana 1530–1734* (Naples, 1979), 65–96.

128. Istituto di Restauro di Monumenti, *Firenze. Studi e ricerche sul centro storico antico* (Pisa, 1974), 1: 87; C. Elam, "Lorenzo dei Medici and the Urban Development of Renaissance Florence," *Art History* 1 (1978) 49–51. G. Cataldi, "Palazzetti a schiera in Via dei Servi a Firenze," *Edilizia seriale pianificata in Italia, 1500–1600*, 165–83. Lapini, *Diario fiorentino*, 72–73 gives June 1510 as the date of their construction. Cataldi rightly points out (167) that structures similar to the *palazzetti* are represented on the "Chain" view of Florence that dates to the third quarter of the fifteenth century.

129. For the structures surrounding Piazza San Marco, see G. Samona et al., *Piazza San Marco* (Padua, 1970), measured drawings inserted between pages 68–69. For Bologna, see R. J. Tuttle, "Vignola's Facciata dei Banchi in Bologna," *JSAH* 52 (1993): figs. 13–15.

130. Satkowski 1979, 131. For the Servite Loggia, see I. del Badia, "La Loggia a destra nella Piazza SSma. Annunziata," *Arte e storia* 1 (1986):82–83; C. Elam, "Lorenzo de'Medici and the Urban Development of Renaissance Florence," 50–51; and G. Satzinger, *Antonio da Sangallo der Ältere und die Madonna di San Biagio bei Montepulciano* (Tübingen, 1991), 141–44.

131. Satkowski 1979, 129–134.

132. Borsi, *Firenze del Cinquecento*, 192. Parigi was married to Laura Ammannati, sister of Bartolomeo Ammannati.

133. M. Villani, *Cronica di Matteo Villani* (Florence, 1846), 8:38; W. Braunfels, *Mittelalterliche Stadtbaukunst in der Toskana* (Berlin, 1953), 203–6.

134. Mercantini, *Palazzo di Fraternita*, 34.

CHAPTER SIX

1. For the concept, see H. Jedin, *Kathölische Reformation oder Gegenreformation* (Lucerne, 1946). For a discussion of the validity of the term "Catholic Reformation," see the introductory remarks in J. O'Malley, ed., *Catholicism in Early Modern History: A Guide to the Research* (St. Louis, 1988), 4–5. A useful bibliography of the discussion engendered by the concept is in C. Black, *Italian Confraternities in the Sixteenth Century* (Cambridge, 1989), 5n.13.

2. M. Lewine, "The Roman Church Interior, 1527–

1580" (Ph.D. diss., Columbia University, 1960). See also Lewine's summary of his dissertation in "Roman Architectural Practice During Michelangelo's Maturity," *Stil und Überlieferung in der Kunst des Abendlandes*. Akten des 21 Internationalen Kongress für Kunstgeschichte, 2 vols. (Berlin, 1964), 2:20–26.

3. For confraternities during this period, see Black, *Italian Confraternities*, and R. Weissman, *Ritual Brotherhood in Florence* (New York and London, 1982).

4. P. Pirri, *Giovanni Tristano e i primordi dell' architettura gesuitica* (Rome, 1955); Idem., *Giuseppe Valeriano S.I. architetto e pittore 1542–1596* (Rome, 1970); P. Pirri and P. Di Rosa, "Il P. Giovanni de Rosis (1538–1610) e lo sviluppo dell' edilizia gesuitica," *Archivium Historicum Societatis Iesu* 44 (1975), 3–104; R.Bösel, *Jesuitenarchitektur in Italien 1540–1773* (Vienna, 1986), 13.

5. Boase, *Vasari*, 23–28; M. D. Davis, "Vasari e il mondo ecclesiastico minore," *Giorgio Vasari* 1981, 48–49.

6. J. C. Almond, "Olivetans," *The Catholic Encyclopedia*, 15 vols. (London, 1907–12), 11: 244–45; R. Capra, "Benedettini olivetani," *Enciclopedia Cattolica*, 12 vols. (Vatican City, 1948–54), 2:1248–49; C. Picasso, "Congregazione benedettina olivetana," *Dizionario degli istituti di perfezione*, 8 vols. (Rome, 1974–), 2:1493–96.

7. A. Giabbani, "Camaldoli," *Enciclopedia cattolica*, 3:421–22; G. Cacciamani, *Dizionario degli istituti di perfezione*, 1:1718–25.

8. For the Florentine response to the Counter-Reformation, see A. d'Addario, *Aspetti della controriforma a Firenze* (Rome, 1972). Much useful information is also contained in *La comunità cristiana fiorentina e Toscana nella dialettica religiosa del Cinquecento*, Firenze e Toscana dei Medici nell' Europa del Cinquecento, 5 (Florence, 1980).

9. *La comunità cristiana*, 48.

10. D'Addario, *Aspetti della controriforma a Firenze*, 55–56.

11. Weissman, *Ritual Brotherhood*, 206–9.

12. Weissman, *Ritual Brotherhood*, 234.

13. G. Alberigo, "Antonio Altoviti," *Dizionario biografico degli italiani*, 39 vols. (Rome, 1960–), 2: 572–73.

14. D'Addario, *Aspetti della controriforma a Firenze*, 179.

15. D'Addario, *Aspetti della controriforma a Firenze*, 120–24.

16. Lapini, *Diario fiorentino*, 156–57.

17. D'Addario, *Aspetti della controriforma a Firenze*, 226–41.

18. Vasari-Milanesi, 7: 691; G. Mancini, *Cortona nel Medievo* (Florence, 1897), 327; A. del Vita, "Un'opera d'architettura del Vasari poco nota," *Il Vasari* 4

(1931):178–88; Frey, 3: 106–8; M. Salmi, *Civiltà artistica della terra aretina* (Novara, 1971), 104–5; Lessmann 1975, 173–4; Satkowski 1979, 148–49; P. N. Holder, *Cortona in Context* (Clarksville, Tenn., 1992), 197–98.

19. Salmi, *Civiltà artistica*, 52; M. Mercantini, *La Pieve di S.Maria ad Arezzo* (Arezzo, 1982).

20. Mercantini, *La Pieve*, 67.

21. Proposed by A. Cecchi in *Giorgio Vasari* 1981, 308–9; see also C. Monbeig-Goguel, *Vasari et son temps* (Paris, 1972), 201.

22. Vasari-Milanesi, 1:475–76; G. B. Ristori, *Nuova guida della città di Arezzo* (Florence, 1871), 60–65; C. Isermeyer, "Die Capella Vasari und der Hochaltar in der Pieve von Arezzo," *Eine Gabe der Fruende für Carl Georg Heise* (Berlin, 1950), 137–53; idem, "Il Vasari ed il restauro delle chiese mediovali," *Studi vasariani* (Florence, 1952), 229–36; idem, "Le chiese del Vasari ed i suoi interventi in edifici sacri mediovali," *Bolletino del Centro Internazionale di Studi di Architettura "Andrea Palladio"* 19 (1977): 281–95; Lessmann 1975, 179; M. Hall, *Renovation and Counter-Reformation: Vasari and Duke Cosimo in Sta Maria Novella and Sta Croce* (Oxford, 1979), 4; Boase, *Vasari*, 172–75; *Arch. Arezzo* 1985, 50–63.

23. For Cortona, see *Arch. Arezzo* 1985, 216–19; for Lucignano, see ibid., 268–71; C. Verani, "Un' ignota opera di architettura del Vasari, S. Maria della Querce a Lucignano," *Il Vasari* 11 (1940), 85–88; U. Procacci, "L'architettura nell' aretino: il medio ed il tardo Rinascimento," *Atti del XII Congresso di storia dell' Architettura, Arezzo, 1961* (Rome, 1969), 142–46. Mercantini, *La Pieve*, 14, suggests without conclusive documentation that the Pieve's nave may have been vaulted after Vasari's death.

24. Frey, 1:71–76.

25. Hall, *Renovation and Counter-Reformation*, 8–9; W. Lotz, "Le trasformazioni vasariane e i nuovi edifici sacri del tardo '500," in *Arte e religione nella Firenze de' Medici* (Florence, 1980), 87–88.

26. D. Howard, *Jacopo Sansovino* (New Haven and London, 1975), 74. For a general introduction to the topic, see R. Lewcock, "Acoustics," *Grove's New Dictionary of Music and Musicians*, 20 vols. (London, 1980), 1:51–57.

27. K. G. Fellerer, "Church Music and the Council of Trent," *Musical Quarterly* 39 (1953): 576–94; L. Lockwood, *The Counter-Reformation and the Masses of Vincenzo Ruffi* (Venice, 1970), 130–35; for a review of recent literature, see N. Rasmussen, "Liturgy and the Liturgical Arts," *Catholicism in Early Modern History* (St. Louis, 1988), 287–88.

28. Frey, 1:422–3; Hall, *Renovation and Counter-Reformation*, 4.

29. P. Farulli, *Annali ovvero notizie storiche dell' antica nobile e valorosa città di Arezzo in Toscana* (Foligno, 1717), 188–89; *Giorgio Vasari* 1985, 69.

30. Frey 2:155–57.

31. Frey, 2:157–58.

32. Frey, 2:71–72. For a discussion of Vasari's drawing (Hamburg, Kunsthalle, 21512) showing the front side of the altar presumably in its original condition, see Isermeyer, "Die Capella Vasari," 153. There is no evidence to support Isermeyer's assertion that the drawing was meant to be the last sheet in Vasari's *Libro dei Disegni*.

33. Boase, *Vasari*, 172.

34. C. De Tolnay, *The Tomb of Julius II* (Princeton, 1954), 30–36 and fig. 96; M. Hirst, *Michelangelo and his Drawings* (New Haven and London, 1988), 94 and plates 171–73.

35. Vasari-Milanesi, 3:585–86; W. Lotz, "Michelozzos Umbau der SSma. Annunziata in Florenz," *MKIF* 5 (1940): 402–27 and fig. 2: L. Heydenreich, "Intorno un disegno di Leonardo da Vinci per l'antico altare di SSma. Annunziata," *MKIF* 5 (1940), 436–37; Paatz, *Kirchen*, 1:127. Isermeyer, "Die Capella Vasari," 150.

36. Frey, 2:137.

37. Vasari-Milanesi, 6:629–60; Pope-Hennessy, *Italian High Renaissance and Baroque Sculpture* (London and New York, 1970), 357–58; G. Kubler, "Drawings by G. A. Montorsoli in Madrid," *Collaboration in Italian Renaissance Art*, ed. W. Sheard and J. Paoletti (New Haven and London, 1978), 145–46.

38. Vasari-Milanesi, 6:653–54.

39. R. Gaston, "Liturgy and Patronage in Florence," in *Patronage, Art, and Society in Renaissance Italy*, ed. F. Kent and P. Simon (Oxford, 1987), 123–24.

40. Vasari-Milanesi, 2:421, and 8:98–99; J. Clearfield, "The Tomb of Cosimo de' Medici in San Lorenzo," *Rutgers Art Review* 2 (1981):24.

41. P. Barolsky, *Giotto's Father and the Family of Vasari's Lives* (University Park, and London, 1992), 50.

42. The history of the grandiose monastic church is complex and the authorship of its design is not clear. A claim for Vasari's authorship was incorrectly advanced by his nephew Marcantonio (Frey, 2:884–85), other attributions to Vignola and Ignazio Danti have been made, and the church's documented history includes contributions by Nanni di Baccio Bigio and Martino Longhi the Elder. For further documentation, see M. Viale-Ferrero, *La Chiesa di Santa Croce a Bosco Marengo* (Turin, 1959); Heydenreich and Lotz, 284–85; G. Ieni, "Architetti e fabbricieri del complesso conventuale (1566–1572). Nuove conclusioni sulla base del materiale documentario," in *Pio V e Santa Croce di Bosco. Aspetti di una commit-*

tenza papale, ed. C. Spantigati and G. Ieni (Alessandria, 1985), 3–25.

43. For the history of Vasari's altar, see Vasari-Milanesi, 7:705; Frey, 2:881; Monbeig-Goguel, *Vasari et son temps*, 152; Boase, *Vasari*, 319–20; Viale-Ferrero, *La Chiesa di Santa Croce a Bosco Marengo*, 18–20; G. Ieni, " 'Una macchina grandissima quasi a guisa d'arco trionfale': l'altare vasariano," in *Pio V e Santa Croce di Bosco*, 49–62.

44. S. Serlio, *Estraordinario libro di architettura* (Lyons, 1551), pl. XVIII.

45. Vasari-Milanesi, 7:705–6.

46. G. Richa, *Notizie istoriche delle chiese fiorentine*, 10 vols. (Florence 1754–62), 1:203; Paatz, *Kirchen*, 2:291; Isermeyer, "Capella Vasari," 152; Corti, *Vasari*, 125.

47. Vasari-Milanesi, 7:672–73; Monbeig-Goguel, *Vasari et son temps*, 150.

48. Frey, 2:434.

49. For the Cathedral facade, see Paatz, *Kirchen*, 3:336–37 and 473n. 34; C. Cresti et al., *L'avventura della facciata: Il Duomo di Firenze 1822–1887* (Florence, 1987); *Due granduchi, tre re e una facciata* (Florence, 1987).

50. G. B. Ristori, *Diario dei restauri del Tempio di S. M. della Pieve eseguiti dall'anno 1864 all' anno 1878* (Arezzo, 1928), 30. A copy of this exceedingly rare publication is in the Biblioteca Communale, Arezzo.

51. H. Jedin, "La politica conciliare di Cosimo I," *Rivista storica italiana* 57 (1950):345–74 and 477–96; N. Rodolico, "Cosimo I e il Consiglio di Trento," *Archivio storico italiano* 122 (1964): 5–8.

52. A. Legrenzi, *Vincenzo Borghini* (Udine, 1919); G. Falena, "Vincenzo Borghini," *Dizionario biografico degli italiani*, 12:680–89; *Giorgio Vasari* 1981, 152–53; R. Williams, "Vincenzo Borghini and Vasari's *Lives*" (Ph.D. diss., Princeton University, 1988).

53. T. Lecissotti, "La congregazione benedettina di S. Giustina e la riforma della chiesa del '400," *Archivio della R. Deputazione per la storia patria*, 67 (1944), 451–69; G. Penco, *Storia del monachesimo in Italia* (Rome, 1961); M. Fois, "I movimenti religiosi dell'osservanza nel '400," *Riforma della Chiesa. Cultura e spiritualità nel Quattrocento veneto*, ed. G. Trolese (Cesena, 1984), 225–26; B. Collett, *Italian Benedictine Scholars and the Reformation: The Congregation of Santa Giustina* (Oxford, 1985); A. Panton, "Congregazione benedettina cassinese," *Dizionario degli istituti di perfezione*, 2:1477–85. Ludovico Barbo (1382–1443) founded the congregation in 1404 by uniting the numerous sects following the Rule of St. Benedict, and it received papal recognition in 1419. Known at first as *De Unitate*, the order acquired its name in 1504 when the abbey of Montecassino entered the congregation.

54. G. Penco, "Vita monastica e spiritualità nel Quattrocento veneto," *Riforma della Chiesa*, 30.

55. Satkowski 1979, 45–75 and 178–94. Borghini's role is confirmed by a request made by the Badia's abbot to build over a public right of way "secondo il disegno del S. Prior degli Innocenti, et Giorgio Vasari aretino" (ASF, Capitani di Parte, 718 nero, 181).

56. There is a tradition asserting that Vasari's church was built on a foundation of a fifteenth-century renovation begun by Giuliano da Maiano (most recently stated in G. Marchini, "L' architettura nell' aretino: il primo rinascimento," *Atti del XII Congresso di Storia dell' Architettura*, 108–11). No documentary proof substantiates this claim. To the contrary, an early contract refers to Vasari's project as "de volentis restaurare, atque et amplionem et maiorem facere" (ASF, Conventi Soppressi, No. 7, SS. Flora e Lucilla, filza 6, 191; also in Satkowski 1979, 181).

57. T. Lecissotti, "Le condizioni economiche dei monasteri cassinesi di Toscana alla metà del '600," in *Studi in onore di Amintore Fanfani*, 6 vols. (Milan, 1962), 5:289–312.

58. Satkowski 1979, 194. The manuscript report is in the library of the Basilica of San Paolo fuori le mura, Rome, *Status monasteriorum cassensis anno 1650*, 212. For the condition of the Badia prior to the restoration begun in 1988–89, see *Arch. Arezzo* 1985, 26–29.

59. R. Krautheimer, "Alberti's *Templum Etruscum*," *Müncher Jahrbuch der bildenden Kunst* 12 (1961): 65–72; republished in *Studies in Early Christian, Medieval, and Renaissance Art* (New York and London, 1969), 333–44.

60. J. MacAndrew, "San Andrea della Certosa," *AB*, 51 (1969):19–28; J. S. Ackerman, "Observation on Renaissance Church Planning in Venice and Florence, 1470–1570," *Venice and Florence: Comparisons and Relations*, 2 vols. (Florence, 1980), 2:287–307.

61. For San Salvatore, see particularly M. Tafuri, *Venice and the Renaissance*, trans. J. Levine (Cambridge and London, 1989), 15–50.

62. For the Byzantine revival in Venice, see Ackerman, "Observations," 287–92.

63. B. Zevi, *Biagio Rosetti architetto ferrarese* (Turin, 1960), 309–12; Heydenreich-Lotz 118.

64. G. Fiocco et al., *Santa Giustina: arte e storia* (Castelfranco Veneto, 1970); Heydenreich-Lotz 317–18; Ackerman, "Observations," 298–99.

65. G. Cattin, "Tradizioni e innovatrici nella normative e nella practica liturgico musicale del Congregazione Cassinese," *Benedictina* 19 (1970):259n.26.

66. Only a few blocks from the Badia, the facade of Antonio da Sangallo the Elder's church of the San-

tissima Annunziata prominently displays a serliana that serves as a cipher for the Blessed Virgin, as indicated by the inscription that it contains. For this church, see G. Satzinger, *Antonio da Sangallo der Ältere und die Madonna di San Biagio bei Montepulciano* (Tübingen, 1992), 134–41. Even more important in this context are the ingenious designs created by Baldassare Peruzzi for the renovation of San Domenico in Siena. In one of his proposals Peruzzi showed great skill in using the serliana to create a unified interior space (Uffizi 149A), and in another the Badia's plan is anticipated (Uffizi 338A). This project was not carried out, and Vasari's familiarity with it is uncertain. For San Domenico, see G. Chierici, "Baldassare Peruzzi e la chiesa di San Domenico a Siena," *Rassegna d'arte senese* 16 (1923):70–75; H. Wurm, *Baldassare Peruzzi, Architekturzeichnungen* (Tübingen, 1984), 219–38.

67. Frey, 2:241.
68. Frey, 2:235.
69. E. Panofsky, "The First Page of Vasari's *Libro*," *Meaning in the Visual Arts* (New York, 1955), 214.
70. E. Pillsbury, "The Temporary Facade on the Palazzo Ricasoli," *Report and Studies in the History of Art* (1969):80; Hall, *Renovation and Counter-Reformation*, 113.
71. V. Borghini, *Discorsi*, 2 vols. (Florence, 1585), 1:439; M. Hall, "The *Ponte* in Santa Maria Novella," *JWCI* 37 (1974):158.
72. For an extensive analysis of Vasari's statements on medieval architecture in the *Lives*, see Williams, "Vincenzo Borghini," 196–242.
73. Satkowski 1979, 68–71.
74. Vasari-Milanesi, 1:231–37.
75. Collett, *Italian Benedictine Scholars*, 256–57.
76. Collett, *Italian Benedictine Scholars*, 261.
77. The main study is Hall, *Renovation and Counter-Reformation*, which includes all earlier bibliography. See also C. Isermeyer, "Le chiese del Vasari," 287–90; M. Hall, "The Italian Rood Screen: Some Implications for Liturgy and Function," *Essays Presented to Myron P. Gilmore*, 2 vols., ed. S. Bertelli and G. Ramakus (Florence, 1978), 2:213–18; Lotz, "Le transformazioni vasariane" 81–89; M. A. Lavin, *The Place of Narrative: Mural Decoration in Italian Churches, 431–1600* (Chicago and London, 1990), 252–53.
78. M. Hall, "The *Tramezzo* in S. Croce and Domenico Veneziano's Fresco," *BM* 113 (1970):797–99; idem, "The *Ponte* in S. Maria Novella," *JWCI* 37 (1974):157–73; idem, "The *Tramezzo* in Santa Croce, Florence, Reconstructed," *AB* 56 (1974):325–41.
79. Lapini, *Diario fiorentino*, 152; Heydenreich and Lotz

395n.16; Hall, *Renovation and Counter-Reformation*, 17 and 22–23; Lotz, "Le transformazioni vasariane," 88.
80. Hall, *Renovation and Counter-Reformation*, 11. For a proposal by Cigoli to build niches between the altars, see Morrogh 1985, 171–72.
81. Hall, "The Operation of Vasari's Workshop," 207.
82. Hall, *Renovation and Counter-Reformation*, 10.
83. P. Pecchai, "I lavori fatti nella chiesa della Minerva per collaocarvi le sepolture di Leone X e Clemente VII," *Archivi d'Italia* ser. 2, 17 (1950):199–207; W. Buchowiecki, *Handbuch der Kirchen Roms: der römische Sakralbau in Geschichte und Kunst von der altchristlichen Zeit bis zur Gegenwart*, 3 vols. (Vienna, 1967–74), 3:695.
84. I. Fenlon, "The Gonzaga and Music," *Splendours of the Gonzaga* (London, 1981), 89.
85. For the cathedral, see M. Tafuri, "Il duomo di Mantova," in *Giulio Romano* (Milan, 1989), 550–57.
86. J. S. Ackerman, "The Gesù and Contemporary Church Design," *Baroque Art: the Jesuit Contribution*, ed. I. Jaffe and R. Wittkower (New York, 1972), 15–28. Reprinted in J. S. Ackerman, *Distance Points: Essays in Theory and Renaissance Art and Architecture* (Cambridge, Mass., and London, 1991), 417–51.
87. Lotz, "Le trasformazioni vasariane," 85–86.
88. H. Teubner, "Das Langhaus der SS. Annunziata in Florenz. Studien zu Michelozzo und Giuliano da Sangallo," *MKIF* 22 (1978):27–60; A. Luchs, *Cestello: a Cistercian Church of the Florentine Renaissance* (New York and London, 1977).
89. Tafi, *Arezzo*, 364–71.
90. Vasari-Milanesi, 2:440–41; Hall, *Renovation and Counter-Reformation*, 23; H. Teubner, "San Marco in Florenz. Umbauten vor 1500," *MKIF* 23 (1979):239–72.
91. Teubner, "San Marco," 254.
92. Lapini, *Diario fiorentino*, 144 and 150.
93. For Ognissanti, see Hall, *Renovation and Counter-Reformation*, 2. For the Carmine, see Paatz, *Kirchen*, 3:189 and 240n.15. The project for the Carmine is especially interesting because its history follows lines similar to S. Croce and S. Maria Novella. The nave was whitewashed, the choir removed, and the old altars were replaced by ones in pietra serena. Although Baccino di Filippo d'Agnolo was appointed to oversee the renewal, it is likely that Vasari formulated the idea for the project because he had erected an altar tabernacle similar to those employed in his other renovations. The project, however, appears to have lacked the direct involvement of Duke Cosimo, and as a consequence developed in a somewhat haphazard manner. On 29 January 1771 a fire destroyed much of the church, and what remained

of the altars was removed in the reconstruction that followed.

94. R. Lanardi, "Ristrutturazione vasariane di Santa Maria Novella," *Memorie domenicane* 19 (1988): 403–15.

95. Z. Wazbinski, *L'Accademia Medicea del Disegno a Firenze nel Cinquecento: idea e istituzione*, 2 vols. (Florence 1987), 155–76; see also Pope-Hennessy, *Italian High Renaissance and Baroque Sculpture*, 61–62 and 366–71.

96. M. Trionfi Honorati, "Un tabernacolo ligneo su disegno del Vasari e l'intagliatore Alberto Alberti," *Antichità viva* 14, no.3 (1975):57–61; Hall, *Renovation and Counter-Reformation*, 19; *La comunità cristiana*, 216–18. Vasari designed two other ciboria. The one requested in 1564 by Bishop Ricasoli for Pistoia Cathedral has been lost; the other, designed in 1573 for the Cathedral of Ascoli Piceno, is now in the Chiesa del Crocefisso.

97. Vasari-Milanesi, 4:336.

98. L. Medri "Fortuna e decadenza dell' altare vasariano in Santa Croce," *Santa Croce nell'800*, ed. M. G. Ciardi Duprè Dal Poggetto (Florence, 1986), 249–63.

99. For a review of the question see Williams, "Vincenzo Borghini," 56n.71.

100. Vasari-Milanesi, 7:710.

101. For documentation and drawings for Buontalenti's renewal of Santa Trinita, see V. Giovanozzi, "La vita di Bernardo Buontalenti scritta da Gherardo Silvani," *Rivista d'Arte* 14 (1932):510n.5, and idem, "Ricerche su Bernardo Buontalenti," *Rivista d'Arte* 15 (1933):315–16; For Arezzo Cathedral, see G. Marchini, "Su i disegni d'architettura del Vasari," *Giorgio Vasari* 1974, 105.

CHAPTER SEVEN

1. The best introductions to this area are R. Strong, *Art and Power* (Berkeley and Los Angeles, 1984), and B. Mitchell, *The Majesty of State: Triumphal Progresses of Foreign Sovereigns in Renaissance Italy (1494–1600)* (Florence, 1986). For primary sources, see B. Mitchell, *Italian Civic Pageantry in the High Renaissance: A Descriptive Bibliography of Triumphal Entries and Other Festivals* (Florence, 1979); for secondary sources, see R. Baldwin, "A Bibliography on the Literature on Triumph," in *Art and Pageantry in the Renaissance and Baroque*, 2 vols., ed. B. Wisch and S. S. Munshower (University Park, 1991), 1:357–85.

2. J. Shearman, "A Functional Interpretation of the Villa Madama," *RJ* 20 (1983):313–27.

3. For Charles V, see J. H. Elliott, *Imperial Spain, 1469–1716* (London, 1963), 164–211; and H. G. Koenigs-berger and G. L. Mosse, *Europe in the Sixteenth Century* (London, 1978), 174–79.

4. The indispensable account is G. Giordano, *Della venuta e dimora in Bologna del Sommo Pontefice Clemente VII per la coronazione di Carlo V imperatore* (Bologna, 1842). The most useful recent studies are A. Chastel, "Les entrées de Charles Quint en Italie," *Les Fêtes de la Renaissance*, 3 vols., ed. J. Jacquot (Paris, 1959–75), 2: 197–206, and Mitchell, *Majesty of State*, 135–47.

5. V. Saletta, "Il viaggio in Italia di Carlo V," *Studi meridionali* 9 (1976): 286–327 and 452–79; 10 (1977): 78–114, 268–92, and 420–42; 11 (1978):329–41; Mitchell, *Majesty of the State*, 151–74.

6. Vasari-Milanesi, 6:571–2.

7. M. L. Madonna, "L'ingresso di Carlo V a Roma," *La città effimera e l'universo artificiale del giardino*, ed. M. Fagiolo (Rome, 1980), 61–68.

8. Vasari-Milanesi, 5:464.

9. Mitchell, *Majesty of State*, 165; A. Sala, *Ordine, pompe, et cerimonie della solenne intrata di Carlo quinto imperatore sempre Augusto nella città di Roma* (Rome, 1536), quoted in F. Cruciani, *Teatro del Rinascimento: Roma, 1450–1550* (Rome, 1983), 578.

10. V. Cazzato, "Vasari e Carlo V: L'ingresso trionfale a Firenze del 1536," *Giorgio Vasari* 1981, 179–204.

11. Frey, 1:49.

12. Frey, 1:65–69; Mitchell, *Majesty of the State*, 172.

13. Frey, 1:52–62; Cazzato, "Vasari e Carlo V," 196–99.

14. F. Hartt, *Giulio Romano* (New Haven, 1958), 271–72.

15. A good brief survey is D. Mignani, *Le Ville Medicee di Giusto Utens* (Florence, 1980), 7–18.

16. For confiscated properties, see G. Spini, *Architettura e politica da Cosimo I a Ferdinando I* (Florence, 1976), 22–24.

17. C. Lazzaro, *The Italian Renaissance Garden* (New Haven and London, 1990), 167–89; D. R. Wright, "The Villa Medici at Olmo a Castello" (Ph.D. diss., Princeton University, 1976).

18. Vasari-Milanesi, 6:72–85.

19. Wright, "Villa Medici," 156 and 164–65.

20. Wright, "Villa Medici," 180–84.

21. Lazzaro, *Italian Renaissance Garden*, 191–95.

22. Vasari-Milanesi, 6:180, describes the original project as a "vivaio." For recent discussions of Buontalenti's completion of the Grotta Grande, see Lazzaro, *Italian Renaissance Garden*, 200–8, and D. Heikamp, "The Grotta Grande in the Boboli Garden. A Drawing in the Cooper-Hewitt Museum," *Connoisseur* 199 (1978):38–43. F. Gurrieri and J. Chatfield, *Boboli Gardens* (Florence, 1972), 38–40, incorrectly states that Vasari designed the facade for Michelangelo's unfinished slaves, which were brought to the Boboli only in 1585.

23. The evidence for the history of Grotta Grande is far

from straightforward. The contract for its completion was signed in September 1583, but it is uncertain precisely how much new construction this entailed. The Grotta Grande is shown in Fra Stefano Bonsignori's 1584 view of Florence with an arched opening and a pediment above it, a design that may represent the condition of Vasari's structure.

24. For example, see the studies illustrated in D. Lewis, *The Drawings of Andrea Palladio* (Washington, D.C., 1981), 132–35.

25. Vasari-Milanesi, 1:112; Lazzaro, *Italian Renaissance Garden*, 312n.2.

26. Wright, "Medici Villa," 199–202.

27. Frey, 1:521.

28. Vasari-Milanesi, 6:76; Lazzaro, *Italian Renaissance Garden*, 186.

29. Frey, 1:594 ("et l'ordine di mezzo, fin dove a da posare le figure"); Ibid., 625–28 ("A Castello ci son stato, e si lavora; et Lunedi per conto di quelle canne della fonte del vivaio ci staro tutto il giorno; et sara bella et richa opera").

30. Vasari-Milanesi, 6:77.

31. H. Keutner, "Niccolo Tribolo und Antonio Lorenzi, Der Äskulapbrunnen im Heilkräutergarten der Villa Castello bei Florenz," *Studien zur Geschichte der europäischen Plastik. Festschrift Theodor Müller* (Munich, 1965), 241–43; W. Aschoff, "Tribolo disegnatore," *Paragone* 29, no. 209 (1967):45–47. A plan of the Grotto drawn by G. B. Sangallo has been published by C. Conforti, "La grotta 'degli animali' o 'del dilivio' nel giardino di Villa Medici a Castello," *Quaderni di Palazzo Te* 6 (1987). The plan (Uffizi 1640Av) was discussed by Wright, "Villa Medici," 161–62.

32. B. H. Wiles, *The Fountains of the Florentine Sculptors and their Followers, from Donatello to Bernini* (Cambridge, Ma., 1933), 73–74.

33. G. Gaye, *Carteggio inedito d'artisti dei secoli XIV, XV, XVI*, 3 vols. (Florence, 1840), 2:344; D. Coffin, *Gardens and Gardening in Papal Rome* (Princeton, 1991), 37.

34. Wright, "Villa Medici," 202; Lazzaro, *Italian Renaissance Garden*, 181.

35. Vasari-Bellosi, 37–38.

36. Vasari-Milanesi, 1:141.

37. Alberti, 2:806–7,

38. For modern works, see P. Ginori Conti, *L'apparato per le nozze di Francesco de'Medici e di Giovanna d'Austria* (Florence, 1936), and R. Starn and L. Partridge, *Arts of Power: Three Halls of State in Italy, 1300–1600* (Berkeley and Los Angeles, 1992), 168–74, 178–80, 185–86, and 267–304. See also A. M. Nagler, *Theatre Festivals of the Medici, 1539–1637* (New Haven and London, 1964), 13–35; G. Gaeta Bertela and A. Petrioli Tofani, *Feste e apparati medicei da Cosimo I a Cosimo I,* Cataloghi Gabinetto Disegni e Stampe degli Uffizi, 31 (Florence, 1969), 15–20; and R. Strong, *Art and Power*, 26–27 and 130–31. For contemporary accounts, see D. Mellini *Descrizione dell Entrata Della sereniss. Reina Giovanna d'Austria Et dell' Apparato, fatto in Firenze nella venuta & per le felicissime nozze di S.Altezza Et del Illustrissimo & Eccelentissimo S. Don Francesco Medici, Principe di fiorenza & Siena* (Florence, 1566), and G. B. Cini, *Descrizione dell' apparato fatto in firenze per le nozze dell'illustrissimo ed Don Francesco de' Medici principe di Firenze e Siena e della serenissima regina Giovanna d' Austria* (Florence, 1566). Reprinted in Vasari-Milanesi, 8:517–622.

39. G. G. Bottari, *Raccolta di lettere sulla pittura scultura ed architettura*, 4 vols. (Rome, 1757), 1:90–147. Hereafter cited as Borghini, Letter. For Borghini's categories of entries, see page 93.

40. Starn and Partridge, *Arts of Power*, 200–3.

41. For *La Cofanaria*, see *Il luogo teatrale a Firenze* (Milan, 1975), 95–98. For *La Genealogia degli Dei*, see J. Seznec, "La Mascarade des dieux a Florence en 1565," *Mélanges d'archeologie et d'histoire* 52 (1935):224–43; and A. M. Petrioli, *Mostra di disegni vasariani. Carri trionfali e costumi per 'La Genealogia degli Dei'*. Gabinetto Disegni Stampe degli Uffizi, 22 (Florence, 1966).

42. G. De Caro, "Bianca Cappello," *Dizionario biografico degli italiani*, 10:15–16.

43. Lapini, *Diario fiorentino*, 148.

44. Lapini, *Diario fiorentino*, 151.

45. A. M. Testaverde, "Festee medicee: la visita, le nozze, e il trionfo," *La città effimera*, 69–100; Idem, "La decorazione festiva e l'itinerario della città negli ingressi trionfali a Firenze tra XV e XVI secolo," *MKIF* 32 (1988):323–52. For a discussion of Borghini's alternative proposal to direct the entry towards the Mercato Nuovo, see Partridge and Starn, *Arts of Power*, 169.

46. N. Rubinstein, "Vasari's Painting of *The Foundation of Ancient Florence* in the Palazzo Vecchio," in *Essays in the History of Architecture Presented to Rudolf Wittkower*, ed. D. Fraser et al.(London and New York, 1967), 64–73.

47. For the rituals involved in the foundation of an ancient Roman town, see J. Rykwert, *The Idea of a Town* (London, 1976), 65–68 and 200–1.

48. Ginori-Conti, *L'apparato*, 33–39.

49. E. Pillsbury, "Drawings by Vasari and Borghini for the *Apparato* in Florence in 1565," *Master Drawings* 5 (1967):281–83.

50. Satkowski 1979, 156–57.

51. D. Friedman, *Florentine New Towns: Urban Design in the Late Middle Ages* (Cambridge and London, 1988), 208–11.

52. Borghini, Letter, 98; Ginori-Conti, *L'apparato*, 24–28.

53. Borghini, Letter, 98; Ginori-Conti, *L'apparato*, 28–33.

54. Borghini, Letter, 99; Ginori-Conti, *L'apparato*, 43–46.

55. J. Jacquot, "Panorama des fêtes et ceremonies du regne," *Fêtes*, 2:463.

56. Satkowski 1979, 156.

57. E. Pillsbury, "The Temporary Facade on the Palazzo Ricasoli: Borghini, Vasari, and Bronzino," *Report and Studies in the History of Art 1969* (Washington, D.C.), 74–83.

58. R. Cevese, "La 'riformazione' delle case vecchie secondo Sebastiano Serlio," *Sebastiano Serlio: Sesto Seminario Internazionale di Storia dell'Architettura*, ed. C. Thoenes (Milan, 1989), 196–202.

59. L. Zorzi, introduction to *Il luogo teatrale* (Milan, 1975), 1–51, esp. 26. Reprinted with notes as idem, "Firenze: il teatro e la città," *Il teatro e la città* (Turin, 1977), 61–233.

60. K. W. Forster, "Stagecraft and Statecraft: The Architectural Integration of Public Life and Theatrical Spectacle in Scamozzi's Theater at Sabbioneta," *Oppositions* 7 (1979):63–89.

61. *Il luogo teatrale*, 93.

62. Borghini, Letter, 135, states "che mi vuol ricordare la veduta di Via Maggio di Carlo Quinto Imperatore è stato giudicato per una delle belle cose, che gli paresse mai veduta."

63. Borghini, Letter, 134, describes the design "un teatro da potersi levare, e porre per servizio di commedie e altri spettacli, che si avresso fare in detta sala da potersene servire ora."

CHAPTER EIGHT

1. Vasari-Milanesi, 4:373–74.

2. For almost every element in the Uffizi facade there are several possible sources. To Vasari the ground floor of the magistracies must have represented a sort of universal, archetypal motif deriving from the Pantheon and subsequently employed in buildings as diverse as the Florentine Baptistery, Peruzzi's Palazzo Massimo and his frescoes in the Villa Farnesina, Michelangelo's Palazzo dei Conservatori, and Vasari's own facade for the Grotta Grande in the Boboli Gardens. The startling perforation of the portico's vault derives from cryptoportici that Vasari must have studied at Hadrian's Villa during his early visits to Rome, as well as from the cryptoporticus-inspired vault in the courtyard of the Palazzo Massimo. The vaulting of the riverfront loggia echoes the facade of the Pazzi Chapel. The piano nobile is articulated by three tall windows that infuse a particular severity into a type employed by Bramante in the Palazzo Caprini or by Raphael on the Palazzo Pandolfini in Florence. The continuous open loggia on the upper floor is expressed as a continuous altana, the open belvedere often found on the uppermost floors of Florentine palaces. The overall composition, which links elements both horizontally and vertically, is comparable to Venetian designs of Serlio and Sanmicheli.

3. Satkowski 1979, 142–43; Corti, *Vasari*, 111 and 142.

4. Frey, 1:56.

5. For the origins of *concetto* in the artistic theory of Benedetto Varchi, see D. Summers, *Michelangelo and the Language of Art* (Princeton, 1981), 212–13. I have selected this term, rather than the more theoretical *idea*, which Vasari often employed, to characterize his approach to architectural design because it more closely approximates his architectural intention. For the importance of *idea* in Vasari, see E. Panofsky, *Idea: A Concept in Art Theory*, trans. J. J. S. Peake (New York, 1968), 60–3.

6. For Vasari's artistic activity during his first visit, see J. Schulz, "Vasari at Venice," *BM* 103 (1961):500–11.

7. Vasari-Milanesi, 7:672.

8. For the original condition of the garden facade of the Palazzo del Te in Vasari's time (Düsseldorf, Kunstmuseum, drawing FP 10922), see Heydenreich and Lotz, plate 233.

9. Vasari-Milanesi, 5:467–68; 7:248–57.

10. Vasari-Milanesi, 7:712, Morrogh, "Vasari and Coloured Stones," *Giorgio Vasari* 1985, 315–18.

11. Vasari-Bellosi, 901.

12. H-W. Kruft, *Geschichte der Architekturtheorie: von der Antike bis zur Gegenwart* (Munich, 1985), 105.

13. P. Barolsky, *Why Mona Lisa Smiles and Other Tales by Vasari* (University Park and London, 1991), 105.

14. Vasari-Bellosi, 354–58; Vasari-Milanesi, 2:535–48.

15. Barolsky, *Why Mona Lisa Smiles*, 13–4; B. Preyer, "The Rucellai Loggia," *MKIF* 21 (1977):183–98.

16. Satkowski 1979, 154–55.

17. Frey, 1:673; P. Foster, *A Study of Lorenzo de'Medici's Villa at Poggio a Caiano*, 2 vols. (New York and London, 1978), 1:428–29; F. Gurrieri and D. Lamberini, *Le stalle della villa medicea a Poggio a Caiano* (Prato, 1980).

18. X. De Salas, "Un exemplaire des *Vies* de Vasari annoté par Le Greco," *Gazette des Beaux-Arts* 69 (1967): 177–180; idem, "Las notas del Greco a la Vida de Tiziano de Vasari," *Studies in the History of Art* 13 (1984):161–69; M. Hochmann, "Les annotations marginales de Federigo Zuccaro en une exemplaire des *Vies* de Vasari: la reaction anti-vasarienne à la fin du XVIe siècle," *Revue de l'art* 80 (1988):64–71;

M. Fanti, "Le postille carraccesche alle 'Vite' del Vasari; il testo originale," *Il Carrobbio* 5 (1979):148–64; C. Dempsey, "The Carracci *Postile* to Vasari's *Lives*," *AB* 68 (1986):72–76; F. J. Sanchez Canton, "La libreria de Velásquez," *Homenaje ofrecido a Menéndez Pidal* (Madrid, 1925), 3:400.

19. "Cominceròmmi dunque dall' architettura, come dalla più universale e più necessaria ed utile agli uomini, ed al servizio e ornamento della quale sono l'altre due" (Vasari-Milanesi, 1:104).

20. Jones's copy of the 1568 edition (hereafter cited as Vasari-Jones) is in the library of Worcester College, Oxford, LR.A.3.13. It is a partial copy, the *prima volume della terza parte*. It seems likely that Jones owned a full copy, although the other two volumes have not been discovered. For the importance of this volume on Jones' figural studies, see J. Wood, "Inigo Jones, Italian Art, and the Practice of Drawing," *AB* 74 (1992):247–70.

Vincenzo Scamozzi's copy of the *Lives* was also annotated. This volume was later in the possession of the French architect Hippolyte Destailleur (*Catalogue de Livres et Estampes . . . Provenant de la Bibliothèque de Feu M. Hippolyte Destailleur* [Paris, 1895], 18no.77). Henri Geymüller had seen the volume and passed on his notes to Milanesi, who mentioned the material in a note to Vasari's biography of Parmigianino (Vasari-Milanesi, 5:234n.1). This information was kindly brought to my attention by David Cast.

21. G. Higgott, "The Making of an Architect: Inigo Jones's Second Tour to Italy, 1613–14," *Inigo Jones: Complete Architectural Drawings*, ed. J. Harris and G. Higgott (New York, 1989), 52–61.

22. For example, see the passage about how "architecture must be massive and solid" in the life of Baccio d'Agnolo (Vasari-Jones, 282) or the discussion about "he who hath not desine" from a discussion of Baccio Bandinelli (Vasari-Jones, 283).

23. "This is a description of a dasine maad by Fra Giocondo for ye rialto" (Vasari-Jones, 247).

24. Vasari-Jones, 330.

25. "Vasarii is roang in his description of the pallas" (Vasari-Jones, 334). Although this note is located at the end of Vasari's artful description of the Sala dei Giganti, it must refer to his mention of the rusticated doors, windows, and fireplaces at the outset of his account. For this, see F. Hartt, *Giulio Romano* (New Haven, 1958), 153.

26. J. Summerson, *Inigo Jones* (Harmondsworth and Baltimore, 1966), 39. Jones took into account Vasari's visit to Mantua, where he notes "Julio shows to Giorgio Vassari (sic) all the *piante* of Rome, Naples, and Pozzuolo and Camapania" (Vasari-Jones, 337).

27. For a discussion of the various systems of artistic patronage, see P. Burke, *The Italian Renaissance: Culture and Society in Italy* (Princeton, 1986), 88–100.

28. Vasari-Milanesi, 2:546. The passage does not appear in the 1550 edition.

29. M. B. Hall, "The Operation of Vasari's Workshop and the Designs for Santa Maria Novella and Santa Croce," *BM* 115 (1973):204–9.

30. For Ammannati's activity in Pistoia, see E. Vodoz, "Studien zum architektonischen Werk des Bartolomeo Amannati," *MKIF* 6 (1941): 4; for Parigi, see Satkowski 1979, 119.

31. For the identification of the personalities involved in the execution of the Palazzo Vecchio, see the synopses of documents throughout E. Allegri and A. Cecchi, *Palazzo Vecchio: guida storica* (Florence, 1980). The documentation for the Uffizi can be found in Lessmann 1975, 227–358.

32. Morrogh 1985, 31–47.

33. For the funeral, see R. & M. Wittkower, *The Divine Michelangelo: the Florentine Academy's Homage on his Death in 1564* (London, 1964); Z. Wazbinski, *Accademia Medicea del Disegno a Firenze: idea e istituzione*, 2 vols. (Florence, 1987), 95–103.

34. Frey, 2:23–24; Wittkower, *The Divine Michelangelo*, 11–12.

35. Wittkower, *The Divine Michelangelo*, 22–23.

36. E. Cochrane, *Italy, 1530–1630*, ed. J. Kirshner (London and New York, 1988), 42–47.

37. For a brief discussion of Vasari and other artists in the model of *The Courtier*, see Burke, *The Italian Renaissance*, 83. See also D. A. Trafton, "Structure and Meaning in *The Courtier*," *English Literary Renaissance* 2 (1972):283–97; and R. W. Hanning and D. Rosand, eds., *Castiglione: The Ideal and the Real in Renaissance Culture* (New Haven and London, 1983).

38. A. Blunt, *Artistic Theory in Italy, 1450–1600* (Oxford, 1940), 96–97. See also Summers, *Michelangelo*, 178.

39. B. Castiglione, *The Courtier*, trans. C. Singleton (Garden City, 1959), 1:49.

40. *Courtier*, 1:46.

41. *Courtier*, 4:9.

42. *Courtier*, 4:36.

43. *Courtier*, 4:44.

44. For an overview of Farnese patronage, see C. Robertson, *'Il Gran Cardinale': Alessandro Farnese, Patron of the Arts* (New Haven and London, 1992). Fig 162 on page 174 erroneously shows a photograph of Vasari's Loggia in Arezzo as Giacomo della Porta's Bishop's Palace in Velletri.

45. For Turin, see M. D. Pollak, *Turin, 1564–1680* (Chicago and London, 1991), 16–18 and 26–30.

46. For Pietro's interest in Vasari's large scale decorations, see J. B. Scott, *Images of Nepotism: The Painted Ceilings of the Palazzo Barberini* (Princeton, 1991), 163–65.

S E L E C T E D
B I B L I O G R A P H Y

I. EDITIONS OF VASARI'S *LIVES*

Vasari, G. *Le vite de più eccelenti architetti, pittori et scultori italiani, da Cimabue insino a tempi nostri*. Florence, 1550.

Vasari, G. *Le vite de' più eccellenti pittori, scultori, ed architetti. . . .* Florence, 1568.

Vasari, G. *Le vite de' più eccellenti pittori, scultori, ed architetti. . . .* Ed. G. Milanesi. 9 vols. Florence, 1875–85. The most commonly cited version of the 1568 edition.

Vasari, G. *Le vite de più eccellenti architetti, pittori et scultori italiani, da Cimabue insino a tempi nostri*. Ed. L. Bellosi and A. Rossi. Turin, 1986. Reprint of the 1550 edition with annotations, bibliographic and testalogical notes, and a useful chronology of Vasari's career.

Vasari, G. *Lives of the Most Eminent Painters, Sculptors, and Architects*. Trans. of the 1568 edition by G. Du C. de Vere. 2nd ed. New York, 1979. The best English translation of the 1568 edition, with an introduction by Sir Kenneth Clark and a useful new index.

Vasari, G. *Vasari on Technique*. Trans. L. M. Brown of the Introduction to the 1568 edition of the *Lives*. Ed.

G. B. Brown New York, 1907. Reprinted New York, 1960.

II. GENERAL STUDIES

Ackerman, J. S. "The Planning of Renaissance Rome, 1480–1580." In *Rome in the Renaissance: The City and its Myth*, ed. P. Ramsey 3–18. Binghamton, 1982.

Ackerman, J. S., and Rosenfeld, M. N. "Social Stratification in Renaissance Urban Planning." In *Urban Life in the Renaissance*, ed. S. Zimmerman and R. F. E. Weissman. 21–49. Newark, Del., 1989.

Ackerman, J. S. *The Architecture of Michelangelo*. 2 vols. London and New York, 1961.

Ackerman, J. S. "Observation on Renaissance Church Planning in Venice and Florence, 1470–1570." In *Venice and Florence: Comparisons and Relations*. 2 vols. 2:287–307. Florence, 1980.

Ackerman, J. S. "The Gesù in the Light of Contemporary Church Design." In *Baroque Art: the Jesuit Contribution*, ed. I. Jaffe and R. Wittkower. 15–28. New York, 1972. Reprinted in idem, *Distance Points: Essays in Theory and Renaissance Art and Architiecture*. 417–512. Cambridge, Ma., and London, 1991.

Ackerman, J. S. *The Cortile del Belvedere*. Studi e documenti per la storia del Palazzo Apostolico Vaticano, 3. Vatican City, 1954.

Adriani, G. B. *Istoria de' suoi tempi*. Florence, 1583.

Alberti, L. B. *L'architettura*. 2 vols. Milan, 1966.

Aldrovandi, U. *Delle statue antiche che per tutta Roma in diversi luoghi si veggono*. Venice, 1556.

Andres, G. *The Villa Medici in Rome*. 2 vols. New York and London, 1976.

Angellucci, A. *Memorie per servire di guida al forestiero in Arezzo*. Florence, 1819.

Anzilotti, A. *La constituzione interna dello Stato Fiorentino sotto Il Duca Cosimo I de' Medici*. Florence, 1910.

Avery, C. *Giambologna: the Complete Sculpture*. Oxford, 1987.

Berti, L. "L'architettura manieristica a Firenze e in Toscana." *Bolletino del Centro Internazionale di Studi di Architettura 'Andrea Palladio'* 9 (1967):211–19.

Black, C. *Italian Confraternities in the Sixteenth Century*. Cambridge, 1989.

Black, R. "Humanism and Education in Renaissance Arezzo." *I Tatti Studies: Essays in the Renaissance* 2 (1987): 171–238.

Blunt, A. *Artistic Theory in Italy, 1450–1600*. Oxford, 1940.

Bocchi, F., and Cinelli, G. *Le belleze della città di Firenze*. Florence, 1677.

Boethius, A. *The Golden House of Nero: Some Aspects of Roman Architecture*. Ann Arbor, 1960.

Booth, C. *Cosimo I Duke of Florence*. Cambridge, 1927.

Borsi, F. *L'architettura del principe*. Florence, 1980.

Borsi, F. *Firenze del Cinquecento*. Rome, 1974.

Bösel, R. *Jesuitenarchitektur in Italien 1540–1773*. Vienna, 1986.

Bottari, G. G. *Raccolta di lettere sulla Pittura Scultura ed Architettura*. 4 vols. Rome, 1757.

Braunfels, W. *Mittelalterliche Stadtbaukunst in der Toskana*. Berlin, 1952.

Burke, P. *The Italian Renaissance: Culture and Society in Italy*. Princeton, 1986.

Burroughs, C. "Palladio and Fortune: Notes on the Meaning of the Villa Rotunda." *Architectura* 15 (1988):59–91.

Bush, V. "Bandinelli's *Hercules and Cacus* and Florentine Traditions." In *Studies in Italian Art and Architecture, 15th through 18th Centuries*, ed. H. A. Millon. 163–206. Cambridge, 1979.

Campbell, M. "Observations on Ammannati's Neptune Fountain:1565 and 1575." In *Renaissance Studies in Honor of Craig Hugh Smyth*, ed. A. Morrogh et al. 2 vols. 2:133–36. Florence, 1985.

Cataldi, G. *Rilievi di Pienza*. Florence, 1977.

Cochrane, E. *Florence in the Forgotten Centuries, 1527–1800*. Chicago and London, 1974.

Cochrane, E. *Italy 1530–1630*. Ed. J. Kirshner. London and New York, 1988.

Coffin, D. R. *The Villa in the Life of Renaissance Rome*. Princeton, 1979.

Coffin, D. R. *Gardens and Gardening in Papal Rome*. Princeton, 1991.

Collett, B. *Italian Benedictine Scholars and the Reformation: The Congregation of Santa Giustina*. Oxford, 1985.

Concilium tridentinum. Diariorum actorum epistularum tractatum. 11 vols. Freibourg i. B., 1901–38.

Cox-Rearick, J. *Dynasty and Destiny in Medici Art*. Princeton, 1984.

D' Addario, A. "Burocrazia, economia, e finanze dello Stato Fiorentino alla metà del Cinquecento." *Archivio storico italiano* 121 (1963):362–456.

D'Addario, A. *Aspetti della controriforma a Firenze*. Rome, 1972.

D'Agostino, G. "Il governo spagnolo nell Italia meridionale (Napoli dal 1503 al 1580)." In *Storia di Napoli*, 10 vols. 3:3–159. Naples, 1967.

Del Vita, A. *Guida di Arezzo*. Arezzo, 1953.

Del Migliore, F. *Firenze. Città Nobilissima*. Florence, 1684.

Diaz, F. *Il Granducato di Toscana. I Medici*. Storia d' Italia, vol. 13. Florence, 1976.

Dreyer, P. "Beitrage zur Planungsgeschichte des Palazzo Farnese in Piacenza." *Jahrbuch des Berliner Museen* 18 (1966):160–203

Egger, H. *Römische Veduten*. 2 vols. Vienna, 1931.

Elias, N. *Power and Civility*. Trans. E. Jephcott. New York, 1982. From *Über den Prozess der Zivilisation*. Vol. 2, *Wandlungen der Gessellschaft. Entwurf zu einer Theorie der Zivilisation*.

Elliot, J. H. "Spain and its Empire in the Sixteenth and Seventeenth Centuries." In *Early Maryland in a Wider World*, ed. D. B. Quinn. 58–83. Detroit, 1982. Reprinted in Elliot, J. H. *Spain and its World, 1500–1700. Selected Essays*. 7–26. New Haven and London, 1989.

Eubel, K. *Hierarchica catholica medi et recentibus aevi*. 8 vols. Regensburg, 1898–1978.

Fabbriche romane del primo '500. Rome, 1984.

Fader, M. "Sculpture in the Piazza della Signoria as an Emblem of the Florentine Republic." Ph.D. diss., University of Michigan, 1977.

Falciai, M. *Storia di Arezzo dalle origini alle fine del Granducato Lorenese*. Arezzo, 1928.

Fanelli, G. *Firenze: architettura e città*. 2 vols. Florence, 1973.

Farulli, P. *Annali ovvero notizie storiche dell' antica nobile e valorosa città di Arezzo in Toscana*. Foligno, 1717.

Fasano Guarini, E. *Lo stato mediceo di Cosimo I*. Florence, 1973.

Fois, M. "I movimenti religiosi dell osservanza nel '400." In *Riforma della Chiesa. Cultura e spiritualità nel Quattrocento veneto*, ed. G. Trolese. 225–26. Cesena, 1984.

Forster, K. W. "Metaphors of Rule. Political Ideology and History in the Portraits of Cosimo I de' Medici." *MKIF* 15 (1971):65–104.

Fossi, M. *Bartolomeo Ammannati architetto*. Cava dei Tirreni, n.d.

Fossi, M., ed. *La città di Bartolomeo Ammannati*. Rome, 1970.

Foster, P. *A Study of Lorenzo de'Medici's Villa at Poggio a Caiano*. 2 vols. New York and London, 1978.

Franchetti Pardo, V. *Arezzo*. Bari, 1986.

Fraser Jenkins, A. D. "Cosimo de' Medici's Patronage of Architecture and the Theory of Magnificence." *JWCI* 33 (1970):162–70.

Frommel, C. L. "Papal Policy: The Planning of Rome During the Renaissance." In *Art and History*, ed. T. K. Rabb and J. Brown. 39–66. Cambridge, 1988.

Frommel, C. L. *Der römische Palastbau der Hochrenaissance*. 3 vols. Tübingen, 1973.

Frutaz, A. *Le piante di Roma*. 3 vols. Rome, 1962.

Galluzzi, R. *Istoria dell' Granducato di Toscana sotto il governo dell' casa Medici*. 5 vols. Livorno, 1820.

Gaye, G. *Carteggio inedito d'artisti dei secoli XIV, XV, XVI.* 3 vols. Florence, 1840.

Giovio, P. *Lettere.* Ed. G. G. Ferrero. 2 vols. Rome, 1956.

Godoli, A., and Natali, A. *Luoghi della Toscana medicea.* Florence, 1980.

Goldthwaite, R. *The Building of Renaissance Florence.* Baltimore and London, 1980.

Gombrich, E. H. "The Early Medici as Patrons of Art; A Survey of Primary Sources." In *Italian Renaissance Studies: a Tribute to the Memory of the Late Cecilia M. Ady,* ed. E. F. Jacob. 279–311. London, 1960. Reprinted in idem, *Norm and Form.* 35–57. London, 1966.

Guarnieri, G. *L'Ordine di Santo Stefano e i suoi aspetti interni sotto il Gran Magistero Mediceo.* Pisa, 1966.

Guarnieri, G. *I cavalieri di Santo Stefano nella storia della Marina Italiana.* Pisa, 1960.

Gurrieri, F. *Pasquale Poccianti Architetto, 1774–1858.* Florence, 1974.

Hanning, R. W., and Rosand, D., eds. *Castiglione: The Ideal and the Real in Renaissance Culture.* New Haven and London, 1983.

Hartt, F. *Giulio Romano.* 2 vols. New Haven, 1958.

Herlihy, D. *Pisa in the Early Renaissance.* New Haven and London, 1958.

Herlihy, D. *Medieval and Renaissance Pistoia.* New Haven and London, 1967.

Heydenreich, L., and Lotz, W. *Architecture in Italy, 1400–1600.* Harmondsworth, 1974.

Hibbard, H. *Carlo Maderno.* University Park and London, 1971.

Holderbaum, J. *The Sculptor Giovanni Bologna.* New York and London, 1983.

Howard, D. *Jacopo Sansovino.* New Haven and London, 1975.

Il luogo teatrale a Firenze. Milan, 1975.

Jacquot, J., ed. *Les Fêtes de la Renaissance.* 3 vols. Paris, 1959–75.

Jedin, H. *Kathölische Reformation oder Gegenreformation.* Lucerne, 1946.

Jedin, H. *History of the Council of Trent.* Trans. Dom E. Graf. 2 vols. St. Louis, 1957–61. From *Geschichte des Konzil von Trient.* 2 vols. Freiburg im B., 1949–52.

Jedin, H. "La politica conciliare di Cosimo I." *Rivista storica italiana* 57 (1950):345–74 and 477–96.

Keller, F-E. *Zum Villenleben und Villenbau am Römischen Hof der Farnese.* Berlin, 1980.

Kirwin, W. C. "Vasari's Tondo of Cosimo I with his Architects, Engineers, and Sculptors in the Palazzo Vecchio." *MKIF* 15 (1971): 105–22.

Kruft, H-W. *Geschichte der Architekturtheorie: von der Antike bis zur Gegenwart.* Munich, 1985.

Kubler, G. *Building the Escorial.* Princeton, 1982.

Kummer, S. *Anfänge und Ausbreitung der Stuckdekoration im Römischen Kirchenraum (1500–1600).* Tübingen, 1987.

L'oldradi. *L'entrata dell' Eccellenza S. Duca e Signora Duchessa di Firenze in Roma.* Rome, 1560[?].

La comunità cristiana fiorentina e Toscana nella dialettica religiosa del Cinquecento. Firenze e Toscana dei Medici nell' Europa del Cinquecento, 5. Florence, 1980.

Labrot, G. *Baroni in città. Residenze e comportamenti della aristocrazia napoletana 1530–1734.* Naples, 1979.

Lanciani, R. *Storia degli scavi di Roma.* 4 vols. Rome, 1902–12.

Langedijk, K. *The Portraits of the Medici, 15th–18th Centuries.* 2 vols. Florence, 1981.

Lapini, A. *Diario fiorentino di Agostino Lapini.* Ed. G. Corazzini. Florence, 1900.

Lavin, I. *Bernini and the Crossing of Saint Peter's.* New York, 1968.

Lavin, I. *Bernini and the Unity of the Visual Arts.* New York and London, 1980.

Le Palais Farnèse. 2 vols. in 3. Rome, 1981.

Lecissotti, T. "Le condizioni economiche dei monasteri cassinesi di Toscana alla metà del '600." In *Studi in onore di Amintore Fanfani*. 6 vols. 5:289–312. Milan, 1962.

Lecissotti, T. "La congregazione benedettina di S. Giustina e la riforma della chiesa del '400." *Archivio della R. Deputazione per la storia patria* 67 (1944):451–69.

Lewine, M. "Roman Architectural Practice During Michelangelo's Maturity." In *Stil und Überlieferung in der Kunst des Abendlandes*. Akten des 21 Internationalen Kongress für Kunstgeschichte. 2 vols. 2:20–26. Berlin, 1964.

Lewine, M. "The Roman Church Interior, 1527–1580." Ph.D. diss., Columbia University, 1960.

Lieberman, R. *Renaissance Architecture in Venice*. New York, 1982.

Litchfield, R. B. *The Emergence of a Bureaucracy: The Florentine Patricians, 1530–1790*. Princeton, 1986.

Litchfield, R. B. "Office Holding in Florence after the Republic." In *Renaissance Studies in Honor of Hans Baron*. 553–55. Florence and DeKalb, Il., 1971.

Livorno. Progetto e storia di una città tra 1500 e 1600. Pisa, 1980.

Lotz, W. "Mannerism in Architecture. Changing Aspects." In *Studies in Western Art, 2: The Renaissance and Mannerism. Acts of the Twentieth International Congress of the History of Art*. 239–46. Princeton, 1963.

Lotz, W. *Vignola-Studien*. Hamburg, 1938.

Lotz, W. *Studies in Italian Renaissance Architecture*. Cambridge, Ma., and London, 1977.

Luchs, A. *Cestello: a Cistercian Church of the Florentine Renaissance*. New York and London, 1977.

MacDonald, W. L. *The Architecture of the Roman Empire*. 2nd ed. New Haven and London, 1982.

MacDougall, E. B. "*L'Ingegnoso Artifizio*: Sixteenth-Century Garden Fountains in Rome." In *Fons sapientae: Renaissance Garden Fountains*. 85–114. Washington, 1978.

MacDougall, E. B. "Imitation and Invention: Language and Decoration in Roman Renaissance Gardens." *Journal of Garden History* 5 (1985):119–34.

MacDougall, E. B. "The Villa Mattei and the Development of the Roman Garden Style." Ph.D. diss., Harvard Univ., 1970.

Mack, C. R. *Pienza: The Creation of a Renaissance City*. Ithaca and London, 1987.

Mignani, D. *Le Ville Medicee di Giusto Utens*. Florence, 1980.

Miller, N. *Renaissance Bologna*. New York, 1989.

Millon, H. A., and Smyth, C. H. *Michelangelo Architect*. Milan, 1988.

Millon, H. A. and Smyth, C. H. "Michelangelo and Saint Peter's. Observations on the Interiors of the Apses, a Model of the Apse Vault, and Related Drawings." *RJ* 16 (1976):137–206.

Millon, H. A. and Smyth, C. H. "A Design by Michelangelo for a City Gate: Further Notes on the Lille Sketch." *BM* 117 (1975):162–66.

Mitchell, B. *The Majesty of State: Triumphal Progresses of Foreign Sovereigns in Renaissance Italy (1494–1600)*. Florence, 1986.

Mitchell, B. *Italian Civic Pageantry in the High Renaissance: A Descriptive Bibliography of Triumphal Entries and Other Festivals*. Florence, 1979.

Morrogh, A. *Disegni di architetti fiorentini 1540–1640*. Gabinetto Disegni e Stampe degli Uffizi, 43. Florence, 1985.

Nash, E. *Pictorial Dictionary of Ancient Rome*. 2 vols. New York, 1961.

Nova, A. *The Artistic Patronage of Pope Julius III (1550–1555): Profane Imagery and Buildings for the De Monte Family in Rome*. New York and London, 1988.

Nudi, G. *Storia di Livorno*. Venice, 1959.

O'Malley, J., ed. *Catholicism in Early Modern History: A Guide to the Research*. St. Louis, 1988.

Paatz, W. and E. *Die Kirchen von Florenz: ein kunstgeschichliches Handbuch*. 6 vols. Frankfurt am Main, 1940–54.

Palladio, A. *Descritione de le Chiese, Stationi, Indulgenze, et Reliquie de Corpi Sancti, chi sonno in la Città de Roma.* Rome, 1554. Reprinted in P. Murray. *Five Early Architectural Guides to Rome and Florence.* Farnborough, 1972. An English translation and commentary can be found in E. Howe, *Andrea Palladio: The Churches of Rome.* Binghamton, 1991.

Panofsky, E. "The First Page of Vasari's *Libro.*" In *Meaning in the Visual Arts.* 169–235. New York, 1955. Trans. of idem, "Das erste Blatt aus dem Libro Giorgio Vasaris. . . ." *Städel-Jahrbuch* 6 (1930):25–72.

Panofsky, E. *Idea: A Concept in Art Theory.* Trans. J. J. S. Peake. New York, 1968. From idem, *Idea: Ein Beitrag zur Begriffsgeschichte der alteren Kunstheorie.* 2nd corrected ed. Berlin, 1960.

Parks, N. R. "The Placement of Michelangelo's *David*: A Review of the Documents." *AB* 56 (1975):560–70.

Pastor, L. *History of the Popes.* 40 vols. St. Louis, 1913–53.

Pedretti, C. *Leonardo da Vinci: the Royal Palace at Romarantin.* Cambridge, Ma., 1972.

Penco, G. *Storia del monachesimo in Italia.* Rome, 1961.

Pepper, S., and Adams, N. *Firearms and Fortifications: Military Architecture and Siege Warfare in Sixteenth Century Siena.* Chicago and London, 1986.

Pevsner, N. *A History of Building Types.* Princeton, 1976.

Pietro Leopoldo d'Asburgo Lorena. *Relazioni sul governo della Toscana.* 2 vols. Ed. R. Salvestrini. Florence, 1970.

Pinto, J. A. "The Landscape of Allusion: Literary Themes in Gardens of Classical Rome and Augustan England." *Smith College Studies in History* 48 (1980):97–113.

Pirri, P. *Giovanni Tristano e i primordi dell' architettura gesuitica.* Rome, 1955.

Pirri, P. *Giuseppe Valeriano S.I. architetto e pittore 1542–1596.* Rome, 1970,

Pirri, P., and Di Rosa, P. "Il P. Giovanni de Rosis (1538–1610) e lo sviluppo dell' edilizia gesuitica." *Archivium Historicum Societatis Iesu* 44 (1975):3–104.

Plesner, J. "Una rivoluzione stradale del Dugento." *Acta Jutlandica* (Aarsskrift for Aarhus Universitet, X) 10 (1938):1–105.

Pope-Hennessy, J. *Italian High Renaissance and Baroque Sculpture.* London, 1970.

Pollak, M. D. *Turin 1564–1680.* Chicago and London, 1991.

Posner, K. W-G. *Leonardo and Central Italian Art: 1515–1550.* New York, 1974.

Princeton Encyclopedia of Classical Sites. Ed. R. Stilwell et al. Princeton, 1976.

Procacci, U. "L'architettura nell' Aretino." In *Atti del XII Congresso di Storia di Architettura.* 123–51. Rome, 1969.

Raffaello architetto. Ed. M. Tafuri et al. Milan, 1984.

Repetti, E. *Dizionario geografico fiscico storico della Toscana.* 6 vols. Florence, 1833–48.

Richa, G. *Notizie istoriche delle chiese fiorentine.* 10 vols. Florence, 1754–62.

Richelson, P. *Studies in the Personal Imagery of Cosimo I de'Medici, Duke of Florence.* New York and London, 1977.

Ristori, G. *Nuova Guida della Città di Arezzo.* Florence, 1871.

Robertson, C. *'Il Gran Cardinale': Alessandro Farnese, Patron of the Arts.* New Haven and London, 1992.

Rondinelli, G. *Relazione sopra lo stato antico e moderno di Arezzo.* Arezzo, 1755.

Rosenfeld, M. N. "Sebastiano Serlio's Late Style in the Avery Version of the Sixth Book on Architecture." *JSAH* 28 (1969):155–72.

Rosenthal, E. E. *The Palace of Charles V in Granada.* Princeton, 1985.

Rubinstein, N. "The Piazza della Signoria in Florence." In *Festschrift Heinrich Siebenhüner.* 19–26. Wurzburg, 1978.

Saalman, H. *Filippo Brunelleschi. The Cupola of Santa Maria del Fiore.* London, 1980.

Saalman, H. "Michelozzo Studies: The Florentine Mint." In *Festschrift für Ulrich Middeldorf*. 2 vols. 140–42. Berlin, 1968.

Salmi, M. *Civiltà artistica della terra aretina*. Novara, 1971.

Sanpaolesi, P. "San Pier Scheraggio." *Rivista d'arte* 16 (1934):1–24.

Saslow, J. M. *Ganymede in the Renaissance: Homosexuality in Art and Society*. New Haven and London, 1986.

Scott, J. B. *Images of Nepotism: The Painted Ceilings of the Palazzo Barberini*. Princeton, 1991.

Scritti dell' arte del Cinquecento. 3 vols. Ed. P. Barocchi. Milan-Naples, 1977.

Segarizzi, A., ed. *Relazioni degli ambasciatori veneti*. 3 vols. in 4. Bologna, 1916.

Serlio, S. *Sebastiano Serlio's On Domestic Architecture*. Cambridge, Mass., and New York City, 1978.

Serlio, S. *Tutte l'opere di architettura*. Venice, 1619. Reprinted Ridgewood, N.J., 1964.

Sestini, A. "Studi geografici sulla città minori di Toscana." *Rivista geografica italiana* 45 (1938):22–65.

Severini, G. *Architetture militari di Giuliano da Sangallo*. Pisa, 1970.

Smyth, C. H. *Mannerism and Maniera*. Locust Valley, N.Y., 1963. Rev. ed. Vienna, 1992.

Soprintendenza per i beni ambientali, architettonici, artisti, e storici di Arezzo. *Architettura in terra d'Arezzo. I restauri dei beni architettonici dal 1975 al 1984*. Vol. 1. Arezzo-Valdichiana-Valdarno-Florence, 1985.

Spielmann, H. *Palladio und die Antike*. Munich, 1966.

Spilner, P. "*Ut civitatis amplietur*: Studies in Florentine Urban Development." Ph.D. diss., Columbia Univ., 1987.

Spini, G. *Cosimo de'Medici e la indipendenza del principato mediceo*. Pisa, 1945.

Spini, G. "Architettura e politica nel principato mediceo del Cinquecento." *Rivista storica italiana* 83 (1971):792–845. Reprinted with emendations as the introduction to

G. Spini. *Architettura e politica da Cosimo I a Ferdinando I*. 9–77. Florence, 1976.

Strazzullo, F. *Edilizia e urbanistica a Napoli dal '500 al '700*. Naples, 1968.

Strong, R. *Art and Power*. Berkeley and Los Angeles, 1984.

Summers, D. *Michelangelo and the Language of Art*. Princeton, 1981.

Summers, J. D. *The Sculpture of Vincenzo Danti. A Study in the Influence of Michelangelo and the Ideals of the Maniera*. New York and London, 1979.

Tafi, A. *I vescovi di Arezzo*. Cortona, n.d.

Tafuri, M. *Venice and the Renaissance*. Trans. J. Levine. Cambridge and London, 1989. From *Venezia e il Rinascimento*. Turin, 1985.

Tanzer, H. *The Villas of Pliny the Younger*. New York, 1924.

Teubner, H. "Das Langhaus der SS. Annunziata in Florenz. Studien zu Michelozzo und Giuliano da Sangallo." *MKIF* 27 (1978):27–60.

Teubner, H. "San Marco in Florenz. Umbauten vor 1500." *MKIF* 23 (1979):239–72.

Thiem, G. and C. *Toskanische Fassanden-dekoration in Sgraffito und Fresko 14. bis 17. Jahrhundert*. Munich, 1964.

Tolaini, E. *Forma Pisarum*. Pisa, 1979.

Tomei, P. *L'architettura a Roma nel Quattrocento*. Rome, 1942.

Trachtenberg, M. "What Brunelleschi Saw: Monument and Site at the Palazzo Vecchio." *JSAH* 47 (1988):14–44.

Trafton, D. A. "Structure and Meaning in *The Courtier*." *English Literary Renaissance* 2 (1972):283–97.

Tuttle, R. J. "Vignola's Facciata dei Banchi in Bologna." *JSAH* 52 (1993):68–87.

Urban, G. "Die Kirchenbaukunst des Quattrocento in Rom." *RJ* 9–10 (1961–2):176–218.

Venturi, A. *Storia del arte italiana*. 11 vols. in 25. Milan, 1901–40.

Vettori, P. *Orazione recitata nell' esequie del Sereniss. Cosimo de' Medici, Gran Duca di Toscana*. Florence, 1574.

Von Moos, S. "The Palace as Fortress: Rome and Bologna under Julius II." In *Art and Architecture in the Service of Politics*, ed. L. Nochlin and H. A. Millon. 46–79. Cambridge and London, 1978.

Wackernagel, M. *The World of the Florentine Renaissance Artist*. Trans. A. Luchs. Princeton, 1981. From idem, *Das Lebensraum des Künstlers in der florentinischen Renaissance: Aufgaben und Auftraggeber, Werkstatt und Kunstmarkt*. Leipzig, 1938.

Wazbinski, Z. *L'Accademia Medicea del Disegno a Firenze nel Cinquecento: idea e istituzione*. 2 vols. Florence, 1987.

Weil-Garris, K. "On Pedestals. Michelangelo's *David* and Bandinelli's *Hercules and Cacus* and the Sculpture of the Piazza della Signoria." *RJ* 20 (1983):377–416.

Weissman, R. *Ritual Brotherhood in Florence*. New York and London, 1982.

Westfall, C. W. *In This Most Perfect Paradise. Alberti, Nicholas V and the Invention of Conscious Urban Planning in Rome, 1447–55*. University Park, Pa., and London, 1974.

Wilinski, S. "La serliana." *Bolletino del Centro Internazionale di Studi di Architettura "Andrea Palladio"* 8 (1965):115–25.

Williams, R. "Vincenzo Borghini and Vasari's *Lives*." Ph.D. diss., Princeton University, 1988.

Wisch, B., and Munshower, S. S., eds. *Art and Pageantry in the Renaissance and Baroque*. 2 vols. University Park, 1991.

Wittkower, R. *Gothic vs. Classic. Architectural Projects in Seventeenth-Century Italy*. New York, 1974.

Wittkower, R. and M. *Born under Saturn*. New York, 1962.

Wittkower, R. and M. *The Divine Michelangelo: the Florentine Academy's Homage on his Death in 1564*. London, 1964.

III. GENERAL STUDIES ON VASARI

The Age of Vasari. Notre Dame, Ind., and Binghamton, N.Y., 1970.

Alpers, S. "Ekphrasis and Aesthetic Attitudes in Vasari's *Lives*." *JWCI* 23 (1960):190–215.

Babcock, R., and Ducharme, D. "A Preliminary Inventory of the Vasari Papers in the Beinecke Library." *AB* 71 (1989):300–4.

Barocchi, P. *Studi vasariani*. Turin, 1984.

Barocchi, P. "Il Vasari architetto." *Atti dell' Academia Pontaniana* 6 (1958):113–36.

Barocchi, P. *Vasari pittore*. Milan, 1964.

Barolsky, P. *Giotto's Father and the Family of Vasari's Lives*. University Park and London, 1992.

Barolsky, P. *Michelangelo's Nose: A Myth and its Maker*. University Park, Pa., and London, 1990.

Barolsky, P. *Why Mona Lisa Smiles and Other Tales by Vasari*. University Park and London, 1991.

Boase, T. S. R. *Giorgio Vasari: The Man and the Book*. A. W. Mellon Lectures in the Fine Arts, 1971. Princeton, 1979.

Bull, G. "Popes, Princes, and Peasants. The Diversity of Patronage in Vasari's *Lives*." *Journal of the Royal Society of Arts* 135 (1987):419–29.

Chastel, A. "Vasari économiste." In *Fables, Formes, Figures*. 387–89. Paris (1978).

Corti, L. *Vasari. Catalogo completo*. Florence, 1989.

Degli Azzi, A. "Documenti vasariani." *Il Vasari* 4 (1931): 216–31.

Draper, J. L. "Vasari's Decorations in the Palazzo Vecchio. The *Ragionamenti* Translated with an Introduction and Notes." Ph.D. diss., University of North Carolina at Chapel Hill, 1973.

Frey, K. *Der literarische Nachlass Giorgio Vasaris*. 2 vols. Munich, 1923–30. Third volume published as *Neue Briefe von Giorgio Vasari*. Ed. H-W. Frey. Burg bei M., 1940.

Giorgio Vasari. Florence, 1981.

Giorgio Vasari: Tra decorazione ambientale e storgrafia artistica. Ed. G. C. Garfagnini. Florence, 1985.

Jacopo Barozzi Il Vignola e gli architetti del cinquecento. Re-

pertorio bibliografico. 216–20. Vignola, 1974. Contains useful bibliography of writings on Vasari's architecture to 1973.

Jacks, P. J. "The Composition of Giorgio Vasari's *Ricordanze*: Evidence from an Unknown Draft." *Renaissance Quarterly* 45 (1992):739–84.

Kallab, W. *Vasaristudien*. Vienna and Leipzig, 1908.

Monbeig-Goguel, C. *Vasari et son temps*. Inventaire général des dessins italiens, 1. Paris, 1972.

Morrogh, A. "Vasari and Coloured Stones." In *Giorgio Vasari* 1985. 309–20.

Pillsbury, E. "Vincenzo Borghini as a Draftsman." *Bulletin. Yale University Art Gallery* 34 (1973):6–11.

Ragghianti-Collobi, L. *Il Libro dei Disegni del Vasari*. 2 vols. Florence, 1974.

Ragghianti-Collobi, L. "Il 'Libro de Disegni' del Vasari. Disegni di architettura." *Critica d' arte* 20, fasc.127 (1973):3–120.

Satkowski, L. G. *Studies on Vasari's Architecture*. New York and London, 1979.

Schulz, J. "Vasari at Venice." *BM* 103 (1961):500–11.

Studi vasariani. Florence, 1952.

Trionfi Honorati, M. "Un tabernacolo ligneo su disegno del Vasari e l'intagliatore Alberto Alberti." *Antichità viva* 14, no.3 (1975):57–61.

Il Vasari storiografo e artista. Florence, n.d.

IV. STUDIES OF SPECIFIC BUILDINGS AND PROJECTS

Organ Loft of Arezzo Cathedral

Pasqui, A. and U. *La cattederale di Arezzo*. Arezzo, 1880.

Del Vita, A. *Il Duomo di Arezzo*. Milan, 1915.

Tavanti, C. "Il basamento dell' organo del Duomo e la casa del Vasari in Arezzo." *Studi e documenti di architettura* 6 (1976):83–86.

Casa Vasari

Bombe, W. "Giorgio Vasaris Häuser in Florence und Arezzo und andere italienische Künstlerhäuser der Renaissance." *Belvedere* 13 (1928):55–59.

Burckhardt, J. *The Architecture of the Italian Renaissance*. Trans. James Palmes. Chicago, 1985. From idem. *Geschichte der Renaissance in Italien*. 1867.

Cheney, L. *The Paintings of the Casa Vasari*. New York and London, 1985.

Hüttinger, E., ed. *Künstlerhäuser von der Renaissance bis zur Gegenwart*. Zurich, 1985.

Leopold, N. S. C. "Artist's Houses in Sixteenth Century Italy." Ph.D. diss., The Johns Hopkins University, 1982.

Paolucci, A., and Maetzke, A-M. *La casa del Vasari in Arezzo*. Florence, 1988.

Secchi, A. "La Casa del Vasari in Arezzo." In *Giorgio Vasari* 1974. 75–87.

Tavanti, C. "Il basamento dell' organo del Duomo e la casa del Vasari in Arezzo." *Studi e documenti di architettura* 6 (1976):83–86.

The Refectory Ceiling of Santa Anna dei Lombardi in Naples

De Castris, P. L. "Napoli 1544: Vasari e Monteoliveto." *Bolletino d'Arte* 66 no.12 (1981):59–88.

The Del Monte Chapel

Davis, C. "Ammannati, Michelangelo, and the Tomb of Francesco del Nero." *BM* 118 (1976):472–84.

Davis, C. Catalogue entry in *Giorgio Vasari* 1981. 93–94.

Davis, C. "The Tomb for Mario Nari for SS. Annunziata in Florence." *MKIF* 21 (1977):69–94.

Nova, A. "The Chronology of the De Monte Chapel in San Pietro in Montorio." *AB* 66 (1984):150–54.

Pope-Hennessy, J. *High Renaissance and Baroque Sculpture*. 2nd ed. New York and London, 1970.

Villa Giulia

Associazione per il rilievo, lo studio, ed il restauro del parimonio architettonico. *La Villa di Papa Giulio III*. Architettura del Cinquecento a Roma, 2. Rome, 1987. Measured drawings of the Villa Giula, with an introductory essay.

Bafile, M. "I disegni della Villa Giulia nella collezione Burlington-Devonshire." *Palladio* 2 (1952):54–64.

Bafile, M. *Villa Giulia: L'Architettura-Il Giardino*. Rome, 1948.

Belli-Barsali, I. *Ville di Roma*. Ville italiane, Lazio 1. 164–83. Milan, 1970.

Cocchia, S., Palminteri, A., and Petroni, L. "Villa Giulia, un caso esemplare della cultura e della prassi costruttiva nella metà del Cinquecento." *Bolletino d'Arte* 72, no.42 (1987):47–90.

Coffin, D. R. *Gardens and Gardening in Papal Rome*. Esp. 39–40 and 80–82. Princeton, 1991.

Coffin, D. R. *The Villa in the Life of Renaissance Rome*. 150–79. Princeton, 1979.

Coolidge, J. "The Villa Giulia: A Study of Central Italian Architecture in the Mid-Sixteenth Century." *AB* 25 (1943):178–225.

Davis, C. "Four Documents for the Villa Giulia." *RJ* 17 (1978):219–26.

Davis, C. "Villa Giulia e la 'Fontana della Vergine.'" *Psicon* 4 (1977):132–41

Erculei, R. "La Villa di Giulio III: Suoi usi e destinazioni." *Nuova Antologia* 110 (1890):83–106.

Falk, T. "Studien zur Topographie und Geschichte der Villa Giulia in Rom." *RJ* 13 (1971):101–78.

Fossi, M. *Bartolomeo Ammannati architetto*. Cava dei Tirreni, n.d.

Hess, J. "Amaduzzi and Jenkins in Villa Giulia." *English Miscellany* 6 (1955):175–204.

Hess, J. Resume of a lecture on the Villa Giulia. *Rendiconti. Atti della Pontifica Accademia Romana di Archeologia* 27 (1953):155.

Hoffmann, P. "Scultori e stuccatori a Villa Giulia. Inediti di Federico Brandini." *Commentari* 18 (1967):48–66

Lojacono, P. "Le fasi costruttive di Villa Giulia." *L'Urbe* (15 Sept.-Oct. 1952) 12–22.

Lucchini, F., ed. *L'area Flaminia. L'auditorium-Le ville-I musei*. Rome, 1988.

Lucchini, F., and Pallavacini, R. *La Villa Poniatowski e la Via Flaminia*. Rome, 1981.

Moore, F. L. "A Contribution to the Study of the Villa Giulia." *RJ* 12 (1969):171–94.

Smyth, C. H. "The Sunken Courts of the Villa Giulia and the Villa Imperiale." In *Essays in Memory of Karl Lehmann*. 304–13. New York, 1965.

Stern, G. *Piante, elevazioni, profili, spaccati di edifici dell villa suburbana di Giulio III*. Rome, 1784.

Stevens, G. P. "Notes on the Villa di Papa Giulio." *Journal of the American Institute of Architects* 2 (1914):539–40.

Vodoz, E. "Studien zum architektonischen Werk des Bartolomeo Ammannati." *MKIF* 6 (1941):1–31.

Walcher-Casotti, M. *Il Vignola*. 2 vols. N.p., 1960.

Uffizi

Barocchi, P. "La storia della Galleria degli Uffizi e la storiografia artistica." *Annali della Scula Normale Superior di Pisa* 12 (1982):1411–1523.

Bemporad, N. "Il complesso degli Uffizi di Firenze." *Quaderni dell' Istituto di Storia dell' Architettura* 23, fasc.133–8 (1976):103–16.

Bemporad, N. "Considerazioni sul fabbricato degli Uffizi." *Giorgio Vasari* 1974, 225–32.

Bemporad, N. "Gli Uffizi e la scala buontalentiana." *L'architettura* 14 (1968–1969):611–19.

Cataldi, G. "La Fabbrica degli Uffizi ed il Corridoio vasariano." *Studi e document di architettura* 6 (1976):103–43.

Crum, R. J. "*Cosmos, the World of Cosimo*: The Iconography of the Uffizi Facade." *AB* 71 (1989):237–53.

Dorini, U. "Come sorse la fabbrica degli Uffizi." *Rivista storica degli archivi toscani* 5 (1933):1–40.

Forti, A. "L'Opera di Giorgio Vasari nella fabbrica degli Uffizi." *Bolletino degli Ingegneri* 19 (1971):23–25, 33–39; and 20 (1972):13–25.

Heikamp, D. "La Galleria degli Uffizi descritta e designata." In *Gli Uffizi: quattro secoli di una galleria*, ed. P. Barocchi and G. Ragioneri. 2 vols. 1:461–541. Florence, 1983.

Heikamp, D. "Zur Geschichte der Uffizientribuna und der Kunstschränke in Florenz und Deutschland." *Zeitschrift für Kunstgeschichte* 26 (1963):193–268.

Heikamp, D. "Il Teatro Mediceo degli Uffizi." *Bolletino del Centro Internazionale di Studi di Architettura "Andrea Palladio"* 16 (1974):323–34.

Kauffmann, G. "Das Forum von Florenz." In *Studies in Renaissance and Baroque Art Presented to Anthony Blunt*. 37–43. London, 1967.

Lamberini, D. *Il principe difeso. Vita e opere di Bernardo Puccini*. Florence, 1990. pp.145–62.

Lessmann, J. "Studien zu einer Baumonographie der Uffizien Giorgio Vasaris in Florenz." Ph.D. diss., Bonn, 1975.

Lessmann, J. "Gli Uffizi: aspetti di funzione, tipologia, e significato urbanistico." In *Giorgio Vasari* 1974, 233–47.

McCarthy, M. "The Drawings of Sir Roger Newdigate: The Earliest Unpublished Record of the Uffizi." *Apollo* 134 (1991):159–68.

Prinz, W. "Informazione di Filippo Pigafetta al Serenissimo di Toscana per una stanza di piantare lo studio di architettura militare." In *Gli Uffizi: quattro secoli di una galleria*. 1:343–52. Florence, 1983.

Palazzo Vecchio

Allegri, E., and Cecchi, A. *Palazzo Vecchio e i Medici*. Florence, 1980.

Baxter, P. "Vasari's *Ragionamenti*: the Text as the Key to the Decorations of the Palazzo Vecchio." Ph.D. diss., University of Edinburgh, 1988.

Campbell, M. "Observations on the Salone dei Cinquecento in the Time of Cosimo I de' Medici." In *Firenze e la Toscana dei Medici nell' Europa del '500*. 3 vols. 3:819–31. Florence, 1983.

Carocci, G. "Breve notizie sopra alcuni edifici di Piazza San Biagio, Via Por S.Maria, e Borgo San Jacopo." *Bolletino dell' Associazione per la difesa di Firenze antica* 2 no.1 (1901):41–42.

Cox-Rearick, J. "Bronzino's *Crossing of the Red Sea* and *Moses Appointing Joshua*. Prolegomena to the Chapel of Eleonora of Toledo." *AB* 49 (1987):45–67.

Del Badia, I. "Il vecchio palazzo del Parte Guelfa." *Bolletino dell' Associazione per la difesa di Firenze antica* 2, no.3: (1901) 63–74.

Heikamp, D. "Ammannati's Marble Fountain for the *Sala Grande* in the Palazzo Vecchio of Florence." In *Fons Sapientae. Renaissance Garden Fountains*, ed. E. B. MacDougall. 115–73. Washington, D.C., 1978.

Lensi, A. *Palazzo Vecchio*. Milan, 1929.

Lensi-Orlandi, G. *Il Palazzo Vecchio di Firenze*. Florence, 1977.

Maffei, G. "Gli interventi vasariani in Palazzo Vecchio." *Studi e documenti di architettura* 6 (1976):49–66

Mandelli, E. "La funzionalità degli interventi vasariani nel Palazzo Vecchio." *Studi e documenti di architettura* 6 (1976):67–82.

Muccini, U. *The Salone del Cinquecento*. Florence, 1989.

Muccini, U., and Cecchi, A. *Le stanze del principe in Palazzo Vecchio*. Florence, 1991.

Paul, J. *Der Palazzo Vecchio. Ursprung und Bedeutung seiner Form*. Florence, 1969.

Pillsbury, E. "An Unknown Project for the Palazzo Vecchio Courtyard." *MKIF* 14 (1969):57–66.

Pillsbury, E. "Vasari's Staircase in the Palazzo Vecchio." In *Collaborations in Italian Renaissance Art*, ed. W. S. Sheard and J. Paoletti. 125–41. New Haven and London, 1978.

Rubinstein, N. "Classical Themes in the Decoration of the Palazzo Vecchio." *JWCI* 50 (1987):29–43.

Rubinstein, N. "Vasari's Painting of the Foundation of Florence in the Palazzo Vecchio." In *Essays in the History of Architecture Presented to Rudolf Wittkower*. 64–73. London, 1967.

Starn, R., and Partridge, L. *Arts of Power: Three Halls of State in Italy, 1300–1600*. Berkeley and Los Angeles, 1992.

Trachtenberg, M. "Archeology, Merriment, and Murder: The First Cortile of the Palazzo Vecchio and its Transformation in the Late Florentine Republic." *AB* 71 (1989): 565–611.

Wilde, J. "The Hall of the Great Council of Florence." *JWCI* 7 (1944): 65–81. Reprinted in Creighton Gilbert, ed. *Renaissance Art*. 92–132. New York, 1970.

The Corridoio

Bemporad, N. "Il restauro del corridoio vasariano." *Architetti* 20 (1953):45–54.

Cataldi, G. "La fabbrica degli Uffizi ed il Corridoio vasariano." *Studi e document di architettura* 6 (1976):103–43.

Del Badia, I. "Il corridore dal Palazzo Vecchio al Palazzo Pitti." *Miscellanea Fiorentina* 1 (1902):3–11.

Lessmann, J. In Lessmann 1975, 175–77.

Satkowski, L. "The Palazzo Pitti. Planning and Use in the Grand-Ducal Era." *JSAH* 42 (1983):336–49.

Satkowski, L. In Satkowski 1979, 76–97 and 195–99.

The Cupola of the Madonna dell' Umilità

Bargiacchi, L. *Tempio e opere della Madonna della Umilità in Pistoia*. Pistoia, 1890.

Buscioni, M. "La Chiesa della Madonna dell' Umilità." In *Ventura Vitoni e il Rinascimento a Pistoia*. 39–44. Pistoia, 1977.

Chiti, A. *Il santuario della Madonna dell' Umilità in Pistoia*. Pistoia, 1952.

Durm, J. "Santa Maria dell' Umilità. Grosskonstructionen der italienischen Renaissance." *Zeitschrift fur Bauwesen* (1902):13–14.

Fossi, M. "La Basilica della Madonna del Umilità in Pistoia. I Lavori di Bartolomeo Ammannatti." *Atti e memorie della accademia toscana di scienze e lettere 'La Colombaria'* 24 (1973):83–136.

Fossi, M. "Regesto dei lavori eseguiti alla Basilica dell' Umilità di Pistoia dal 1585 al 1637. Direzione di Jacopo Lafri e Jacopo e Lionardo Marcacci." *Antichità viva* 22 (1983):22–28.

Fossi, M. "Il Vasari e la basilica della Madonna dell' Umilità in Pistoia." In *Giorgio Vasari* 1976, 127–42.

G. C. Romby, "Jacopo Lafri, architetto pistoiese del Cinquecento. Nuova documentarie." *Bulletino Storico Pistoiese* 91 (1989):78–80.

Sanpaolesi, P. "Ventura Vitoni, architetto pistoiese." *Palladio* 3 (1939):248–66.

Satkowski, L. In Satkowski 1979, 12–44 and 167–77.

Il tremisse pistoiese. 17 n. 2–3 (1992). Issue devoted mainly to the Madonna dell' Umilità.

Santo Stefano della Vittoria

Borri Cristelli, L. "Un' architettura da restituire al Vasari: il Tempio di S.Stefano della Vittoria," *Storia Architettura* 8 (1985):37–42.

Piazza dei Cavalieri

Capovilla, G. "Giorgio Vasari e gli edifici dell' ordine militare di Santo Stefano," *Studi storici* 17 (1908):305–79; 18 (1909):581–602; 19 (1910):27–226.

Karwacka Codini, E. "Piazza dei Cavalieri ed edifici adiacenti." In *Livorno e Pisa*. 223–41. Pisa, 1980.

Karwacka Codini, E. *Piazza dei Cavalieri: urbanistica e architettura dal Medioevo al Novocento*. Florence, 1989.

Salmi, M. *Il Palazzo dei Cavalieri e la Scuola Normale Superiore di Pisa*. Bologna, 1932.

Von Henneberg, J. "The Church of Santo Stefano dei Cavalieri in Pisa: New Drawings." *Antichità viva* 30, no. 1–2 (1991):29–43.

Von Henneberg, J. "I disegni di architettura del codice ottoboniano latino 3110 di Pier Leone Ghezzi." *Miscellanea bibliothecae vaticanae* 4 (1990):79–87.

The Loggia in Arezzo

Mercantini, M. *Il Palazzo di Fraternita in Piazza Grande ad Arezzo*. Arezzo, 1980.

Ramagli, R. "Le Logge vasariane in Arezzo." *Studi e documenti di architettura* 6 (1976):87–104.

Roselli, P. "La vicenda costruttiva delle Logge Vasari ad Arezzo." *Quasar* 1 (1989):31–42.

Satkowski, L. In Satkowski 1979, 98–135 and 200–225.

Viviani-Fiorini, D. "La costruzione delle Logge Vasariane di Arezzo." *Il Vasari* 21 (1941): 109–117, and 13 (1942): 39–46.

Santa Maria Nuova in Cortona

Mancini, G. *Cortona nel Medievo*. Florence, 1897.

Del Vita, A. "Un'opera d'architettura del Vasari poco nota." *Il Vasari* 4 (1931):178–88.

Church Renovations in Arezzo and Florence

Bartoli, M. T. "La Badia delle SS. Flora e Lucilla in Arezzo." *Studi e documenti di architettura* 6 (1976): 27–38.

Hall, M. B. "The Italian Rood Screen: Some Implications for Liturgy and Function." In *Essays Presented to Myron P. Gilmore*, ed. S. Bertelli and G. Ramakus. 2 vols. 2:213–18. Florence, 1978.

Hall, M. B. "The Operation of Vasari's Workshop and the Designs for Santa Maria Novella and Santa Croce." *BM* 115 (1973):204–9.

Hall, M. B. "The *Ponte* in S. Maria Novella." "The *Tramezzo* in Santa Croce, Florence, Reconstructed." *AB* 56 (1974):157–73, 325–41.

Hall, M. B. *Renovation and Counter-Reformation; Vasari and Duke Cosimo in Sta Maria Novella and Sta Croce*. Oxford, 1979.

Hall, M. B. "The *Tramezzo* in S. Croce and Domenico Veneziano's Fresco." *BM* 113 (1970):797–99.

Ieni, G. "Architetti e fabbricieri del complesso conventuale (1566–1572). Nuove conclusioni sulla base del mate-

riale documentario." In *Pio V e Santa Croce di Bosco. Aspetti di una committenza papale*, ed. C. Spantigati and G. Ieni. 3–25. Alessandria, 1985.

Ieni, G. "'Una macchina grandissima quasi a guisa d'arco trionfale: l'altare vasariano." In *Pio V e Santa Croce di Bosco. Aspetti di una committenza papale*. 49–62. Alessandria, 1985.

Isermeyer, C. A. "Die Capella Vasari und der Hochaltar in der Pieve von Arezzo." In *Eine Gabe der Fruende für Carl Georg Heise*. 137–53. Berlin, 1950.

Isermeyer, C. A. "Le chiese del Vasari ed i suoi interventi in edifici sacri mediovali." *Bolletino del Centro Internazionale di Studii di Architettura "Andrea Palladio"* 19 (1977):281–95.

Isermeyer, C. A. "Il Vasari ed il restauro delle chiese mediovali." In *Studi vasariani*. 229–36. Florence, 1952.

Lanardi, R. "Ristrutturazione vasariane di Santa Maria Novella." *Memorie domenicane* 19 (1988):403–15.

Lotz, W. "Le trasformazioni vasariane e i nuovi edifici sacri del tardo '500." In *Arte e religione nella Firenze de' Medici*. 81–89. Florence, 1980.

Medri, L. "Fortuna e decadenza dell' altare Vasariano in Santa Croce." In *Santa Croce nell'800*, ed. M. G. Ciardi Duprè Dal Poggetto et al. 249–63. Florence, 1986.

Mercantini, M. *La Pieve di S. Maria ad Arezzo*. Arezzo, 1982.

Ristori, G. B. *Diario dei restauri del Tempio di S. M. della Pieve eseguiti dall'anno 1864 all' anno 1878*. Arezzo, 1928.

Salmi, M. "Ricerche intorno alla Badia di SS. Flora e Lucilla ad Arezzo," *L'Arte* 15 (1936):281–92.

Satkowski, L. In Satkowski 1979, 45–75 and 241–250.

Santa Croce nell '800. Ed. M. G. Ciardi Duprè dal Poggetto et al. Florence, 1986.

Taddei, D. "Gli antecedenti stilistici della Badia delle SS. Flora e Lucilla." *Studi e documenti di architettura* 6 (1976): 39–48.

Viale-Ferrero, M. *La Chiesa di Santa Croce a Bosco Marengo*. Turin, 1959.

Viviani-Fiorini, D. "La Badia di Arezzo e Giorgio Vasari." *Il Vasari* 12 (1941):74–84.

Triumphal Entries

Cazzato, V. "Vasari e Carlo V: L'ingresso trionfale a Firenze del 1536." In *Giorgio Vasari* 1981, 179–204.

Chastel, A. "Les entrées de Charles Quint en Italie." In *Les Fêtes de la Renaissance*. 3 vols. Ed. J. Jacquot. 2:197–206. Paris, 1959–75.

Cini, G. B. *Descrizione dell' apparato fatto in Firenze per le nozze dell'illustrissimo ed Don Francesco de' Medici principe di Firenze e Siena e della serenissima regina Giovanna d'Austria*. Florence, 1566. Reprinted in Vasari-Milanesi, 8:517–622.

Gaeta-Bertela, G., and Petrioli-Tofani, A. *Feste e apparati medicei da Cosimo I a Cosimo I*. Cataloghi Gabinetto Disegni e Stampe degli Uffizi, 31. Florence, 1969.

Ginori Conti, P. *L'apparato per le nozze di Francesco de'Medici e di Giovanna d'Austria*. Florence, 1936.

Giordano, G. *Della venuta e dimora in Bologna del Sommo Pontefice Clemente VII per la coronazione di Carlo V imperatore*. Bologna, 1842.

Jacquot, J. "Panorama des fêtes et cérémonies du règne," In *Les Fêtes de la Renaissance*. 2 vols. Ed. J. Jacquot. 2:413–91. Paris, 1959–75.

Madonna, M. L. "L'ingresso di Carlo V a Roma." In *La città effimera e l'universo artificiale del giardino*, ed. M. Fagiolo. 61–68. Rome, 1980.

Mellini, D. *Descrizione dell Entrata Della sereniss. Reina Giovanna d'Austria Et dell' Apparato, fatto in Firenze nella venuta & per le felicissime nozze di S.Altezza Et del Illustrissimo & Eccelentissimo S. Don Francesco Medici, Principe di Fiorenza & Siena*. Florence, 1566.

Mitchell, B. In *Majesty of the State*. 151–74. Florence, 1986.

Nagler, A. M. *Theatre Festivals of the Medici, 1539–1637*. New Haven and London, 1964.

Petrioli, A. M. *Mostra di disegni vasariani. Carri trionfali e costumi per 'La Genealogia degli Dei.'* Gabinetto Disegni Stampe degli Uffizi, 22. Florence, 1966.

Pillsbury, E. "Drawings by Vasari and Borghini for the *Apparato* in Florence in 1565." *Master Drawings* 5 (1967): 281–83.

Pillsbury, E. "The Temporary Facade on the Palazzo Ricasoli." In *Report and Studies in the History of Art 1969*. 74–83. Washington, D.C.

Rousseau, C. "The Pageant of the Muses at the Medici Wedding of 1539." In *Art and Pageantry*. Papers in Art History from the Pennsylvania State University, 2. 2 vols. Ed. B. Wisch and S. S. Munshower. 425–27. University Park, 1990.

Saletta, V. "Il viaggio in Italia di Carlo V." *Studi meridionali* 9 (1976): 286–327 and 452–79; 10 (1977):78–114, pp.268–92, and 420–42; 11 (1978):329–41;

Seznec, J. "La Mascarade des dieux a Florence en 1565." *Mélanges d'archeologie et d'histoire* 52 (1935):224–43.

Scorza, R. "A Florentine Sketchbook: Architecture, *Apparati*, and the Accademia del Disegno." *JWCI* 54 (1991):172–85.

Testaverde, A. M. "La decorazione festiva e l'itinerario della città negli ingressi trionfali a Firenze tra XV e XVI secolo." *MKIF* 32 (1988):323–52.

Castello and the Boboli Gardens

Aschoff, W. "Tribolo disegnatore." *Paragone* 29, no. 209 (1967): 45–47.

Conforti, C. "La grotta 'degli animali' o 'del dilivio' nel giardino di Villa Medici a Castello." *Quaderni di Palazzo Te* 6 (1987).

Heikamp, D. "Il giardino di Castello: per una ricognizione archeologica." In *Fiorenza in villa*, ed. C. Acidini Luchinat. 9–13. Florence, 1987.

Heikamp, D. "The Grotta Grande in the Boboli Garden: A Drawing in the Cooper-Hewitt Museum." *Connoisseur* 199 (1978):38–43.

Keutner, H. "Niccolo Tribolo und Antonio Lorenzi, Der Äskulapbrunnen im Heilkräutergarten der Villa Castello bei Florenz." In *Studien zur Geschichte der europäischen Plastik. Festschrift Theodor Müller*. 241–43. Munich, 1965.

Lazzaro, C. *The Italian Renaissance Garden*. New Haven and London, 1990.

Wright, D. R. "The Medici Villa at Olmo a Castello." Ph.D. diss., Princeton University, 1976.

Zanghieri, L. "Le piante de' condotti dei giardini di Castello e l Petraia." *Bolletino degli Ingegneri* 19 (1971):19–28.

Zanghieri, L. *Ville della Provincia di Firenze; la città*. Ville italiane, Toscana 1. 60–78. Milan, 1989.

I N D E X

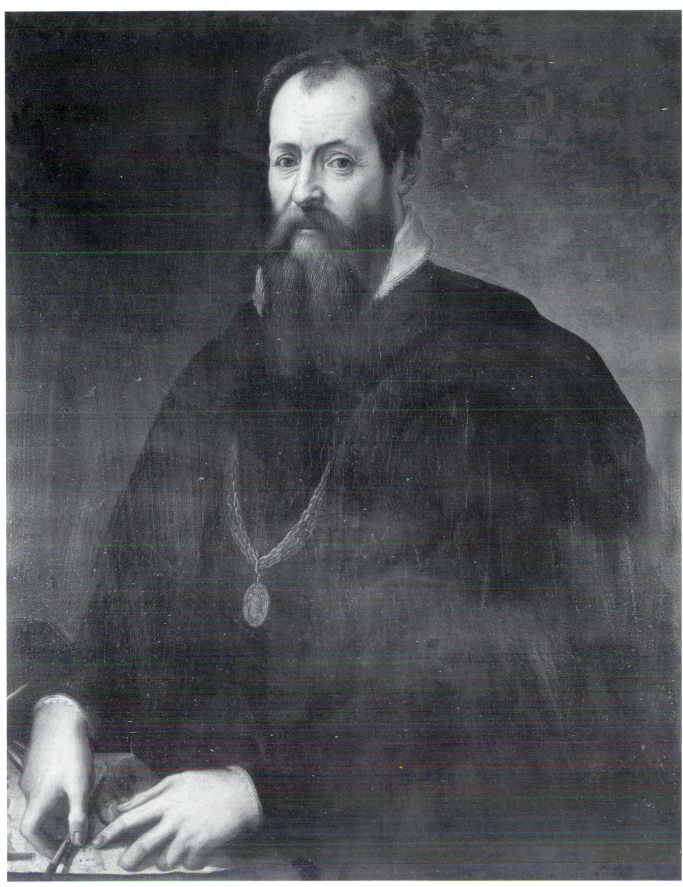

1. Giorgio Vasari (attr.), Self-portrait

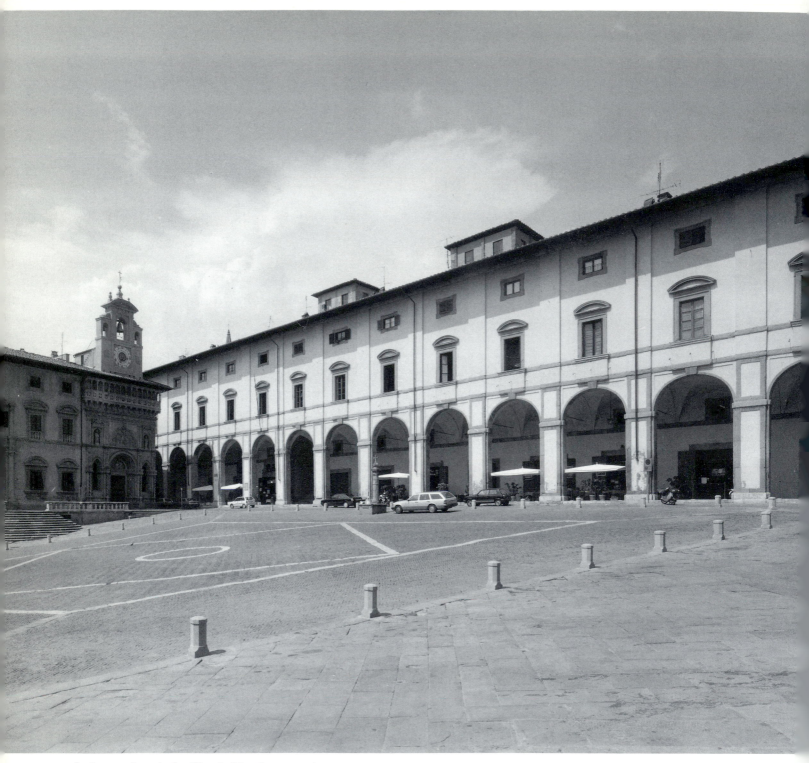

2. Arezzo, Loggia, by Giorgio Vasari, 1570–96

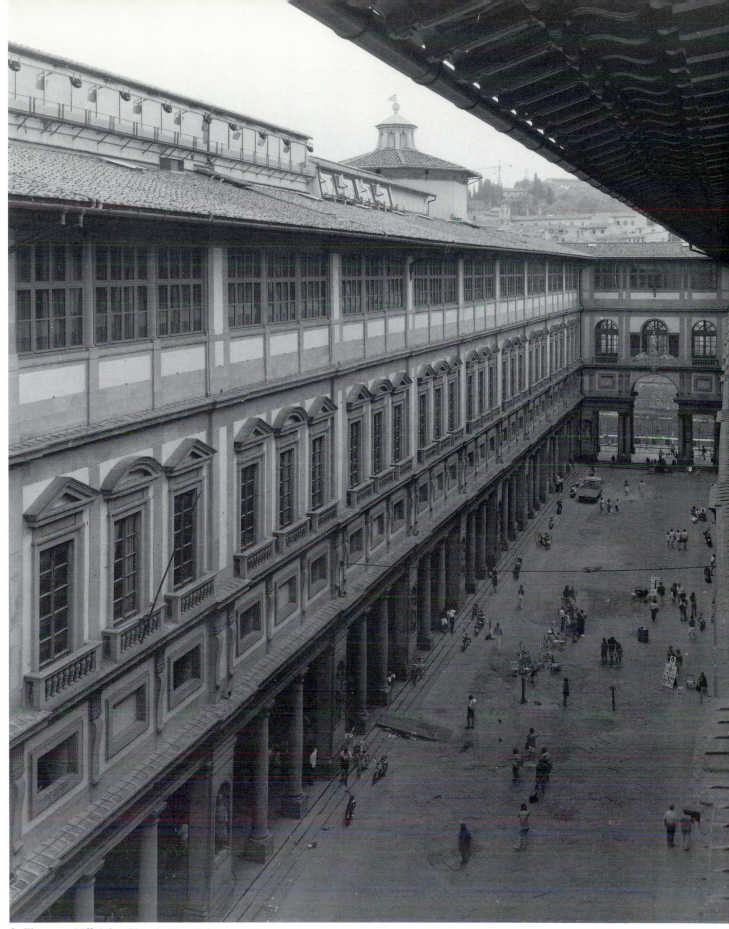

3. Florence, Uffizi, by Giorgio Vasari, begun 1561

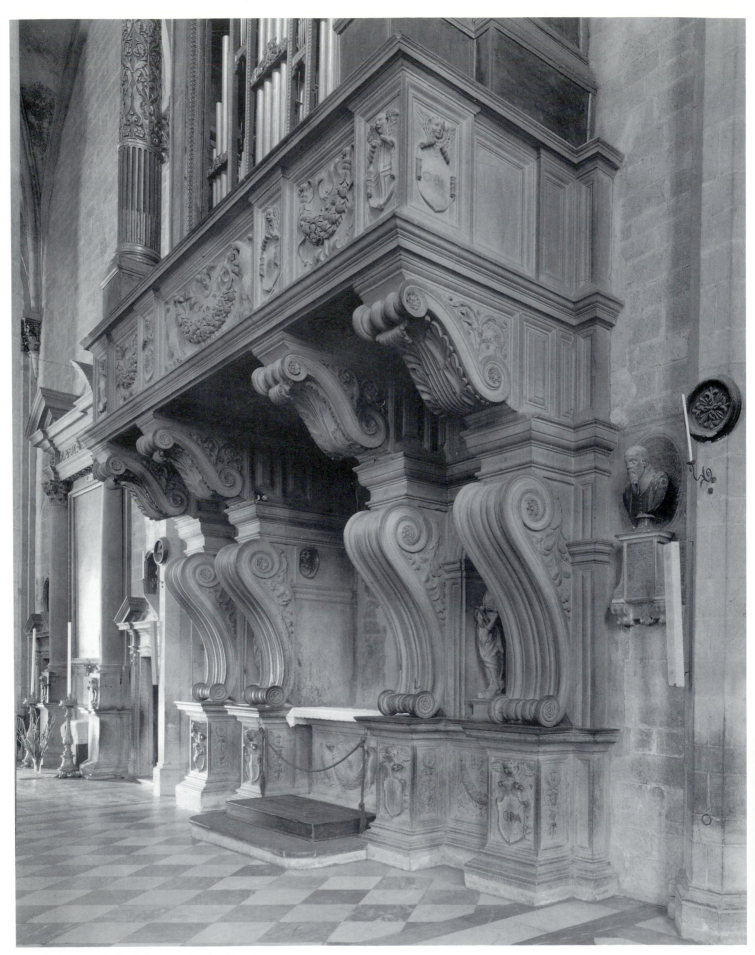

4. Arezzo, Cathedral, organ loft by Vasari, 1535–37

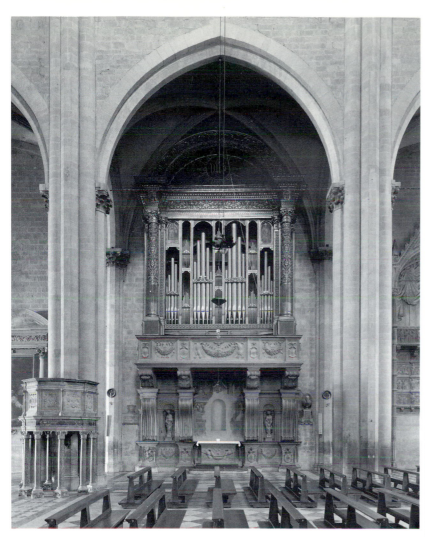

5. Arezzo, Cathedral,
organ loft by Vasari, view from nave

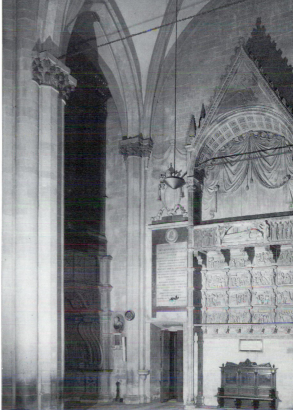

6. Arezzo, Cathedral, Monument to
Guido Tarlati by Agostino di Giovanni
and Agnolo di Ventura, c. 1329–32

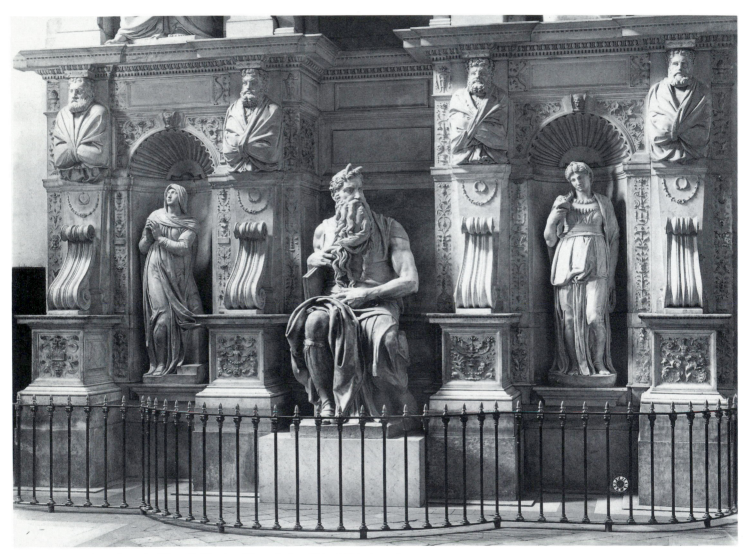

7. Rome, San Pietro in Vincoli, Tomb of Pope Julius II by Michelangelo

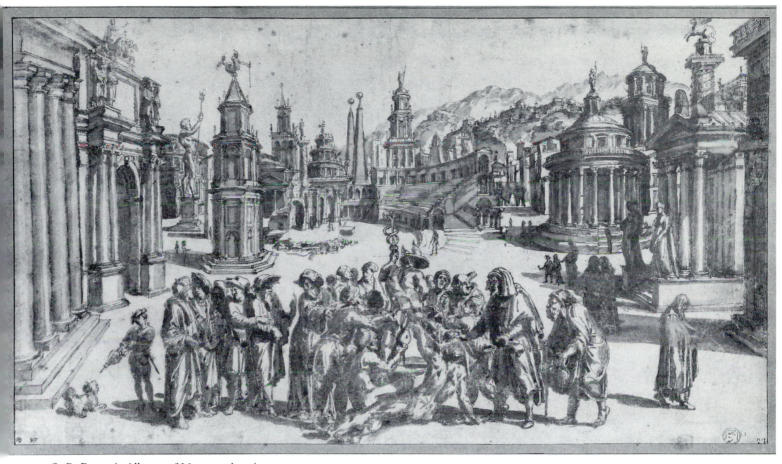

8. B. Peruzzi, *Allegory of Mercury*, drawing

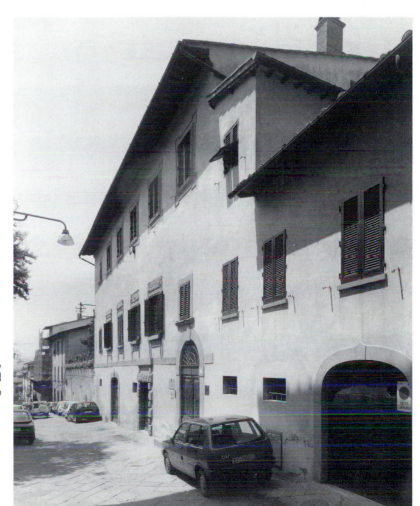

9. Arezzo, Casa Vasari, completed and decorated by Giorgio Vasari c. 1541–50

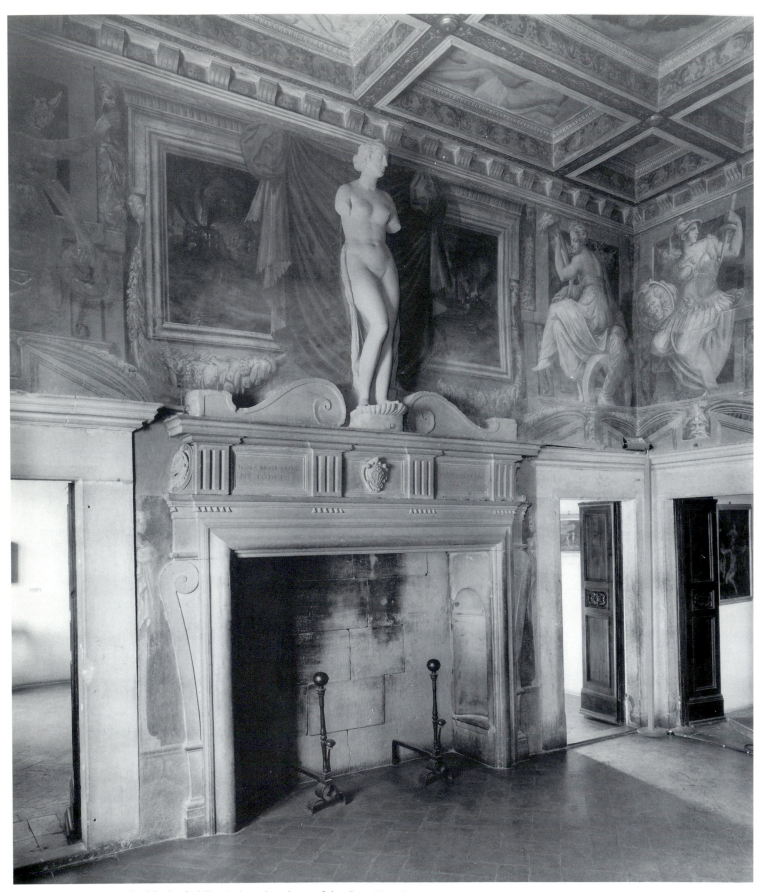

10. Arezzo, *Sala del trionfo della virtù*, main salone of the Casa Vasari

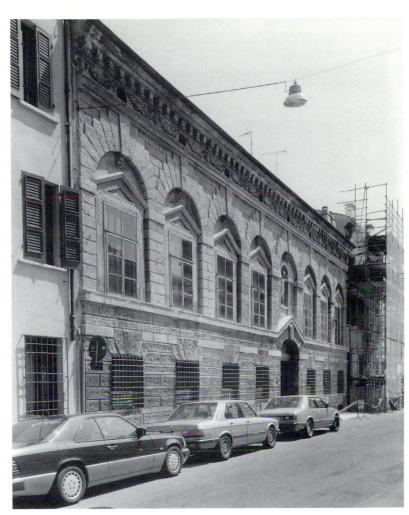

11. Mantua, House of
Giulio Romano,
renovated c. 1540—44

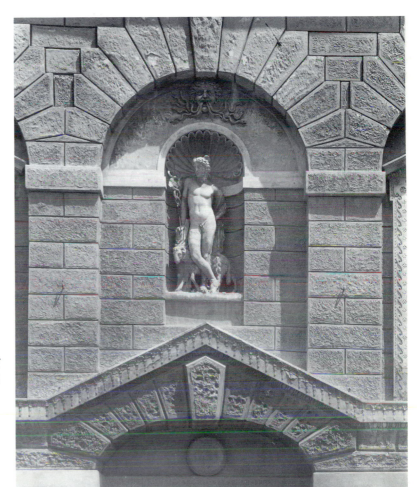

12. Mantua, House of
Giulio Romano, detail

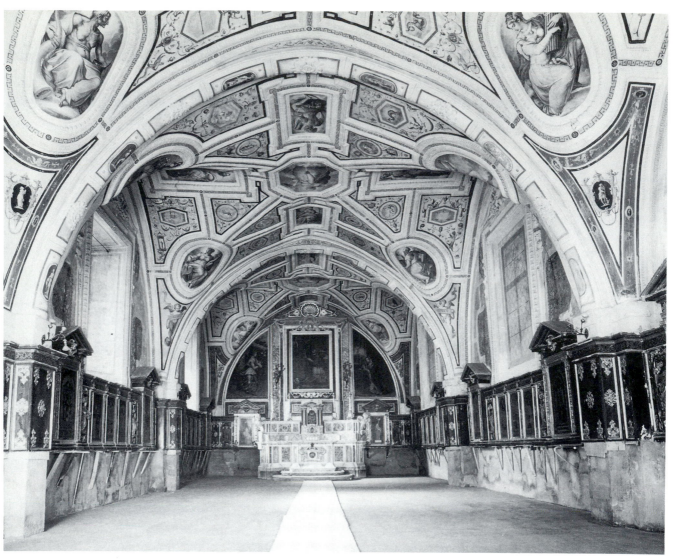

13. Naples, Santa Anna dei Lombardi,
refectory vaulting altered and decorated by
Vasari, 1544

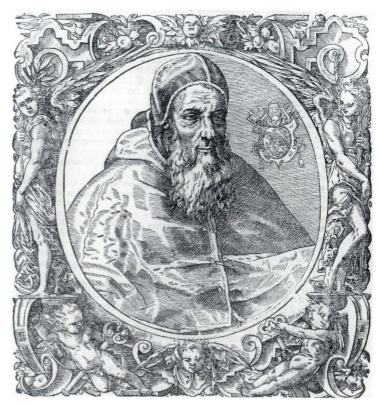

15. Portrait of Pope Julius III,
sixteenth-century German woodcut

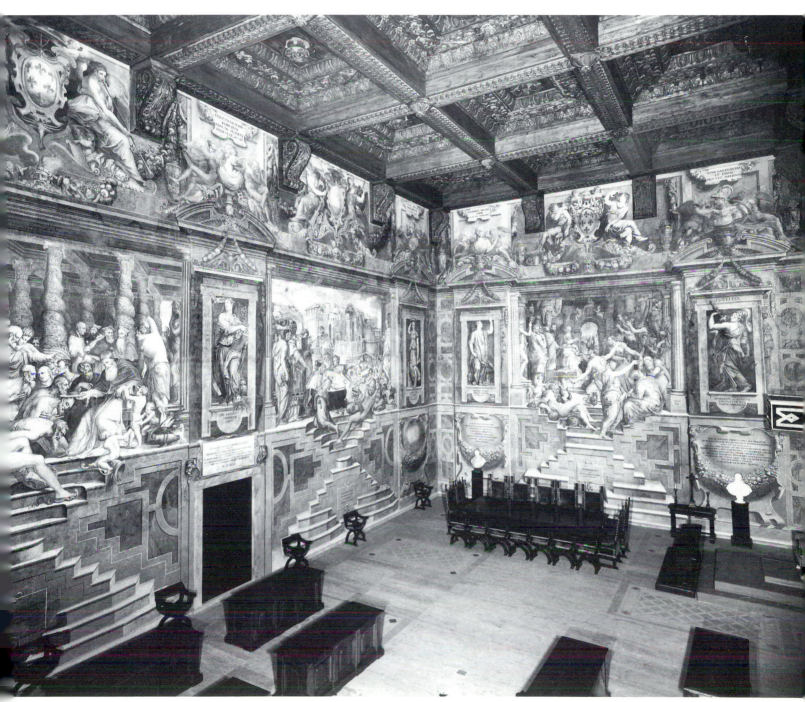

14. Rome, Palazzo della Cancelleria, Sala dei Cento Giorni, fresco decorations by Vasari, 1546

16. Rome, San Pietro in Montorio, Del Monte Chapel, initial sketch by Vasari, 1550.
(the drawing of the *Pietà* affixed to Vasari's sheet is not related to the commission)

17. Rome, Santa Maria della Pace,
Cesi Chapel by Antonio
da Sangallo the Younger, 1529

18. Rome, Del Monte Chapel, alternative design by Vasari

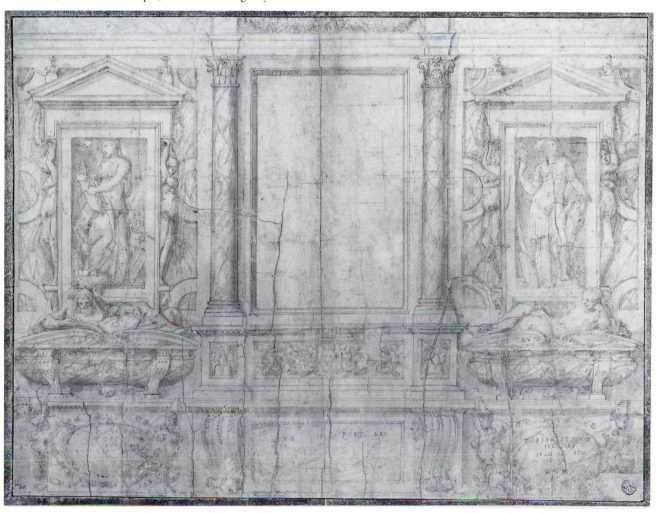

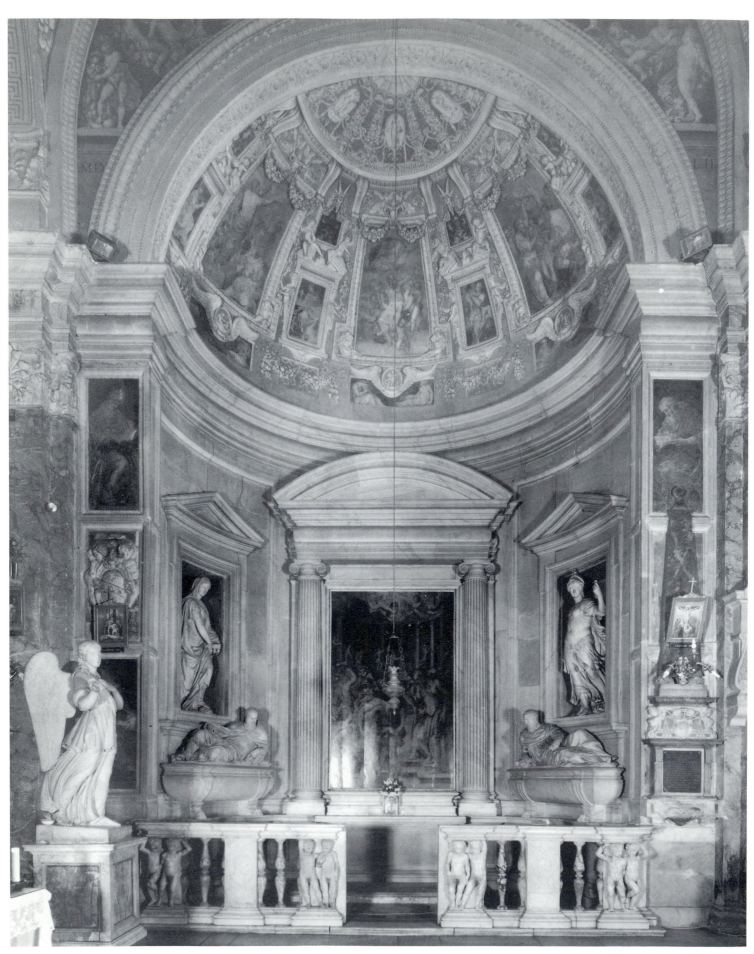

19. Del Monte Chapel, general view

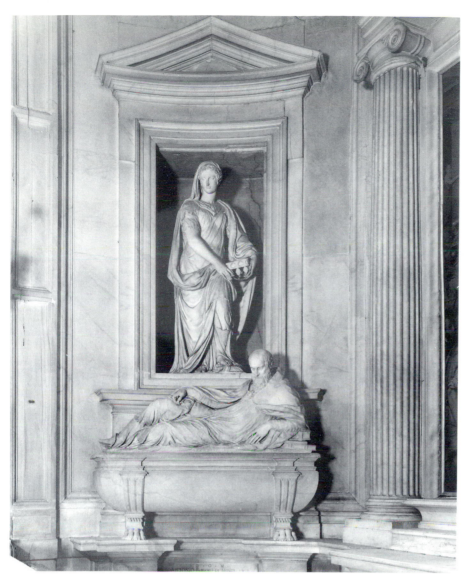

20. Del Monte Chapel, detail showing effigy of Antonio del Monte and figure of Religion

21. Del Monte Chapel, detail of tabernacle

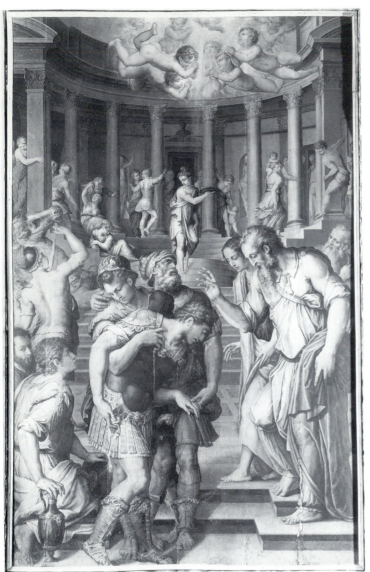

22. Del Monte Chapel,
Ananias Healing the Blinded Saul
by Vasari, 1551

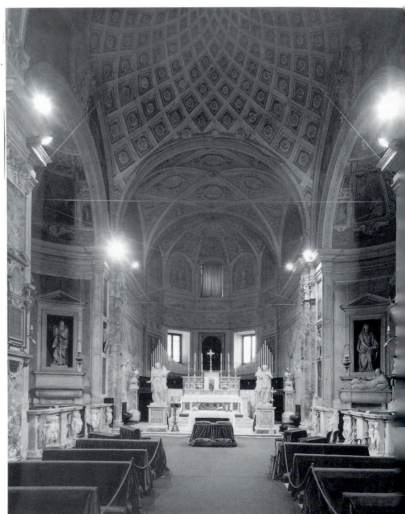

23. Del Monte Chapel
as seen from the nave of
San Pietro in Montorio

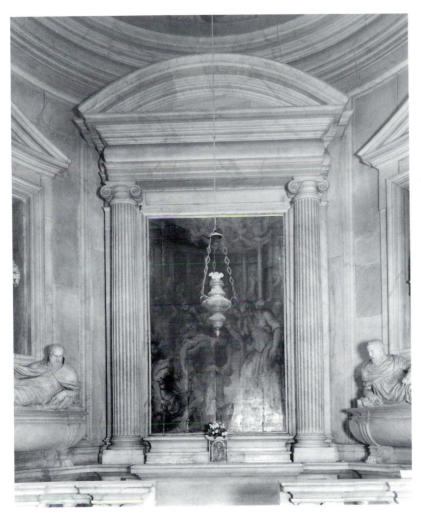

24. Del Monte Chapel, main tabernacle

25. *Ananias Healing the Blinded Saul*,
detail of lower left-hand corner
showing self-portrait of Vasari

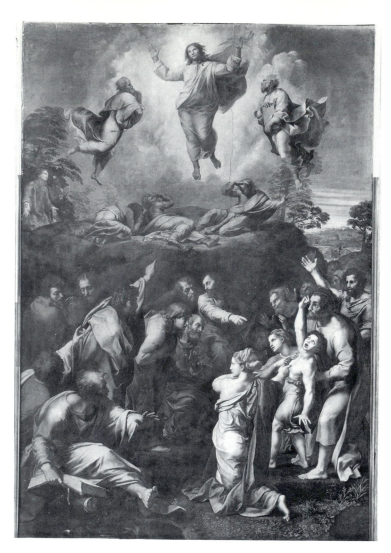

26. Raphael, *Transfiguration*, 1518–20

27. Andrea Palladio, fanciful
reconstruction of the Temple of
Fortuna Primigenia at Palestrina, detail

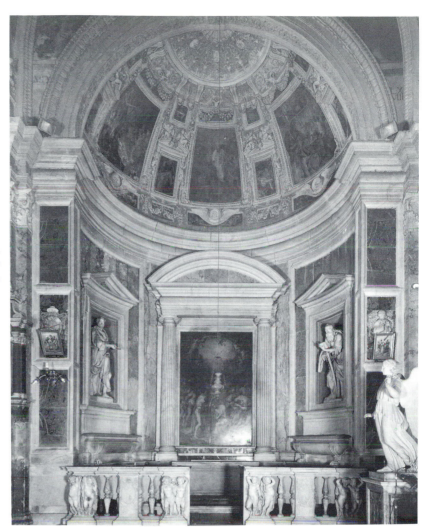

28. Rome, San Pietro in Montorio,
Ricci Chapel by Daniele
da Volterra, 1560s

29. Rome, Villa Giulia, 1551–55, exterior view of casino by Vignola

30. D. Boguet, view of the Villa Giulia in the eighteeenth century

31. Arezzo, Casa Vasari, fresco by
Vasari showing landscape
with the Basilica of Maxentius

32. Onofrio Panvinio,
map of Ancient Rome, 1565, detail
showing site of the Villa Giulia

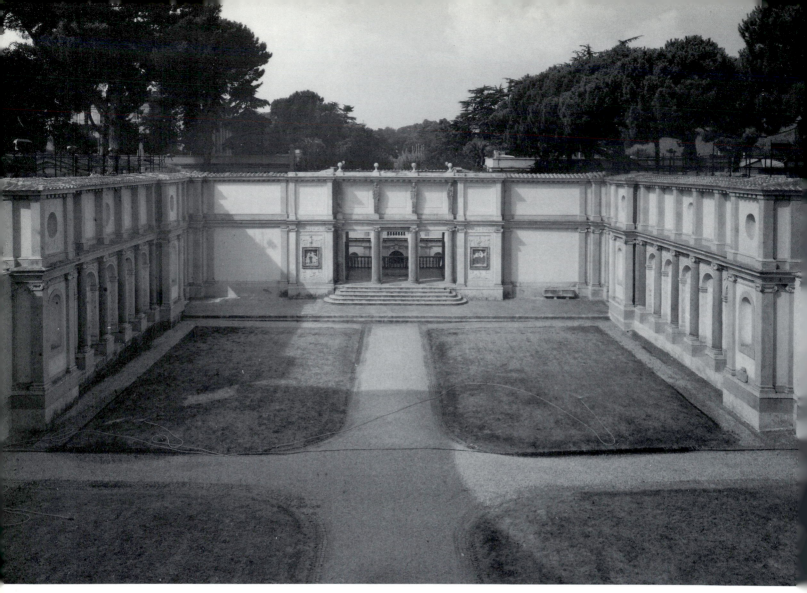

ABOVE: 33. Villa Giulia, garden court by Ammannati
BELOW: 34. Villa Giulia, facade of the loggia c. 1690, drawing attr. to G-M. Oppenordt

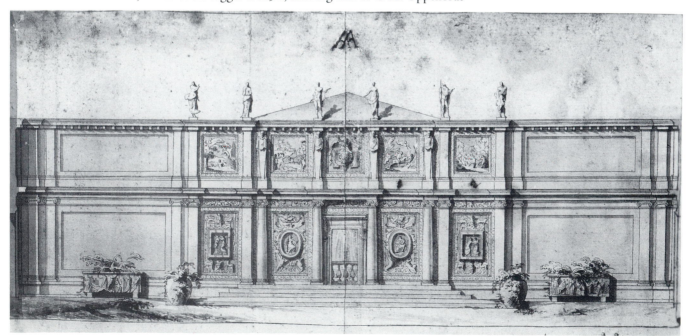

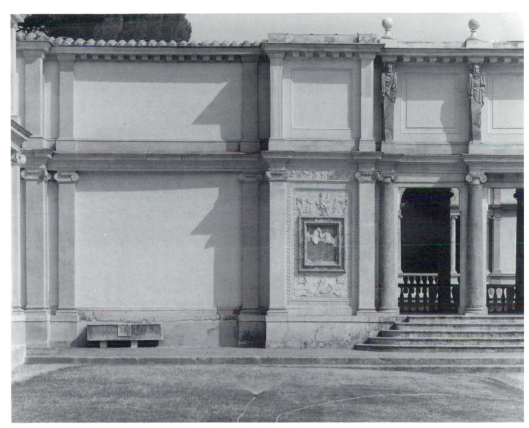

35. Villa Giulia, composite image showing above, detail of loggia, and below, anonymous sixteenth-century French (?) drawing with proposed decoration

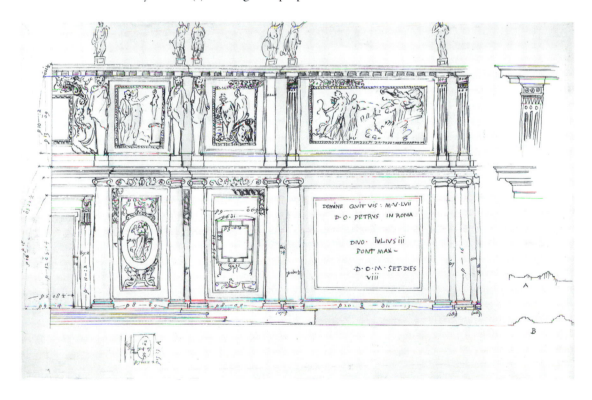

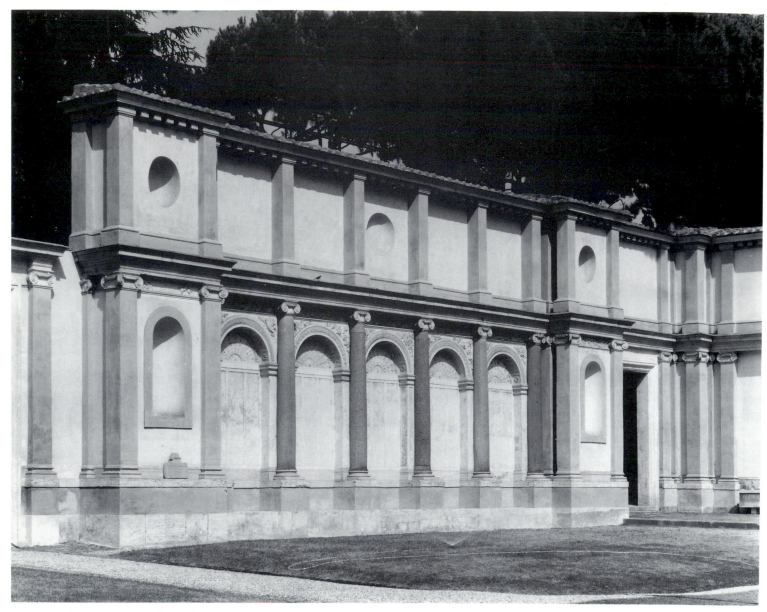

36. Villa Giulia, detail of side walls of garden court

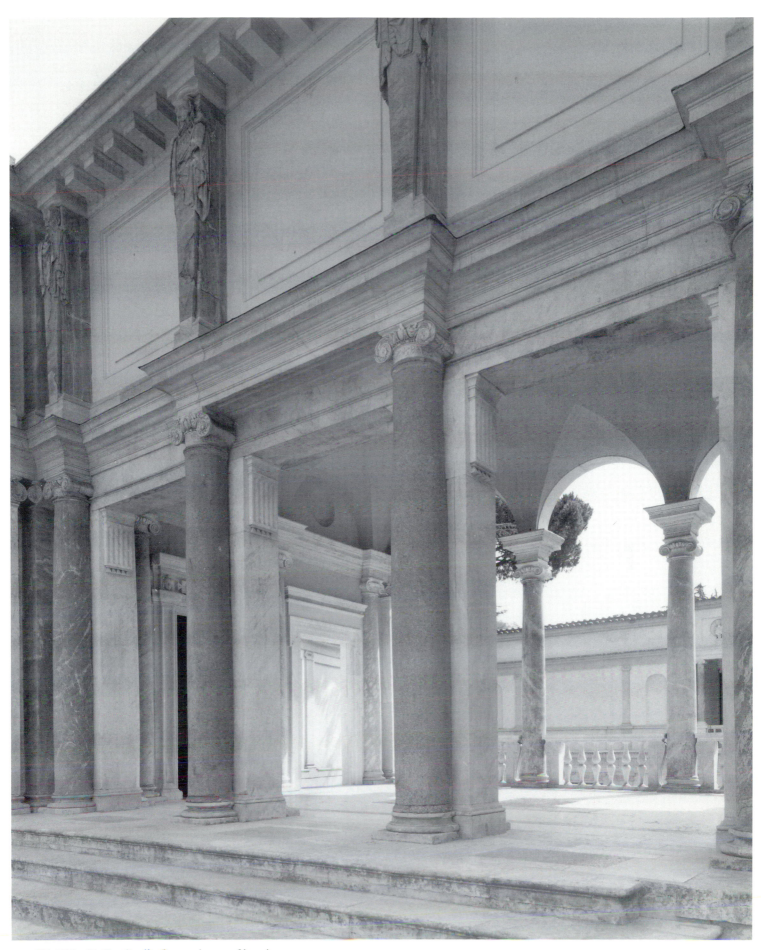

37. Villa Giulia, detail of central part of loggia

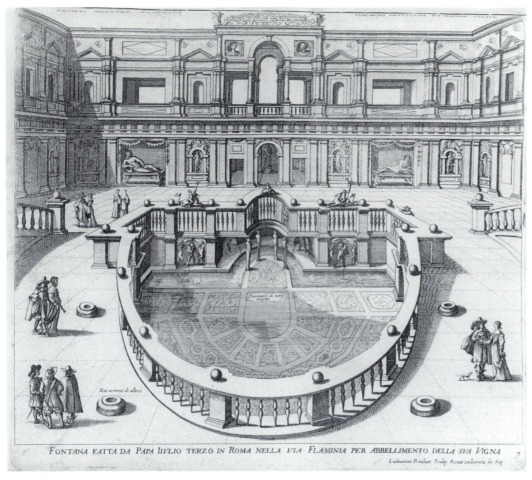

38. Villa Giulia, nympheum by Ammannati and Vasari, engraving

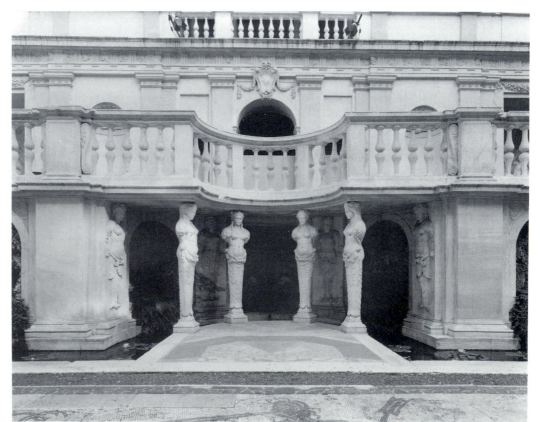

39. Villa Giulia,
nympheum,
detail of lowest level

40. Villa Giulia, nympheum, view towards loggia

41. Villa Giulia, drawing of unexecuted scheme for nympheum court

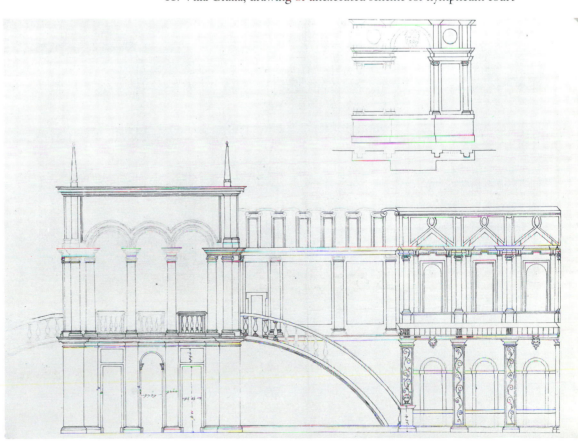

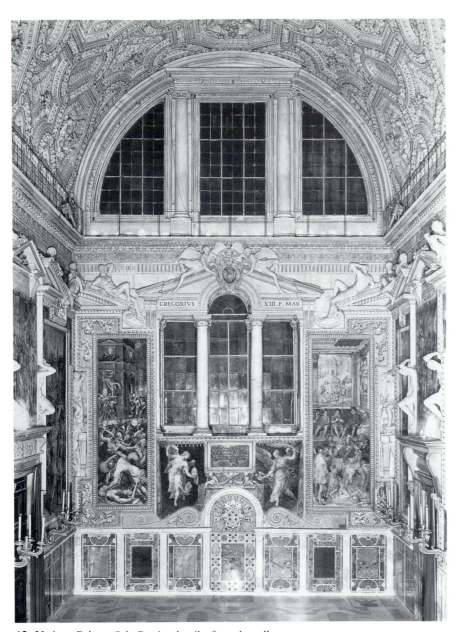

42. Vatican Palace, Sala Regia, detail of north wall

OPPOSITE:
43. Florence, aerial view of Piazza della Signoria,
and surrounding area

44. Piazza della Signoria, view towards
San Pier Scheraggio, detail of Piero di Cosimo
(attr.), *Portrait of a Warrior*, c. 1504

45. Florence, Via della Ninna,
bays of San Pier Scheraggio
still visible in the ground floor
of the Uffizi

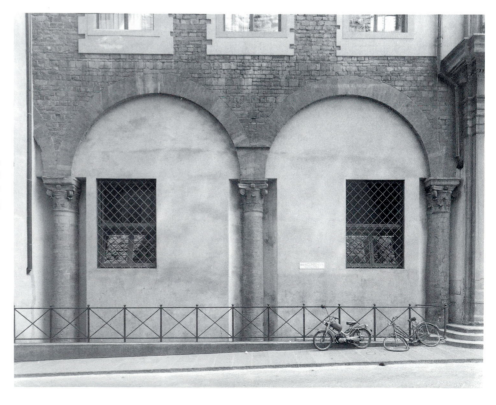

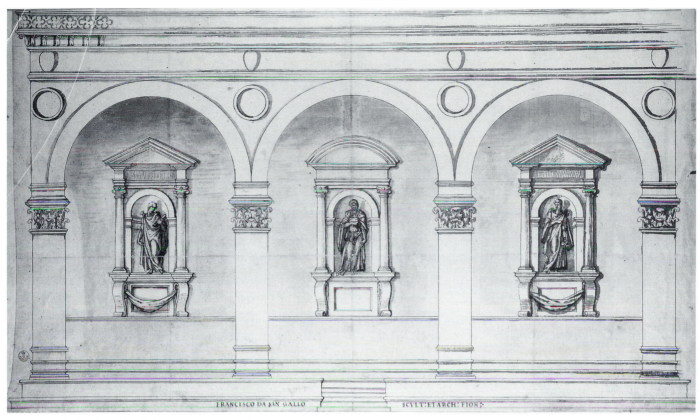

46. Piazza della Signoria, design by Francesco da Sangallo for
an extended version of the Loggia della Signoria, c. 1546

47. Piazza della Signoria, view of *strada nuova*
opened in 1546, from *Entry of Pope Leo X into
Florence* by Vasari, c. 1561–62, Palazzo Vecchio,
Sala di Leone X

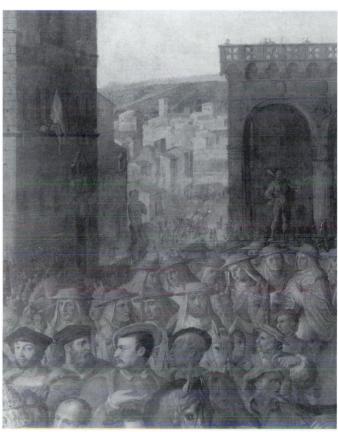

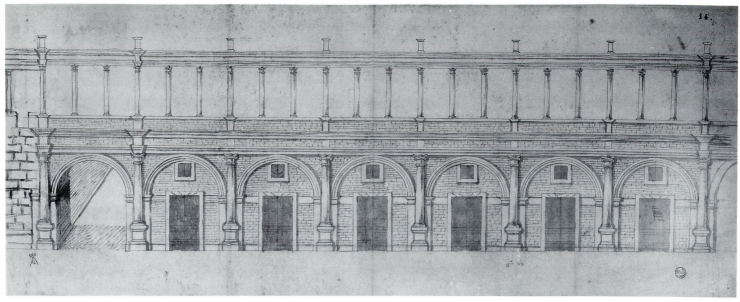

48. Florence, proposal by Francesco da Sangallo for a building on the site of the *strada nuova*

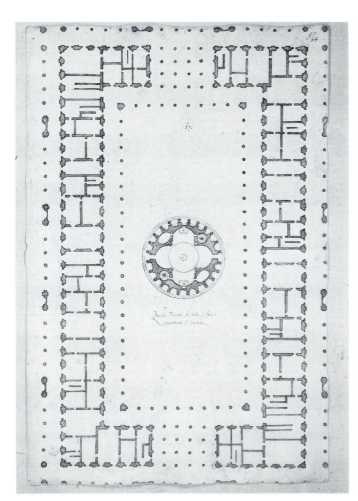

49. Uffizi, rejected first design by Vasari, drawing by Giorgio Vasari il Giovane

A

50. Uffizi, 18th-century plans by
Giuseppe Ruggieri

A: Ground floor
B: Piano nobile
C: Gallery level

B

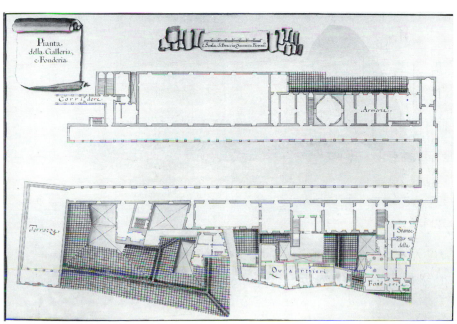

C

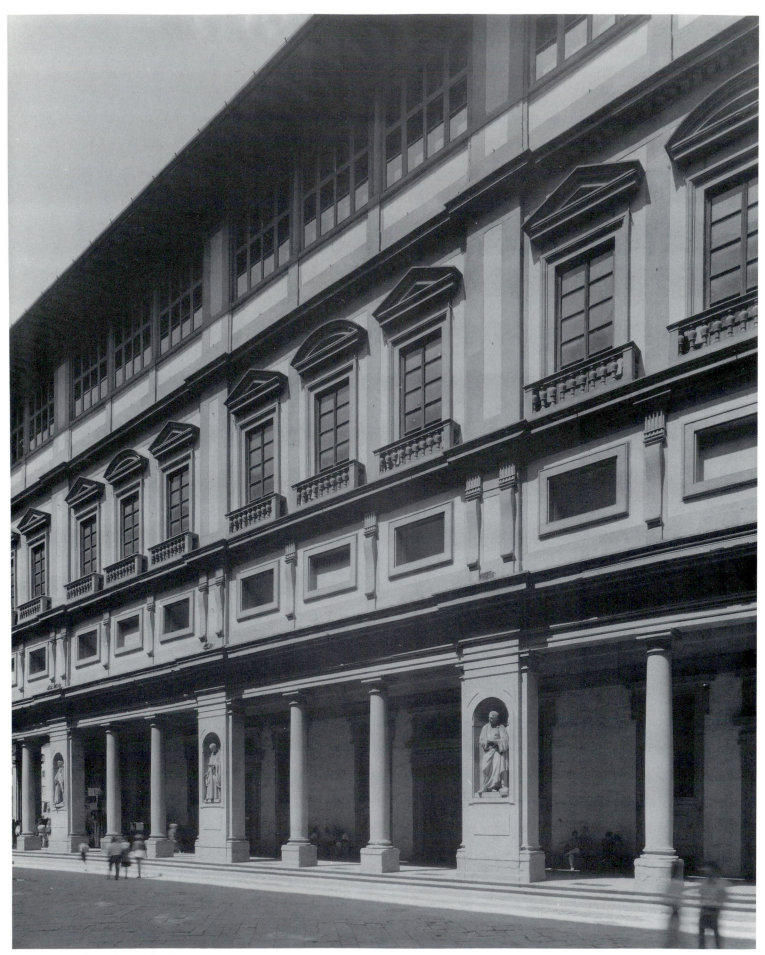

51. Uffizi, view of facade

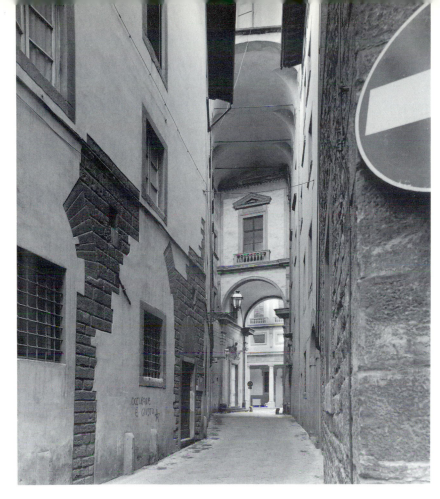

52. Uffizi, view from Via Lambertesca

53. Uffizi, detail of facade as it passes
over the Via Lambertesca and the exterior
of the Florentine Mint

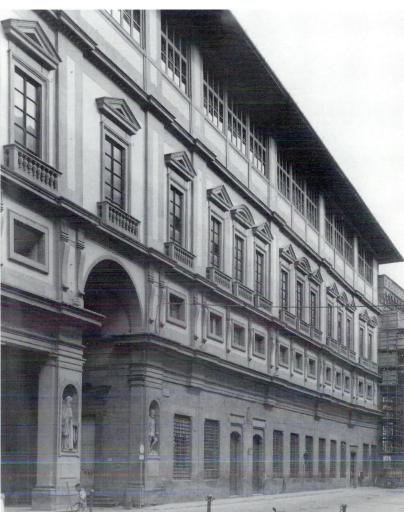

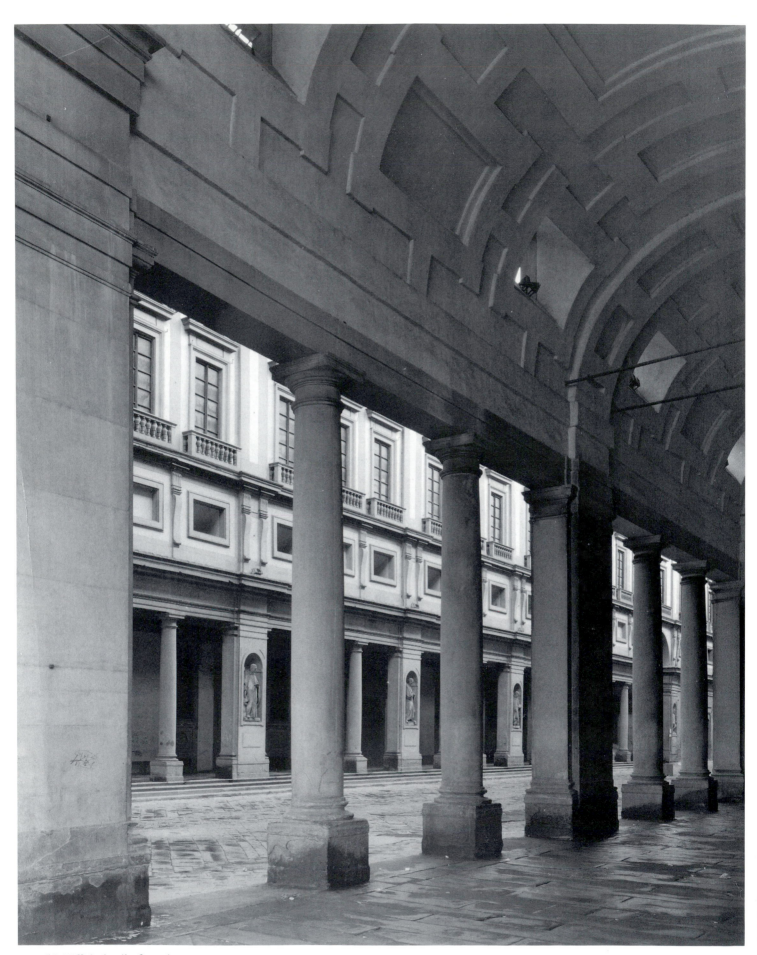

54. Uffizi, detail of portico

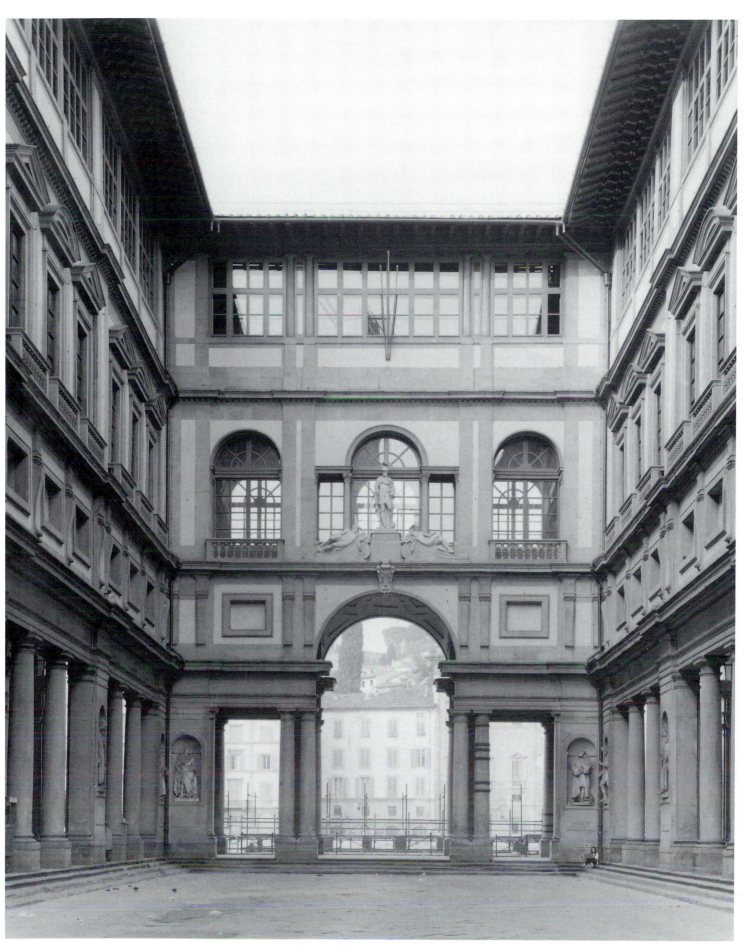

55. Uffizi, view of *testata*

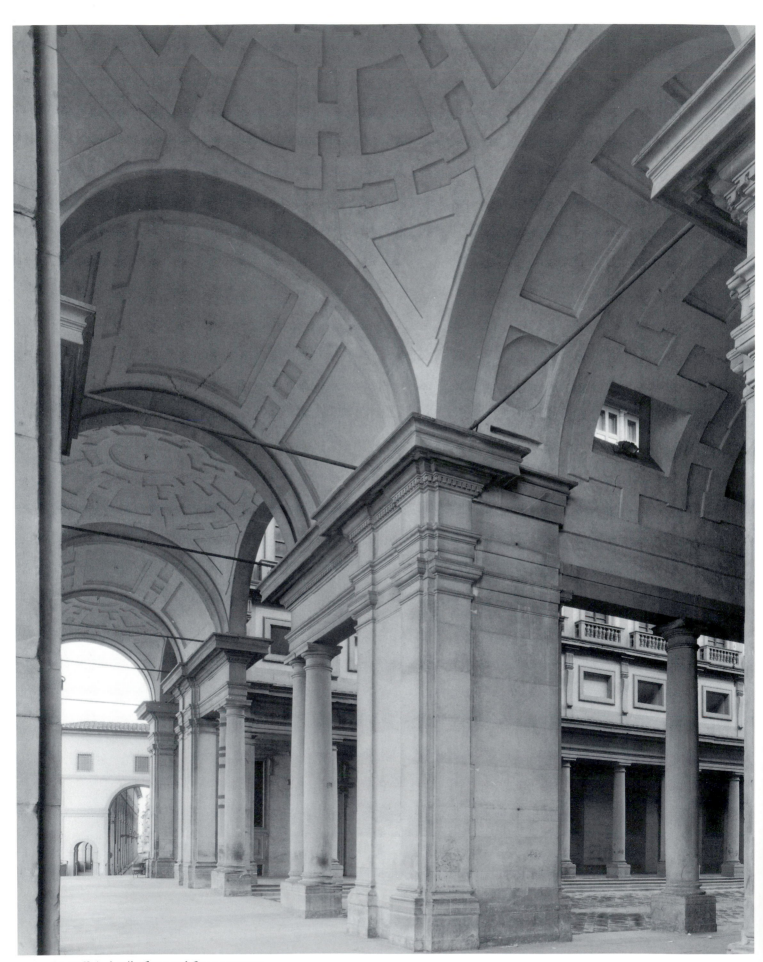

56. Uffizi, detail of ground-floor at *testata*

57. Uffizi, view of main magistracy chamber (Pupilli) in western wing

58. View of secondary chamber (Pupilli) in western wing

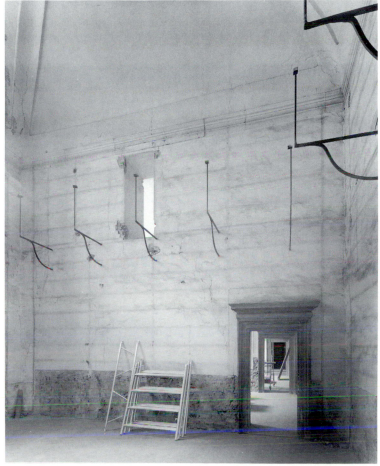

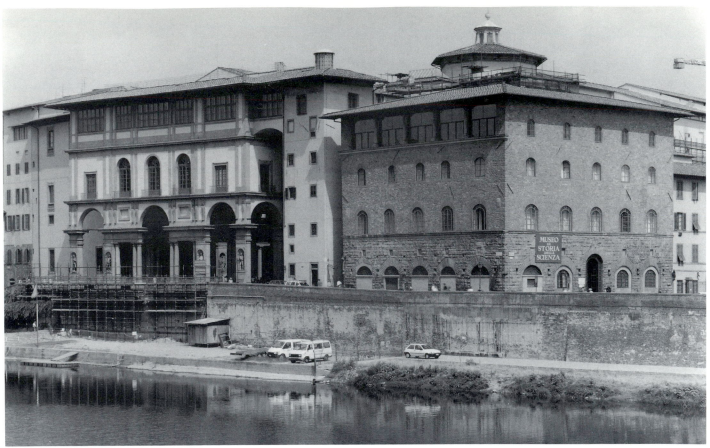

59. Uffizi, view showing
river-front facade and the Palazzo
dei Giudici

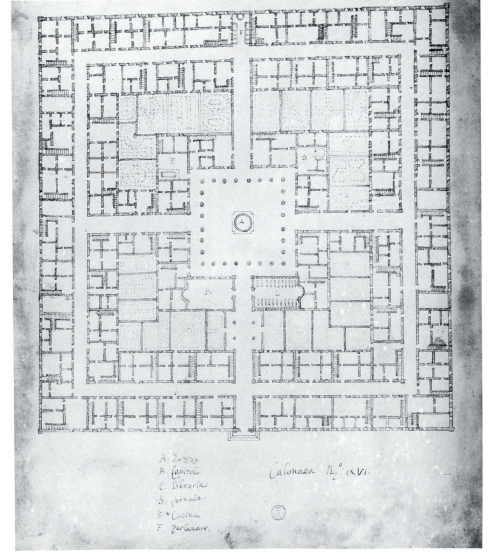

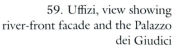

60. Bartolomeo Ammannati,
plan of a *calonaca*

61. Bartolomeo Ammannati, drawing of Vasari's facade for the Uffizi

62. Bartolomeo Ammannati, proposal for the facade of the Uffizi

63. Uffizi, detail of northern end of portico

64. Florence, Palazzo Pitti, drawing by Ammannati of courtyard facade

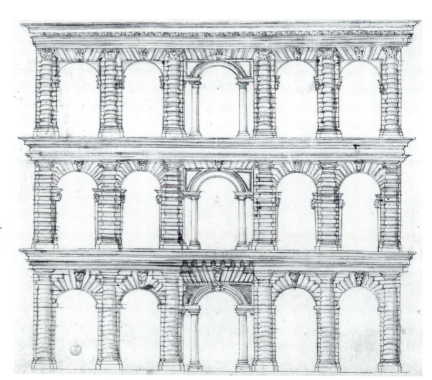

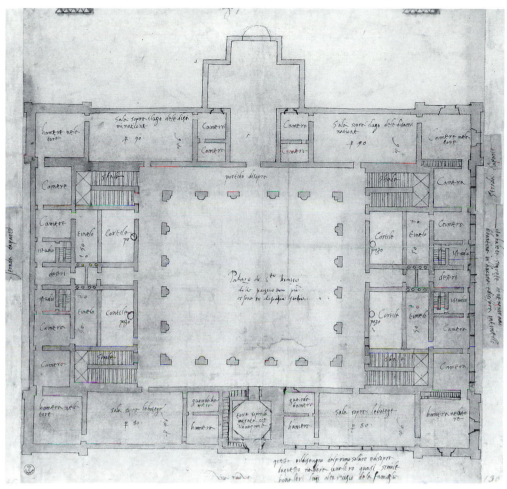

65. Rome, Palazzo dei Tribunali, plan of piano
nobile by Antonio da Pellegrino, c. 1506

66. Naples, detail of 1566
view of city by Lafreri showing
Castel Capuano (number 47)

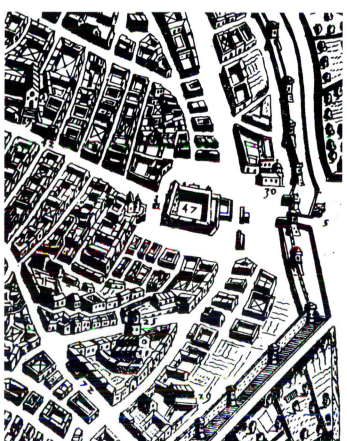

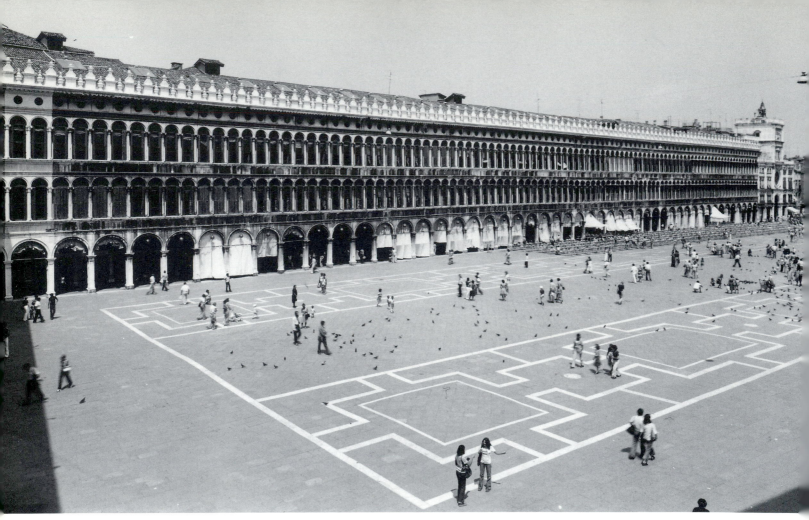

67. Venice, Procuratie Vecchie, begun 1514

68. Florence, Via delle Farine,
view from Piazza della Signoria

69. Florence, Via dei Calzaiuoli,
view from Piazza della Signoria

70. Rome, Palazzo Farnese, project
for the rear wing, after Michelangelo,
engraving published by A. Lafreri, 1560

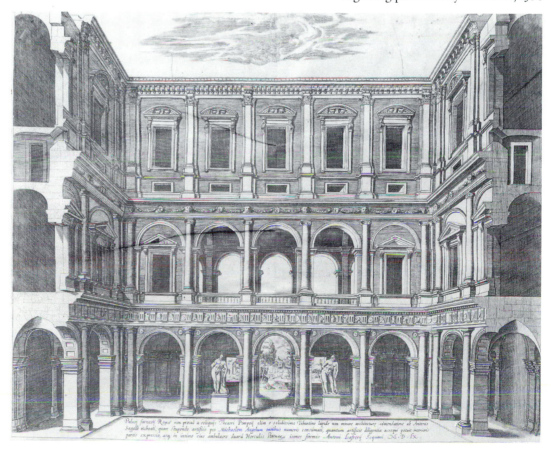

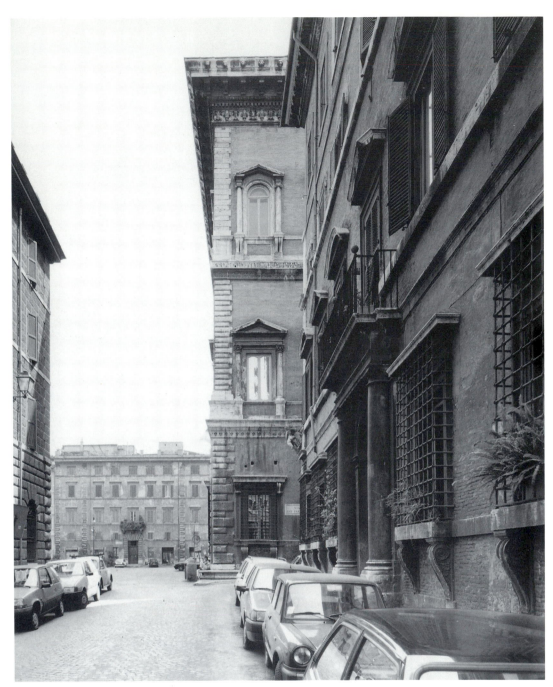

71. Rome, Palazzo Farnese, view from Via Monserrato

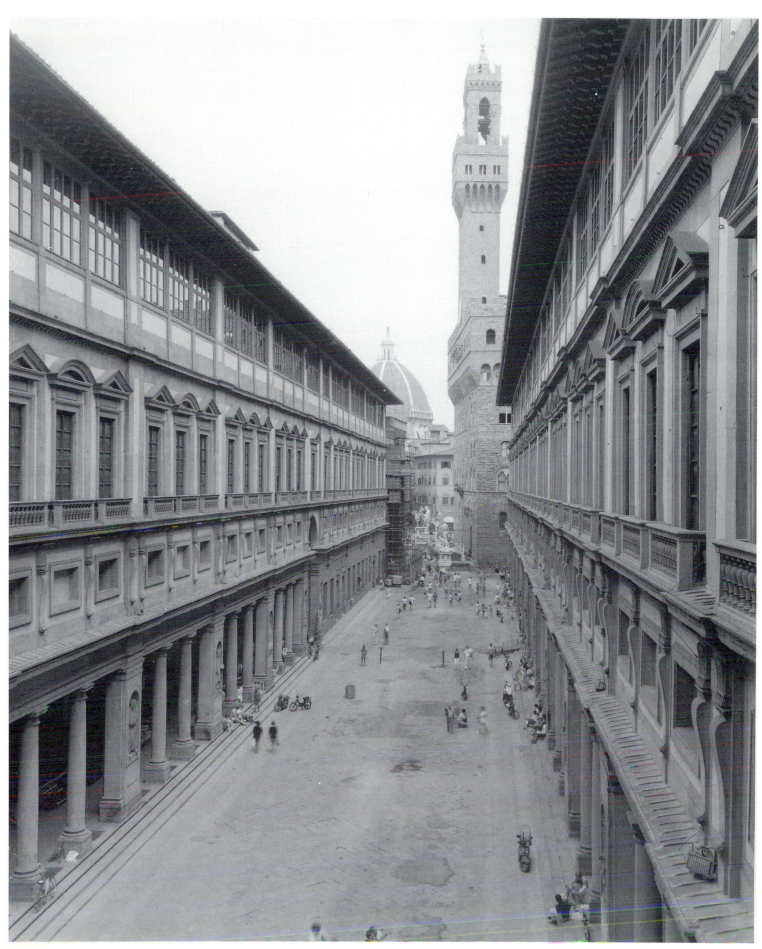

72. Uffizi, view towards Palazzo Vecchio

73. Florence, Piazza della Signoria, detail showing
Michelangelo's *David* (modern copy) and Bandinelli's
Hercules and Cacus

74. Uffizi, foundation medal
by Domenico Poggini, 1561

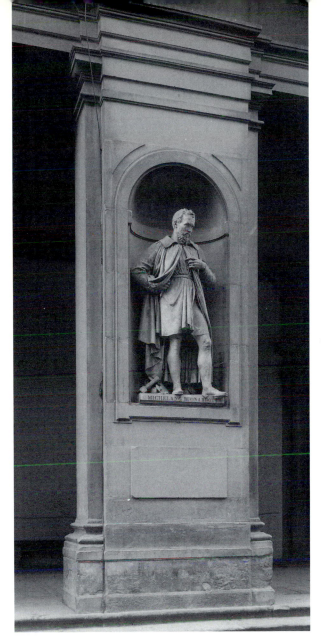

75. Uffizi, detail showing nineteenth-century
statue of Michelangelo

76. Anon. sixteenth-century Italian,
drawing of the Uffizi's riverfront loggia

77. Dosio (attr.), drawing showing facade of riverfront loggia with seated figure of Cosimo I

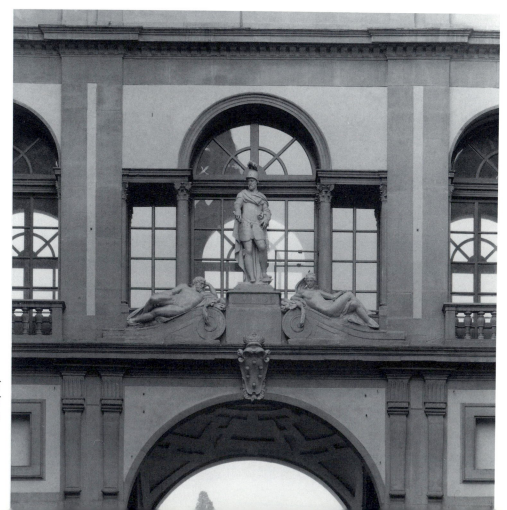

78. Uffizi, detail of riverfront loggia with figure of Cosimo I by Giambologna

ABOVE: 79. Uffizi, interior view of serliana on main floor of the riverfront loggia
BELOW: 80. Vatican, Sala Regia, engraving by Duperac showing coronation of Cosimo I as Grand Duke of Tuscany

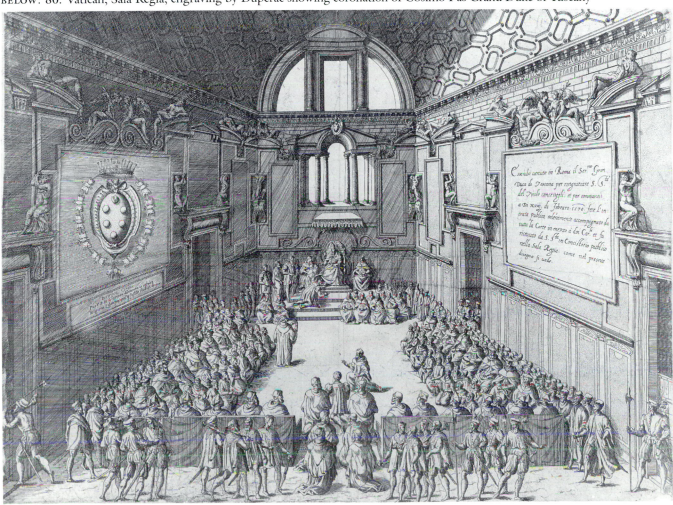

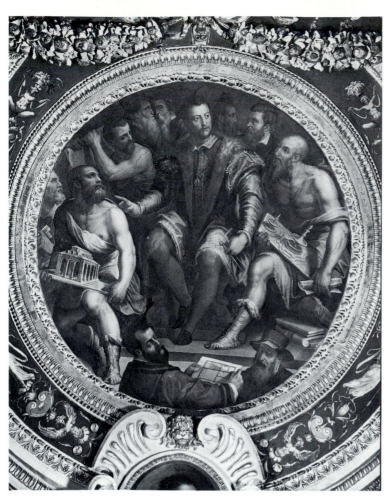

81. Palazzo Vecchio, Sala di Cosimo I,
Vasari's portrait of Cosimo I
surrounded by his artists, 1556–60

82. B. Lanci, backdrop for *La Vedova*, 1569

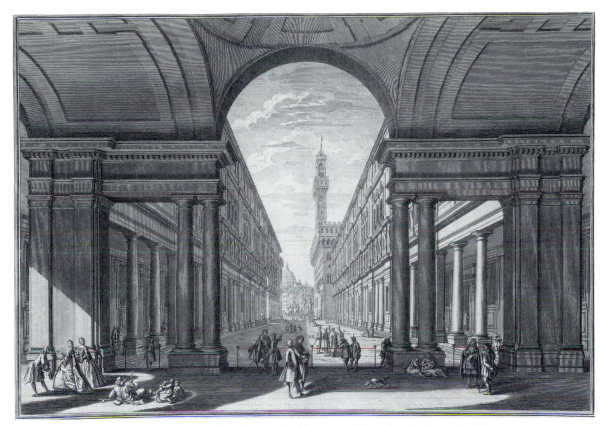

83. G. Zocchi, engraving of Uffizi and the Palazzo Vecchio as seen from the riverfront loggia, 1744

84. P. Poccianti, proposal to place Michelangelo's *David* underneath the riverfront loggia

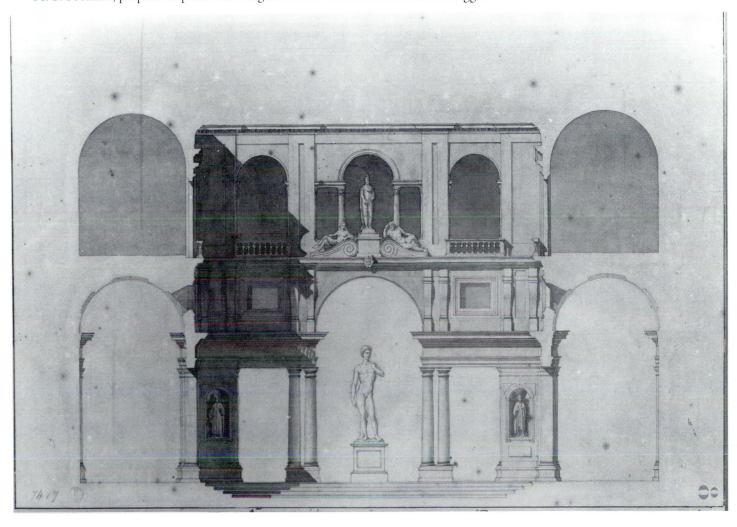

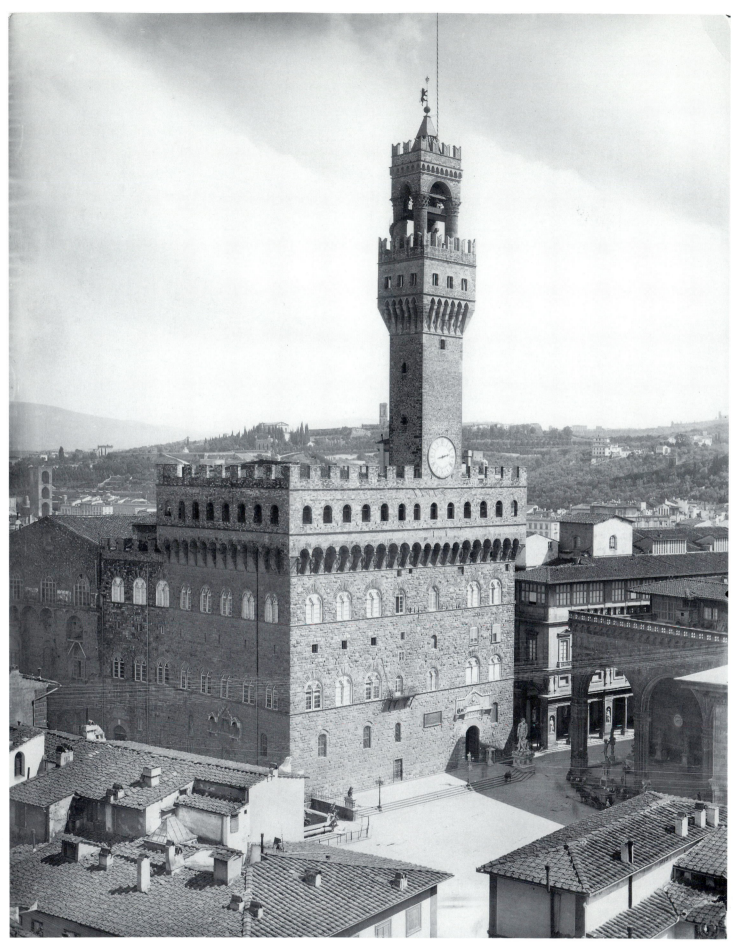

85. Florence, Palazzo Vecchio, begun 1296

86. Palazzo Vecchio, northern facade of Salone dei Cinquecento
(Vasari contributed the upper story and its three arched windows)

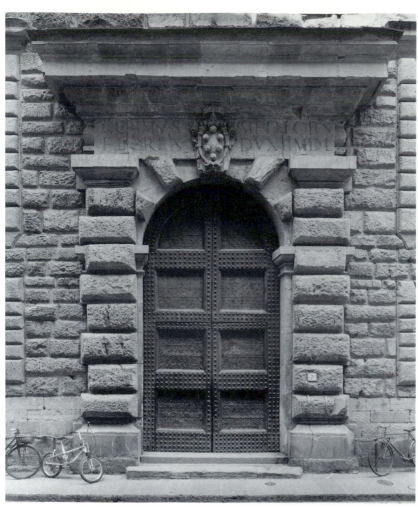

87. Palazzo Vecchio, portal on Via dei Leoni by Battista del Tasso, 1550–52

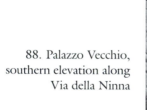

88. Palazzo Vecchio, southern elevation along Via della Ninna

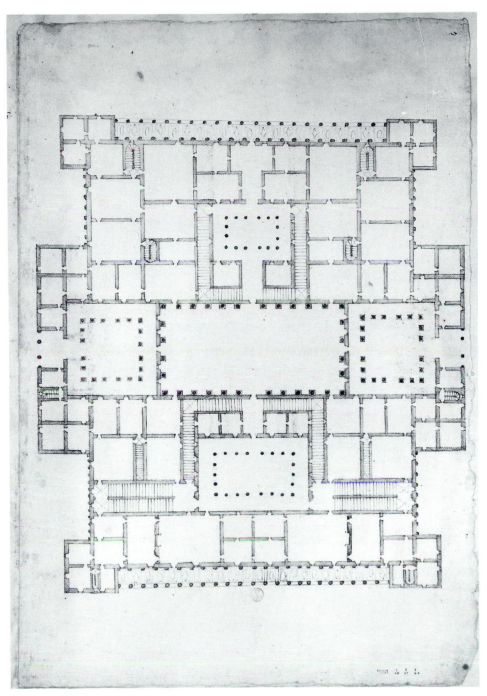

89. Bartolomeo Ammannati, project for a ducal place,
adjacent to the Piazza della Signoria

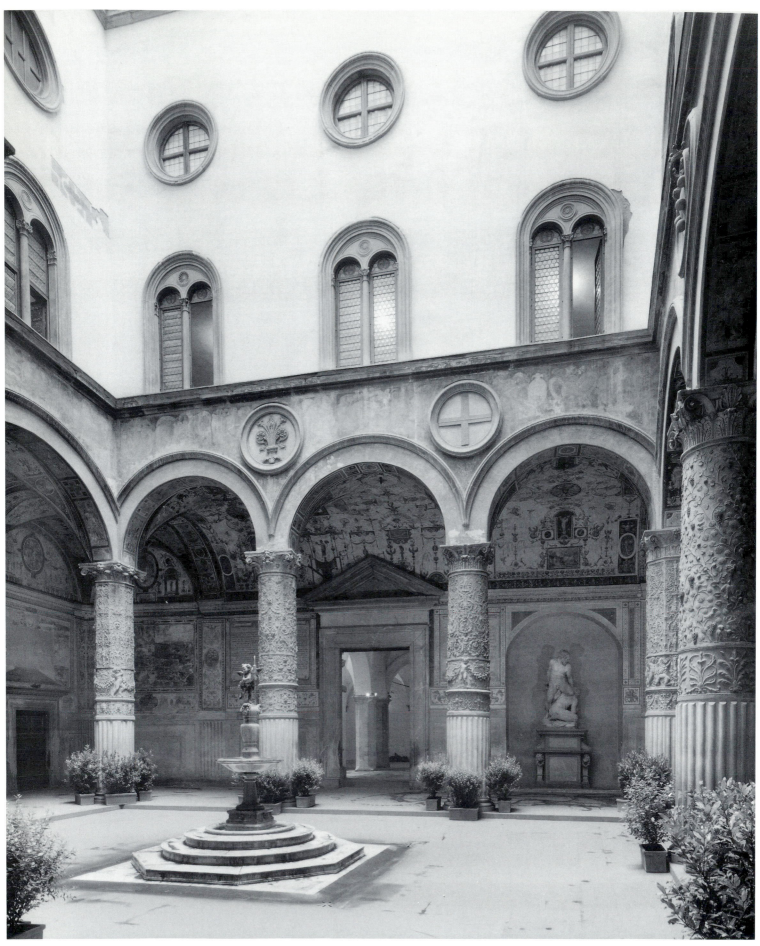

90. Palazzo Vecchio, view of courtyard from main entry

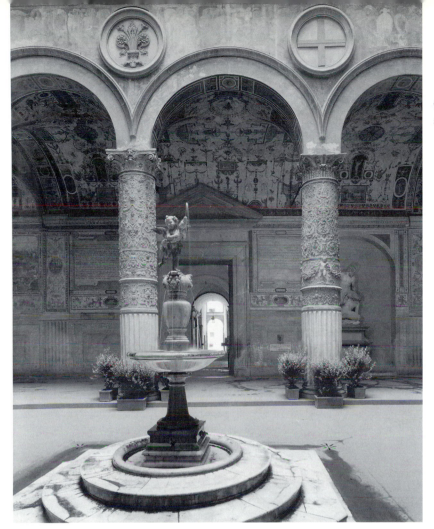

91. Palazzo Vecchio, view of courtyard
along axis of central bay

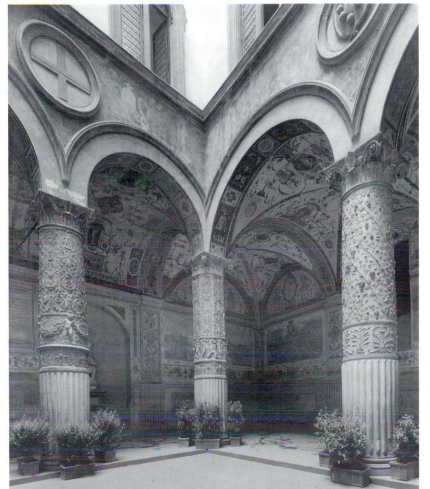

92. Palazzo Vecchio, detail of door jamb
on eastern side of courtyard

93. Palazzo Vecchio, detail of
southeastern corner of courtyard

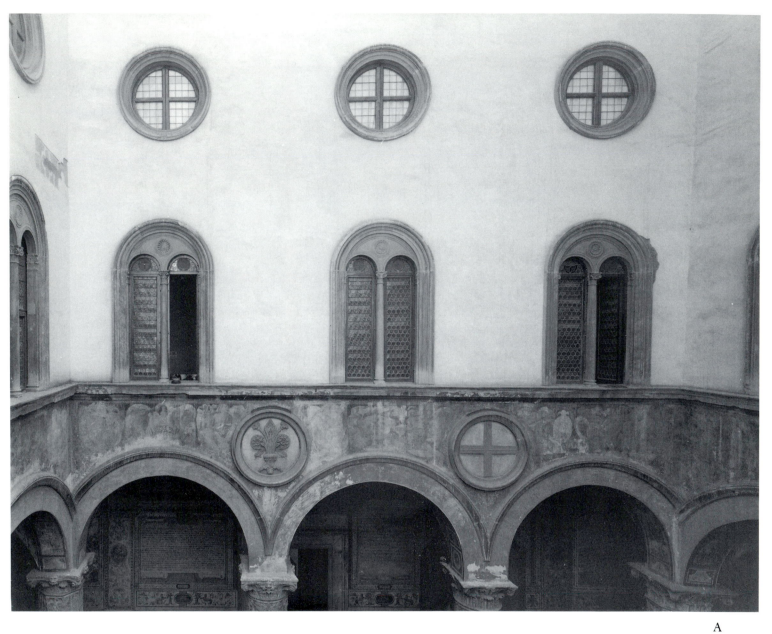

A

94. Palazzo Vecchio, courtyard

A: elevation of eastern wall
B: V. Borghini (attr.), proposal for the decoration of the
 courtyard of the Palazzo Vecchio, 1565

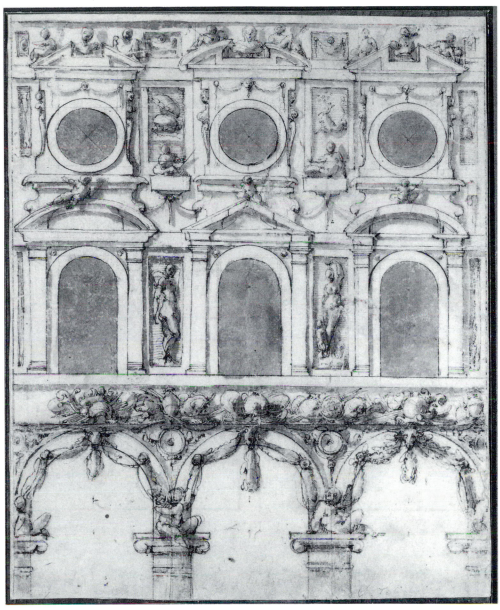

B

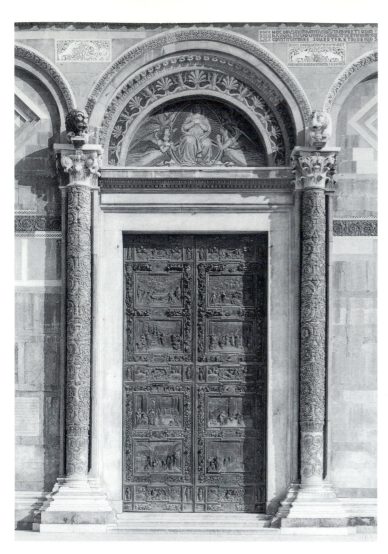

95. Pisa, Cathedral,
detail showing columns
flanking main doorway

96. Palazzo Vecchio,
Quartiere di Eleonora, *Esther and
Ahasuerus* by Stradano, 1561–62

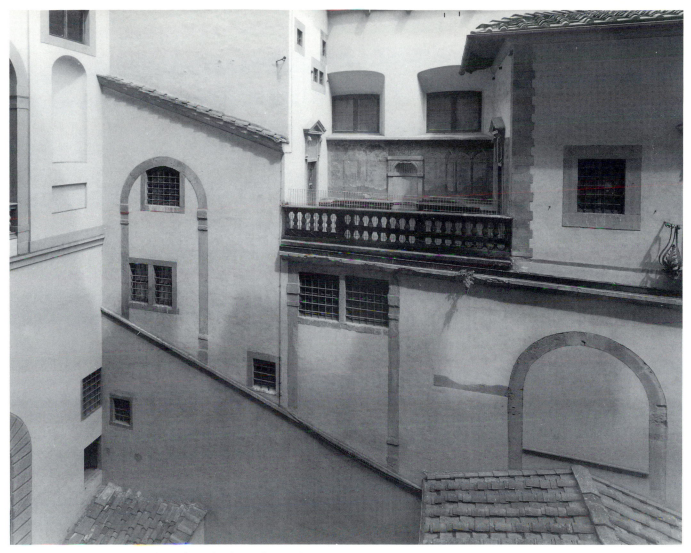

97. Palazzo Vecchio, view of remains of staircase by Battista del Tasso, 1549

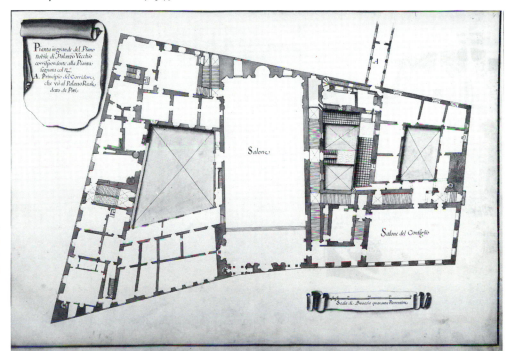

98. Palazzo Vecchio,
plan
in the eighteenth century
by Giuseppe Ruggieri

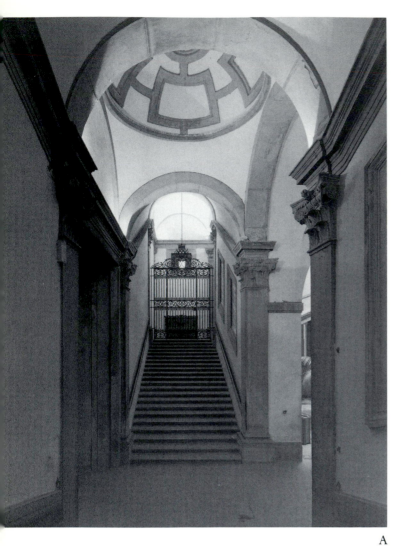
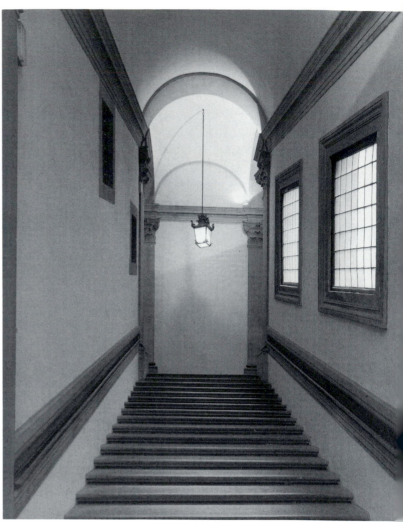

A B

99. Florence, Palazzo Vecchio, main staircase by Vasari, 1560–71

A: view of ramps from ground level
B: view along second ramp, north
C: view of eastern ramps from the entrance
 to the Salone dei Cinquecento
 towards the north

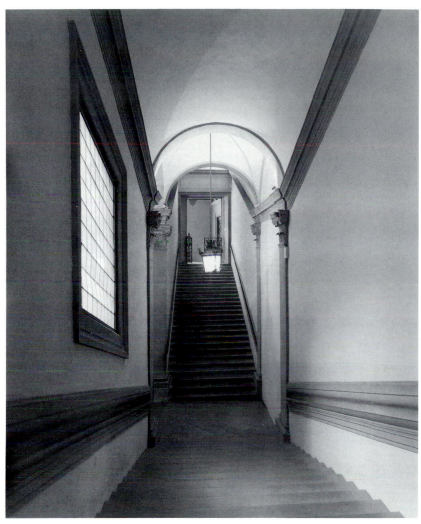

C

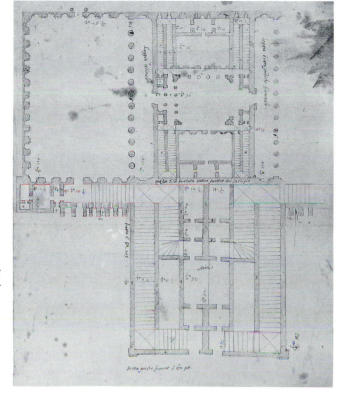

100. Rome, plan drawn by
Bartolomeo Ammannati of
staircases leading to Temple of
Serapis on the Quirinal Hill

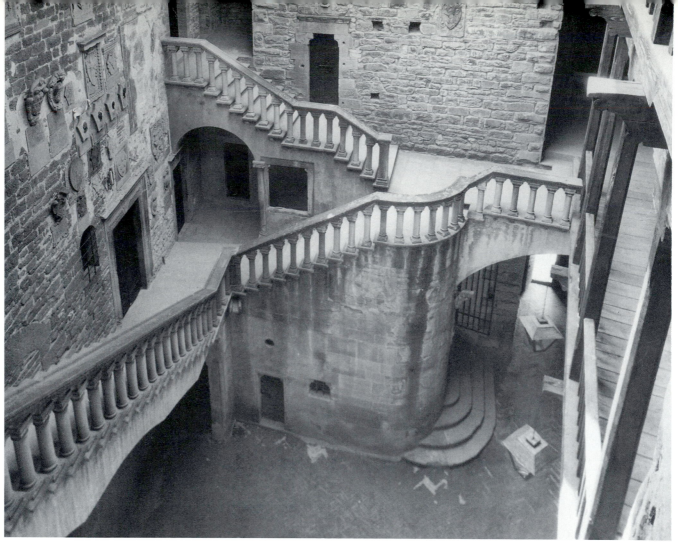

101. Poppi, Palazzo Communale, staircases in courtyard

102. Venice, staircase of the
Scuola Grande di San Giovanni
Evangelista by Mauro Codussi, 1498

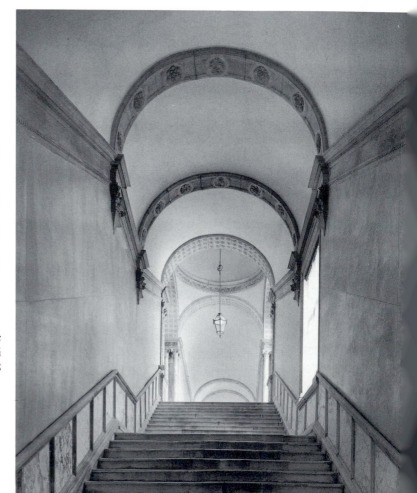

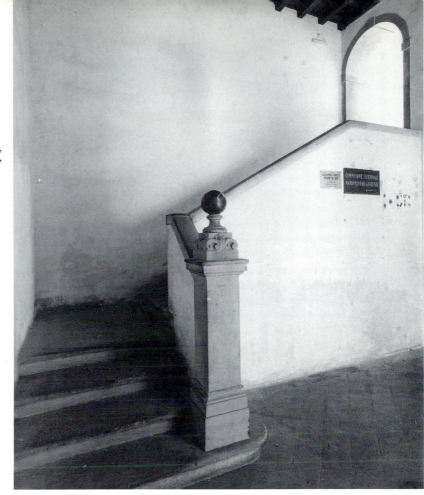

103. Florence, Monte di Pietà,
staircase by Vasari, 1557

104. Palazzo Vecchio,
view of Salone dei Cinquecento as
renovated by Vasari, 1560–65

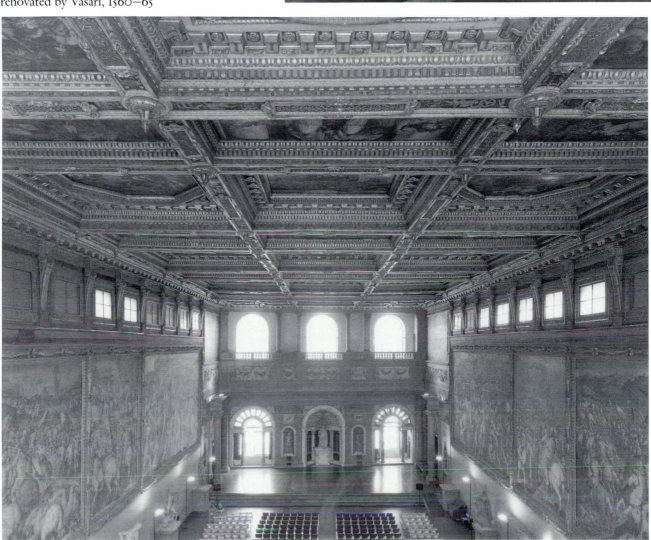

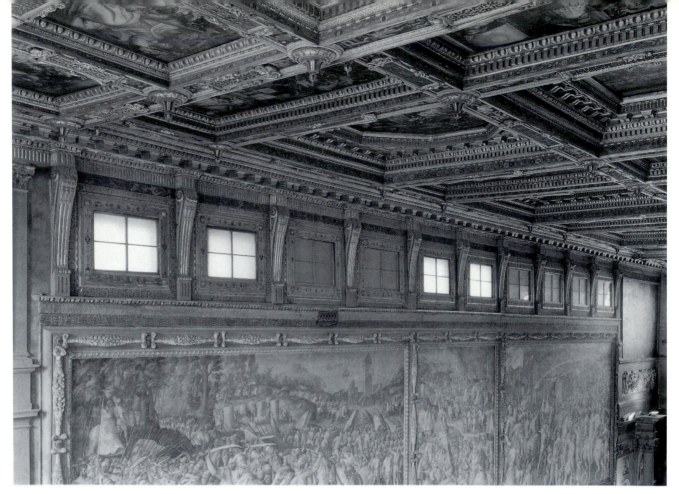

105. Florence, Palazzo Vecchio, detail of clerestory windows in the Salone dei Cinquecento

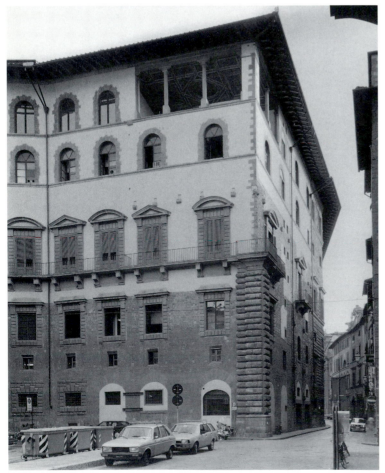

106. Palazzo Vecchio, exterior of apartments at southeast corner (the Quarter of the Elements and the Terrace of Saturn are on the uppermost floor; the Quarter of Leo X is on the middle level and is identified by the rusticated windows with pediments)

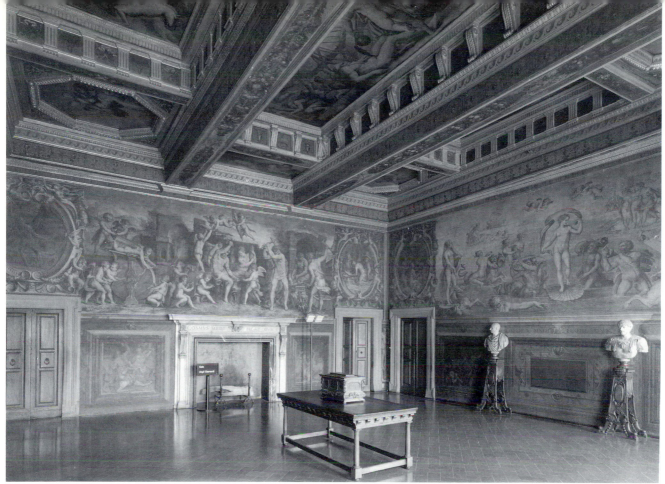

ABOVE: 107. Palazzo Vecchio, Sala degli Elementi, renovated by Vasari, 1555–57
BELOW: 108. Florence, Palazzo Vecchio, Sala di Leone X, renovated by Vasari, 1555–62

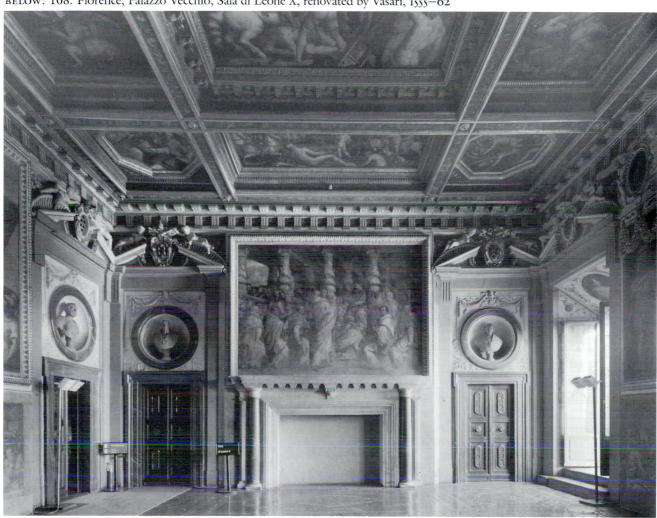

109. Florence, San Lorenzo, New Sacristy

110. Palazzo Vecchio, Sala di Leone X,
detail of fireplace attributed to Ammannati

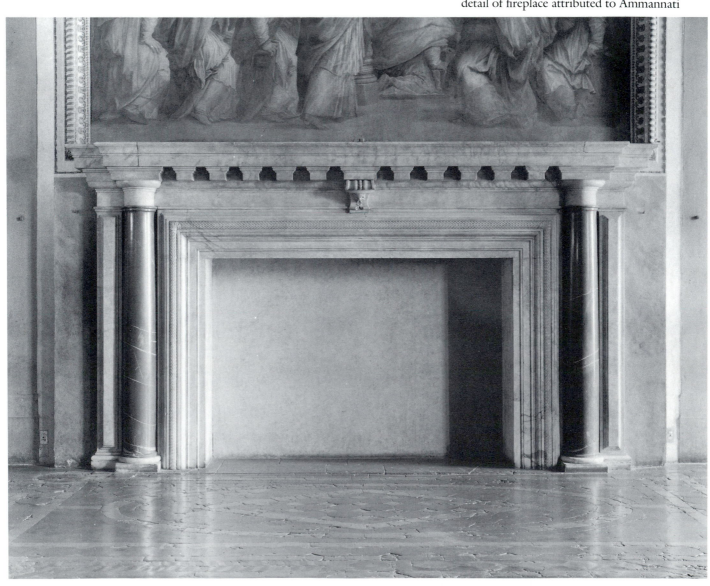

111. Florence, Corridoio by Vasari, eighteenth-century plan

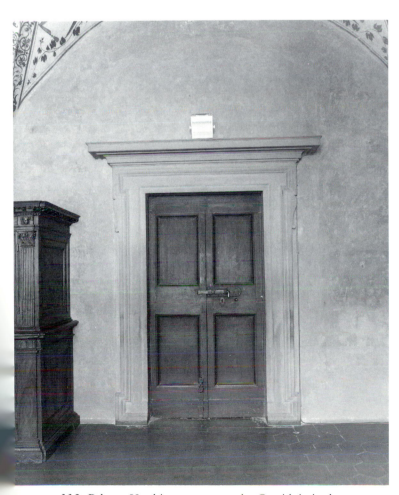

112. Palazzo Vecchio, entrance to the Corridoio in the
Camera Verde

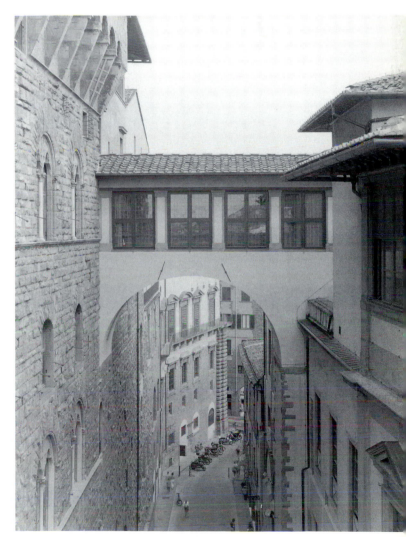

113. Corridoio, detail along Via della Ninna

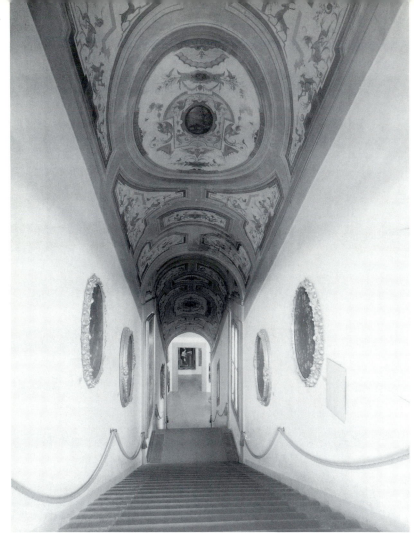

114. Corridoio, detail of stairs
descending from the Uffizi

115. Corridoio, detail of sector along the Arno

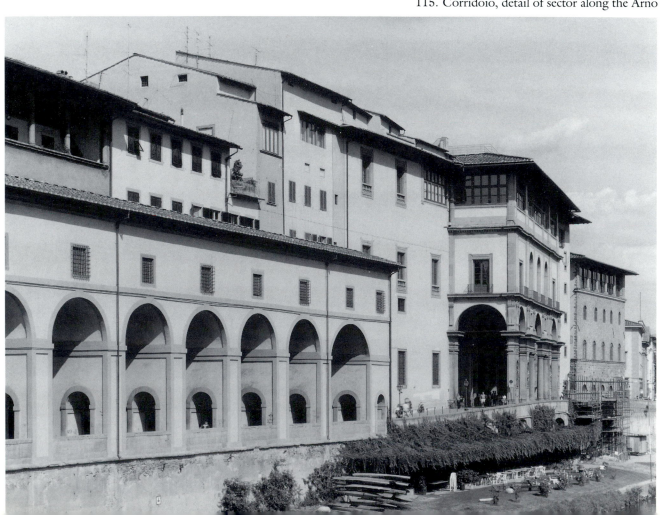

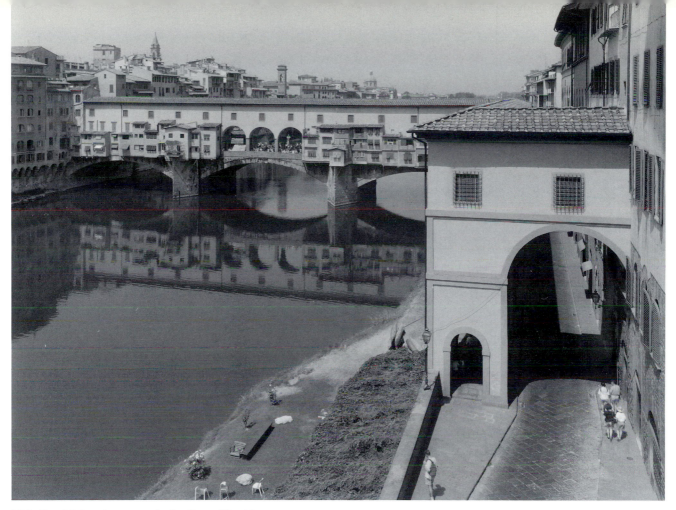

116. Corridoio, view towards the Ponte Vecchio

117. Corridoio, detail along the Ponte Vecchio

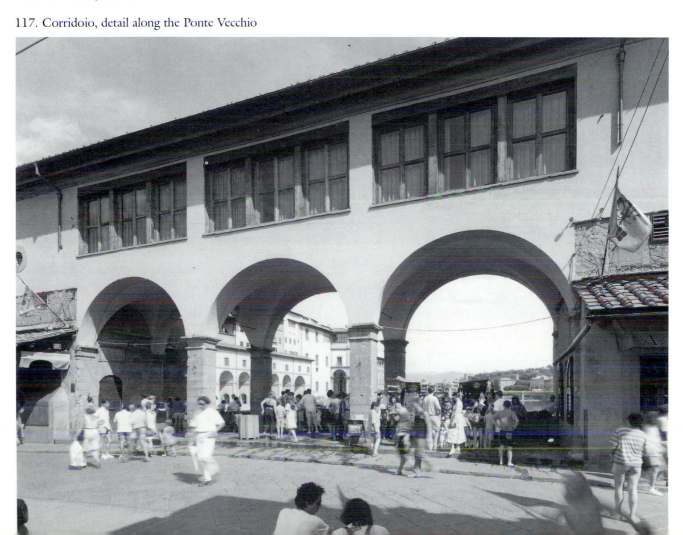

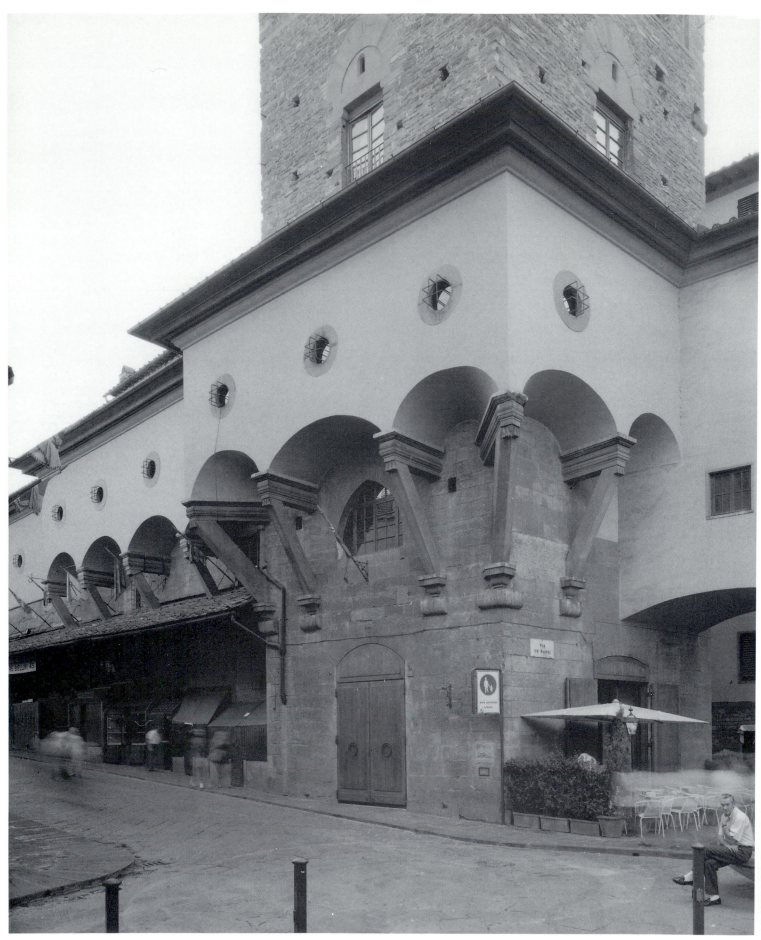

118. Corridoio, detail at southern end of the Ponte Vecchio

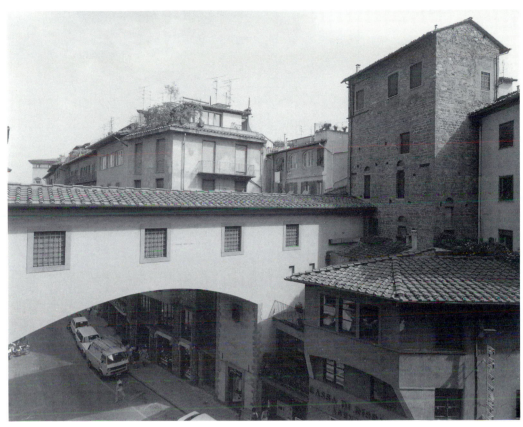

119. Corridoio, detail along Via dei Bardi

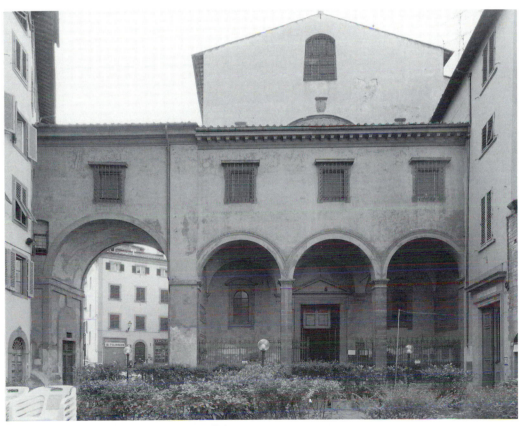

120. Corridoio, detail at Piazza Santa Felicita

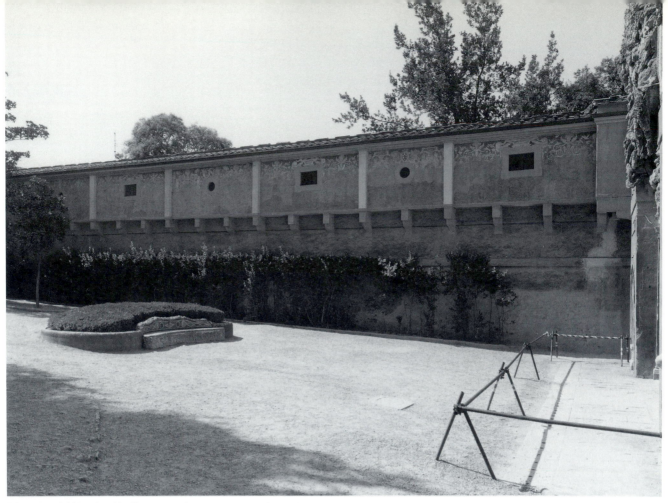

121. Corridoio, detail adjacent to the Grotta Grande in the Boboli Gardens

122. Corridoio, detail of interior along the Ponte Vecchio

123. Corridoio, detail of interior along the Arno looking east

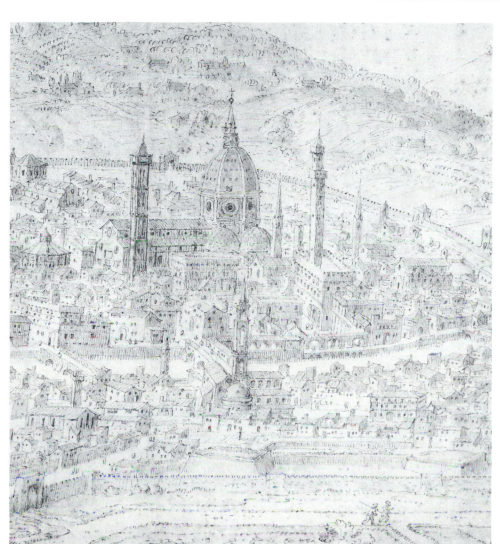

124. H. van Cleve, detail of a view of Florence in 1565

125. Rome, detail of the Passetto

126. Pistoia, detail of engraved view by F. B. Werner, 1705

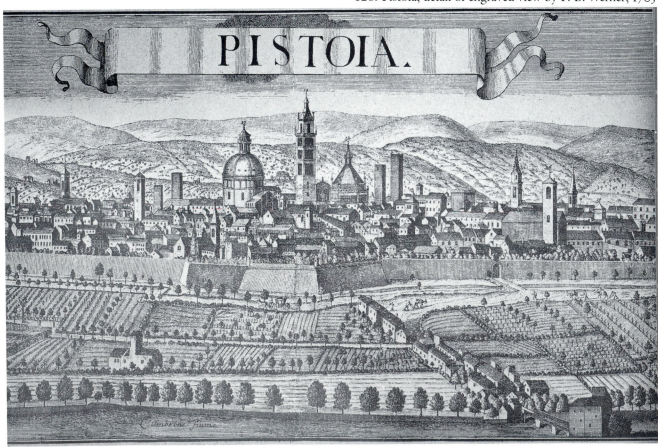

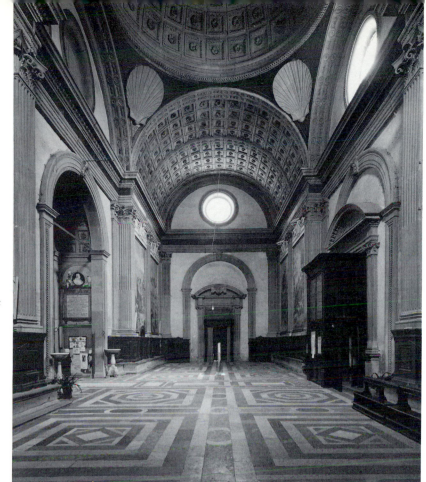

127. Madonna dell Umilità, vestibule

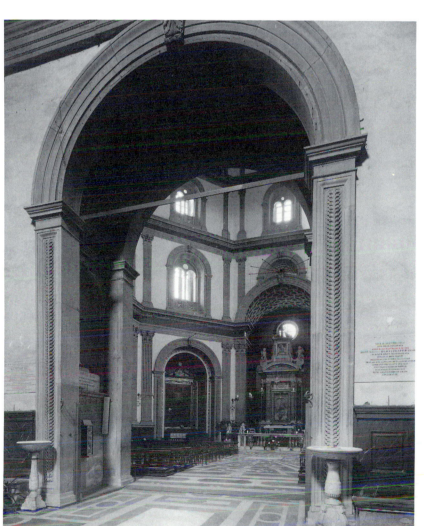

128. Madonna dell' Umilità,
view into sanctuary

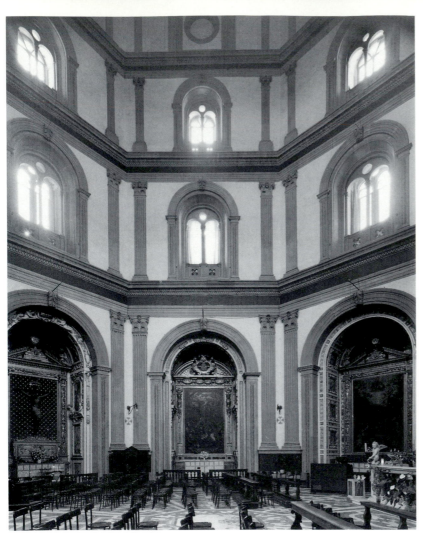

129. Madonna dell' Umilità,
interior elevation of sanctuary

130. Madonna dell' Umilità,
detail of fourth story added by Vasari

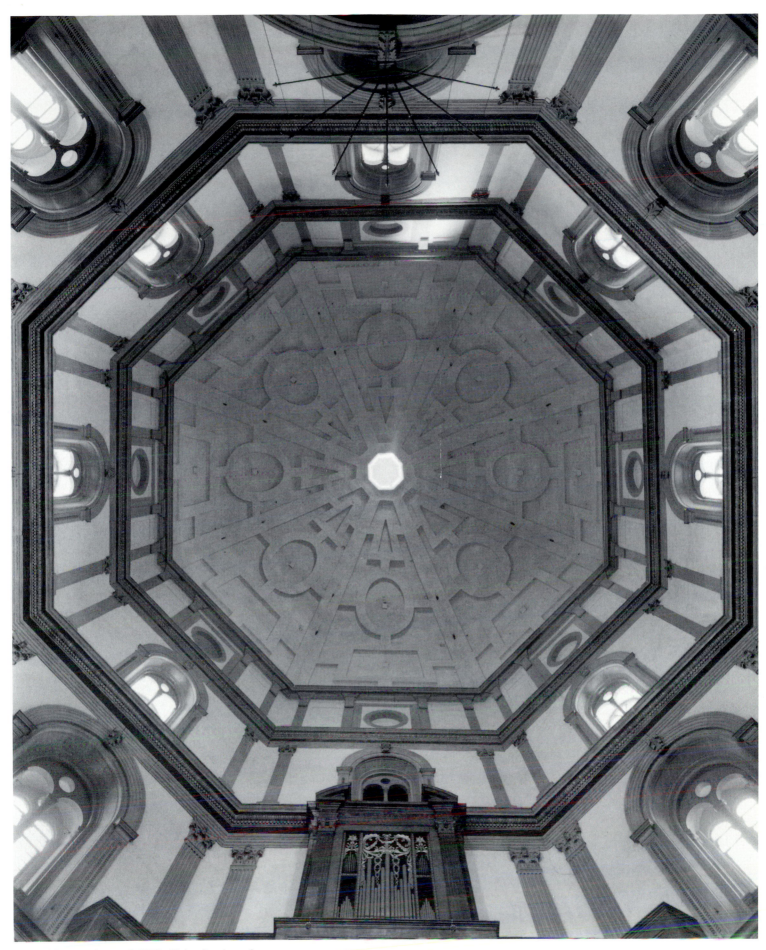

131. Madonna dell' Umilità, view into dome

132. Madonna dell Umilità, detail of radial rib

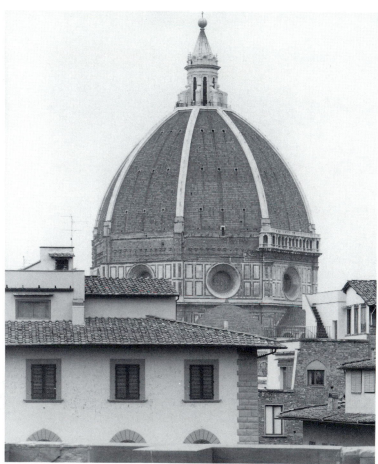

133. Florence, Cathedral, cupola by
Brunelleschi, distant view

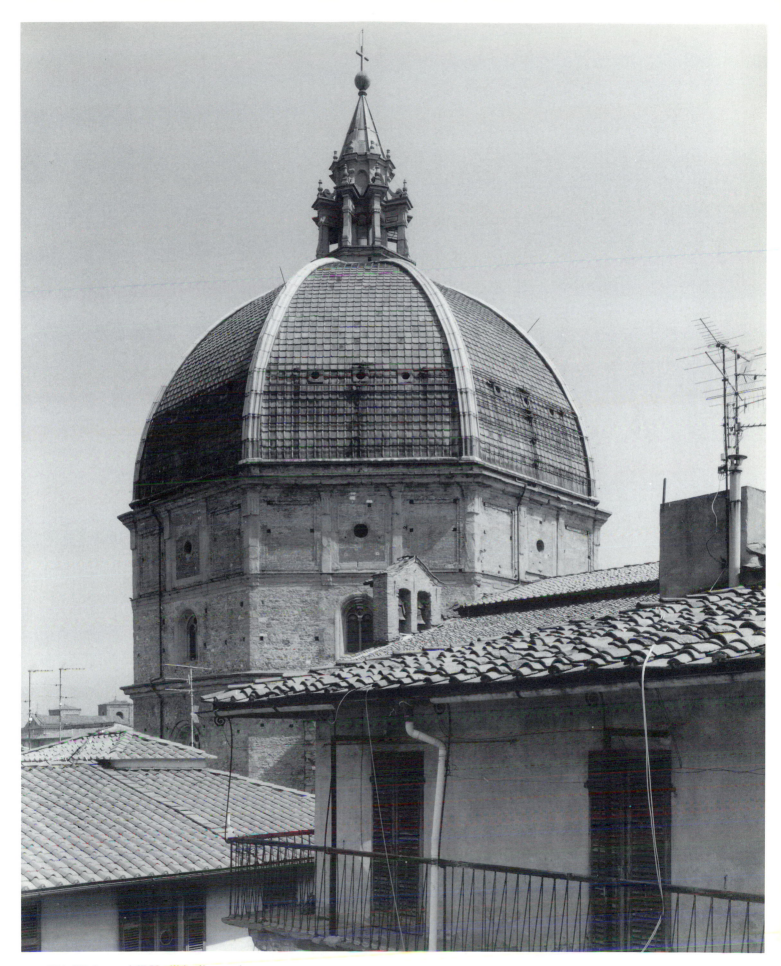

134. Madonna dell' Umilità, distant view

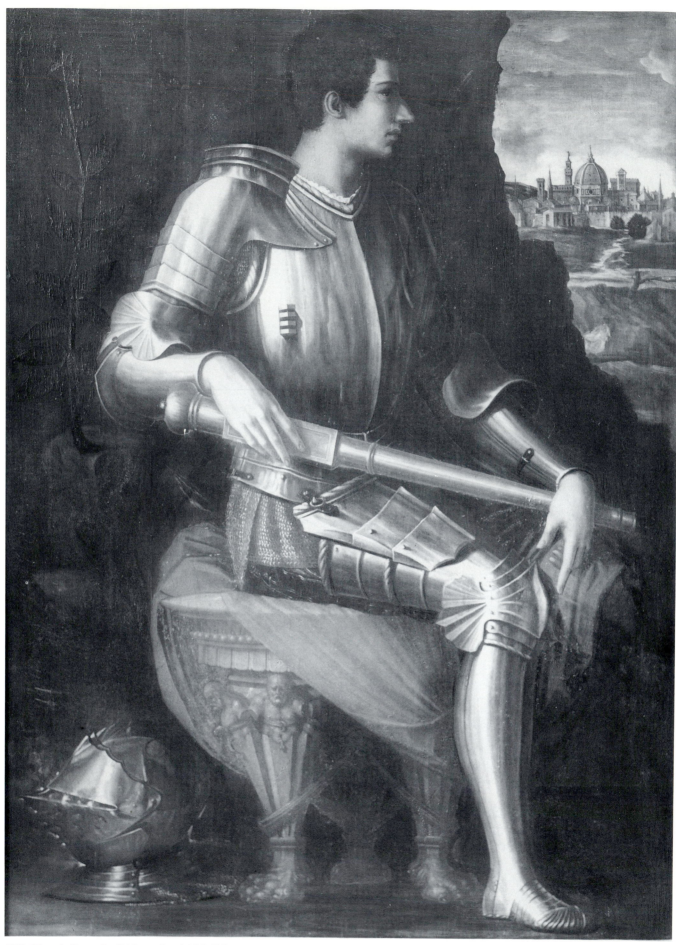

135. Vasari, *Portrait of Alessandro de' Medici*, 1534

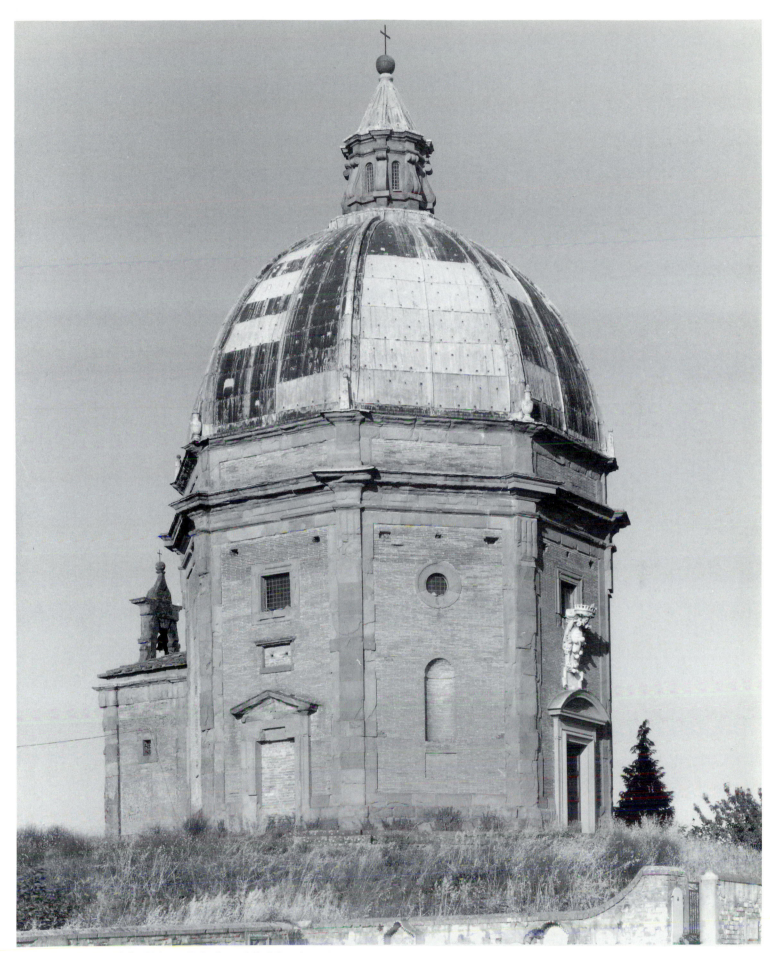

136. Foiano della Chiana, S. Stefano della Vittoria, 1569—72

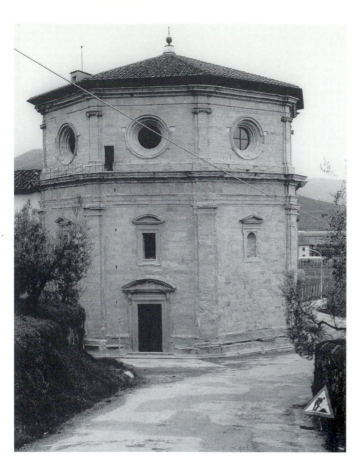

137. Castiglion Fiorentino,
Madonna della Consolazione,
begun 1565

138. Pisa, Palazzo dei Cavalieri, facade, renovated by Vasari 1561—66

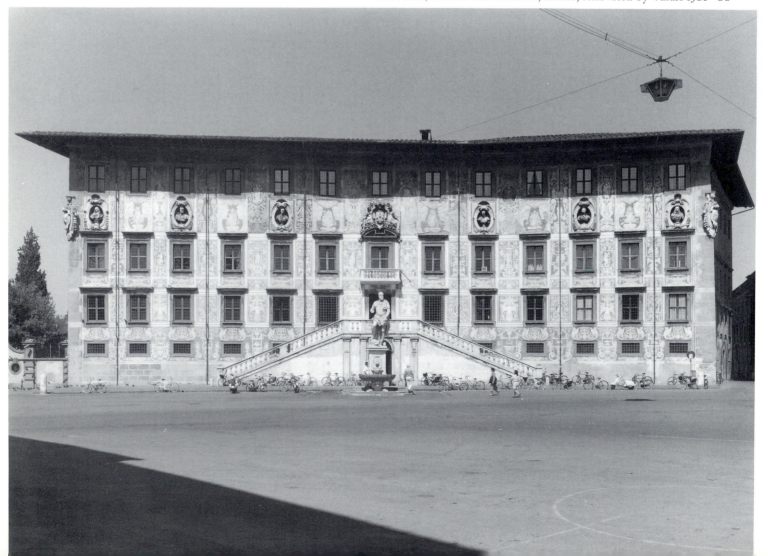

139. Pisa, Piazza dei Cavalieri, detail of facade

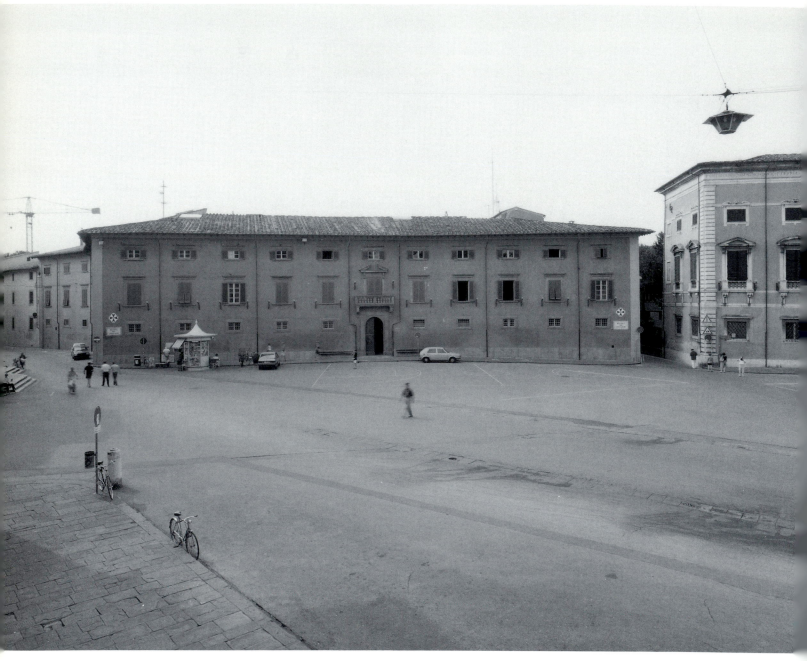

A

140. Pisa, Piazza dei Cavalieri, three views from the steps of
the Palazzo dei Cavalieri

A: South, towards the Canonica
B: West, towards the Palazzo del Consiglio dei Dodici
C: North-west, towards the Palazzo del Orologio

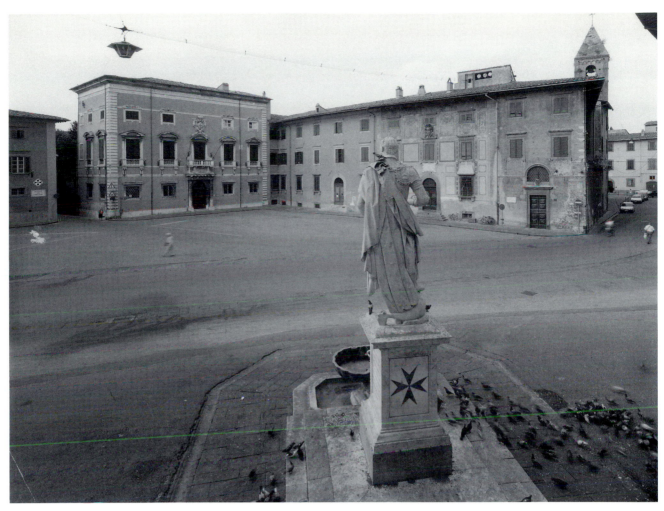

B

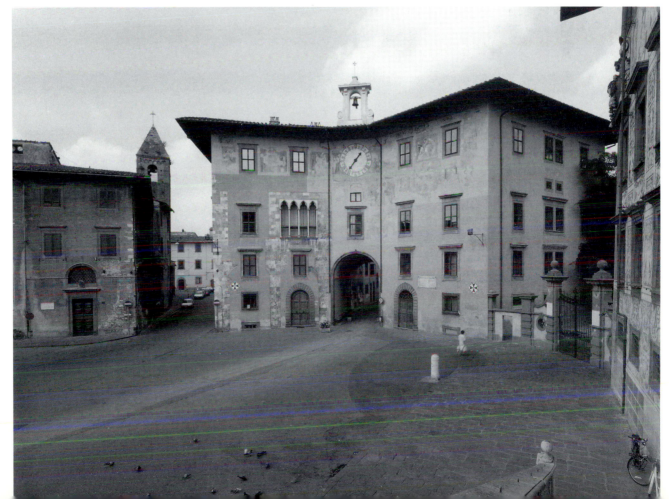

C

141. Pisa, Palazzo del Orologio, facade
prior to restoration in 1919

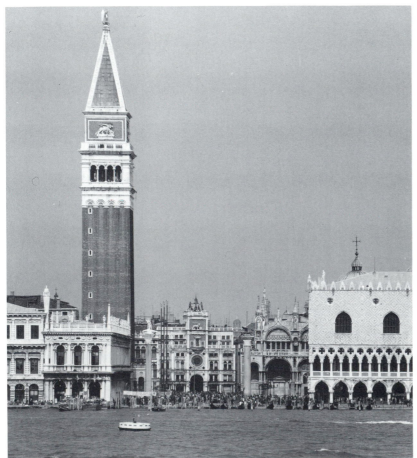

142. Venice, Piazza San Marco,
view towards Clock Tower

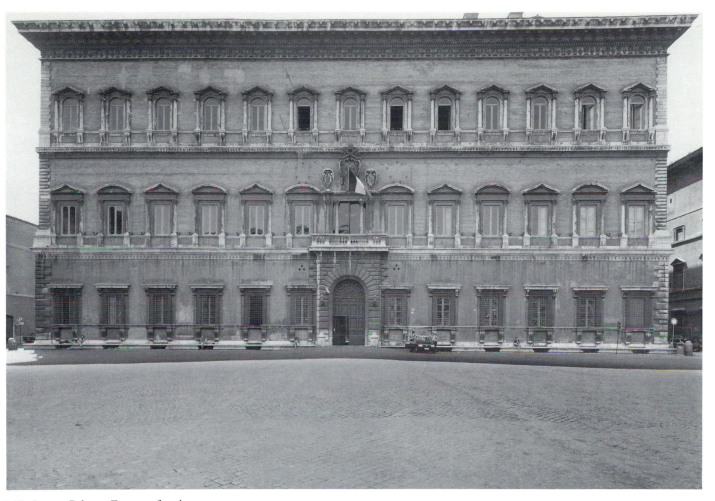

143. Rome, Palazzo Farnese, facade

144. Anon. sixteenth-century Italian, view of the Campidoglio, c. 1550

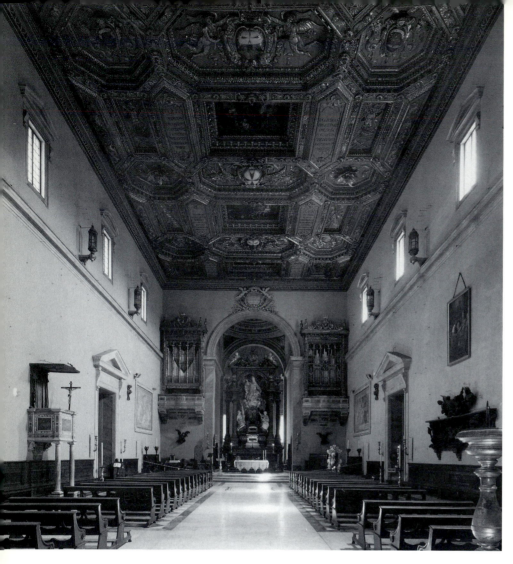

145. Pisa, Chiesa dei Cavalieri by Vasari, 1565–67, interior

146. Pisa, Chiesa dei Cavalieri, drawing from Vasari's workshop with details and plan of church

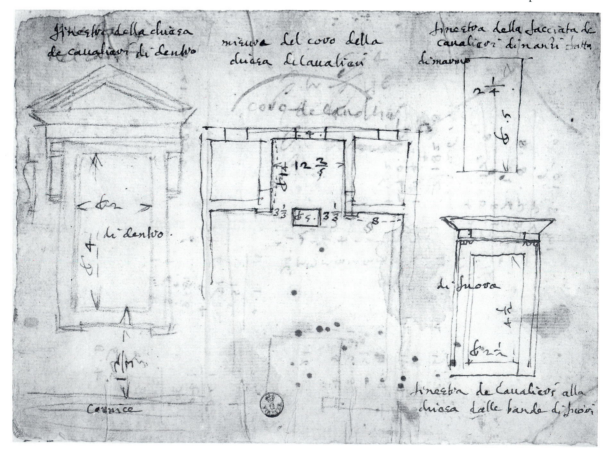

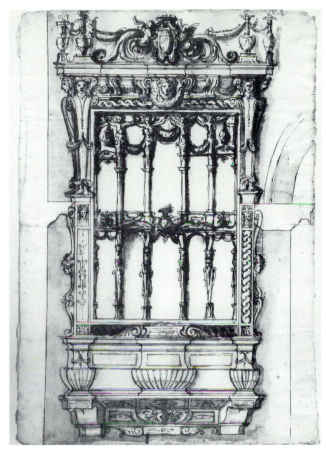

147. Pisa, Chiesa dei Cavalieri,
design for the organ loft by Vasari

148. Piazza dei Cavalieri, drawing showing Palazzo del
Orologio, Palazzo dei Cavalieri, and the Chiesa dei Cavalieri
prior to 1596

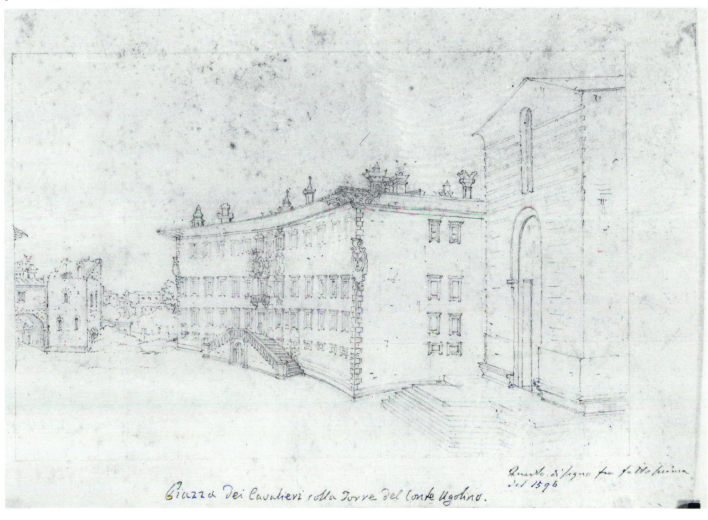

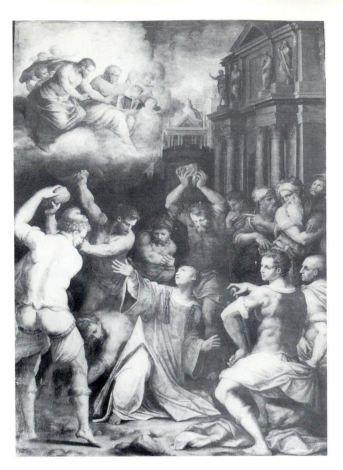

149. G. Vasari, *Martyrdom of St. Stephen*, 1571

150. Pisa, Chiesa dei Cavalieri,
facade by Don Giovanni dei Medici, 1593

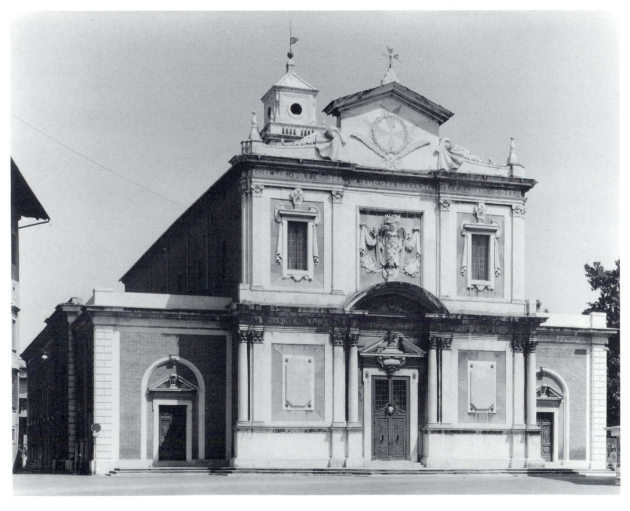

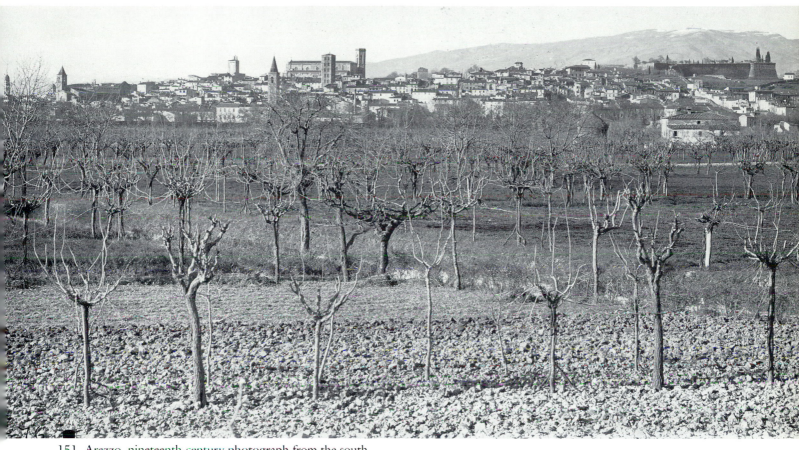

151. Arezzo, nineteenth-century photograph from the south

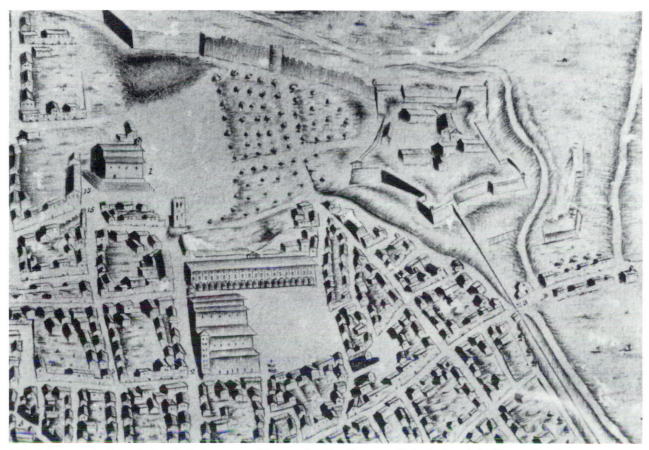

152. Marcantonio Betacci, detail of 1642 map of Arezzo showing Fortress, Cathedral, and the Piazza Grande

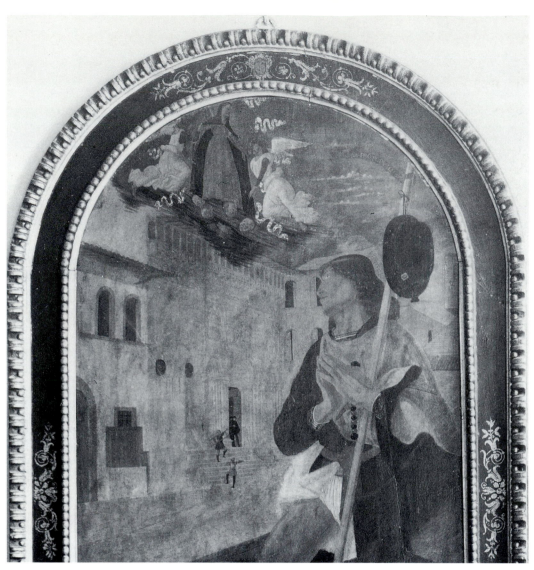

153. Bartolomeo della Gatta, *San Rocco*, 1478, detail

154. Arezzo, Palazzo della Misericordia,
detail of belfry by Vasari, 1548

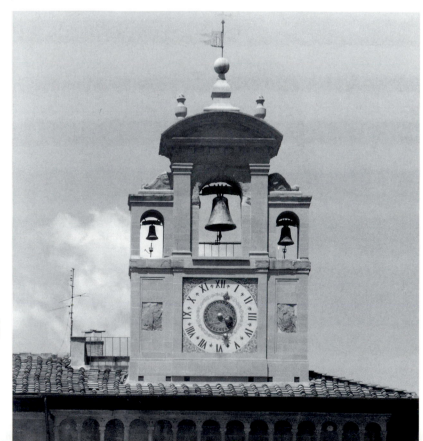

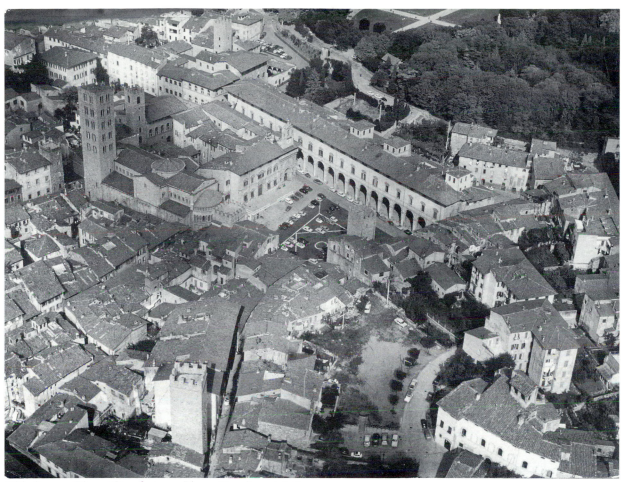

155. Arezzo, Piazza Grande (now Piazza Vasari), aerial view

156. Arezzo, Loggia, facade on Piazza Grande

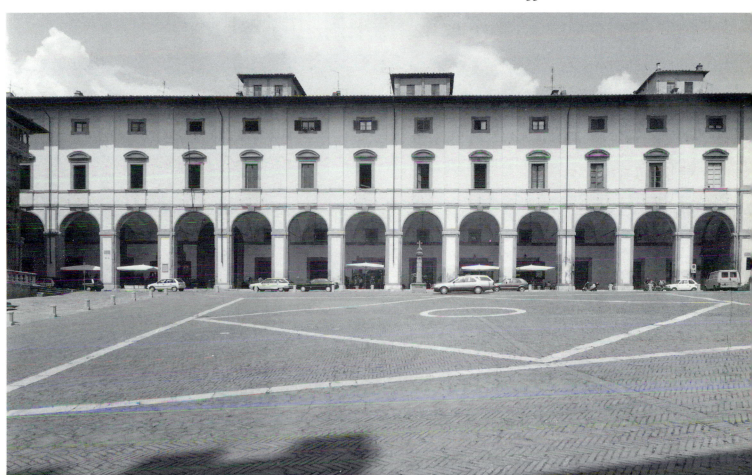

157. Arezzo, Loggia, details of stairway

A: From Piazza Grande
B: From upper level

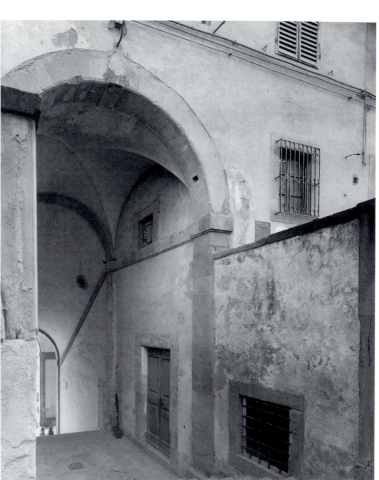

A

B

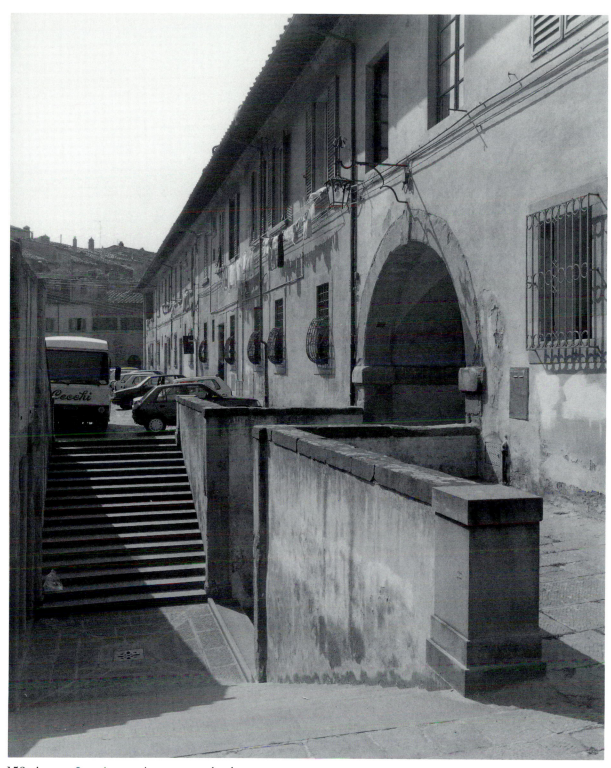

158. Arezzo, Loggia, exterior on upper level

159. Arezzo, Palazzo della Misericordia, facade, lower part fourteenth-century, upper by Bernardo Rosselino, 1433

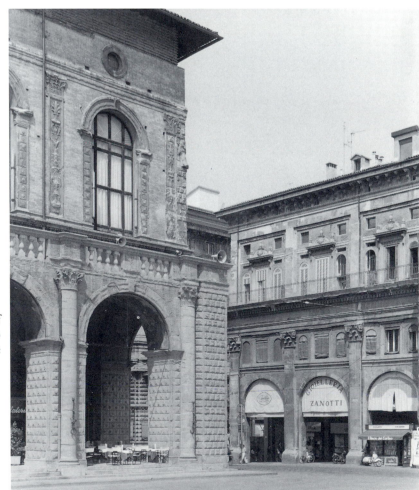

160. Bologna, view of Palazzo del Podesta (left) and Portico dei Banchi (right) from Piazza Maggiore

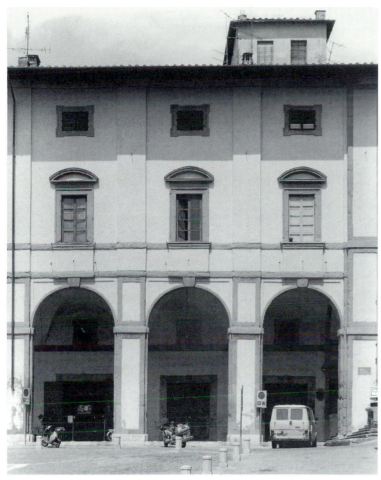

A

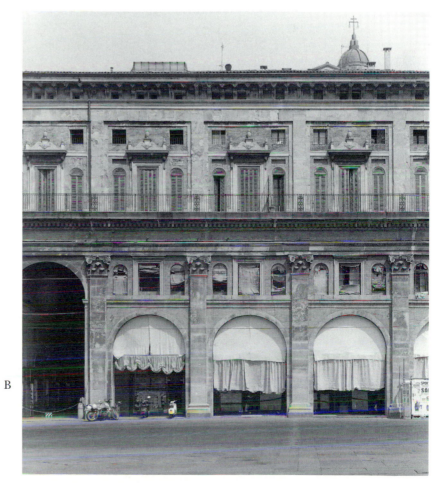

B

161. Comparison of facades

A: Arezzo, Loggia, detail
B: Bologna, Portico dei Banchi
by Vignola, begun 1565–68

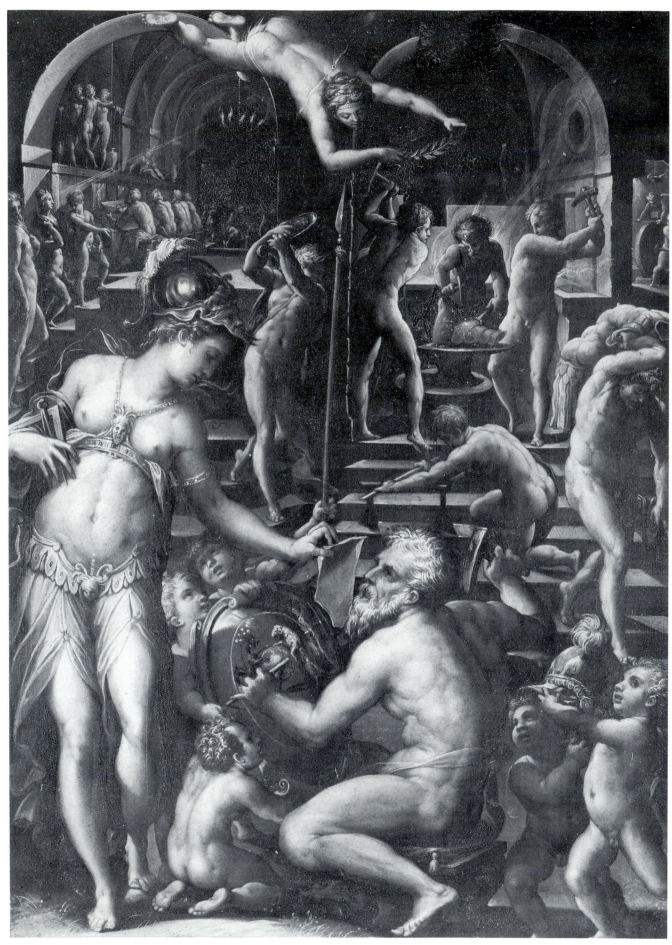

162. G. Vasari, *Forge of Vulcan*, 1565–70

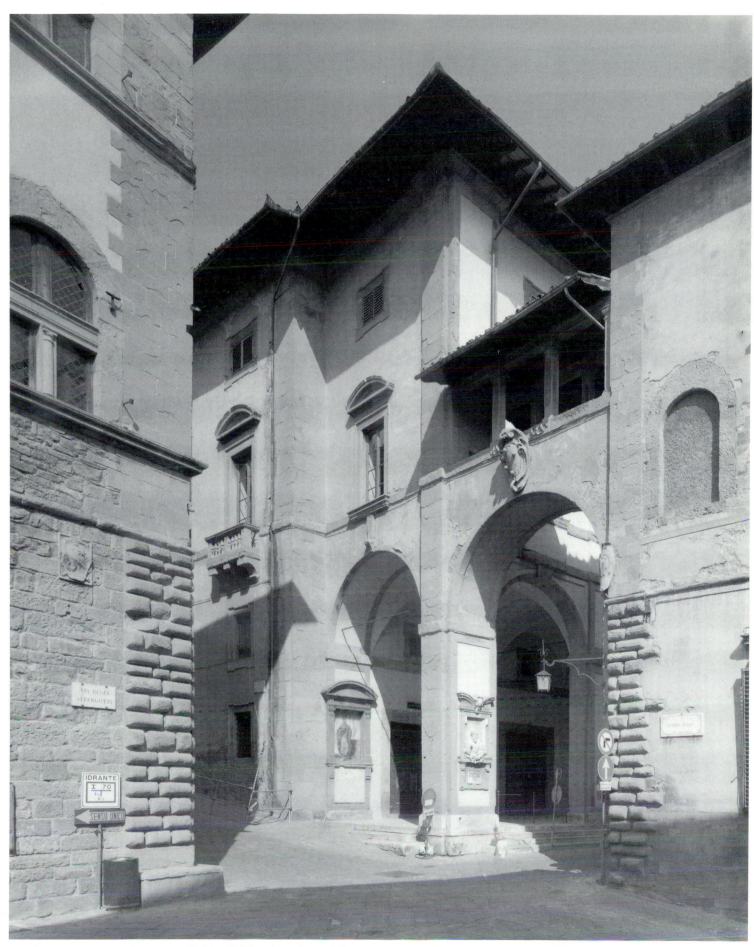

163. Arezzo, Loggia, detail of bridge linking the Palazzo della
Miscricordia with the Loggia

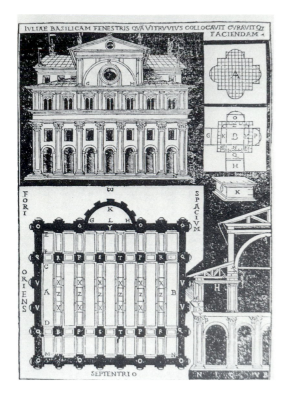

164. Cesariano, reconstruction of
Vitruvius's Basilica at Fano

165. Padua, Monte di Pietà by Falconetto, 1530

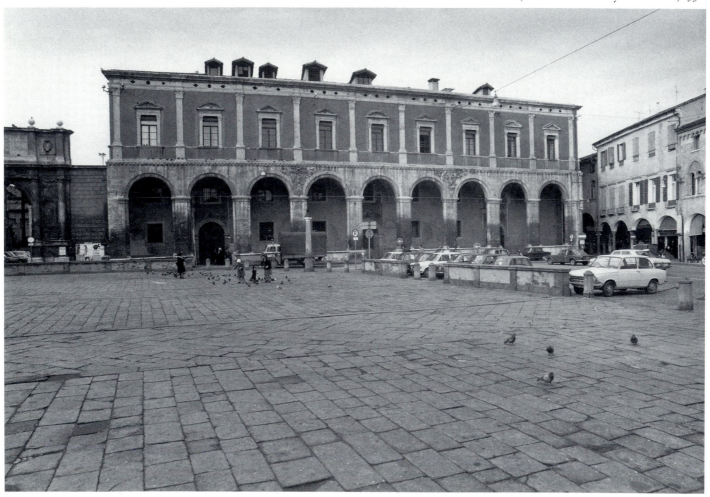

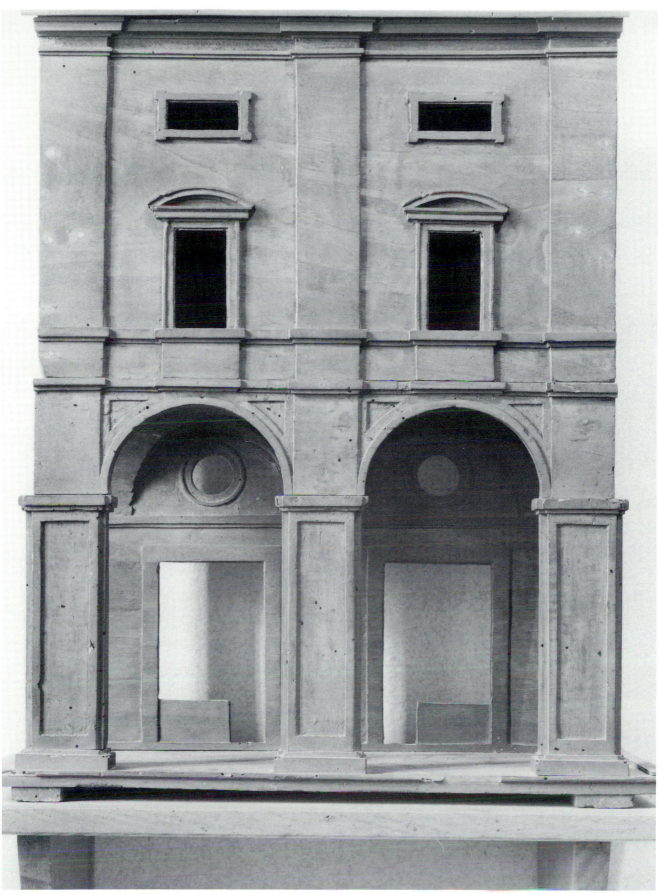

166. Loggia, wooden model, 1572

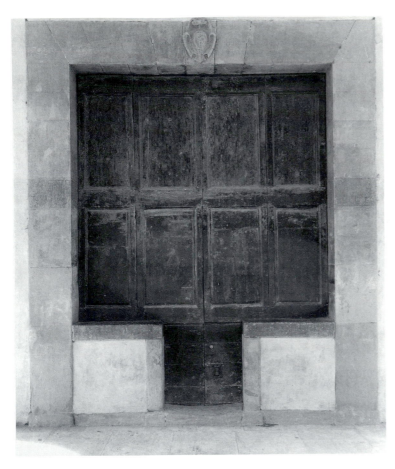

167. Loggia, detail of a shop exterior

168. Florence, Servite Loggia,
Antonio da Sangallo the Elder, begun 1516

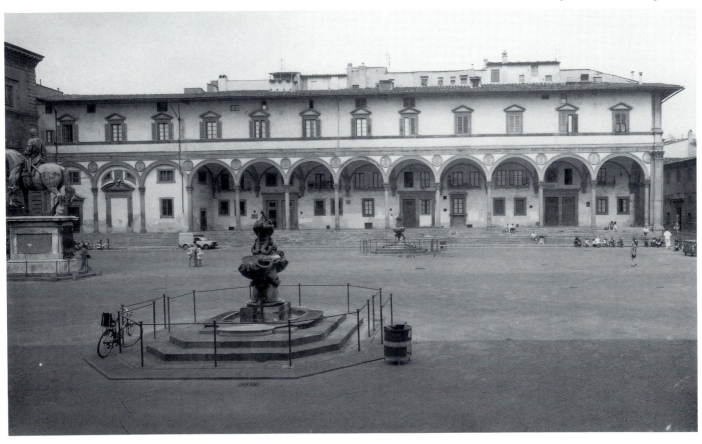

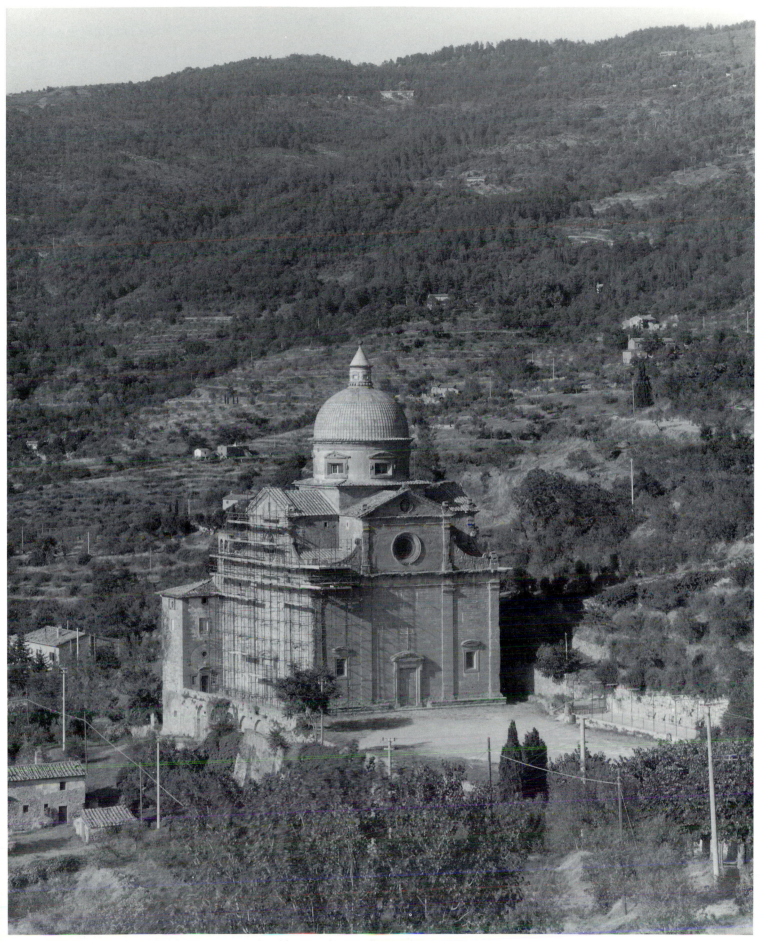

169. Cortona, Santa Maria Nuova, completed by Vasari, 1554, distant view

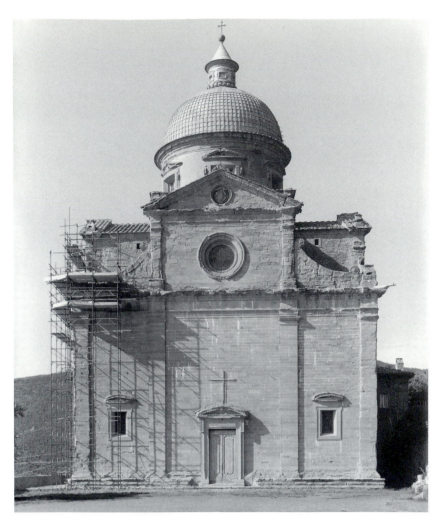

170. Cortona, Santa Maria Nuova, facade

171. Cortona, Santa Maria Nuova, interior

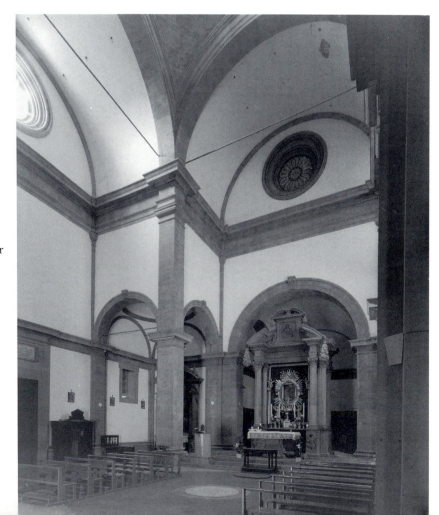

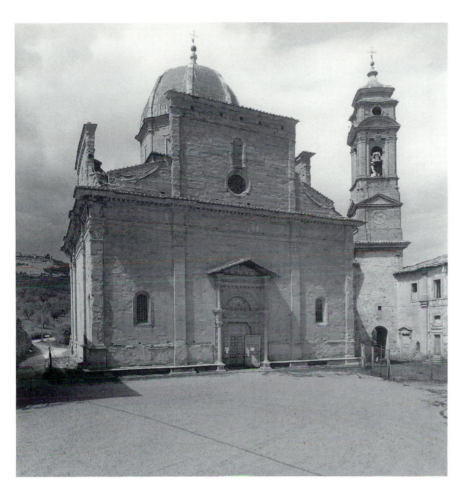

172. Mongiovino, sanctuary church
by Rocco da Vicenza, begun 1526

173. Mongiovino, sanctuary church,
interior

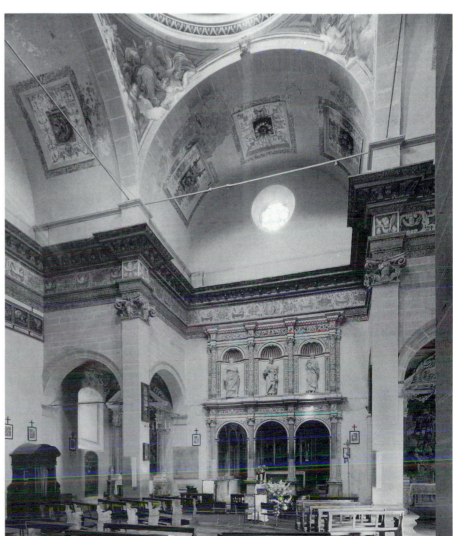

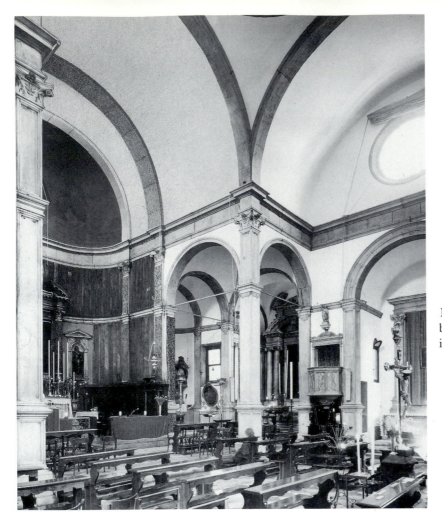

174. Venice, San Giovanni Crisostomo
by Mauro Codussi, begun 1497,
interior with reconstruction of choir vault

175. Arezzo, Pieve, interior after
renovation begun in 1865

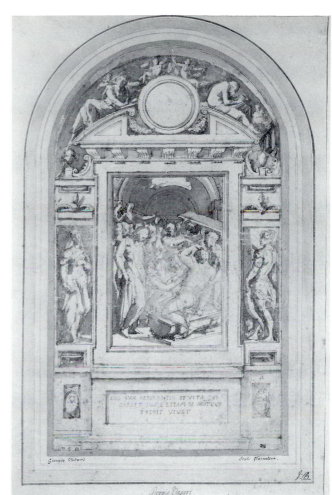

176. Pieve, preparatory drawing
for the Vasari Chapel, c. 1559

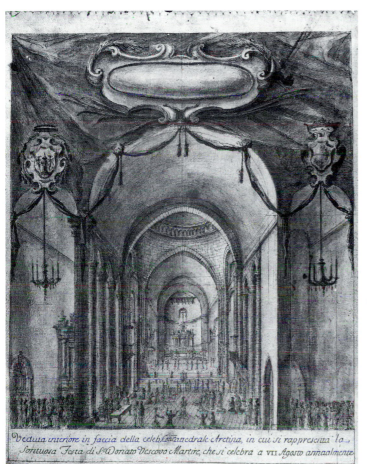

177. Pieve, eighteenth-century drawing
of interior by Vincenzo Meucci

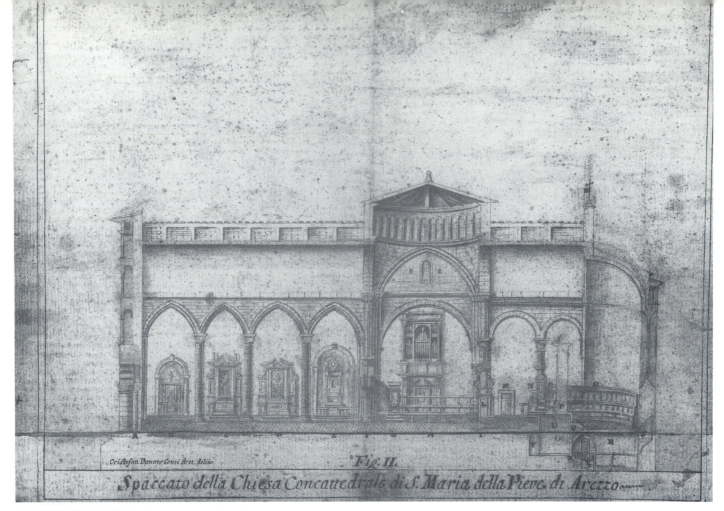

Fig. II.

Spaccato della Chiesa Concattedrale di S. Maria della Pieve di Arezzo

178. Pieve, eighteenth-century section drawn
by Cristofano Donato Conti

179. Pieve, Vasari altar, completed 1564,
now in the Badia of Saints Flora and Lucilla

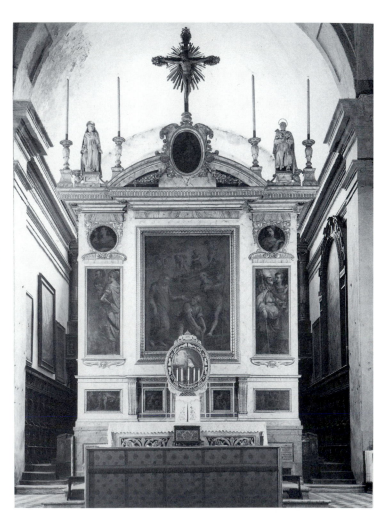

180. Bologna, Santa Maria dei Servi, high altar by Fra
Giovanni Montorsoli, 1558—61, view from choir

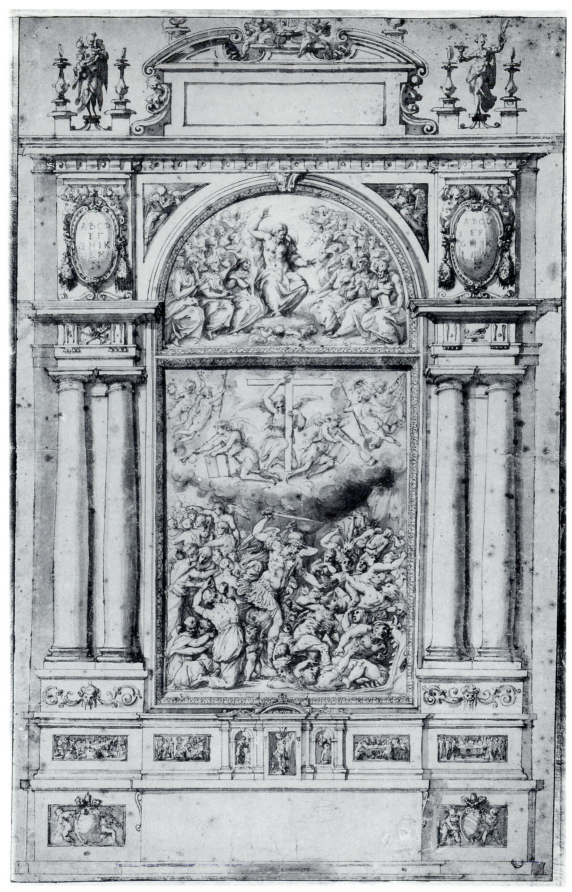

181. Bosco Marengo, Santa Croce, drawing for high altar by Vasari, 1567–69

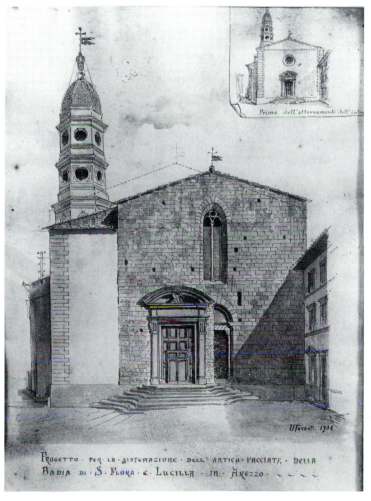

182. Arezzo, Badia of Saints Flora and Lucilla,
renovation by Vasari begun 1565

A: Exterior at the end of the nineteenth century
B: Project by Ugo Tavanti for restoration of
 facade, 1908

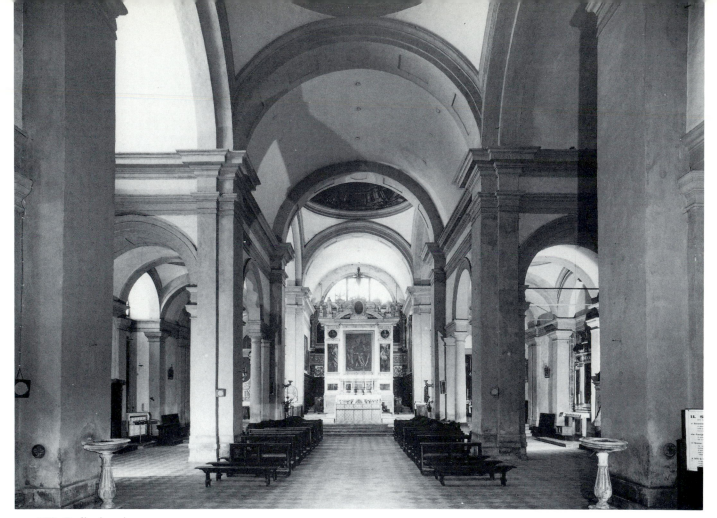

183. Badia, interior

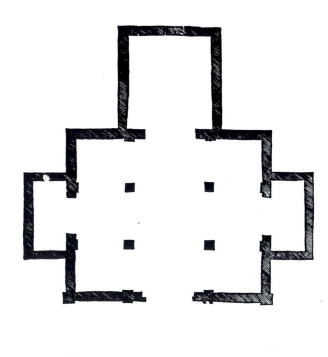

184. *Templum Etruscum* from Cosimo Bartoli's translation of Alberti, *De re aedificatoria*, 1550

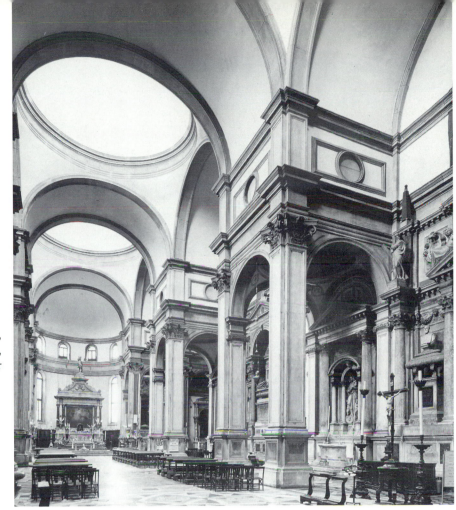

185. Venice,
San Salvatore by Spavento,
begun 1506, interior

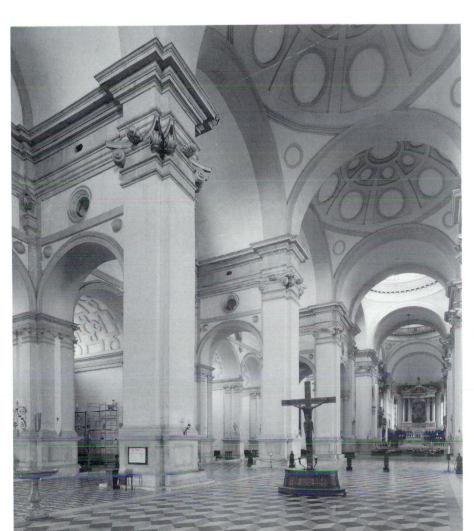

186. Santa Giustina, interior

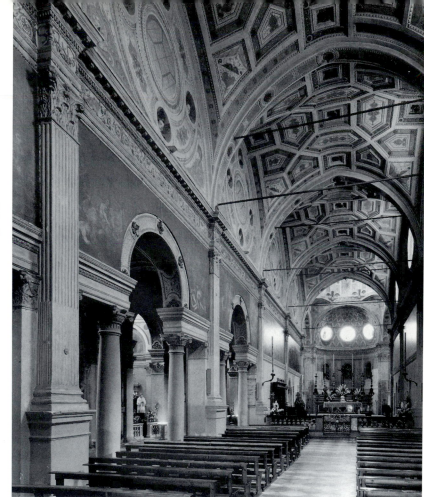

187. Polirone (near Mantua),
San Benedetto al Po, renovations by
Giulio Romano begun 1540

188. San Benedetto al Po,
detail of Serliana in nave

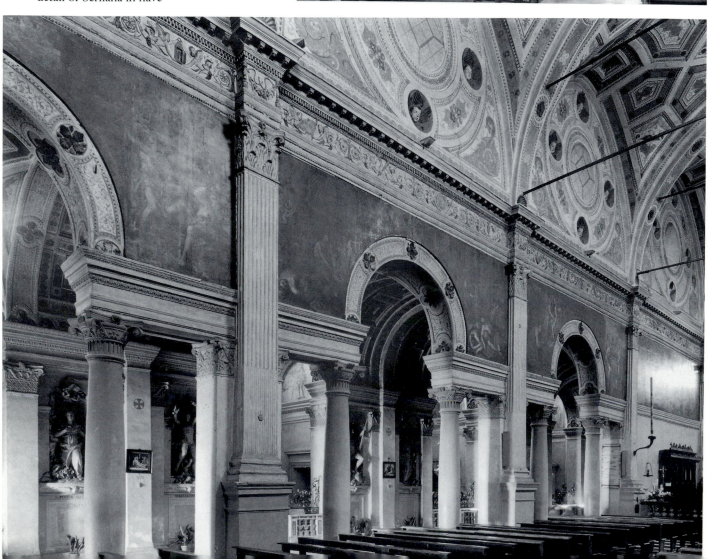

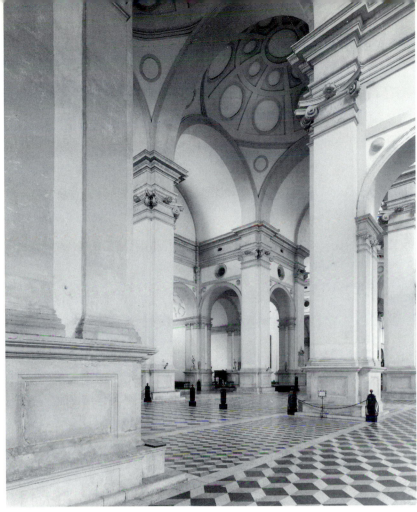

189. Santa Giustina,
detail of nave near crossing

190. Badia, detail of nave

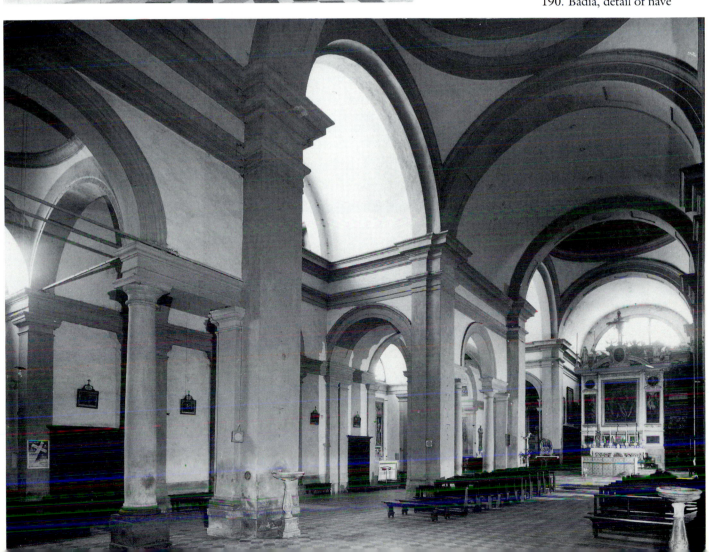

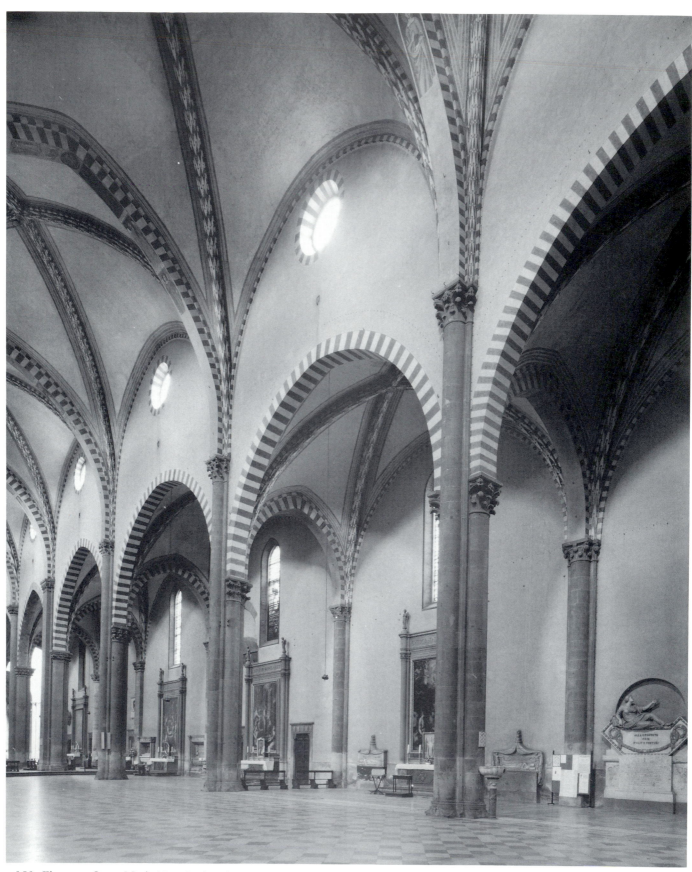

191. Florence, Santa Maria Novella, interior

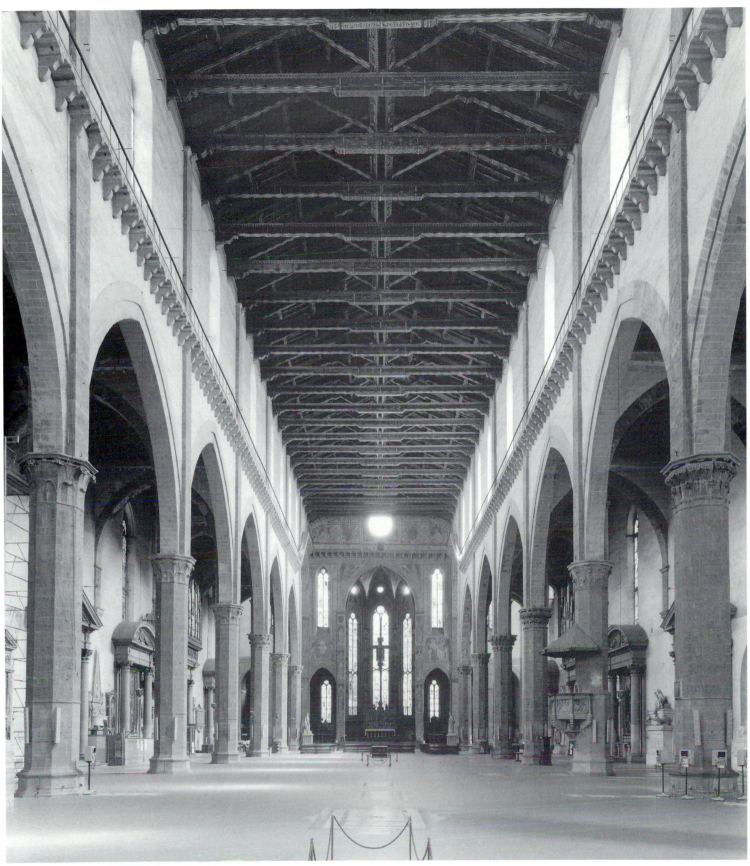

192. Florence, Santa Croce, interior

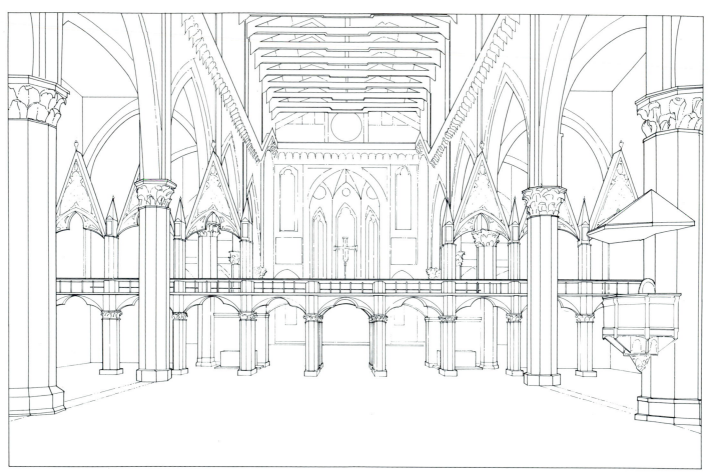

193. Santa Croce, reconstruction of nave with *tramezzo*

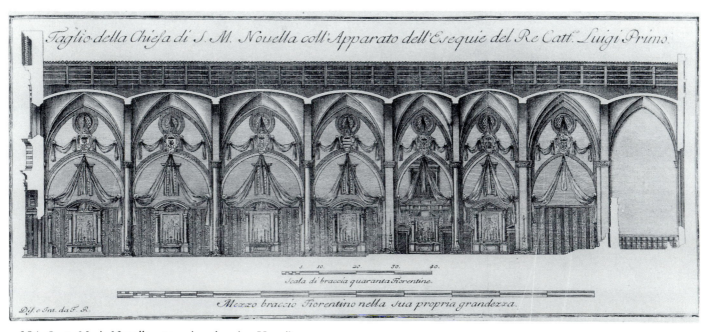

194. Santa Maria Novella, engraving showing Vasari's
(destroyed) tabernacles in 1724 for the funeral of King Louis I of Spain

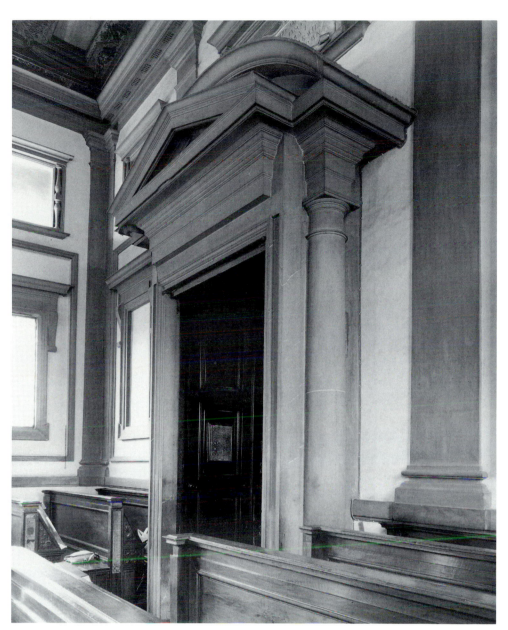

195. Florence, San Lorenzo, Laurentian Library by
Michelangelo, detail of doorway

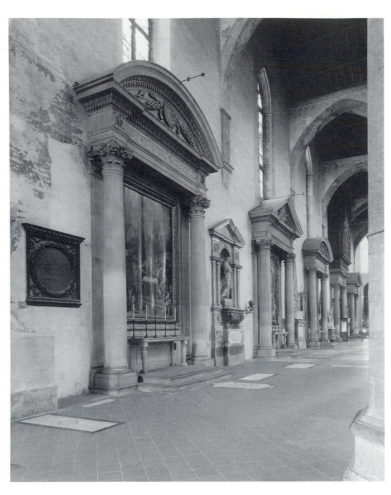

196. Santa Croce, details of altars in left and right aisles

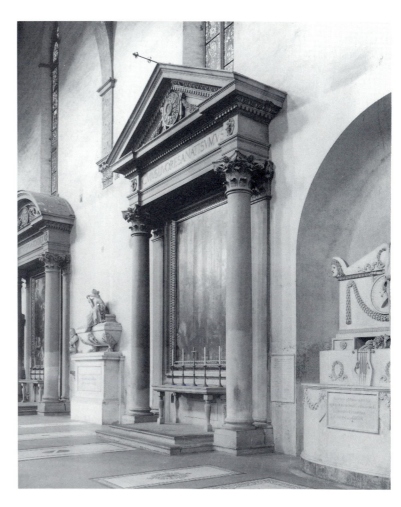

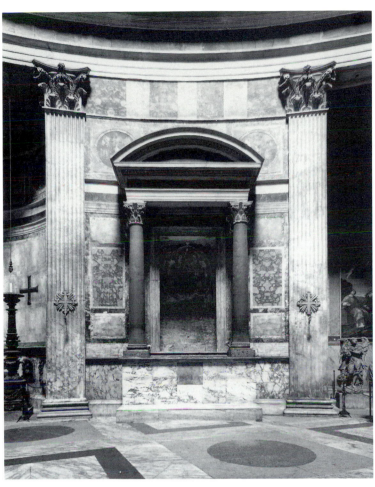

197. Rome, Pantheon, details of aedicular tabernacles

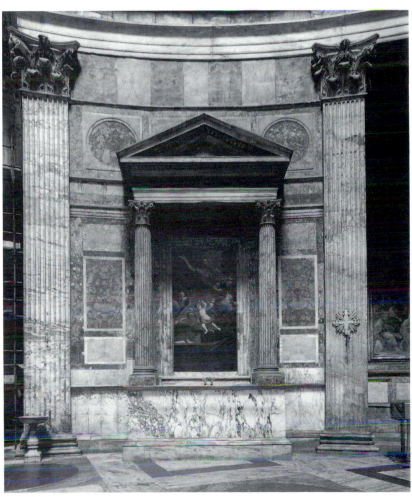

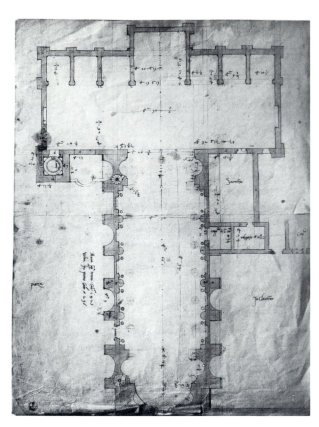

198. Siena, San Domenico, project by B. Peruzzi for the reconstruction of the nave

199. Arezzo, San Francesco, interior

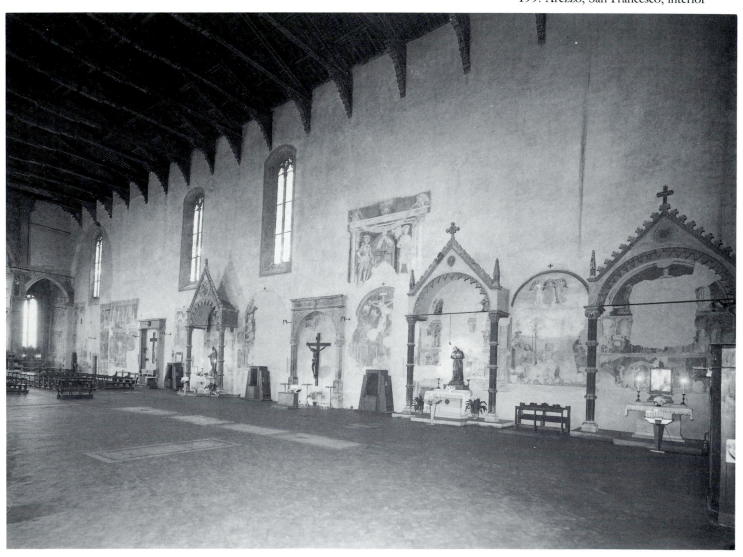

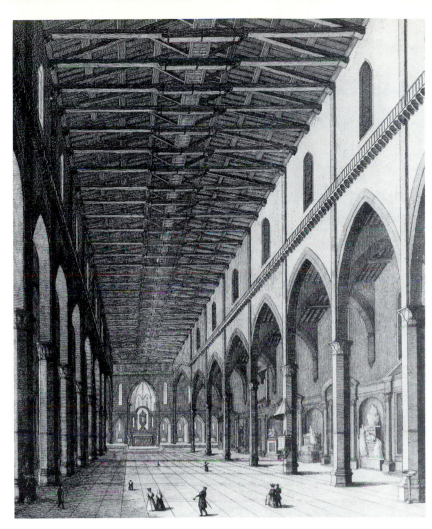

200. Santa Croce, nineteenth-century
engraving of nave

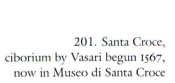

201. Santa Croce,
ciborium by Vasari begun 1567,
now in Museo di Santa Croce

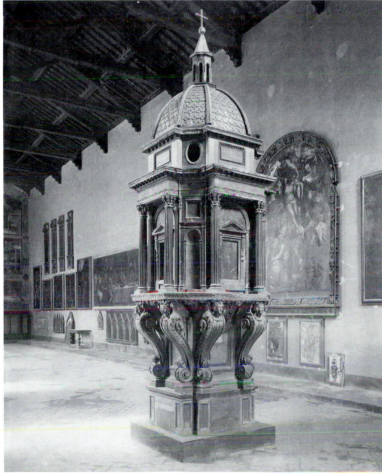

202. Rome, temporary archway for entry adjacent to Palazzo Venezia, 1536, detail of a drawing by Antonio da Sangallo the Younger

203. Florence, view along Via Mazzetta

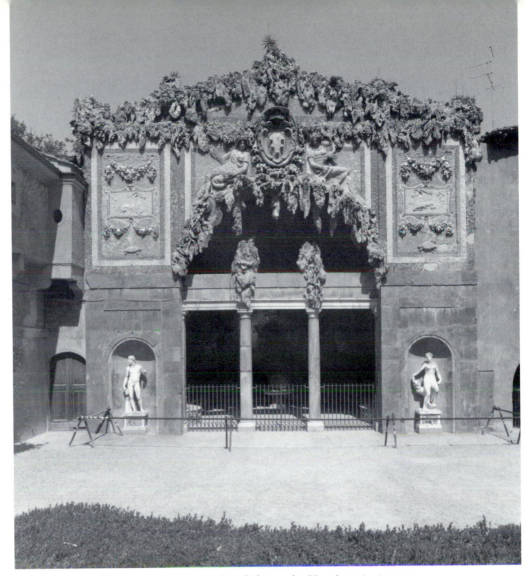

204. Florence, Boboli Gardens, Grotta Grande begun by Vasari, 1556–60

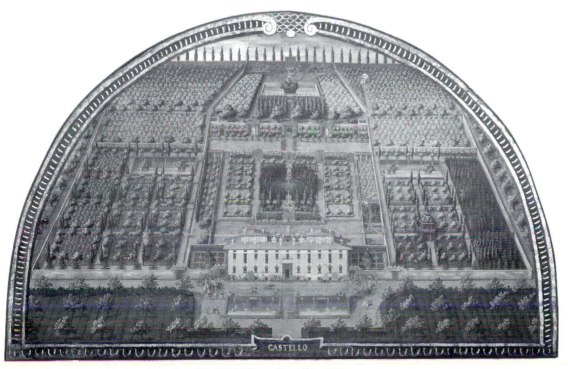

205. Giusto Utens, lunette depicting Medici Villa at Castello, 1599

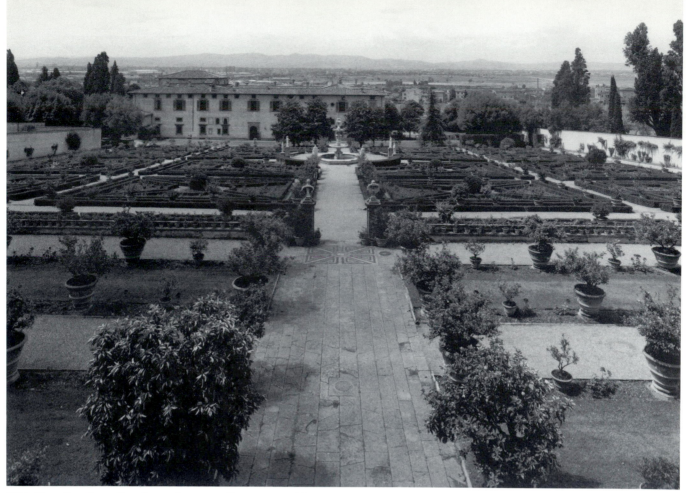

206. Castello, view of garden and surrounding countryside towards the south

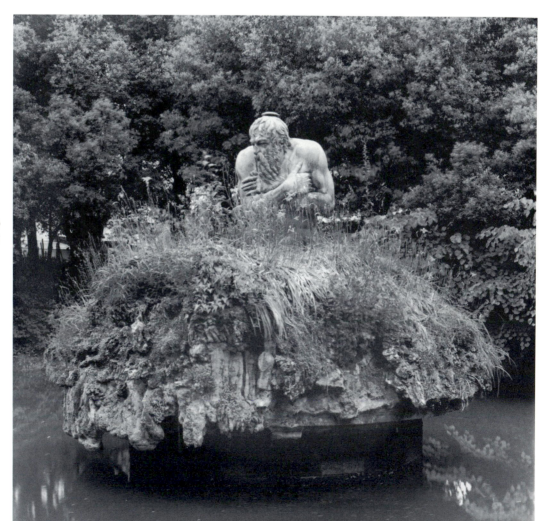

207. Castello, Appennino
by Ammannati, 1563—65

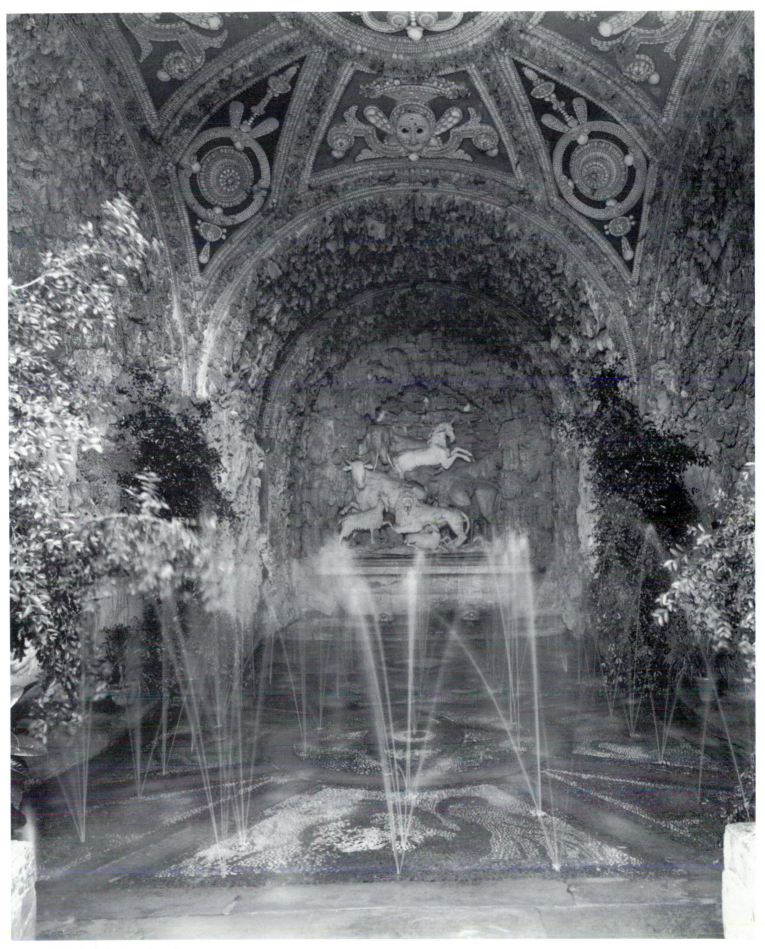

208. Castello, interior of grotto

Michael Angelo allievo.

209. Castello, drawing for grotto by Tribolo

210. Triumphal entry of Johanna of Austria, archway at Canto alla Paglia

 A: View of site
 B: Plan and elevation of archway by Vincenzo Borghini

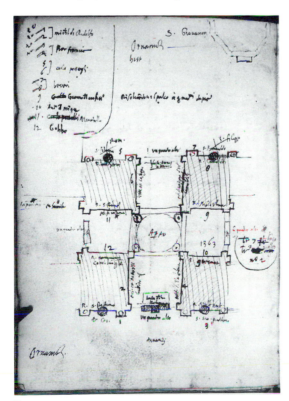
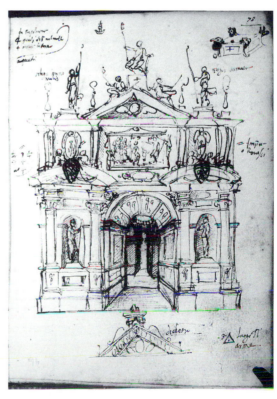

B

A

211. Triumphal entry of Johanna of Austria, archway in Via dei Gondi

 A: site
 B: drawing of archway by Vincenzo Borghini

B

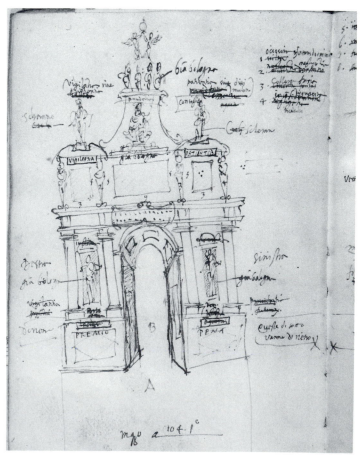

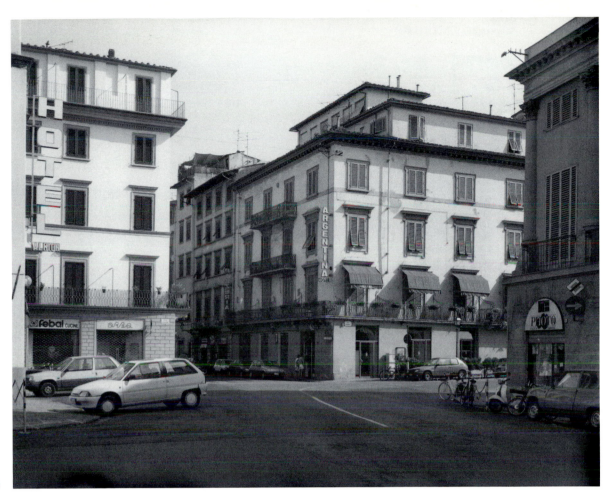

A

B

212. Florence, triumphal entry of Johanna of Austria, rejected design for archway at entrance to the Borgo Ognissanti

 A: Site
 B: Drawing of archway by Vasari

213. Triumphal entry of Johanna of Austria, archway in
Via dei Tornabuoni

A: Site
B: Drawing of archway by Borghini
(In Vasari's time the northern stretch of
the street was considerably narrower)

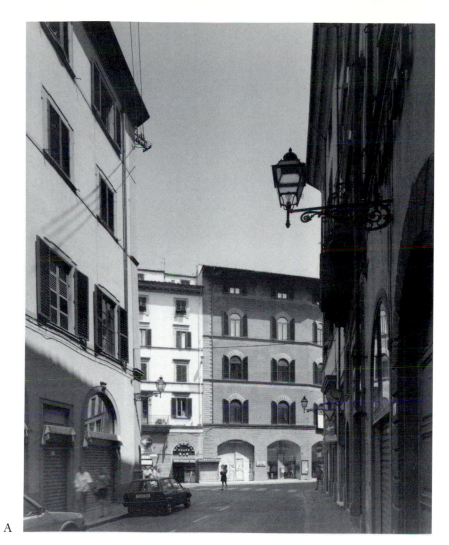

A

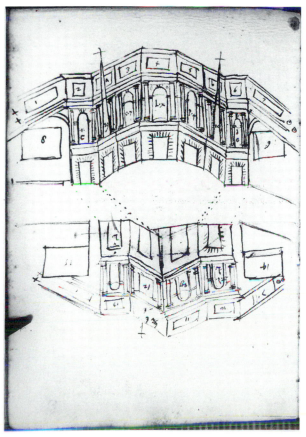

B

214. Triumphal entry of Johanna of Austria, amphitheater at Canto dei Carnesecchi

A: Site
B: Drawing of amphitheater by Borghini

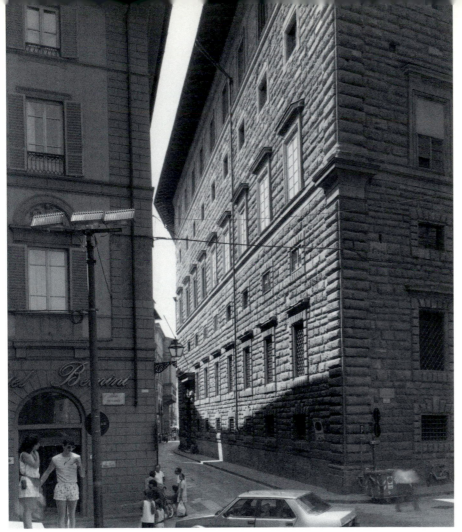

A

215. Triumphal entry of Johanna of Austria, archway
in Via dei Leoni

 A: Site
 B: Drawing of archway by Borghini

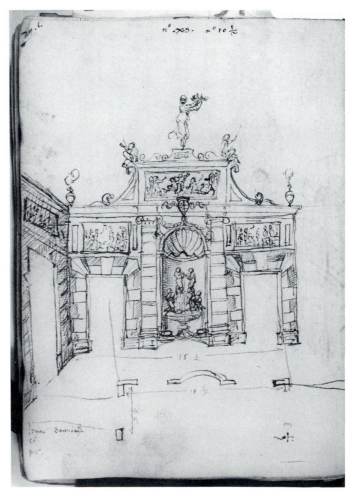

B

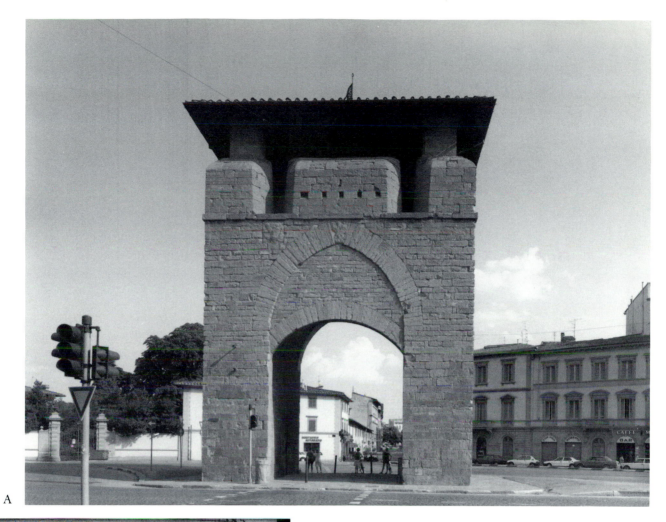

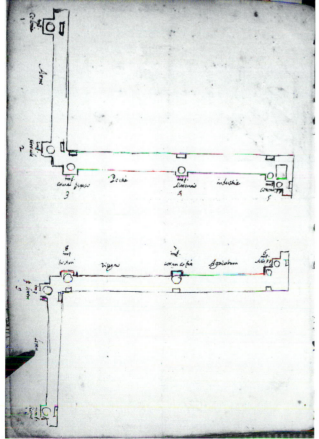

216. Triumphal entry of Johanna of Austria, construction at Porta al Prato

 A: Site
 B: Plan of construction by Borghini

A

B

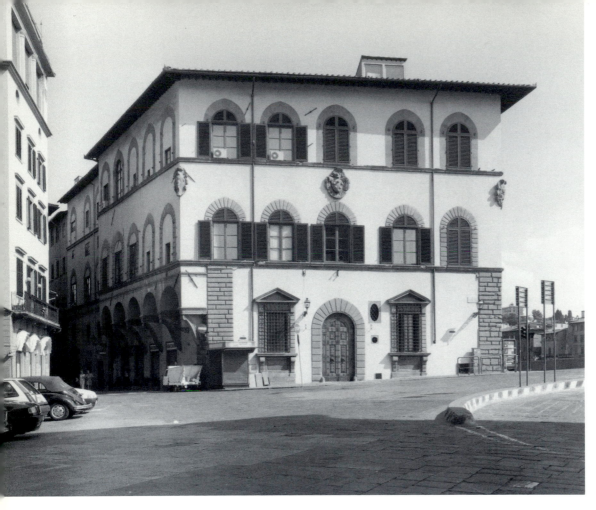

A

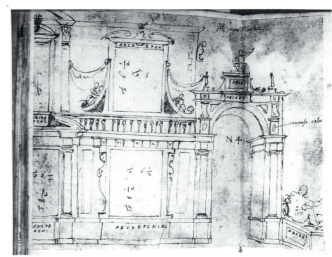

B

217. Triumphal entry of Johanna of Austria, temporary facade on the Palazzo Ricasoli

A: Exterior of Palazzo Ricasoli
B: Alternative proposal, drawing by Borghini
C: Alternative proposal, drawing by Vasari (attr.)

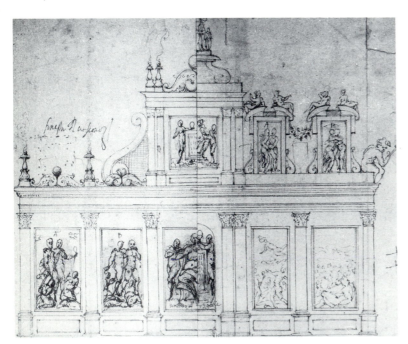

C

218. Serlio, renovation
of a palace exterior

219. Triumphal entry of Johanna of Austria,
screen wall at Ponte Santa Trinita

A: Site
B: Drawing of wall by Borghini

A

B

220. Triumphal entry of Johanna of Austria,
main entry to Palazzo Vecchio,
drawing by Borghini

221. St. Paul, Minn., triumphal arch erected at Sixth and
Wabasha Streets for the return of the 151st Field Artillery on 18 May 1919

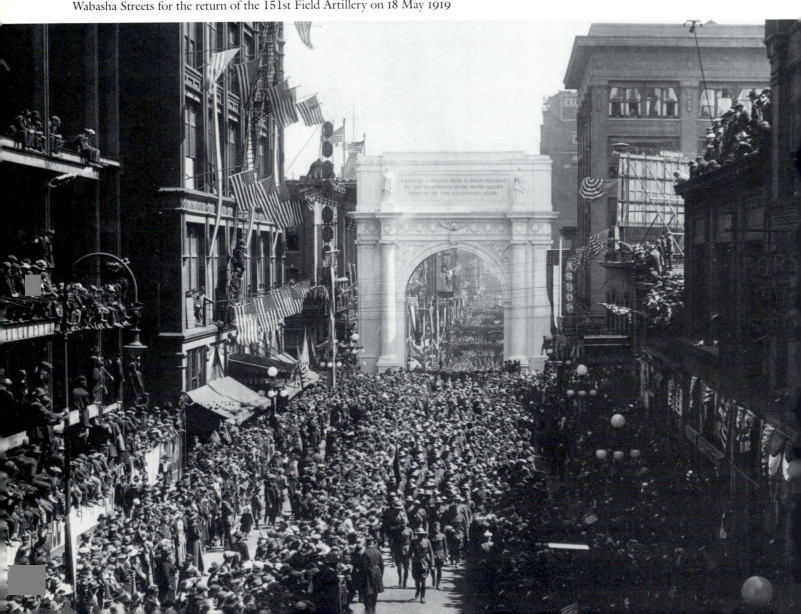

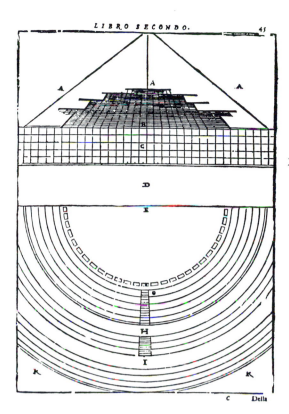

222. Serlio, plan of a theater

223. Triumphal entry of Johanna of Austria, theater
built in the Salone dei Cinquecento, view of model

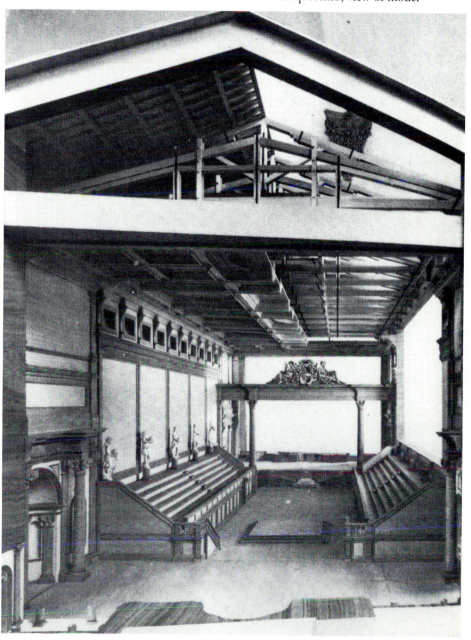

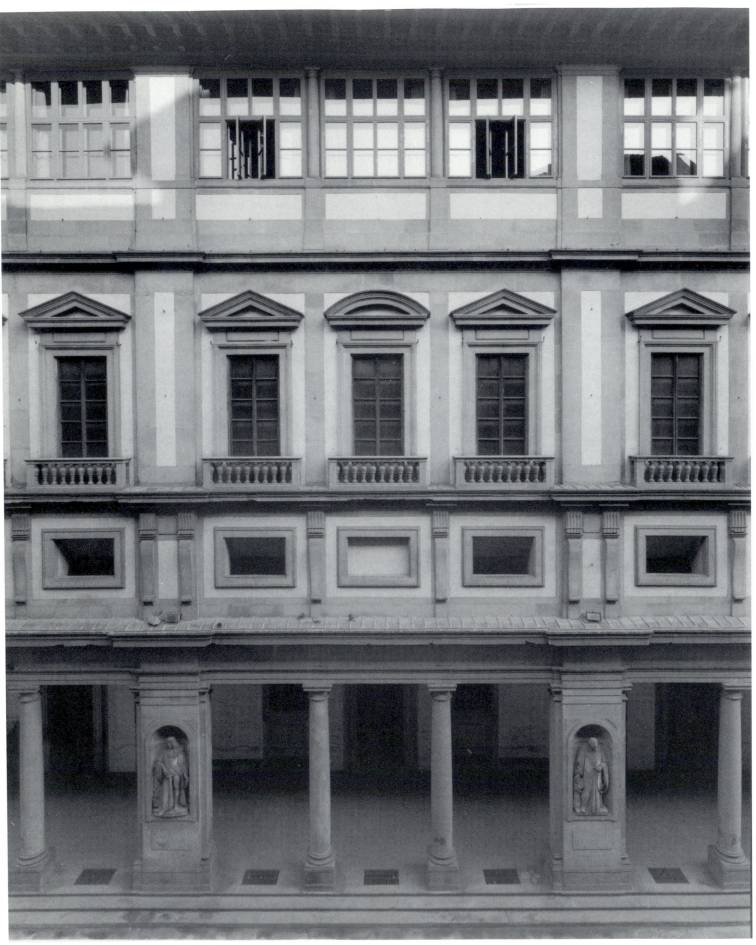

224. Uffizi, detail of facade unit

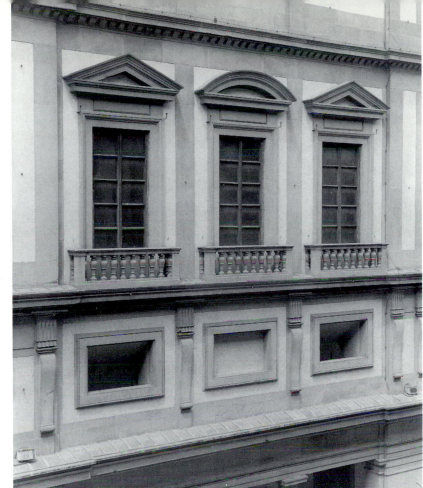

225. Uffizi, detail of
windows on main level

226. Florence, Palazzo Pandolfini by
Raphael and others, begun c. 1518,
detail of facade

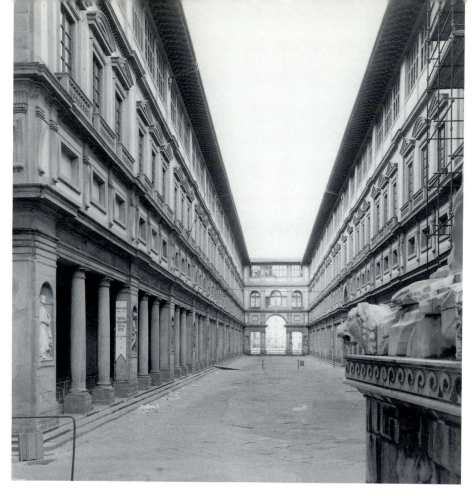

227. Uffizi, view from main entry to Palazzo Vecchio

228. Uffizi, view from ground level

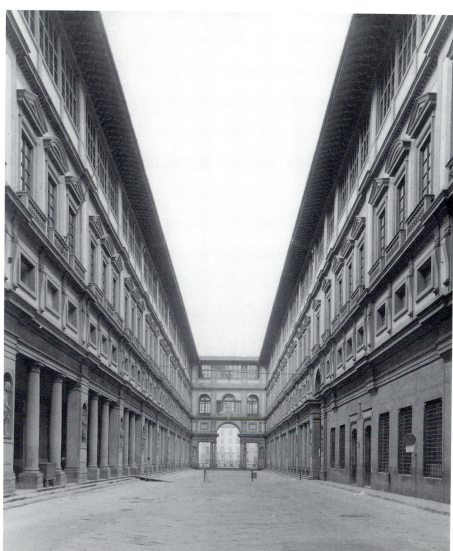

229. Serlio, Tragic Scene

230. Florence, Porta Romana, view from end of Via dei Serragli

231. Serlio, facade for a Venetian palace

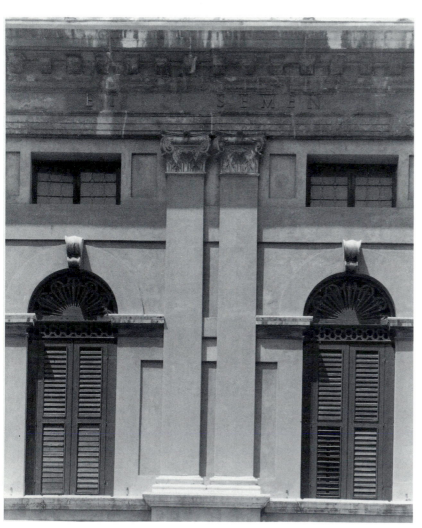

232. Verona, Palazzo Canossa by
Sanmicheli, begun c. 1532, detail of facade

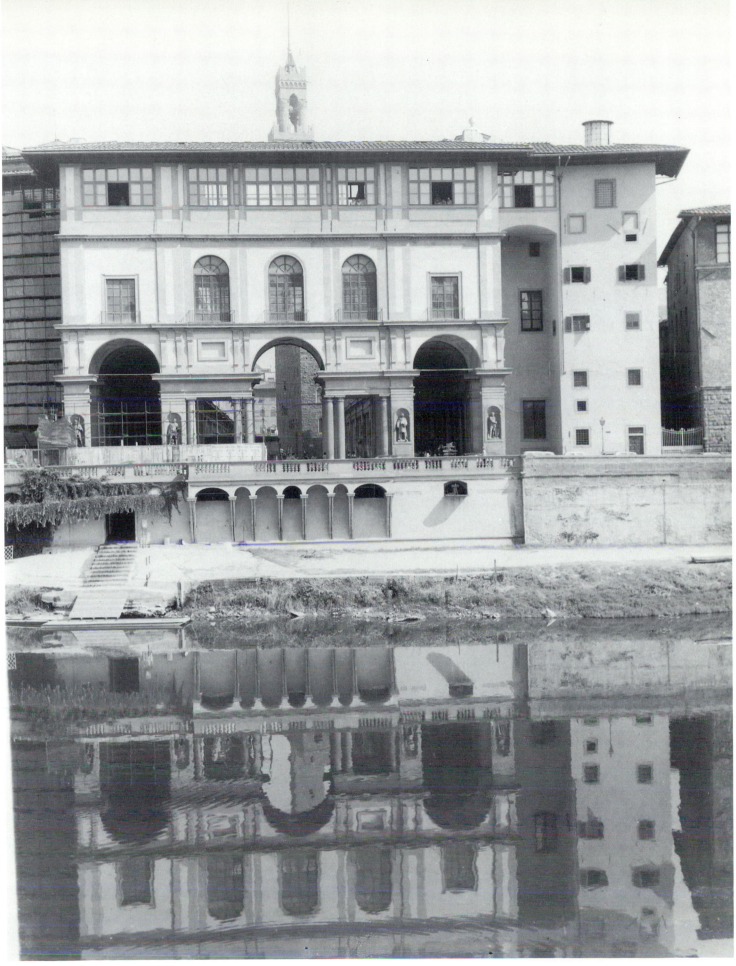

233. Uffizi, facade along the Arno

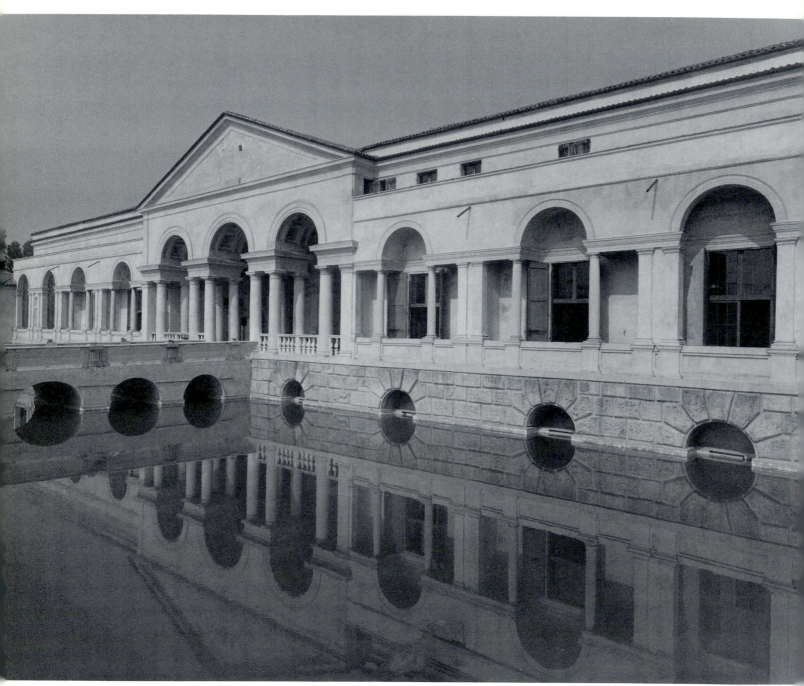

234. Mantua, Palazzo del Te by Giulio Romano, begun 1525

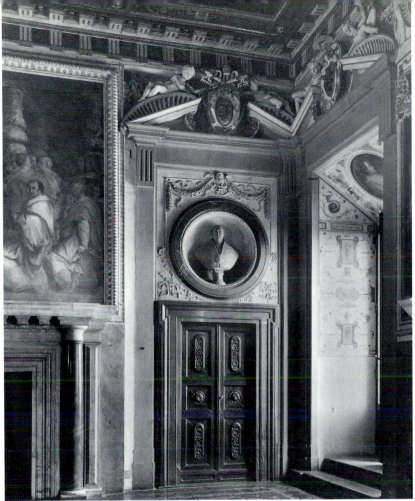

A

235. Comparison of doorways

 A: Sala di Leone X by Vasari
 B: New Sacristy, San Lorenzo by
 Michelangelo

B

A

236. Comparison of lanterns

A: Pistoia, Madonna dell' Umilità by Vasari
B: Florence, San Lorenzo, New Sacristy
by Michelangelo

B

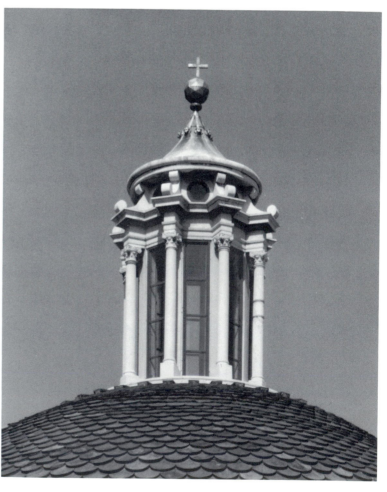

237. Florence, Monte di Pietà, entry by Vasari, c. 1558

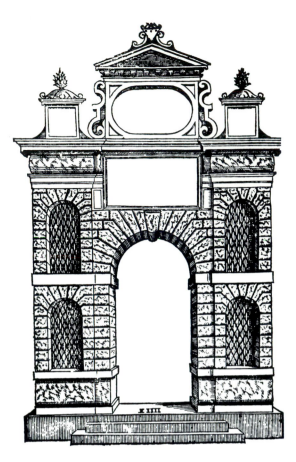

238. Serlio, gateway

239. Poggio a Caiano, Medici Villa, gateway by Vasari, 1562

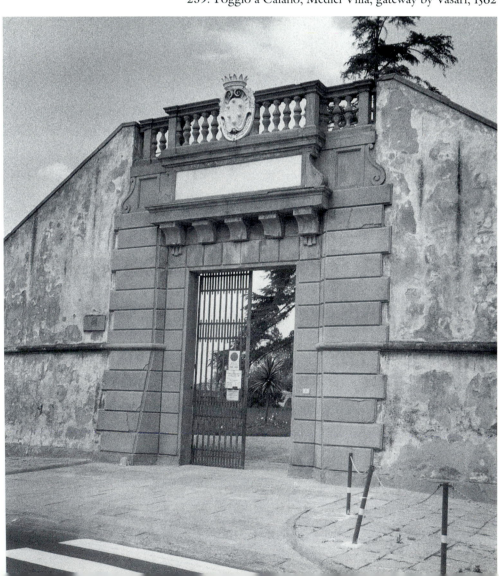